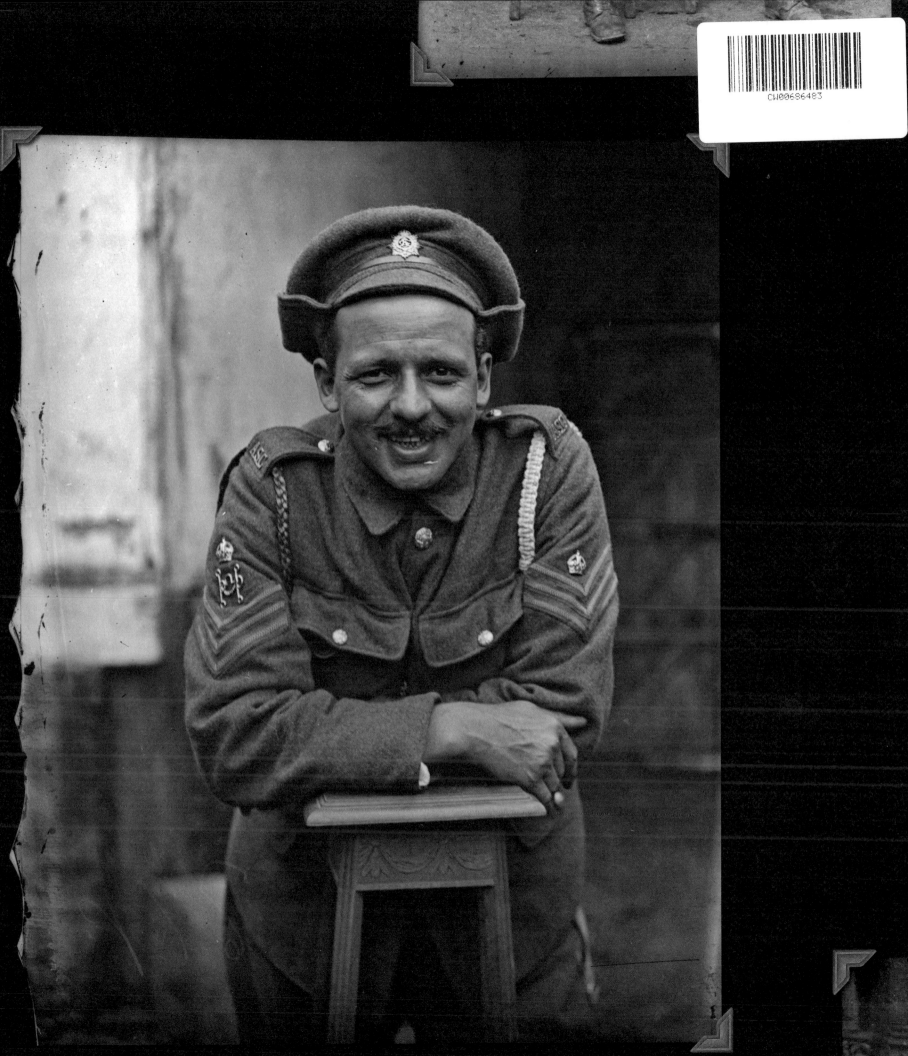

THE LOST TOMMIES

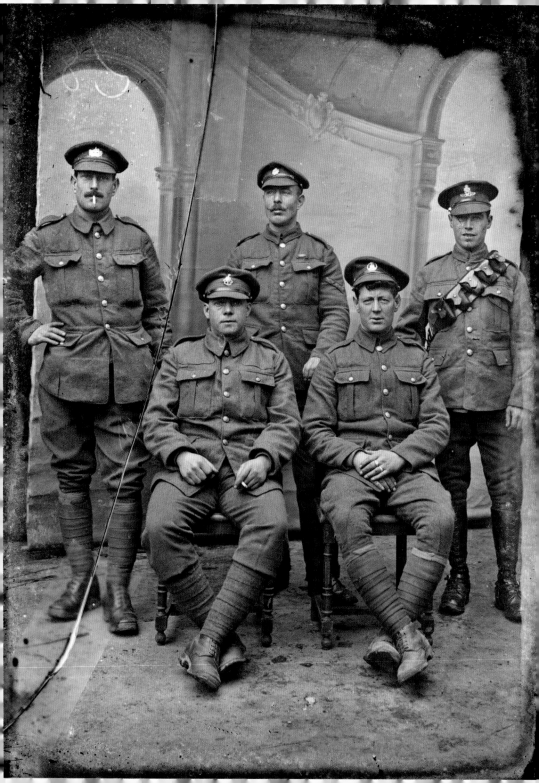

THE LOST TOMMIES

Ross Coulthart

WILLIAM
COLLINS

Contents

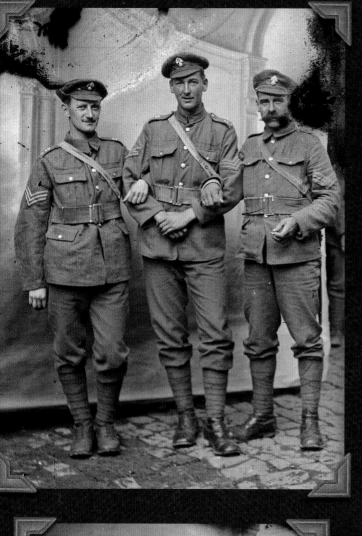
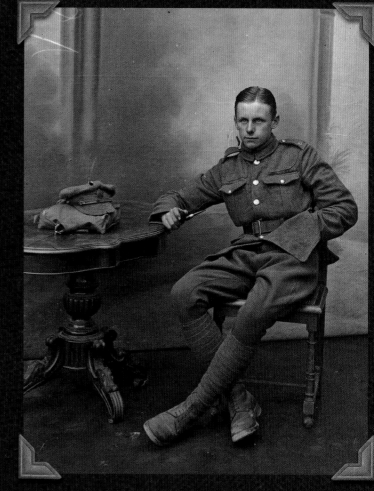

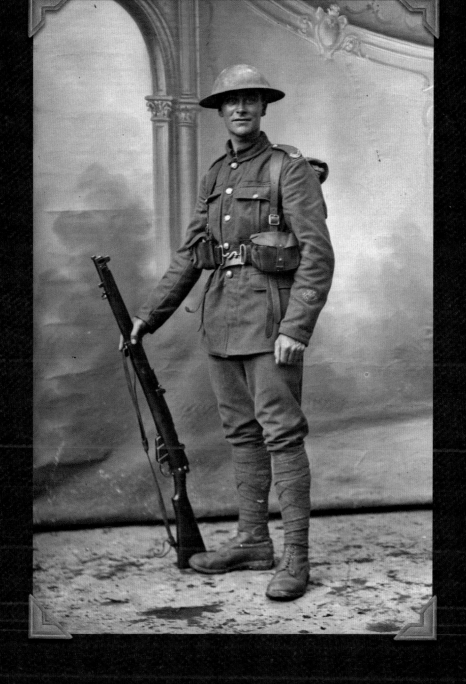

The men who were boys when I was a boy are dead. Indeed they never even grew to be men.
They were slaughtered in youth; and the parents of them have grown lonely, the girls they would have
married have grown grey in spinsterhood, and the work they would have done remains undone.

J.B. Priestley[1]

Prologue

… average men and women were delighted at the prospect of war … the anticipation of carnage was delightful to something like ninety per cent of the population. I had to revise my views on human nature.

<div align="right">Bertrand Russell, on 1914[2]</div>

There was a time before, and, for those who survived, there was a time after. But for generations of men and women, the cataclysm of the First World War left a raw emotional scar, a legacy of loss and tragedy that still lingers today. It is difficult to comprehend one century on just how readily so many young men clamoured to go to war. The patriotic fervour that followed the declaration of war in August 1914 may seem quaintly naive today but for many of the men rushing to enlist the biggest fear was that the fighting would all be over before they got the chance to teach the Germans a lesson.

On 4 August 1914 thousands of men already serving in territorial reserve regiments, including those with the Prince of Wales' Own West Yorkshire Regiment, received the long green envelopes marked 'Mobilization – Urgent'. Recruitment offices were also overwhelmed by young men rushing to enlist, willing to do their duty for King and country; a flood reaching 30,000 a day at its peak.

I went to Bellevue Barracks, home of the 6th West Yorks, a Territorial battalion, and found there were crowds round there. Everybody was excited and every time they saw a soldier he was cheered. It was very patriotic and people were singing 'Rule Britannia', 'Land of Hope and Glory', all the favourites. A challenge had been laid down over Belgium and they were eager to take it up. I should have been home at nine but I stayed there until late at night. Everybody stood in groups saying 'We've got to beat the Germans' and quite a number were already setting off to enlist.[3]

PLATE 1 A soldier from the 7th or 8th Battalion, Leeds Rifles. They were part of the West Yorkshire Regiment – he wears the West Yorkshire shoulder badge.

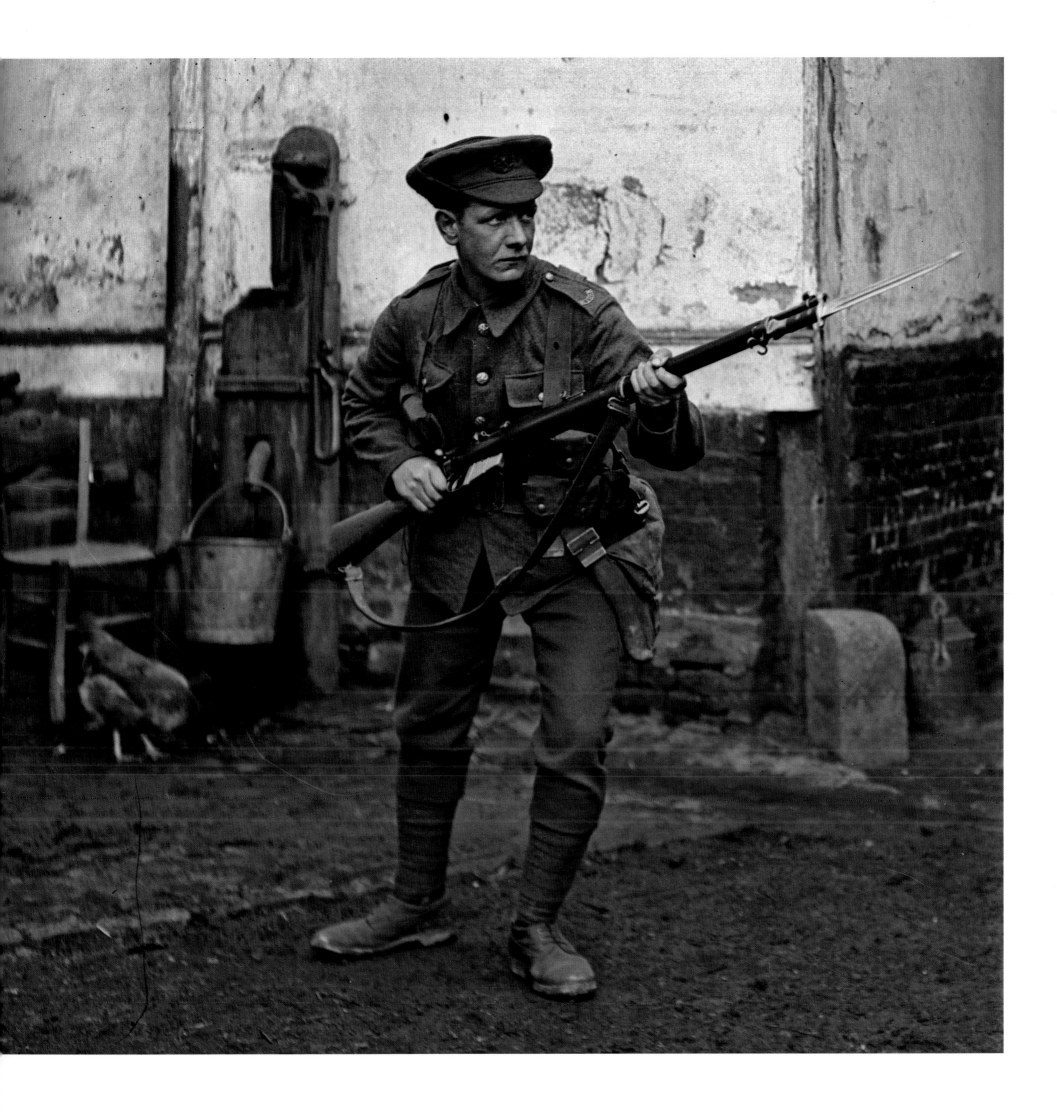

Few anticipated the horror of what was to come. But the survivors would never forget it. George Morgan was one of the first volunteers for the West Yorkshires. When he admitted to the recruiting sergeant that he was only sixteen, the sergeant advised him to go outside, come back and tell him something different. George returned with the implausible claim that he was now in fact nineteen; he was then sworn in to service.

It was the biggest incident in my life. I've lived sixty years afterwards, and I've never, never got over it. It's always been there in my mind. It was the biggest thing that ever happened to me. We'd all got to know each other very well and we were all very good comrades, in fact I don't think there's ever been better comradeship ever ... and then all at once when this day, this terrible day of 1st July, we were wiped out.[4]

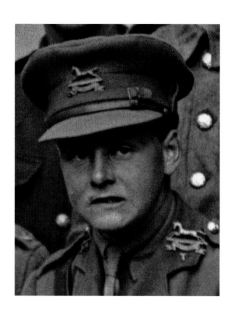

Just two years into the war, on that first day of the Battle of the Somme, 1 July 1916, it was one battalion in particular of those eager West Yorkshires, the 10th, that was to earn the dubious distinction of having suffered more casualties on that dreadful day than any other British Army unit. Twenty-two officers and 688 men were either killed or wounded, from a unit normally 1,000-strong; more than two-thirds of the men failed to answer the roll call the following day. During the months the Battle of the Somme raged, some one million men from both sides of the conflict combined would be either killed or wounded – and for little discernible gain to either side.

The West Yorkshires was just one of dozens of regiments that went over the top on the first day of the Somme – over 20,000 British soldiers would die in that first twenty-four hours alone; there were 57,470 casualties. Such losses are so overwhelming in their magnitude, so great was the industrial scale of the slaughter, that one can sometimes overlook the fact that each of those broken bodies was a father, a son, a brother, a lover or friend.

Throughout the war, in a quieter corner of Picardy just behind the Somme front lines, soldiers from regiments like the West Yorkshires enjoyed brief respites from the conflict. It was in the small village of Vignacourt that thousands of soldiers met a local French couple who dedicated themselves throughout the war to photographing the soldiers – partly to supplement their income but also because they no doubt realized the profound historic significance of what they were witnessing on their doorstep.

PLATE 2 Close-up of Captain Walter Alexander Scales, 6th Battalion West Yorkshires.

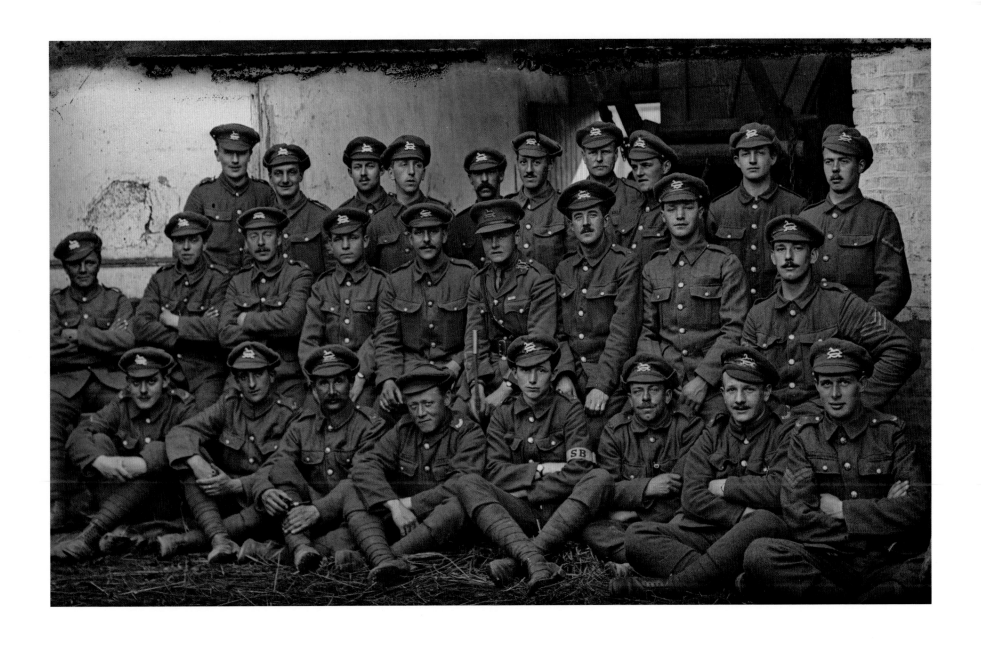

PLATE 3 Soldiers of the 6th Battalion West Yorkshire Regiment in Vignacourt while they were billeted in the area from early April 1916 through to 9 June.

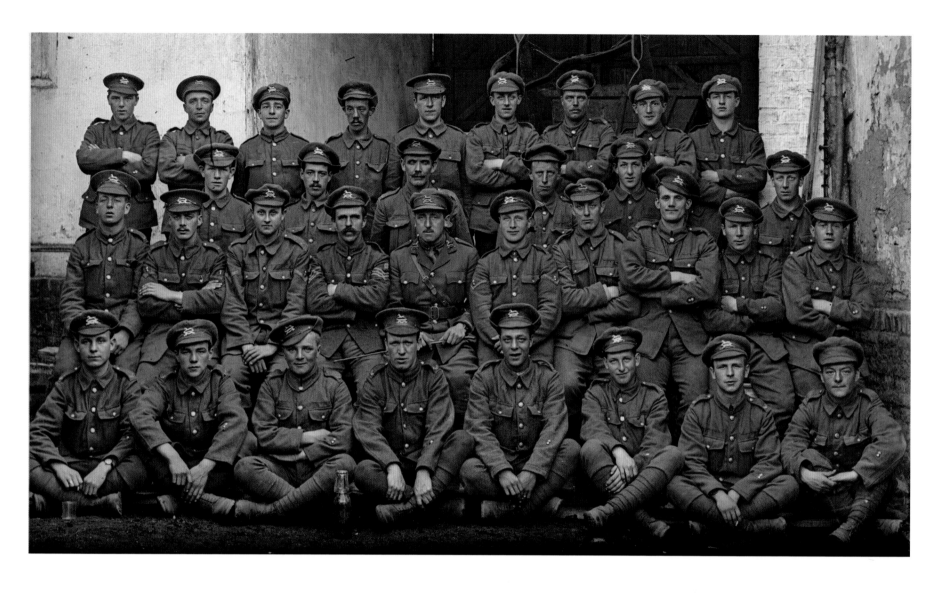

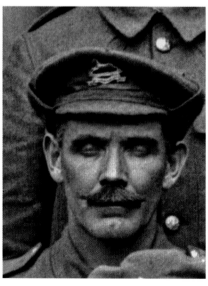

They were civilian amateur photographers Louis and Antoinette Thuillier and, as battalion after battalion visited their village of Vignacourt, the couple captured images of the men (individually and in groups) before they were once again thrown back into the trenches, all too often to suffer grievous wounding or death. Among the pictures taken by Louis and Antoinette is the one on p. 11 featuring members of the 6th Battalion of the West Yorkshire Regiment.

One of those West Yorkshiremen photographed was a young Bradford man, Walter Scales, a twenty-year-old clerk when his 6th Battalion West Yorkshires was mobilized. He was an officer – barely out of his teens – in a proud territorial unit made up largely of volunteer city workers like himself. Walter looked so young when he joined up that his brother officers called him 'the Babe'. Within weeks of this photograph being taken by the Thuilliers, he was to lead his men into the horrors of the Battle of the Somme.

For all the troops, Vignacourt was a welcome relief from the front line. A 6th Battalion history records the eight weeks the unit spent training and resting in and around Vignacourt as one of the happier times the battalion enjoyed throughout the entire war:

> If we looked at this Vignacourt period from the point of view of the official War Diary we should dismiss it in a few words, something as follows:- 'Training carried on vigorously: Battalion and Field Days weekly: Reinforcements of three officers and 170 other ranks received in May: two officers and 100 other ranks provided for work on New Railway Sidings at Vignacourt; battalion provides Brigade Head Quarters' Guard every fourth day, etc, etc.' The War Diary would thus compress the life of eight weeks into as many lines, whereas a few lurid hours in the Leipzig Salient on July 15th would fill a page. Most of the members of the Battalion would reverse the emphasis, however, and become eloquent on a joy ride to Amiens: a favourite estaminet at Vignacourt: an anniversary dinner: a jolly billet; and they would dismiss the affair in the Leipzig Salient with a shrug, as hardly being worth mentioning in comparison.[5]

There were also the 'bombers' of the West Yorkshires, who arrived in Vignacourt on 5 April 1916 for a well-earned rest from months of fighting. Among them were Bernard Coyne, John Bannister and Harry Duckett. The bombers were a unit of men specially trained in the use of hand grenades, a form of warfare that required close and bloody fighting at the sharpest point of the front lines. These men knew their odds were not good going into the coming Somme offensive. Two of that trio would fall within weeks; the other would almost make it through the war, only to fall in its final few weeks.

For eight weeks the West Yorkshires took their rest and training in Vignacourt but they knew what was coming. One history records that the men came to regard their time in the village as their 'fattening up for the slaughter'.[6]

PLATE 4 Bombers of the 1/6th Battalion of the West Yorkshire Regiment in Vignacourt during their eleven days in the area from 5 April 1916.
PLATES 5–7 (left to right) 1/6th West Yorkshire bombers Bernard Coyne, John Bannister and Harry Duckett.

Within possibly just days and certainly weeks of his photograph being taken in Louis Thuillier's farmyard (Plates 8 and 9, opposite), Second Lieutenant Cuthbert George Higgins, the smooth-faced young officer sitting in the middle of the men of C Company from the 6th Battalion of the West Yorkshires, was dead. Higgins was a Londoner from Hanover Square – his father, William, is listed in the 1901 census as clerk to a brewing company – and it is not clear how his son came to be commissioned with the West Yorkshires. Within hours of the beginning of the Battle of the Somme, on 1 July 1916, the twenty-four-year-old was killed in the British Army's massive attack on the town of Thiepval. Assaulting the town required the breaching of a maze of trenches heavily protected with a huge number of machine guns, across an open and exposed no man's land. Higgins was in the reserves, waiting in Thiepval Wood to follow the leading waves of troops that had gone over the top at 6.30 a.m. When the order finally came at around 3.30 p.m. for his company to advance, logistical failures meant the 6th Battalion had to go over alone:

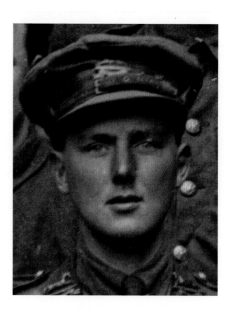

> *It is a misnomer to say they attacked Thiepval, for not a man got more than a hundred yards across No Man's Land. 'The men dropped down in rows, and platoons of the other companies following behind remained in our lines, as to do anything else was suicide. It is impossible to describe the angry despair which filled every man at this unspeakable moment. It was a gallant attack,' said the Brigade Diary, 'but could not succeed from the first.' The enemy's parapet was alive with machine guns. Again and again attempts were made to climb the parapets and advance, but all in vain, those who succeeded in reaching No Man's Land only added their bodies to the pile of dead and dying. The 1/6th was the only Battalion of the 146th Infantry Brigade which succeeded in obeying the orders to advance, with what result has been described – every third man in the Battalion had become a casualty – the results were nil!*[7]

It puts the war's appalling losses in some perspective to pause and consider that toll; one-third of this one small battalion, men whose faces are probably among these Thuillier images, was wounded or killed on the very first day of the Somme … so many casualties in just one day of fighting, in a war that was to last for years.

Almost a century later it is easy to imagine that the ghosts of these lost Tommies still linger in the ancient French farmhouse where these photographs were taken. On a bitterly cold winter morning, above the very farm courtyard where thousands of young soldiers posed, I am stumbling up an ancient wooden spiral staircase on the last leg of what has been an intriguing historical detective story chasing the clues in the Thuillier

PLATE 8 Close-up of Second Lieutenant, C. G. Higgins, C Company, 6th Battalion West Yorkshire Regiment, taken during the battalion's eight-week stay in Vignacourt from April to June 1916.

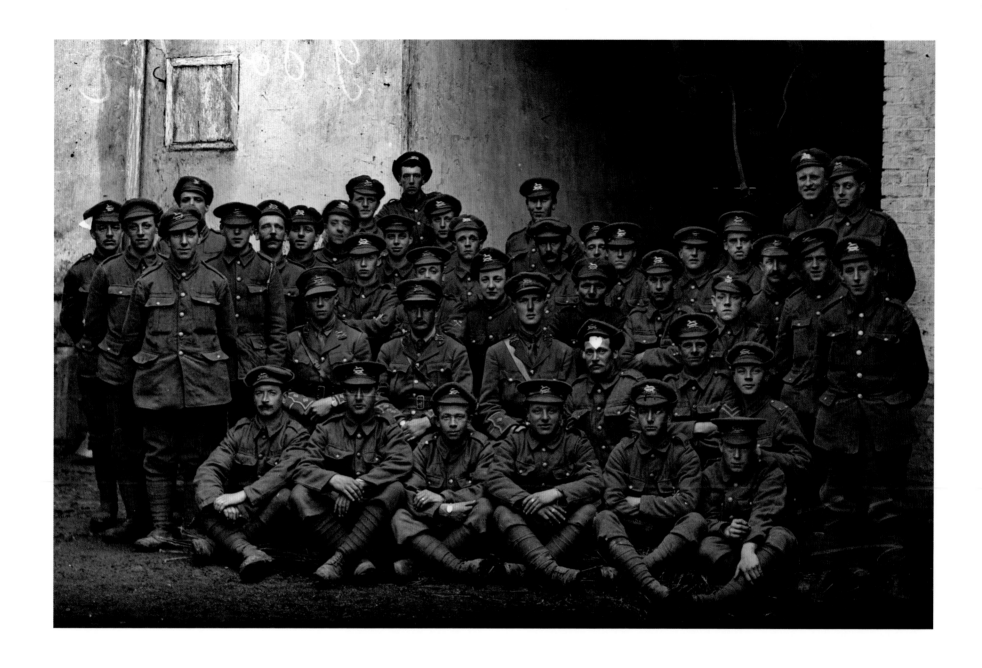

PLATE 9 West Yorkshire Regiment
6th Battalion soldiers, probably from
C Company under the command of then
Captain R. A. Fawcett (seated, second
row, second from left). The officer first
from left is a Lieutenant Hornshaw.
The officer third from left is Second
Lieutenant C. G. Higgins.

images. Each step takes me further back in history, through the detritus of a family home stretching back generations. The wobbly and uneven steps are layered with dust, and I have to steady myself against the crumbling plaster and brick walls. I feel my way in the murky gloom as I step into the attic of this old farmhouse.

The attic is a long, dusty, oak-floored room. Although I am wrapped against the bitter cold of a French winter, the biting chill still penetrates the gaps in the eaves and walls. We move aside old leather suitcases, saw blades and bottles, a stack of empty salvaged Second World War American jerrycans; in one corner is an elegant, perfectly preserved nineteenth-century baby's carriage with large painted cast-iron wheels. Above our heads the knots of old tree limbs can still be seen in the hand-chiselled oak beams supporting the heavy tiled roof.

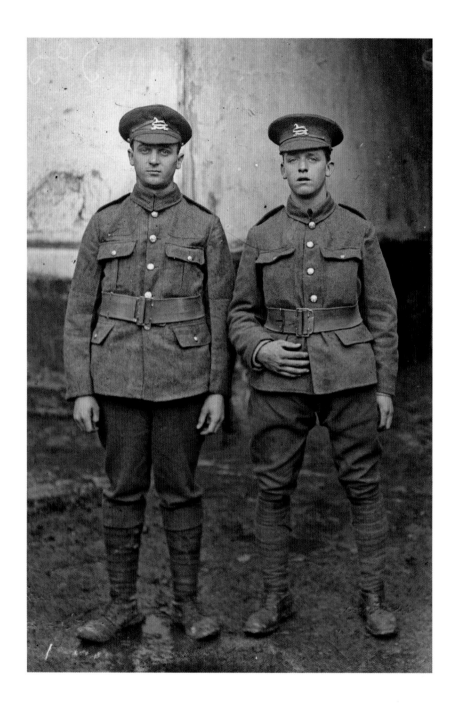

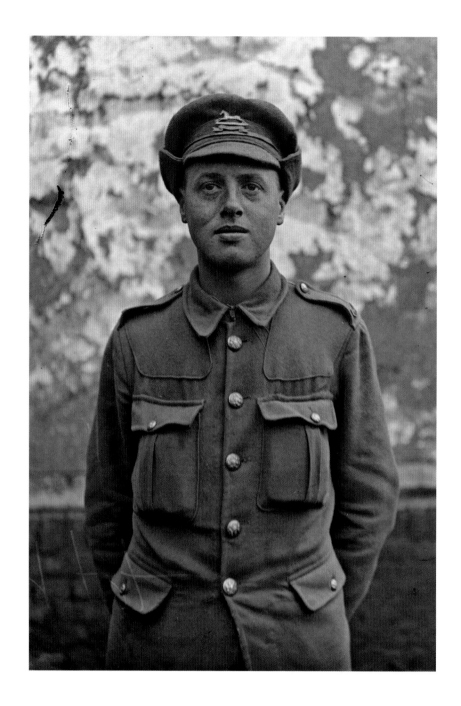

PLATES 10–12 Young soldiers of the West Yorkshire Regiment just before the Battle of the Somme – a final few days' rest in Vignacourt before the Big Push.

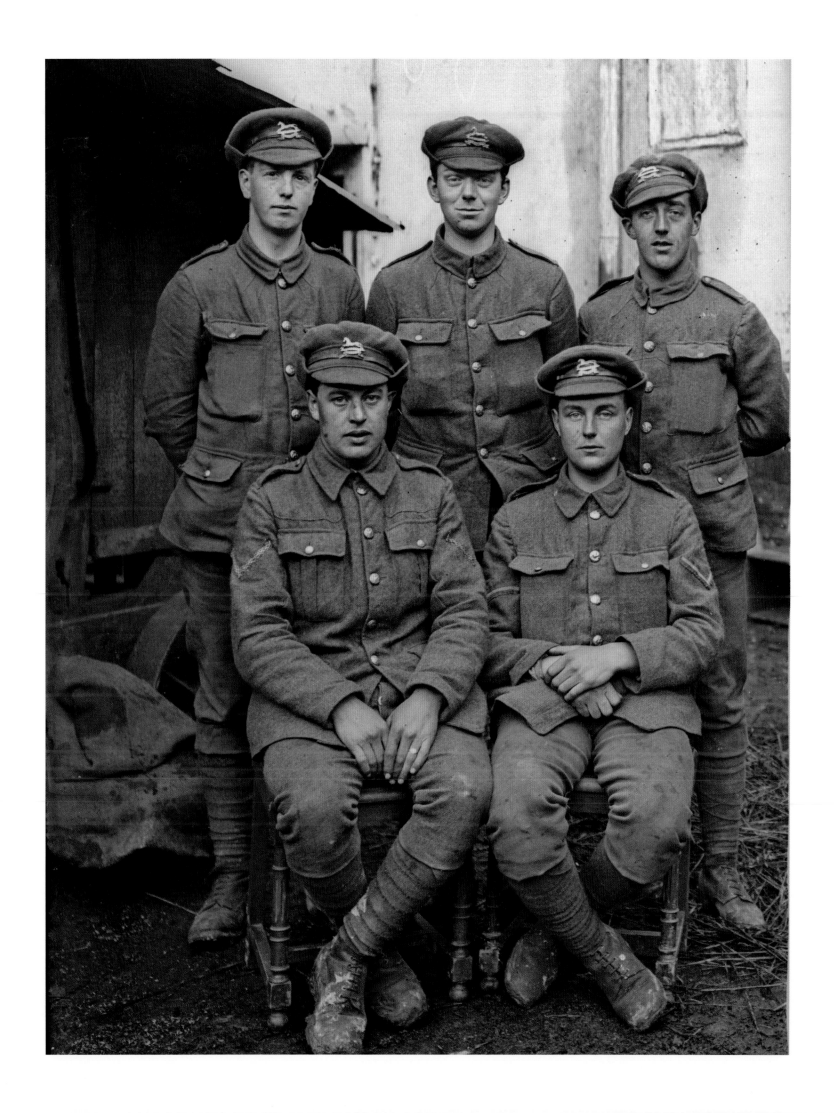

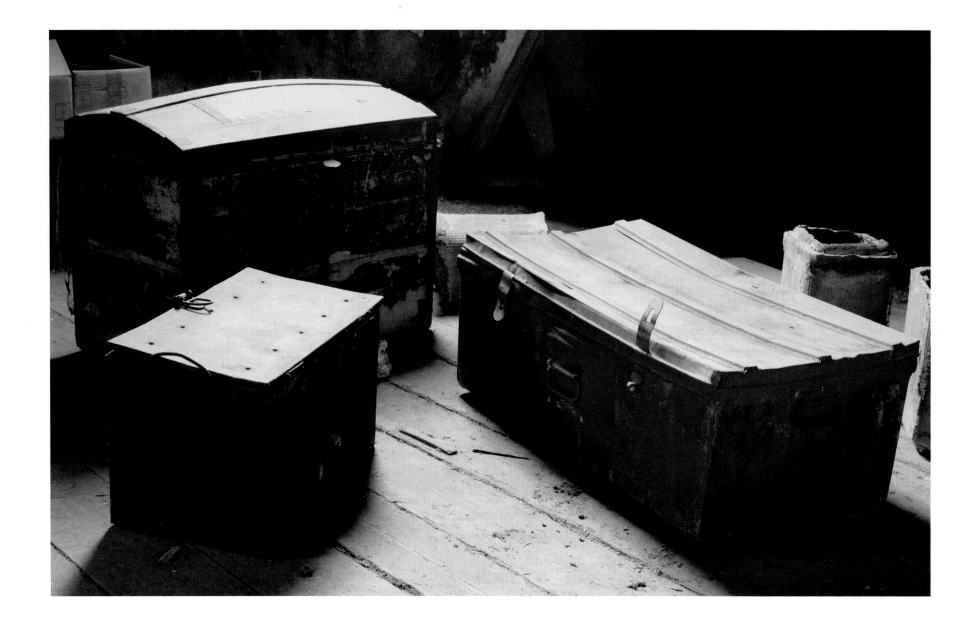

My breath is visible as condensation in the frigid air. There is only the sound of feet shuffling up the stairs behind me, and the muffled noise of the occasional vehicle outside. We are all mute with anticipation. It scarcely seems possible that this decrepit attic could be, after months of searching, the place where a treasure trove of extraordinary First World War photographs has lain hidden. There are mounds of old motorcycling magazines from the 1930s that we carefully lift aside, peeling back the decades of a family's jumble. Everything is covered in a thick layer of dust.

Then, by the light of an attic window, we see three old chests.

I lift the lid of one of them, a battered ancient metal and wood chest. And there they are: thousands of glass photographic plates – candid images of First World War British soldiers behind the lines. There were also Australian, New Zealand, Canadian, American, Indian, French and other Allied troops.

PLATE 13 The battered chests in which the glass plates were stored. (Courtesy Brendan Harvey)

THE ORIGINS OF 'TOMMY'

There was a touching naivety among the officers and men who had marched to war as 'Pals' and volunteers; the depth of patriotic feeling and the urge to rush off to war to defend Mother England may seem extraordinary today. But this was an era of the great British Empire and there was enormous pride and loyalty to King and country. Men were proud to be British 'Tommies', a curious term for British soldiers that many believe has its origins in a story that underlines the blood and sacrifice that for most Britons back then made Great Britain and its empire 'Great'. The term 'Tommy Atkins' was being used as a generic description of British troops early in the eighteenth century. But one account of how First World War troops came to be known as 'Tommies' was that it was appropriated from the story of a British soldier named Tommy Atkins who had died in a battle in Flanders, Belgium, in 1794. The story went that the Duke of Wellington was inspecting badly wounded soldiers after a battle. One of the wounded men was named Tommy Atkins. It was the stuff of legend that Tommy, asked if he was in pain, reassured the Duke: 'It's all right, sir. It's all in a day's work.' Tommy's stiff upper lip just before he died was seen as exemplifying the best of British courage and dogged persistence against terrible odds.

Perhaps, as the notable historian Richard Holmes has more soberly suggested, the real derivation was an 1815 War Office publication which used the name of 'Private Tommy Atkins' as an example to show soldiers how to fill out their *Soldiers Pocket Book*.[8]

Whatever the true reason, the term 'Tommy' or 'Tommies' became a well-known generic and affectionate name for British soldiers throughout the war.

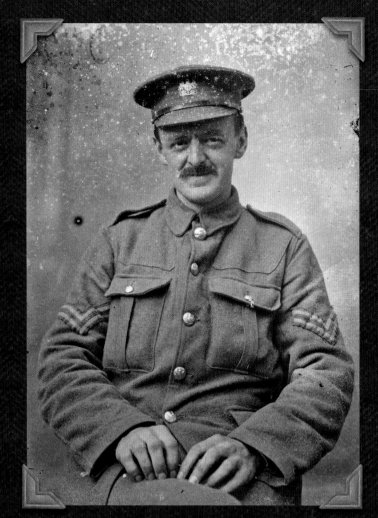
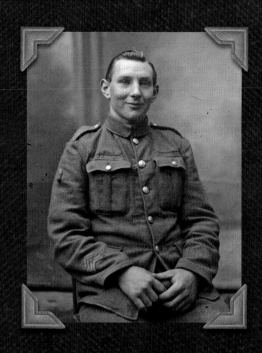

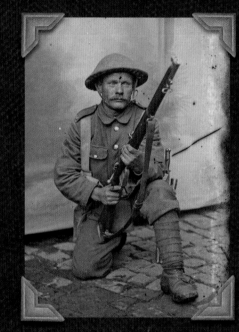
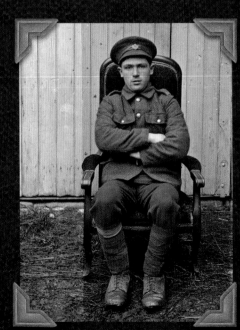
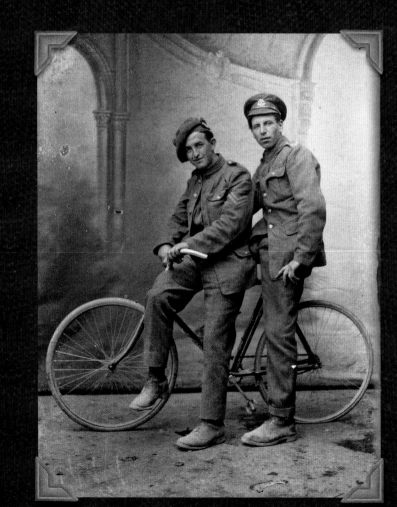
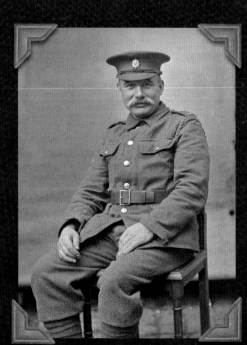

Part One

THE DISCOVERY

Finding the Thuillier Photographic Plates

The astonishing discovery all started with a healthy journalistic hunch. In a series of articles in May 2009, London's *Independent* newspaper published images of some glass negatives of First World War soldiers. Most of the photographs were of British 'Tommies' and a handful depicted Allied soldiers from the far corners of the then British Empire. The accompanying articles said the photographs were rescued from a rubbish heap somewhere in northern France. The high-definition, near-century-old images generated great interest both in the United Kingdom and overseas and were by far the most visited items on the *Independent*'s website in that period. Intriguingly, the articles, written by John Lichfield, shed no light on who took the photographs – saying only that the photographer was 'unknown'. The *Independent* stories recorded that the small cache they published had probably been stored in the attic of a barn at Warloy-Baillon, only a short distance from the original battlefield front lines. Warloy-Baillon was the site of an Allied clearance hospital during the war. In 2007 the barn was renovated and the plates were thrown into a rubbish skip but they were 'rescued' by passers-by. Dominique Zanardi, proprietor of the 'Tommy' café at Pozières, uncovered the Warloy-Baillon photographic plates with the help of a local photography enthusiast Bernard Gardin. Zanardi told the newspaper that the photographs were possibly the work of two separate photographers, but that attempts to find the location where they were shot or the photographers' descendants had failed.

When the *Independent* stories were published online I was enthralled by the images – especially by the small number of images of Australian soldiers among them. There were also a handful of images held in the Australian War Memorial archives which, intriguingly, showed groups of men, clearly in a different location, photographed in front of the same distinctive canvas backdrop. Were there more? I and my colleagues wondered.

Outside of the war photographs taken mainly by British official photographers, there are relatively few high-quality images captured around the Western Front in France and Belgium during the First World War – especially images of the life immediately

PLATE 14 A 1918 image of a group of Royal Fusiliers. The soldier seated on the ground is a machine gunner.

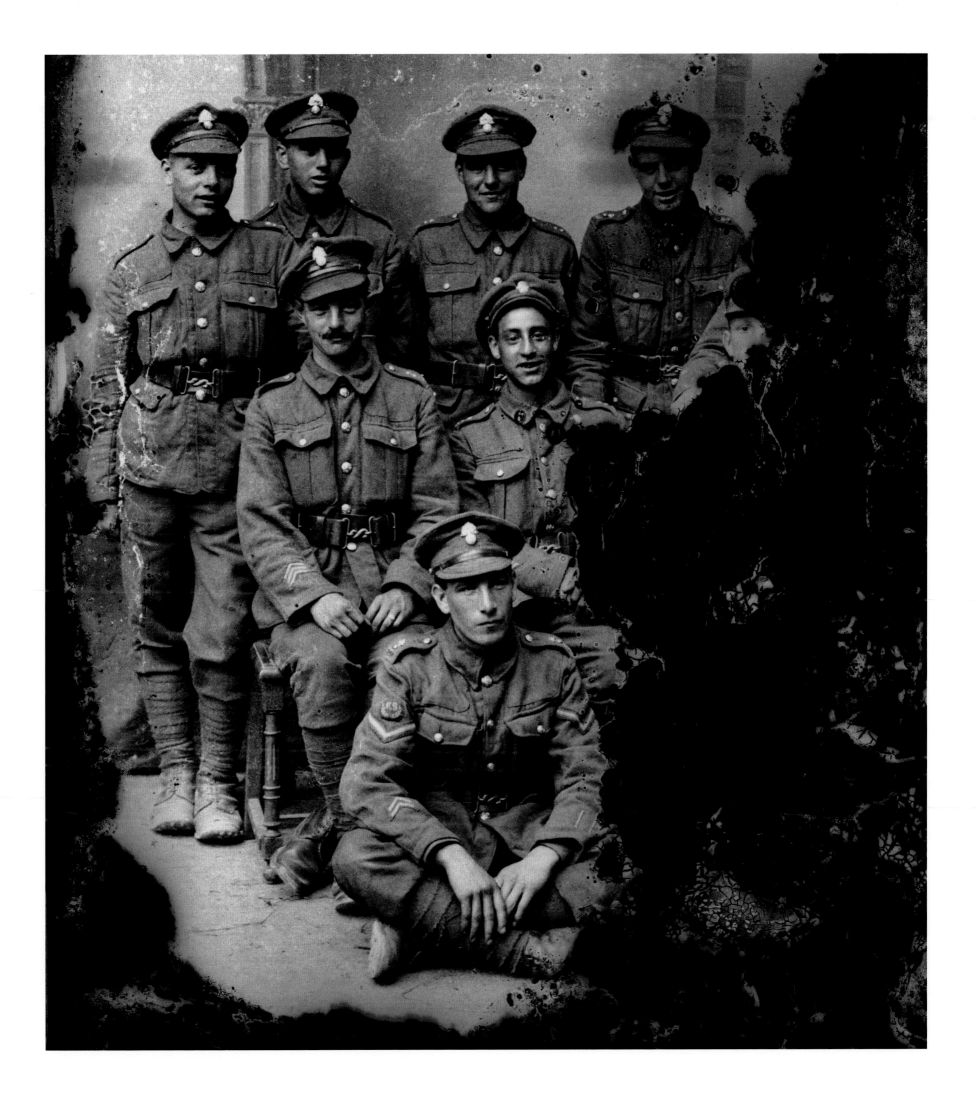

behind the lines in the rest and training areas like Vignacourt. Unlike at the Dardanelles, where many Allied soldiers took cameras into the front lines, on the Western Front the British command strictly banned servicemen from taking cameras into battle zones. From early in the war, authorized military photographers took most photographs but even these were limited for reasons of security. The images published in the *Independent* fuelled speculation that there might be more images like them taken by French locals or others not in an official role. Were there more photographs to be found? It seemed a reasonable prospect for further investigation.

The real hero of this story is Laurent Mirouze, a Loire Valley antiques and furniture dealer as well as a published historian and experienced journalist. Late in the 1980s, one of Laurent's friends, who knew of his passion for military history, mentioned that he had seen some beautiful photographs of First World War soldiers on the walls of a council building in the small Picardy town of Vignacourt, just north of the city of Amiens. Sensing a good story, Laurent decided to drive the few hours from his home to Vignacourt to take a look. There, hanging on the walls of the tiny council offices, were the most extraordinary pictures featuring Allied soldiers, mainly British and Australians. Only about twenty pictures were exhibited, but Laurent eventually tracked down the photographer who had printed them from the original plates, a Vignacourt resident, Robert Crognier.

When Laurent visited Monsieur Crognier at his home in 1989, he was astonished to discover that the photographs he had seen displayed at the local council offices were just the tip of an iceberg. There were thousands of pictures on photographic glass plates, he was told. He learned of Louis and Antoinette Thuillier and Monsieur Crognier told him the plates were still in the possession of the family. (Monsieur Crognier was a nephew of Louis and Antoinette, and he had reproduced the images from the plates with the permission of Roger Thuillier, one of their sons.) Monsieur Crognier explained to Laurent that the collection was housed at the time in a family home in Vignacourt and, while he let Laurent take photographic prints of several hundred of the plates, he never disclosed the precise location of the full collection. As it turned out, this was an entirely separate collection from the photographs later published by the *Independent*.

Laurent realized very quickly that the plates were hugely important not only to British but all other First World War Allied countries' military history. They were also a cracking good story for this aspiring military historian. He had himself photographed

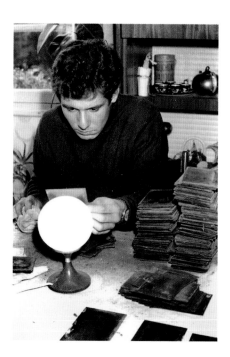

PLATE 15 Robert Crognier. (Courtesy Madame Crognier)
PLATE 16 Laurent Mirouze inspecting some of the Thuillier plates in 1989 before they disappeared. (Courtesy Laurent Mirouze)
PLATE 17 Two Royal Fusiliers. The soldier standing wears the stiff service cap and the soldier seated the softer cloth cap introduced after the war began.

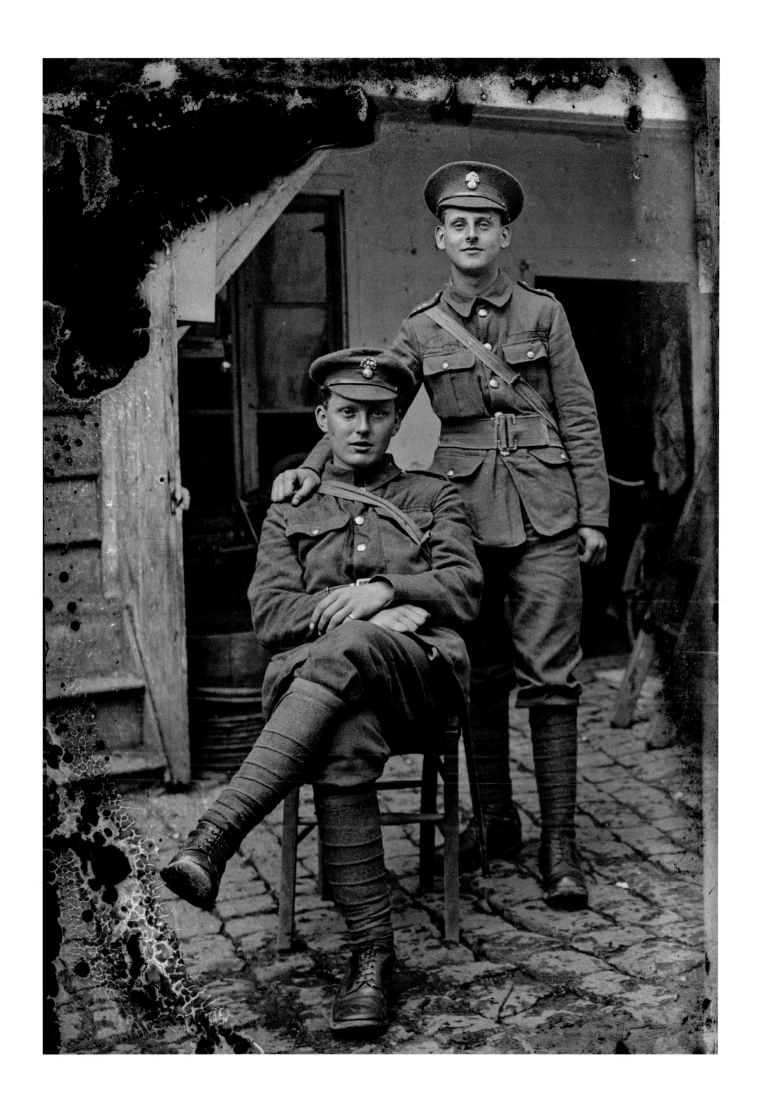

Unveiling of the sign proclaiming "Rue des Australiens" by the Honorable Alan R WOOD, former Minister of the Public Works of Australia, showing the name plate. Inauguration de la "Rue des Australiens" - Monsieur le Ministre Alan R WOOD, dévoilant la plaque.

reviewing the plates, thinking – not without good reason – that he would have media and military historians beating a path to his door to view the collection. With the permission of Robert Crognier, Laurent wrote an article in France and England, revealing the discovery and publishing some of the images.

In the spring of 1990 Laurent also rang the Australian Embassy in Paris, formally writing to them and sending them copies of some of the pictures so they could see for themselves. 'I said there's hundreds of them – could this be of any interest to you?' Laurent recalls. 'But I could feel very clearly that they were not very interested in the story. A shame!' Laurent laconically comments today, 'Maybe these people are not interested in the First World War.' Laurent never heard back from anyone at the Australian Embassy, nor did he get much interest from British researchers. Despite this, he made one last effort to alert military historians to his discovery by publishing a story about the Thuillier collection in a British military magazine, *Military Illustrated*, in November 1991. Absurdly, nobody ever contacted Laurent Mirouze. So he got on with his life, thinking no one was interested.

The minister Mr Alan R. WOOD, admiring the photographs collection.

The French kid Henri DUBOILLE, got on well with these two diggers of the 2nd division. The man on the right is a veteran of the Gallipoli war.
Ce petit français Henri DUBOILLE s'est fait deux amis en la personne de ces deux Diggers de la 2e Division. L'homme de droite est un vétéran de la campagne de Gallipoli.

Between two dills, this Australian Sergeant came to have his photograph taken: He gives an idea of the assault dress wore by the Australian infantry.
Entre deux exercices ce Sergent Australien est venu se faire photographier, il donne une juste idée de la tenue d'assaut de l'infanterie Australienne.

But there was someone else also trying to track down the Thuillier plates. Peter Burness, a historian from the War Memorial in Australia, is a tenacious military history investigator and a passionate First World War buff. In about 1990 a small commemorative pamphlet published in Vignacourt had landed on his desk. It featured a small sample of the prints of Allied soldiers which had been retrieved from the Thuillier plates by Robert Crognier. The pamphlet even helpfully told readers that these pictures were a fraction of the 3,000 or more images taken by Thuillier and his wife. 'The photographs of this booklet are only samples of the collection,' the pamphlet reads.

The pamphlet had been produced for a commemorative ceremony on 22 April 1988 in Vignacourt. The guests included dignitaries and officials from the Australian Embassy in France. They were there for the dedication of one of the town's streets to Australia, to be called 'Rue des Australiens', a tribute organized by Robert Crognier, the mayor Michel Hubau, and René Gamard, a Vignacourt historian. The Frenchmen were

PLATES 18–19 The cover and images from the Vignacourt brochure featuring some of the Thuillier pictures.

PLATES 20–21 Laurent Mirouze back where the trail started in 1989, and showing Peter Burness what he found on the walls of Vignacourt's council chambers.

honouring a promise made back in 1918 by the town's then mayor, Monsieur Thuillier-Buridard, to keep an 'eternal bond' with Australia and other Allied nations that had fought for France's freedom.

For the ceremony, a small number of the Thuillier images were displayed by the proud locals. Like so many French people, the villagers of Vignacourt still honour the Allied soldiers who died for their freedom. Unfortunately the visiting officials seemed to have had no idea of the significance of the photographs and were still ignorant of their importance two years later when Laurent approached the Australian Embassy in Paris. However, gazing at the pamphlet on his desk, Peter Burness recognized the plates' historical importance and set about trying to track down the source. Sadly, by the mid-1990s, Robert Crognier was ill and in 1997 he passed away. Repeated efforts to contact the remaining Thuillier relatives through the town council offices failed. Despite years of searching, it seemed the more Peter hunted for the elusive Thuillier collection, the more he sensed a deliberate evasiveness by some around Vignacourt. So the whereabouts of these photographic plates remained unknown.

In the course of our investigations, we approached a British historian, Paul Reed, who is well known for his books on the First World War and who also lives part of the year in a house in the Somme countryside. Paul was unable to shed any further light on the

provenance of the Warloy-Baillon collection, but he did tell us about Laurent Mirouze, whom he had heard might know something about another collection of photographs.

From the moment we first spoke to Laurent, the Frenchman was overjoyed that somebody had finally contacted him. 'I've been waiting twenty years for this,' he said to us in our first phone call late in 2010. He told us that his photographer friend Robert Crognier had died in 1997, but Laurent agreed to help in the search for the full collection of plates. It was not an easy task. Each time we rang Vignacourt locals, our efforts to find Thuillier relatives were met with a polite rebuff. The family members with knowledge of the collection seemed to have disappeared. It was only later, when we actually knocked on their door, that we learned of an internal family rift; some members of the Thuillier family did not want the collection to be found. We learned that the Thuillier images had 'disappeared', probably because some family members, now dead, resented the way that all First World War memorabilia was being acquired by the French government in order to build up the collections of its war museums – including the large regional museum in nearby Péronne. It would seem the Thuillier plates went underground after the 1988 ceremony because some locals did not want the French government to plunder a piece of Vignacourt heritage without giving adequate compensation in return.

And so it happened that on a cold February morning in early 2011 in Vignacourt, we began where Laurent's quest had ended twenty years earlier, at Vignacourt's council building. There in the council chambers we saw the handful of tantalizing pictures hanging on the walls. The Australian War Memorial historian Peter Burness was with us and he was amazed by the quality and clarity of the images on the council chambers' walls. The big question now was, where was the rest of the collection?

The breakthrough came after a day or so of knocking on doors led us to Madame Henriette Crognier, Robert's widow, who still lived in the town. We were ushered into her cluttered living room and, as her cat purred under the table, Madame Crognier's bright eyes scanned ours as we spoke of our search for the pictures. When we explained in detail the enormous historical significance of the pictures, and expressed our hopes that the Australian images at least would be displayed at the War Memorial, Madame finally let a gentle smile lift the corners of her mouth and with a twinkle in her eye she left the room.

Laurent was acting as our translator, and I anxiously asked him if we had said something to upset her. 'No,' he replied. 'She says she has something for you.' Madame Crognier had decided to trust us. Within a few minutes she returned with a couple of

PLATE 22 Madame Crognier shows Peter Burness and Laurent Mirouze her secret stash of Thuillier plates. (Photo: Ross Coulthart)

Second World War ammunition boxes under each arm, and a big smile on her face. She slid the metal cases over the table and, with her hand on one of them, said with a Gallic flourish, '*Pour les Australiens,*' and flicked the lid open.

After all these years she still had some of the Thuillier glass plates her husband had retrieved from the family's hiding place. Better still, she believed the remaining thousands of plates were indeed still in Vignacourt in a farmhouse owned by Louis Thuillier's grandson and granddaughter. We sat there stunned. 'Thousands of plates?' I asked. 'Thousands of plates,' Laurent confirmed the translation. I stumbled on for confirmation: '… that have never been seen before?' '*Oui,*' Madame replied, now delighted with our reaction.

Through Madame Crognier we learned of the surviving descendants of Louis and Antoinette Thuillier, among them their granddaughter, Madame Eliane Bacquet, and their grandson, Christian Thuillier. Neither of them lived in Vignacourt any more but

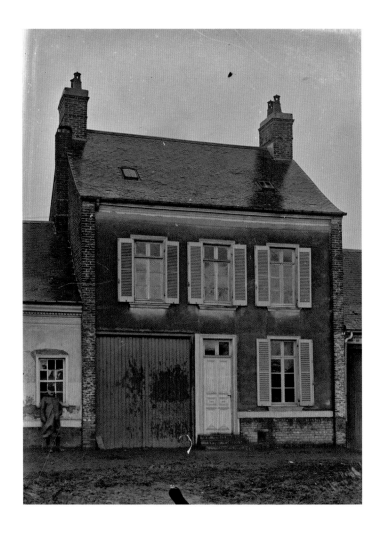

they did still jointly own the empty farmhouse where Louis and Antoinette had offered their photographic services to passing soldiers. Finally, after days of intense negotiations, they agreed to take us to the farmhouse. As it happened, our timing was propitious because the family was thinking of selling the old farmhouse and, in a few months, we were told its contents might well have been thrown on to a rubbish heap.

At the old kitchen table in the run-down farmhouse, Madame Bacquet told a sad story from the Great War. Her mother, the daughter-in-law of Louis and Antoinette, had described how as a young woman during the war she had heard the screams of young wounded men passing through the village in horse-drawn ambulances. 'They were calling for their mothers,' she said. 'It was very sad.'

Madame Bacquet would have made a good probing military interrogator in another life, questioning us for several hours about our motives. As it became clear to her that our quest was an honourable one and that the proud memory of her ancestors would be fulsomely acknowledged, she brought out a collection of Thuillier family photographs. For the first time we laid eyes on Louis and Antoinette.

PLATE 23 A wartime photograph of the front of the Thuillier home at the time when many of the photographs were taken. (From the Thuillier collection)
PLATE 24 Exterior of the Thuillier farmhouse, Vignacourt, February 2011. (Photo: Ross Coulthart)

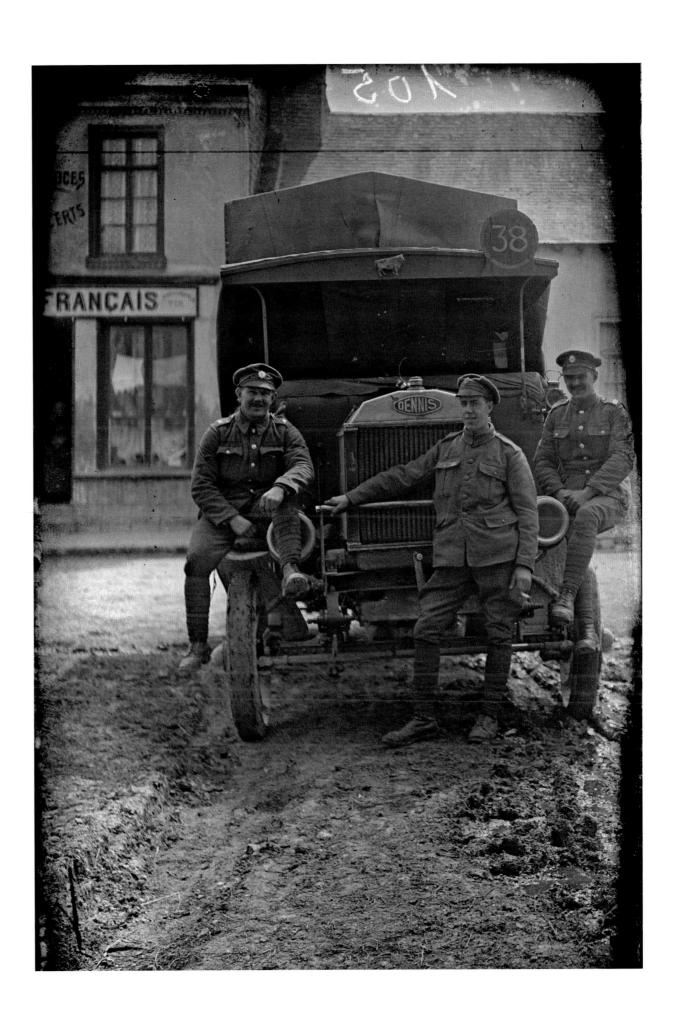

PLATE 25 Soldiers of the Army Services Corps pose with their Dennis troop-carrier truck in the main street of Vignacourt during the war. The buildings behind them still stand today.

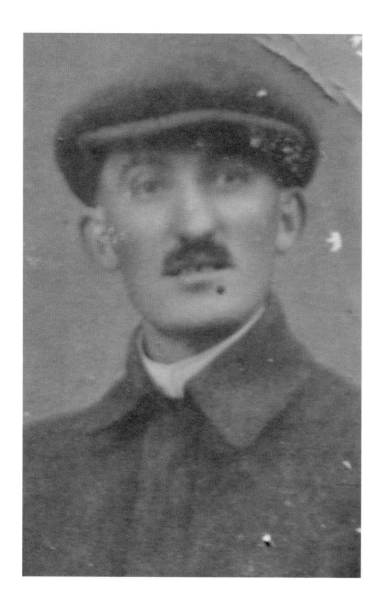

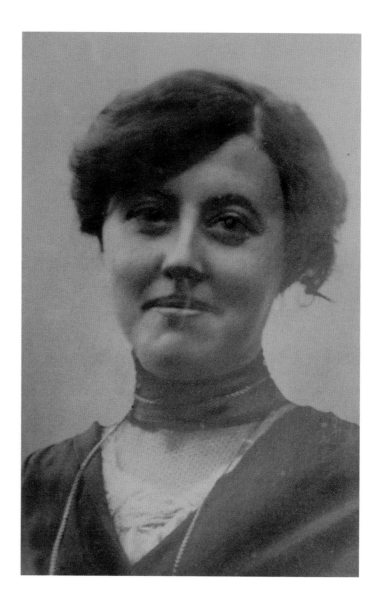

Christian Thuillier, Louis and Antoinette's grandson, is a Normandy businessman. He had been nominated by the family to show us around the farmhouse, and it was Christian who, with a wry smile, conceded that the answer to our quest for the photographs might lie in the attic above the building. We stepped out of the kitchen anteroom into a huge outside courtyard, our hearts missing a beat or two as he led us up several flights of stairs to the attic where the Thuillier photographic plates had been stored for nearly a century. It was as if Louis and Antoinette had just walked away from their massive project and dumped everything upstairs. In the gloom we could discern boxes of unused glass plates and empty bottles that had once no doubt contained the chemicals used to develop the prints. No sign of the original camera. But there, under the light of an attic window … three chests. As soon as we opened the first of them we knew our search was over.

PLATE 26 Louis Thuillier.
(Courtesy Bacquet family)
PLATE 27 Antoinette Thuillier.
(Courtesy Bacquet family)

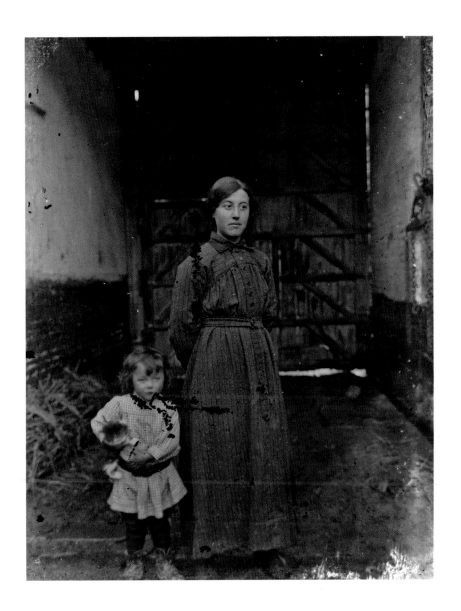

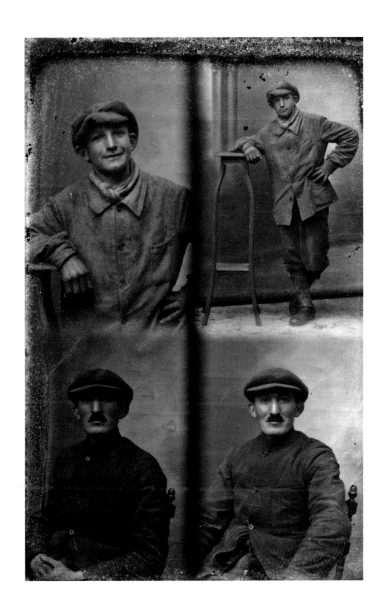

PLATE 28 Antoinette Thuillier poses with her son in the same position where she and her husband photographed thousands of Allied soldiers during the First World War.

PLATE 29 The man in the bottom of this single four-exposure slide is a young Louis Thuillier, almost certainly taken by his wife, Antoinette – perhaps while she was learning to use the cameras?

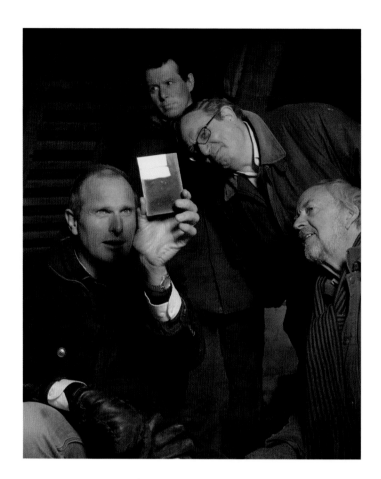

Laurent recognized some boxes immediately. He had helped Robert Crognier
sort through them nearly a quarter of a century earlier, but he had never learned of their
hiding place. After Robert's death, the plates had clearly been dumped and forgotten
here in the attic. As we excitedly searched through box after box, we could hardly believe
what we were seeing. The battered boxes were filled with thousands of glass negative
photographic plates, and for hours we held them up to the attic window light, revealing
often perfectly preserved ghostly negative images of thousands of British Tommies,
Welshmen, Irishmen, Scots, Australian 'diggers', turbaned Sikhs, and French, Canadian
and American soldiers. There were gasps of awe and excitement from all of us, especially
Peter Burness, as he pulled out plate after plate. It seemed scarcely possible that this dusty
attic, freezing in winter and no doubt stifling in the French summer, could have preserved
the photographs so well. On this especially chilly winter's day, it was sobering for all of
us to think what it must have been like for the young soldiers in a French winter, nearly a
hundred years earlier, as they endured the appalling conditions in the open trenches just
twenty to thirty kilometres to the north-east.

Our quest for the elusive Thuillier collection was over, but our investigations into
the stories behind the thousands of plates had only just begun.

PLATE 30 Ross Coulthart looks at the Thuillier plates with, from left, Laurent Mirouze, Christian Thuillier and Peter Burness. (Courtesy Brendan Harvey)
PLATE 31 An original Takiris silver bromide photographic paper box found in the attic. (Photo: Ross Coulthart)
PLATES 32–35 These soldiers belonged to (clockwise from top left) Labour Corps, Royal Army Medical Corps, Royal Engineers, Dorsetshire Regiment.

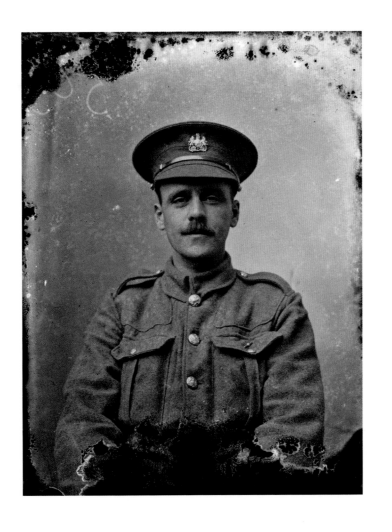
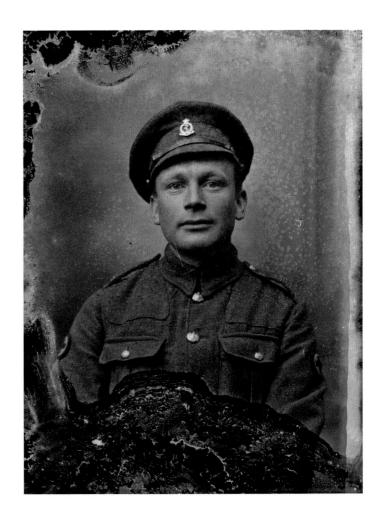
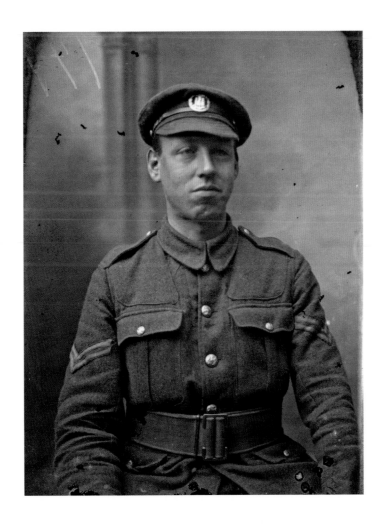
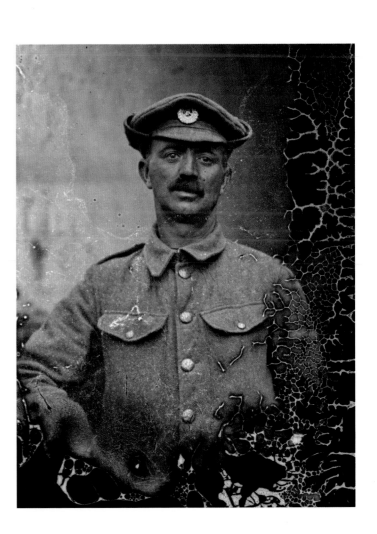

Identifying the Tommies

In February 2011, the Australian Channel Seven TV Network aired a documentary about the discovery of the Thuillier glass plates. Shortly after that 'Lost Diggers' story was broadcast, we posted thousands of the Thuillier collection photographs of the Allied soldiers on the programme's website and also on a specially created Facebook page, which still exists today. It became an unprecedented social media phenomenon for a history archive, with millions viewing the pictures online from all over the world. Within days, the volume of emails, excited phone calls, letters and Facebook messages we were receiving showed just how much the images had touched so many. Hundreds of thousands of viewers wrote us emotional and passionate accounts of their response to the faces of the Australian diggers and British Tommies in particular:

Goose bumps watching the show …

This is so wonderful, I can barely believe it's true. Many of the faces showed signs of great fatigue and yet they managed to smile and pose for a photo forever preserving the moment in time …

A few tears shed knowing some of these fellows never made it home. What a wonderful discovery for many families around the world.

For so many of the people who have since viewed the photographs online it has become a personal odyssey to find a connection with the as yet unidentified soldiers:

These photos brought tears to my eyes. I had eight great uncles who all fought on the western front. Five of them were brothers. One of them was killed in action five weeks before Armistice Day, after surviving three years of that bloody hell. He is our only Digger out of eight that we have no photographic record of. Maybe he is one of these men.

PLATE 36 A sad soldier of the Royal Fusiliers – a close-up from the high-resolution scan of his fatigued face shows him lost in thought. This same soldier also appears in Plate 216 on p. 200.

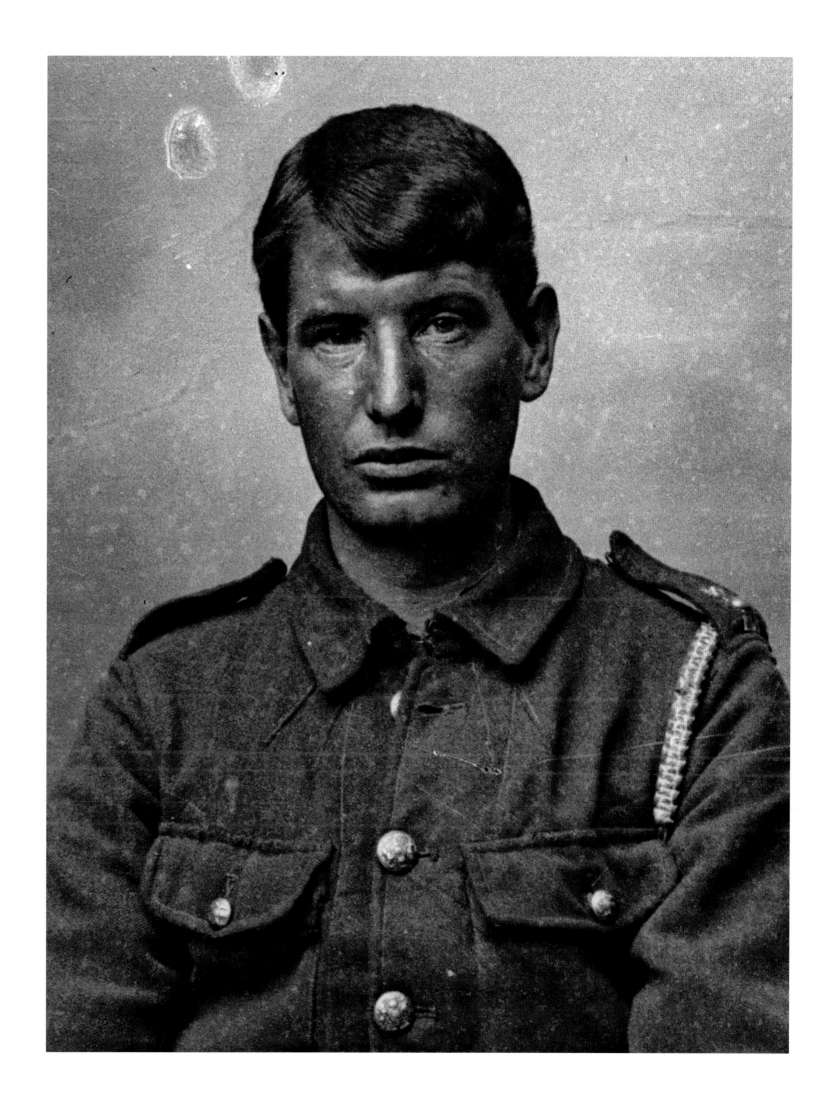

*Thank you so much for making these great photographs available. My mother lost her
uncle in France in 1915. We have no info' on him, not even a photo. We have always
tried to find his records but without a regiment number, we are up against a brick wall.
I sit here with tears in my eyes, wondering if he is one of these brave men. You have done
a wonderful thing.*

*Our grand uncle … died of wounds … How amazing to think his image could be among
these photos.*

*I carefully examined each and every photo looking for any resemblance to the many family
members who fought in WW1, some of whom never returned.*

Then began the calls for the Australian images to be brought home:

Don't let them be forgotten. Bring these historical plates to their rightful home.

*These photos … should be treated as national treasures and every single one of them
should be brought home immediately.*

*These young men gave their lives in order to protect and fight for our country; these photos
are an amazing part of the history of Aussie diggers in battle and the campaign they were
involved in … Lest we forget.*

*Many relics of these men may remain in France but these treasured photos need to be
honoured on Australian soil. It is now our turn to answer the call of duty and return these
photos to their home for safekeeping.*

*Ohh I have tears of pure joy and total sadness after looking through these pics … History
in front of our very own eyes … Thank you for sharing. Never forgotten.*

In July 2011, with the generous support of the Seven Network's chairman, Kerry
Stokes AC, the entire Thuillier collection of around 4,000 glass photographic plates,
including the British images, was purchased from the living descendants of Louis and
Antoinette Thuillier, the couple who had supplemented their farming income during the
First World War by selling pictures to passing Allied soldiers. If Louis and Antoinette
were alive today they would no doubt be chuffed and probably very surprised to see just
how much passion their portraits of thousands of young soldiers from a war so long ago
has aroused.

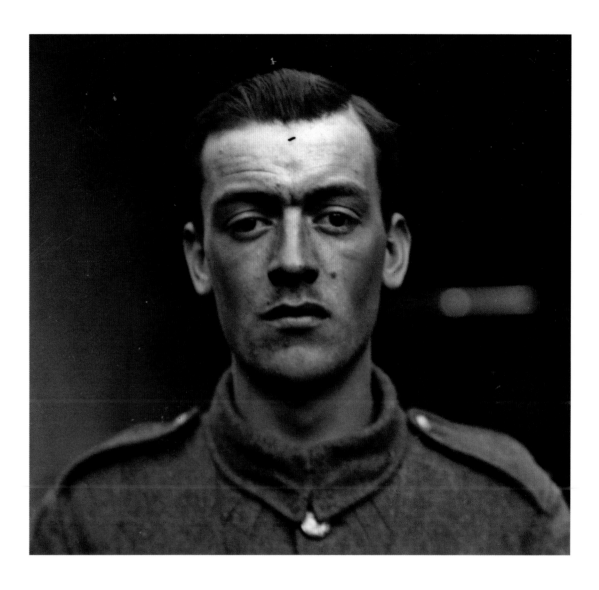

PLATE 37 An equally sad-looking soldier
– no regimental badge.

In late 2011 the precious glass plates did finally 'come home', in a gigantic packing case, purpose-built to carry them, along with the Thuilliers' canvas backdrop. After months of planning, cataloguing, careful cleaning and scanning, the Australian digger plates were gifted to the Australian War Memorial for permanent display. Many of the more intriguing images and the stories behind them formed the basis of a nationwide touring photographic exhibition organized by the AWM. The remaining thousands of British and other Allied soldier plates have been preserved by the Kerry Stokes Collection in a secure repository in Perth, Australia.

More than once in our research it has struck us how impermanent many of the records that we rely on today are in comparison with the handwritten files, letters, printed photographs and glass photographic plate negatives that have made this such a rich collection. As we began examining the plates, drawing on the expertise of people like

Peter Burness, it was a revelation to discover how, in many ways, the photographic plates used by the Thuilliers are actually a superior storage medium to the standard celluloid photographic negative, let alone digital imaging. Not only have they already lasted nearly a century, but so much information is packed into these enormous negative plates that it was often possible for us to zoom in on a colour patch, medal ribbon or cap badge to help identify a soldier. There is something terribly poignant about being able to zoom in to the pained and weary eyes of an individual soldier – actually to see the mud on his boots and the texture of his uniform.

As we applied modern photo-processing software, it was astonishing to see faces emerge from the murk of so many plates – images that could so easily have been lost forever. We have asked ourselves many times how much of today's history will survive to the same extent. How many personal handwritten letters have we preserved today that will record the thoughts and experiences of our loved ones for future generations to read? What was once recorded in a letter just a few decades ago is now just an electronic impulse stored on magnetic media whose lifespan can still currently only be surmised. Will the digital records of today – the photographs, emails and the writings on other online ephemera such as Facebook, Twitter and websites – allow people in a hundred years to explore the history of our present era with as many resources as remain from the First World War? How much of our heritage and experiences will be lost as contemporary storage media slowly fade or are carelessly deleted?

The process of identifying, at least by regiment, as many of the Thuillier images as possible for this book has been a painstaking and often frustrating process. Many of the soldiers were photographed in front of the distinctive painted canvas backdrop and that has been a useful fingerprint in identifying Thuillier pictures which made their way back home into family collections or regimental history books. On rare occasions the identification was easy because a particular soldier features and is actually named in one of the rare Thuillier images reproduced in regimental history books or contained in personal collections. There have been other occasions where photographs taken of soldiers after the war have allowed us to 'match' them with a soldier in a Thuillier image (see the Royal Fusiliers). Once identified, it has also been difficult to find out more about a particular soldier because so many of the British service files are incomplete or were destroyed completely in German bombing raids during the Second World War.

PLATE 38 An unidentified soldier. No clues as to his regiment can be seen in the photograph.

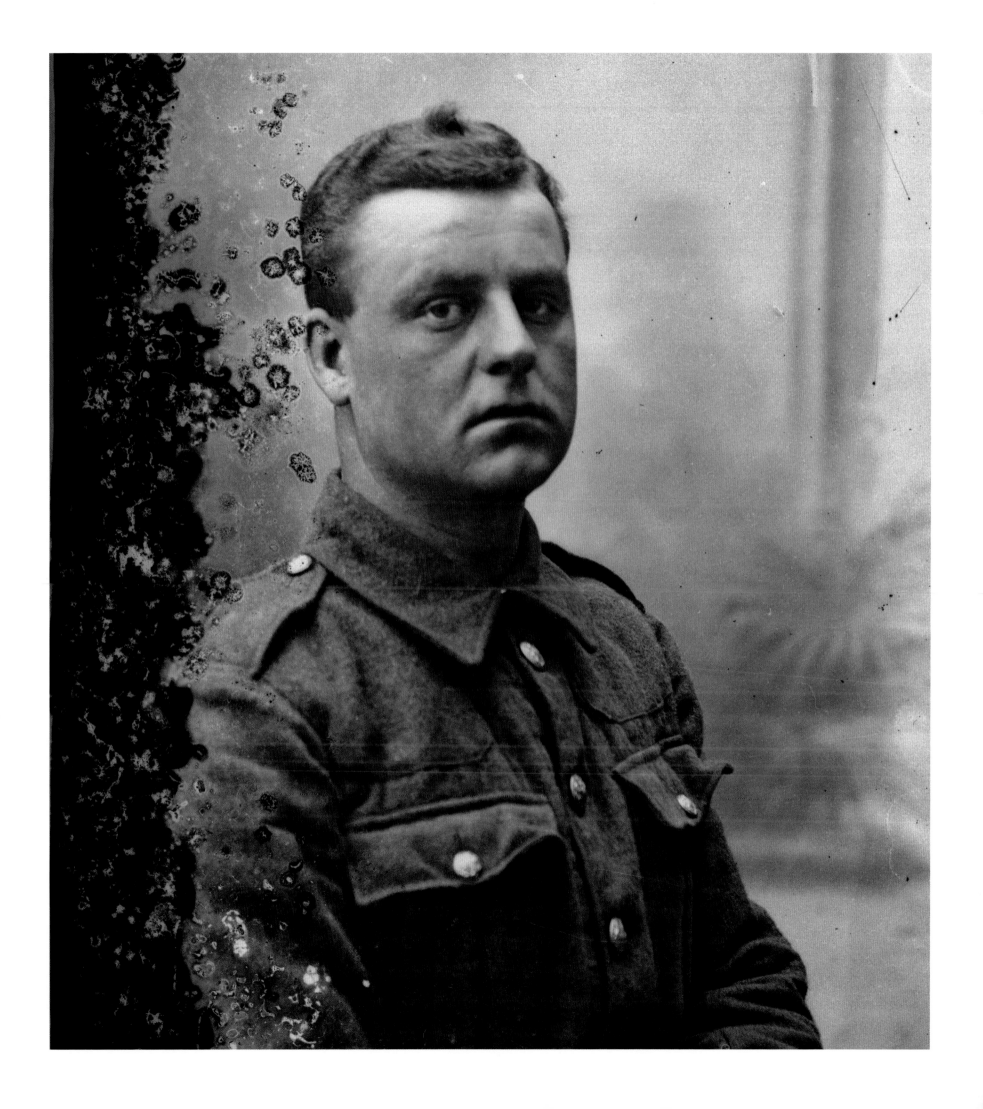

The Backdrop

One of the key clues that helped us track the Thuillier collection was the distinctive backdrop that appears behind soldiers and civilians in many of the pictures. Well before the discovery of the Thuillier portraits, historians at the Australian War Memorial had noticed the length of painted canvas in a handful of images of different soldiers held in its collection, and they were excited by what it implied. If a photographer had taken the trouble to paint a backdrop for posed photographs somewhere behind the front line, maybe there were more to be found than the dozen or so that had made their way into official collections.

Never did we think it possible that the backdrop used by Louis and Antoinette Thuillier could have survived nearly a century in a dusty attic. But, as we fumbled around in the eaves of the family attic in Vignacourt back in early 2011, we found, wedged between two roof beams, a tight roll of canvas mounted on a wooden pole. Eager to see what was inside, but anxious not to damage it, we lugged the dusty canvas roll down the three flights of stairs to the courtyard … and gently unrolled it.

It is a little damaged from its near-century in a draughty attic, but the distinctive double archway seen in many of the photographs is still clearly visible.

There are hundreds of photographs in the Thuillier collection which clearly predate the painted canvas backdrop – many of them are probably pre-war images of French civilians and then, when war broke out in 1914, they feature the French soldiers who used the town as a staging post before they headed up to the front lines. As business picked up, Louis and Antoinette must have decided that a painted canvas backdrop offered a more professional look for their clients and so the first images using the backdrop began to appear.

PLATE 39 An excellent Thuillier image showing how the backdrop was used – the soldier is probably from the 6th (Inniskilling) Dragoons.

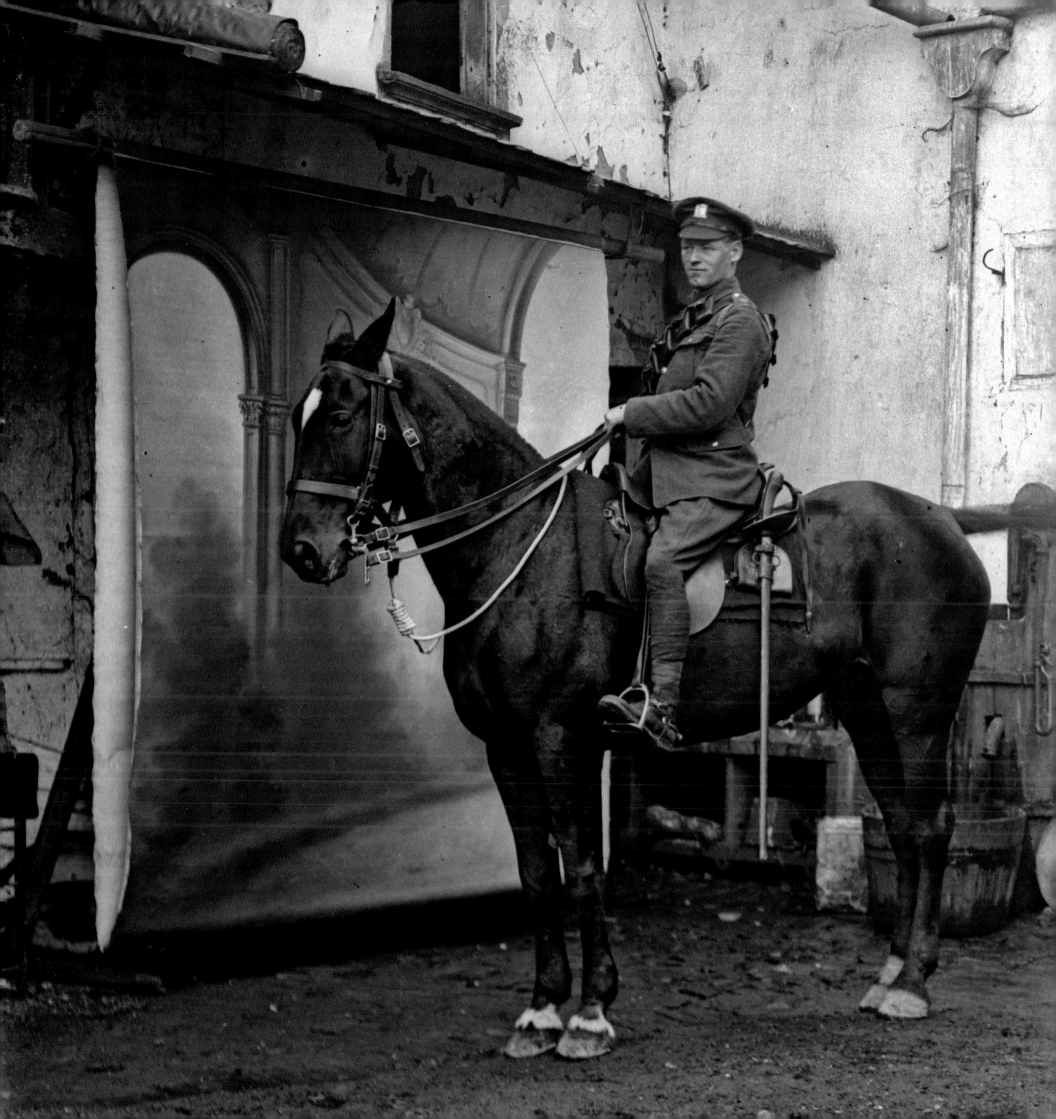

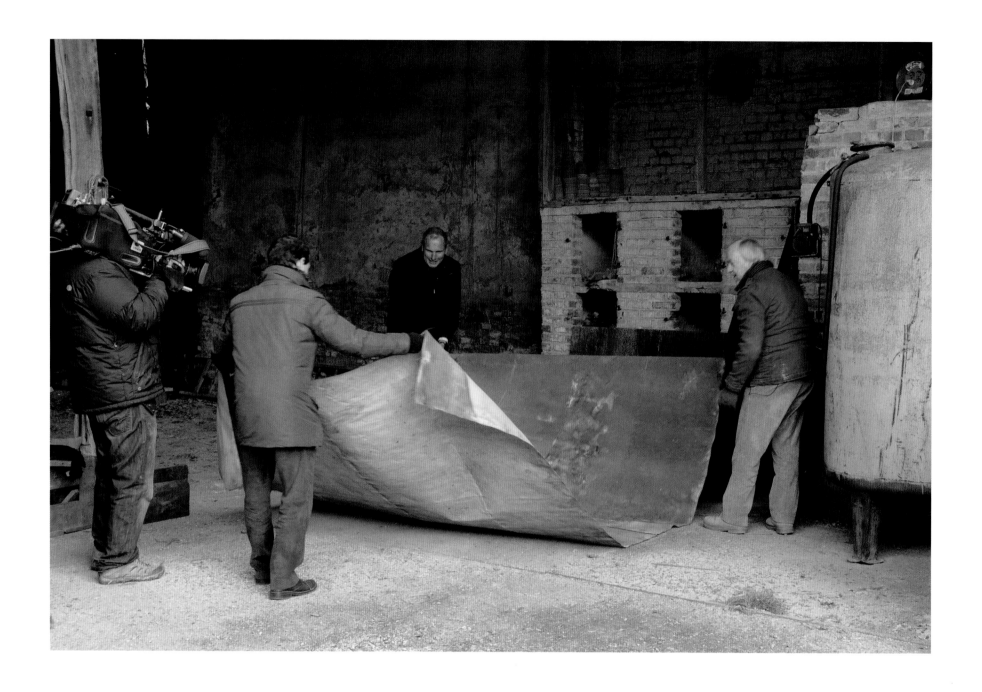

PLATE 40 Unfurling the backdrop.
(Courtesy Brendan Harvey)

PLATE 41 An early Thuillier photograph of a French second lieutenant, of the 4th Colonial Infantry Regiment, and his wife, without the distinctive backdrop. Likely to have been taken sometime in July 1915 when the French 1st Colonial Corps was billeted in Vignacourt.

PLATE 42 A French soldier and his family in front of the distinctive Thuillier canvas backdrop.

PLATE 43 Close-up of the backdrop.
(Courtesy Brendan Harvey)

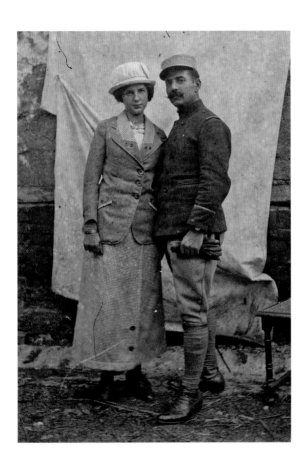

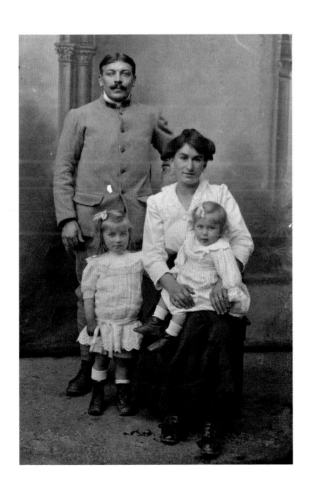

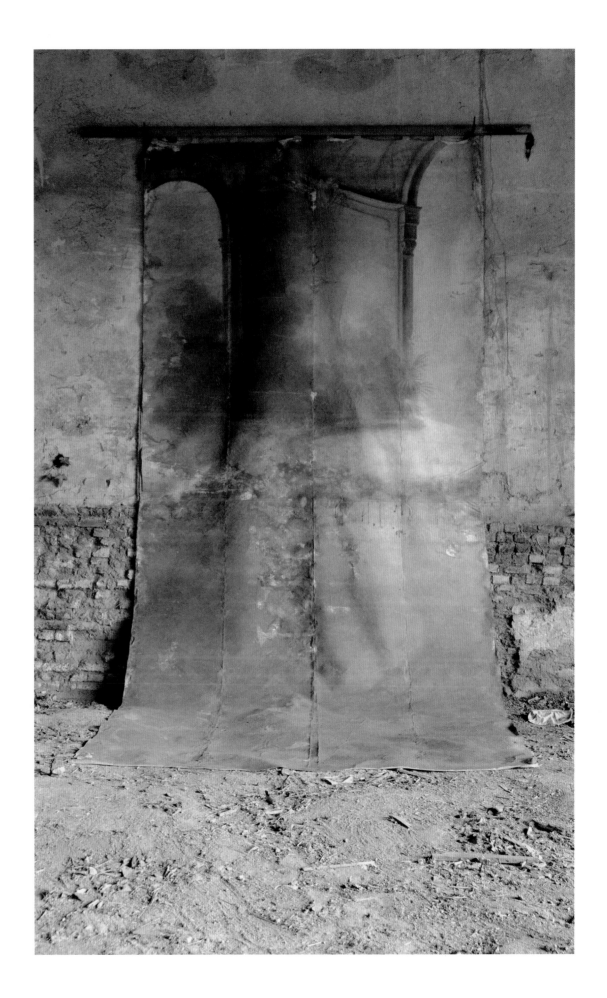

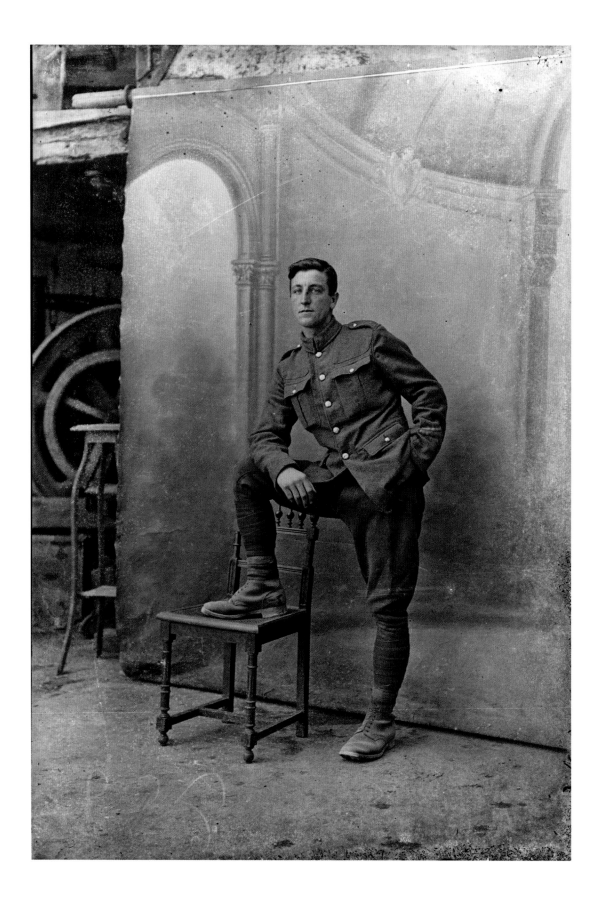

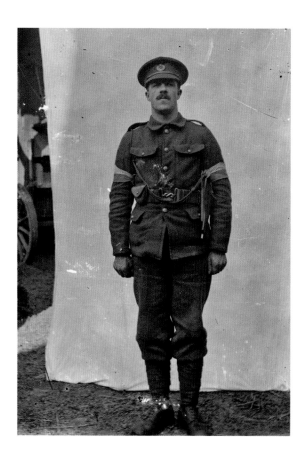

PLATE 44 A soldier poses in front of the Thuillier backdrop, using a chair as a prop. The distinctive high table used in many other photographs can be seen just to the left. This soldier has two good-conduct chevrons on his lower left sleeve, indicating that he has six years with a clean record of service on his army record.

PLATE 45 A soldier from the Royal Engineers. His armbands show he is a qualified signaller. Possibly taken when the engineers were in and around Vignacourt in early 1916 preparing transport links and hospitals for the Somme offensive.

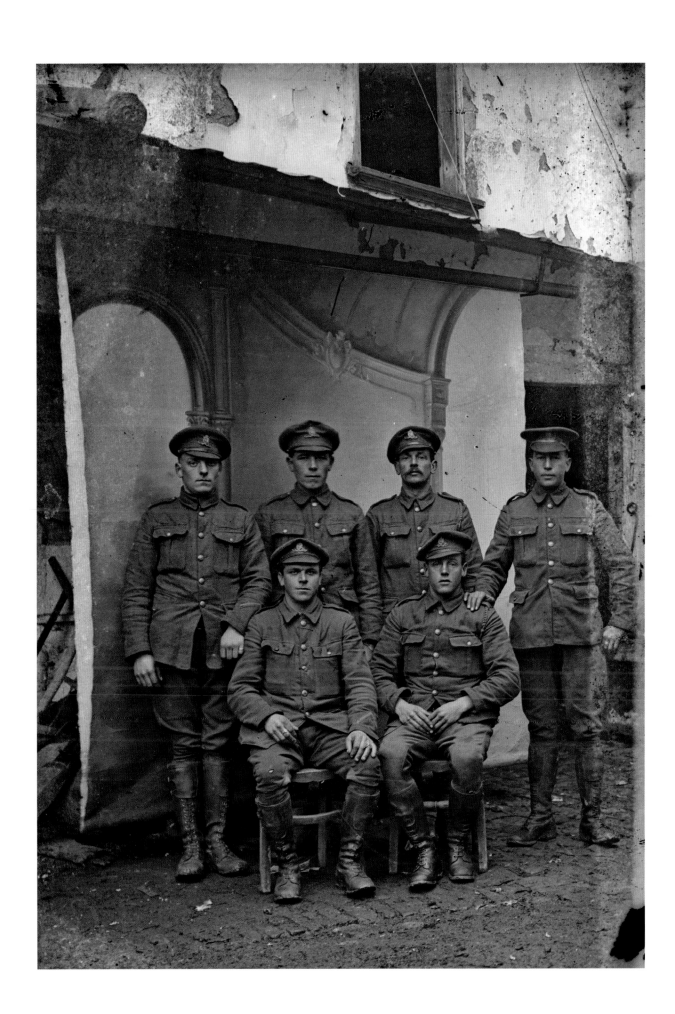

PLATE 46 Soldiers of the Royal Artillery Regiment, two with good-conduct chevrons. Clearly Thuillier moved his backdrop according to the state of the weather. The soldier in Plate 44 opposite stands on a smooth cement floor in a covered area. This image is taken outside on cobblestones. It seems likely the smoother-floored area was used by Thuillier later in the war – hence this image predates Plate 44. However, the tunic worn by the soldier seated left is an 'economy tunic' without pleated pockets and without the rifle patches over the shoulders – which was issued only in 1916.

THE VIGNACOURT BREAD BOY

The discovery of the Thuillier glass plate images has been as moving for many of the villagers of Vignacourt as it has been for the numerous families who have searched for their relatives among them. In November 2011 hundreds of townsfolk came to Vignacourt's town hall to view the two Australian Seven Network television documentaries that had been produced at that time on the 'Lost Diggers', subtitled in French for the occasion. For the village it was a chance to learn more about a chapter in the region's history that only a few of the elderly villagers still recalled. Around the walls of the town hall, many poster-sized prints of some of the iconic Thuillier photographs also drew an excited response. For even after nearly a hundred years, some Vignacourt families were excitedly identifying their loved ones among several of the pictures taken of civilians during the conflict.

The young lad in Plate 47 was recognized by his family as Abel Théot. At the time this photograph was taken by the Thuilliers, the boy's life was one of hardship and sadness brought about by the war. Abel was one of five brothers, two of whom died fighting in the French army against the Germans. His father was away at war, too, and Abel sold bread and pastries to Allied troops to bring in extra money to help his mother and family survive. Tragically, after this photograph was taken, Abel learned that his father had also died in the fighting; another of his brothers returned with serious wounds.

PLATE 47 Abel Théot, the Vignacourt bread boy.

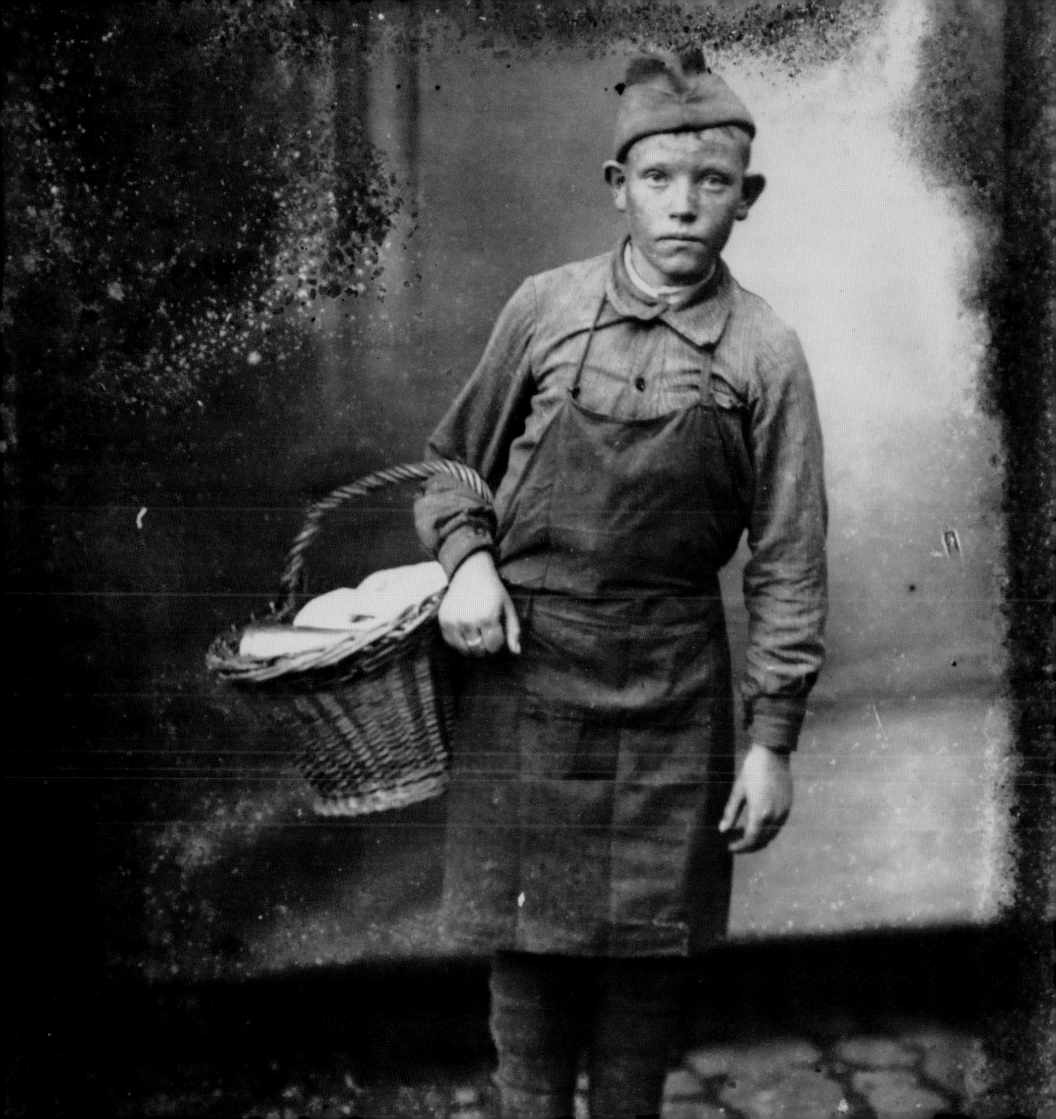

How the Thuilliers Took Their Photographs

It was another Frenchman, Louis Daguerre, who had invented one of the most important precursors of modern photography, the daguerreotype, in the 1830s – the Polaroid of its day. The daguerreotype produced a single image, which was not reproducible. In the 1850s, more than sixty years before the outbreak of the First World War, William Henry Talbot devised the negative process in which a glass plate negative allowed any number of prints to be made. But the glass plate technology came under threat from the nascent celluloid film cameras produced by Kodak in the late 1880s. By the outbreak of the Great War in 1914, black and white box brownie cameras were relatively common and it is intriguing to speculate just why Louis and Antoinette Thuillier did not opt for the much cheaper film cameras that were by then available. Perhaps the pair were purist professional photographers – and there were many right up even to the 1970s – who continued to favour glass plates because of concerns that the early celluloid films could not provide the sharp images so beautifully rendered by the older glass plate negative technology. Glass plates are still used for photography today in some scientific applications. The problem of sharpness in the early celluloid film cameras was caused by the poor lenses; and nor could early film camera technology provide a sufficiently reliable flat focal plane compared with that provided by a glass plate camera. This was because the celluloid film, although stretched across the back of the camera, still curved slightly and this made for less crisp images. All the better for amateur historians a century later, because the glass plate negatives used by the Thuilliers allow for an extremely high-quality print in comparison with the old celluloid film negatives, most of which have degraded to the point where they are unusable.

Another good reason for photographers like Louis and Antoinette Thuillier to use glass plates could have been one of economy: they had the option to reuse the glass plates once they had developed them and sold the positive prints. Reusing a plate would have simply entailed cleaning off the silver image on it. But the Thuilliers clearly kept most,

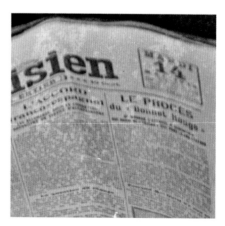

PLATES 48–49 An example of the high resolution possible from modern scanning of the Thuillier plates – the date on the *Parisien* newspaper in this elderly Frenchwoman's lap can be read in the close-up image. Translated, it says either 'Tuesday, 4 May 1915' or 'Tuesday, 14 May 1918'.

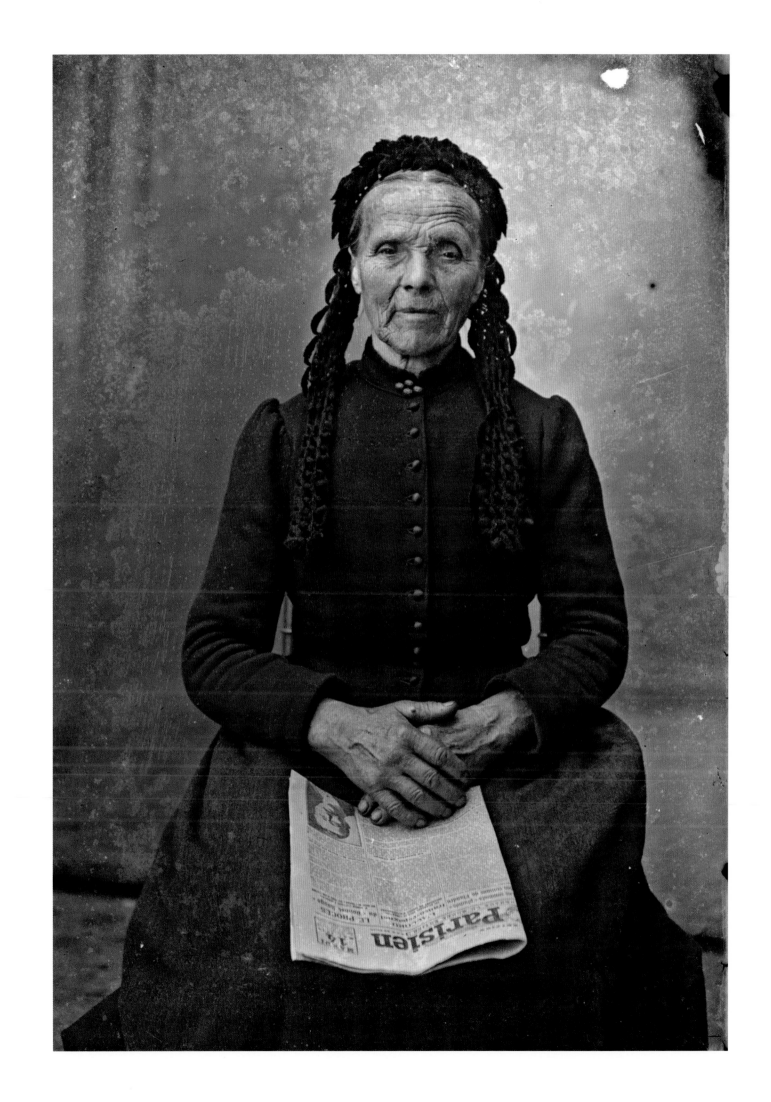

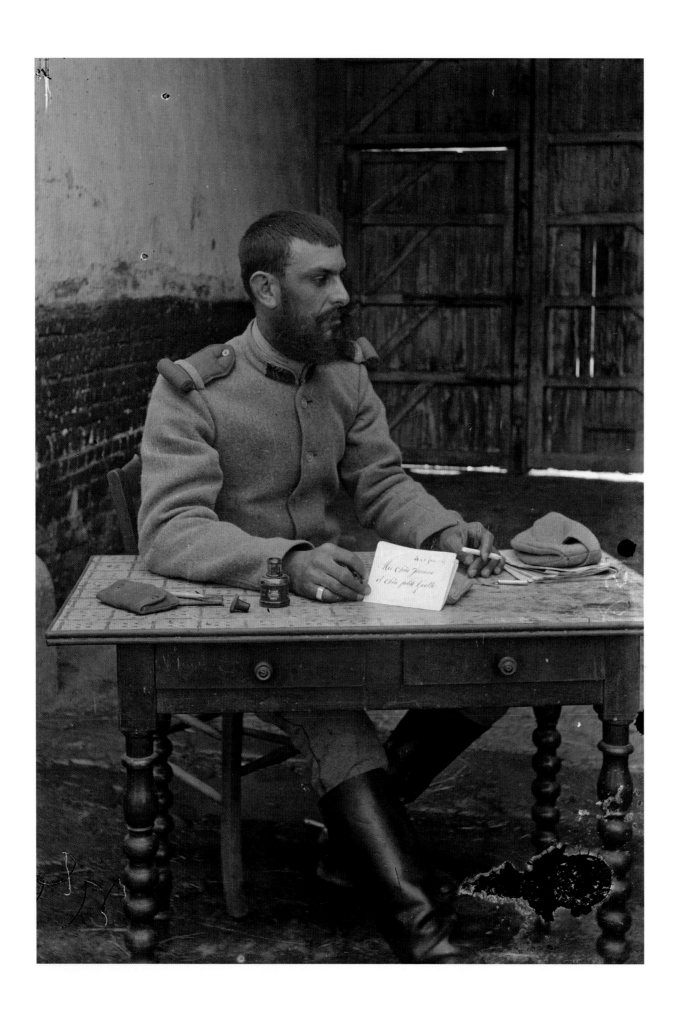

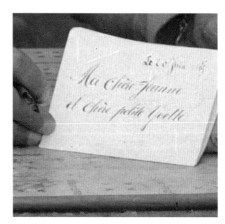

PLATES 50–51 A French cavalryman of the 1st Cavalry Division writes a letter to his family on 20 June 1915. The glass plate's high resolution allows us to read what he has written: 'My dear Jeanne and my dear little Yvette'. The division was based in Vignacourt from May to June 1915.

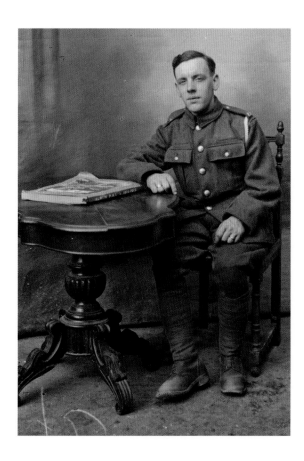

if not all, of the plates they shot. What is exciting about this is what it suggests about their motives for taking the photographs in the first place. For if Louis and Antoinette Thuillier had only cared about their portrait subjects as commercial transactions, they could easily have recycled the plates once they had sold each soldier his picture. For whatever reason, Louis and Antoinette preserved the exposed plates; and, by the look of it, they kept nearly all of them, filling their attic with thousands. It is possible they realized the wartime portraits they were taking would one day be of enormous historical significance and worth. Even today in the Thuillier family attic there are sections of what appear to be old glass window plates from which Louis and Antoinette had cut glass in the size and shape of negatives. Glass was clearly so precious a commodity during the war that they were removing it from windows to fulfil demand.

There is no information on the Thuilliers' camera or cameras. Their equipment was stolen by the Nazis in 1940 when Vignacourt was evacuated during the German Somme offensive (many Vignacourt homes were looted at that time). But because there are different-sized glass plates in the surviving collection, the couple probably used a camera that allowed interchangeable sizes of backing so that different sizes of glass plates could be fitted. It was also possible to have one sheet of glass – a 'single dark' – or a 'double dark', which allowed two glass sheet exposures to be taken using a sliding magazine.

The basic concept of glass plate photographic cameras is no different from the more modern photographic film and printing papers. All contain an emulsion of silver-halide crystals suspended in gelatin. The plate is exposed to light in the camera as the photograph is taken, then, to 'develop' the image, the plate is immersed in a chemical bath to render the exposed silver halides into the metallic silver that makes the image visible. To stop the silver from reacting any further to light, the image on the plate is 'fixed' by immersing it in a bath of 'hypo' (sodium hyposulphate). Any leftover chemical then has to be washed out of the image to stop the picture from leaching.

To print copies of the plate speedily for their soldier customers, Louis and Antoinette may have used a process that did not require a darkroom to develop the printing paper in a wet bath. Known as 'POP' – short for printing-out paper – it allows a photographer to produce a visible image upon exposure to light without using chemicals. The plate was exposed against a sheet of light-sensitive paper, producing an image the same size as the glass sheet – a technique also known as a 'direct contact print'. One limitation of this POP technology was that the paper print tended to fade, which perhaps explains why so few of the Thuillier prints survived the past century. Those faded pieces of yellowed cardboard sitting in the family archives of old servicemen may well be the speedy postcard snaps produced in Vignacourt by the Thuilliers.

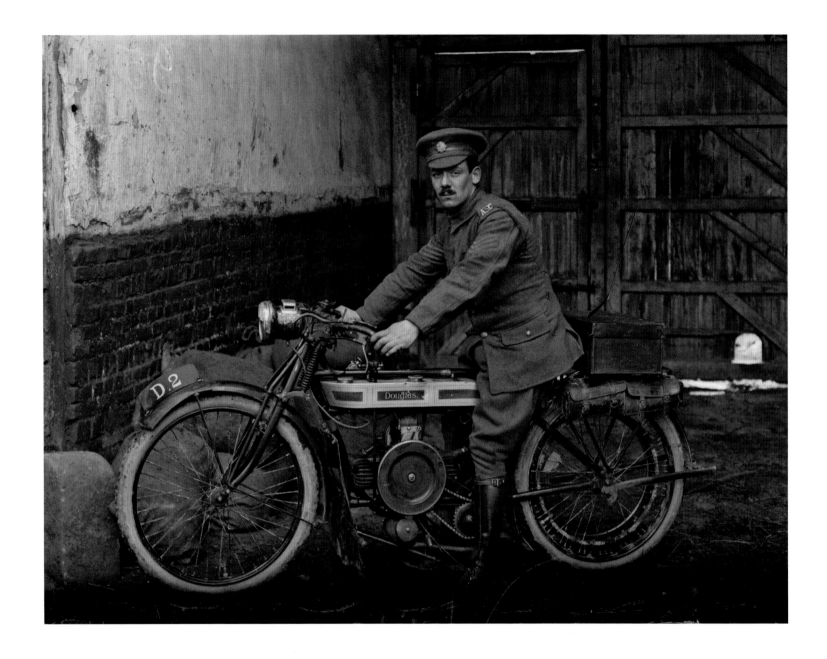

What is even more extraordinary about the images in this book is that they are reproduced at a resolution far higher than their subjects ever saw when they purchased prints around a hundred years ago from the photographers. Methodical cleaning and high-resolution scanning have reproduced digital copies of the plates, which were then optimized using computer software such as Photoshop. The rare Thuillier images that did survive the past century are those that were rephotographed after the war using more stable photographic techniques.

The photographic plate digital scanner used to reproduce the images in this book has a resolution one hundred times better than the print paper used in 1914–18. Even though Plate 55 opposite is slightly damaged, it is still possible to read this soldier's map.

PLATE 53 A sharp image of an Army Services Corps sergeant on a Douglas motorcycle. During the war the Bristol-based Douglas Company supplied more than 70,000 motorcycles. They were used by dispatch riders, signallers and engineers. The ASC sergeant pictured was probably carrying medical supplies in the attached leather cases.
PLATES 54-55 An Australian dispatch rider's map case. A close-up shows he has a map detailing the area north of Amiens.

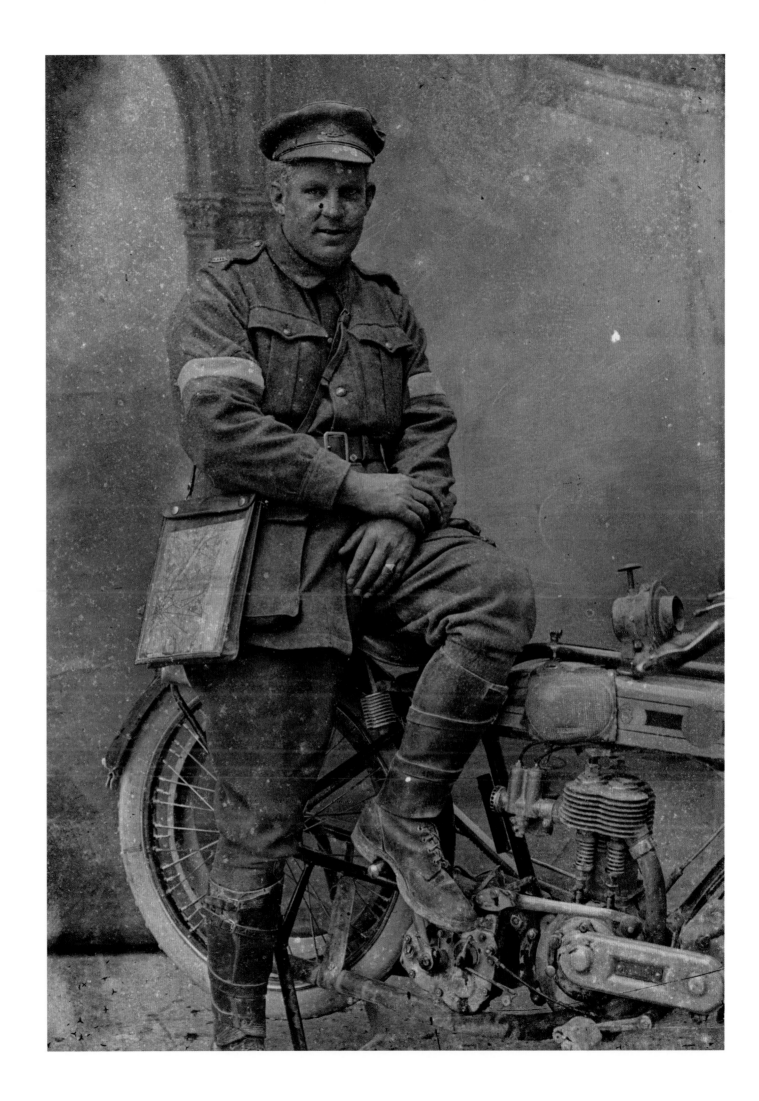

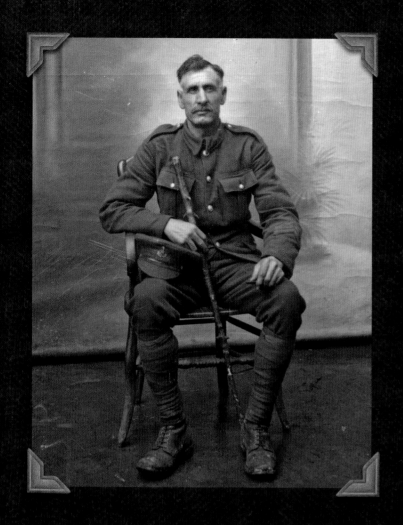
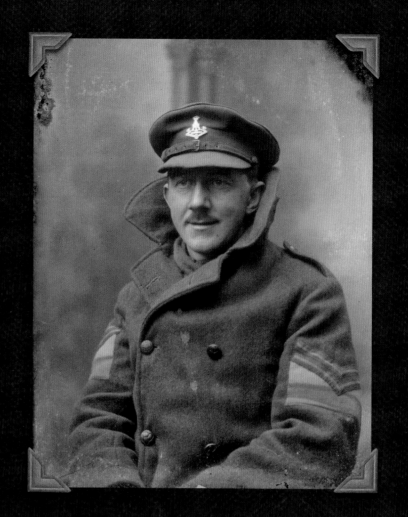
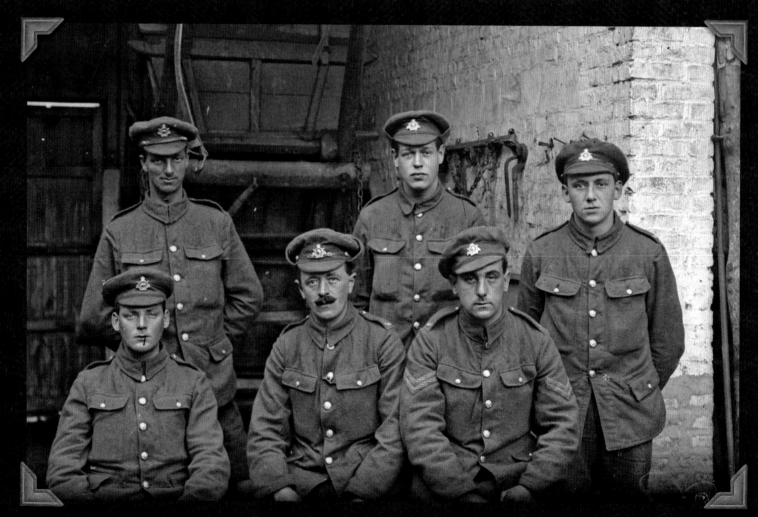

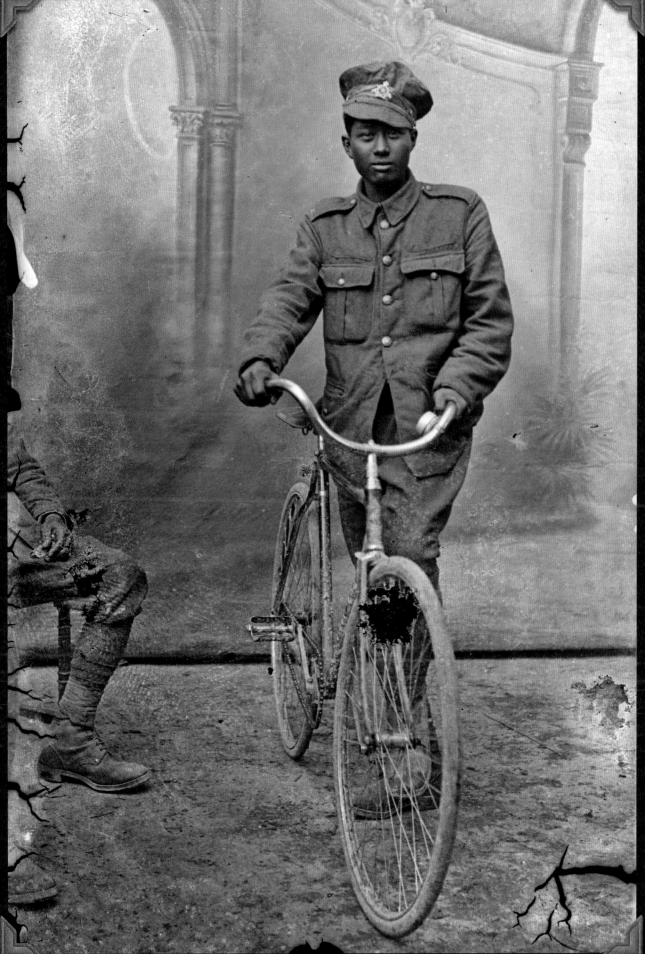

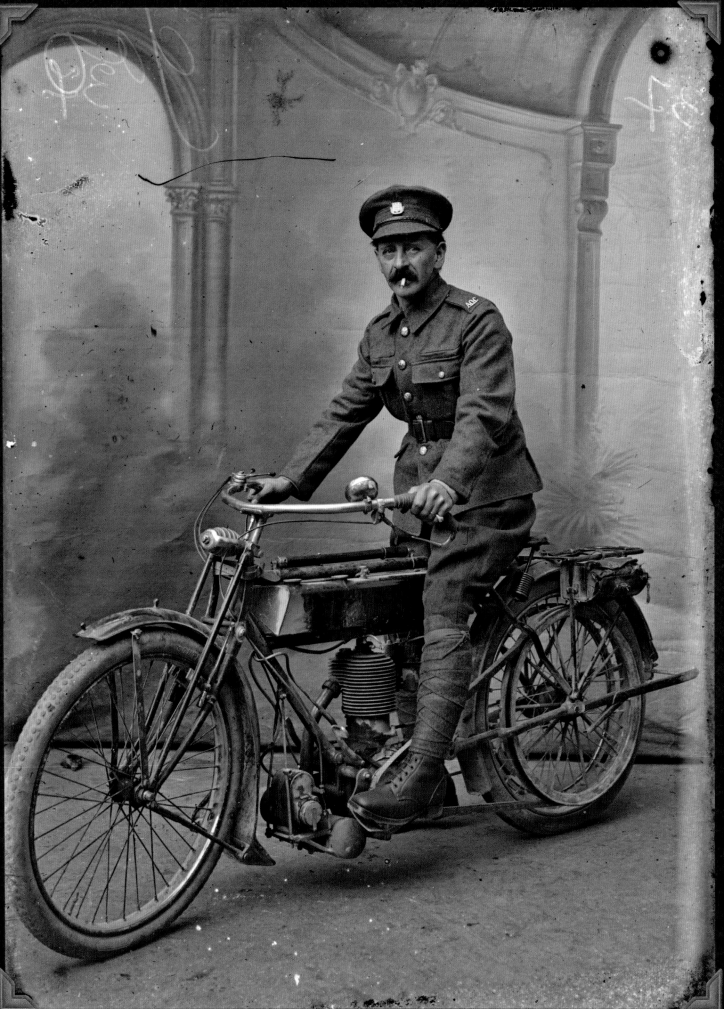

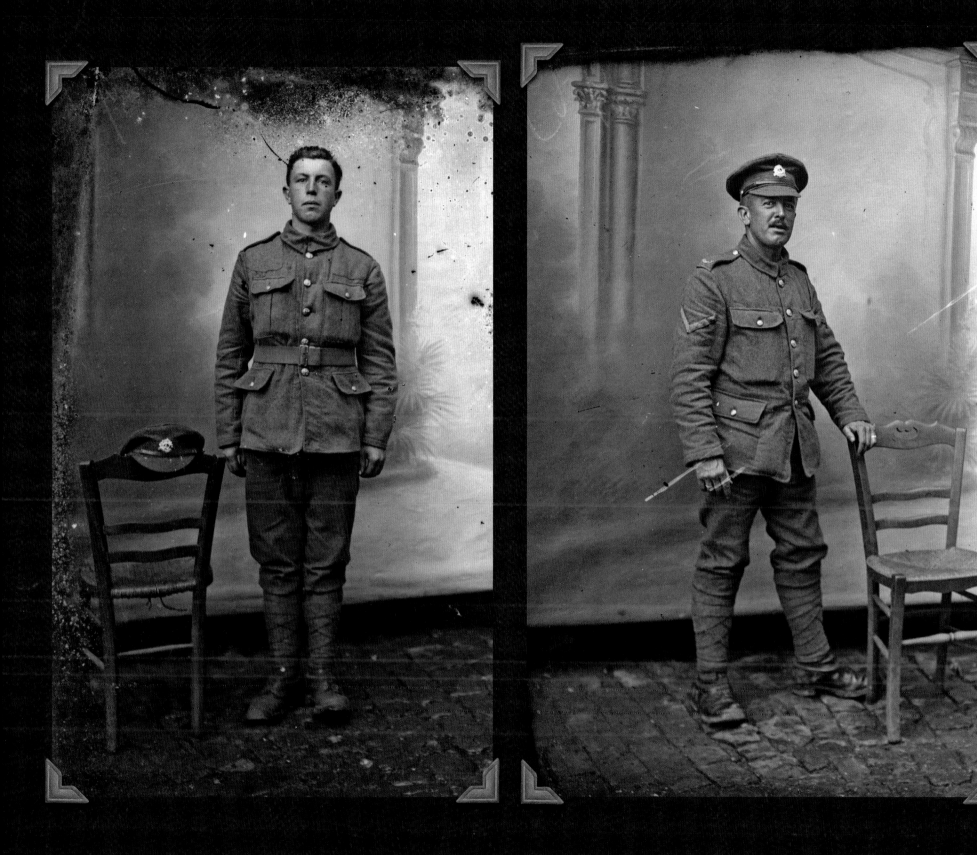

Louis and Antoinette Thuillier and the Town of Vignacourt

We have little information about Louis and Antoinette Thuillier, the pair behind the camera. What is known is that Louis was born on 29 July 1886 into a modest Picardy farming family, and that as well as working as a farmer he embraced the new technologies of the early twentieth century with zeal. He married a beautiful local girl, Antoinette Thuillier (same family name, but no relation), when he was twenty-six and started up what soon became a thriving farm machinery business.

Vignacourt locals knew Louis as 'Peugeot' Thuillier because he also set up a Peugeot bicycle repair shop in 1907 in addition to his own agricultural machinery hire firm. To this day the backyard of his old farmhouse complex is cluttered with rusting machinery, old wheels and the well-tooled workshop of an avid machinist who was clearly very good with his hands. At some stage Thuillier taught himself glass plate photography and he began photographing local villagers.

The Peugeot sign he placed on the front of his house as an advertisement to passing cyclists also appears in his images (see Plates 65–66, p.67).

Louis enlisted soon after war broke out, but his war service is something of a mystery because his service file was one of many destroyed in a bombing raid in 1940. He was a dispatch rider, taking signals and documents between positions on the front lines, a job that almost certainly cemented Louis's lifelong passion for motorcycles (which feature in many of the Thuillier pictures, and explain the piles of motorcycle magazines in the attic). Louis was wounded and after recuperating in a hospital he was demobilized and home in Vignacourt by 1915. The war also took its toll on Antoinette's family. She had two brothers, Louis (another Louis, to confuse matters) and Gustave. Brother Louis was captured by the Germans and became a prisoner of war, but he survived to return home after the Armistice. Gustave, who served with the 72nd Infantry Regiment, was killed in a German gas attack on 20 March 1918, aged twenty-four.

PLATE 56 A British supply wagon outside the Thuillier farmhouse during the First World War. Note the 'photo' sign in the window above the front door at the left of the image.

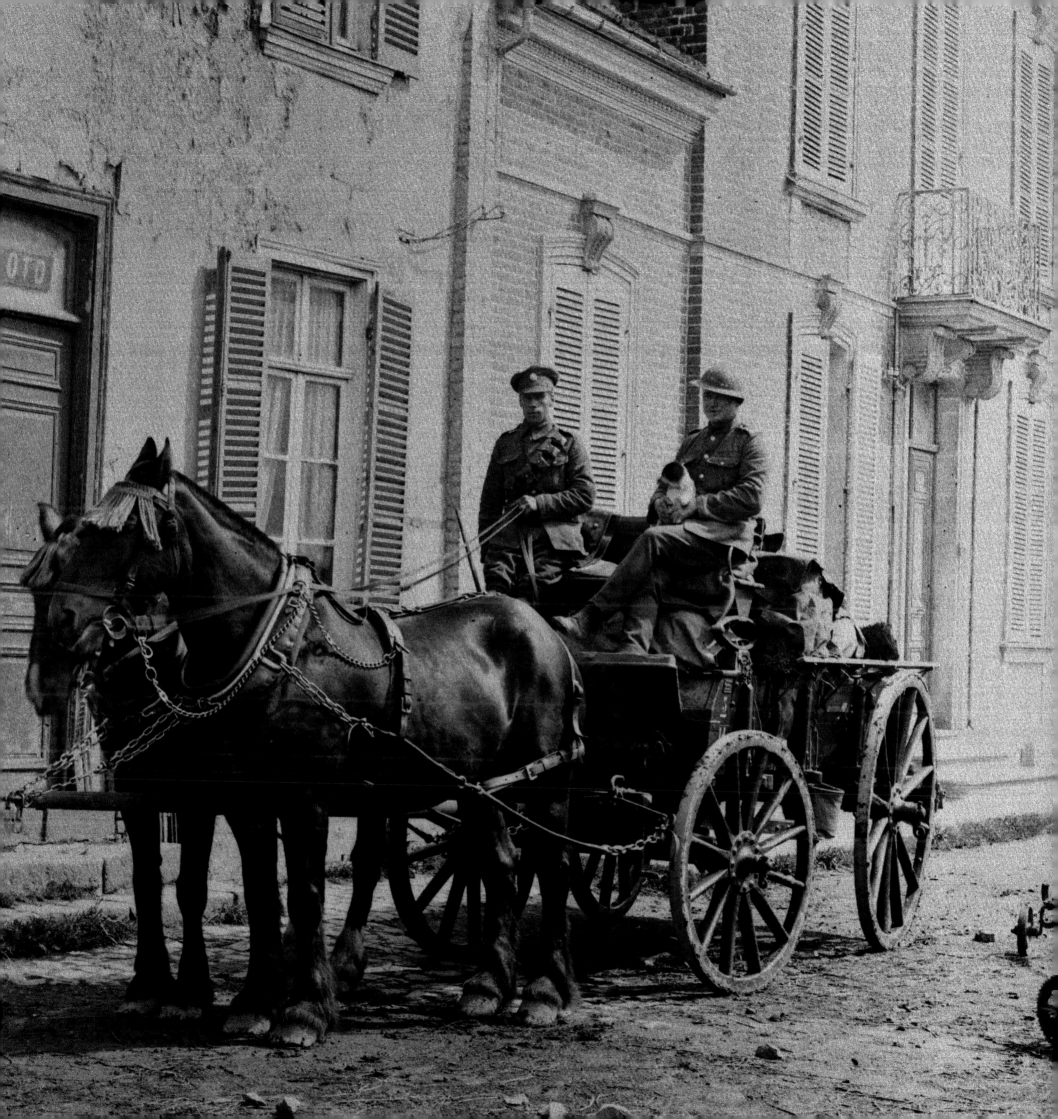

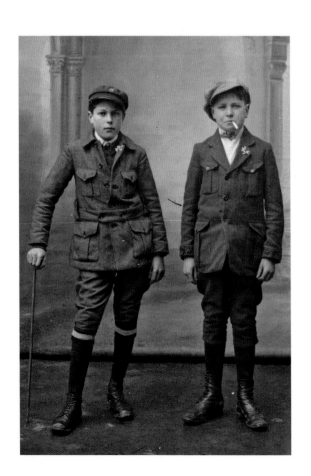

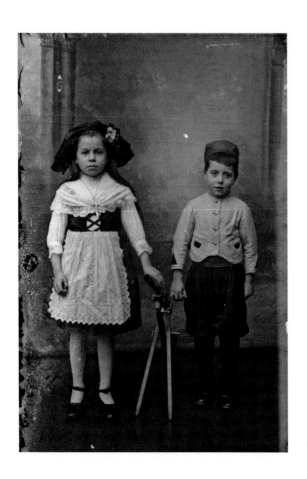

PLATES 57–58 A local Vignacourt woman poses in a beautiful polka-dot dress and a boy poses with a garland and communion Bible.

PLATES 59–60 Two young lads – one smoking! – pose for the Thuilliers and (right) a sobering illustration of how the war influenced young local children: this boy has a toy machine gun and uniform.

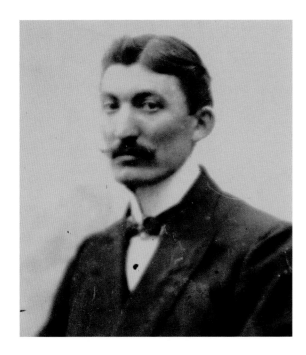

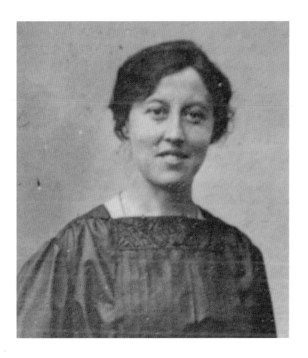

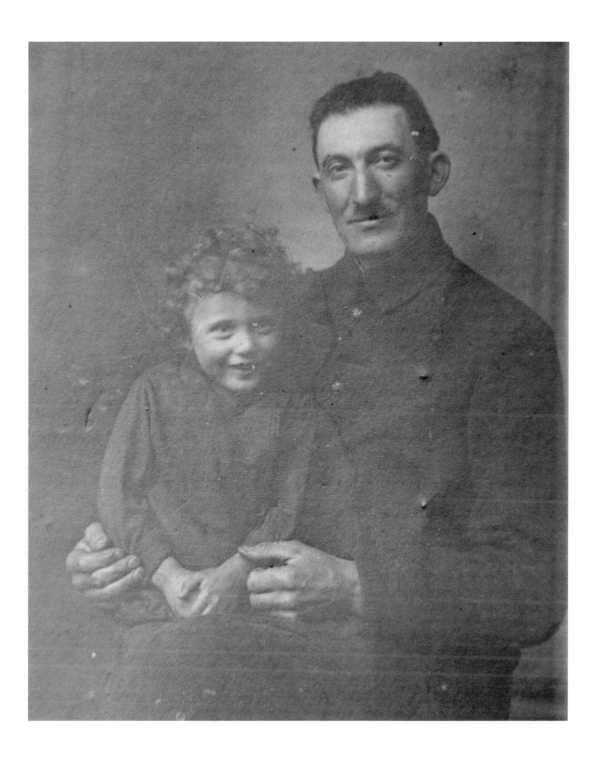

PLATE 61 Louis Thuillier (from the Thuillier collection), probably taken by his wife, Antoinette.
PLATE 62 Antoinette Thuillier. (Courtesy Bacquet family)
PLATE 63 Louis Thuillier in French army uniform, c.1915, with an unidentified child (perhaps Robert Thuillier, born 1912). (Courtesy Bacquet family)

By the time Louis Thuillier returned home from his wartime service as a dispatch rider, the town was full of French troops waiting to head up to the front lines, and he began photographing them for extra money. He taught Antoinette how to take photographs as well because he also had to run the family farm. Vignacourt was becoming a key rest and hospital village behind the front lines, and the couple realized they could make good money selling portraits to the passing French and Allied soldiers.

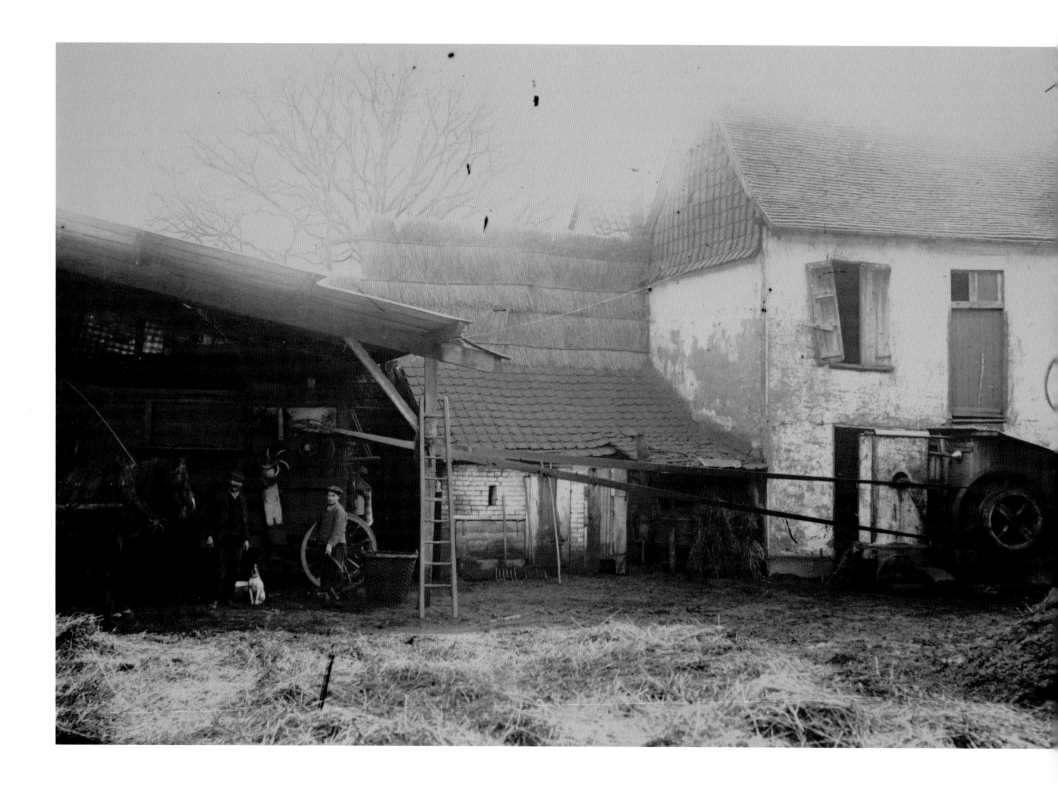

PLATE 64 The Thuillier family's farmyard, probably before or very early in the war, one of the earliest photographs in the collection. This is where Thuillier hung his backdrop and photographed thousands of soldiers throughout the war. The backyard still exists today – and still looks much the same.

PLATES 65–66 Exteriors of the Thuillier home, with Peugeot sign. Both soldiers are members of the Royal Horse Artillery.

IDENTIFYING BRITISH REGIMENTS

During the First World War every British regiment and corps had its own cap badge and it is these badges, worn on the uniform or caps of soldiers, which have allowed us to identify the individual British Army regiments in the Thuillier collection. For example, close examination of Plates 68 and 69 reveals that all the soldiers featured have the distinctive Royal Welsh Fusiliers cap badge.

A diary kept by Abbé Leclerq, the Vignacourt village priest at the time,[1] reveals that the Royal Welsh Fusiliers, one of the British Army's oldest regiments, was one of the first regiments to be based in and around Vignacourt during the First World War. On 27 September 1915 he noted the arrival of the first British troops in the area – the Royal Welsh Fusiliers, one of the South Wales Borderers regiments and a platoon of Royal Engineers, who settled in and around Vignacourt in billets and nearby camps.

Vignacourt was to become home to the staff of the British 13th Army Corps between January and July of 1916. The Royal Engineers are very nearly the most photographed unit among those in the Thuillier collection, probably because, as Abbé Leclerq recorded, they came to Vignacourt so early in the war, and units of engineers were there for the duration.

PLATE 67 A version of the Royal Welsh Fusiliers cap badge.
PLATES 68–69 A corporal and a lance corporal of the Royal Welsh Fusiliers (left), and a major (right). The Royal Welsh Fusiliers were probably one of the first British regiments to be based around Vignacourt in late September 1915.

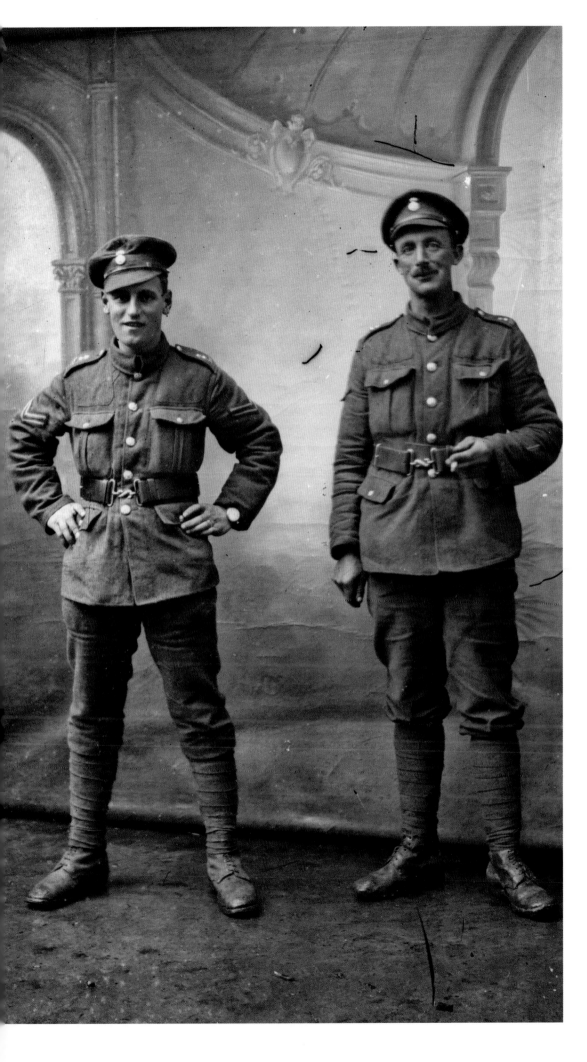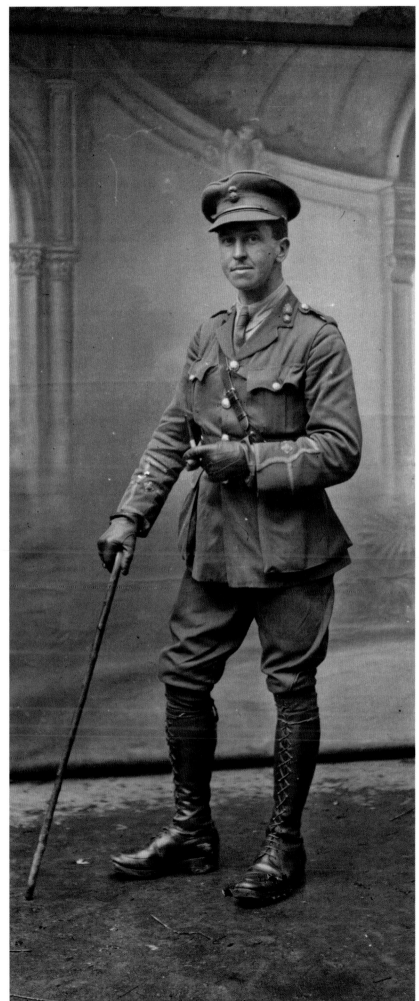

PLATE 70 Two soldiers of the Royal Engineers Corps pose in the Thuilliers' farmyard. Both wear armbands indicating they were in the Royal Engineers Signal Service. The soldier on the left wears the distinctive 'T' of the territorial force on his left shoulder.

PLATE 71 A lance corporal in the Royal Engineers photographed in the Thuilliers' farmyard. Probably taken in the first half of 1916

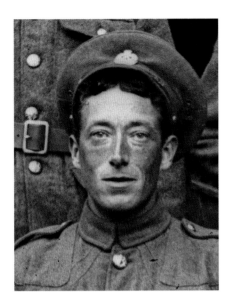

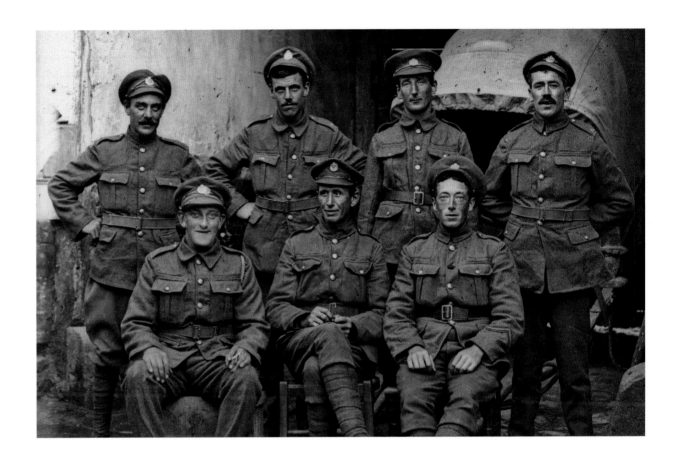

PLATES 72–73 The haggard faces of these Royal Engineers, especially the man seated on the right (and shown in close-up above), suggest these men have not been long away from the front lines.

PLATE 74 A young soldier from the Royal Engineers Signal Service.

PLATE 75 Another image featuring the young man from Plate 74 (on right in photograph) wearing a Royal Engineers cap badge and posing with a friend. Both men wear shorts and the lad on the right is wearing the winter service dress 'Gorblimey' cap with its distinctive flaps issued in early 1915. This picture is probably from the warmer months in 1916, the year after the Royal Engineers first arrived in Vignacourt and before the beginning of the Battle of the Somme in July.

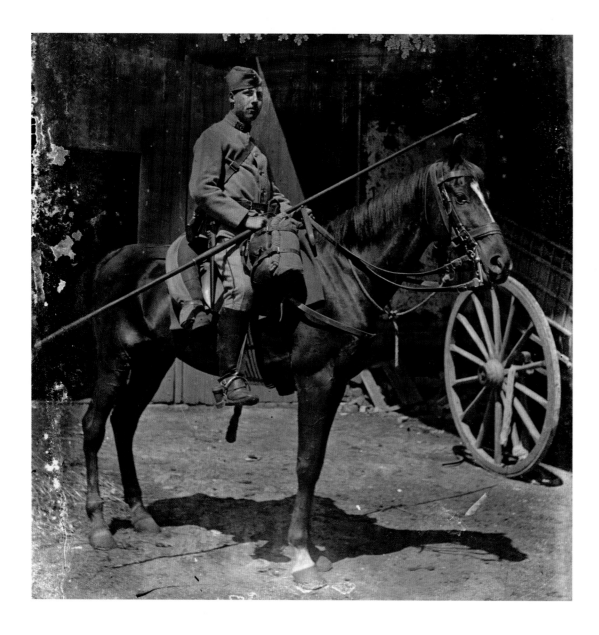

The Thuillier images also trace the movement of French troops through
the Picardy town, many of them dressed in colourful, antiquated nineteenth-century-style
uniforms; there are even cavalrymen posing with their lances, relics of an earlier type of
warfare. The British and the French both deployed lancers in early First World War battles
but they were woefully ineffective against the machine gun and modern artillery.

It is sobering to think of the hell these French troops went into, their quaint and
colourful nineteenth-century-era uniforms absurdly impractical for the industrial warfare
they were to face. Just like the Germans on the other side, everyone thought the war would
be over soon. On the Somme alone, within just a few months, from 1 July to 18 November
1916, when the Battle of the Somme was finally called off, there would be 195,000 French
casualties (and 425,000 British).

PLATE 76 A French cavalryman holds the
2.97-metre steel lance used by dragoon
and cavalry regiments during the war.
The lance was soon abandoned after the
war's disastrous early battles using such
antiquated weapons.

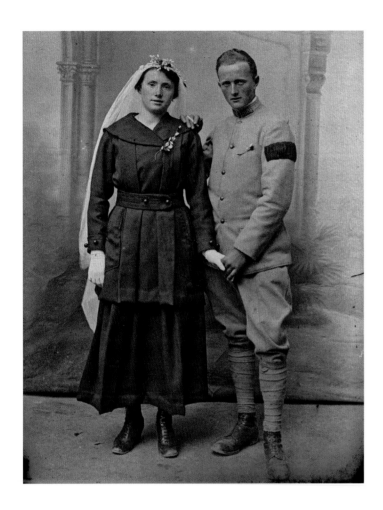

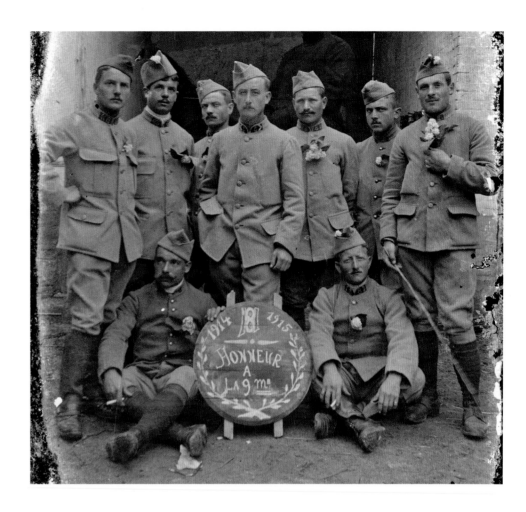

PLATE 77 A rushed wedding before the new husband heads off to defend his homeland? A French soldier with his bride.

PLATE 78 'Honour to 9 May': almost certainly a reference by these French soldiers to the disastrous Second Battle of Artois a year earlier (9 May–18 June 1915), which resulted in 102,500 French and 27,809 British casualties but failed to break through the German lines. The shadow of another negative – featuring a ghostly image of a soldier on horseback – has adhered to this plate from when they were stacked in the Thuillier attic.

PLATE 79 Proud French colonial troops, cavalrymen of the 8th Regiment of Hussars, strike a pose – summer 1915.

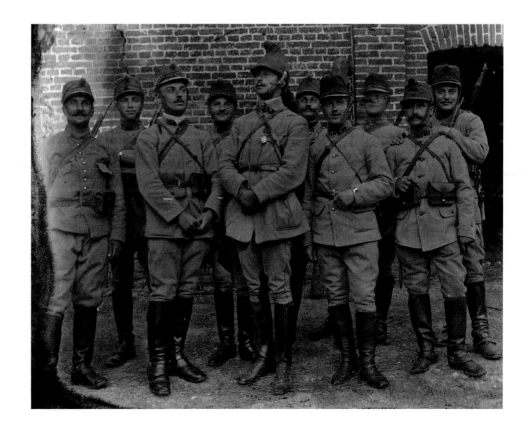

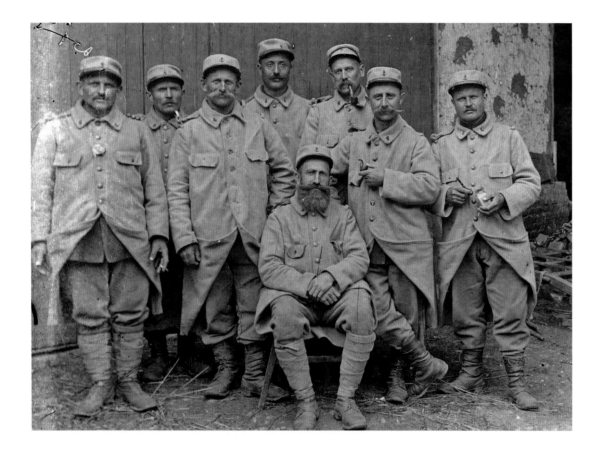

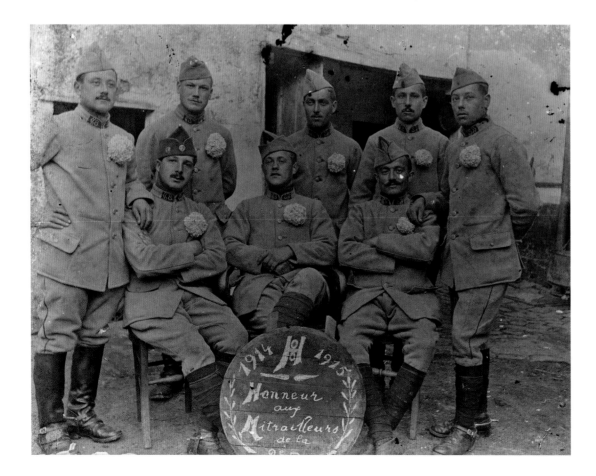

PLATE 80 The French soon abandoned such nineteenth-century uniforms because their bright colours made them easy targets for German gunners.

PLATE 81 French soldiers pose with a dedication to the *mitrailleurs* – the machine-gunners – probably honouring their comrades who fell in the battles of 1915.

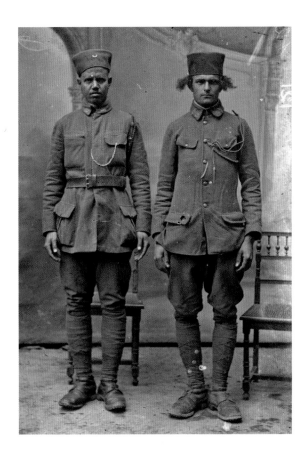

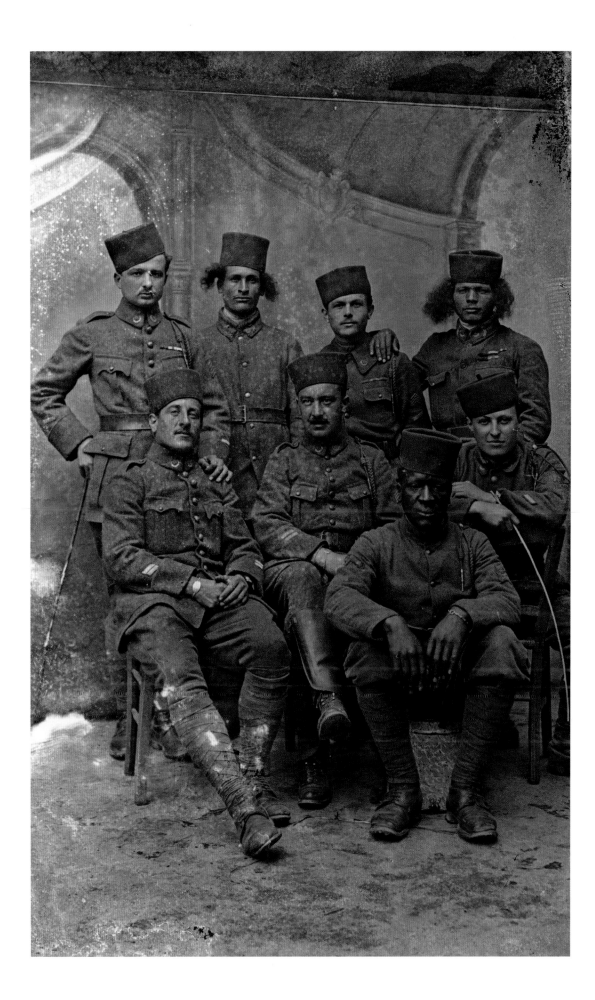

PLATE 82 Moroccan *tirailleurs*. The soldier
on the right sports the typical Berber
haircut of the day.

PLATE 83 Moroccan light infantrymen –
or *tirailleurs* – in Vignacourt. North African
tirailleurs served with distinction on the
Western Front and at Gallipoli. They were
assigned their own regiment in 1914 and
suffered heavy losses.

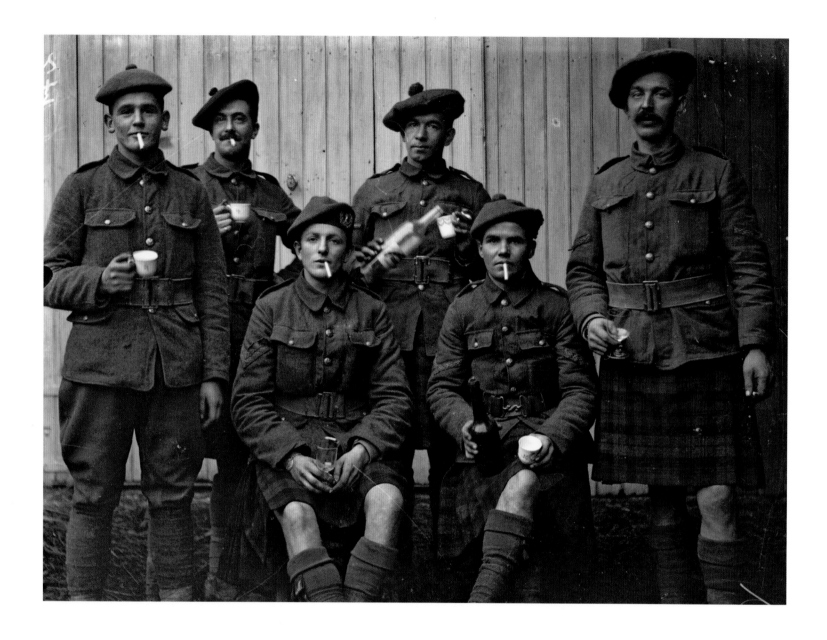

In late 1915 Vignacourt came under the military control of the British Expeditionary Forces (BEF), and the Thuillier images reflect that change, thousands of the plates showing British Tommies and kilt-wearing Scots.

Louis Thuillier also roamed the streets and the nearby army camps in search of subjects to photograph.

PLATE 84 A Thuillier image of some hard-looking Scots soldiers in kilts, most probably Gordon Highlanders.

PLATE 85 A dapper lieutenant colonel with the South Staffordshire Regiment in front of the stairs that today still lead up to the Thuillier attic where the photographic plates were discovered. He is a decorated officer who has been twice wounded, as indicated by the two wound stripes on his left sleeve. The three small chevrons on his right sleeve show he is in his third year of overseas service. These chevrons were introduced in January 1918, which places this image in the final year of the war.

PLATE 86 Royal Engineers dispatch riders in Vignacourt – a typically humorous and informal Thuillier picture.

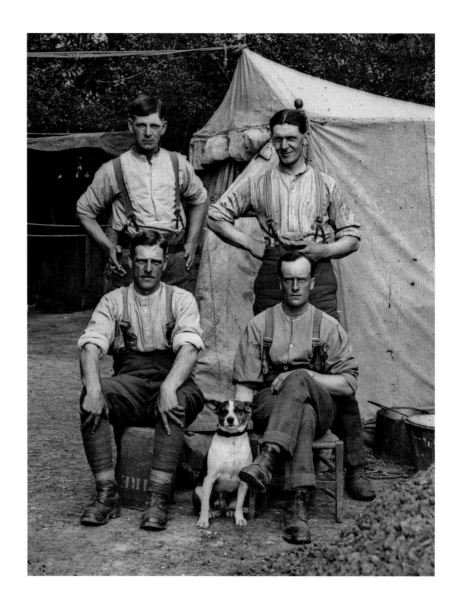

PLATES 87–88 A sergeant and a private soldier in front of their tent, probably at one of the many military camps, and (right) these men have adopted a local dog.

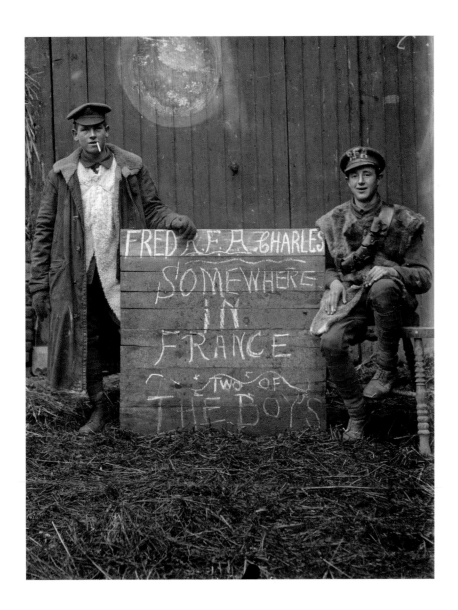

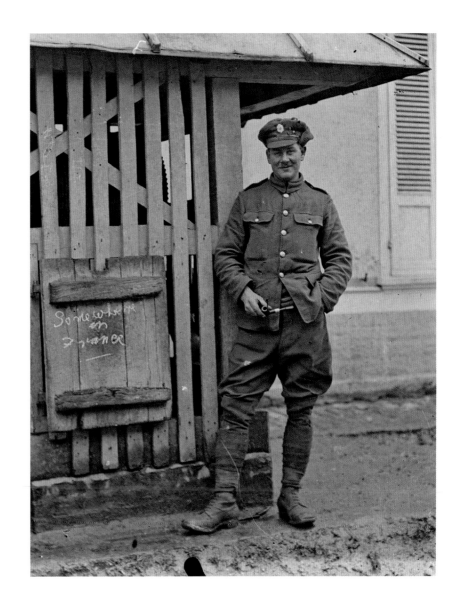

PLATE 89 Two British lads or the Royal Field Artillery – friends or perhaps brothers? – send a message home during the colder months on the Western Front – possibly leading into the winter of 1916–17. For reasons of security 'Somewhere in France' was all they were allowed to say about their location. They are wearing variations of the animal-skin vests the soldiers used to keep warm.

PLATE 90 A Royal Engineers private, 'somewhere in France'.

WE ARE SEVEN

In 1798, the English Romantic poet William Wordsworth wrote a poem called 'We Are Seven', asking:

> *A simple Child,*
> *That lightly draws its breath,*
> *And feels its life in its every limb,*
> *What should it know of death?* …

In the poem, the questioner meets a little girl who initially seems to know very little about death because she appears to be in denial about the death of her siblings and she still sings and talks to them. It ends, though, with the notion that maybe the little girl knows more about death than the adult to whom she is speaking. The little girl refuses to be wretched about death or to forget about the dead, and she gets on with her life as happily as she can:

> *How many are you, then, said I,*
> *If they two are in heaven?*
> *Quick was the little maid's reply,*
> *O Master! We are seven.*

> *But they are dead; those two are dead!*
> *Their spirits are in heaven!*
> *'Twas throwing words away; for still*
> *The little Maid would have her will*
> *And said, Nay, we are seven!*

Perhaps these seven young British soldiers posing in front of this sign simply did not realize the significance of their words in terms of Wordsworth's poem, but is it possible they were sending a gentle message to their loved ones back home? That whatever happened to them in the war, they preferred their families not to become incapacitated by grief – or ever to forget them, just like the little girl.

PLATE 91 'We Are Seven' might be a reference by these soldiers of the Machine Gun Corps to a William Wordsworth poem of the same name.

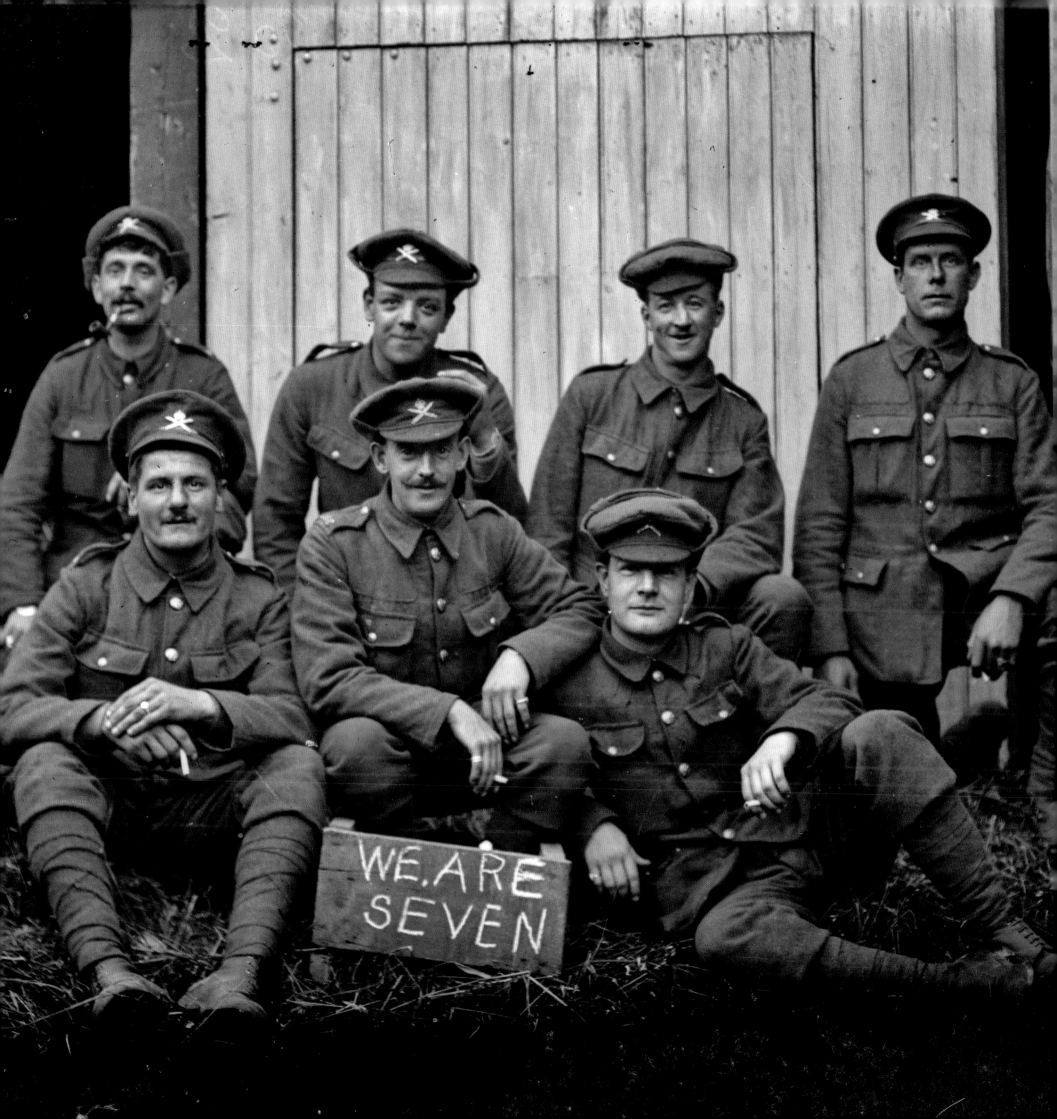

WE.ARE
SEVEN

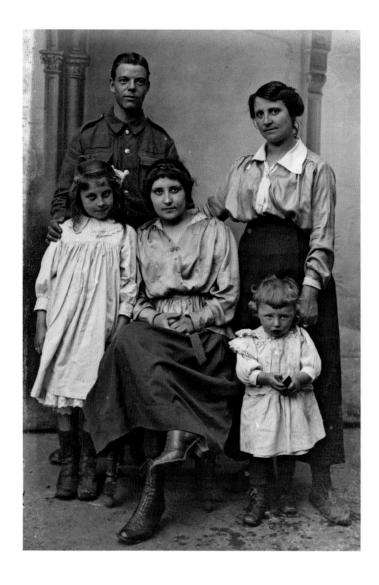
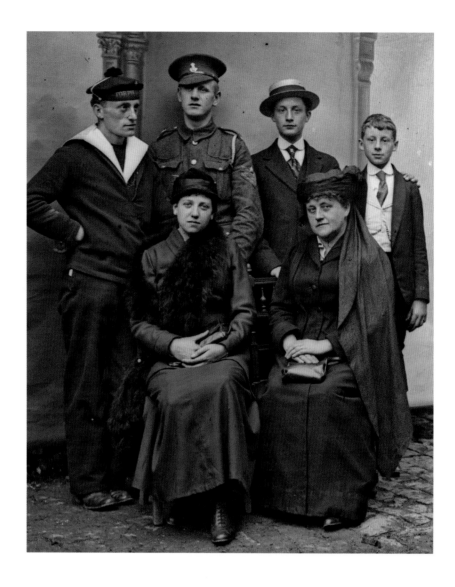

Early in the war Vignacourt was designated as one of the main rest areas for Allied soldiers. An easy day's march from the Somme front lines, it offered exhausted troops the opportunity to rest and revive themselves in the local bars, called estaminets, but it was close enough to allow an easy deployment back into the fighting. The town also had a large hospital and the engineers helped build a new railway siding that brought wounded men straight from the front. There was also a small British airfield (but most of the aviation casualties at Vignacourt came from the main Allied base at Poulainville). What made Vignacourt especially popular with the soldiers was that it had large bathing and resupply facilities for the soldiers. The military bath was one of Vignacourt's main attractions. Soldiers filthy and lice-ridden from the front lines would be issued with a new uniform, which perhaps explains why so many of the soldiers in the images are not wearing the requisite regimental identification – because often they had only just been issued with fresh clothing. In the three images on the facing page, the soldiers appear to

PLATE 92 This private with his clean uniform and freshly combed hair probably wanted a photograph to remind him of this French family who perhaps boarded him as a billet while he was behind the lines. Most of these French villagers never saw their British soldier friends again.

PLATE 93 A sergeant from the Durham Light Infantry with a French family and a family member or friend from the French navy. Perhaps the sergeant was billeted with them in Vignacourt.

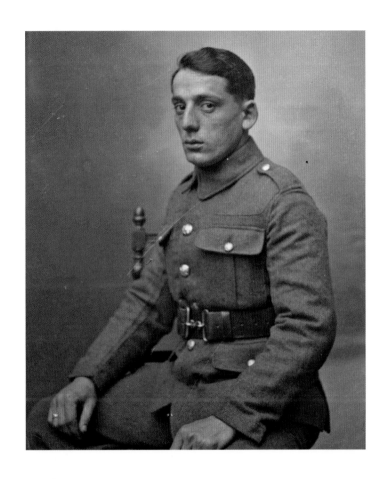

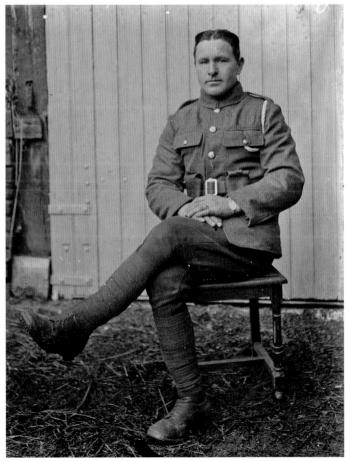

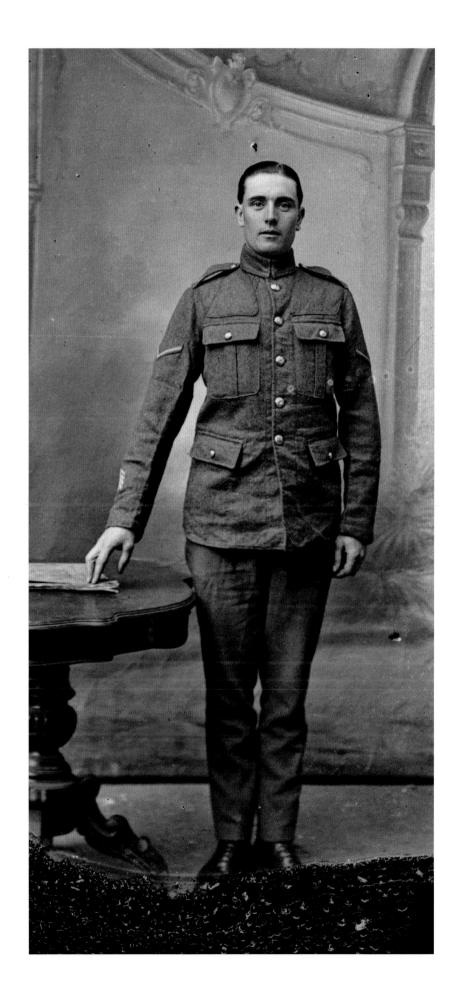

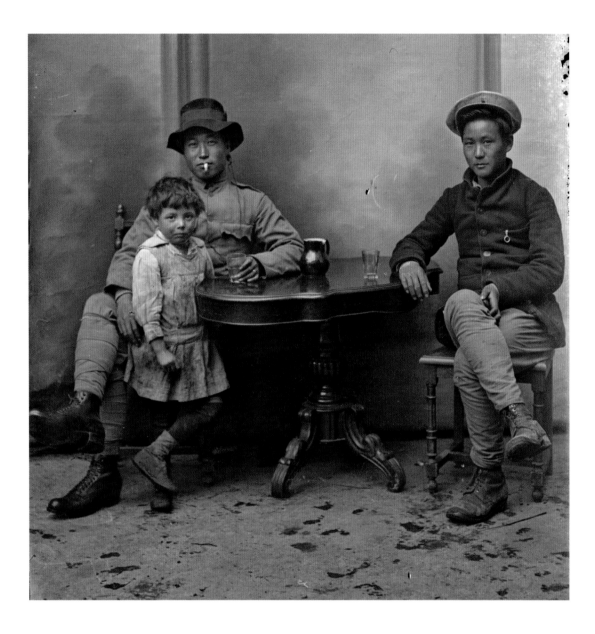

have newly washed and combed hair, ready to have their photographs taken for loved ones back home; or perhaps they have just had a bath and been issued with a new uniform after weeks in the trenches.

Vignacourt soon became a veritable United Nations of nationalities from across the British and French colonial empires. As well as soldiers from the French and British armies, including English, Scots, Welsh and Irishmen, there were Australians, Canadians, Moroccans and Nepalese soldiers all passing through, often sharing a glass of wine or two in the local bars.

The Chinese men in the Thuillier images were all non-combatants; while China joined the Allied nations in declaring war on Germany on 14 August 1917, the French government had earlier contracted their Chinese counterparts in May 1916

PLATE 94 Chinese labourers in a relaxed pose with a local child.

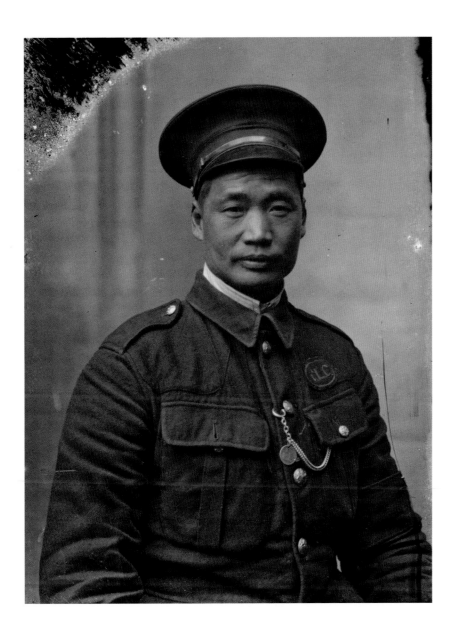

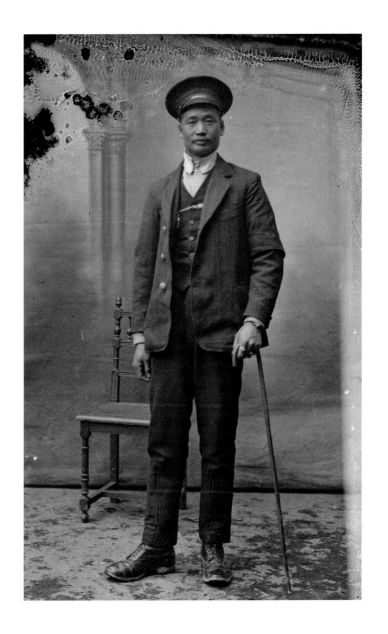

PLATES 95–96 A Chinese Labour Corps soldier with CLC insignia over his breast pocket and (right) the same soldier dressed in civilian clothes.

to supply 50,000 labourers – sadly, known by a racial slur as 'coolies'. The British followed suit to form the Chinese Labour Corps (CLC) and the men from that corps are probably the Chinese nationals featured in these images since Vignacourt was a British base. They were prodigiously hard workers, labouring long hours every day digging trenches, transporting supplies and building and repairing roads and railways. They came mainly from Shandong Province but also from Liaoning, Jilin, Jiangsu, Hubei, Hunan, Anhui and Gansu. About 140,000 Chinese labourers served on the Western Front, several winning awards for bravery, and at least 2,000 (and probably many more) died during the conflict, mostly from the Spanish influenza epidemic at the end of the war. All were classified as war casualties and are buried in graveyards on the Somme battlefields.

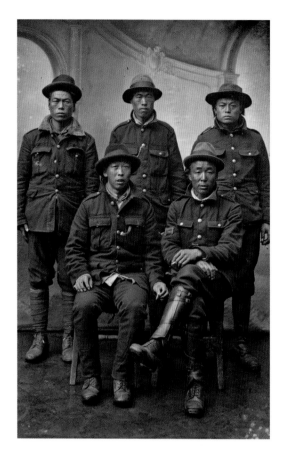

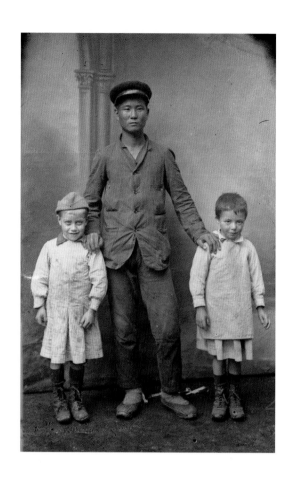

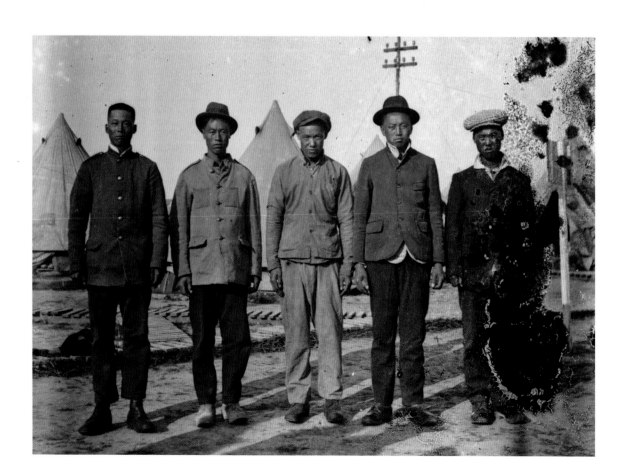

PLATES 97–98 Chinese labourers in Vignacourt.

PLATES 99–100 (Top right) A Chinese labourer with local children, and (left) the Chinese labour camp at Vignacourt.

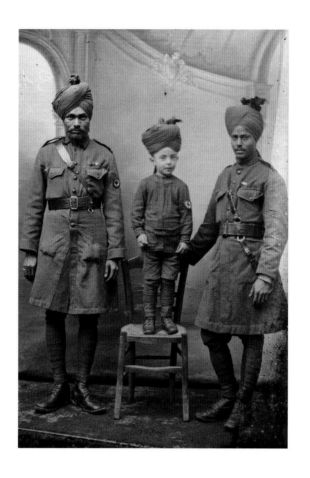

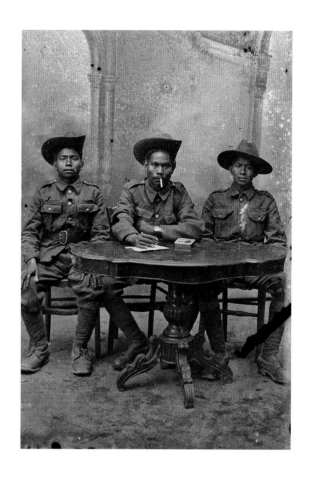

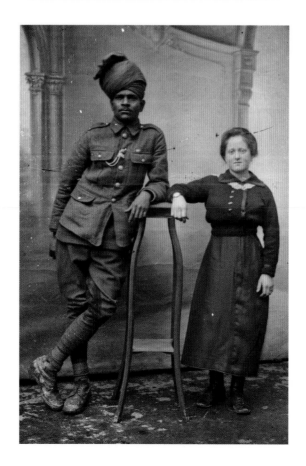

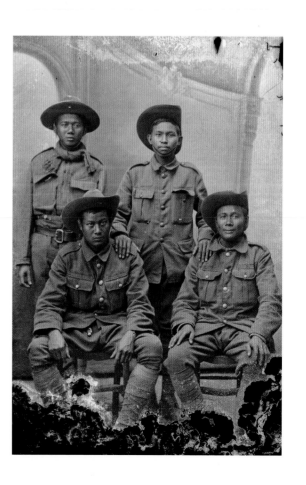

PLATES 101–102 A delightful picture of a child, probably Robert Thuillier, the photographers' son, with Indian Rajput Cipaye cavalrymen, and (right) Gurkhas from Nepal.

PLATES 103–104 An Indian cavalryman towers over a local lady, and (right) Nepalese Gurkhas fix the camera with their trademark gaze.

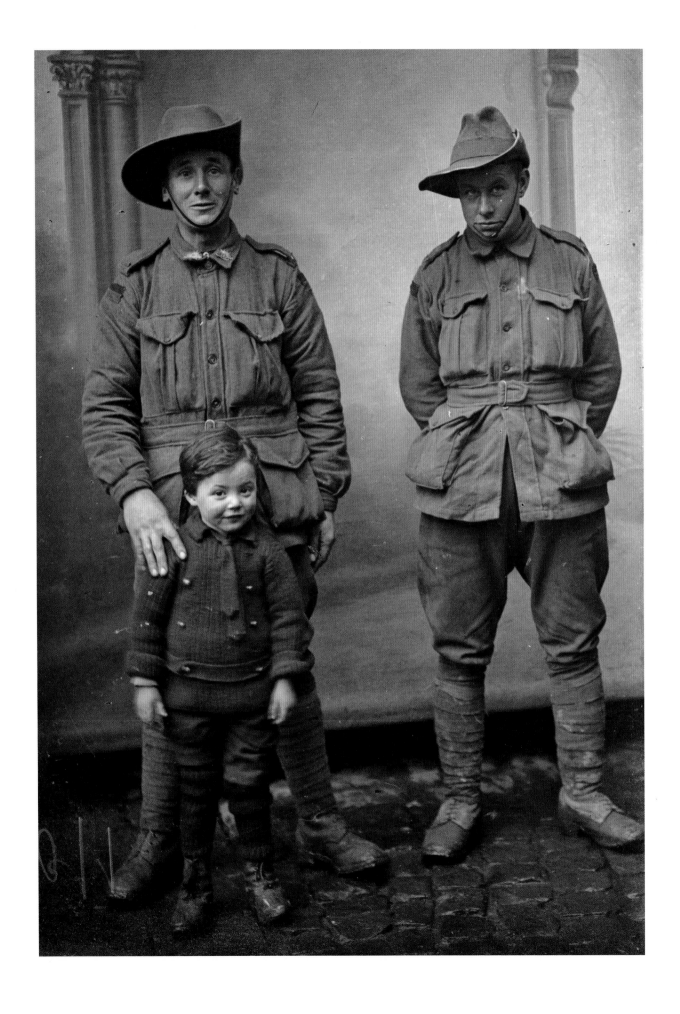

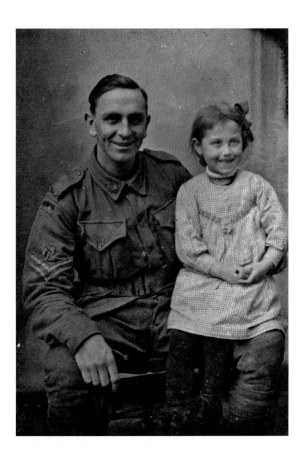

The first Australians moved into the Somme valley in July 1916, and Vignacourt was soon full of the Australian diggers as well as British Tommies. Within weeks, the Australian and British soldiers from here would experience a baptism of blood just to the north of the river Somme at a town called Pozières. There were also large Australian camps very close by, at Pernois and Flesselles, and many of the diggers who appear in the photographs are likely to have walked several kilometres into Vignacourt from those camps to have their picture taken by the Thuilliers. One of the best descriptions of these rest towns appears in the book *The Gallant Company: An Australian Soldier's Story of 1915–18*, by Harold R. Williams, in which he describes going to a rest camp at the town of Buire:

> *Its one main street was churned into mud with the ceaseless stream of transports and marching infantry passing to and from the line. Its inhabitants consisted of aged men, frightened looking children and women with care-lined faces ... Every second house was an estaminet which dispensed vin blanc and vin rouge of dubious vintage. These places were open for troops only during certain hours ... its immediate merit was that the Army here provided steaming hot baths ... no words can describe the desire for it of men whose bodies and clothes were overrun with vermin and foul with trench mud ... Dried, we went to the store and were issued with garments in lieu of those we had handed in. Sometimes this underclothing was new, but mostly it was the laundered and disinfected wear of others who had been through the baths. Invariably these contained the eggs of lice which survived treatment and eventually hatched out ...*[2]

So while it was a supply and support hub for the war effort, Vignacourt became a place primarily for rest and recreation – a sanctuary from the horrors of the war just twenty to thirty kilometres to the north-east.

Unlike so many of the soldiers they photographed, Louis and his wife survived the war. Perhaps because he had been exposed to so many motorcycles during the conflict – there are many in his photographs – Louis indulged a passion post-war for motorbike racing and, ever one with an eye for an opportunity, in 1920 he became a dealer in army surplus. Judging from his attic, and the mountains of early motorcycle-racing magazines strewn around his photographic gear, it seems the Thuillier photographic plates were

PLATES 105–106 Soldiers of the Australian 5th Battalion pose with Robert Thuillier, and (above) a smiling Australian corporal in the Signals Corps sits a young local girl on his lap.

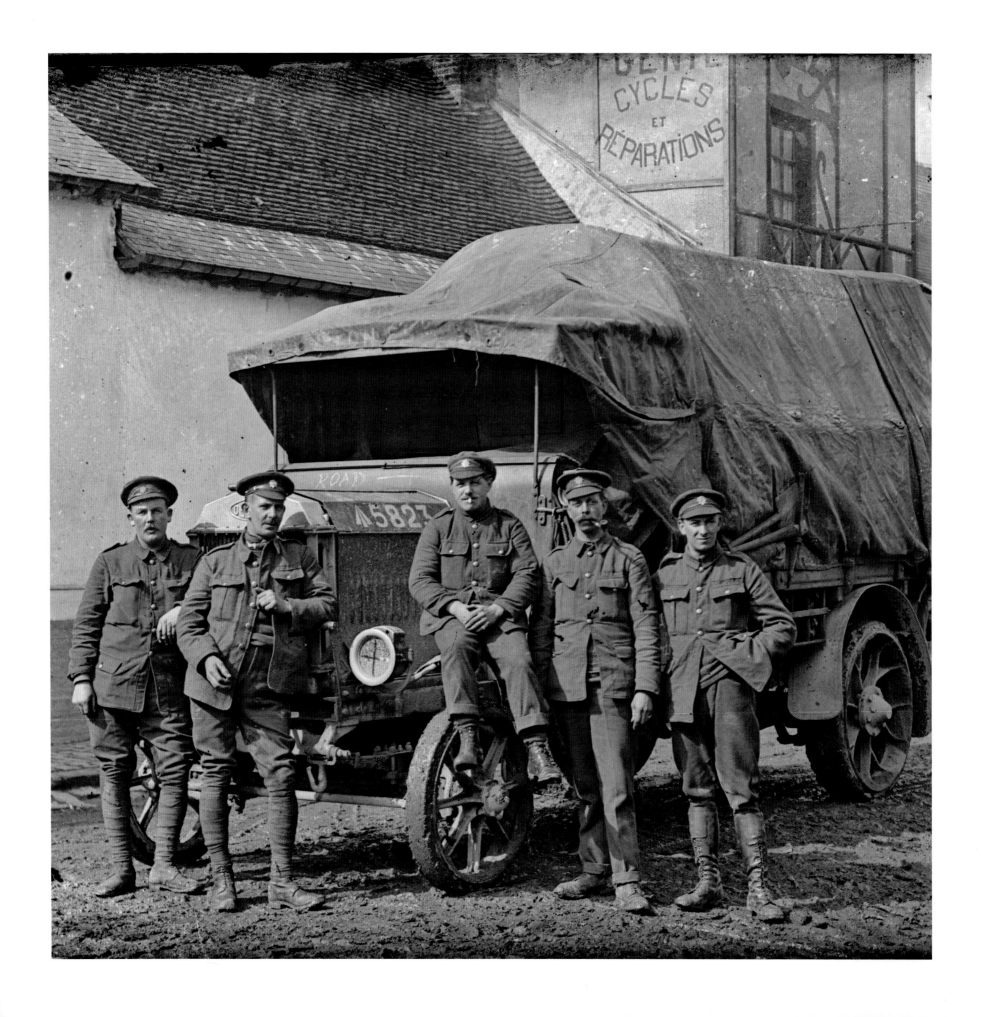

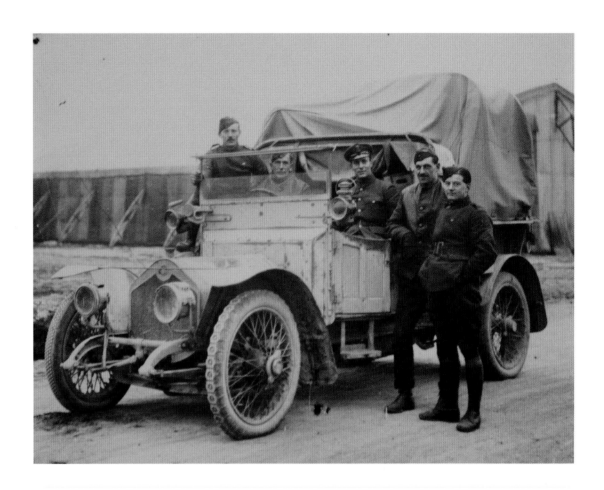

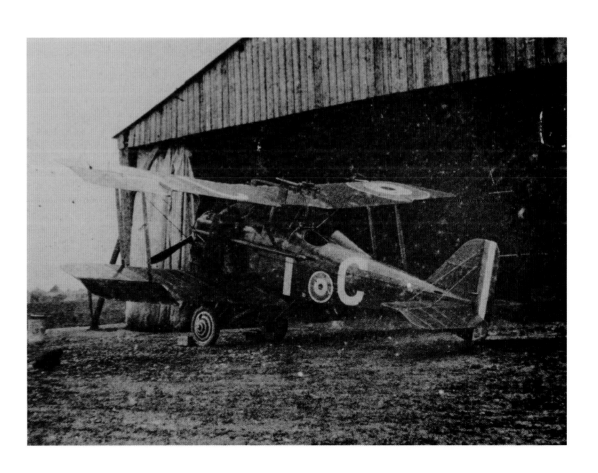

PLATE 107 British Army Services Corps soldiers with troop-carrier vehicle in the Vignacourt main street.

PLATE 108 Another image of ASC soldiers with troop vehicles in Vignacourt. The churned-up condition of the road is clear.

PLATE 109 British Royal Flying Corps soldiers outside the nearby aerodrome.

PLATE 110 A rare Thuillier image of the nearby British aerodrome at Vignacourt. This is a British Royal Aircraft Factory SE5 or SE5A biplane.

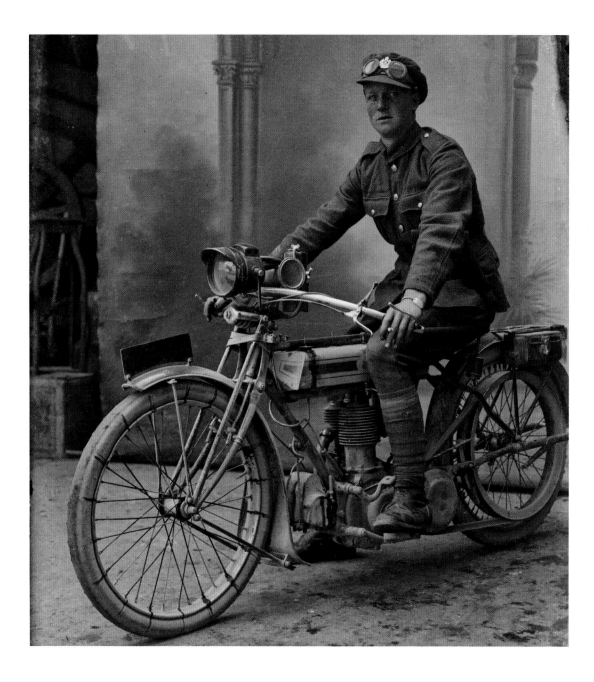

left exactly as they were immediately the war ended, forgotten until Robert Crognier first tried and then Laurent Mirouze succeeded in bringing them to the world's attention decades later. There are no plates in the Thuillier collection beyond about 1919 or 1920, so it seems likely Louis and Antoinette wanted a break from photography after the war years.

There is a tragic twist to the story of Louis Thuillier, related by his nephew Robert Crognier, in a letter he wrote to Laurent Mirouze shortly after they met, in 1989. For years after the war, Louis struggled with depression and, despite the concern and care of his family, he withdrew from them and sank into a deep despair. One early morning in

PLATE 111 A private of the Royal Engineers on his motorcycle. The chevrons on his lower right sleeve show he is in his third year of overseas service and date this image to January 1918 or later.

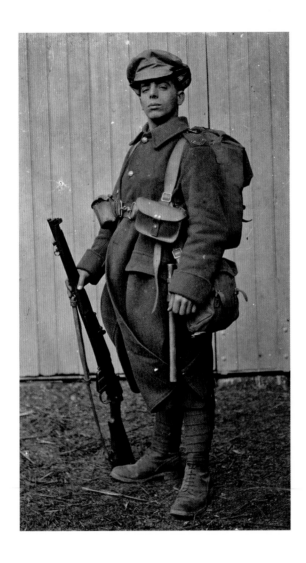

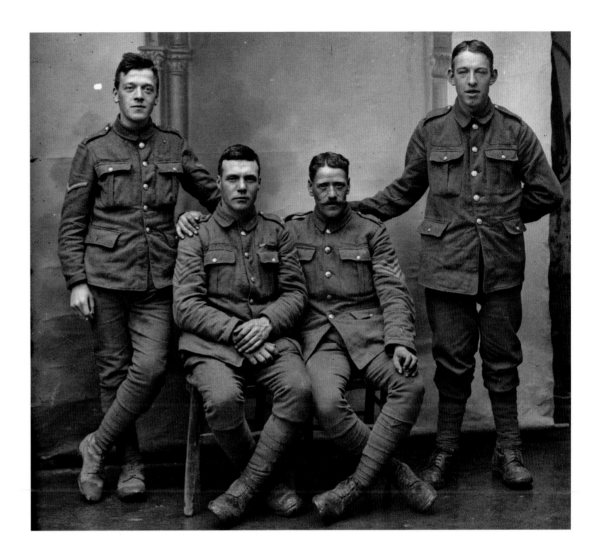

PLATE 112 A proud young Tommy from the Royal Warwickshire Regiment with all his kit.

PLATE 113 Two seated sergeants (the one on the left has a Military Medal ribbon on his left breast). A corporal stands on the left and a private on the right, regiment unknown.

January 1931, a furious knocking on the door of their house woke Robert's parents. It was the husband of Louis's sister, Louisa, who lived nearby. They were told 'Louis Peugeot' had committed suicide at the age of forty-four. He had shot himself in the head.

There is no one from the family who knows for sure what drove Louis to end his life. But it is entirely plausible that he was traumatized and pushed into depression by his own wartime experiences; tormented by the memory of the thousands of young men who went on to their deaths after sitting or standing before his camera in his Vignacourt courtyard. There was not the understanding back then that there is today of the effects of battlefield trauma on a human soul.

Louis's suicide perhaps explains why the extraordinary photographic collection was placed in the family attic after his death and forgotten. For Antoinette, who lived until the 1970s, it may well have been too painful for her to recall this enormously creative period during the First World War when she and her husband lived such a vital and social life, welcoming soldiers from all over the world into their home, Louis often working well into the night to print the latest photographs.

The couple had two children, both boys, Robert and Roger. Robert was born in 1912 and features in many of the 'Lost Diggers' wartime pictures. Roger was born after the war, in 1920.

For the many Allied soldiers, a child's innocent face was doubtless a blessed relief after everything they had experienced in the trenches. The delightful, happy images of the town's children sitting with soldiers suggests they clearly enjoyed playing with the troops, many of whom were fathers themselves.

Robert Thuillier never married and had no children. Roger's children are Madame Eliane Bacquet, born in 1945, and Christian Thuillier, born in 1947, both of whom we have already met. It is with their kind cooperation that the entire Thuillier collection was carefully removed from the family farmhouse attic, cleaned, packed and then brought to Australia for preservation.

PLATE 114 A Thuillier family photograph – Robert and Roger Thuillier, after the war. (Courtesy Bacquet family)
PLATE 115 Soldiers, possibly of the Army Services Corps, with Roger Thuillier, on the right, and another little friend.

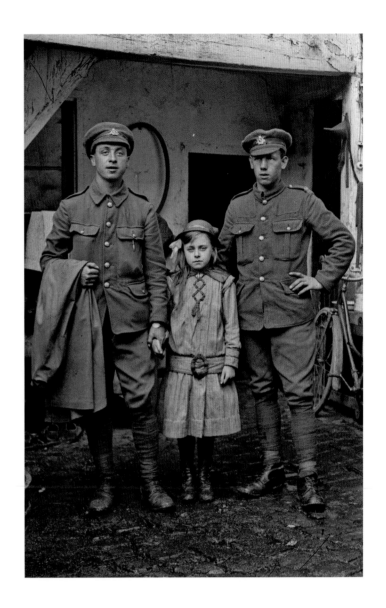

PLATE 116 A slightly damaged plate of
Royal Engineers soldiers posing with a
Thuillier child and another local.
PLATE 117 Two Army Cyclist Corps privates
with a young French girl.

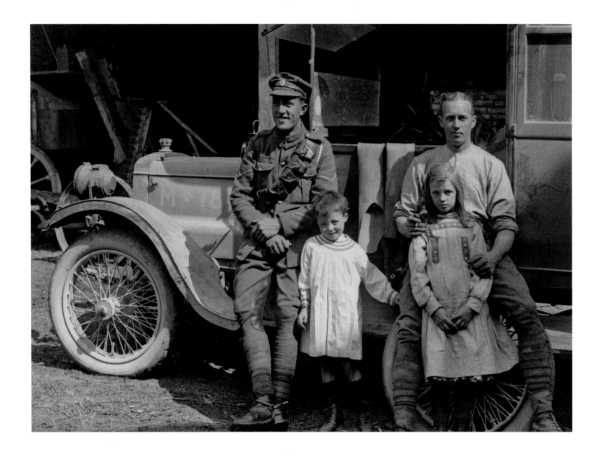

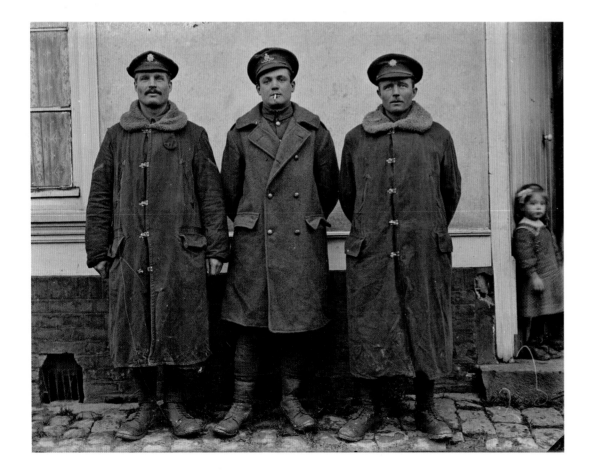

PLATE 118 An Army Services Corps lance corporal with bandolier and spurs, posing in front of a bus.

PLATE 119 A Royal Artillery Regiment soldier (left) with two Army Services Corps men, clearly in the winter.

PLATE 120 A classic informal Thuillier image of three Royal Artillery soldiers with three Australian diggers and a young Thuillier relative.

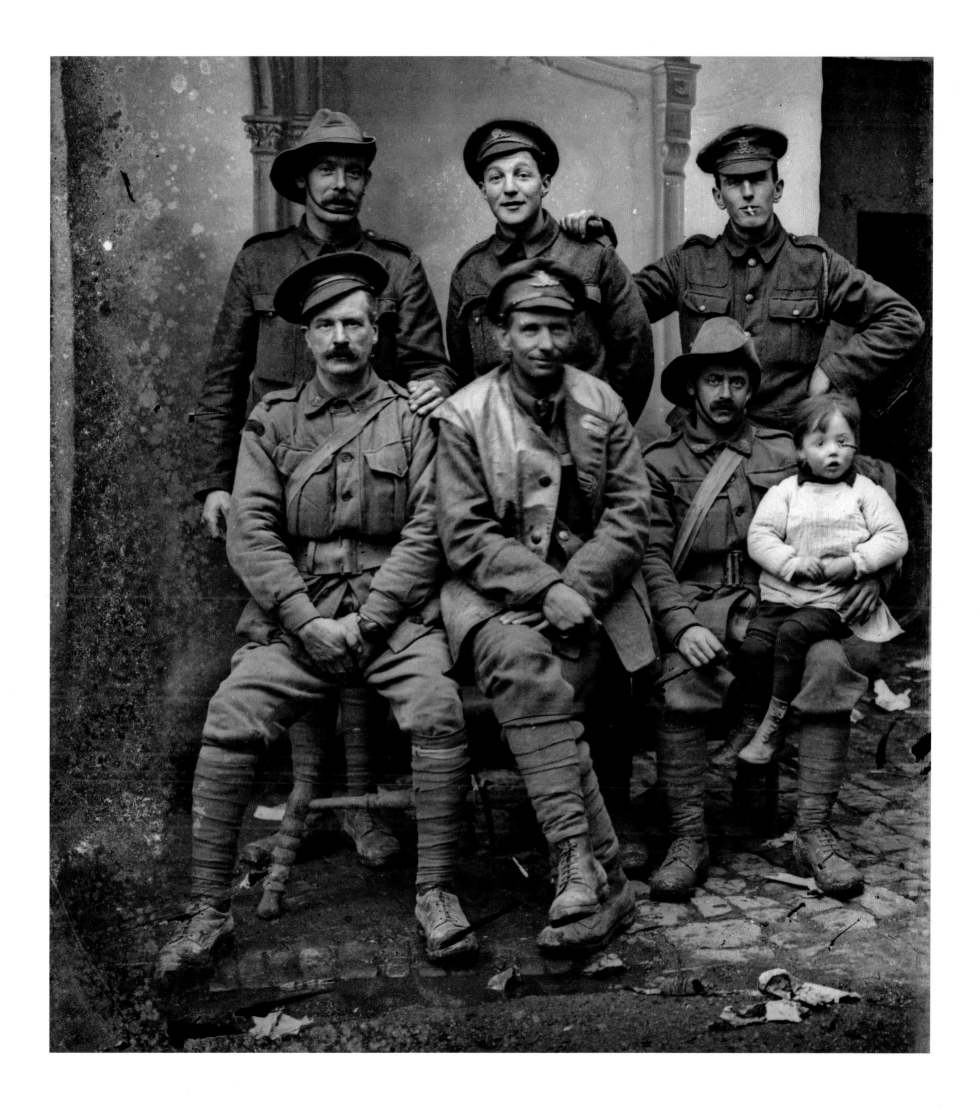

The War

On 28 June 1914, the assassination in Sarajevo of Archduke Franz Ferdinand, heir to the Austro-Hungarian throne, unleashed the apocalypse we now know as the First World War. Militaristic Prussians had long wanted to expand Germany's empire; the German Kaiser Wilhelm II had launched an arms race with Britain, and scrambled to snap up colonies and global resources. After years of simmering tensions, the shooting of the Archduke in the Balkans was the spark that ignited the war. One by one the great powers of Europe plunged into the abyss as treaty obligations pushed nations on to either side of the conflict. France, bound by treaty to Russia, found itself at war with Germany and Austria-Hungary. Within weeks, Germany had invaded Belgium, aiming for Paris. By 4 August 1914, Britain and soon after, its empire, had also entered the war. By late September 1914, the Allied armies and their German adversaries were locked in a trench-warfare stalemate – each side dug in to a roughly matched pair of trench lines running often just metres apart, over a distance of 700 kilometres from the Swiss border in the south to the North Sea coast of Belgium.

Attempts by each side to outflank the other had failed and the only solution was 'digging in' to trenches. The stalemate was created by modern artillery and the new machine guns, capable of extraordinary rates of fire.

During the American Civil War, just a generation earlier, soldiers took a minute and a half to reload their single-shot muskets, and so the slow rate of fire meant a frontal assault was not too catastrophic an undertaking. But by the beginning of the First World War, military strategy lagged behind new military technologies. A single machine-gunner on the Western Front could pump out a thousand bullets in the time it took a Civil War soldier to reload. Sadly, it wasn't until later in the war that both sides began to grasp the strategies necessary to combat this new technology of killing. Military commanders persisted with a strategy of attrition, ordering troops over the top into full-frontal assaults against the enemy trenches.

PLATE 121 French soldiers head north-west along the Rue de Daours in Vignacourt towards the front line. Because the men are no longer wearing the red trousers originally issued to soldiers, this is likely to be during 1915. As the war went on, the French changed their uniform to the bluey-grey tunic worn by soldiers in this picture instead of the earlier colourful uniform which was an impractical relic of the Franco-Prussian War.

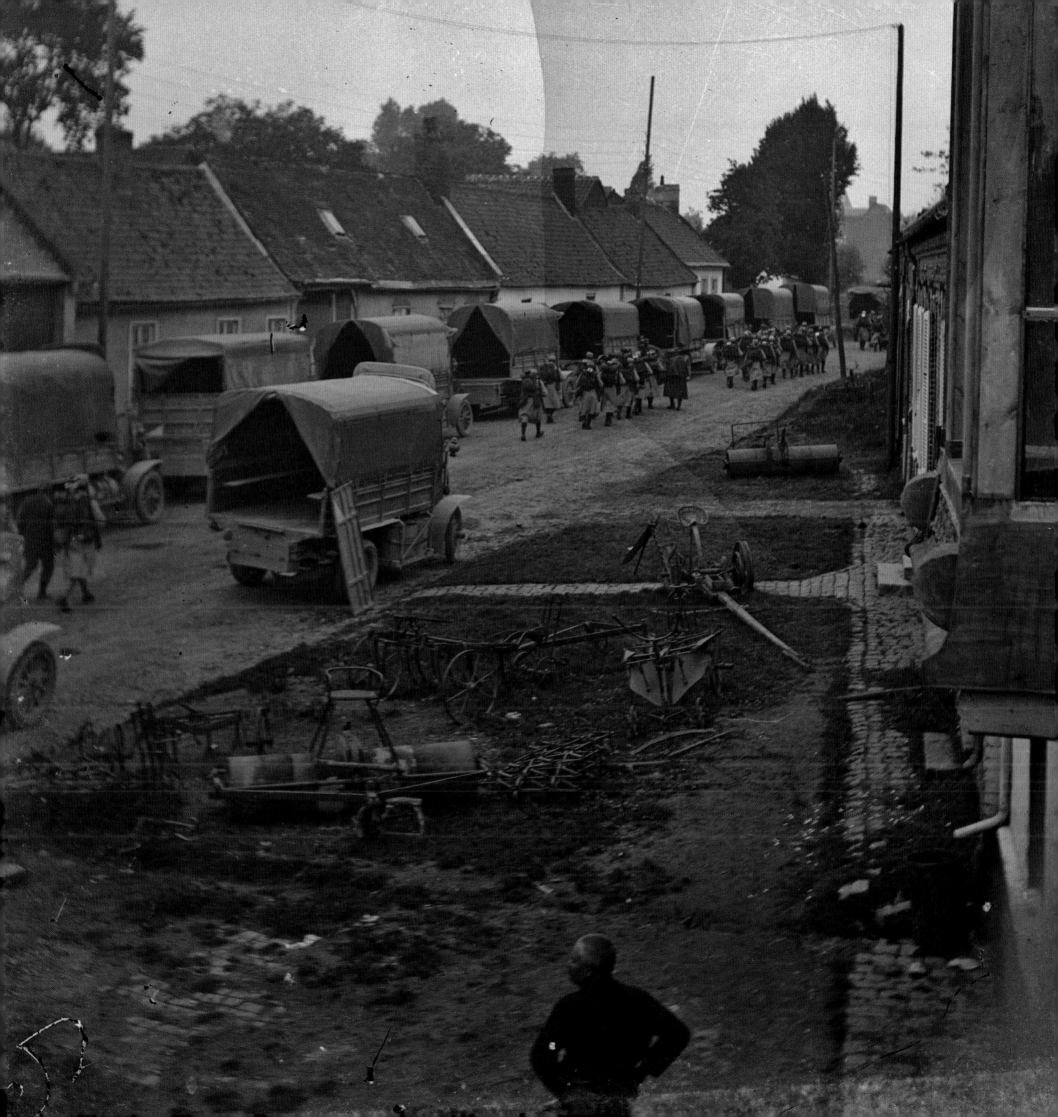

In December 1915 General Sir Douglas Haig was appointed Commander-in-Chief of the British armies in France in place of Field Marshal Sir John French; French had commanded through the disastrous Battle of Loos in September, losing tens of thousands of troops for little gain, and hopes of a quick victory now seemed remote. As John Keegan has written, Field Marshal French

> *… had been worn down by the attrition of his beloved army of regulars, the old sweats of his Boer War glory days, the keen young troopers of the cavalry in which he had been raised, the eager colonels who had been his companions on the veldt and in the hunting field. The death of so many of them – there had been 90,000 casualties among the original seven infantry divisions by November 1914, rather more than a hundred per cent of mobilised strength – afflicted him …*[3]

But there was one huge difference beginning to show by the start of 1916: as Haig planned the big breakthrough in the German lines, Lord Kitchener's massive enlistment drive had allowed the formation of six 'New Armies' – each five divisions strong – to supplement the existing (now very depleted) eleven regular army divisions and the twenty-eight infantry divisions of the territorials. It meant that by the spring of 1916 Britain would have seventy divisions available for a massive offensive aimed at breaking the German lines.

PLATE 122 Trench warfare. An intriguing picture of what appears to be an Austrian mortar battalion in the trenches. Historian Laurent Mirouze believes this plate may well have been obtained by the French 47th Division which was billeted in Vignacourt. They had just returned to France from fighting with the Italians against the Austrians in northern Italy. Perhaps the intelligence service of the 47th asked Thuillier for prints off these plates.

PLATE 123 Royal Artillery soldiers pose with what appears to be a 6-inch howitzer on a Vignacourt street during winter on the Western Front. The wooden-spoked wheels were often fitted with girdles to get the gun over mud. One of the British Army's most important weapons during the war, these guns fired 22.4 million rounds on the Western Front.

In late December 1915 Haig agreed with French General Joffre that 1916 would
be the year that France and Britain mounted a joint offensive at the point where their two
armies met in the middle of the Western Front, on the Somme. The Allied lines along
this section of the Western Front – beautiful lush countryside of rolling green hills and
chalky soil – had been relatively quiet since 1914 and the Germans had exploited the
calm to massively reinforce their own lines, building huge underground bunkers, burying
communications cables and creating arcs of fire with machine guns and barbed wire
which made crossing no man's land towards their lines a near-suicidal undertaking. Facing
them were twenty relatively less well-prepared Allied divisions – most of them the New
Army British recruits, the patriotic citizens who had rushed to join the Pals battalions –
and there was a small number of regular army units. There were also the territorials, who
had only been in France for six months; this meant that most of the Allied infantry had
little or no experience of combat at all.

General Haig transformed the thirty kilometres west of the Somme front lines
into a massive armed camp, building new roads and railway lines, artillery emplacements
and shell dumps, that would provide the support for the massive infantry attack. Even
at Vignacourt, a brand-new casualty clearing station was being built and, as the soldiers
caroused in the estaminets and restaurants of Vignacourt and nearby Amiens's red light
district, all knew there was hell to pay on the horizon.

Haig's plan was to break the German lines by levelling their front lines with a
massive bombardment in the week before the attack. Nineteen British and three French
divisions would then advance across no man's land in the expectation that the enemy
would be so shattered that barbed wire could be cut and their trench lines seized, allowing
them to advance into the open country behind. As John Keegan explains, Haig and his
advisers were so confident of the impact of their artillery that '… they had decided not
to allow the inexperienced infantry to advance by the tried and tested means of "fire
and movement", when some lay down to cover with rifle volleys the advance of the rest,
but to keep them moving forward upright and in straight lines'.[4] The advancing troops
would walk straight across with a creeping barrage of artillery falling ahead of them,
which was designed to keep the Germans out of their parapets before the Allies were on
top of them. But, as history records, the coming attack would prove to be an unmitigated
disaster; all the Allied expectations would be dashed in a dreadful and bloody carnage of
machine-gun- and shellfire. And, as Keegan comments, the generals should have known:

PLATE 124 These three soldiers from
an unidentified regiment wear identity
bracelets on their wrists. The flags on the
sleeve of the private in the middle show
he is a qualified signaller. His friends
hold the rank chevrons of a corporal (the
soldier on the left) and lance corporal.

'The simple truth of 1914–1918 trench warfare is that the massing of large numbers of
soldiers unprotected by anything but cloth uniforms, however they were trained, however
equipped, against large masses of other soldiers, protected by earthworks and barbed wire
and provided with rapid-fire weapons, was bound to result in very heavy casualties among
the attackers.'[5]

As will be evident in the following photographs, what makes them so special is
their intimacy and humour. Madame Thuillier took many of the portraits and perhaps
it was the sight of her beautiful face that sparked a smile from the weary men straight
from the trenches. It is the very special humanity and humour of the Thuillier pictures,
their normality at a time when so many of these young men went off to their deaths, that
makes them so distinctive. Perhaps these soldiers realized their chances of surviving this
war unscathed were remote and that this was a last opportunity to send a photograph
back home.

Most of the photographs are of British soldiers and a few airmen, Scots in their
kilts and English, Welsh and Irish regiments. But there were also Indians, Nepalese and a
host of other nationalities from across the British Empire. For one brief, horrific moment
in history they were all thrust together into a brutal, ghastly killing maw only a short

distance from the ordinary daily life of this small French country town. And when those soldiers came to rest, recuperate and nurse their wounds before they returned to the front lines, Vignacourt was where they relaxed and tried to forget the war.

During research for this book, the common and frequently voiced refrain from descendants of First World War veterans is how little their fathers or grandfathers ever spoke about their experiences on the Western Front. Sebastian Faulks described this conspiracy of silence admirably in his historical novel *Birdsong* through his fictional character Captain Stephen Wraysford, writing of his time on the Western Front:

> *No child or future generation will ever know what this was like. They will never understand. When it is over, we will go quietly among the living and we will not tell them. We will talk and sleep and go about our business like human beings. We will seal what we have seen in the silence of our hearts and no words will reach us.*[6]

This unwillingness by the soldiers who came home to tell of what they had seen perhaps explains why the Thuillier images, nearly a century on, now arouse so much emotion. One hundred years' passing has healed much of the initial grief felt by the families of those who died, those who were horribly maimed or those who were simply never seen or heard of again. The temptation to put that horror in the past, to tell the children never to talk about it, must have been intense. Now, with the centenary of 1914–18, there is renewed focus on the grief but there is also an intense pride and curiosity. The names of the battles of the First World War stand as grim metaphors for suffering: Mons, Ypres, Arras, the Somme, Fromelles, Pozières, Passchendaele … and the men who fought in them are long dead. But the soldiers you see in these pages strode those fields; many died, many were wounded and every one of them suffered.

'Never before in our history had such an army been gathered, and never again would such an army be seen … True we launched greater armies and won greater victories in the two years that followed; but – the very flower of a race can bloom but once in a generation. The flower of our generation bloomed and perished during the first four months of the First Battle of the Somme. We shall not look upon their like again.'

Major J. H. Beith in *The Willing Horse* (1921) by Ian Hay

PLATE 125 The service caps on the ground represent several famous British regiments: (left to right) Essex, Royal Berkshire, Suffolk (two caps) and Norfolk.

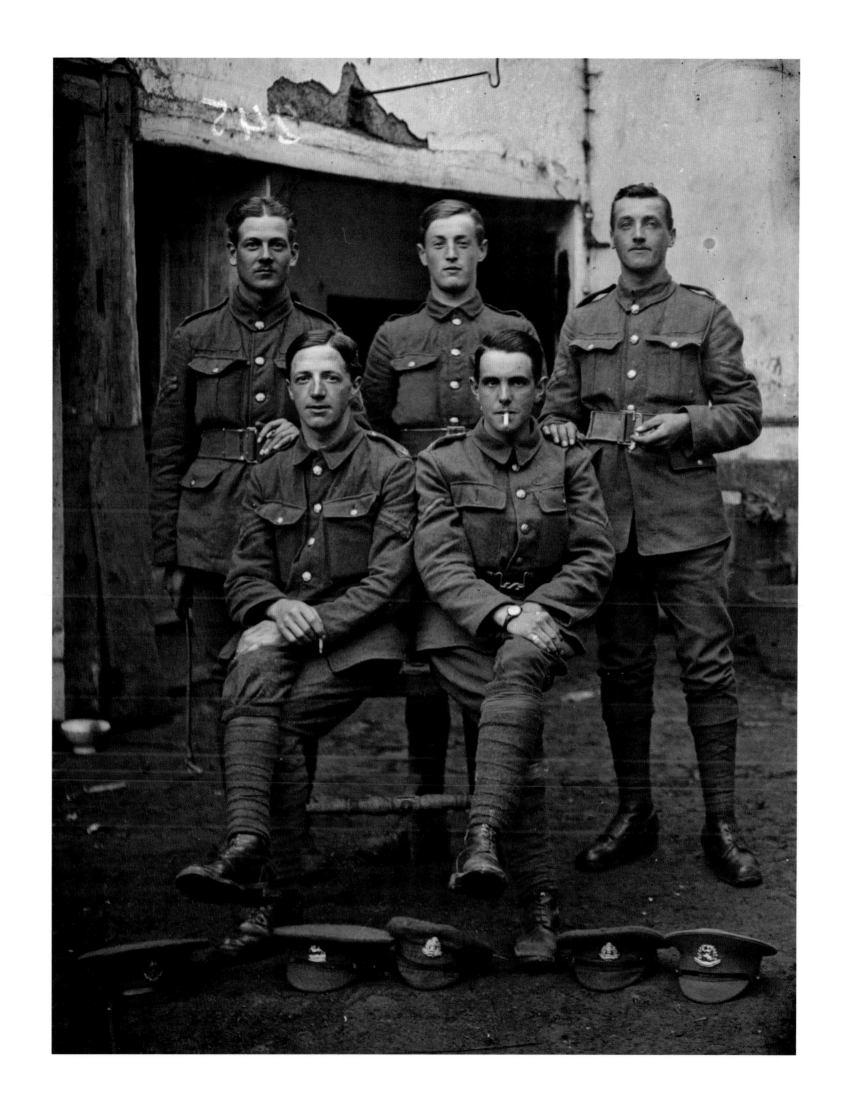

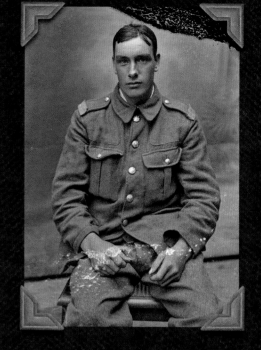
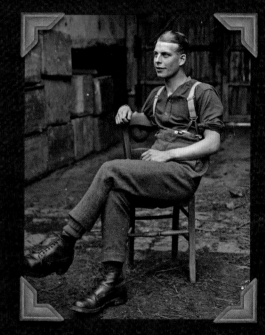
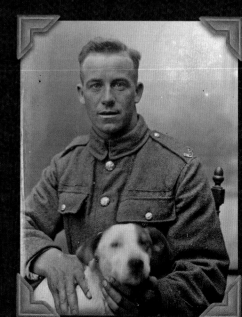

Part Two
THE TOMMIES

York and Lancaster Regiment

'Going in with the lads'

By the time the photograph opposite was taken, these two high-ranking officers of the 9th Battalion of the York and Lancaster Regiment had been through more than eighteen months on the Western Front, including the Battle of Loos in late September 1915. For months since the disastrous British losses at Loos, the battalion's commander, Lieutenant Colonel Arthur Addison, and his second-in-command, Major Harry Lewis, had pushed their men – most of them Yorkshire miners – extremely hard in training near the French town of Saint-Omer, preparing them for an assault somewhere on the entrenched German front lines that they knew was soon to come. Both officers finally learned the attack would be on the Somme when, in January 1916, their 9th York and Lancaster Battalion was deployed 100 kilometres south from Saint-Omer to Vignacourt. We know this photograph was taken sometime in late March 1916, in the final weeks of their time there – and, sadly, we also now know it to be the final months of both their lives.

It is wonderful to be able to identify these two dignified-looking senior officers because their faces and story might so easily have been lost in the fog of war; and they are two of the highest-ranking officers identified up to now in the Thuillier images. For within a few months of their photographs being taken by the Thuilliers, Lieutenant Colonel Addison and Major Lewis would be two of the thousand or so British officers who would die 'on the German wire' on the very first day of the Somme. We only know who they are because, over half a century later, in February 1970, an elderly gentleman by the name of Philip Brocklesby, who had been a lieutenant in the 13th York and Lancasters, and was clearly a chum of Addison and Lewis, took the trouble to remember both men because, he lamented, so little was told of their steadfastness and courage in the regiment's official history. He sent his story and a faded print of the Thuillier image to the regimental journal's editors.

PLATE 126 The cap badge of the York and Lancaster Regiment

PLATE 127 Two of the highest-ranking officers identified in the Thuillier collection: 9th Battalion York and Lancaster commander Lieutenant Colonel Arthur Addison (left) poses with his second-in-command Major Harry Lewis (right) at Vignacourt in late March 1916. On the following 1 July, both men elected to lead their men into battle on the first day of the Somme – and both would die, within three months of this photograph being taken.

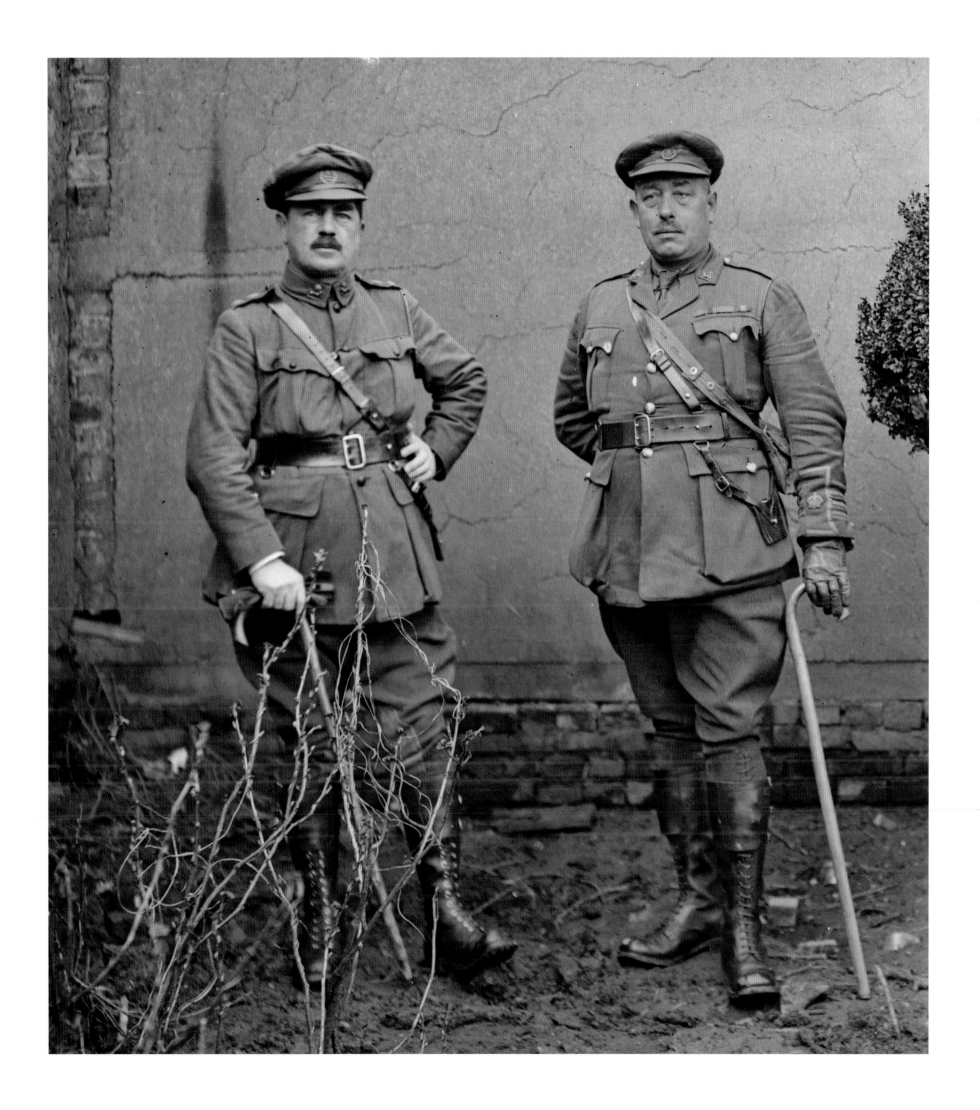

Brocklesby had been an orderly room clerk private with the 9th from May to November 1915, no doubt winning a commission after Loos, but he wrote of the warm affection and regard in which all the men of the 9th held both Addison and Lewis. Of Colonel Addison he quoted one soldier describing him as a 'pleasant, quiet, Regular officer recalled from half-pay, not a dynamic man but a responsible soldier with right principles about training troops'.[1] His second-in-command, Major Harry Lewis, was a former Guards sergeant major who was remembered for his formidable discipline and drill training. As the account in the regimental journal *The Tiger & Rose* details:

> *Major Lewis impressed on me and my friends one lesson at least; that young officers have no privileges and no rights; but only duties. Woe betide any subaltern who ever so much as enquired after his dinner until he had seen his men fed and made comfortable; or who kept them standing at 'attention' when they might have been 'standing at ease'.*[2]

PLATE 128 A York and Lancaster soldier (standing) with a soldier from the Sherwood Foresters. The Sherwood Foresters were also part of the 70th Brigade attack on 1 July 1916.

There was also the story of how, when they were training in England, the colonel had led them on a sixteen-mile route march; four miles into the hike with full kit Addison turned them around and made them pick up the litter they had left at their departure point. 'The 9th never left any more litter after that!'[3] The men also joked how Major Lewis had the loudest voice of command that anyone had ever heard, claiming that his commands could be heard from four miles away.

In 1916, Lieutenant Colonel Addison was a married man of forty-nine and Major Lewis was fifty-four. Both had families back in England but, after the horrors of 1915, they knew as British officers that they had little chance of surviving the war unscathed. Colonel Addison had a lot to live up to; his father, Thomas Addison, was a general in the British Army and Arthur had followed him into the regular army, serving in the Royal Irish Rifles. When war was declared he was living in England and he was recalled into the army to head up the 9th Battalion when it was formed in the West Riding of Yorkshire in September 1914. Major Lewis had started off in the ranks, earning his stripes in the 1898 Sudan campaign to become a sergeant major in the Grenadier Guards before he moved across to the York and Lancaster Regiment. The 8th and 9th Battalions of the York and Lancaster were part of the 70th Brigade initially attached to the British 23rd Division. But in the lead-up to the Battle of the Somme, their 70th Brigade was transferred to the 8th Division under General Sir Henry Rawlinson's Fourth Army. Beside them in the 70th were other Yorkshiremen: the 8th Battalion the King's Own Yorkshire Light Infantry and the 11th Battalion the Sherwood Foresters. None of them, their commanders included, really had any idea what kind of impossible attack they were about to be sent into.

In the lead-up to the beginning of the Somme offensive, the 70th Brigade moved into the Le Boisselle–Thiepval sector. In this part of the front, no man's land was very wide and was particularly hazardous because it lay under the sights of the higher German-held trenches and their machine-gun posts. It was also wide open to the German artillery spotters.

On 30 June, the brigade, along with the rest of the 8th Division, was in position – the 8th York and Lancaster and the 8th King's Own Yorkshire Light Infantry were to be in the initial assault with the 11th Sherwood Foresters and the 9th York and Lancaster coming up behind in reserve. What followed at 7.30 a.m. on 1 July when the barrage lifted, as with so many other battalions all along the Allied line, was a massacre. The Allied barrage had not destroyed the German defences and, as the Tommies went over the top, they were cut down by the heavy machine-gun fire pouring down from the German positions. When it was time for the 9th to go over in the following waves at 8.40 a.m., they must have known what would be their fate. But in the face of certain death the two commanders made a fateful decision.

Instructions had been issued to commanders during the battle plan for the opening attack that officers who were second in command should remain behind, to ensure the battalions could re-form under experienced leadership if the commander fell in battle. However, as Philip Brocklesby's 'Tiger & Rose' account details, Major Lewis refused to stay behind in safety, insisting on 'going in with the lads he had trained'. It was a noble and courageous decision but a wretchedly pointless one; he and Lieutenant Colonel Addison were cut down by German artillery and machine-gun fire within seconds of leaving their trenches. By 7 p.m., the few bloodied remnants of their 9th Battalion had made it back to the British lines, although more than half of their number lay out on the battlefield behind them.

The artillery barrage in front of the 70th Brigade had actually cut the German wire defences and the first and second lines on the Thiepval ridge were captured. But by the time the 9th York and Lancasters came up in support the Germans had rallied their defence and even before they left their assembly point one of the four 9th Battalion companies had lost half of its men to precise German artillery fire. One account, from Lance Corporal John Cook of the 9th Battalion, describes how he could hear the wounded screaming for help in the battlefield; it sounded 'like enormous wet fingers screeching across an enormous pane of glass. Some of the wounded screamed, some muttered, some wept with fear, some called for help, others shouted in delirium or groaned in pain.'[4] The men who had seized the German lines at Thiepval fought bravely for another six hours until they were overwhelmed and killed by the Germans. Most of those who died were mates from the Pals battalions in Sheffield and Barnsley.

The 9th Battalion lost twenty-three officers and 517 other ranks on that single day, the blackest in British military history. Their chums from the 8th Battalion suffered even worse, losing twenty-three officers and 617 other ranks. Two hundred of those men of the 9th lay dead, in rough lines where they had fallen across no man's land, among them the bodies of Lewis and Addison. The commander's body could not be recovered for months because the fire across the open ground was so intense during the Battle of the Somme. It is a painful detail, recorded in Anthony Seldon and David Walsh's book *Public Schools and the Great War*, that when Lieutenant Colonel Addison's body was found, his diary was also retrieved. It revealed he had lived for two or three days before succumbing to his wounds on the battlefield.[5] Poignantly, he had also written in his diary: 'Tell the Regiment I hope they did well.' Back in England, Mildred Addison of Chelsea and Charlotte Lewis of Hertford were about to receive the news they must have dreaded. Lieutenant Colonel Addison is buried in Becourt Military Cemetery but the body of Major Lewis was never found. He has no known grave but is remembered on the Thiepval Memorial. As an elderly Philip Brocklesby wrote in 1970: 'Perhaps ... these two will be remembered.'

PLATE 129 An officer of the York and Lancaster Regiment (right) with an officer of the West Yorkshires (left).

The Prince of Wales' Own West Yorkshire Regiment

The poignant looks on the faces of the officers in this extraordinary Thuillier image say it all; with quiet dignity every man shows the limp, battle-weary gaze of 'the thousand-yard stare', the unfocused gaze of the battle-traumatized soldier. Louis Thuillier captured the feelings of the 6th Battalion headquarters staff for the Prince of Wales' Own West Yorkshire Regiment, felt after weeks of holding a front-line trench around Thiepval on the Somme, followed by another month of preparations for the attack on the German trenches in front of it. Vignacourt was to offer brief respite before they were thrown back into the carnage of the Somme; the coming battle was to be a disaster so great for volunteer New Army regiments such as the West Yorkshires that back home in England Bradford newspapers black-bordered their front pages in sorrow, page after page featuring images of their lost young men.

Before arriving in Vignacourt, the 6th Battalion, often referred to as the 1/6th because it was the first deployment of the 6th Battalion, had on 12 February 1916 relieved the Lancashire Fusiliers in trenches opposite the village of Thiepval. It was part of the deployment of the British 49th Division around the town during February and March to prepare for the Battle of the Somme. For the officers in this picture it was an opportunity to study the terrain and fortifications on the German side that they would be expected to attack in a few months. What they saw must have chilled them. The hilly country gave the Germans a natural advantage because all their trenches sat on the crests of hills overlooking the English positions. With classic understatement, the battalion history records the depressing effect this had on the West Yorkshiremen: 'It will easily be understood that the effect upon the morale of British troops of being compelled to cling painfully to the western slope of positions dominated by the enemy was not good.'[6]

The battalion had just come from the waterlogged front lines of Fleurbaix and Neuve Chapelle and several especially horrific months in trenches at Ypres, where, in the winter rains, they became a morass of mud, human waste and decaying bodies.

PLATE 130 'The thousand-yard stare' – officers of the battalion HQ of the 6th Battalion West Yorkshires arrive for rest in Vignacourt after a harrowing time on the Thiepval front line. They would go back into action on the Somme a few weeks later. Back row, left to right, Lieutenant W. N. Mossop, unknown officer, Captain A. Hamilton RAMC, Captain R. Whincup, battalion chaplain. Front row, left to right, battery second-in-command Major C. E. Scott, battery commander Lieutenant Colonel H. O. Wade, Captain and Quartermaster W. H. Hill.

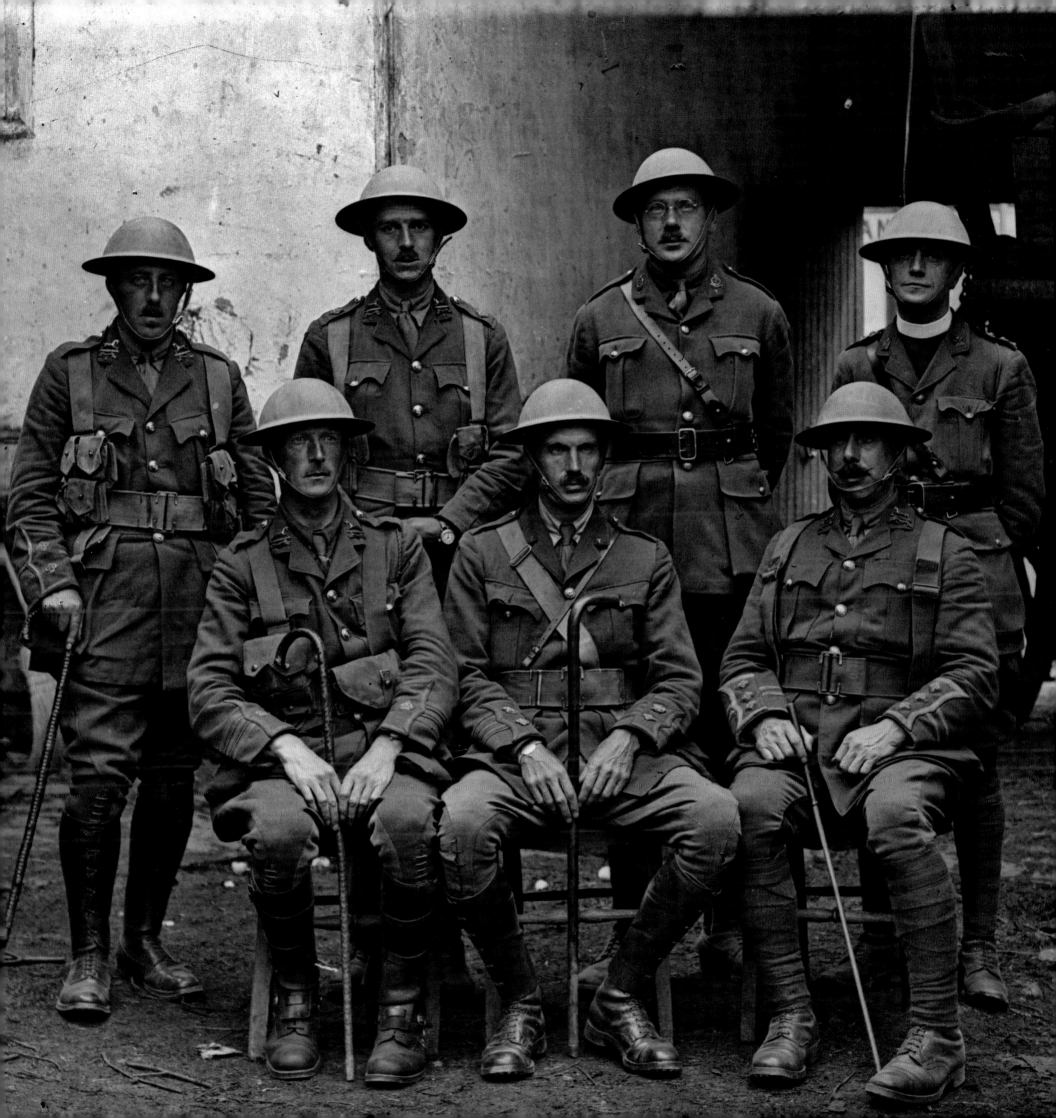

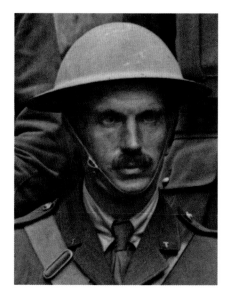
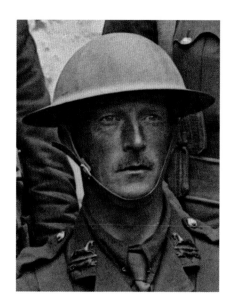
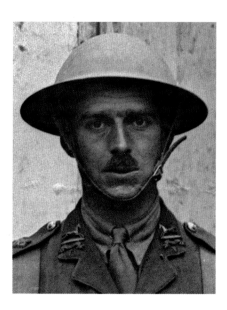
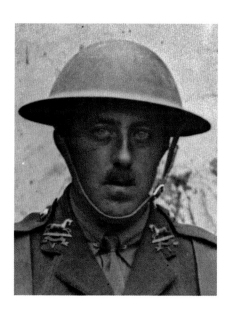

The battalion had held off a final German attack at Ypres a week before Christmas 1915 but, in doing so, they lost sixteen men dead and eighteen wounded – many to a German discharge of poisonous gas. It is a measure of the ferocity of the fighting that one 6th Battalion soldier, Sam Meekosha, won a Victoria Cross for continuing to rescue wounded and buried men at Ypres in full view of the enemy. The men had marched out of there expecting a break but hopes that Thiepval would offer respite for the West Yorkshiremen were soon dashed by constant enemy artillery and machine-gun fire. It was also bitterly cold, with heavy snowfalls, and many soldiers were already suffering from trench foot because of the sodden Ypres trenches. Because so many men were absent

PLATES 131–134 Close-ups (clockwise from top left) of the haggard faces of 6th Battalion commander Lieutenant Colonel H. O. Wade, his second-in-command Major C. E. Scott, Lieutenant W. N. Mossop and an unknown officer.

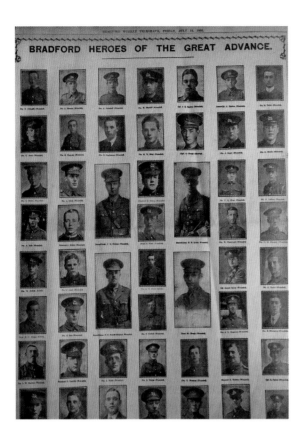

being treated for rotting ulcers and, in the worst cases, gangrene, brought about by trench foot, the battalion had to work its men extra hard to keep the numbers to hold the line. The Germans were also using gigantic 64-kilogram '*Minenwerfer*' trench mortars to blow apart the English trenches and the men in them.

Men who were caught disappeared entirely; in some cases it was necessary to parade a platoon in order to find out who was missing, as there was no other method. Candles in dugouts 300 yards from the explosion were blown out and men lifted off their feet and thrown against the trench side …[7]

The battalion's padre, the Reverend Richard Whincup (standing on the right in the battalion HQ photograph in Plate 130, page 115), was only saved from being blown to pieces by a *Minenwerfer* because a sharp sentry gave him sufficient warning to run for it; the spot where he had just been standing was obliterated. But even after being relieved at Thiepval, the battalion was then tasked with building roads and railways that would support the coming Somme attack and it was not until 3 April that the West Yorkshiremen were finally allowed to march wearily into Vignacourt.

It no doubt felt like an eternity since the British territorial 6th Battalion had left England in August 1914, in the now fruitless expectation that the war would be over by Christmas that year. As territorial reservists the men had all held civilian jobs before the war – doing part-time military service – and they had been mobilized the moment war was declared. Territorials were often mocked as 'Saturday afternoon soldiers' but the 6th was known proudly in Bradford as 'the Bradford Rifles', wearing the regiment's white horse of the House of Hanover on their cap badges and the Prince of Wales' plumes on their collars.

There was a considerable amount of civic pride in being a member of the Bradford Rifles and the men of the 6th also wore a 'T' badge that signified their territorial status on their lapels. Most of them came from jobs in the Bradford textile industry, but the commanding officer in Plate 130, Lieutenant Colonel Henry Wade, and his second-in-command, Charles Edward Scott, were both solicitors from Colonel Wade's father's Bradford firm of Wade, Bilbrough and Tetley.[8] In peacetime they had carried out target practice with the men on the local moor and they knew every individual by name; as territorials they were all closer than usual for a British Army battalion and they knew each other's family and social background. It would make the tragedy of what was to come even more wretched.

The bonds between the Bradford Rifles had become even stronger in the trenches of Ypres and Aubers Ridge, so when they arrived in Vignacourt with the rest of the 146th Infantry Brigade, and learned of the presence of a local photographer, they seized the chance to have their photograph taken with their chums. It had long been a complaint among the troops that tight battlefield security meant cameras were routinely confiscated

PLATE 135 One of many newspaper pages honouring the casualties of the Battle of the Somme, this one from the *Bradford Weekly Telegraph* on 14 July 1916. (Picture courtesy of Newsquest – Yorkshire & NE Ltd – www.TelegraphandArgus.co.uk)

on the Western Front, especially now as the Somme battle loomed. The image of the 6th Battalion headquarters staff on p. 115 (Plate 130) was probably taken around the time that they and other British infantry were first given their steel hard hats, during the eight weeks they spent in Vignacourt from April to June 1916. The helmets were such a novelty that for several weeks some of the tough men in the battalion took bets that they could stand any blow to their helmeted head with an entrenching tool handle, with predictable casualties.

This was the first time the people of Vignacourt had been asked to billet any substantial numbers of Allied troops and they welcomed them warmly into their homes and local estaminets. As well as enjoying a well-earned rest, the entire 146th Infantry Brigade was training for the coming battle on grounds just outside the town and the bombers of the 1/6th Battalion won a divisional prize for their bombing skills. It caused much hilarity that the generals judging overheard the 6th bombers' enthusiastically bloodthirsty 'purple flow of language' as they 'bombed up' a mock enemy trench.[9] The photograph of the bombers in the Thuillier collection (Plate 140, p. 121) was probably taken before or just after that competition because a few days later the bombers' officer Lieutenant H. A. Jowett (seated second row fifth from left) was wounded during practice. In hindsight, knowing now what the bombers would go into a few weeks hence, his was a fortunate wound.

As the great push drew closer, lectures in the Vignacourt village concert hall were used to instil 'attack spirit' into the men; one went into such gruesome detail on the use of the bayonet that even the most hardened soldiers were squirming:

> *He described the whole science of butchery, and seemed to enjoy describing the most*
> *horrible aspects of bayonet fighting. He explained in a quiet bloodthirsty voice exactly how*
> *to pierce the liver or kidneys or 'lights' of the enemy, and described with a ghoulish gurgle*
> *the soft thud of the bayonet as it was pulled out of the quivering body of a German.*[10]

In early May units began leaving Vignacourt to work on the communications cables, assembly trenches and other logistics for the beginning of the Battle of the Somme scheduled for the end of June. By mid-May the entire 6th Battalion had marched to Puchevillers, close to the battle zone, and all the men were sobered by the sight of a huge casualty clearing station being built within a few minutes' walk of their camp. Gallows humour took over as the men enjoyed the local estaminets – '"There's no sense in being killed with money in your pocket",' was one saying.[11] On the final Sunday in June, almost every man in the battalion turned out for the final church service before the battle. There were three cheers for the King the following day and another lecture where the troops were told that the Germans had almost no guns left, that its infantrymen were tired of the war and that two days into this battle the cavalry would be chasing the Germans in full retreat towards the Rhine.

In darkness on 27 June the 6th Battalion marched out of Puchevillers towards the

PLATE 136 An example of the West Yorkshire Regiment cap badge.
PLATE 137 A close-up of an officer's lapel shows how they also wore the West Yorkshire Regiment badge with a bronze 'T' to indicate their status as volunteer territorial soldiers. This confirms that these men are from the 1/6th Territorial Battalion of the West Yorkshire Regiment.

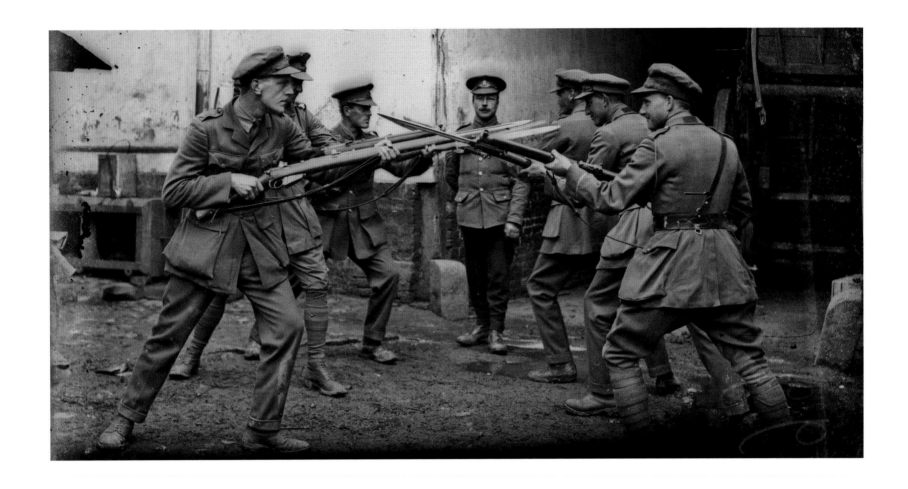

PLATE 138 A group of officers demonstrating bayonet practice in Louis Thuillier's farmyard. One of them (second from left) wears a York and Lancaster Regiment badge and the man to his right is from the West Yorkshire Regiment. The sergeant instructor in the middle wears the Musketry and Gymnastics Corps badge. Two of the men on the right wear black patches on the backs of their jackets that were used to identify officers as they led their men into an attack.

front, nineteen kilometres away, civilians solemnly watching as the men proudly marched past singing and shouting on their way towards the heavy, glowing Allied bombardment that was now raging on the horizon. Rain had delayed the originally scheduled attack and it was not until the evening of 30 June that the 6th marched into its trenches at Thiepval. The regimental history reports a mood of optimism – 'there was no foreboding or pessimism'[12] – and it even uses the words from Shakespeare's *Henry V* to evoke the feeling among the men that night:

We would not die in that man's company
That fears his fellowship to die with us . . .
We few, we happy few, we band of brothers;
For he to-day that sheds his blood with me
Shall be my brother; be he ne'er so vile,
This day shall gentle his condition:
And gentlemen in England now abed
Shall think themselves accursed they were not here . . .

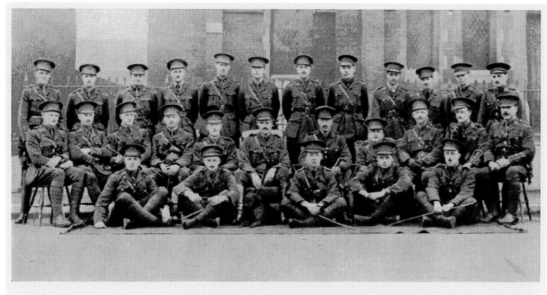

GROUP OF OFFICERS, 1914.

TOP ROW.—LIEUTS. HESELTON, DOBSON, MYERS, WATSON, T. E. ARMISTEAD, BIRCH, TETLEY, HAMILTON, MCLAREN, MUSGRAVE, HORNSHAW AND ODDY.

CENTRE ROW.—CAPTS. FELL, BARKER, WALKER, FAWCETT, MAJ. SCOTT, LT.-COL. WADE, MAJ. CLOUGH, CAPT. AND ADJT. G. R. SANDEMAN, CAPTS. ANDERTON, MULLER, AND CAPT. AND QUARTERMASTER W. H. HILL.

BOTTOM ROW.—LIEUTS. SAVILLE, KNOWLES, GRICE, FAWCETT, AND MOSSOP.

The grim reality is that all along the Somme men were afraid and many correctly apprehended the likelihood of their own deaths:

> *My darling* au revoir. *It may well be you will only have to read these lines as ones of passing interest. On the other hand, they may well be my last message to you. If they are, know through all your life that I loved you and baby with all my heart and soul, that you two sweet things were just all the world to me. I pray God I may do my duty, for I know, whatever that may entail, you would not have it otherwise.*[13]

The enemy the British were going up against was a formidably well-trained force in comparison; the German army's long-standing system of conscription meant that half of all its young men had gone through at least two years of military training between the ages of twenty and twenty-two, before passing into a reserve force which required training right through until a man was thirty-nine. In contrast British soldiers were relatively inexperienced: a so-called 'New Army', relying during peacetime largely on volunteer forces such as the West Yorkshire Regiment territorials in the 6th Battalion.

PLATE 139 West Yorkshire Regiment 1/6th Battalion officers in 1914 before they left England. Regimental photographs such as this one have allowed many of the men in the Thuillier image in Plate 130 to be identified, including Lieutenant Colonel Wade, Lieutenant Mossop and Quartermaster Hill.

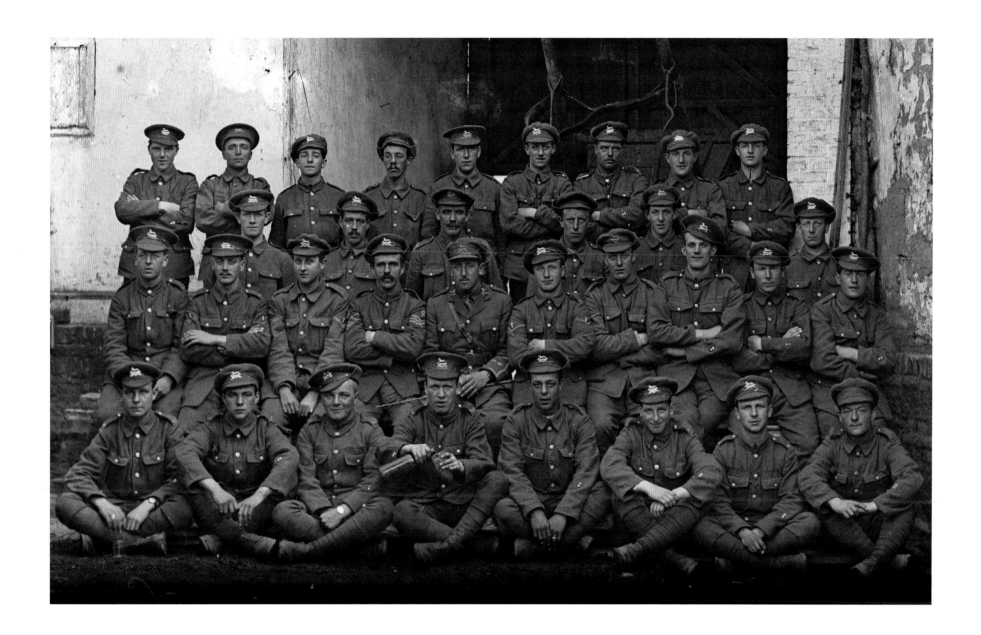

PLATE 140 The bombers of the 1/6th Battalion of the West Yorkshire Regiment sometime in April/May 1916. A similar Thuillier group picture taken the same day, which made its way home into the battalion's 1921 history written by Captain E.V. Tempest, allows all these men to be identified. Many of them would die on the Somme within weeks.

Back row: Metcalfe, Jones, Wilson, Hudson, Fishburn, Jefferson, Pritchard, Fox, Reece.
Third row: Parkinson, Duckett, Coyne, Thistlewaite, Robinson, Roome.
Second row: Cawthra, Lance Corporal Andrews, Lance Corporal Butterfield, Sergeant McIvor, Lieutenant H.A. Jowett, Lance Corporal Foulding, Lance Corporal Foster, Brown, Haigh, Brady.
First row: Swithenbank, Waterworth, Hanson, Ward, Brown, Hall, Bannister, Morris.

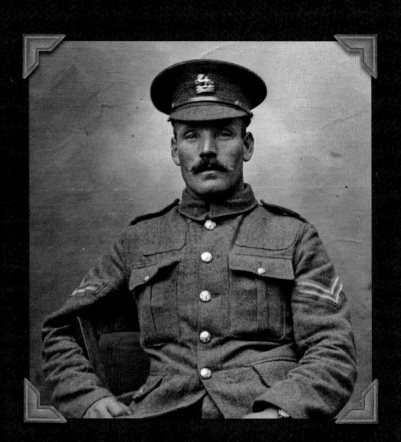

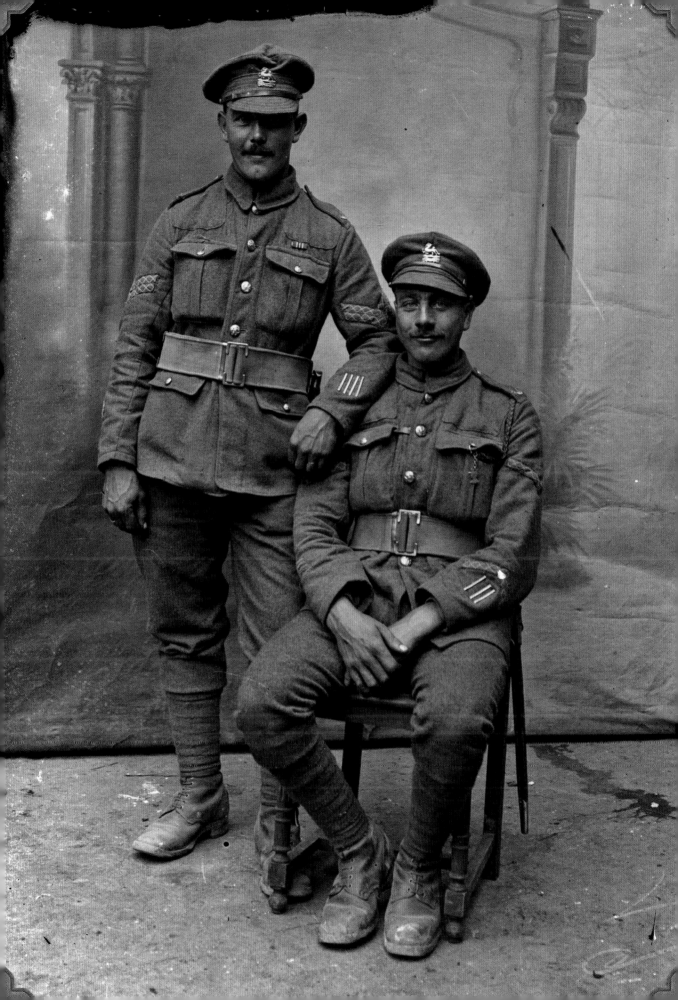

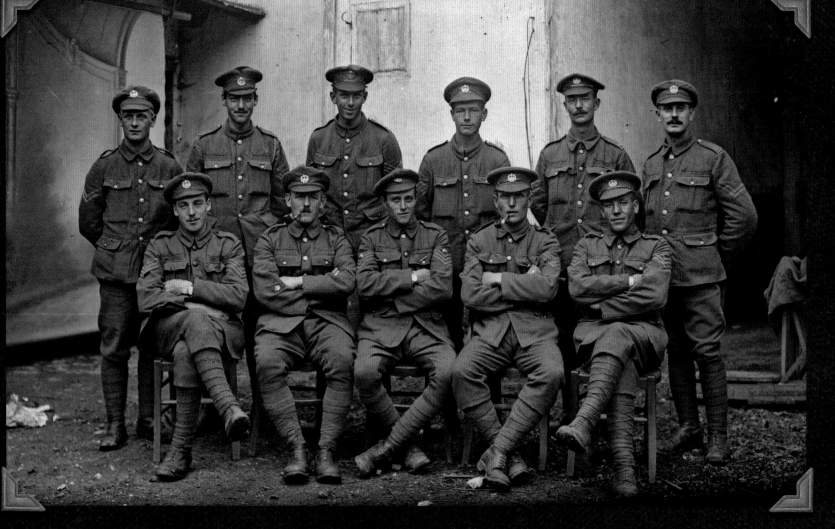

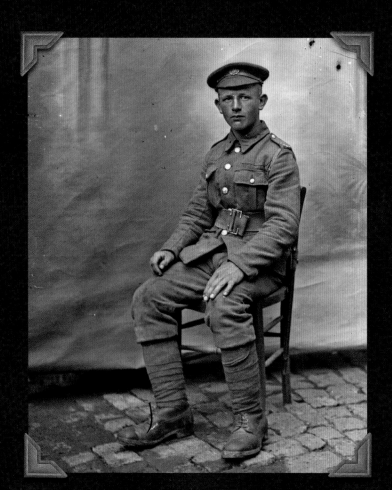

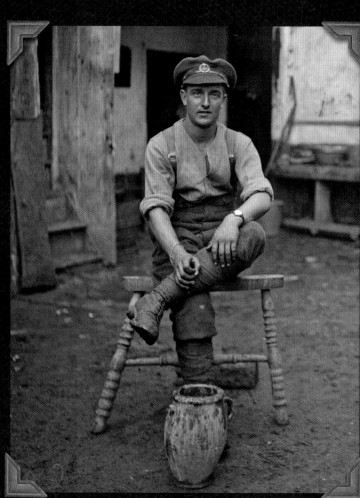

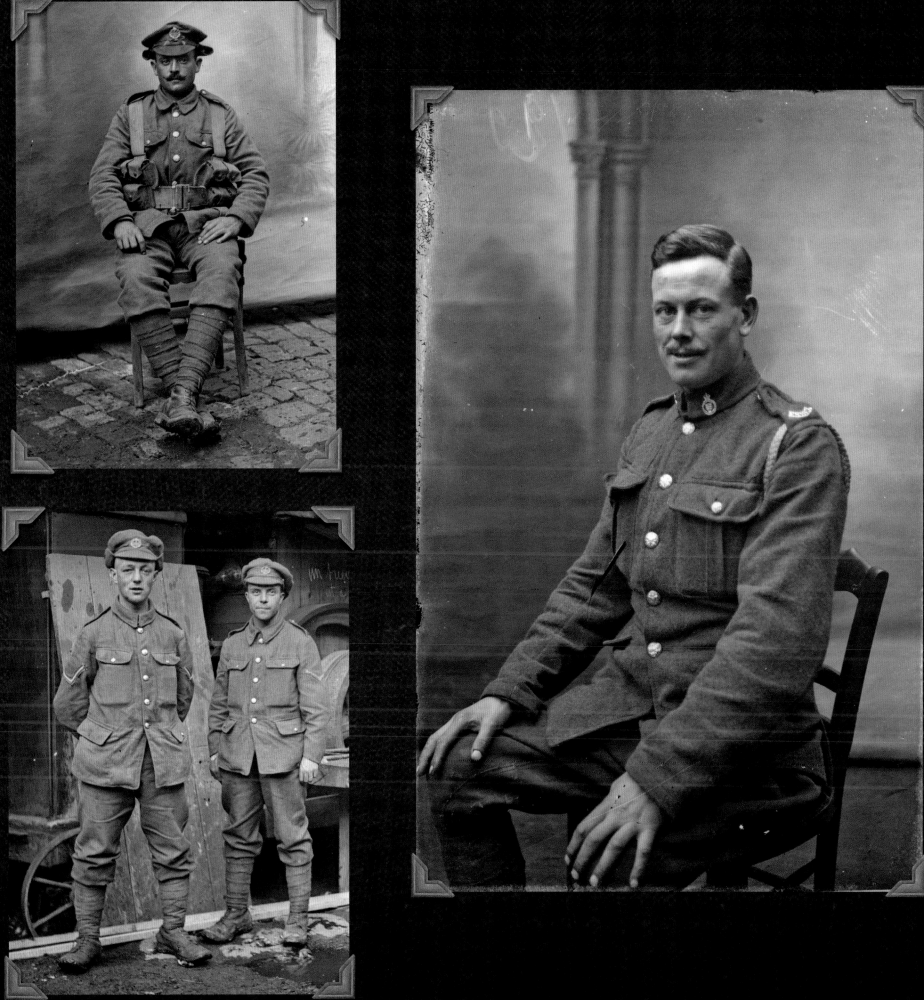

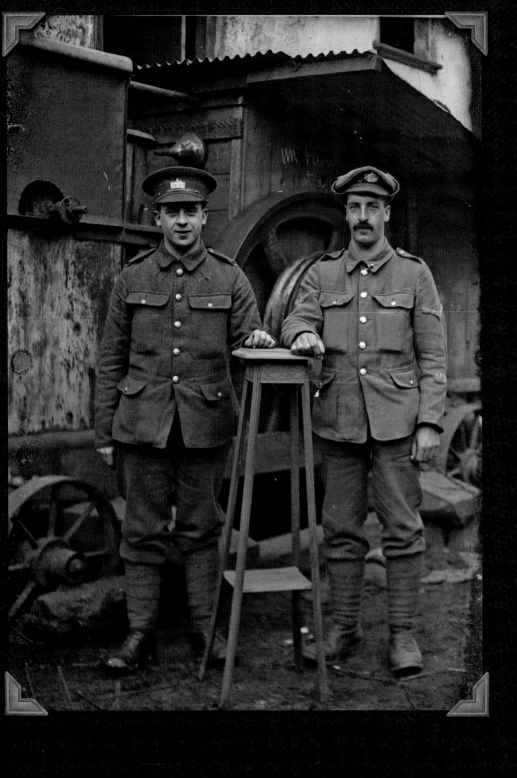
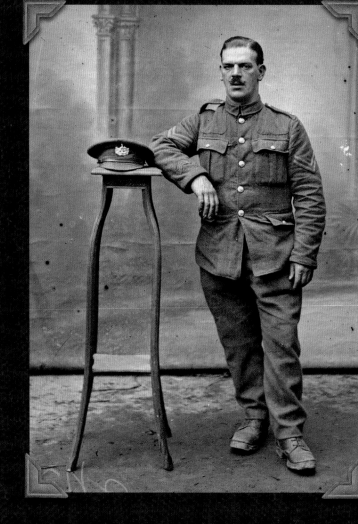
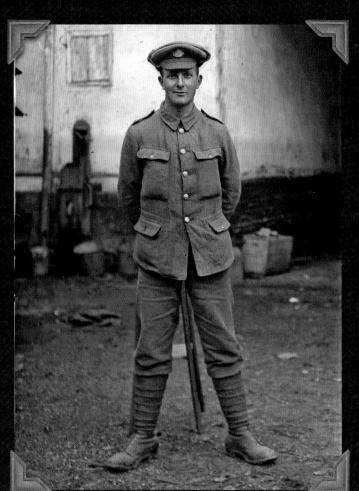

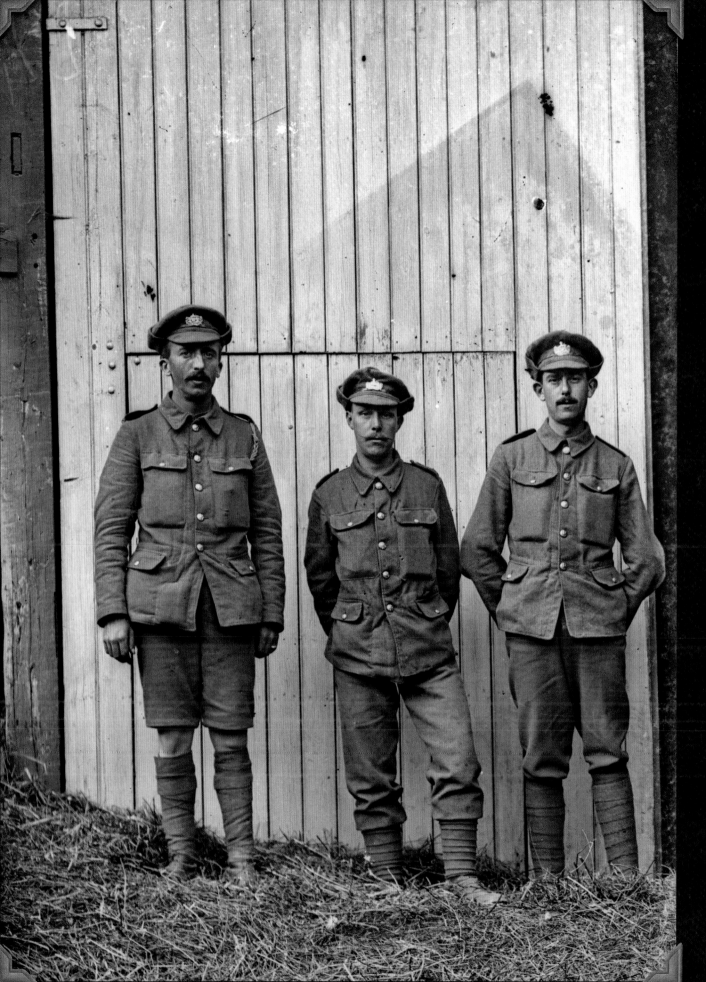

The Battle of the Somme – 1 July 1916

'It's bloody murder out there.'

The early battles of the First World War had by 1916 left the Allied armies and the Germans deadlocked in a bitter trench-war stalemate. Desperate to stop the Germans from reaching the French coast, the French had managed to hold them to the north and east of the village of Albert in Picardy, north-eastern France – part of a massive line of fortified trenches running all the way from the French coast in the north-west to the Swiss border in France's south-east. While each side had dug and fortified ground tracking roughly along each side of the Somme river, the Germans in particular had secured massive fortified defences on high ground overlooking the Allies, turning local villages into seemingly impregnable bunkers. The British took over this sector of the front lines, set in the picturesque Picardy and Somme river countryside, from August 1915 and, in part because this was where the two armies of France and Britain met along the front lines, it was also conceived as the spearpoint where a massive Allied attack would breach the German lines to supposedly end the war. This series of months-long battles was to become known collectively as the Battle of the Somme.

Allied planners had conceived an initial attack spanning twenty-four kilometres down either side of the Somme river south of the town of Serre, which sits north of the Ancre river near Albert. The week before the attack, an extraordinary 1.6 million artillery shells were fired in an attempt to break up the German lines; troops were assured they would then be able to stroll towards the enemy trenches because the German lines must surely be broken. At 7.20 a.m. on Saturday, 1 July 1916 Royal Engineers detonated the first of seventeen mines in tunnels dug under the German trenches. Then, ten minutes later, as the Allied artillery barrage finally ended, whistles sounded for men to go over the top. What the British did not know was that the Germans had escaped most of the bombardment by taking cover in superior underground shelters, many fortified with

PLATE 141 Major R. Clough (later Lieutenant Colonel, MC), 6th Battalion, poses on his horse in this Thuillier image. Clough, later to become 6th Battalion commander, was wounded on the first day of the Somme. Officers soon learned horses were of no use against enemy machine guns and artillery fire. Note also how thin his mount is. It was often difficult to get enough decent feed for the horses on the Western Front and many died of malnourishment.

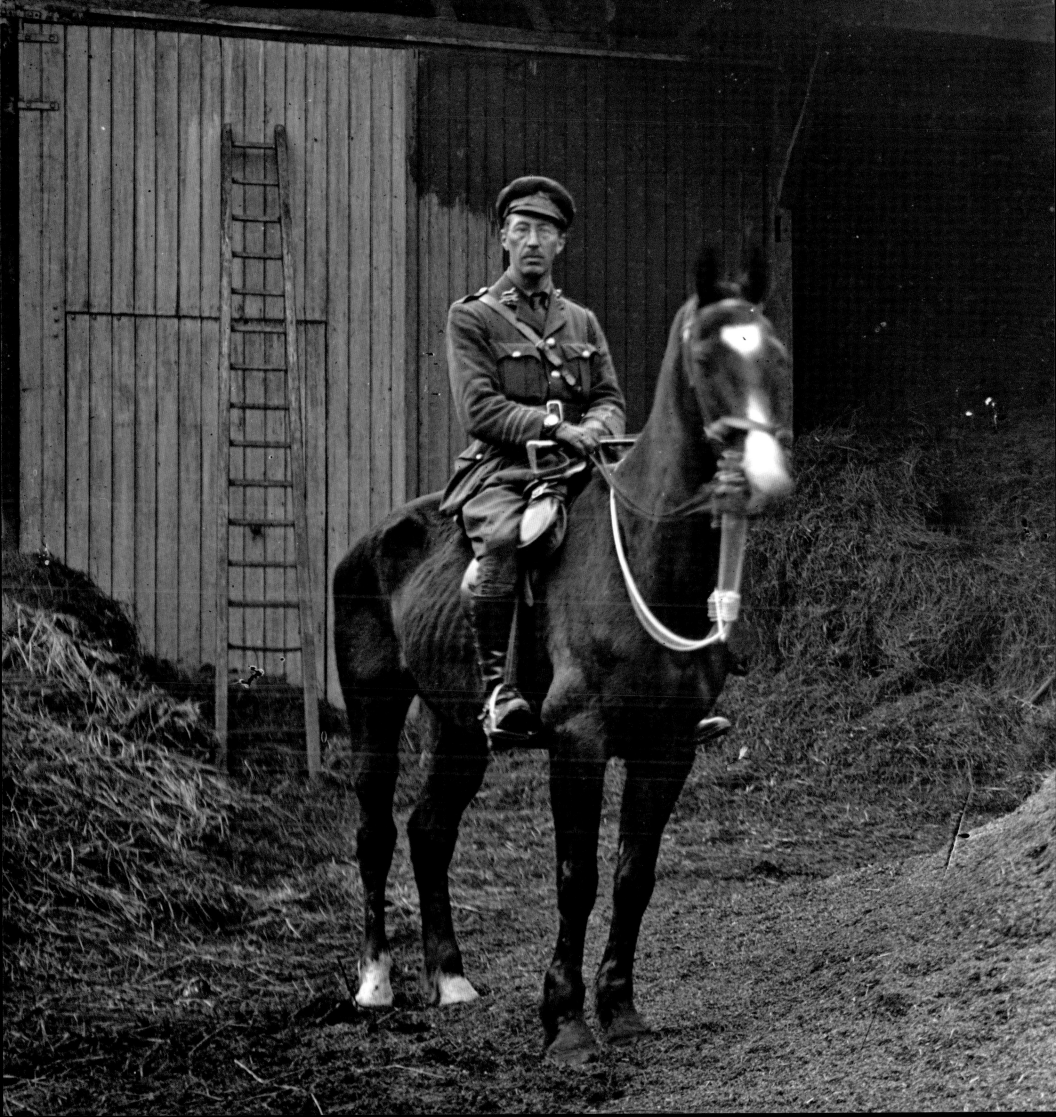

concrete; they now left their bunkers mostly unharmed and positioned themselves ready for the British attack.

Across from the enemy trenches in front of Thiepval, the 6th Battalion West Yorkshiremen waited in assembly trenches at Thiepval Wood from early morning to late afternoon, hearing the extent of the apparent disaster all along the Somme front lines. It was a slaughter; the Tommies were mown down in their droves, and shattered by massive enemy artillery barrages. Enemy machine-gunners had emerged from dugouts behind the attacking divisions and scythed lines of troops from behind. By the afternoon, as the 6th waited in reserve, it was clear the entire 49th Division attack had been a disaster. Yet, even as the hopelessness of the position became clear, an astonishing order came through for the 6th Battalion at 3.30 p.m. They were told to make a full-frontal attack on Thiepval in just half an hour's time, together with their comrades in the 1/5th Battalion and another unit. It was by any measure an insane order; why any commander thought two battalions could take a position that two entire divisions had already failed to capture was anyone's guess, but the West Yorkshiremen obeyed orders. So rushed was the attack that most officers and certainly none of the men even knew for sure where Thiepval lay; so they made their way from the wood where they were gathered up a deep valley towards the German lines.

> In extended order and as steadily as though on parade, the Battalion doubled across
> this valley. The enemy could see the whole Battalion from his trenches in the front line
> and near the Schwaben Redoubt, and a murderous Machine Gun and Artillery fire was
> opened upon our men. But no one wavered.[14]

The Germans began shelling the assembly area in Thiepval Wood even before the Yorkshiremen began their advance and it was here that the battalion's third most senior officer, Major R. Clough, was wounded by artillery fire that splintered the trees above him. Clough survived his injuries to become a lieutenant colonel and take over command of the 6th Battalion in 1918 but he would be wounded again in October 1918, just one month before the war ended.

Two of the officers in the battalion headquarters photograph (Plate 130, p. 115) would also now fall in the march across the valley – the battalion commander, Lieutenant Colonel Wade, and his medical officer, Captain Hamilton, were both wounded. As the

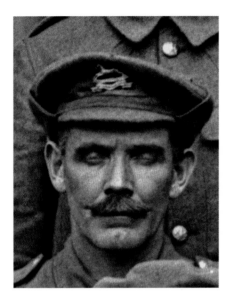
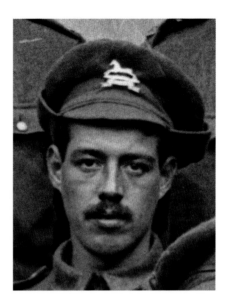
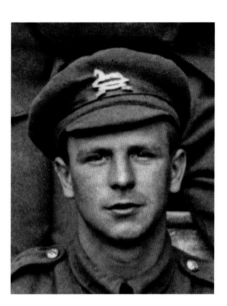

history bitterly records, the attack was a futile 'forgone conclusion … Hardly a man came back unwounded from No Man's Land and no one advanced more than a hundred yards.'[15] Entire platoons were obliterated in the confusion, rows of men cut down. Platoons following behind stayed in their positions because they knew that to attempt to advance was suicide. 'It is impossible to describe the angry despair which filled every man at this unspeakable moment.'[16] 'It's bloody murder out there,' men were heard to call as they staggered back into their lines. Fourteen officers and 250 other men were killed or wounded – one-third of the battalion lost in an attack that senior commanders now weakly described as a mere feint to draw the enemy from the main advance; whatever it was meant to be, it had failed miserably.

Among the proud 6th Battalion bombers was Bernard Coyne, a Bradford gas-fitter who joined up at the age of thirty-seven (the third man from the left in the third row in the bombers picture in Plate 4). He had married an Irish girl in Bradford and left her and their three daughters behind when he joined up with the 1/6th in 1915. Older men like him were often selected as bombers because they were seen as having steadier nerves for the deadly task of bomb throwing. But he was to die somewhere in the chaos of the failed advance on that first day of the Battle of the Somme; his wife Anne was for some unexplained reason denied a pension and left to support herself and her children by working as a cook at the Ear and Eye Hospital in Bradford until she reached the age of seventy-four, by then crippled with arthritis.[17] Bernard Coyne was just one of the mind-boggling number of 20,000 British troops who died on this first day of the Somme. His fellow bomber John Bannister would die in September while the Somme battles still raged. Harry Duckett almost made it – he died in combat in October 1918, just a few weeks before the end of the war.

PLATES 142–144 Bombers Bernard Coyne, John Bannister and Harry Duckett.

Twenty-year-old Lieutenant Walter Scales – 'the Babe' – was in A Company on 1 July when the 6th Battalion was ordered into the full-frontal attack on Thiepval. It was pure luck that A Company was held in reserve and he survived while entire platoons were cut down in front of him. Scales, later promoted to temporary captain, won a Military Cross medal for his gallantry the following March in further Somme valley battles, rescuing and leading men under fire. But that luck would run out in 1918 – Scales was killed in battle at Ypres, aged just twenty-four, after nearly three years on the Western Front. There is an interesting connection to Walter Scales' story, provided for us by our friends at the Bradford World War I group: Walter Scales' niece is the well-known actress Prunella Scales.

The 6th Battalion's padre, the Reverend Richard Whincup, survived his three years with the men on the front lines, finally returning to England in August 1918. It was the Reverend Whincup who had often written letters home to grieving families struggling to come to terms with the loss of a father or son, and he was loved and respected by the men and officers for his courage in visiting them up in the lines and for his sense of humour. He would become the Rector of St Barnabas at Heaton in Yorkshire, raising his own family. He was the grandfather of the well-known novelist Jilly Cooper. When he created the new church of St Martin's post-war, he dedicated it to his brother soldiers who lost their lives after the Battle of Tours – hence St Martin of Tours. Jilly Cooper, who was thrilled to see the photograph of her grandfather (Plate 146), describes the Reverend Whincup as '… an absolutely darling man … he was … adored by all his parishioners and known as Saint Richard. But I know he suffered very badly from his nerves and never really got over the horrors of the Somme and he used to have these terrible nerve attacks. I don't remember him very well myself except he used to steal upstairs when I was about five and give me peppermint creams, which I shouldn't have been eating before I went to bed.'[18]

Every single West Yorkshire battalion fought in the Somme battles that raged through to 18 November 1916. By the time the Battle of the Somme came to an end more than a million men had died on both sides, an almost incomprehensible 624,000 Allied casualties among them. While just what it achieved, if anything, will exercise historians for millennia, by raw numbers in blood it remains indisputably the biggest disaster in British military history. It also destroyed Britain's 'New Army' of volunteers and necessitated compulsory conscription to keep up the numbers.

PLATE 145 There is a solemnity about the face of 'the Babe' – Captain Walter Scales – in Vignacourt after he had won his MC for gallantry in March 1916. He lived through the Battle of the Somme but would be killed on 6 January 1918.
PLATE 146 Canon Richard Whincup MC MA, vicar of St Barnabas, Heaton, Bradford, from 1918 until 1944, and St Martin's parish church from 1932 through to his death in 1944. (Courtesy St Martin's Church, Heaton, Bradford)

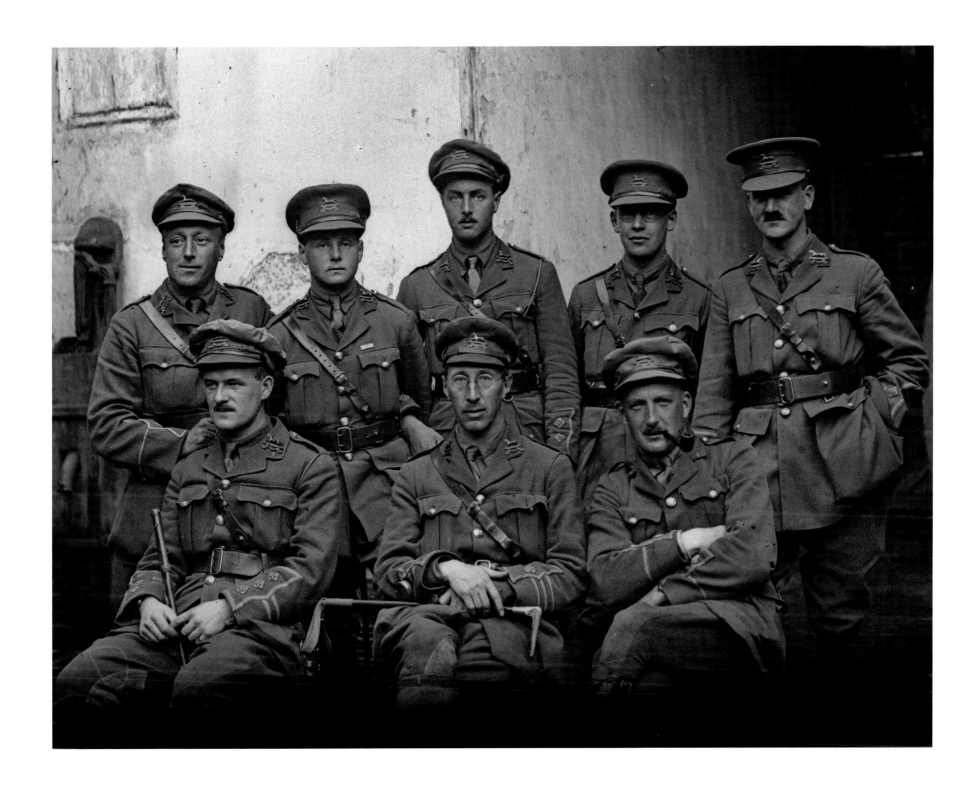

PLATE 147 Brothers-in-arms. There's a touching camaraderie about the way Lieutenant Walter Scales links arms with his fellow lieutenant in this image. Scales' MC, earned in March 1916, can be seen on his tunic. Major R. Clough, who was wounded on the first day of the Somme, sits front middle. To Major Clough's right is Captain (later Major) N. Muller.

The Pals

If only the Generals had not been content to fight machine-gun bullets with the breasts of gallant men, and to think that that was waging war.

<div align="right">Winston Churchill[19]</div>

In 1914, a stocky twenty-two-year-old named Edward Raymond Hepper was working at his father Edward's chartered surveyors, auctioneers and estate agents firm in Leeds when war was declared. By December he had volunteered as a second lieutenant with the West Yorkshire Regiment and found himself assigned to C Company of the 17th Battalion, one of the so-called Pals battalions.

Early in the war, the idea of Pals battalions was conceived by the War Office as a way of maintaining recruitment numbers and then of coping with the flood of men clamouring to enlist. One of the solutions was to encourage men from a similar trade, profession, background or community to join up together. In late August 1914 the Secretary of State for War, Lord Kitchener, made a public appeal for 100,000 more men to sign up for the so-called 'New Army'; and, as David Raw's *Bradford Pals* history records, the notion of a Pals battalion was then first mooted by Lord Derby at a public meeting in Liverpool:

> *We have got to see this through to the bitter end and dictate our terms of peace in Berlin if it takes every man and every penny in the country. This should be a Battalion of Pals, a battalion in which friends from the same office will fight shoulder to shoulder for the honour of Britain and the credit of Liverpool...*[20]

Probably the first Pals battalion from Leeds to join the Prince of Wales' Own West Yorkshire Regiment was the 15th, which was quickly followed by two battalions of Bradford Pals – the 16th and 18th battalions. When Raymond Hepper joined up in

PLATE 148 Raymond Hepper in Vignacourt, wearing his winter fur vest.

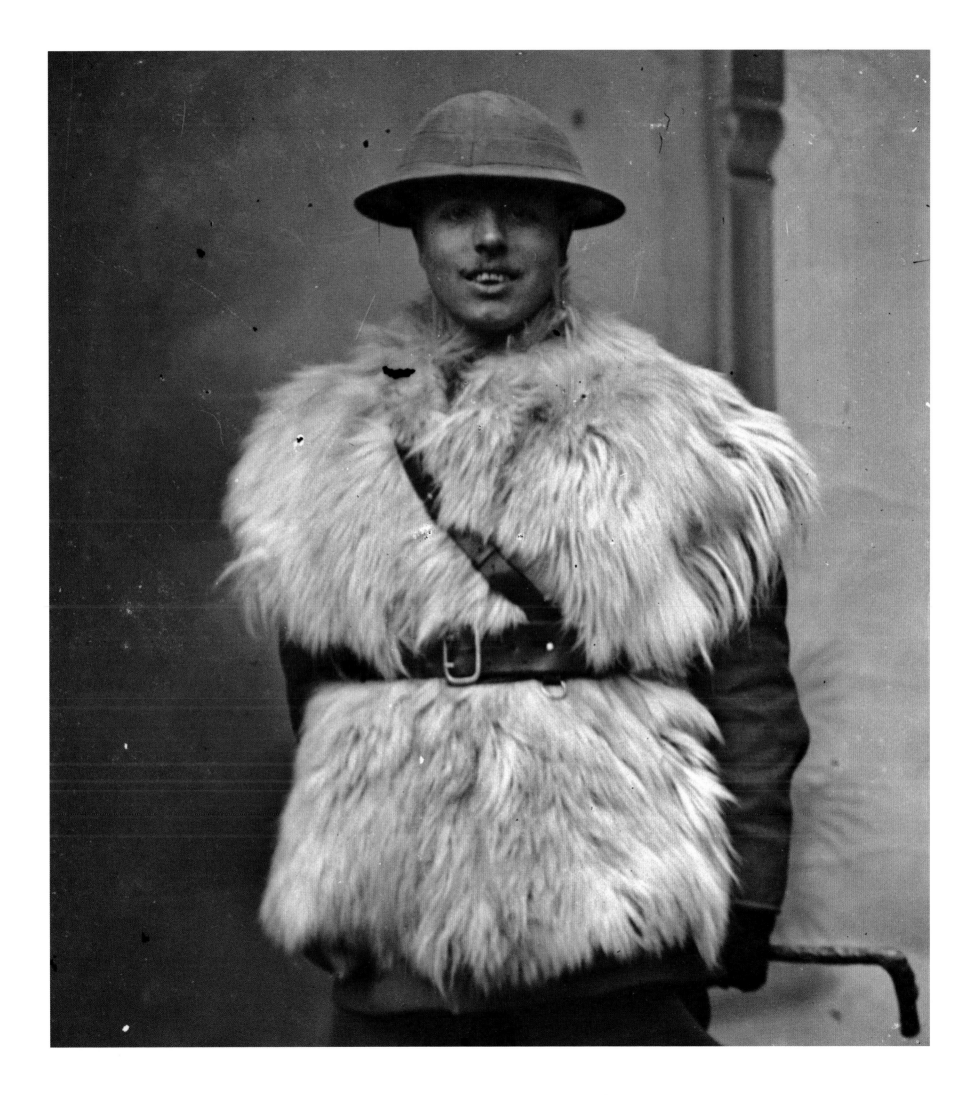

December 1914 he was assigned to the second of the Leeds Pals battalions, the 17th, which was also known as a 'Bantam' battalion because it comprised men who were under the previously required height of five foot three inches.

In the surge of patriotism that followed the declaration of war, communities such as Leeds and Bradford formed their own 'Citizens Army Leagues' that actually took over the logistics of raising new local battalions from the War Office and also met most of the cost of supplying and training them. The Pals battalion was an extraordinary phenomenon of intense patriotism and civic pride; but the very fact that the Pals battalions were all men from the same communities and workplaces was to have disastrous and unforeseen consequences.

Raymond Hepper kept a diary throughout the war detailing his experiences on the Western Front, including a visit to the Thuillier home at Vignacourt which we can exactly date to 17 February 1917, when he wrote how he and three friends were photographed wearing the animal fur jerkins many troops were issued with during the dreadful winter of 1916–17:

> *DeWitt, Thurgood, White and I go to Vignacourt to be photographed. We hump a pack containing our 'woolly bears' and tin hats on our heads. The operation is over, we smiled and looked pleasant and have apparently been logged up for the North Pole Expedition. We trust the photograph will be a success. I hate being photographed and I think I shall turn a Mohammedan or whatever sect it is which has to turn the head away when being taken; it is much more becoming.*[21]

The image in Plate 149, opposite, is clearly the one Raymond Hepper refers to in his diary, featuring him and his mates DeWitt, Thurgood and White. The goat and sheepskin jerkins became known in the trenches as 'woolly bears' or 'teddy bears'. The photograph has miraculously survived decades of Picardy winters and summers but the levity of the occasion is obvious, despite the peeling emulsion. There are also two other single images of two of his three friends in Plates 150 and 151 (pp. 138 and 139). Unfortunately, the furs cover their regimental badges but it is likely they were friends of his from the 17th Battalion.

It is only chance that allowed the story of the Raymond Hepper behind these images to be told. A very faded print of Hepper and his chums (who, despite the coyness suggested in his diary, actually seems rather to enjoy himself in this photograph) made its way back to his family in England, enabling him to be clearly identified in the Thuillier glass plate negative images discovered nearly a century later. The 'woolly bear' vests, as he

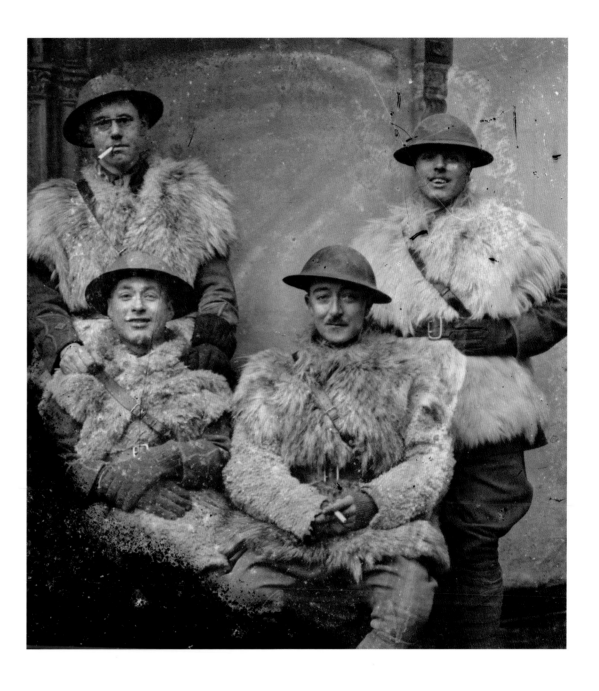

PLATE 149 Raymond Hepper standing on right with DeWitt, Thurgood and White (in unknown order).

called them, were initially very popular among the troops but soon became infested with body lice, which hatched, even after the furs had been thoroughly washed, when the men's bodies warmed up the eggs hidden in the seams. Lice were one of the trials of life in the trenches.

By the time he arrived in Vignacourt to be photographed in February 1917, Second Lieutenant Hepper, later to be promoted to captain, had already been through the double horrors of the Battle of the Somme and the ghastly winter that ensued. At the end of a few weeks of front-line fighting in July 1916, he wrote: 'Horror on horror . . . the barrage continues to fall all along the trench. God this is awful. Shall we ever get out alive?'[22]

Hepper's often charming diary is an insight into a man who maintained good humour despite the carnage, including an account of waiting hours in the rain for a review by Lord Kitchener:

We are standing in three inches of water waiting for Lord Kitchener. Two hours later –
still waiting. Two hours later still – Lord Kitchener arrives, receives the salute, walks
along the front of each Battalion and departs. We are soaked through and several men
have fainted. Amused how quickly staff chauffeurs drive cars backwards.[23]

Mercifully, Raymond Hepper was not with the Leeds Pals in the 15th Battalion when they went over the top on the first day of the Somme. Those Leeds Pals men who did join the 31st Division attack on the village of Serre were shelled in their trenches before they even began their attack and then, as those who had survived the bombardment advanced, they were cut to pieces by German machine-gun and artillery fire – notoriously, the Germans killed wounded men who were still stranded on the wire in front of their position. Within just a few minutes of the attack at 7.30 a.m. most of the Leeds Pals battalion were killed or wounded: twenty-four officers and 504 other ranks. 'We were two years in the making and ten minutes in the destroying,' one survivor lamented.[24] On 5 July Hepper was in a camp west of Thiepval and he witnessed the 'remains of the Leeds Pals ... who are just passing through. We understand that they went too far in their attack on July 1st, and the Boche came up behind them. Whatever the story is, they were very badly hit in the taking of Serre.'[25]

Just ten days later, Captain Hepper had another lucky escape when he was camped around Montauban village. He was about to move into what looked to be a more secure dugout when he noticed there was a crack in the roof; when he climbed up on top to inspect it he discovered it had been seriously weakened by shellfire. 'I decided to remain in my own place. A few hours later a shell landed in the doorway of that dugout completely demolishing it. I bless my powers of observation for spotting that wee crack in the roof.'[26] On 30 July, when the Liverpool Pals were sent into the Somme attack, Hepper solemnly recorded the regiment's devastating losses:

The attack has failed and only a few of those who left this trench this morning have got back.
Only about forty. Poor brave lads, Liverpool Pals battalion ... It is useless putting into writing
the sights I have seen today for they will ever be in my mind as a momento [sic] of July 30.[27]

What is breathtaking to readers today no doubt is how gladly and how naively men like Hepper went off to fight in a war, and especially the Pals. The apocryphal story

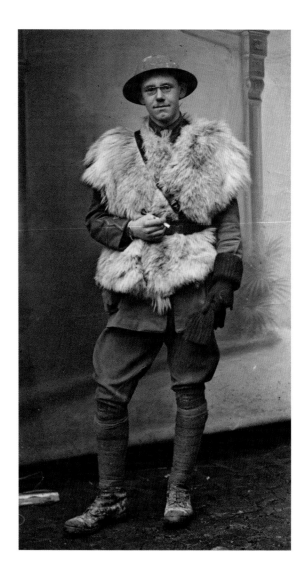

PLATE 150 One of Captain Raymond Hepper's friends photographed at Vignacourt in February 1917 – possibly from the 17th Battalion of the Prince of Wales' Own West Yorkshire Regiment, either DeWitt, Thurgood or White.

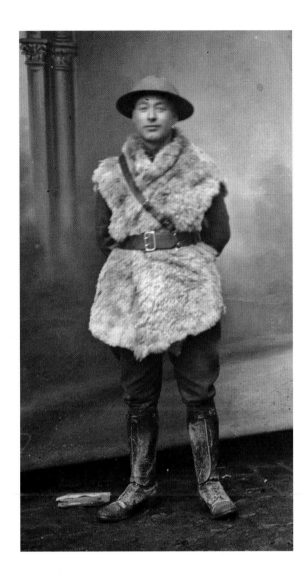

was actually true, that at least one officer in the folly of the initial July offensives had led his men into an attack on fortified German lines by kicking a football towards them. The officer, a Captain Neville of the East Surrey Regiment, had written on the ball: '*The Great European Cup, The Final, East Surreys v Bavarians, Kick-off at Zero Hour 1 July 1916*'.[28] Sadly, he and most of his men fell within minutes of kick-off.

The shocking contemporary accounts of what happened as the English New Army Pals and volunteers battalions met the mechanized German industrial killing machine, heavy machine guns and artillery reveal mounting incredulity at the scale of the early losses:

> *… in our advance, we passed the majority of 'A' company laying killed or wounded, halfway between Leeds trench and the front line. I found in the front line a good many men of the 15th battalion West Yorks and what was left of the Durham Light Infantry Company who were attached to us. Also a few of the King's Own Yorkshire Light Infantry. I found no officers or N.C.O.'s of these Regiments or of my own Regiment.*[29]

Across Yorkshire the very closeness of the Pals battalions, drawn from friends who worked together or lived in the same streets, now added to the grief and sorrow of the loss; entire communities were obliterated in just a few minutes of carnage during the weeks and months of the Somme. Several platoons and companies in the West Yorkshire volunteers had simply ceased to exist and the terrible dilemma for the British command as the Somme battles waged on was that there seemed to be no solution as to how to break through the German lines without even greater sacrifice. One officer on the staff of General Sir Douglas Haig revealed the British Army's frustrating lack of preparedness for the new technology of twentieth-century warfare:

> *It would seem as if the only differences that numbers in an attack make to a properly located machine gun defence, when there is light and time to see, is to provide a better target.*[30]

Bradford was hit particularly hard. Two thousand men had joined the two Bradford Pals battalions and only 223 survived the Battle of the Somme. The Bradford-born novelist and commentator J. B. Priestley spoke for the country when he mourned the loss of the 'intellectual and physical elite of the nation'[31] as the Pals and volunteers fell in their serried rows.

Hepper was demobilized in January 1919 in Shropshire and returned to work in the family business in Leeds. He married Ada Cecilia Heasman in 1924, returning to France on honeymoon. Hepper died in 1970 in Leeds aged seventy-eight.

PLATE 151 Another image of one of Captain Raymond Hepper's chums at Vignacourt in February 1917, possibly from the 17th Battalion West Yorkshire Regiment, either DeWitt, Thurgood or White.

The Leeds Rifles

In the midst of the bitter fighting around Thiepval on the first day of the Somme, what happened to one small group of men in the Yorkshire volunteer territorials unit known as the Leeds Rifles is now the stuff of legend.

The Leeds Rifles – fully described by its title of the Prince of Wales' Own West Yorkshire Regiment Leeds Rifles – was a volunteer rifle corps raised in 1859 in Leeds with the support of local businesses. Even before the First World War the Leeds Rifles had served in the 1860 campaign against Garibaldi in Naples as well as the Zulu and Boer Wars. The unit was attached to the Prince of Wales' Own West Yorkshire Regiment in 1881 but had a different cap badge.

On the first day of the Somme, the 7th and 8th Leeds Rifles battalions were part of the West Yorkshire Brigade (including the aforementioned 6th Battalion West Yorkshire Regiment territorials) that was being held in reserve in Thiepval Wood. When the order came through late in the afternoon for what proved to be a disastrous full-frontal attack on Thiepval village, two companies of the 7th Leeds Rifles attacked the Germans in the formidable Schwaben Redoubt that loomed above their lines – even though the rest of the attack had already been cancelled; they knew they were attacking against impossible odds. Enemy machine-gunners in this fortified position had already slaughtered a large number of their West Yorkshire colleagues right in front of them. At huge cost, the 7th actually seized parts of the Schwaben Redoubt, only for most of the battalion to be forced out later in the night. But one group of thirty men from the 7th Leeds Rifles was left behind in the chaotic withdrawal and they held out doggedly in the middle of the German lines for the next two days. George Sanders, a corporal with the 7th from Leeds, would win the Victoria Cross for leading his handful of men to hold the position at all costs, driving off repeated counterattacks and even rescuing prisoners from the German lines. He and his mates were finally rescued after thirty-six hours without food or water. Sanders

PLATE 152 The Prince of Wales' Own West Yorkshire Regiment Leeds Rifles cap.
PLATE 153 A West Yorkshire soldier with a comrade from the Leeds Rifles.

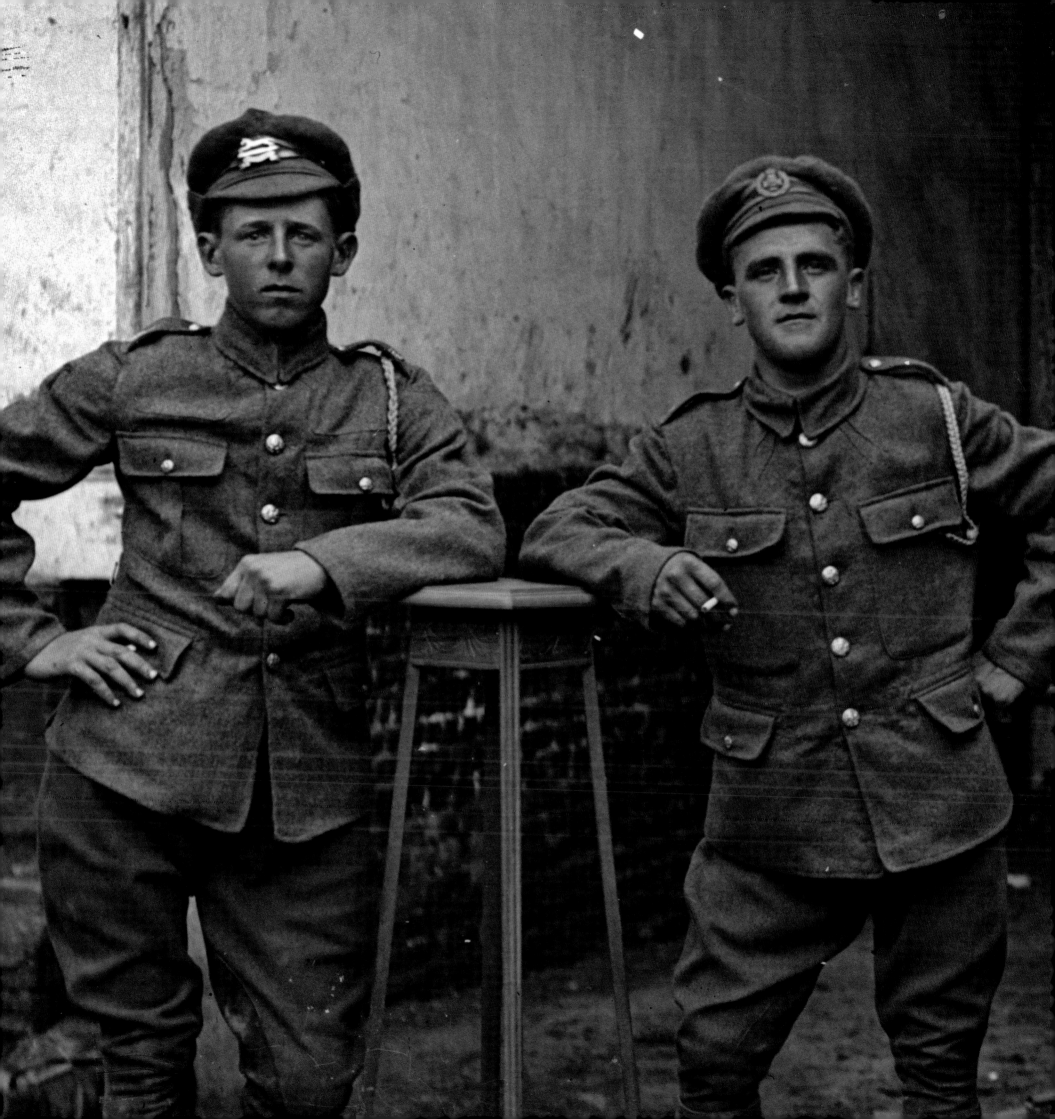

Corpl. G. SANDERS, V.C.

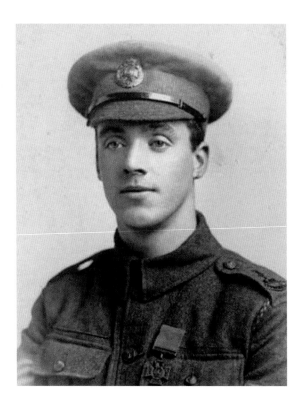

was one of nine Victoria Crosses awarded on the first day of the Somme, and was later promoted to captain.

There are dozens of excellent images of Leeds riflemen among the Thuillier glass plates, most of them probably taken just before the Somme began. One in particular features a corporal with a battle-weary, seemingly cross-eyed gaze, in Plate 156, who is standing beside a colleague and clearly wearing a dark medal ribbon on his tunic. Could this be George Sanders? There is some resemblance but it is impossible to be sure. As always, the best hope is that somewhere in the United Kingdom there is a family member with a faded copy of the Thuillier image who can definitively confirm the soldier's name.

Many of the Leeds Rifles soldiers pose with mates wearing the West Yorkshire Regiment cap badge. The Leeds Rifles badge is also very similar to the Prince Consort's Own Rifle Brigade badge, another unit with a proud history that saw distinguished service at Waterloo, so they may actually be men of the rifle brigade – it is impossible to be certain because the badges are so alike. But because we know the Leeds Rifles were with the Prince of Wales' Own West Yorkshires for at least two months prior to the Battle of the Somme, it is very probably them in these images. Using cap badges to positively identify a regiment or battalion will always be an inexact science. The clarity of these images is astonishing; knowing what we know now about the carnage these men went into on the Somme, it begs the nagging question: did they survive what was to come?

PLATES 154–155 1/7th Battalion Leeds Rifles Corporal (later Captain) George Sanders VC.
PLATE 156 The Leeds Rifles corporal on the right wears a medal ribbon.

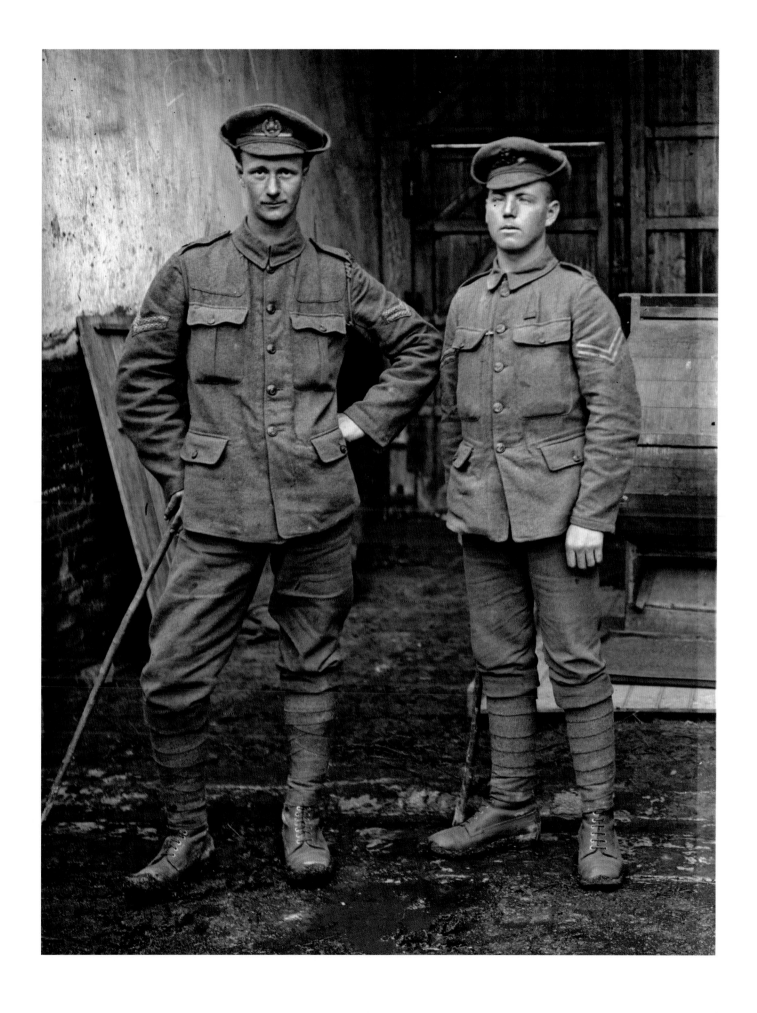

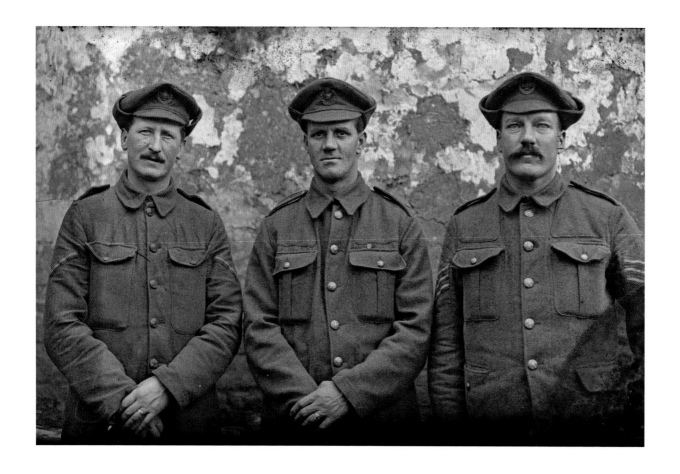

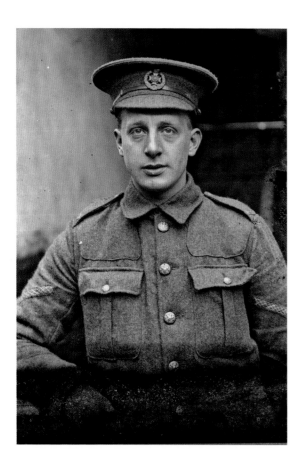

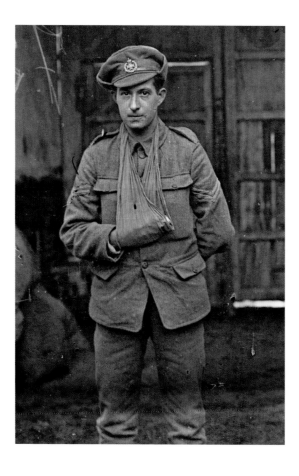

PLATE 157 Soldiers of the Leeds Rifles at Vignacourt. The man on the left is a lance corporal, the man on the right a sergeant.
PLATE 158 A very clear Leeds Rifles badge. This man is a lance corporal and wears a West Yorkshire Regiment badge on his shoulder.
PLATE 159 An injured Leeds Rifleman.

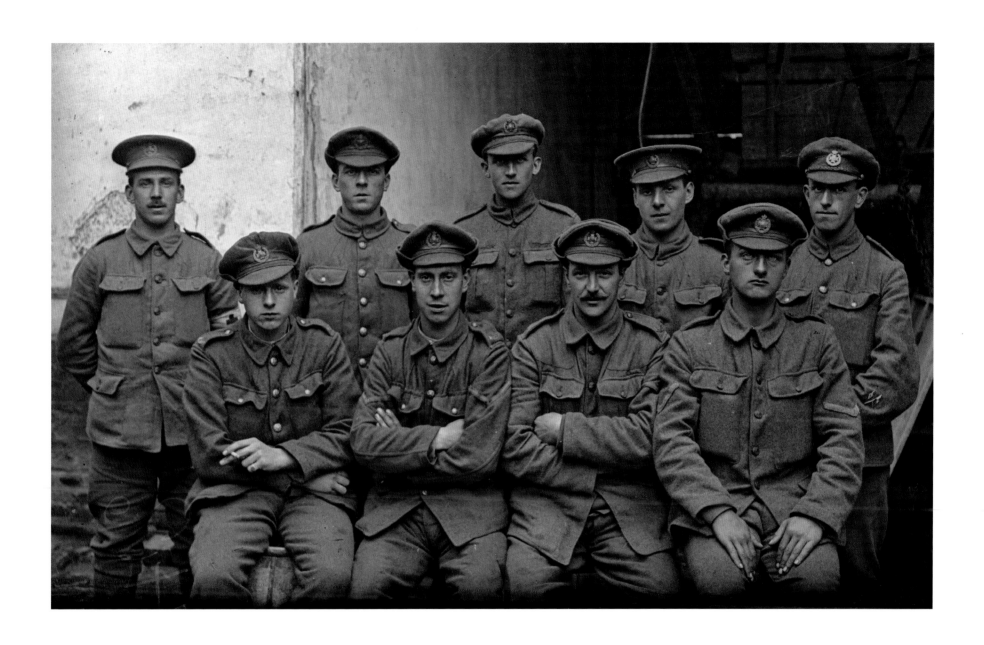

PLATE 160 Leeds Rifles soldiers, wearing the
West Yorkshire Regiment shoulder tabs.

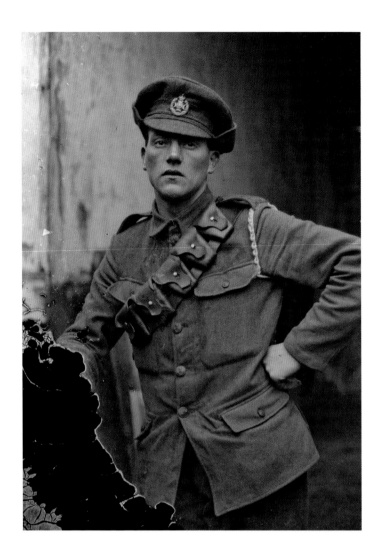

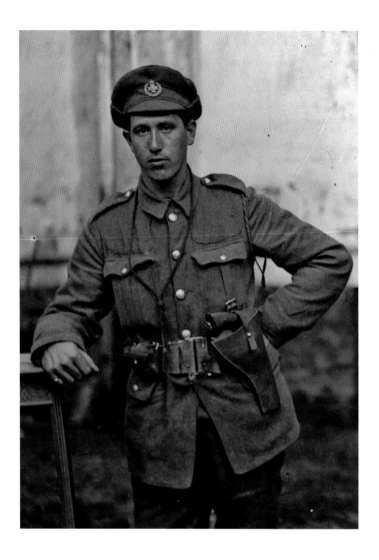

In 2009, Bradford City Council erected a memorial stone in the city's Centenary Square to commemorate all the servicemen of West Yorkshire who lost their lives in the Great War. It reads: 'To the memory of the soldiers of the Bradford Pals and the other servicemen of West Yorkshire who served in the Great War 1914–18. *And lo, a mighty army came out of the North.*'

PLATE 161 This Leeds Rifles soldier wears a bandolier, suggesting he is a cavalryman. Evident are the distinctive buttons on his tunic, depicting a bugle, worn by rifle brigades.

PLATE 162 This soldier wears a holstered pistol. When soldiers other than officers carried a revolver it usually meant they were part of a tank or armoured vehicle crew, or a machine-gun team, or that they were carrying out trench raids.

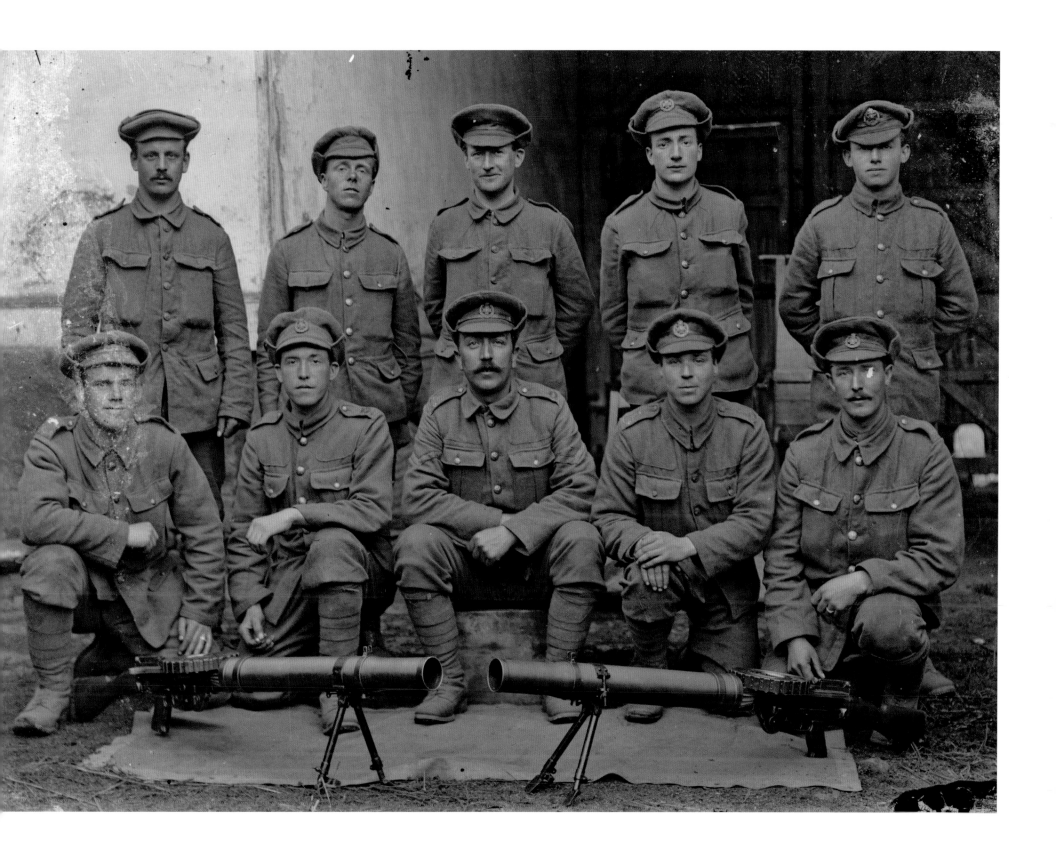

PLATE 163 A Lewis machine-gun unit of a
rifle regiment, probably the Leeds Rifles.

The Liverpool Pals

We were all very anxious to get into action before it was all finished. There was a marvellous feeling of adventure – we were full of beans – we were going to sort them out!

Private W. Gregory, 18th Battalion, King's (Liverpool) Regiment[32]

It is sobering to contemplate the group of smiling soldiers in Plate 165, opposite, in the knowledge that, of the four Liverpool Pals battalions that went to France in late 1915, one in five of the men in them would be dead by 1919. Worse still, when the full casualty figures (those killed or wounded) are taken into account, including any original Pals who transferred to other units, three-quarters of the original Pals battalion members would become casualties – many of the survivors suffering life-long disfiguring wounds and mental torment. Four thousand young men volunteered in 1914 and were formed into the 17th, 18th, 19th and 20th (service) battalions of the King's (Liverpool) Regiment and, by any measure, they served and sacrificed mightily.

Just a few days after war was declared the Secretary of State for War, Lord Kitchener, made a public call for at least 100,000 men to enlist. The nation was awash with patriotism and there was fury at reported German duplicity and alleged atrocities. On 19 August 1914, Lord Derby (a former Member of Parliament, who had served in the Grenadier Guards during the Boer War and was to become Secretary of State for War in 1916 after Kitchener's death) had a letter published in the Liverpool papers calling for volunteers for the city's first service battalion. Within five days he had a full quota of recruits ready for training and its success earned Lord Derby the sobriquet 'England's best recruiting sergeant'. That 11th Battalion was the first service battalion in the country – the first fresh-blood battalion for Britain's so-called New Army – and it went on to serve throughout the war as a pioneer unit. A few months later, when British forces were eviscerated by the bloody early battles of Mons and Le Cateau, suffering terrible losses,

PLATE 164 A brass version of the eagle-and-child cap badge of Lord Derby. Silver versions were presented to the original recruits of all four Liverpool Pals battalions.

PLATE 165 One of Louis and Antoinette Thuillier's most enchanting photographs taken outside their farmhouse studio: the Pals of the 89th Brigade, the Liverpool Pals and the King's (Liverpool) Regiment with Royal Dublin Fusiliers and possibly the Gordon Highlanders.

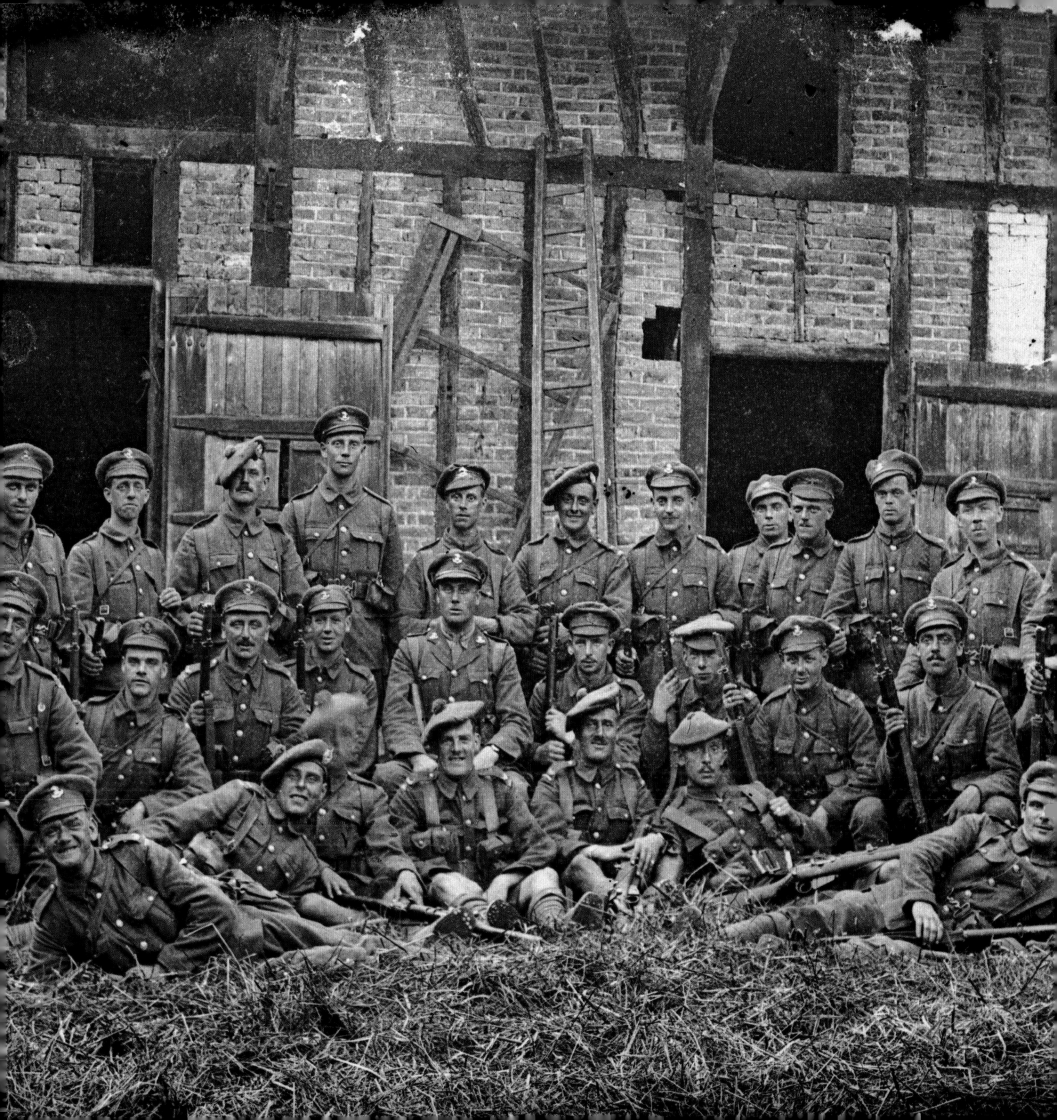

Kitchener asked for another 100,000 recruits and it was then that Lord Derby came up with the idea of a local Pals battalion as a way of encouraging recruitment and supporting these new recruits through training to deployment. Initially Lord Derby proposed to Kitchener that Liverpool raise only one battalion (around a thousand men) drawn from the city's business classes but he and the War Office would be overwhelmed by the extraordinary response.

Derby wrote to every professional office in the city asking them to let all eligible male employees join up; it was further made clear that employers would be expected to pay a minimum 50 per cent of each employee's pay while he was away on war service. It is difficult to conceive of high-finance businesses in the City of London today directly funding the British Army to send their employees off to war but in 1914 some employers even agreed to pay as much as two-thirds of their men's salaries throughout the conflict. As Graham Maddocks' *Liverpool Pals*[33] details, some businesses such as the Cunard shipping company and the Stock Exchange actually formed up their own men first and marched them down to enlist en masse. If any among them were privately unenthusiastic about going to war, they certainly did not get much time to think about it:

> *… the all male office staff of the Liverpool Gas Company assembled as usual for duty in the Duke Street Head Office. Before mid-morning, those of military age (18–35 years), were asked to go to the Board Room on the first floor, as the Chairman, Sir Henry Wade Deacon, wanted to talk to them. The Chairman said that he had received a letter from the Earl of Derby, who had been in touch with the Prime Minister, Mr Asquith. The Premier had outlined to the Earl the grave military situation, and urged the vital necessity for the recruitment of all men who were willing to enlist in the Army … The desks being locked, the embryonic warriors left in a steady stream for St George's Hall, where enlistment was to take place. The final word of farewell was spoken by the Chief Clerk, who no doubt rather rattled by the prospect of operating gas accountancy with a greatly depleted staff, encouraged the recruits with the remark 'Well I think you are all going to have a nice holiday'.*[34]

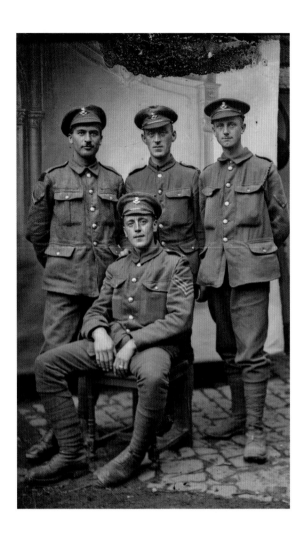

PLATE 166 Liverpool Pals – a seated sergeant with two lance corporals and another soldier. Two wear the economy tunic, introduced in 1916, and the seated soldier has the soft cap worn from early 1917. The black patches visible on the upper sleeves of these men indicate they were from the 17th Liverpool Pals – the 17th were dubbed the 'Black Kings' because of this patch, which was introduced in 1917.

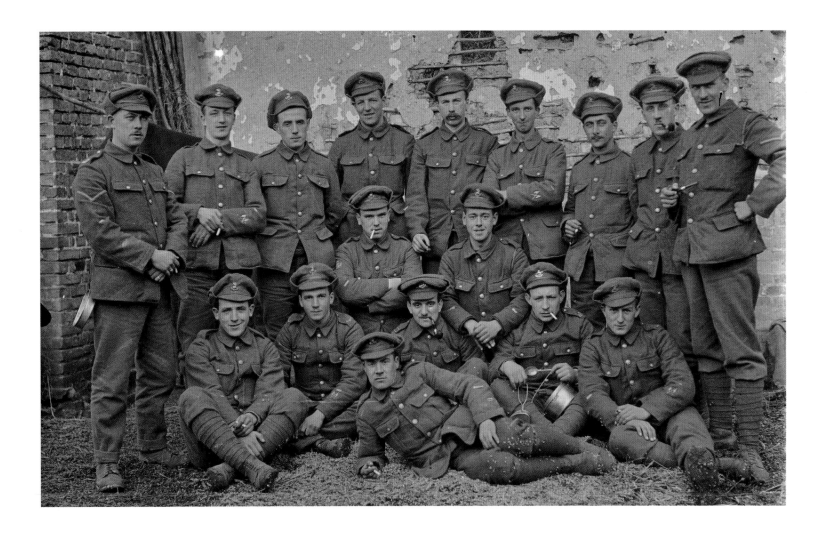

PLATE 167 A large group of Liverpool Pals with one soldier from the King's (Liverpool) Regiment (holding saucepan and spoon). A couple of them have signals flags on their left sleeve – meaning they are signals-qualified.

At the recruitment centre, major employers supervised the recruitment of their own employees – thousands of men clamouring to sign up. They were the cream of Liverpool's business community – lawyers, clerks, accountants, bankers – and by 10 a.m. on the first day of enlistment the War Office had 1,000 men to form the first of Liverpool's Pals battalions, the 17th Battalion of the King's (Liverpool) Regiment. Within the week there were 3,000 men recruited into three battalions – the 17th, 18th and 19th. The first few weeks were chaotic as the new battalions scoured the city for uniforms and weapons – Lord Derby funded accommodation for the Pals to train at his country home and, because of his prominence in the recruitment drive, he received permission from King George V for his family crest to be used as the Liverpool Pals' cap badge insignia. The King's Liverpool Regiment normally wore a white horse of Hanover but the Pals were given badges featuring the Derby crest, an eagle perched on a cradle bearing a baby. Solid silver versions of the badges were paid for and handed out by Lord Derby to every Pal, many of which were passed on to sweethearts and wives as brooches. By October a fourth battalion, the 20th, had been added and there were four New Army Pals battalions in frantic training.

On the first day of the Somme, the Liverpool Pals achieved a significant victory, liberating the village of Montauban, although 257 men would lose their lives after just that single day of fighting. In the mopping up around the village after 1 July the Pals suffered terribly in the battle for a position known as Trones Wood. But, despite the losses they suffered, the spirit of the Pals was intense:

> *… one of the original volunteers and a hard case sailor and soi-disant deserter from the US peacetime navy, had an eye shot out by a sniper's bullet. With the eye salvaged, and in hand, he passed down the communication trench, remarking to the gog-eyed soldiery, 'Haven't you ever seen f—— Lord Nelson? Stand to attention!'*[35]

It was the fight for the village of Guillemont on 30 July 1916 that would become known as Liverpool's blackest day. At 4.45 a.m. the Liverpool Pals climbed out of their trenches towards Guillemont, walking through a thick fog. Initially the battle went their way but, as the fog lifted, the Germans poured heavy fire on to the Pals and supporting Scots Fusiliers. By evening the attack had failed to win any of its

PLATE 168 Snow on the roof behind this Liverpool Pal indicates this is probably the Somme winter of 1916 or 1917.
PLATE 169 Two Liverpool Pals in happier times with a Scottish soldier (with puppy) and a soldier in his undershirt with a young local girl.

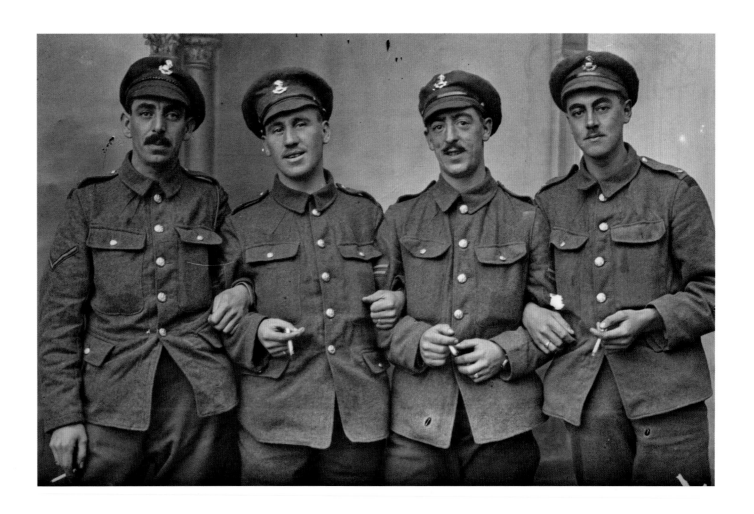

PLATE 170 A Liverpool Pals lance corporal links arms with two corporals and another private. The black patches once again tell us this is the 17th Battalion and it is at least 1917.

objectives and it was becoming painfully clear that casualties were distressingly high. From the three Pals battalions that fought that day, a shocking forty-two officers and 1,073 other ranks were killed, wounded, missing or taken prisoner. More than five hundred Liverpool Pals died as a result of that one day's fighting alone. Tragically, countless wounded men were stranded in no man's land, dying before they could be rescued. The battle was ill-conceived, forcing men to advance up a narrow valley with no cover, and it turned into a bloody rout. A Corporal Williams from the 19th Battalion described the forlorn sight of a pile of loaves of bread and other rations that had no takers after the battle because of the depleted numbers:

Here if ever was a moment of truth! Gone was the excitement, the hope of breakthrough, the early savage satisfaction of getting our own back on Jerry … Only remained the clear realisation of the stark picture of the war. The dreams carried over from civilian life (how many eons ago that seemed) were discarded with the footballs and drums and blithe spirits which the first crossing of No Man's Land would take. Only a grimmer spirit to face the future remained.[36]

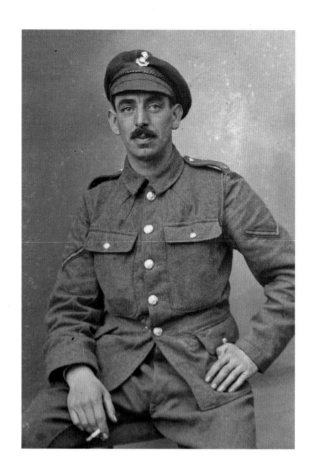

It is very likely, from what we know of the time that the Liverpool Pals spent in Vignacourt, that some or perhaps even all of the men pictured here went into that dreadful month on the Somme. The Thuillier photographs are very probably the last images of many of the men in them. They were camped within walking distance of Vignacourt prior to the Somme offensive and we also know from the battalion histories that in October 1916 the Liverpool Pals battalions were billeted in the village for rest and training. Just before they arrived in Vignacourt the Pals had been through the Battle of Le Transloy and suffered even more appalling losses.

A man could surely be forgiven for having a drink or two after what the Pals had been through on the Somme, but while the 19th Battalion was in Vignacourt there was a minor scandal when its commanding officer, Major Robert Kneale Morrison, was court-martialled for drunkenness and sent home to England. As Graham Maddocks' history sympathetically acknowledges, his lapse 'perhaps illustrates the pressure of front-line command'.[37]

The misery of front-line-attrition warfare groaned on throughout 1917 for the Liverpool Pals. The Battle of Arras which began on Easter Monday of that year took the greatest wartime toll of all on the Pals. Thrown up against German fortifications on the Hindenburg Line, they lost 140 men in the bloody combat there. Then, with barely a break, they were sent straight into the horror of the Ypres Salient – fighting in the Third Battle of Ypres, better known for its mournfully evocative name: Passchendaele. The rain and melting snow had turned the ground to a mire, making the risk of drowning as big a threat to the men as being shot or blown to pieces: 'Conditions were terrible and if you slipped off the duckboards you could sink right in, right up to your neck.'[38]

In just seven months at Passchendaele the Pals lost twenty-two officers and 518 men killed – and three times that number again wounded. The Pals had suffered a terrible war; by May 1918, after the massive German offensive in March, the Liverpool Pals were so decimated that they barely had enough men left to form a single battalion. Three of the heavily depleted Pals battalions were merged into a new 17th (Composite) Battalion and sent into battle at Dickebusch Lake. During that fighting the 17th was completely surrounded and it lost an entire company of men. By 12 May 1918 the Liverpool Pals' formal military unit – the 89th Brigade – was disbanded. Tragically, the Liverpool Pals had ceased to exist quite literally as a fighting force.

PLATE 171 A Liverpool Pals lance corporal.

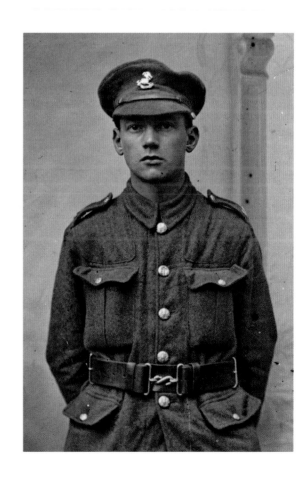

PLATES 172–175 A very young Liverpool Pals soldier wearing a soft-stitched cap, which was worn from 1917 onwards (top left), a private poses with a pipe and newspaper (top right), a seated corporal (bottom left) and another young private (bottom right).

The Stretcher-bearers

It is Thuillier images such as the one opposite that demonstrate just how carefully the husband and wife team composed their pictures. This unidentified stretcher-bearer from the Durham Light Infantry still has the mud on his boots, indicating that he is clearly just in from the front line; he is caught, seemingly oblivious to the camera, lost in a soldier's thousand-yard stare. What horrors has he witnessed? This is not the sort of photograph a father or son would send back to his family to reassure them all is well. This dignified man looks exhausted, sad, and almost wistful, and it is not difficult to understand why that might be the case.

When soldiers were sent into attacks during the war they were actually ordered not to stop and help a fallen chum. It mostly fell to the long-suffering stretcher-bearers to get to wounded men, under fire, lugging the broken bodies of their mates back to the casualty clearing stations behind the lines, often through thick mud and snow. There were two types of stretcher-bearer: the regimental bearers and the Royal Army Medical Corps (RAMC) stretcher-bearers. The Durham Light Infantryman in the image opposite was a regimental stretcher-bearer, and so, more often than not, he would have been a good friend of many of the men he was carrying to safety. Most of the regimental stretcher-bearers were ordinary soldiers who had volunteered for the job and, unlike the RAMC stretcher-bearers, they were still trained to carry and use weapons. The regimental stretcher-bearers worked mainly from the aid posts right up on the front line and they were expected to go into no man's land with the fighting soldiers to retrieve the wounded.

It could take hours of strength-sapping effort in clinging mud to get a wounded man just a few hundred metres. When they were carrying a wounded man, regimental stretcher-bearers did not normally carry weapons but, sadly, all too often that did not make them any less of a target for the Germans. Many of the stretcher-bearers were traditionally members of the regimental band and sometimes they were conscientious objectors, opposed to killing. But no one on the battlefield doubted their heroism and courage.

PLATE 176 A Durham Light Infantry stretcher-bearer with mud still on his boots. A Thuillier classic.

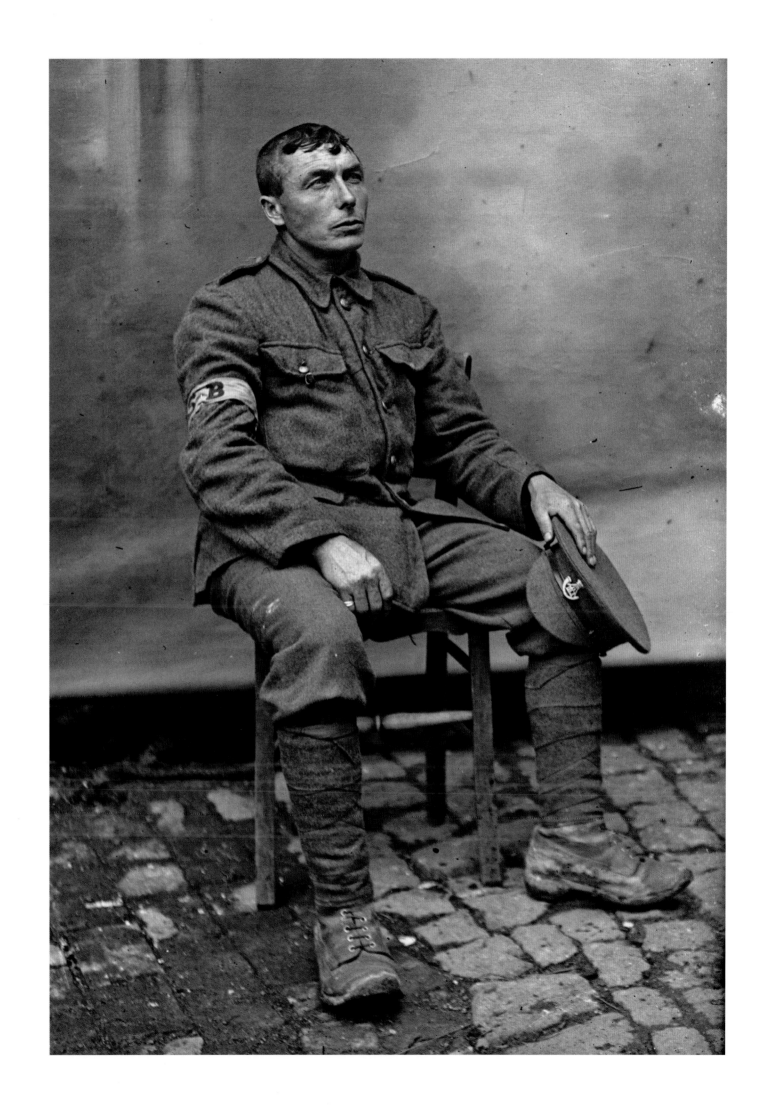

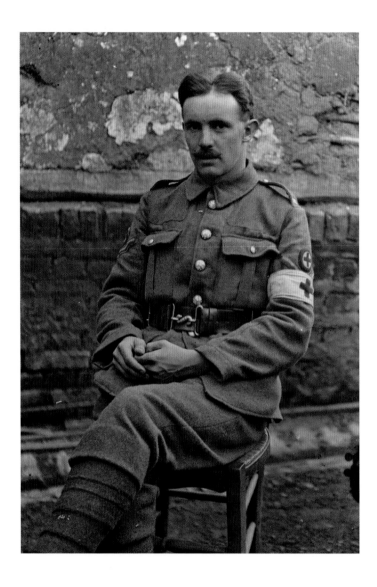
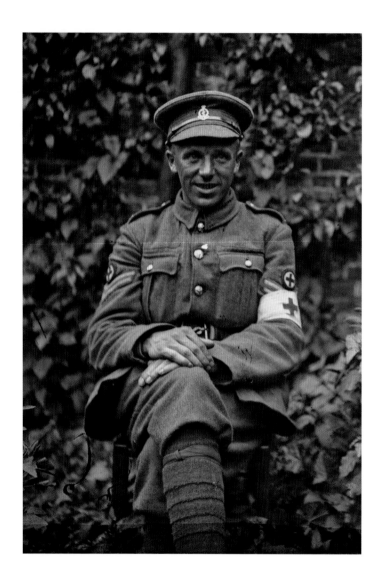

'The Stretcher-bearer' is one of the most popular poems recited in the national 'Poetry By Heart' competition. It is a lament on the horrors a stretcher-bearer has seen – his line 'I tell you what – I'm sick of pain' especially poignant. The poem has been widely attributed to a stretcher-bearer with the 15th Durham Light Infantry, Private Tommy Crawford, who joined up when he was just eighteen years old, working as a stretcher-bearer in the battles of Loos in 1915 and the Somme a year later. Until recently it was believed Tommy was the author, but investigations by Oxford University's Great War Archive recently discovered a slightly different version of the poem in a book called *Rhymes of a Red Cross Man*[39] by Robert W. Service. Service's version was published in 1916, well before Tommy Crawford was ever attributed authorship, so there is clearly some doubt about the poem's provenance. It is speculated that Tommy probably liked what the poem said about the dreadful job he had to do and copied it down. Whoever the author was, his poem has moved generations with its bitter account of human suffering on the frontlines.

THE STRETCHER-BEARER

My stretcher is one scarlet stain,
And as I tries to scrape it clean,
I tell you what – I'm sick of pain,
For all I've heard, for all I've seen;
Around me is the hellish night,
And as the war's red rim I trace,
I wonder if in Heaven's height
Our God don't turn away his face.

I don't care whose the crime may be,
I hold no brief for kin or clan;
I feel no hate, I only see
As man destroys his brother man;
I wave no flag, I only know
As here beside the dead I wait,
A million hearts are weighed with woe,
A million homes are desolate.

In dripping darkness far and near,
All night I've sought those woeful ones.
Dawn suddens up and still I hear
The crimson chorus of the guns.
Look, like a ball of blood the sun
Hangs o'er the scene of wrath and wrong,
'Quick! Stretcher-bearers on the run!',
Oh Prince of Peace! How long, how long.

The Durham Light Infantry

The men from Tommy's home of County Durham, in north-east England, were so keen to enlist in 1914 that recruitment in the cathedral city was 17 per cent higher than the national average; the county sent to war not only its existing regular army and territorial battalions but an extraordinary total of at least 120,000 men, including many new service and Pals battalions. History shows that the sacrifice, courage and fighting ability of the DLI was exceptional. But the Durham Light Infantry saw the worst of the First World War and many of its men did what many of us, when we read of what the Tommies endured, might see ourselves doing in the same situation. For it is the Durham Light Infantry that earned during the war what one historian has dubbed the 'unenviable distinction' of having more men sentenced to death by Field General Courts Martial than any other infantry regiment in the British Army.[40] The reasons cited for most of the courts martial were 'cowardice', 'desertion' or 'quitting'. Reading what the Durhams went through, though, it seems an unfair stain on the regiment and it was perhaps inevitable that most soldiers would break at some time during the war.

Many of the Durham territorial soldiers were miners and shipyard workers, which perhaps explains the short stature of many of the soldiers in these Thuillier pictures. They often fought alongside the West and East Yorkshire Regiments' miners who had also joined up for the duration of the war. John Sheen's history of the Durham Pals and service battalions lauds them as some of the best soldiers in the British Army:

> *The Durham Pitman, small, stocky and hard, used to hard work and danger, had all the attributes needed by the frontline infantryman, but even in peacetime many men escaped the drudgery of the mine by joining the army; regular meals, a bed, a uniform and fresh air to breathe would seem quite attractive during a long dispute with the colliery owners.*[41]

PLATE 177 The Durham Light Infantry cap badge.
PLATE 178 Four stocky Durham Light Infantry soldiers. The seated soldier is a sergeant.

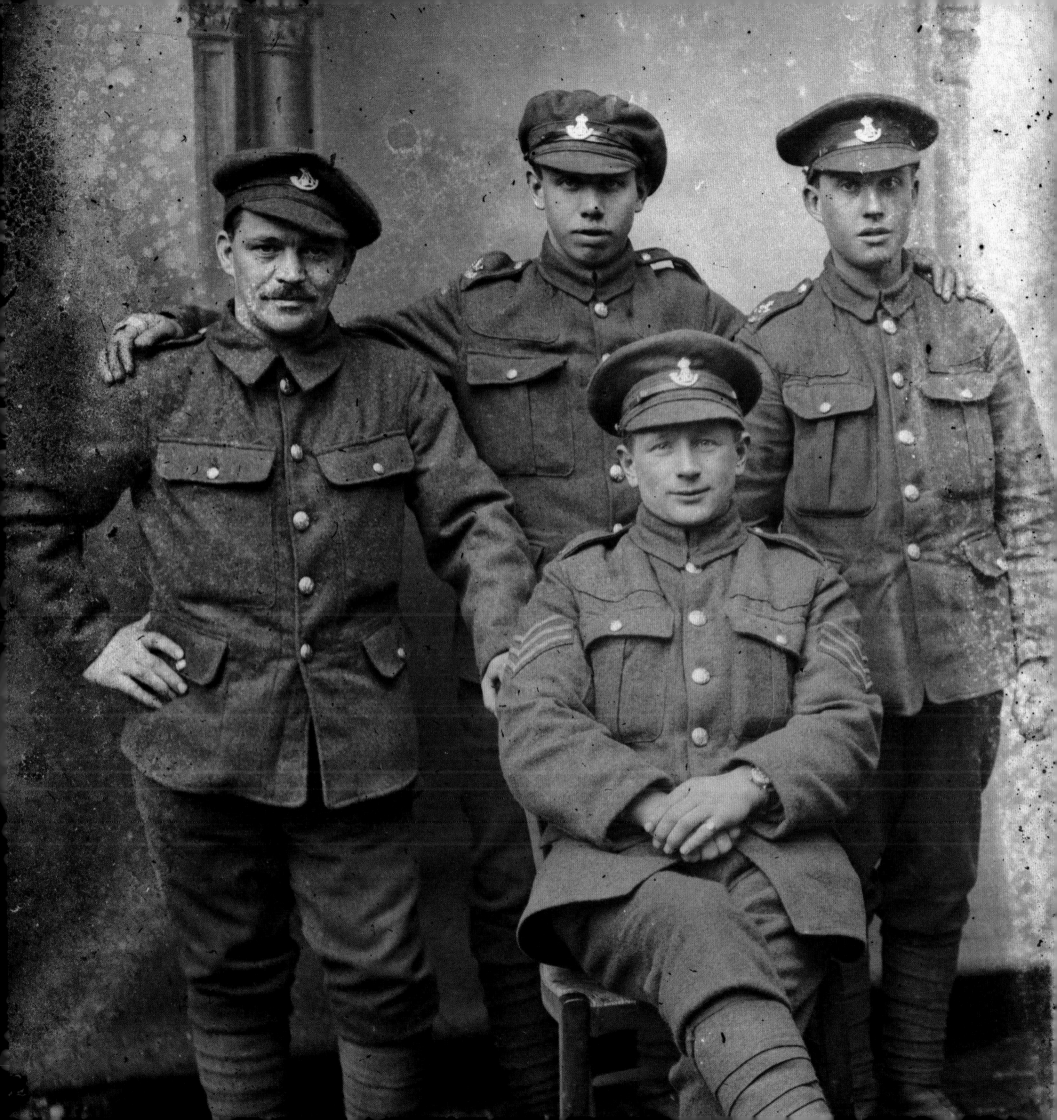

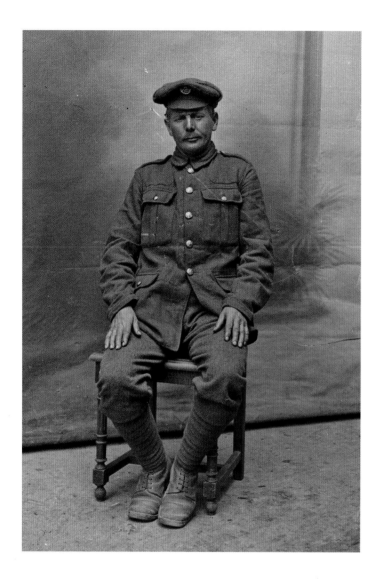

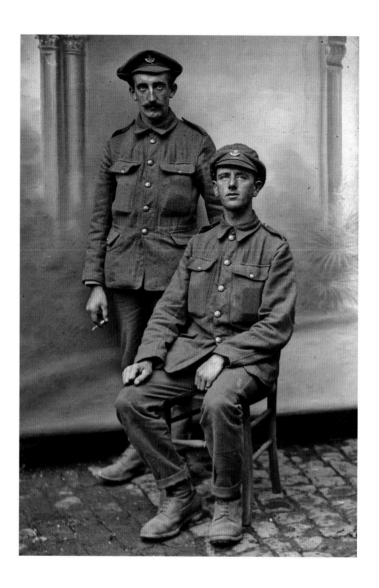

As everywhere else across the United Kingdom, there was a patriotic frenzy in Durham to heed Kitchener's call for volunteers. Local newspapers demanded to know 'What is Durham doing?' There was also a Durham Bantam battalion; the miners under the regulation five feet three inches were desperate to ensure no mere War Office regulation excluded them from the conflict. A special warning instruction had to be issued to stop underage boys from joining up as Bantam soldiers because so many youngsters were arriving on the front lines.

One history of the regiment mentions Durham's future British Prime Minister Anthony Eden, who himself later served on the Western Front, watching its departure for the war: 'So it was that during the third week of April, 1915 the grimy brock towns on the banks of the Tyne, and the bleak pit villages of the hinterland echoed to the tramp of colliers, shipyard workers, foundry men and others wearing the sloppy khaki caps and

PLATES 179–180 A sad-looking DLI soldier and (right) two DLI mates.

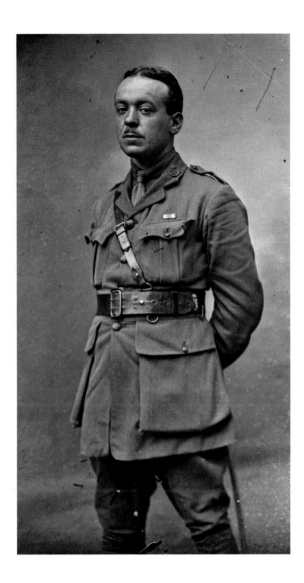

PLATE 181 A dapper DLI officer wears what appears to be a Military Cross medal.

carrying the long Lee-Enfields which identified the Territorials from the Regulars … among those who waved them goodbye was a young man called Anthony Eden.'[42]

It was the Durhams at Ypres in April 1915 who suffered the first poison gas attack of the war. At the Battle of Loos in September 1915, the Durhams were gassed again – this time in a disastrous first attempt by the British Army to use gas on the Germans. Nearly 60,000 British troops were killed or wounded at Loos – so many dead that the Germans dubbed the battlefield the '*Leichenfeld*': the field of corpses.

The war poet and novelist Robert Graves was an officer with the Royal Welsh Fusiliers when the British employed gas at Loos. He described its disastrous consequences:

> *They managed to discharge one or two cylinders; the gas went whistling out, formed a thick cloud a few yards off into No Man's Land, and then gradually spread back into our trenches. The Germans, who had been expecting gas, immediately put on their gas helmets, semi-rigid ones, better than ours. Bundles of oily cotton-waste were strewn along the German Parapet and set alight as a barrier to the gas. Then their batteries opened on our lines. The confusion in the front trench must have been horrible; direct hits broke several of the gas-cylinders, the trench filled with gas, the gas-company stampeded.*[43]

Later in the same battle Graves recorded one of his more memorable lines from the war:

> *When [Captain Samson's] platoon had gone about twenty yards, he signalled them to lie down and open covering fire. The din was tremendous. He saw the platoon on his left flopping down too, so he whistled the advance again. Nobody seemed to hear. He jumped from his shell-hole, waved, and signalled 'Forward'. Nobody stirred. He shouted 'You bloody cowards, are you leaving me to go on alone?' His platoon sergeant, groaning with a broken shoulder, gasped: 'Not cowards, sir. Willing enough. But they are all fucking dead.' The Pope's Nose machine-gun, traversing, had caught them as they rose to the whistle.*[44]

At the beginning of the Battle of the Somme on 1 July 1916 poor command planning meant the mine dug by Royal Engineers under German lines at the Hawthorn Redoubt near Beaumont Hamel was detonated eight minutes early. So by the time the Durham Light Infantrymen advanced, together with Leeds and Bradford Pals, the Germans were back at their machine guns:

> A deadly barrage of steel hit the leading battalions as they were climbing out of the trenches. Those of the Leeds Pals and Bradford Pals that did survive the enemy barrage walked straight into the German machine guns and the battalions literally disappeared. D Company 18/Durham LI, going over with the 1/6 West Yorkshire Regiment was also badly hit… Some of the Company were seen moving near Pendant Copse, well inside the enemy lines, by artillery observers, but they disappeared into the smoke and were never heard of again.[45]

One Durham private, Frank Raine, gives this shocking account of the first day on the Somme:

> I walked on a little bit and looked round. I could not see a soul of any description either in front of me or behind me or anywhere. Oh my God, the ground in front of me was just like heavy rain, that was the machine gun bullets and up above there was these great 5.9″ shrapnels going off and I think that deadened me as I have very little recollection. However I had much sense to know and as I looked around I said, 'Where the hell is everybody, I can't see anybody. I'm not going out there by myself'. I didn't meet a soul.[46]

But it was in October 1916, in a pointless attack on an ancient burial mound called the Butte de Warlencourt in the Somme, that the Durham Light Infantry took perhaps its heaviest losses of the war. Ordered to seize the Butte, the three Durham battalions in the battle lost nearly a thousand men. 'It seems that the attack was one of those tempting, and unfortunately at one period frequent, local operations which are so costly and which are rarely worthwhile,' one Durham Light Infantry commander wrote at the time.[47] The hill was only occupied by Australian troops after the Germans withdrew to the Hindenburg Line in February 1917. By war's end the DLI had fought extensively in every major Western Front battle, winning six Victoria Crosses, but at an awful cost: this tiny north-east England county had suffered nearly 13,000 dead and tens of thousands of men wounded.

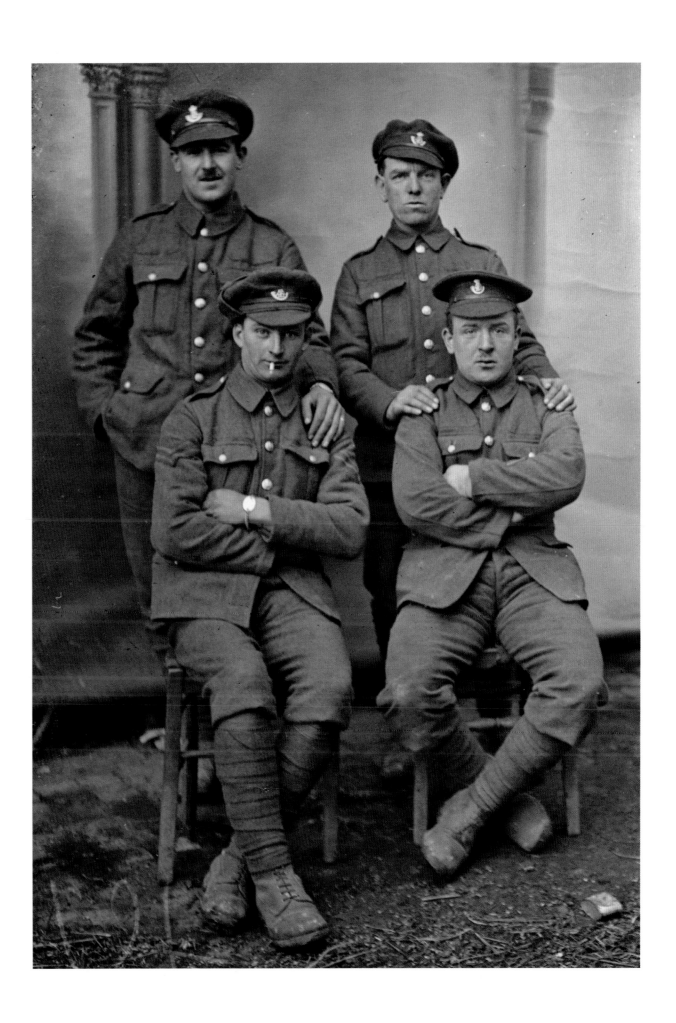

PLATE 182 Four DLI infantrymen. The soldier seated on the left is a corporal.

SHOT AT DAWN

To encourage the others…

Amid all the killing along the Somme in 1916, one event still haunts and shocks those who know what happened – and there were many others like it throughout the war. At dawn one September morning two dishevelled figures wearing British Army uniform were led into a courtyard, tied to stakes and executed by a firing squad of soldiers from their own army. Their families were never told what happened and the full story – that dreadful and humiliating secret – that 306 British Army and Commonwealth soldiers were executed for desertion or cowardice during the First World War was suppressed for seventy-five years.

In mid-June 1916 the men of the 2nd Bradford Pals Battalion were preparing for the start of the massive offensive on the Somme. Two young men among their number were Privates Herbert Crimmins and Arthur Wild, who had both joined the West Yorkshire Regiment very early in the war in that city's surge of patriotic fervour. Their Pals battalion had only just arrived in France from Egypt and the coming attack was to be both young men's first time over the top. Two days before the offensive, both lads watched men from their number make a midnight raid on the German trenches – and were no doubt shocked when three-quarters of those Yorkshiremen were killed or wounded. It did not augur well for either of them for they would be going over the top, in broad daylight, in less than forty-eight hours. At noon on the day before the attack both men were assigned their tasks for the following day and ordered to report back that evening at 5.45 p.m. Not surprisingly, they went to a local estaminet to drown their sorrows and their drinking got out of hand. When they awoke from their drunken stupor in a cornfield next morning they later admitted they were terribly afraid because they knew they would be officially deemed deserters.

While they were comatose from their drinking bout the previous evening, their battalion pals had left their billets in the village of Bus-lès-Artois and headed up to the front line. It was then that Crimmins and Wild made a foolish mistake: they did not try to return to their battalion but stayed out of sight in another local village. Sure enough, when their comrades from the 18th West Yorkshire went over the top the next morning it was a slaughter; the commanding officer was killed along with seven officers and ninety-three other men and absolutely no ground was won for this futile sacrifice.

Three days after that disastrous attack Crimmins and Wild turned themselves in to the military police at Vignacourt. For all we know their faces may very well be among those Bradford Pals who were photographed by Louis and Antoinette Thuillier because so many of the West Yorkshire Regiment soldiers had their pictures taken and remain unidentified. Both Crimmins and Wild were charged with desertion. At his court martial, Arthur Wild tried to defend himself by suggesting that the explosion of a German mortar right next to him that March had given him shell shock, and this was even supported by witnesses who told how, since that explosion, Wild had previously broken down as he was going up to the front lines. Notwithstanding such evidence, both men were sentenced to death, but with recommendations for mercy for both of them because they were by all accounts soldiers with previously exemplary records. The final decision on their execution went to General Haig, whose attitude on mercy was peremptory to say the least; he took the view that it was necessary to kill such deserters '*pour encourager les autres*'. Ralph Hudson's history of the Bradford Pals sadly records the shock among Crimmins and Wild's comrades when they heard what had happened on that September morning:

> *Everyone in their battalion was convinced that they would be reprieved – it was after all a volunteer*
> *battalion – however the Battalion was confined to camp for two days after which they were paraded*
> *and told of the Court's finding, of the sentence and that 'the sentence had been carried out'. One*
> *thousand young volunteers stood on parade in bewildered silence.*[48]

The execution of the two privates, despite pleas for mercy and evidence of shell shock, has been described as 'the most regrettable of the war'.[49] Such shame was attached to the circumstances of their death that even today their names, and the names of all of the executed men, do not appear on official war memorials. Supporters pushed for years for a posthumous pardon for all the 306 soldiers who were executed, arguing they were traumatized by the horrors of the war and not cowards at all. In 2007 the British government finally pardoned all the soldiers in the British and Commonwealth armies who had been executed in the First World War. The then British Defence Secretary Des Browne said:

> *I believe it is better to acknowledge that injustices were clearly done in some cases – even if we cannot*
> *say which – and to acknowledge that all these men were victims of war. I hope that pardoning these*
> *men will finally remove the stigma with which their families have lived for years.*[50]

The Bantams

In the near-carnival atmosphere that engulfed enlistment offices around England early in the war during August and September of 1914, one group of bitterly disappointed men were being turned away in their droves. Many of them were miners and farm workers who were shorter in stature than many other men, but just as tough – and probably tougher – than most; they – and the War Office – were frustrated that the original army regulations in August 1914 required recruits to be at least five feet three inches tall. There was a perception in the armed forces that men of shorter stature were somehow feebler and, as volunteers swamped recruitment offices during August and September, the height requirement was actually raised to five feet six inches to stem the flood. But the brutal reality of the numbers of men needed for the front lines changed all that and during November 1914 the height limit was steadily lowered to five feet four inches and then returned to five feet three inches.

But, especially around Yorkshire, a region with a thriving mining industry featuring a backbone of hardened, stocky miners, it soon became clear that many men who were even shorter than the regulation height would make excellent soldiers. One story has it that when several short-statured miners were rejected after they attempted to join up in Birkenhead, Cheshire, one of them challenged any man there to a fight to prove his worth as a soldier; it apparently took six men to remove him. Hearing of this, the local Member of Parliament Alfred Bigland petitioned the Secretary of State for War, Lord Kitchener, to vary the rules to allow such men to enlist. So in October 1914 the War Office relented and a special type of battalion was created for men between five feet and five foot three inches. They were dubbed Bantams after the feisty chickens of the same name. One of those battalions was Captain Raymond Hepper's Leeds Pals – the 17th Battalion of the Prince of Wales' Own West Yorkshires – whose story has already been told. After the 17th Battalion was annihilated on the Somme, many of the men brought in to replace those lost were, albeit short in stature, discovered not to be as tough as the original miners and farm

PLATE 183 Three Royal Engineers of shorter stature.

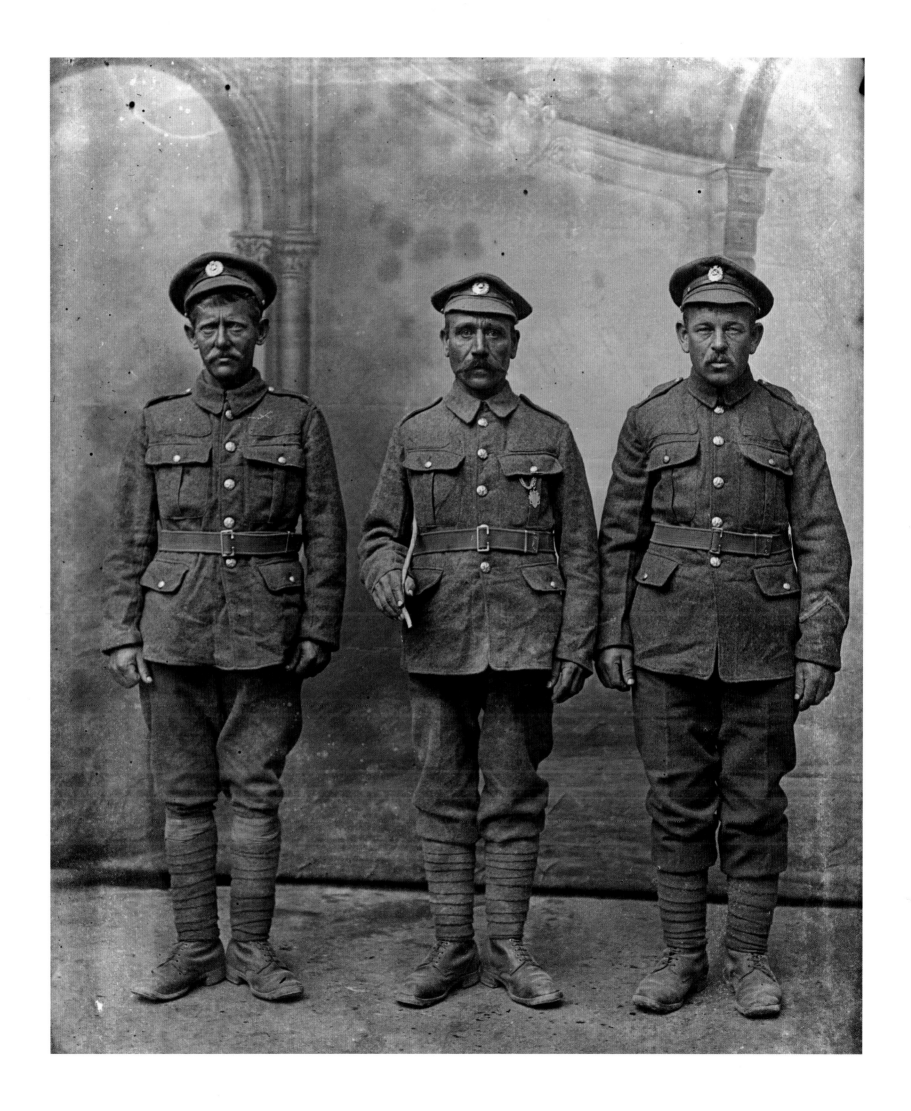

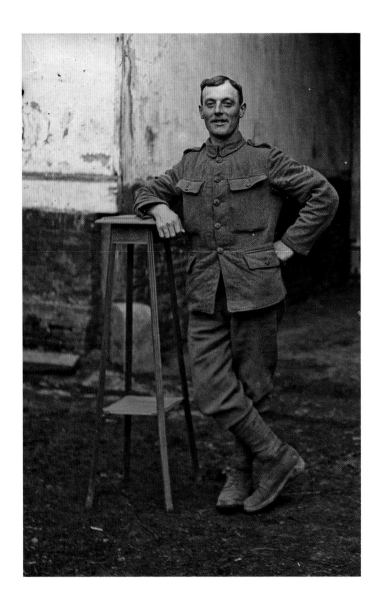

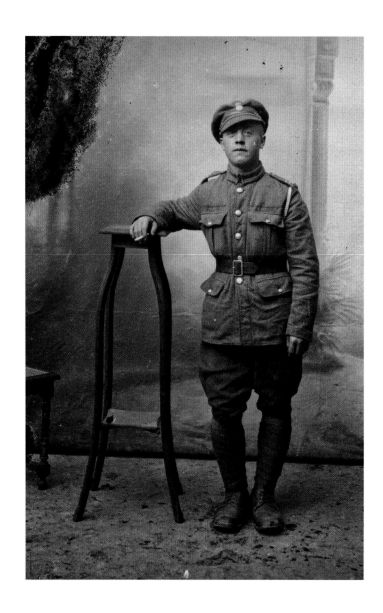

workers who had first joined up; many men who later joined up as Bantams were found to be physically unfit and transferred into the Army Service and Labour Corps (which is probably why so many of the shorter men in the Thuillier images are Labour Corps men).

By the end of the war there were twenty-nine Bantam battalions, including Canadians. One of the most famous Bantam soldiers was the Canadian (later Sir) Billy Butlin, who served as a stretcher-bearer with the 216th (Bantams) Battalion of the Canadian Expeditionary Force, and who would found the eponymous holiday camps in Britain after the war. He famously said he never fired a shot in anger but there were times he would have willingly parted with a leg just to escape the slaughter.[51]

PLATES 184–185 Two soldiers of short stature, both probably Bantam battalion men, pose next to a high table. The man on the left is a corporal and the soldier on the right a fusilier, possibly with the Northumberland or Royal Welsh Fusiliers. The height of the side table provides a handy comparison to judge the height of a soldier.

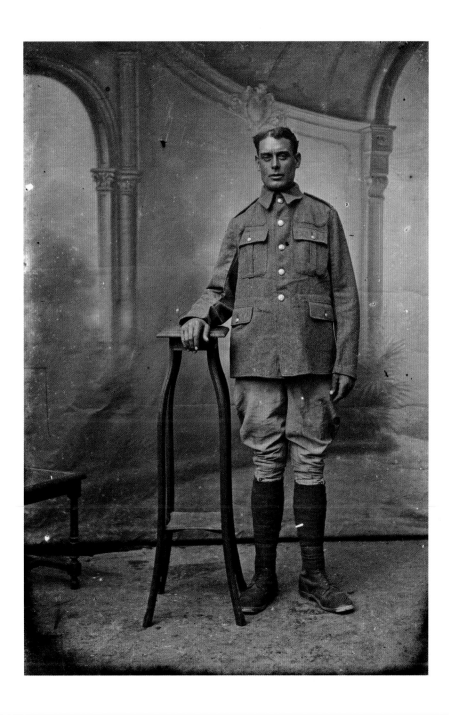

Their distinctive stature made the Bantams the butt of jokes on the Western Front but many individual Bantam soldiers more than proved themselves up to the fight. Correspondent Philip Gibbs referred to them patronizingly as the 'Peter Pans of the British Army – the boys-who-wouldn't-grow-up, and like the heroic Peter Pan himself, who was surely the first of the Bantams, they are eager for single combat with the greatest enemy of England, Home and Beauty who may come along.'[52]

On 15 May 1915 the War Office caved in to the grim reality of the dwindling numbers of men able to enlist and the general height limit for all soldiers was finally lowered to five feet two inches; the Bantams proudly served throughout the war.

PLATE 186 Note the relative height of the side table next to this soldier compared to the soldier in the previous two images.

Faithful in Adversity – the RAMC

Sometime in the 1920s a senior bureaucrat in the British War Office took it upon himself to destroy what were no doubt mountains of military records detailing the service of medical officers in the Royal Army Medical Corps who were granted temporary commissions as officers during the war. Because these doctors only served for the duration, the records of their service were, distressingly, deemed appropriate for destruction, and – as the National Archives patiently explain – only the files of RAMC officers with permanent commissions survived the purge. As fate would have it, for good measure, during the Second World War German bombers also destroyed even more of the British Army's entire commissioned-officer records from the First World War, leaving a gaping hole for researchers and historians wanting to understand the history of those who served as officers in the Great War. It makes tracing the stories of any of the British officers named in the Thuillier images extremely difficult, including that of medical officer Captain A. Hamilton, RAMC, who was attached to the Territorial 1/6th Battalion of the West Yorkshire Regiment, and is seated with his stretcher-bearer colleagues in the Thuillier image on p.175.

We met Hamilton earlier; he was one of the officers in the evocative image of men of the 6th Battalion headquarters, in Plate 130 (p.115), all clearly shattered from the front-line fighting. The British public school predilection for referring to colleagues by their surname meant that initially we did not know for sure what his Christian name was, merely that it began with the letter A – and we only knew that from Captain E. V. Tempest's excellent history of the 6th Battalion published in 1921.[53] As it turns out, Captain A. Hamilton's story is a delightful one, not least because it illustrates the genealogical and archival research needed to put a name to the faces in the Thuillier pictures … and it also has a happy ending.

Sadly, no primary records of Captain Hamilton's war service appear to have survived, which suggests his was indeed a temporary officer's commission. So, turning to

PLATE 187 Three slightly dishevelled young RAMC men. The soldier on the right wears the 'T' on his shoulder badge indicating a territorial battalion. The young fellow on the left is smoking a large cigar.

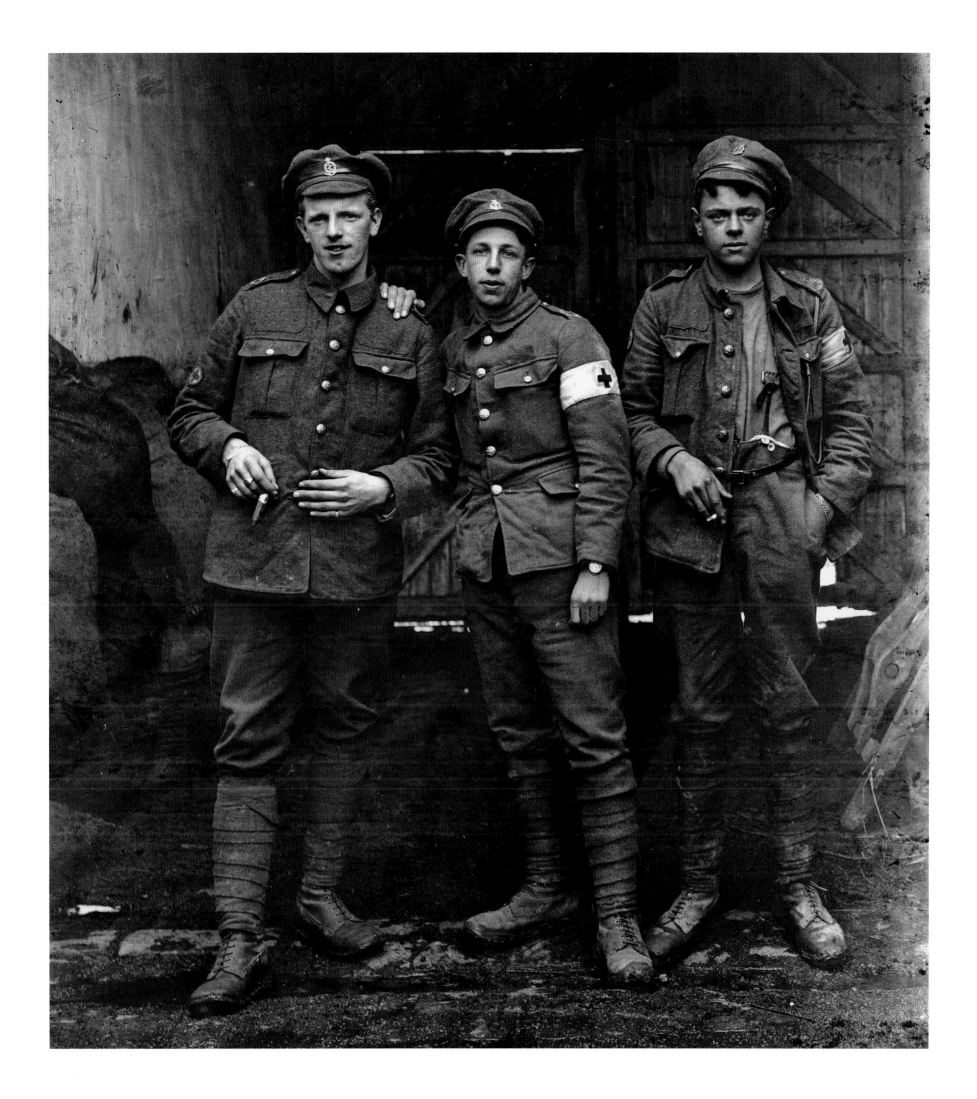

secondary sources, and looking for an A. Hamilton in Yorkshire before the war, we learn that the 1901 census shows that an Archibald Hamilton was listed as a nineteen-year-old medical student, born in Bradford, Yorkshire, in 1882. His father was a Scottish doctor, Dr Robert Hamilton. Then, by a process of elimination and pure luck from an honour roll at Cambridge University, we discover that an 'A. Hamilton' was studying medicine at Cambridge University a year later in 1902, and that he went on to serve as an RAMC medical officer, where he was wounded twice – which made it an odds-on bet that he was the fellow in the West Yorkshire Regiment image because Tempest's history tells us Captain A. Hamilton was wounded twice. Then a pre-war Christ's College, Cambridge, almanac confirms that Dr Archibald Hamilton is almost certainly our man. It records that after he left Cambridge he won a university scholarship to St Mary's Hospital in 1905 and became the House Physician and Ophthalmic Clinical Assistant at the hospital and then the Resident Medical Officer at Chelsea Hospital for Women and then House Surgeon at Great Northern Central Hospital. So he had experience as a surgeon even before he went to war.

Happily, the census also tells us that shortly after he was wounded on the first day of the Somme, Dr Archibald Hamilton married an Italian woman, Silvia Wolff, while home on leave. It took a long time to get there, but let us give medical officer Captain A. Hamilton of the 6th Battalion the dignity of a full name and call him Archibald, with some degree of certainty. RAMC men like Archibald Hamilton were the quiet heroes of the war: walking into combat without a weapon, using the skills of their profession to save the lives of men whose bodies were shattered, torn and eviscerated by weaponry the awfulness of which no one had comprehended before this war began. They deserve to be honoured and remembered.

After the Crimean War of 1853–6, where, despite Florence Nightingale's careful ministrations, disastrous numbers of wounded British troops died through appalling medical neglect, in 1898 the British Army formed a Medical Staff Corps that eventually became the Royal Army Medical Corps. Its motto is 'Faithful in Adversity'. As medical officer with the 6th Battalion of the West Yorkshire Regiment, Captain Hamilton probably enjoyed an extraordinary degree of respect among the men despite his relatively youthful age. Medical officers were afforded enormous discretion, especially on whether the injuries a soldier had suffered justified a 'blighty', a return ticket home to England. In wartime every unit would have a medical officer assigned to it with a cart full of medical equipment; an average of sixteen men per battalion would also be trained in first aid and stretcher-bearer duties.

PLATES 188-189 The Royal Army Medical Corps cap badge can be seen on Captain A. Hamilton's lapel above a 'T' which indicates he was attached to a territorial battalion, the 1/6th Battalion of the West Yorkshire Regiment.

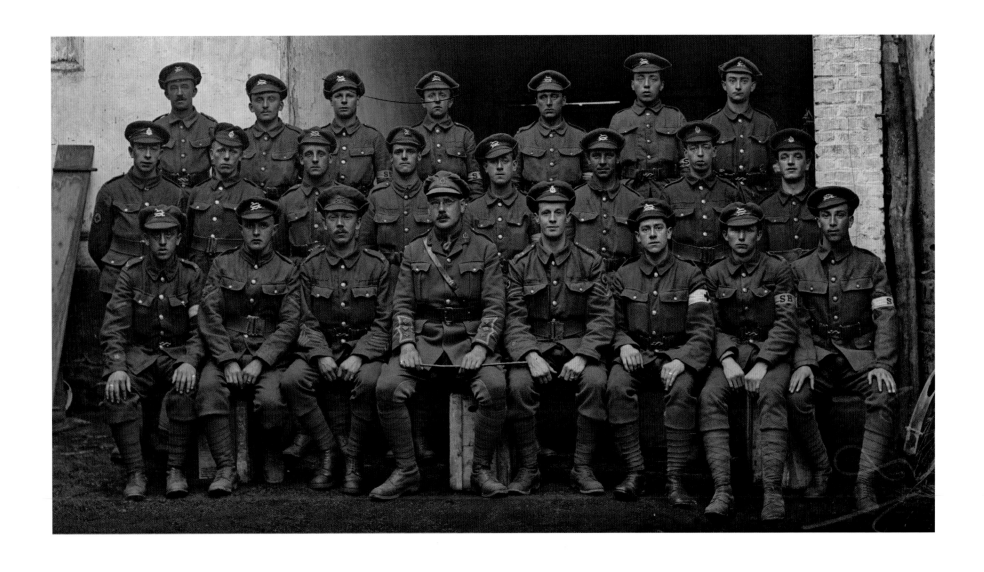

PLATE 190 Royal Army Medical Corps doctor Captain A. Hamilton (seated middle front row) with stretcher-bearers of the West Yorkshire Regiment territorials.

There are fifty-nine images of RAMC-badged soldiers in the Thuillier collection – a considerable number – and this is probably because at different times Vignacourt had a large hospital and, when the battle came closer during the German offensive in 1918, the village also hosted a huge casualty clearing station. There are 518 British soldiers buried in the Vignacourt cemetery, many of whom were treated in the hospital that was based just a few hundred metres away. Casualty clearing stations (CCS) were the first line of the evacuation procedure for a wounded soldier; an injured man would be brought in off the battlefield and either treated there or his wounds stabilized so that he could be evacuated to a full hospital. In Vignacourt the CCS was next to a railway station that had been upgraded by the Royal Engineers to allow quick evacuation of wounded men from the front line. Army archive records show the 61st South Midland Casualty Clearing Station was based at Vignacourt from 18 April to 18 August in 1918, during the defence against the massive German offensive that began in March, which is probably when most of these photographs of RAMC personnel were taken.

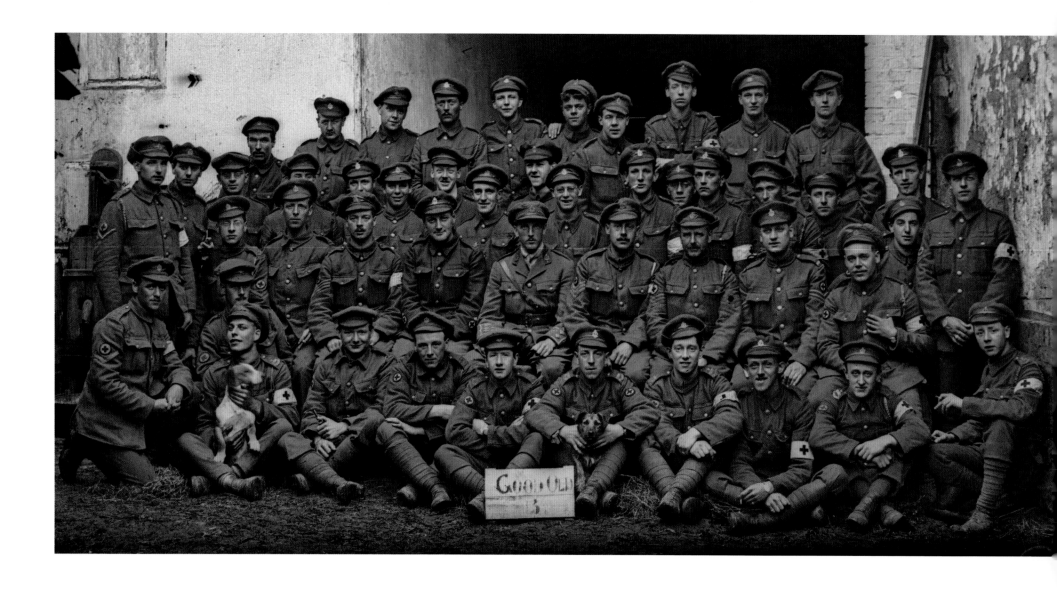

PLATE 191 The 'Good Old 13', the sign reads: but which regiment was this RAMC unit attached to? The regimental badge sits just below the RAMC badge on the shoulders of many of these stretcher-bearers but it is difficult to decipher. Many have a 'T' as well, indicating that this was a territorial unit.

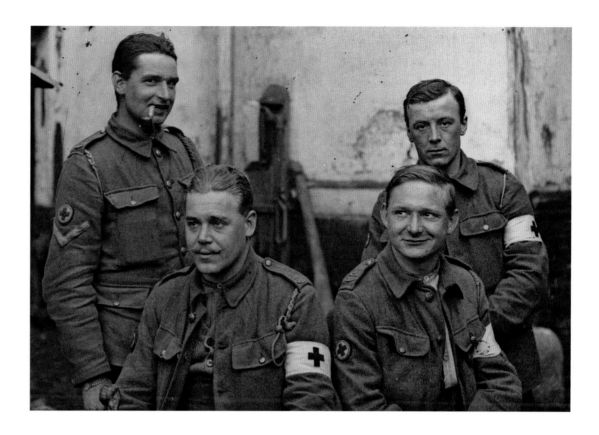

PLATE 192 An informal image of RAMC stretcher-bearers. All wear the economy tunic, meaning that this dates from 1916. The soldier seated on the left has a 'T' on his shoulder, which means he was a territorial. This same soldier is seen in the second row from the front and seated on the right end in Plate 191.

On the battlefield, field ambulance RAMC or regimental stretcher-bearers (such as the Durham Light Infantryman we met earlier) would carry the wounded into dressing stations where urgent life-saving procedures could be carried out with some fairly basic hygiene. More serious cases would be referred on to the casualty clearing station and then to hospital. It was also deadly for many of the stretcher-bearers and medical officers who were in the forward positions rescuing wounded men; the medical corps lost an estimated 6,873 men during the war, out of a total 145,000 who had served in the corps by 1918. Infection was a huge problem; one of the biggest issues on the Somme was that the highly fertile soil in the area was full of bacteria that could turn wounds gangrenous in hours. Nearly three-quarters of all wounds were caused by bomb fragments that pushed filthy shreds of clothing and soil deep into a wound, causing tetanus, gangrene and sepsis.

One history of the 7th Battalion of the Royal Sussex Regiment tells the story of a medical officer, Captain A.M. Thomson, who was killed in action while helping a wounded lieutenant named Stocks on 7 July 1916 near Ovillers. His selflessness and ultimate fate underline the awful risks the RAMC were expected to take on the battlefield:

Thanks to Thomson's presence of mind, my wound was speedily dressed; indeed he used his own cane as a temporary splint on my broken leg. By this time our casualties had reached a considerable number, and for the next few hours Thomson was continuously at work attending to the wounded. With my badly fractured femur, I found it impossible to move and

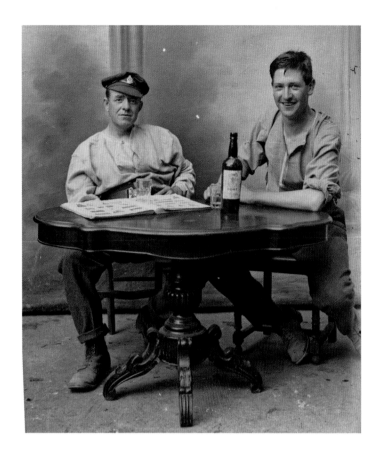

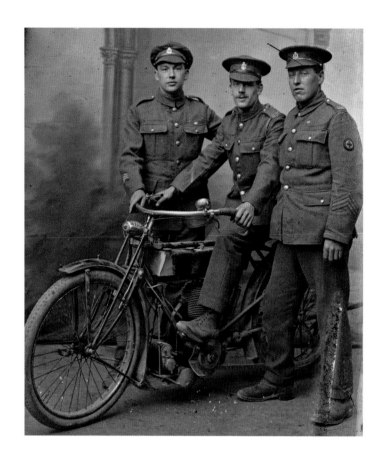

*it must have been after midday when Thomson came to me again and said he was going to
drag me back to a shallow assembly trench not far from where I lay. With an entire disregard
for the enemy's heavy shell and machine gun fire, he managed to haul me onto a ground sheet
and was having me pulled to cover on this improvised sledge when he suddenly fell forward,
almost on top of me without entering a groan, apparently shot through the heart by a sniper.*[54]

Private J.H. Newton of the RAMC, who served as a stretcher-bearer for three
years on the Western Front with the 21st Division, kept a fascinating diary that provides an
insight into the work performed by his colleagues and himself.[55] 'It may help someone to
realise the horrors of modern warfare and so help to make another war like the last one
impossible,' he wrote optimistically.[56] There is no way of telling whether he appears in any
of our photographs of RAMC soldiers, but he was based at the Piquigny camp a short
distance from Vignacourt and his experiences as a stretcher-bearer no doubt mirror those
of the men in our images. He very likely passed by the Thuillier studio.

Early in 1916, after he arrived in France, Newton was dealing with fairly minor
issues in a divisional rest station based in a chateau: patients with boils, scabies and other
infections rampant in the trenches. Then, in April, he found himself in a battlefield aid
post overrun by rats. 'I could get no sleep as they were continually running over me.
We could do with a Pied Piper!'[57] On 1 July on the Somme he found himself at a place

PLATES 193–194 A soldier wearing an
RAMC cap badge enjoys a bottle of port
with his chum, and (right) three RAMC
soldiers with a motorbike. The two
standing soldiers wear medal ribbons.

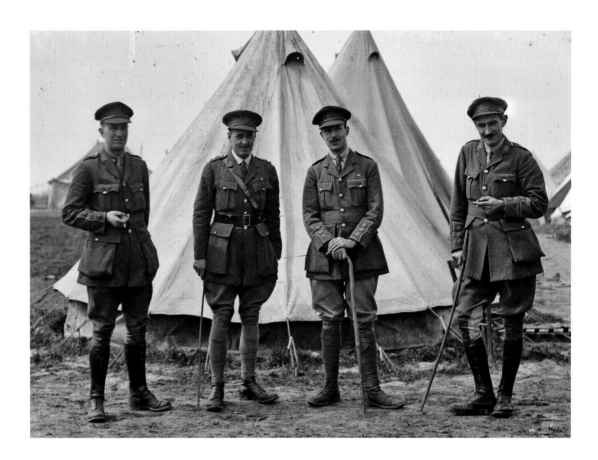

called Queen's Redoubt and 'in a very short time, we were up to our eyes in work'.[58] It was young men like Private Newton who walked the battlefield retrieving the wounded and the dead. 'Many of our dead were scattered about in the open. In the trenches in some places, the Germans lay in heaps. In one place I noticed a young officer, with twelve of his men, all dead.'[59] On 12 July, nearly two weeks into the battle, he sadly noted scores of dead Welsh Fusiliers scattered around a dressing station at Fricourt.

In September, Newton was in the misery of Montauban (where we previously heard the story of the Liverpool Pals): 'I am so fed up that I am quite indifferent to danger, and I almost pray that I might be wounded so as to get out of this hell.'[60] He was having breakfast at Delville Wood when a British shell fell short and landed in their trench line, killing an RAMC corporal.

The shellfire and the mud are simply beyond description and it is a miracle that any escape being hit. We have to carry the wounded shoulder high, the only way it can be done, because of the mud. Your shoulders are made raw by the chafing of the stretcher handles, although we wear folded sandbags under our shoulder straps. Sweat runs into our eyes, until we can hardly see.[61]

For Newton there were all too often agonizing life and death decisions to be made. On one occasion he found a dozen badly wounded men lying on stretchers near a roadside

at Flers. The area was being hit with shellfire but there were not enough stretcher-bearers to carry all the wounded back in one go. He never found out what happened to those men he had to leave because it was impossible to get back in there under the artillery fire. Many times Newton describes having to put a loaded stretcher down and take cover on flat rough ground, resigning himself to imminent death. At Ypres, wounds, death and sickness halved his section of thirty-six stretcher-bearers. 'I only wished to lie down and die in the mud … I had envied the torn and mangled corpses that were scattered about.'[62]

Perhaps the most horrific moment for stretcher-bearer Newton occurred in October 1916 when he was assisting the 7th Leicesters as they went into an attack.

A tank was knocked out, and set on fire, the crew being wounded. One of these men who could walk began to go down the road to the Dressing Station just as another salvo of shells came onto the road, and I kept well down in the trench until they had burst. When the smoke cleared away the wounded man had disappeared, and there was a huge shell hole in the centre of the road … I saw the most awful sight I have seen out here: there was half a man, from the waist upward, propped up in that hole, and he was alive and conscious; 'Oh, chum help me!', he whispered, but what could we do? Bandages and stretchers were no use whatever. A battalion stretcher-bearer came up, and he said the most merciful thing to do would be to put him out of his misery. Then someone remembered the hypodermic syringe in the medical pannier … and our corporal came and injected a full dose of morphia in the poor fellow's arm. He was very soon unconscious and very shortly afterwards, dead.[63]

One corporal from Worcestershire Regiment, W. H. Atkins, wrote a poem about the RAMC stretcher-bearers that says it well:

… We are the men who carry them back,
The wounded, dying and dead
It's 'Halt!' 'Dressing Here!' – 'Come, buck up, old dear.'
You're all right for 'Blighty', so be of good cheer –
'Turn him gently now, bandage his head.'
The 'stretcher-bearers' doing their bit,
Of VCs, not many they score,
Yet are earned every day in a quiet sort of way
By the 'Royal Army Medical Corps'.[64]

There was some feeling among the RAMC stretcher-bearers that they rarely received official recognition for what they did. For example, none of the RAMC men who won the Victoria Cross were enlisted men from the ranks; all were officer doctors.

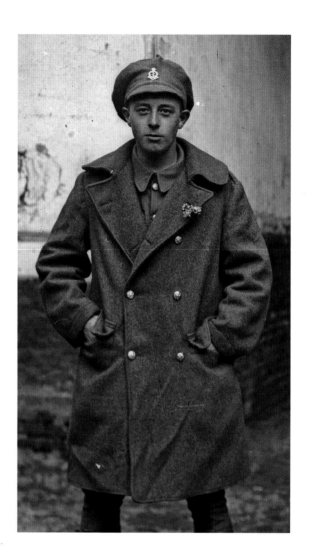

PLATE 196 An RAMC soldier wears a sprig of flowers in his lapel.

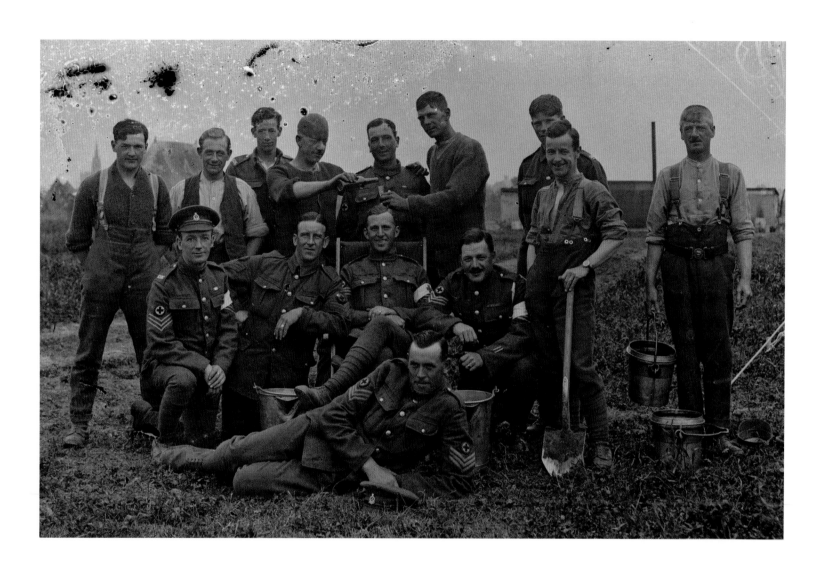

PLATE 197 The uniformed soldiers in this imag are all Royal Army Medical Corps (RAMC). Five of them wear sergeants' chevrons and three of them are decorated (see the small bars over their left breast pockets). The possible date is the second half of 1916 as the sergeant crouching on the right of frame has two wound stripes on his lower left sleeve. These stripes were introduced in August 1916. Vignacourt's cathedral may be seen in the background.

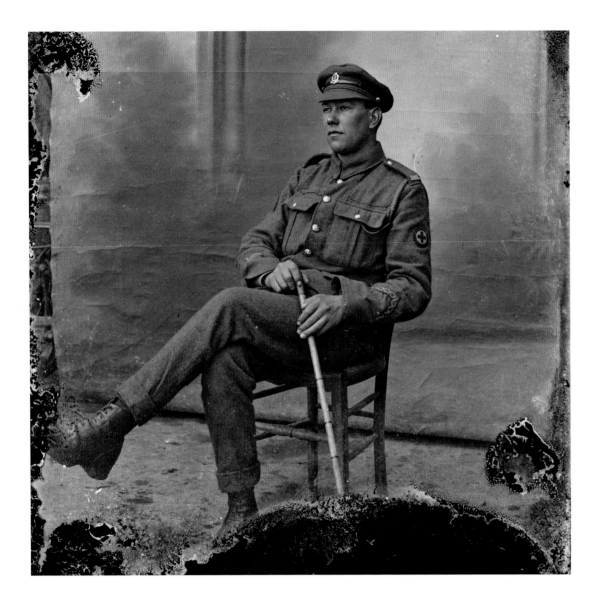

But for their courageous acts men of the RAMC won more than three thousand Military Medals during the war, among them a private soldier who was actually a conscientious objector. Private Ernest Gregory had volunteered to go to the war but had refused to fight and agreed to be a stretcher-bearer instead. During the Battle of Passchendaele in 1917 he won his gallantry award for helping wounded men in terrible conditions, lifting them out under shellfire and wading through shell holes and mud-filled water reaching to the armpits. Many of these RAMC men were highly educated, with a strong moral objection to what they were witnessing; one of them, Charles Horton, wrote a history after the war, bitterly declaiming:

> *Not all the war memorials and Armistice Day festivals can pay a tithe to the tribute*
> *due to those whose lot it was to be offered up as cannon fodder in this most bloody of all*
> *campaigns the world has seen.*[65]

PLATE 198 A pensive RAMC soldier. The sleeve chevrons tell us he is in his third year of overseas service and has two years of good conduct.

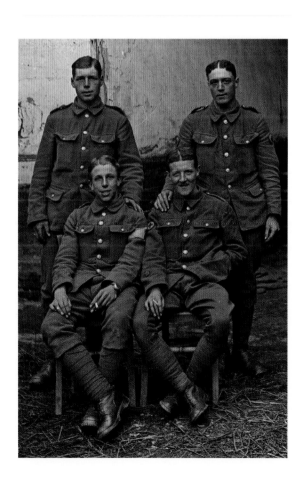

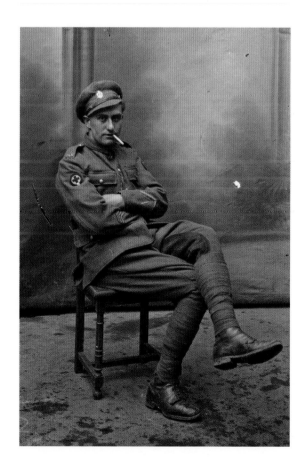

PLATE 199 An RAMC soldier with an injured finger (seated) poses with an artillery soldier who is signals-qualified and wears jodhpurs and spurs.

PLATE 200 Three RAMC men with a local dog. The lad on the left looks no more than a child.

PLATE 201 Four young soldiers cleaned up for the camera – freshly parted hair and smiles – for family back home?

PLATE 202 This sharp image of a handsome RAMC soldier reveals he has served for three years, has two years' good conduct and has been wounded once. It must have been taken after January 1918 as that is the date when the overseas chevrons (worn on the lower right sleeve) were introduced.

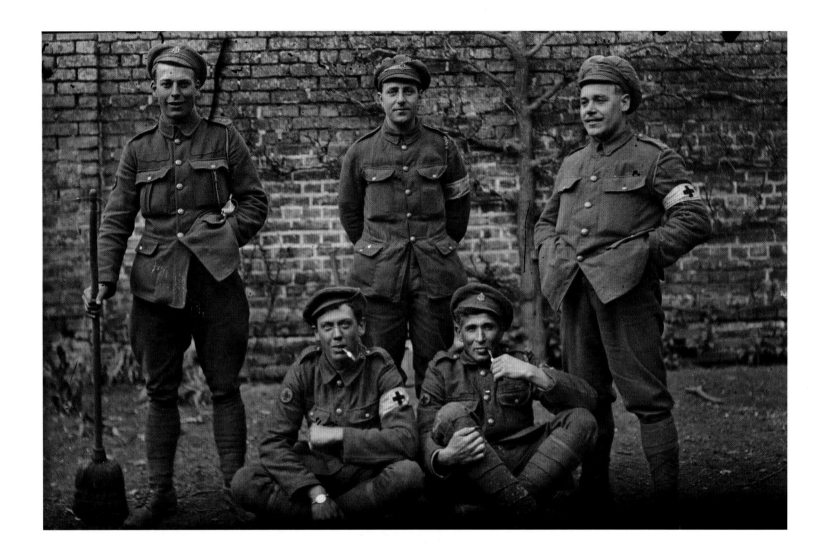

One RAMC doctor, Lieutenant George Chandler, had volunteered for service in France in August 1914 and a book of his letters and diaries reveals his mounting horror at what he witnessed in one advanced dressing station near an August 1917 front line:

> *Oh! The dead, and the wounded, and the dying, and the smell of blood, and the smell*
> *of the exploding shells, and the crush and the crowding, the corpses on stretchers ... We*
> *are in the jaws of hell here. Sunday was awful. I have never been in anything worse.*
> *I am right up in charge of advanced stretcher-bearers at the point of the most awful*
> *salient. My mind is full of mangled men and mules and the frightful concussion of the*
> *crumps bursting.*[66]

Perhaps the greatest RAMC story of all is that of Captain Noel Godfrey Chavasse, the only First World War soldier to be awarded the Victoria Cross twice for gallantry, and one of only three men in history ever to have won a second VC. (It is a measure perhaps of just how great a sacrifice the RAMC made that another of those three double VCs,

PLATE 203 Five relaxed RAMC soldiers. The one standing on the left has a territorial badge and a regimental badge on his shoulder beginning with 'W' – very likely from the West Yorkshire Regiment. Note that the soldier standing on the right also appears in Plates 191 and 192 on pp. 176 and 177.

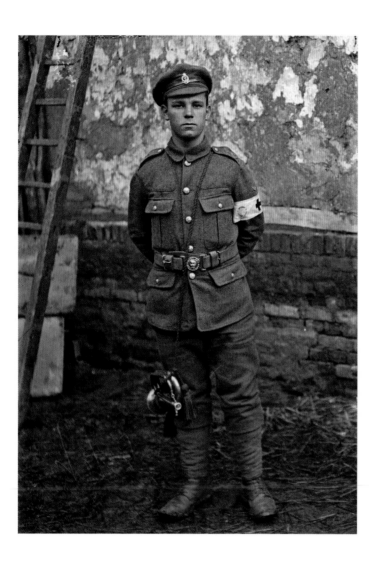
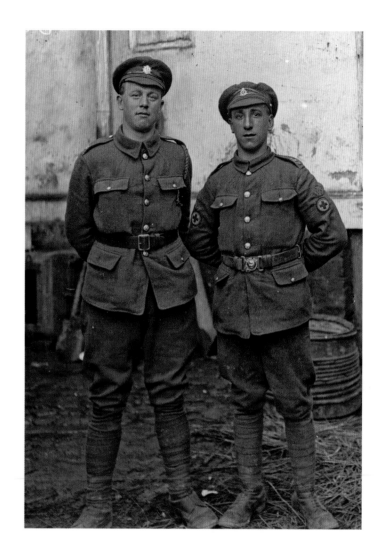

PLATE 204 A young RAMC bugler, wearing a King's Crown belt buckle and a territorial battalion 'T'.

PLATE 205 An RAMC soldier with a territorial battalion. He wears the same Crown belt buckle bearing the words 'Dieu et mon Droit'. The soldier on the left is from the Army Services Corps.

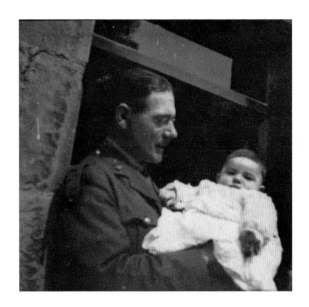

Lieutenant Colonel Arthur Martin-Leake, who had won his first VC in the Boer War, was also a medical officer who earned his second for helping wounded men lying close to an enemy trench on the Western Front.) There was, however, something exceptional about Noel Chavasse's selfless bravery as a non-combatant medical officer in the First World War that won him this singular distinction. One soldier told the Liverpool press about how Chavasse inspired the men around him: 'Hell would have been heaven compared to the place he was in, but he never troubled about it. It's men like him that make one feel the spirit of old is still alive in our midst.'[67]

The son of the Bishop of Liverpool, Chavasse served as medical officer with the 10th Battalion of the King's (Liverpool) Regiment – the Liverpool Scottish. The Scots' first major blooding on the Western Front was on 16 June 1915 at Hooge, near Ypres. Their attack won about a kilometre of ground but at a dreadful cost: 79 killed, 212 wounded and 109 missing out of an original complement of 542 men. A letter Chavasse wrote home shortly after conveys the shock of losing so many of his brother officers: 'In that photo you have of Scottish officers before we left for Belgium, I am the only one left now. All the rest are either killed or wounded or have gone home sick. But some of them I hope will come out again.'[68]

It was in Guillemont in August 1916 that he won his first VC, in the same battle that saw the loss of so many of the Liverpool Pals. Chavasse walked among the slaughter, tending to wounded men in broad daylight, often in full view of the Germans and under heavy fire. He is credited with saving the lives of twenty badly wounded men just metres from enemy trenches. Then, almost exactly a year later at Wieltje in Belgium, despite a bullet wound to his right leg, Captain Chavasse refused to leave his forward aid post for two days, repeatedly going onto the battlefield under heavy fire to rescue wounded men. He was eventually shelled in his trench-line aid post at Passchendaele and died of his wounds on 4 August 1917. His younger brother, Aidan, a lieutenant in the 17th Liverpool Pals, had been killed just a month earlier at Messines. A surviving elder brother, Christopher, served as a British Army chaplain on the Western Front and subsequently became the Bishop of Rochester.

One RAMC doctor did make it home to live a relatively full life despite his injuries and the horrors he had witnessed. The parish records of the Wesleyan Methodist Chapel in Manningham, Yorkshire, show that Captain Archibald Hamilton RAMC returned to his beloved Silvia and the couple had three children.

PLATE 206 Captain Archibald Hamilton RAMC with his son Ian in 1918. (Courtesy Hamilton family)

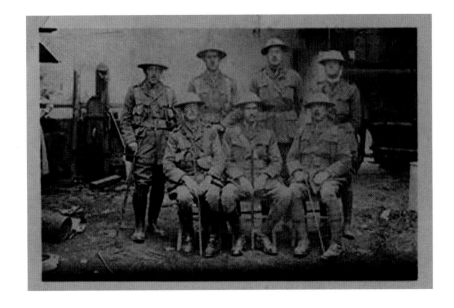

PLATE 207 One of the very few Thuillier
prints that have survived the century –
this very faded and battered photograph of
the 6th Battalion West Yorkshire Regiment
in April 1916 (identical to Plate 130) is a
proud heirloom of the family of medical
officer Captain Archibald Hamilton RAMC.
(Courtesy Hamilton family)

One boy, Ian, was born in March 1918, conceived in 1917 while his father was home on leave after being wounded for the second time with the 6th West Yorkshires. Elizabeth followed in 1920 and Michael in 1923. And, as it happens, one of the family's treasured mementos, held by Captain Archibald Hamilton's granddaughter Charlotte, is a very faded photograph of her grandfather standing in the courtyard of the Thuillier farmyard in Vignacourt in 1916 – incredibly, a battered original Thuillier print of the 'thousand-yard stare' photograph of the battalion headquarters officers of the 6th Battalion West Yorkshires in Plate 130 (p. 115). The parish records also show it was Archibald's wartime chum standing to his right in this image, the Reverend Richard Whincup, who presided over Archibald's marriage to Silvia. Apt, then, that after a century a fresh and crystal-clear version of this recently rediscovered Thuillier image has now found its way back to the Hamilton family.

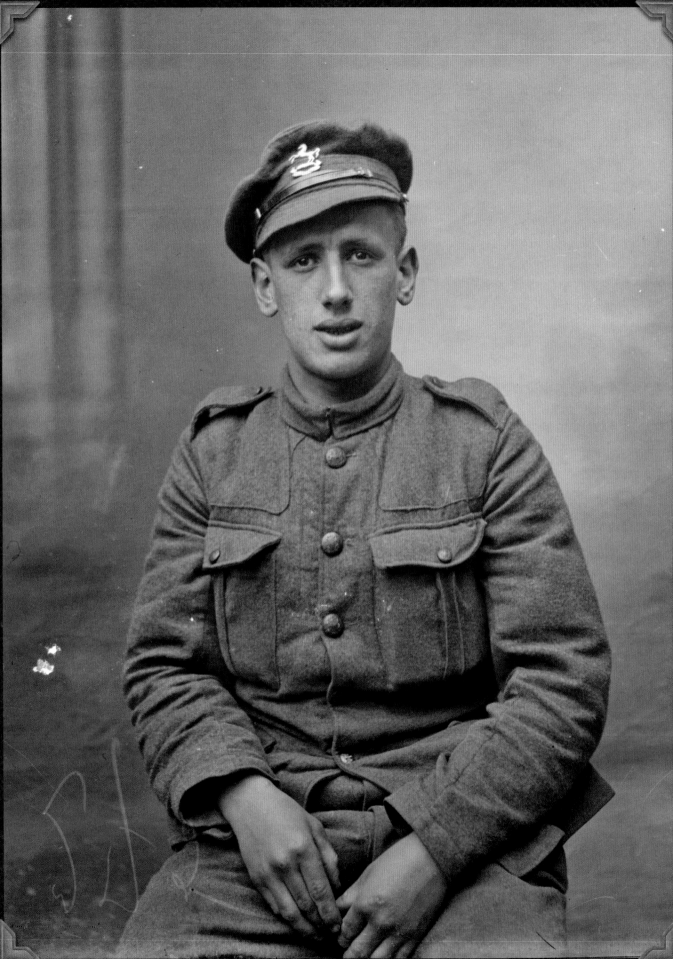

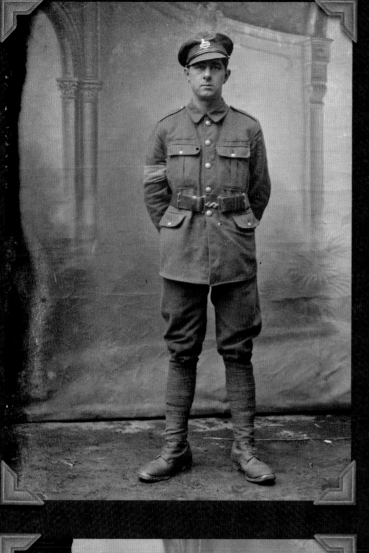
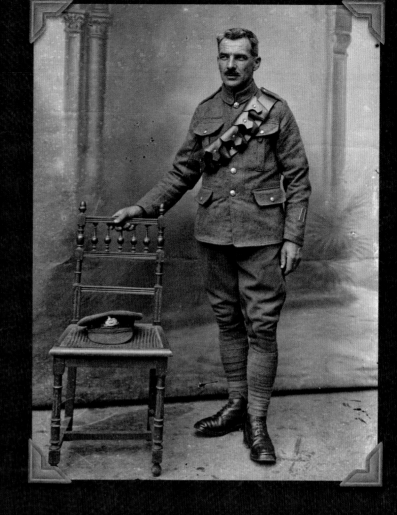
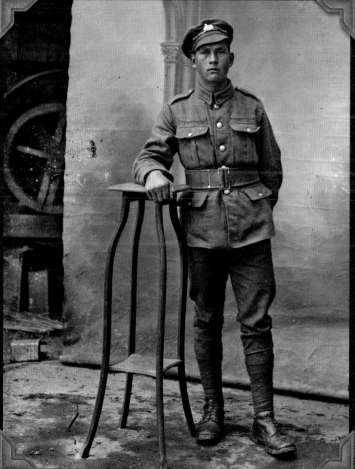
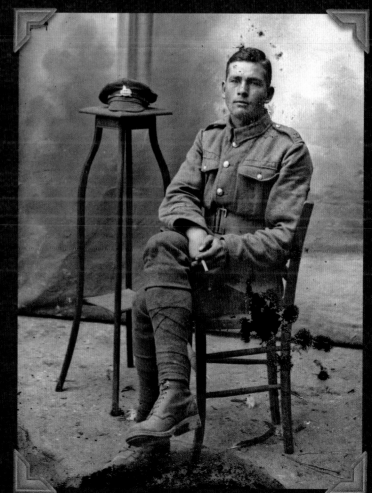

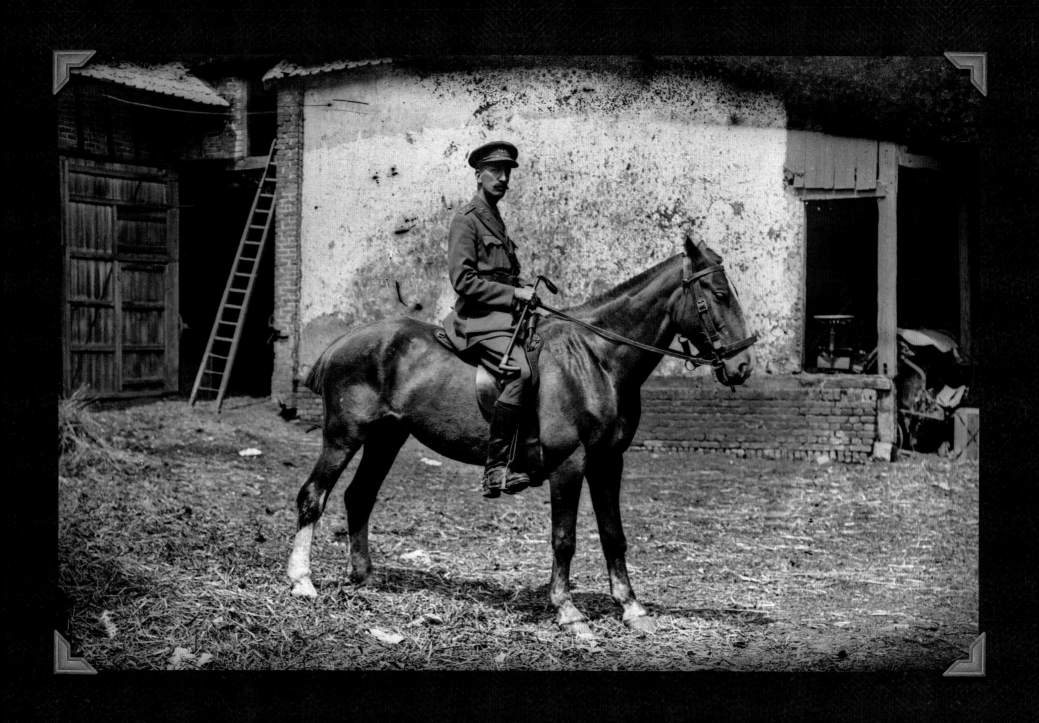

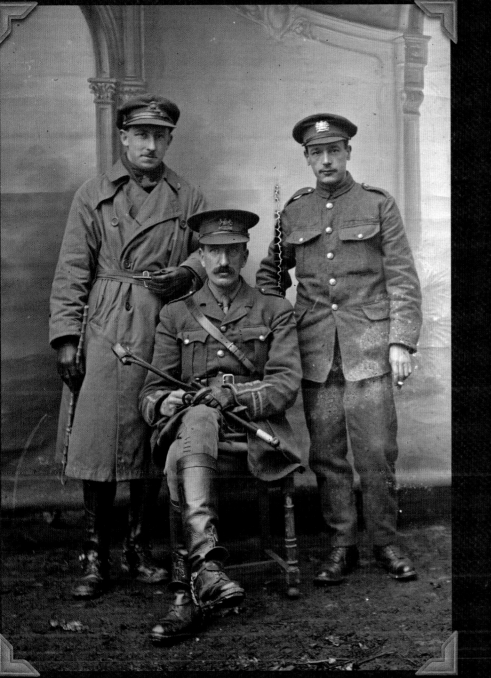
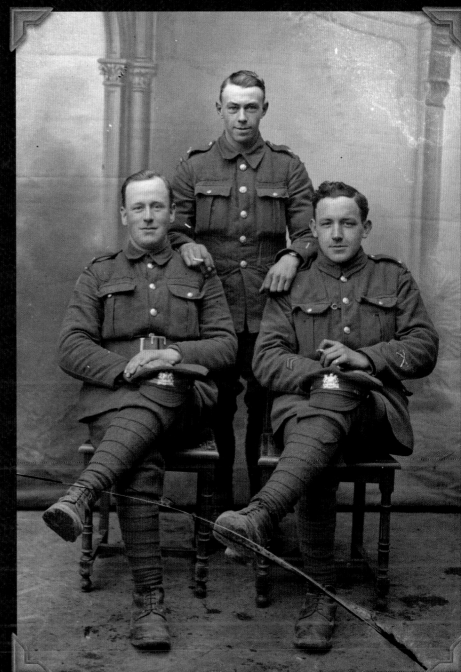

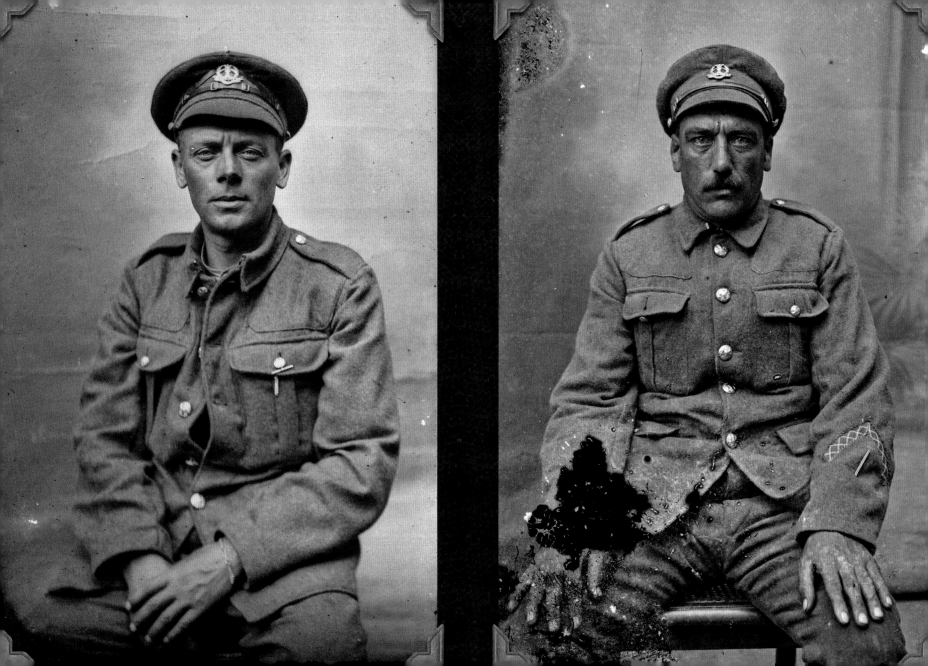

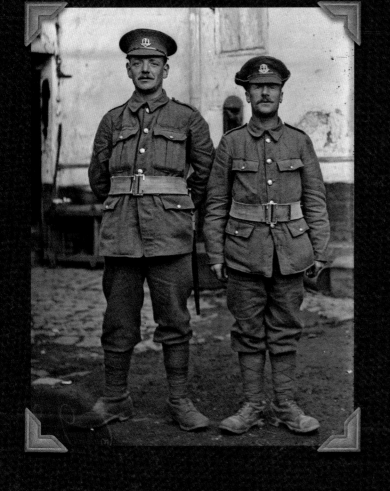
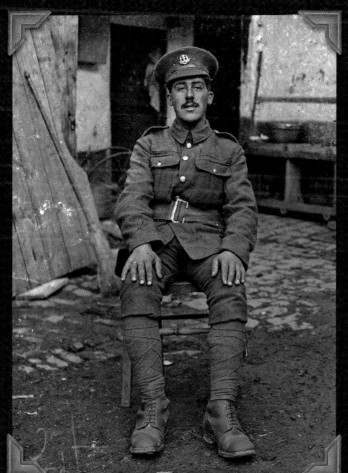
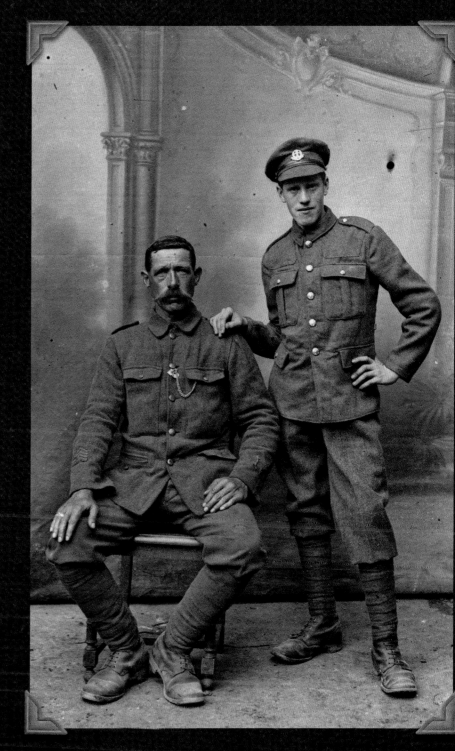

194

The Fusiliers

No doubt it was bitterly cold on the morning of 22 February 1940 when the corpse was spotted floating in the Thames. It had not been there very long, possibly only a few hours, but the victim would have died quickly once he fell into the river at Wraysbury, a rural village in Berkshire to the west of London. No official reports survive to say whether the coroner assessed it as suicide, foul play or an accident, but for the men who hauled the body from the river that morning it was a grim task whatever had caused the poor fellow to drown. As if there was not enough death already, Britain was in the early months of a second world war and all men aged between nineteen and forty-one had just been called up as the country stared down Nazi Germany. On the river bank a search of the body would have revealed the dead man's personal effects and allowed him to be identified; within hours there was probably a knock on the door at the home of sixty-five-year-old war hero Captain George Thomas Shelley MC to tell his wife, Edith, that her husband of thirty-seven years was dead.

It was a wretchedly sad and inauspicious end for a career military officer who had given so much service to his country. Born in Dover, Kent, in 1875, George Shelley entered the First World War as a quartermaster and honorary lieutenant in the Royal Fusiliers (City of London) Regiment, but he was soon promoted to captain, no doubt highly valued for his experience. He and Edith had a son, Percy (perhaps a nod to England's greatest lyric poet), and for the duration of the war the family lived at Finsbury Barracks in City Road in London. Shelley's battalion was one of forty-seven the Royal Fusiliers raised for service during the war; the fifth-largest regiment in the British Army.

The Fusiliers had originated in the seventeenth century as an ordnance regiment, their main role back then being to escort the artillery, and their name stemmed from the fact that being around open barrels of gunpowder required them to carry different weapons from other regiments so as to reduce the risk of a catastrophic explosion. They were therefore equipped with safer flintlock 'fusil' muskets instead of matchlock muskets

PLATE 208 The cap badge of the Royal Fusiliers (London) Regiment.
PLATE 209 Royal Fusiliers in Vignacourt likely mid-1916, including (at this time) Lieutenant (later Captain) G. T. Shelley, seated, middle.

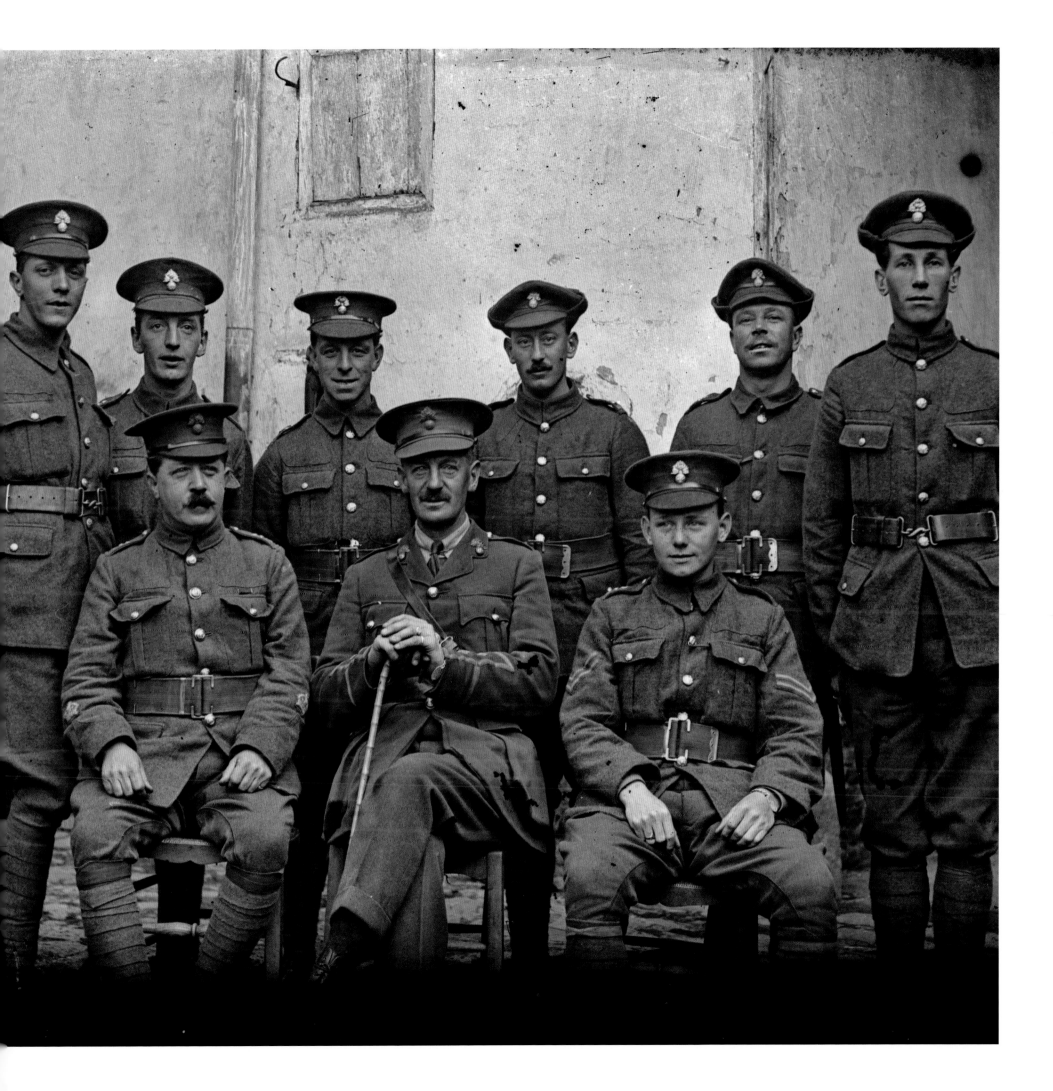

– hence the name 'fusiliers'. When war was declared in 1914 the Royal Fusiliers (London) Regiment became the focus of the same kind of patriotic passion and civic pride as the other Pals battalions in the north; 1,600 members of the London Stock Exchange joined up to form the now famous Stockbrokers' 10th Service Battalion, frantically competing for selection because they feared the war would soon be over. Many of the 10th Pals were educated professional men – clerks and draughtsmen, for instance – and David Carter's excellent history of the Stockbrokers' Battalion records that most chose to join the ranks because they were anxious to ensure they would see action before the war ended by Christmas 1914: 'Waiting for commissions would mean they could not get to France until 1915, when the war would be over';[69] the war would, of course, continue for another four miserable years. There were also Jewish and Sportsman's battalions attached to the Fusiliers, all of whom served with honour, but at a terrible cost. Tragically, a quarter of the 10th (Service) Battalion Royal Fusiliers would die in many of the major battles of the war.

As 9th Battalion quartermaster it was Shelley's role to ensure the supply of stores and provisions to keep the battalion fed, clothed, watered and armed – he was what we would call today the logistics officer. Quartermasters were traditionally officers who had been commissioned from the ranks, normally from the rank of sergeant major, and this is how Shelley came to be promoted to lieutenant in 1914. It appears the then Lieutenant Shelley went to France with the 9th (Service) Battalion, first seeing combat at Loos in May of 1915, where the British Army took a terrible beating, suffering 60,000 casualties. By late 1916, he was again in the thick of one of the bloodiest battles of the Somme, at Pozières, for on 20 October he was awarded the Military Cross, the third-highest military decoration that can be awarded to an officer. The citation reads: 'The King has been graciously pleased to confer the Military Cross on the Officer in recognition of his conspicuous gallantry during operations. On several occasions he showed great determination as transport officer, when bringing up rations and stores under heavy fire. His fine example of coolness and courage had a great effect on his men.'

Frustratingly, as we have seen, enemy bombing during the Second World War destroyed many British Army officer personal records, and these would have included those of poor Shelley, pulled from the Thames in 1940. Very few officer files still exist and the identification of Captain George Shelley, and the scant details we have of his life story, was only possible because of a curious quirk of fate in a Sydney auction house on the other side of the world nearly a century after the Thuillier photograph was taken. The men and officer in Plate 209, p.195, are clearly wearing the badge of the Royal Fusiliers – but how to identify their battalion, never mind their names? There is something warm and kindly, but also melancholy, about Shelley's eyes; clearly he has been through a lot and it is not difficult to imagine that he enjoyed the respect and affection of his smiling men. What was his and their story?

PLATE 210 Close-up of then Lieutenant Shelley. Note his wedding ring and identity bracelet, which is almost legible in this crisp Thuillier image taken in Vignacourt before he was promoted to captain in July 1917.

PLATE 211 The stairs behind these three officers of the Royal Fusiliers still exist and lead up to the attic where the Thuillier glass plate negatives were discovered.

198

ALDERSHOT - 1919.

LT. A.E. PRICE LT. H.E.S.WALL LT. F.J. MITCHELL . M.C. LT F.W COLEMAN .M.C. LT. C.E. ADAMS. D.C.M.

LT. G.T.M. ALLEN. CAPT. G.L. CHIALET. D.S.O. M.C. LT. STRANGE CAPT. BENGLEY LT. C.L MONDEY M.C. CAPT. A.H. CHARLES.
 CAPT. W.R. BUSK. LT. O.W. HEPBURN. M.C.

CAPT. H. OAKES-JONES . MBE. CAPT. R.M LAVERTON LT.COL. A.V. JOHNSON. D.S.O CAPT. J.R.E.GALBRAITH D.S.O. CAPT. G.T.SHELLEY. M.C.
 (Q?. M?.)
 CAPT. H.H. HEBDEN. M.C. COL. B.G. PRICE .C.B. CMG. DSO MAJOR. K.H. PIPON .DSO.M.C. CAPT. H.M. MARSHALL. M.C.

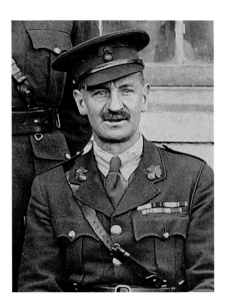

This 1919 group photograph (Plate 212, above) at Aldershot including a Captain G.T. Shelley, held by the Royal Fusiliers regimental museum, enabled his identification at the bottom right by dint of the characteristic jaunty tilt of his cap and his distinctive moustache – he is your classic British Army officer.

Without his First World War personal file it at first seemed impossible to discover which battalion Captain George Shelley served with during the conflict and in what battles he fought. But a breakthrough came when a large brass shell casing (Plate 214) came up for sale as lot 1149 in Sydney in 2011. The catalogue said it was inscribed on the side: 'Captain G.T. Shelley MG 9th Battalion. Royal Fusiliers France 1917'. The auctioneer's staff had clearly misread 'MC' as 'MG' but nonetheless it gave us the information we needed: Captain G.T. Shelley's battalion was the 9th. He was very probably presented with this example of trench art by his men to honour his earning the MC.

The 9th Battalion of the Royal Fusiliers (City of London) Regiment was one of the New Army service battalions and career soldier Lieutenant Shelley was doubtless brought in as an experienced hand to train up the raw recruits. Following the Battle of Loos, where 117 officers and 3,237 men of their 12th Division were killed or wounded, and after a bitter winter in the trenches, on 2 March 1916 the Royal Fusiliers fought a fearsome hand-to-hand battle for the Hohenzollern Redoubt, targeting a position known as the

PLATE 212 Officers of the Royal Fusiliers at Aldershot in 1919 with Captain G.T. Shelley MC seated bottom right. (Courtesy Royal Fusiliers Regimental Museum)
PLATE 213 A close-up of Captain Shelley from the 1919 Aldershot photograph which enabled him to be identified in the Vignacourt Thuillier photograph.

PLATE 214 The shell casing in a Sydney auction house that gave us Captain G. T. Shelley's 9th Battalion.

PLATE 215 The original 9th Battalion Royal Fusiliers' war diary notes recording the 9th's arrival in Vignacourt on 17 June 1916. (Courtesy Royal Fusiliers Museum)

Chord. The 9th Battalion was commended for its bravery by British commander General Gough following the battle but it achieved very little at huge cost; the best description of the earlier 1915 battle for the Hohenzollern Redoubt was an unusually candid admission by the Official Historian General James Edmonds that the fighting did not improve the situation in any way and 'had brought nothing but useless slaughter of infantry'.[70]

The 9th Battalion's original war diary is held in the Royal Fusiliers Museum in the Tower of London; it records that in mid-June 1916 the men of the 9th arrived by train at Amiens and then marched the twenty kilometres in darkness out to Vignacourt, arriving at 2.30 a.m. on 17 June, where they were billeted in the village. This is very probably the time when the photographs of Shelley and the men of the 9th Battalion were taken. It was time for a well-earned rest and that relief can be seen on the faces of the men in these images. Over the next ten days, apart from the occasional route march, map-reading training, practice attacks in the nearby forest and numerous inspection parades, there would have been plenty of leisure time in the local restaurants and estaminets.

On the night before the battalion left for more training at nearby Flesselles, there was also a concert party performance in Vignacourt. One of the concert parties that was performing in the area was a group known as 'the Barn Owls' and it may very well have been the Barn Owls who performed that night. As it happened, a fellow Royal Fusilier,

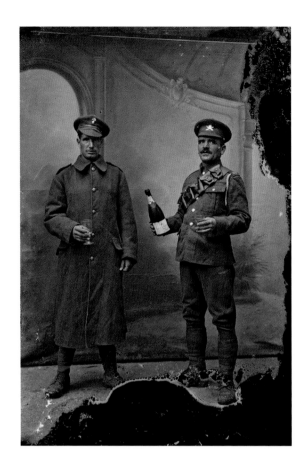 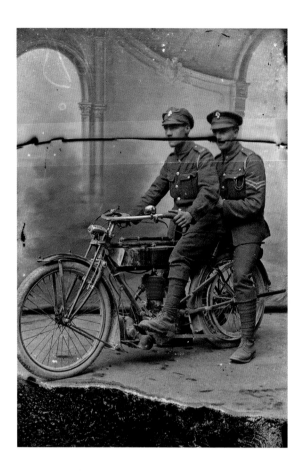

George Knight Young, had been a member of the Barn Owls. Young originally joined up with the Stockbrokers' 10th Pals Battalion with the Royal Fusiliers but late in 1915, because of his fine voice, he was offered a place in a divisional entertainment party, which meant he was excused from his combat role with the 10th. He was torn by the decision – 'After all, one came out here to fight as a soldier, not to sing in a concert party'[71] – and on 28 April 1916 he returned to his pals in the 10th Battalion. Sadly, within days, on 4 May 1916, George Knight Young was killed during a German artillery bombardment of his trench near Berles. If only he had stayed with the Barn Owls; such is the fickle cruelty of war.

So many of the young 9th Battalion men in these Thuillier images would also be dead or grievously wounded within weeks. For, after their training at Flesselles, they were redeployed back into the front-line fighting, relieving at Ovillers-la-Boisselle and attacking the German lines, suffering heavy casualties. 'Few more costly actions were fought in the whole of the battle of the Somme,'[72] the Royal Fusiliers history laments. Ten days after the battalion left Vignacourt, the diary of 7 July 1916 sadly noted:

'A' [Company] of the 9th was 'decimated' by [machine-gun] fire and the same fate met
2 Platoons of 'B' which followed. The remaining platoons of 'B' Coy were ordered to
remain in the trench as it was seen to be useless to send them across at the same place.

PLATE 216 A wonderful shot of a Royal Fusilier soldier in a great coat (also pictured on p. 37) with a chum from the Machine Gun Corps holding a bottle of champagne. Close reading of the label shows the champagne is from La Veuve, a commune in the Marne department in the Champagne-Ardenne region of north-east France, home of Veuve Clicquot champagne.

PLATE 217 A damaged plate shows two Royal Fusiliers soldiers, one of them a corporal, both wearing ceremonial dress braid, posing on a motorbike.

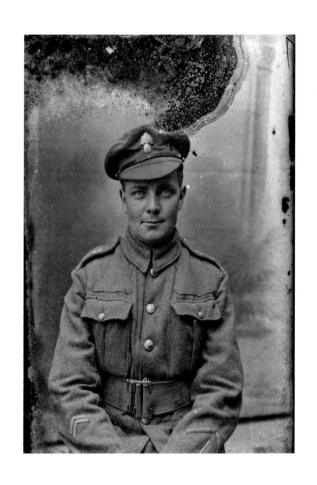

PLATES 218-219 A Thuillier image of a concert party soldier, one of many performance troupes in Vignacourt. (Right) A damaged image of a Royal Fusilier soldier. The two chevrons on his right arm mean he has served two years overseas and the chevron on his left arm was awarded for good conduct. The thin white strip below means he has been wounded once. This suggests this image was taken in at least January 1918, which is when these chevrons were issued.

PLATES 220-221 A Royal Fusilier wears the legionnaire's flap on the back of his cap, worn against the summer heat and (right) three Royal Fusiliers pose in the Thuilliers' courtyard.

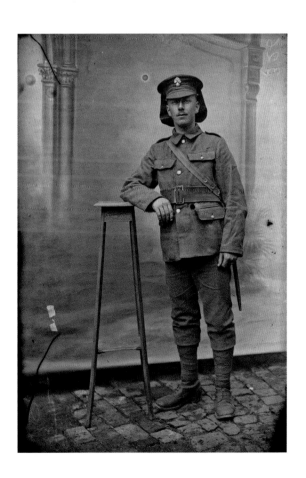

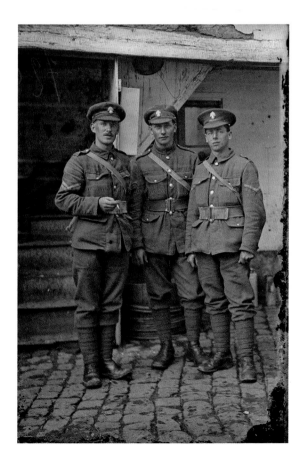

PLATES 222–223 A married Royal Fusilier (note the wedding ring on his finger) poses with a Scots friend and (right) a solemn – sad? – Royal Fusilier.

PLATE 224 A Thuillier image that illustrates beautifully how the little village of Vignacourt became a haven for Allied nations during the conflict. Several Royal Fusiliers officers pose with fellow officers from the King's Own Liverpool Regiment (Noel Chavasse VC's regiment), the Scots Guards, and a French and Canadian officer. Several wear the ribbons of medals awarded for gallantry.

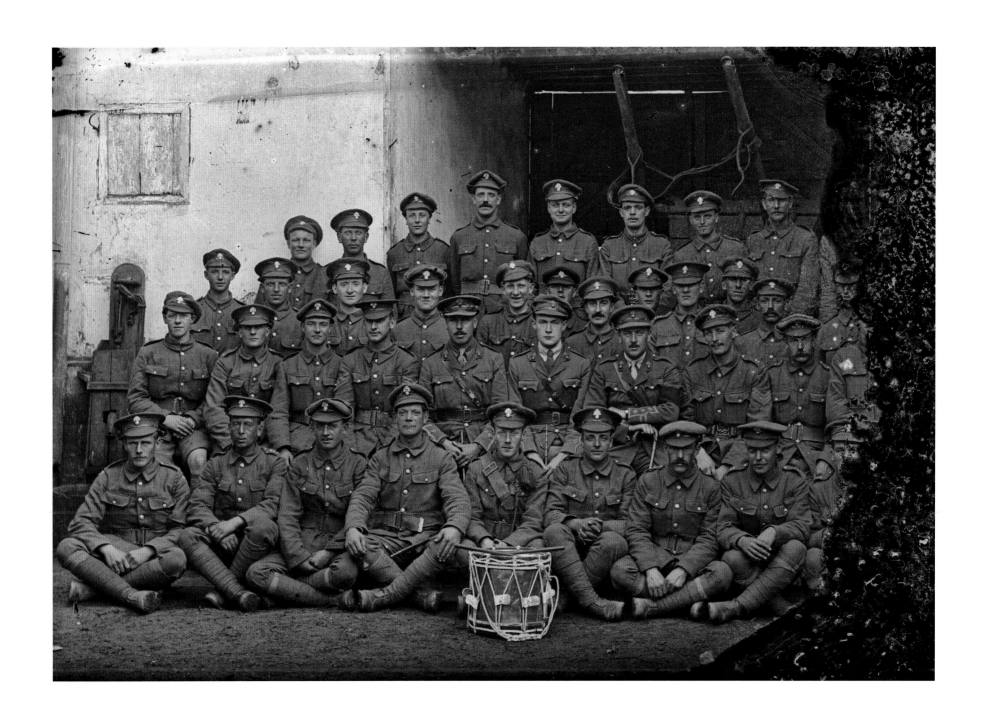

PLATE 225 Another group of Royal Fusiliers (slightly damaged) – including three officers. Many of the men look sunburned – the result of long marches to the beat of a drum in the French sunshine?

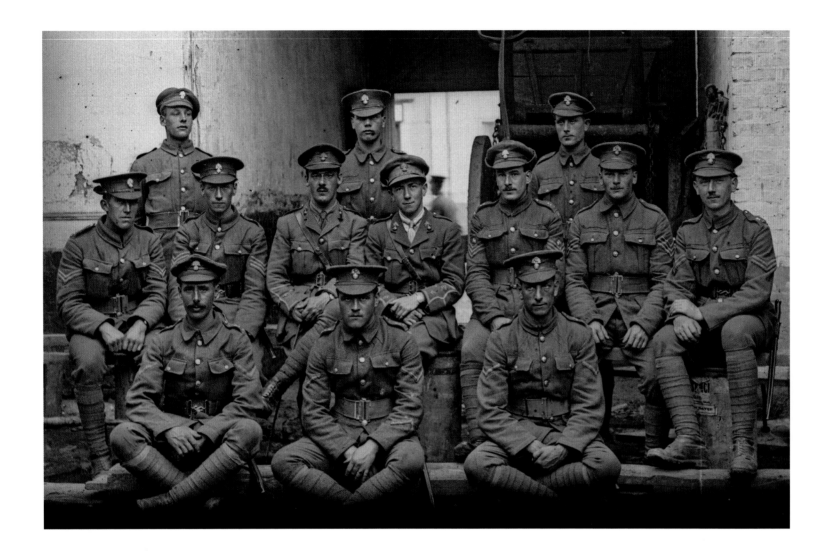

At Ovillers the 9th went into battle as a full battalion but only 180 men answered the roll call the following morning – so great were the numbers of wounded, missing or dead. But there was to be no respite in this grinding war of attrition; in August the surviving members of the 9th were in action at Pozières for six days, capturing an enemy trench, and this was where Shelley earned his Military Cross. Shelley and his fellow officers led their men through numerous battles along the Somme throughout 1917 and 1918. When the Germans launched their offensive in March 1918, the 9th also fought in the Battle of Bapaume, pushing the Germans back throughout that spring in heavy fighting. In the final battles of the Hindenburg Line the 9th was also there at the brutal clashes on the St Quentin Canal, then they fought in the final advance at Artois.

Shelley survived the war and, on reaching the age limit for the British Army, he retired in 1929 after serving in India. To this day there is no explanation as to how or why his body came to be floating in the Thames on that February morning in 1940, eleven years after he retired. Whatever the truth, it was a tragic end to a life of service.

PLATE 226 Two officers pose with fellow Royal Fusiliers soldiers – most of whom look as if they do not want to be there. Have they deliberately left gaps in their ranks, perhaps as a mark of respect to those who did not survive?

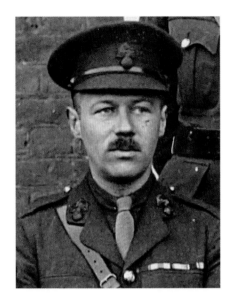

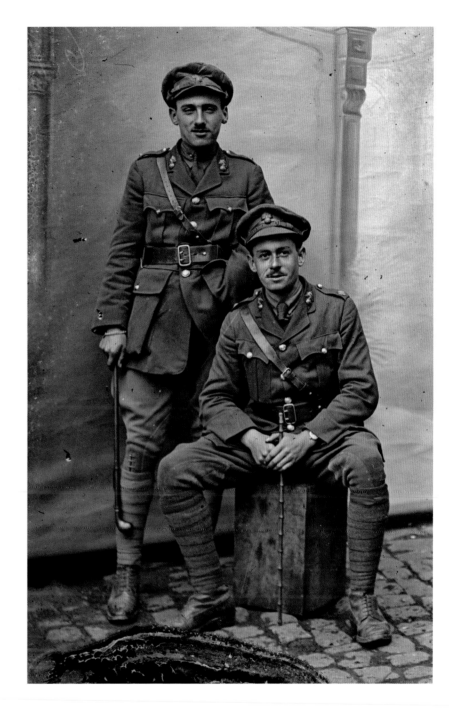

PLATES 227–228 (Top) Captain Guy
Cazalet DSO MC and (below) Lieutenant
G. T. M. Allen. (Close-ups from Plate 212)
PLATE 229 Lieutenant G. T. M. Allen of
the Royal Fusiliers (seated, and with
moustache) poses with an unidentified
fellow Fusiliers officer in Vignacourt.

The post-war Aldershot photograph of Royal Fusiliers officers in Plate 212 (p. 198) also allows us to identify two other Royal Fusiliers, Captain Guy Cazalet and Lieutenant G. T. M. Allen.

Captain Allen appears to have shaved his moustache off for his 1919 Aldershot photograph but it is unquestionably him in Plate 229, above, and he may also be seen seated in the middle of the group of Royal Fusiliers posing in Vignacourt (Plate 230, overleaf).

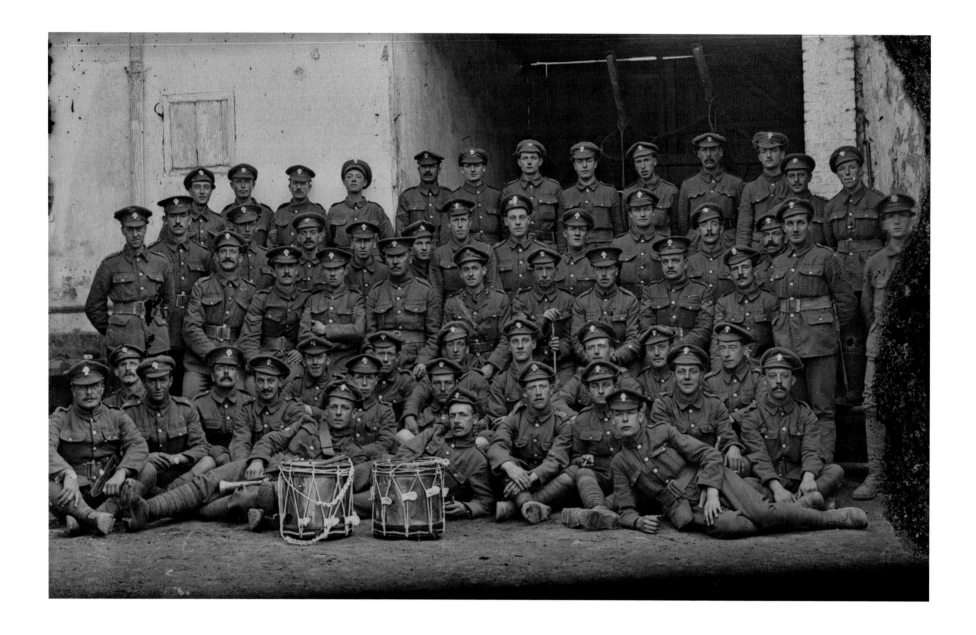

Nine months before Lieutenant Allen arrived with his battalion in Vignacourt, during the Battle of Loos in August 1915, the Germans had unleashed an extraordinary 4,000 rounds of artillery bombs in one attack on Lieutenant Allen's 8th Battalion Royal Fusiliers' position at a place called Frelinghien. During the ensuing battle, a Lieutenant Chell was buried by a cave-in on the trench parapet when the Germans exploded a mine under their position. It is recorded in the battalion's history that with reckless disregard for his own safety the then Second Lieutenant Allen and a Company Sergeant Major Perkins dug out Lieutenant Chell, while completely exposed in the open and under heavy fire.

The other officer identified in these Thuillier pictures is Captain Guy Langston Cazalet, who won both the Military Cross and the Distinguished Service Order during his service on the Western Front. He was also wounded twice.

PLATE 230 A group shot of Royal Fusiliers at Vignacourt, among whom may be seen Lieutenant G. T. M. Allen, seated middle, third row.

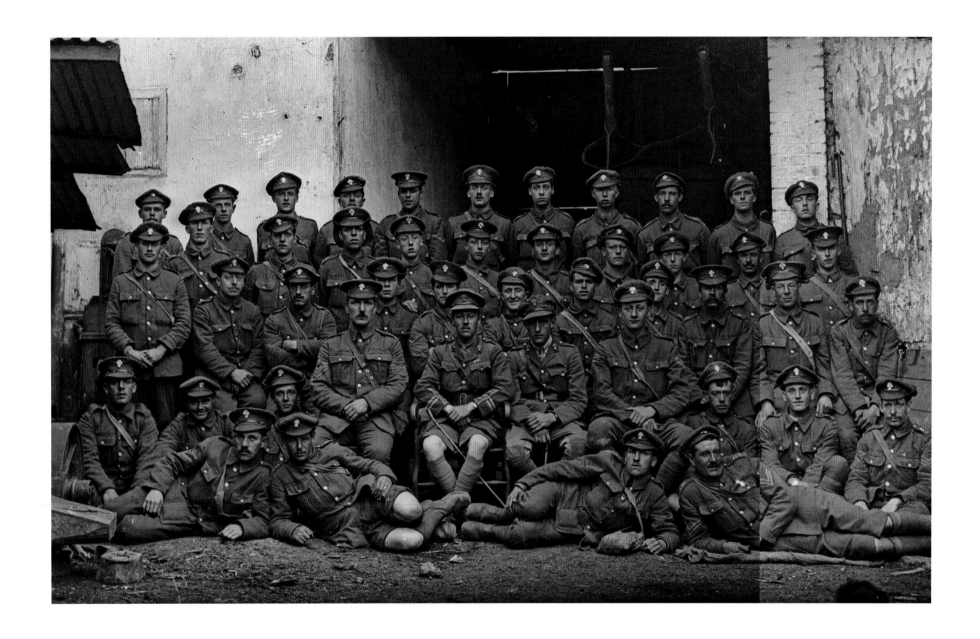

PLATE 231 This is a composite of two negative images of the same group. Captain Cazalet (sitting centre front, in shorts) wears his MC ribbon on his tunic. Posing possibly with members of his A Company Royal Fusiliers – a unit that would be decimated by machine-gun fire at Ovillers within a couple of weeks. Cazalet is not wearing his DSO ribbon, suggesting this image was taken in June 1916 when the 9th Battalion was training at Vignacourt.

Guy Langston Cazalet, the son of an Anglican minister, was born at the rectory in Bentworth, near Alton, Hampshire, in April 1889. He went up to Jesus College, Cambridge, in 1909 and almanacs from the time show he threw himself into university life, including the Footlights, during his time as an undergraduate. Joining up as a lieutenant, he proved to be an extraordinary fighting soldier. First mentioned in despatches in December 1915 for his 'gallant and distinguished service', in January 1916 he earned the Military Cross for his 'exemplary gallantry during active operations against the enemy'. Later, in February 1917, he was again mentioned in despatches for his gallantry, by British commander General Sir Douglas Haig. It was Captain Cazalet's A Company that would be decimated by machine-gun fire at Ovillers within a couple of weeks of the company leaving their rest period at Vignacourt.

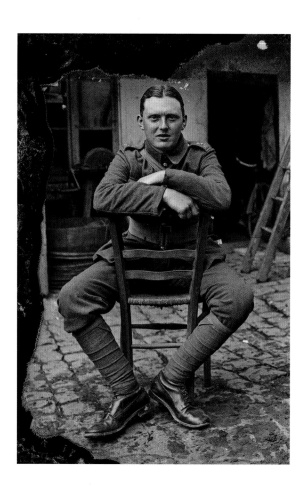

At Pozières on 6 August 1916, Captain Cazalet and his 9th Battalion held off a determined German counterattack and his leadership there would earn him the Distinguished Service Order, a decoration traditionally given to officers ranking major or higher but also sometimes bestowed on more junior officers such as Captain Cazalet who had shown particular gallantry. What earned Cazalet his DSO was his cool command under heavy fire as he and his battalion sought to hold a recently seized position known as Ration Trench. The Germans attacked with a new, terrifying weapon – '*Flammenwerfers*' – flame-throwers:

Many of the men were quite new to warfare. For some it was their first experience of actual fighting, and their bearing was admirable. The assault was made by flammenwerfers, supported by bombers using smoke as a screen. The flames burst through the clouds of smoke from various directions, and all the conditions of panic were present. The fumes alone were sufficient to overpower some of the men. But no panic took place. The situation was handled very coolly. The attack was made on the north end of Ration Trench, and about 20 men were extended in the open on either side of the trench with two Lewis guns. The attack was thus beaten off with a loss of only 40 yards of trench. Many fine incidents marked this defence … Lance-Corporal Cyril Cross took his Lewis gun into a shell-hole outside the trench during the flammenwerfer attack, and engaged the enemy, who were in great strength, at close range, inflicting many casualties until his gun was put out of action. Private Tom Crow continued to throw bombs from the very edge of the flames, showing a complete disregard of the enemy. He was finally wounded by a sniper as he was closely pursuing the enemy. All these men belonged to A Company, commanded by Captain G.L. Cazalet M.C., who had led his men across the open on the night of the 5th, in less than three-quarters of an hour had taken his objective, and was responsible for the defence of 500 yards of Ration Trench, the flank of which was held by the enemy. Though wounded, he refused to leave the trench; and it was chiefly owing to his fine example that his company, though almost quite new to warfare, behaved so finely. He was awarded a well-deserved DSO.[73]

PLATE 232 A very sharp – albeit slightly damaged – image of a Royal Fusilier soldier, sitting outside the Thuillier homestead kitchen, which still exists today. He is also shown in Plate 17 on p. 25, seated and wearing his cap.

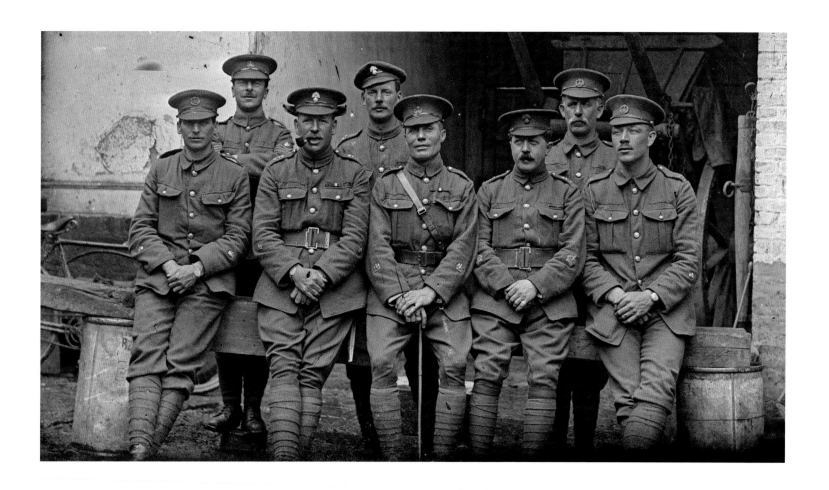

PLATE 233 Three Royal Fusiliers with
soldiers from the Essex Regiment,
including a warrant officer seated in the
middle. He has a medal ribbon, as do two
of the Fusiliers. Perhaps their awards
were won in the same operation?

Guy Cazalet stayed on as a career officer with the Fusiliers for the rest of his
working life, serving in India with Captain Shelley, and he was promoted to major in
December 1931. The incomplete records that do remain suggest that in 1939, close to the
outbreak of the Second World War, he was working in the War Office with the status of
'retired officer re-employed'. He died on 22 April 1955 in Christchurch, Hampshire, at the
age of sixty-six.

In 1968 the Royal Fusiliers Regiment was merged with three other regiments, the
Royal Northumberland Fusiliers, the Royal Warwickshire Fusiliers and the Lancashire
Fusiliers, to form the British Army's first large infantry regiment. All four regiments had
fought in the First World War, raising a total of 196 battalions between them. There are
Lancashire Fusiliers, Northumberland Fusiliers and Royal Warwickshire Fusiliers among
the Thuillier images.

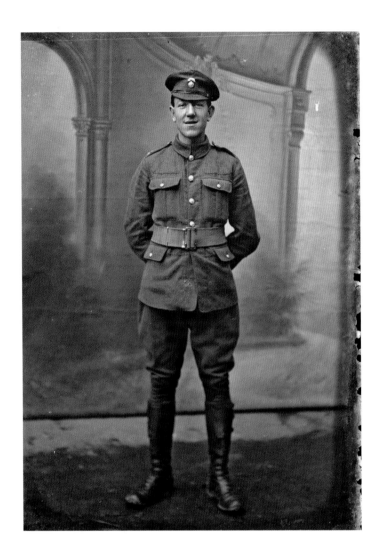

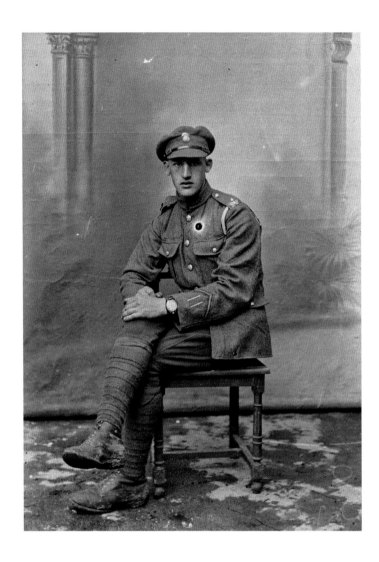

The Northumberland Fusiliers, one of the British Army's most famous regiments, was often known as 'the Fighting Fifth'. This derives from the fact that, until 1881, it was called the Fifth Foot Regiment. It is said that the Duke of Wellington dubbed them 'The ever fighting, often tried, but never failing, Fifth'. Their badge, like that of the Royal Fusiliers, is a flaming grenade but with St George at its centre. During the First World War the regiment raised fifty-two battalions, winning five Victoria Crosses but suffering the dreadful loss of 16,000 men.

One amusing Thuillier image (Plate 239, p. 211) features a group of mischievous British-looking soldiers wearing fezzes, probably borrowed from a Moroccan regiment also based in Vignacourt at the time. One of the Northumberland Fusiliers soldiers standing soberly in Plate 237 (opposite, top left) can also be seen with his mates in this image (sitting front left), so it is a fair bet that some of his comrades are also Northumberland Fusiliers.

PLATES 234-235 Northumberland Fusiliers.
PLATE 236 The cap badge of the Northumberland Fusiliers.

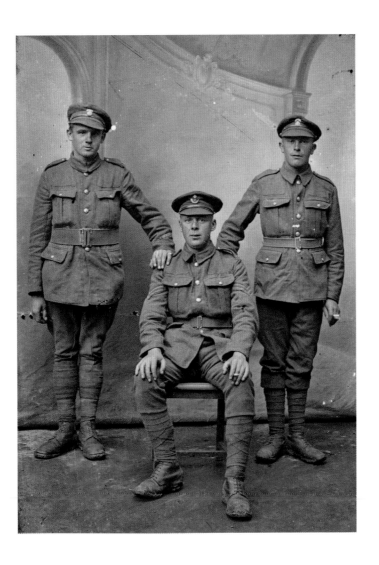

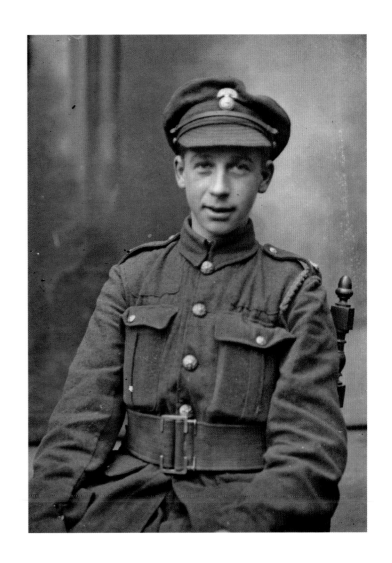

PLATE 237 Two Northumberland Fusiliers (standing) pose with a mate from the Durham Light Infantry.

PLATE 238 Another very young Northumberland Fusilier.

PLATE 239 A delightfully cheeky photograph of British soldiers (the man on bottom left we know from a previous image is a Northumberland Fusilier) posing in Moroccan fezzes with one of the Thuillier children wearing a Labour Corps-badged cap. The soldier seated left on the middle row is also wearing a Durham Light Infantry Regiment badge on his tunic. As the Labour Corps was not created until 1917 this image can be dated from that time. Note the Nepalese men waiting to have their picture taken behind.

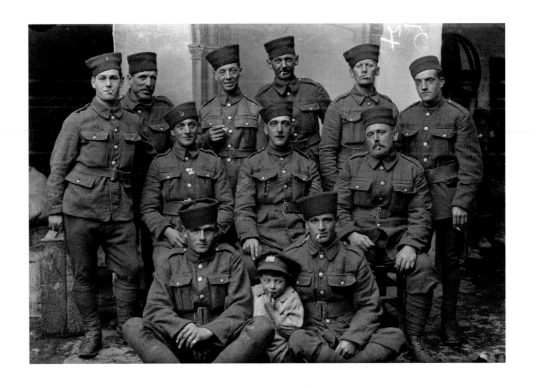

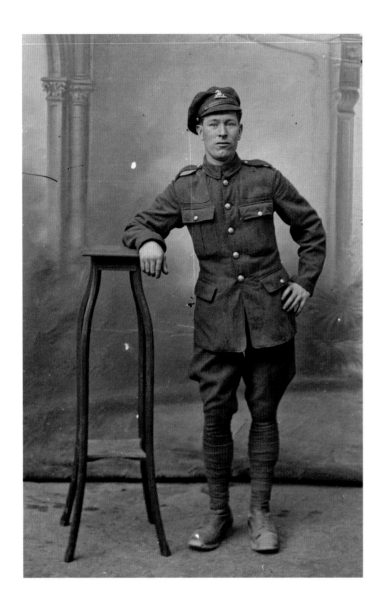

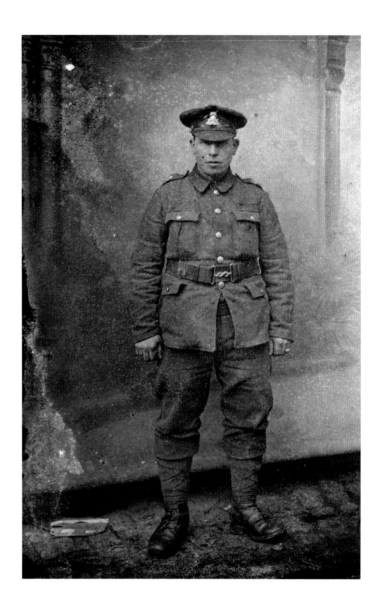

The Lancashire Fusiliers was also one of the oldest infantry regiments of the British Army, formed in 1688. Eighteen of its number won Victoria Crosses during the First World War – many at the Gallipoli landings in the Dardanelles, but most on the Western Front. J.R.R. Tolkien, who would later write *The Hobbit* and *The Lord of the Rings*, also served as a second lieutenant in the 11th Battalion of the Lancashire Fusiliers. So many of the regiment's young men would fall on the Somme. One of the earliest surviving films taken on the first day of the Somme is a famous explosion of the Hawthorn Redoubt mine, near the village of Beaumont Hamel which had been fortified by the Germans. Royal Engineers had dug tunnels through no man's land towards the German lines from a position in front of the 1st Lancashire Fusiliers. But when the mine went off at 7.20 a.m., while it killed the Germans in the immediate vicinity it actually had the effect of alerting the enemy survivors to the fact that a major attack was coming, and the British attack

PLATES 240–241 Lancashire Fusilier, posing with backdrop and stand and (right) a damaged image of a stocky Lancashire Fusilier.

plan gave them time to prepare. Peter Hart's *The Somme* gives a German soldier's view of the Lancashire Fusiliers and other regiments walking towards his waiting guns when they went over the top ten minutes later:

> *This explosion was a signal for the infantry attack, and everyone got ready and stood on the lower steps of the dugouts, rifles in hand, waiting for the bombardment to lift. In a few minutes the shelling ceased, and we rushed up the steps and out into the crater positions. Ahead of us wave after wave of British troops were crawling out of their trenches and coming forward towards us at a walk, their bayonets glistening in the sun.*[74]

Many of the men of the Lancashire Fusiliers along the Somme front lines knew they would be walking to their deaths: 'Handshakes were given, goodbyes were said and I turned away with a lump in my throat and tears in my eyes, as if I had a foreboding of events to come, and deploring the fact that I was not allowed to go with my friends.'[75] The Lancashire lads were slaughtered as they walked into the German machine guns and their attack on the Hawthorn Redoubt never even reached the German front line.

There is a stirring account of the Lancashire Fusiliers from Australia's Official Historian Charles Bean; during March and April 1918 Bean was following the desperate fighting in the defence of Amiens when the Germans launched their massive final offensive of the war. A senior British officer arrived at one Australian post facing German positions at Vieux-Berquin, and addressed an Australian, Lieutenant McGinn:

> *'Boy, is this your post?' said the senior to McGinn.*
> *'Yes, Sir.'*
> *'Are you going to make a fight of it?'*
> *'Yes, Sir.'*
> *'Well, give me your rifle – I'm one of your men.'*
> *And taking a proffered rifle, he jumped into the post. He proved to be the colonel of the 1st Lancashire Fusiliers and his companions were his adjutant and intelligence officer. He was bitterly disappointed with his troops who, he said, for the first time in the regiment's history, had retired from a position which they were ordered to hold. As soon as dusk fell he went out into the village and, finding it unoccupied, collected a number of his men and led them to hold it.*
> *'You can report,' he said to McGinn, 'that the 1st Lancashire Fusiliers held the village to the last.'*
> *All night the Australians could hear fierce machine-gun fire in that direction.*[76]

PLATE 242 The badge of the Lancashire Fusiliers.

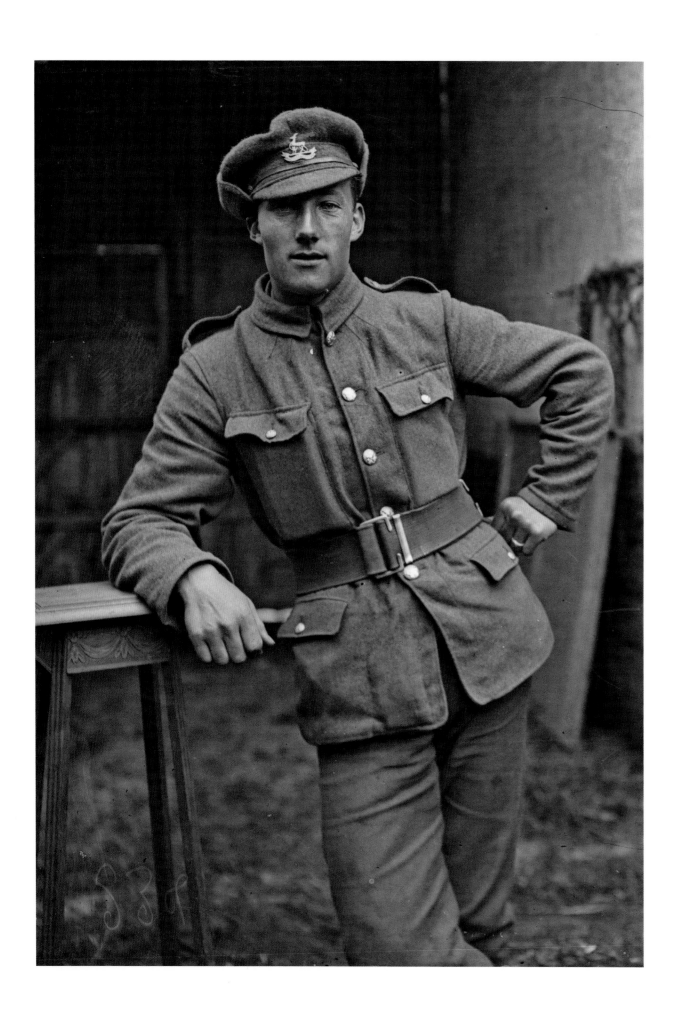

PLATE 243 A strikingly clear image of a young Royal Warwickshire Regiment soldier.

PLATE 244 The badge of the Warwickshire Regiment.

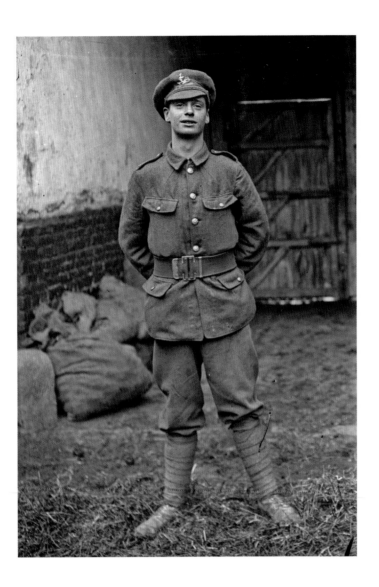 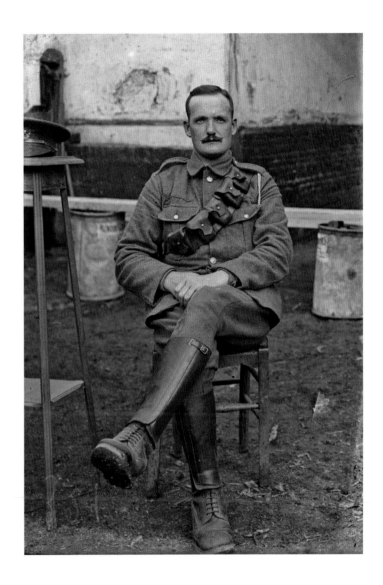

PLATES 245-246 A Royal Warwickshire Fusilier stands in the Thuillier yard and (right) another Royal Warwickshire soldier (his cap badge can just be seen on the stand) poses with bandolier.

The third of the fusilier regiments to be merged with the Royal Fusiliers into the modern-day Royal Regiment of Fusiliers was the Royal Warwickshire Fusiliers, also known as the Royal Warwickshire Regiment or the 6th Regiment of Foot. It was another of the great British infantry regiments, with its origins in the seventeenth century, and during the Great War it raised thirty battalions, including three Birmingham Pals battalions. The Pals had their own badge; they may be among the Warwickshire images in the Thuillier collection but it is impossible to distinguish the Pals badge even with the crisp resolution of the photographs. The Birmingham Pals would suffer terrible losses: 2,334 died across the three city battalions during the war. In just four months of the 1916 Battle of the Somme two of the Pals battalions lost 800 men in the combat. Losses across the whole Royal Warwickshire Regiment during the war totalled 11,610 men. During 1916 the regiment was heavily involved in the Battle of Albert, very close to Vignacourt, so that is very likely when these pictures were taken.

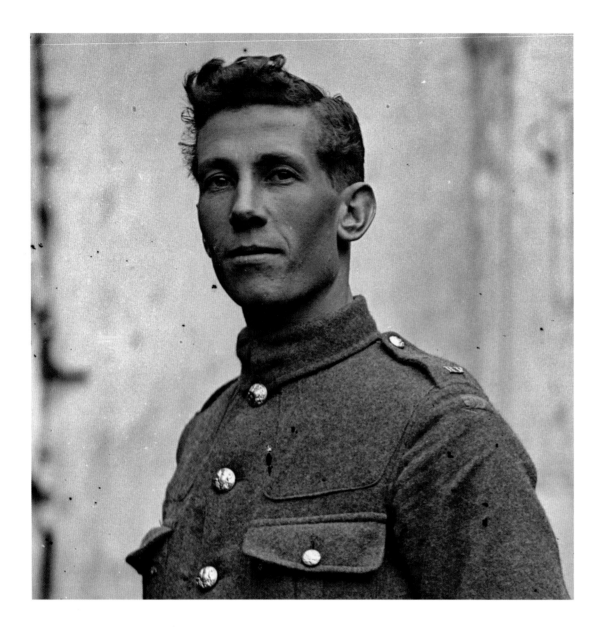

So many of the young men in these Thuillier images went on to serve on the Somme after their training and rest at Vignacourt and nearby villages. Within weeks of leaving, tens of thousands of them were dead or wounded and the fact that almost all those casualties were drawn from the same regimental regions – Northumberland, Warwickshire, Lancashire and the City of London – underlined the awful impact of the casualty lists.

There were sheets and sheets in the papers of dead and wounded with photographs where they could get them of the men. Of course everybody rushed to the paper every day to see if there was anyone they knew. When we got to know of anybody at the school, the headmaster announced them if they had been old boys … It was a very, very sad time – practically everyone was in mourning.[77]

PLATE 247 A Royal Fusiliers soldier – identifiable (only just) by the RF badge on his shoulder. The patch below it appears to say '9th', which suggests he was another soldier with Captain Shelley's 9th Battalion.

MILITARY POLICE

Mounted Military Police with an officer of the Military Foot Police, seated second from left. In this photograph, the officer sitting second from the right has four inverted chevrons on his lower right sleeve, which denote four years of overseas service. He is also decorated. This photograph must have been taken after January 1918 as the chevrons were introduced at this time. This officer also has medal ribbons above his left breast pocket. The NCOs in this photograph are all Corporals, as denoted by the two rank chevrons or stripes worn on their upper sleeves.

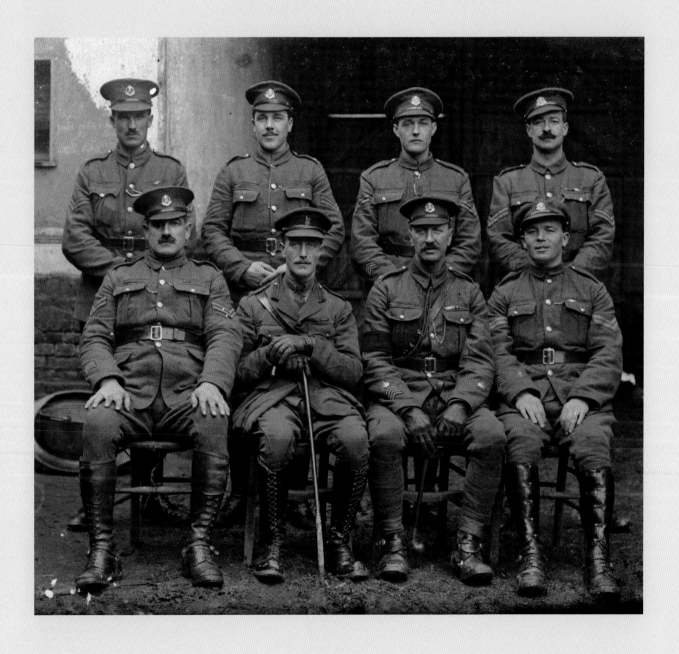

The Suicide Club

It was a unit conceived out of desperate necessity in 1915 because before the war and early in the first year of the conflict the British Army failed to appreciate the revolutionary significance of the new weaponry of rapid-fire machine guns; but the corps's flame would flare brightly in wartime and was then quickly extinguished when the unit was disbanded in 1922. For the duration of the war, the Machine Gun Corps was perceived as an elite corps, often arousing jealousy and resentment as it drew many of the best men from every infantry battalion and cavalry regiment. The Machine Gun Corps was nicknamed the Suicide Club for a very good reason: 170,500 served in the corps and their chances of surviving the war unscathed were considerably less than those of a regular soldier; more than one-third of them (62,049) were either killed or wounded in the conflict, a much higher rate than other units.

When the war began, each British battalion was allocated just two machine-gun sections with one Maxim gun each – capable of firing around 500 rounds per minute – that is, just two guns to cover up to 1,000 men during any advance. This proved woefully inadequate especially when the Germans had a much keener appreciation of the power of machine guns and used more of them to great effect from the very beginning; the standard three-battalion German regiment had six machine guns in its machine-gun company. At the Battle of Loos in September 1915 German observers were shocked to see line after line of British infantry advancing:

> … as if on parade. Consternation turned to amazement, for there was no covering fire, and: 'A target was offered to us such as had never been seen before, nor even thought possible'. The machine-guns opened fire at 1,500 yards (1,365 metres) and, although men fell in their hundreds, the survivors pushed on. 'Never had machine-guns had such straightforward work to do, nor done it so effectively,' recounted one German regimental history.[78]

PLATE 248 The badge of the Machine Gun Corps.
PLATE 249 Five Machine Gun Corps privates. Note the MCG badge on the shoulders of both seated soldiers.

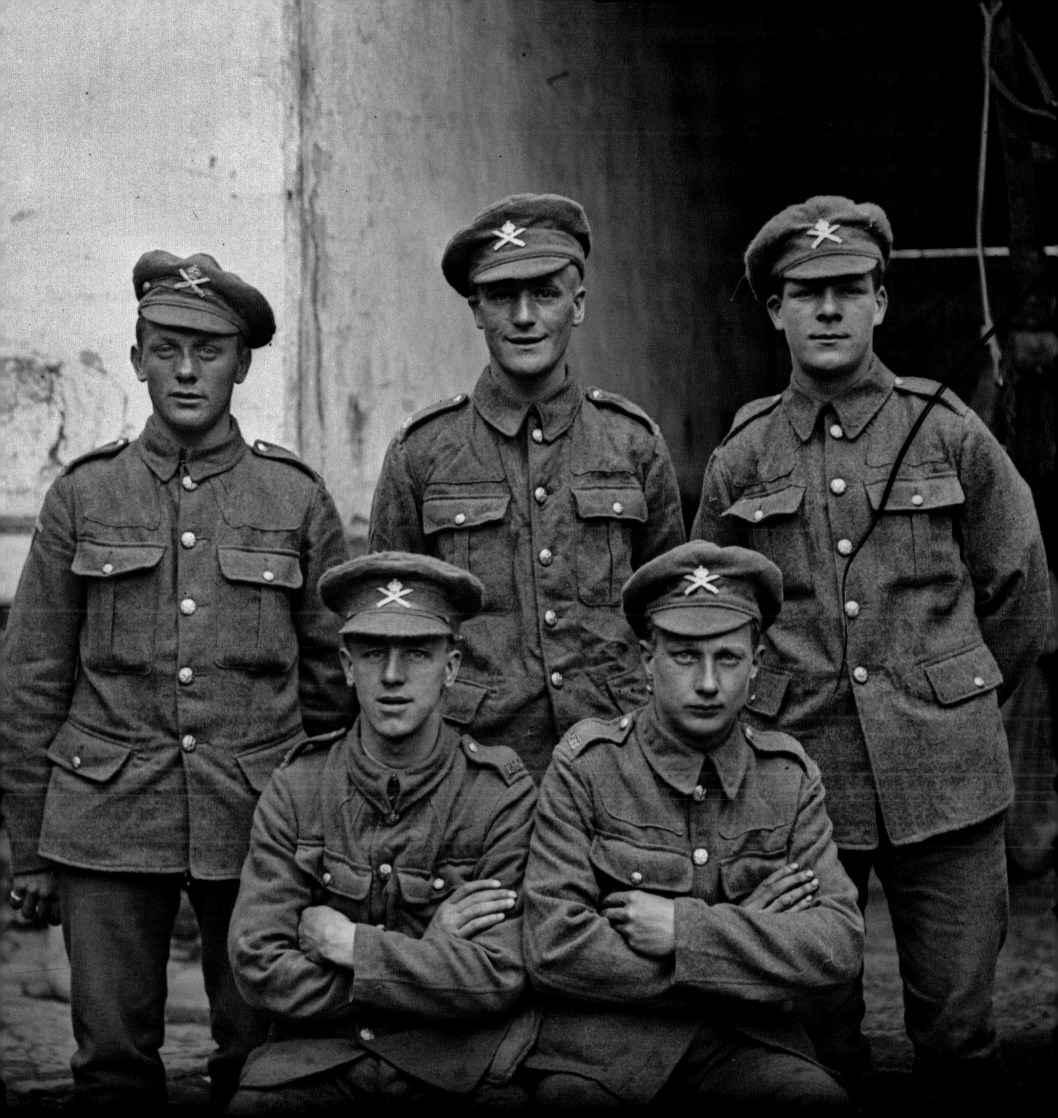

The British Army took note and a year later it was decided a specialist unit was needed and so the Machine Gun Corps – also dubbed the 'Emma Gees' – was established in October 1915, eventually replacing the Maxim with the superior Vickers machine gun. Just how effective the new heavy machine guns were in battle on both sides of the conflict is also shown in one account of a disastrous British attack at Neuve Chapelle in March 1916. The British had pummelled the German front lines with artillery fire but missed knocking out a small section of German trenches that included just two machine guns. These two intact weapons then 'lacerated' two of the attacking battalions, the 1st Middlesex and 2nd Scottish Rifles. Two Allied officers had even (unwisely) brandished swords as they attacked, singling themselves out as marked men for the enemy gunners, and when the German garrison finally surrendered, the Germans walked over massed lines of Allied dead in front of their trench '… estimated at about 1,000, lying literally in rows, whom they had slain that morning…'.[79] The new machine guns proved such effective industrial killing weapons that corps members risked being mercilessly hunted down when either side had taken heavy losses in an attack, and it was common for the gunners to hide their machine-gun badge if capture seemed imminent.

Unfortunately, because the corps only existed for seven years, it is acknowledged as among the most difficult military units to research. A fire also destroyed the corps's entire operational records and regimental orders in 1920. Add to this the destruction of hundreds of thousands of personal files during the Blitz in 1940, and the task of trying to find out more about the identities of the men in the thirty-four Machine Gun Corps images in the Thuillier collection becomes almost impossible.

One thing we can be certain of is that the machine-gunners had one of the toughest and most dangerous jobs on the Western Front; one compilation of corps members' experiences explains why it justified its alarming nickname:

> *They were always at the centre of things. Whenever trouble most threatened or an attack*
> *was planned, there they had to be, right amongst it all. They had tremendous firepower,*
> *and the moment they started they were the targets of every enemy weapon within range.*
> *No wonder the Machine Gun Corps was nicknamed the Suicide Club.*[80]

The corps had three branches: infantry, cavalry and motor. A 'heavy' branch was added early in 1916 and this branch later became the Tank Corps – the other new technology that was to revolutionize warfare on the Western Front. Because many of the corps members in the Thuillier images are on horseback or wearing jodhpurs and

PLATE 250 A young machine-gunner – possibly in 1916 because he wears the stiff service cap and the original-issue uniform design. The bandolier suggests he is cavalry.

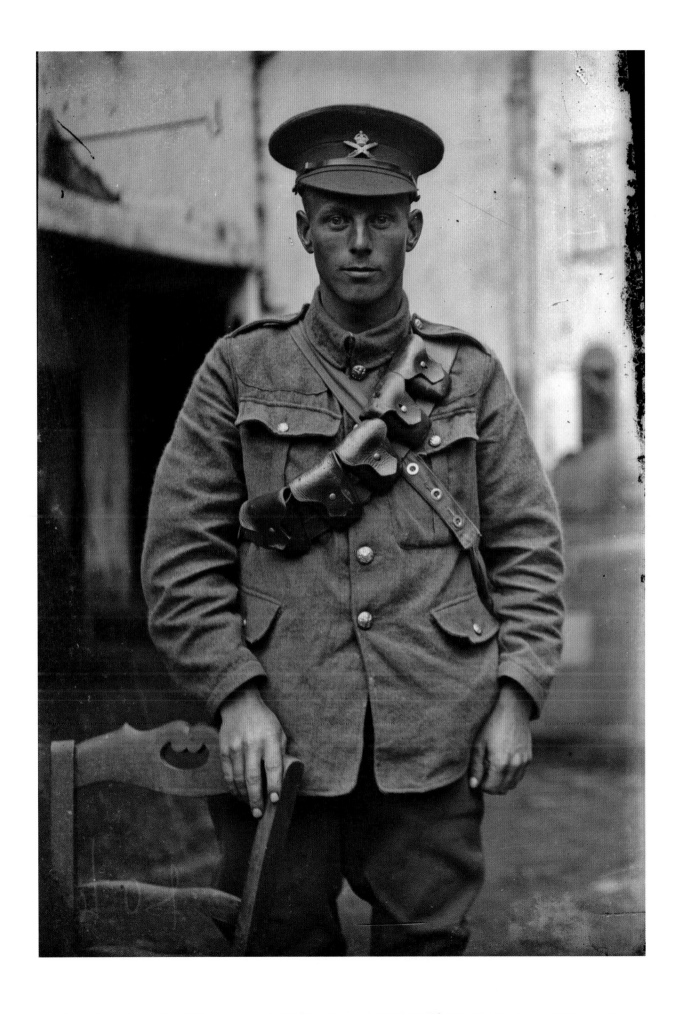

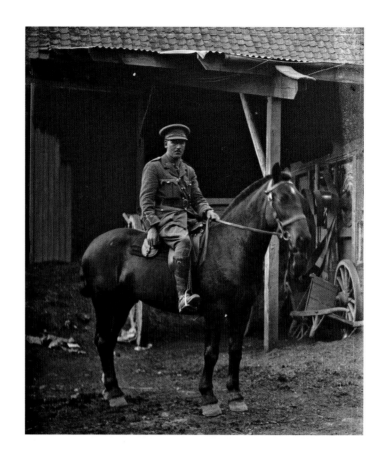

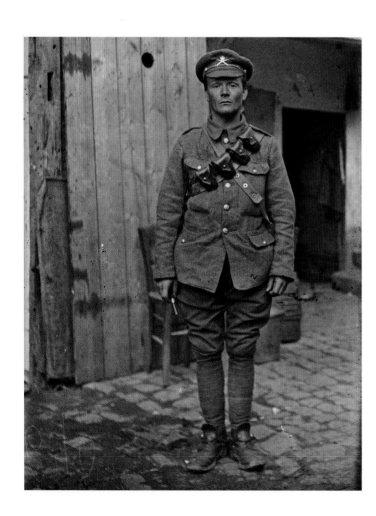

PLATE 251 Two officers of the corps pose with their horses in the Thuillier yard.

PLATE 252 The second lieutenant, on the left in the first image, is also pictured in this second image astride his horse.

PLATE 253 A sombre Machine Gun Corps private, pipe in right hand, wears ammunition bandolier and jodhpurs – suggesting that he was part of a cavalry regiment in the corps.

PLATE 254 A group of Machine Gun Corps soldiers – clearly attached to the West Yorkshire Regiment because the officer wears the territorial badge indicating he is with the 5th or 6th Battalion of the West Yorkshire Regiment.

PLATE 255 The same officer as in Plate 254 above also appears in this smaller group – almost certainly a machine-gun team with the West Yorkshires, normally comprising six to eight men.

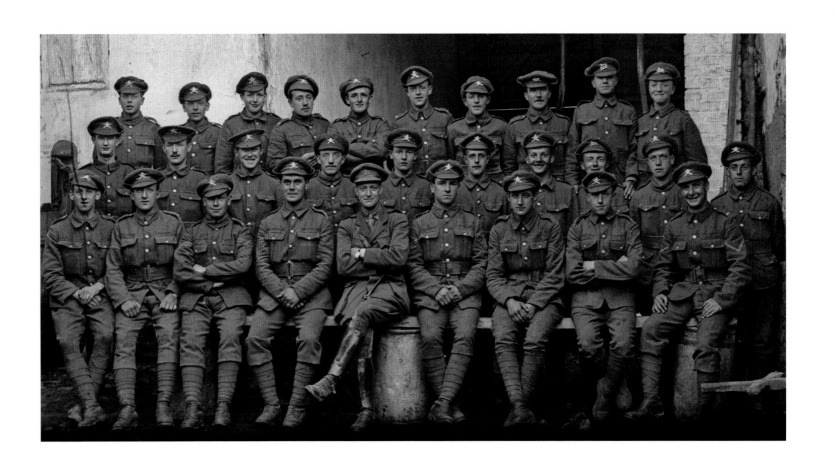

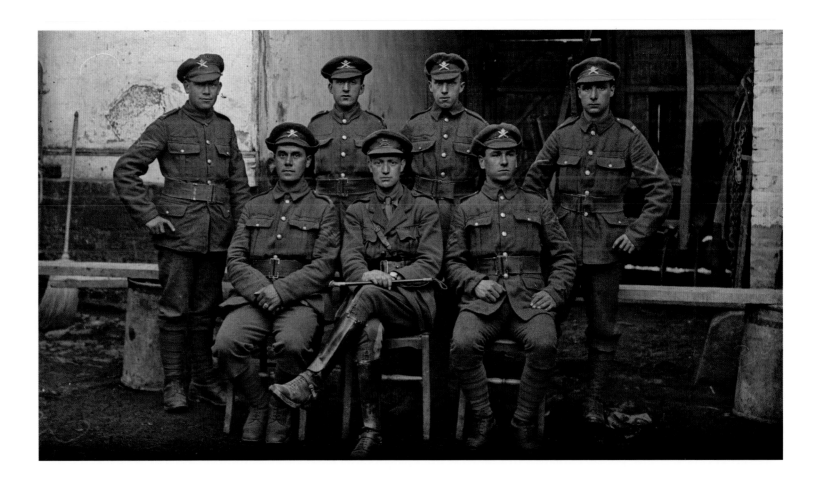

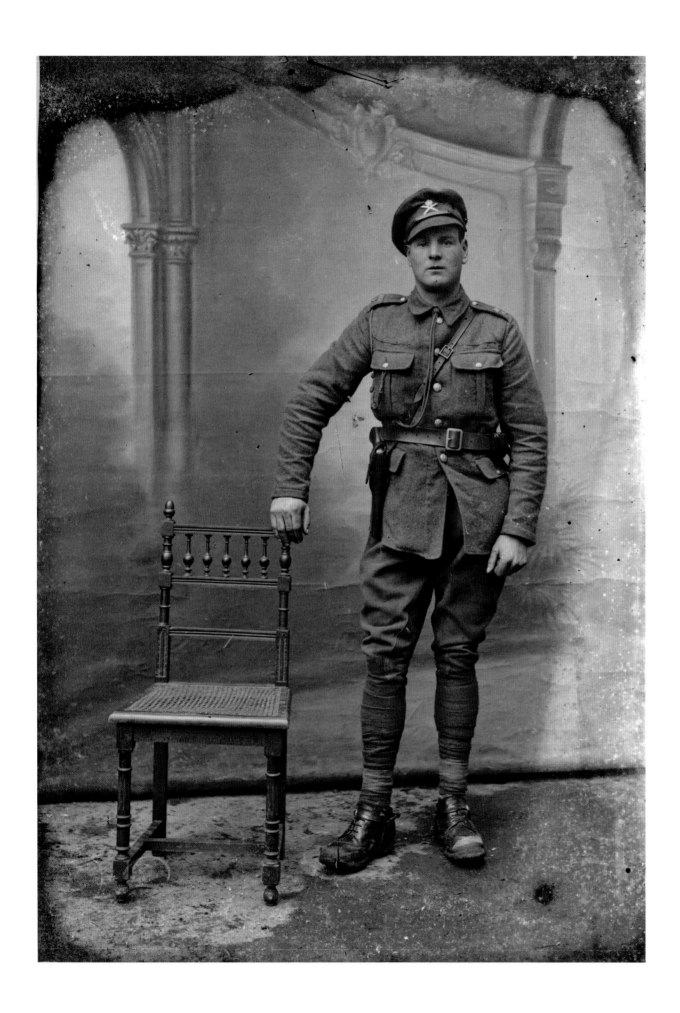

PLATE 256 Machine Gun Corps soldiers were issued with revolvers instead of rifles because they also had to carry their heavy weapons. The spurs on this private's boots indicate he was a cavalry soldier.

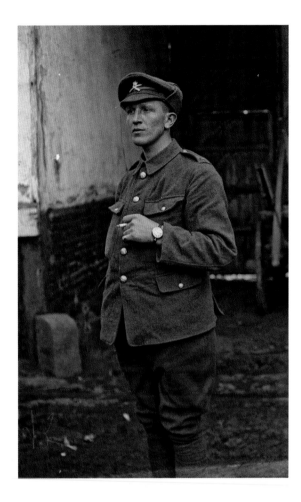

bandoliers, it is likely that these men were mostly from the cavalry branch of the corps. It may sound anachronistic combining cavalry and machine guns in a modern war but the notion that cavalry charges during the Great War always ended in disaster for the horsemen is apparently a myth. Historian William Philpott tells the story of two cavalry squadrons successfully charging and clearing enemy positions between High and Delville Woods in July 1916, even using the antiquated technology of lances astride their mounts:

> *Sixteen unfortunate Germans had been speared by the lancers in the process, and many more casualties were inflicted by the cavalry's rifles and machine guns. After this, they dismounted and dug in, holding a line to the flank until the infantry relieved them. The two cavalry regiments engaged suffered only eight killed and fewer than a hundred wounded.*[81]

PLATES 257–258 This image of a Machine Gun Corps private is so clear that it allows us to read the time on his watch. It is 3.45 p.m. – the light at this time suggests the photograph was taken in the warmer months.

As the photographs show, there were also many young soldiers in the Corps. In his war memoir, *With a Machine Gun to Cambrai*, George Coppard reveals he was just sixteen years and seven months old when he joined up in late August 1914. Initially with the Queen's Royal West Surrey Regiment, he later joined the Machine Gun Corps when

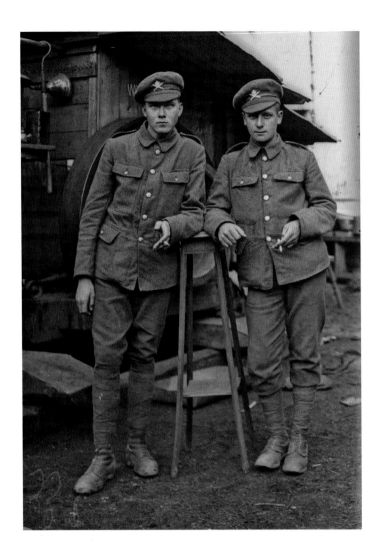

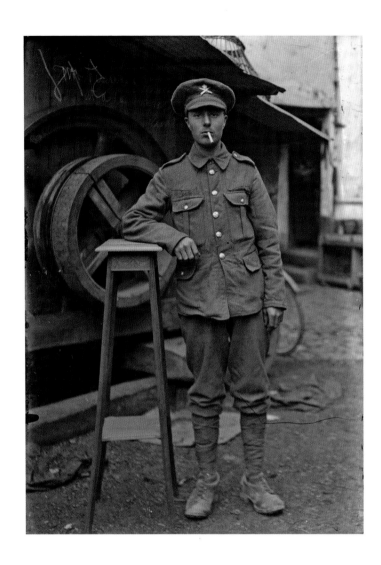

still not yet eighteen. He was first wounded on the Somme in October 1916 when a fellow soldier accidentally shot him in the foot. This raised suspicions that the wound was self-inflicted but Coppard was cleared in the subsequent investigation. He rejoined his Machine Gun Corps company in early 1917 and on 20 November took part in the Battle of Cambrai, which combined the revolutionary new tanks with effective use of machine guns, the Machine Gun Corps using the cover of 400 tanks to advance across no man's land towards the German front line:

> *The tanks, looking like giant toads, became visible against the skyline as they approached the top of the slope. Some of the leading tanks carried huge bundles of tightly bound brushwood, which they dropped when a wide trench was encountered, thus providing a firm base to cross over. It was broad daylight as we crossed No Man's Land and the German front line. I saw very few wounded coming back, and only a handful of prisoners. The tanks appeared to have busted through any resistance. The enemy wire had been dragged about like old curtains.*[82]

PLATE 259 Two young Machine Gun Corps soldiers. Both wear the economy tunic introduced in 1916.
PLATE 260 A private of the Machine Gun Corps wears the original army-issue tunic.

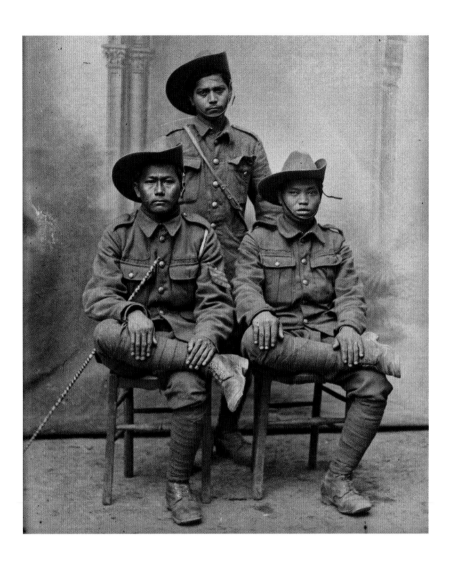

PLATE 261 A Thuillier image of three
Nepalese Gurkha soldiers – men with a
proud and fearsome fighting reputation.

Two days into the battle, Coppard was seriously wounded by a German machine-
gunner. His femoral artery was severed and he would have died but for a colleague
who made a tourniquet from his bootlaces and saved his life. Coppard was awarded the
Military Medal.

The corps also has its fair share of grimly amusing memories; a machine-gunner
from the 11th Inniskillings Regiment, 36th Ulster Division, told how his unit took over a
front-line position from Nepalese Gurkha soldiers where there had previously been heavy
fighting at the Battle of Neuve Chapelle:

*Half an hour later a Ghurkha runner came back with a message from their Commanding
Officer to say one of his men had gone berserk on the way out, killed two of his comrades
with his kukri and made his way back to our trenches! Would we shoot him on sight!
After dark when making our rounds we were far more scared of that one Ghurkha than
the whole German Army, and could see him in every shadow. However he was never
heard of again.*[83]

There are several images of young local children in the Thuillier collection that show them dressed in cut-down uniforms of regiments that had clearly spent time in the village; many men found the sight of happy children so close to a battlefield a joyous diversion from the misery of war. One of the saddest stories of the Machine Gun Corps tells how a group of its men adopted and then tragically lost a little French boy who had befriended them.

C. E. Crutchley tells how he and his mates came across a boy about seven or eight years old in the middle of a devastated battlefield around the French town of Armentières. The child would not leave them alone, but was ravenously hungry and seemed to have no name, so the machine-gunners took him in and nicknamed him Dumbo.

No parents came to claim him. He never said a word, but was eager to sweep up, polish things and make himself generally useful. When the Company moved he was smuggled in a limbered wagon, and after a month or two he was one of the Company. If any senior officer saw him they turned a blind eye. Dumbo's attitude towards the Machine Gunners was one of awed hero-worship. When one of our chaps came back from leave bringing him a small khaki cap, his delight knew no bounds, and when he was ceremoniously presented with a highly polished M.G.C. badge he wept tears of sheer delight, and never was there a prouder member of the old Suicide Club.

He obviously regarded himself now as one of those God-like heroes who used the terrible weapons against those dreadful Germans.[84]

Even the hardened machine-gunners wept when, as they rushed up to support the French at a town called Neuville-Saint-Vaast, little Dumbo was killed by shrapnel fire and quickly buried in a shell hole as they went into battle.

Anyone seeing No. 4 Section going into battle that day might well have thought them a windy lot. When your face is covered with mud, tears make a tell-tale track down your cheeks. Dumbo had meant more than they thought. Away from their wives, children and sweethearts for what seemed an eternity, they had found Dumbo something to love, something which kept alive the human emotions in spite of the evil, soul-destroying job it was their duty to do.[85]

PLATE 262 This young lad, who we know to be a village child named Henri Duboille, has been fitted out with a kilt, cap and badge, from the Argyll and Southern Highlander Regiment while its troops were resting in Vignacourt. His father had died in a German prisoner-of-war camp a year after Henri was born. Clearly someone from the tough Scottish Argylls had a heart of gold.

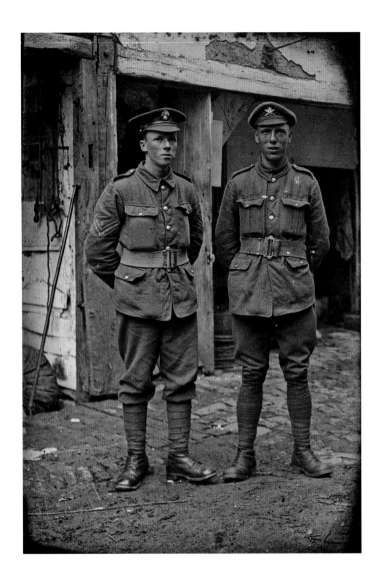

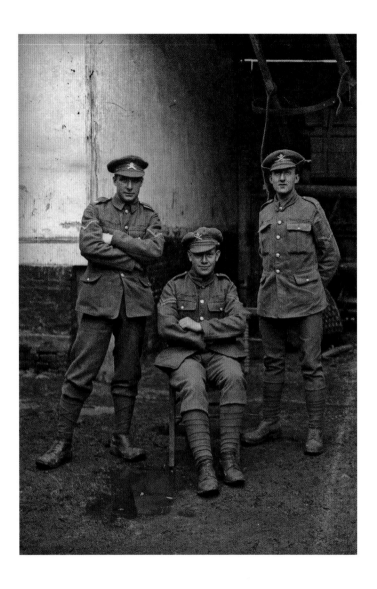

PLATE 263 Two very young Machine Gun Corps soldiers, one a corporal. With one-in-three odds of being killed or wounded in the corps, one wonders if they made it through.

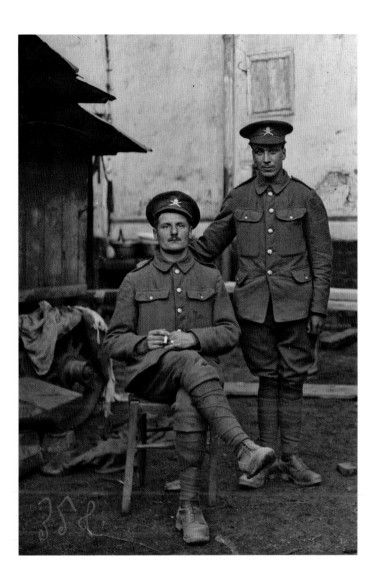

By the end of the First World War it was clear that the machine gun was now a vital piece of weaponry for any infantry or cavalry regiment and the notion of a specialized independent unit of machine-gunners was an anachronism; in 1922 the Machine Gun Corps was disbanded.

No military pomp attended its birth or decease. It was not a famous regiment with glamour and whatnot, but a great fighting corps, born for war only and not for parades. From the moment of its formation, it was kicking. It is with much sadness that I recall its disbandment in 1922, like old soldiers, it simply faded away.[86]

There is a memorial to the Machine Gun Corps in London's Hyde Park. Named 'The Boy David Memorial', it is flanked by two Vickers guns with laurel wreaths laid over them. The inscription on the memorial reads: '*Saul hath slain his thousands but David his tens of thousands*'.

THE LEWIS MACHINE GUN

The Machine Gun Corps generally used heavy machine guns such as the Maxim or the Vickers, but from early in the war a new type of lighter automatic weapon known as the Lewis machine gun became increasingly popular among the infantry troops. Designed by former United States Army colonel Isaac Newton Lewis, it was used in combat right through to the Korean War and it has a distinctive wide cooling tube around its barrel and a top-mounted drum magazine that make it easily recognizable. Colonel Lewis designed the weapon in 1911 but left the US in frustration when the US Army declined to adopt his revolutionary design, setting up his factory instead in Belgium. When war broke out in 1914 he did a deal with the Birmingham Small Arms Company and moved to England, becoming a very wealthy man as his light twelve-kilogram weapon became ubiquitous on the battlefield. First adopted in October 1915, the Lewis gun was issued to infantry battalions along the front lines as a replacement for the much heavier Vickers, which stayed in use with the specialized Machine Gun Corps. The Lewis – nicknamed 'the Belgian Rattlesnake' by the Germans – eventually became the standard-issue British Army machine gun and by 1917 every battalion was meant to have about forty-six Lewis guns. There are several images in the Thuillier collection of troops proudly posing with the popular new Lewis machine guns.

PLATE 264 An infantry company – most likely the Leeds Rifles – with their two Lewis machine guns.
PLATE 265 Soldiers of the Leeds Rifles posing (incongruously!) with local puppies and their two Lewis light machine guns, both capable of firing 500–600 rounds per minute effectively out to 600 metres.

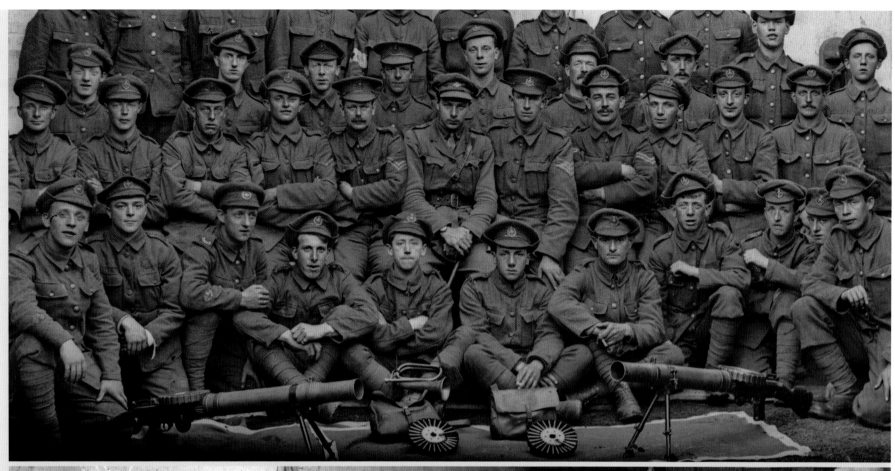
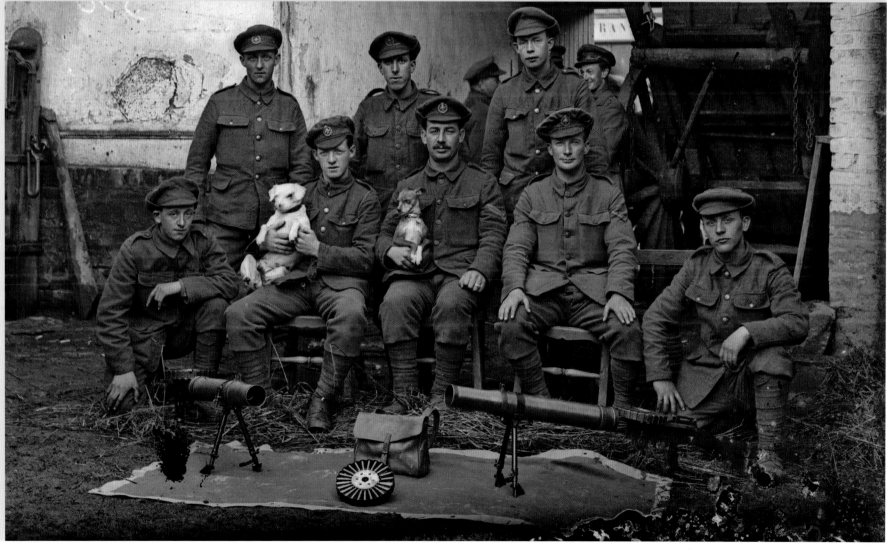

The Irish

THE NORTH IRISH HORSE REGIMENT

On Easter Monday, 24 April 1916, Irish republican sympathizers occupied buildings across British-ruled Ireland in a bid for an independent Irish republic. With the British Army heavily committed to the war on the Continent, the Irish nationalists seized the opportunity to break the union with Britain. Thousands of Irishmen had rushed to volunteer for the British Army in 1914, many out of genuine patriotic zeal and many others supporting the war effort because they believed it would ensure so-called 'Home Rule' – a self-governing Ireland within the United Kingdom. By 1916 the prospect of compulsory conscription was causing a backlash; the Irish secessionists were outraged that Britain was now seeking to impose a policy that would require compulsory conscription before even a self-governing Ireland would be considered. Among the British soldiers in Ireland during the rebellion was Bryant Charles Hamilton, an Australian of Irish-born parents, who would be commissioned as a second lieutenant four months later, on 26 July 1916.

One photograph taken during the uprising and now held by Hamilton's family features soldiers behind a wooden barricade in Holles Street, central Dublin (Plate 269, p. 236), but the family is not certain Lieutenant Hamilton is one of the soldiers in the image. His elderly daughters Anne Magarey and Frances Radford say he never mentioned the Easter Rising to them.

At 12.30 p.m. that Easter Monday, the secessionist leader Padraic Pearse proclaimed the creation of an Irish republic in front of the Dublin General Post Office. But the British Army troops were brought in to ruthlessly suppress the uprising and fighting raged for six days. The insurgents, armed only with rifles and shotguns, numbering less than 1,000, maintained their hold on the city against the military might

PLATE 266 The cap badge of the North Irish Horse Regiment.

PLATE 267 Local children watch as this mounted North Irish Horse soldier has his photograph taken. This same soldier also appears in Plate 270 (p. 237), second from left in the second row. The children wear winter clothes, suggesting it is probably late 1918 or early 1919 when the North Irish Horse A Squadron was in Vignacourt.

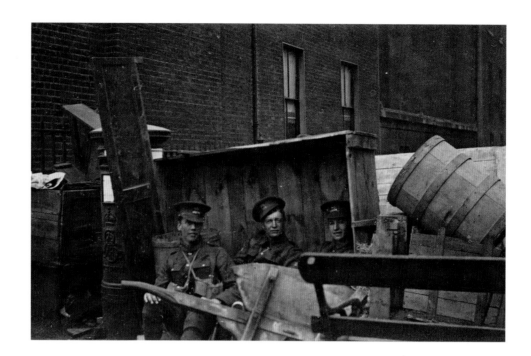

of the British Empire – which had assembled a formidable force including 16,000 troops and 1,000 armed police. The Irish rebels were defeated, with the loss of 64 killed in the uprising and 16 leaders subsequently executed; the British Army took even higher casualties: 132 men killed and 397 wounded. But it was the beginning of a violent republican struggle. We do not know what views Hamilton held on the fight for Irish independence but, whatever their loyalties, by March 1917 Lieutenant Hamilton and his fellow North Irish Horse cavalry soldiers were in France fighting for Britain on the Western Front. The regiment was mainly Belfast-based and it included Catholics and Protestants so it is a fair bet that many of them were republicans.

Hamilton sent a print of the photograph on the facing page (Plate 227) to his family saying 'This is a photo of A Squadron the one I did most of my fighting with', which suggests it was taken either just before or just after the end of the war in November 1918. His fellow lieutenant Edwin Atkinson was also from the Commonwealth; he was originally a sergeant in the 9th Canadian Mounted Rifles Regiment.

Lieutenant Hamilton's 1918 A Squadron had embarked from Dublin for Le Havre in France four years earlier, in August 1914, within days of war being declared. (Hamilton was clearly with another North Irish Horse unit when he was helping suppress the Easter Rising in April 1916.) The North Irish Horse and its sister regiment the South Irish Horse were the first non-regular army soldiers to go into action on the Western Front but the ugly realities of modern warfare meant that by 1917 most of its cavalry troops were dismounted and retrained as infantry soldiers. When the group photograph of A Squadron in Plate 227 was taken it was part of the V Corps Cyclist (North Irish Horse)

PLATE 268 Lieutenant Bryant Charles Hamilton of the North Irish Horse. (Courtesy his daughter, Anne Magarey)
PLATE 269 North Irish Horse soldiers sheltering behind a barricade during the Easter Rising. (Courtesy Anne Magarey)

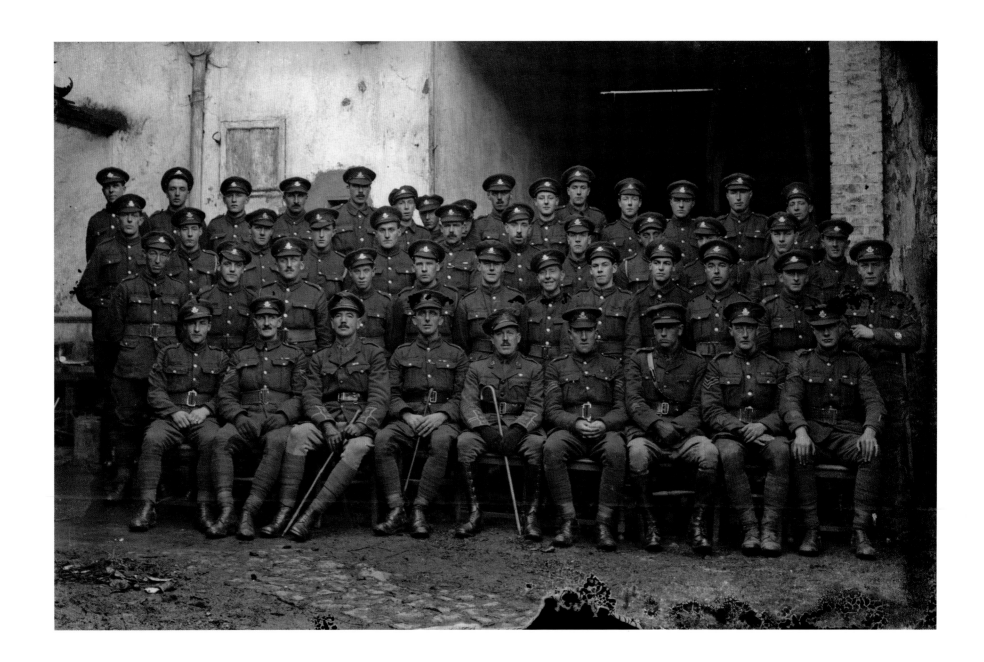

PLATE 270 Officers and men of A Squadron of the North Irish Horse Regiment, which was then a part of the V Corps (North Irish Horse) Cyclist Regiment. Three officers in the front row can be identified. The officer third from left is Lieutenant Edwin Arthur Atkinson, fourth from left is Warrant Officer Class 2 Humphrey Boyd, the officer fifth from left (in middle front row) is Captain Worship Booker and Lieutenant Bryant Charles Hamilton sits front row, third from right. The man in the third row, sixth from the left, is possibly Private George Dodds.

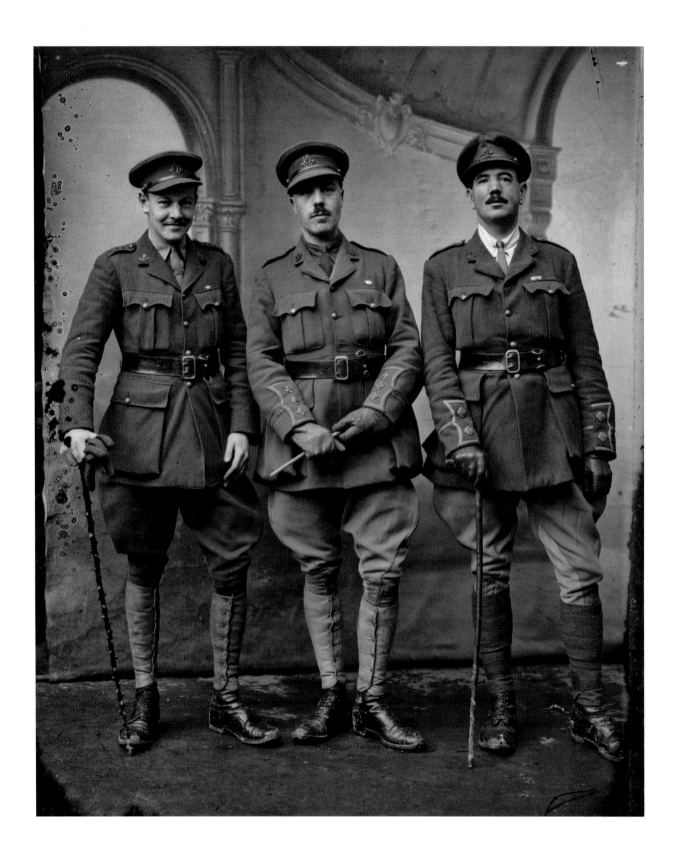

PLATE 271 Lieutenant Edwin Arthur Atkinson of the North Irish Horse also appears, on the right, in this other Thuillier picture. He is wearing a Military Cross medal, awarded for gallantry.

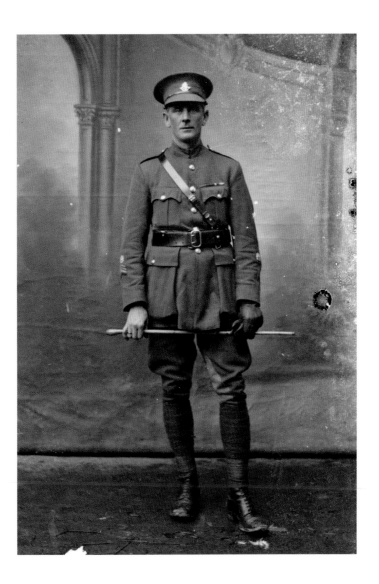

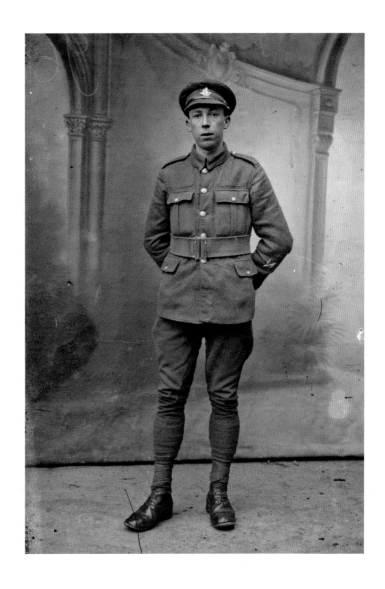

PLATE 272 Warrant officer Jack Wright. A veteran of the Boer War, he was mentioned in despatches (*London Gazette*, 17 February 1915) and awarded the Military Medal (*London Gazette* supplement, 20 August 1919). He was also a well-known footballer from Cliftonville in Belfast, Ireland.

PLATE 273 A North Irish Horse soldier in front of the Thuillier backdrop – his left sleeve badge shows he is signals-qualified.

Regiment, so these men had swapped their steeds for bicycles. Lieutenant Hamilton's family history records that he did go into combat on his horse, and that it was shot from under him during his time on the Western Front. His North Irish Horse Regiment went early to the war and it fought with distinction, earning numerous battle honours. Because they were Irish, including many Catholics sympathetic to the secessionist cause, there was always some suspicion among British imperial commanders about their trustworthiness as soldiers, so the men who served in the NIH felt that they had something to prove.

One of the North Irish Horse's most extraordinary original soldiers was Acting Lieutenant Colonel Richard West, who went to France early in 1914, first clashing on horseback with the German Uhlans – cavalry soldiers – that were advancing ahead of the invading German army. Like so many officers in the cavalry he was reassigned to a new regiment as the impracticalities of throwing horse cavalry against machine guns and artillery became clear, and he was assigned to the new tank weapons.

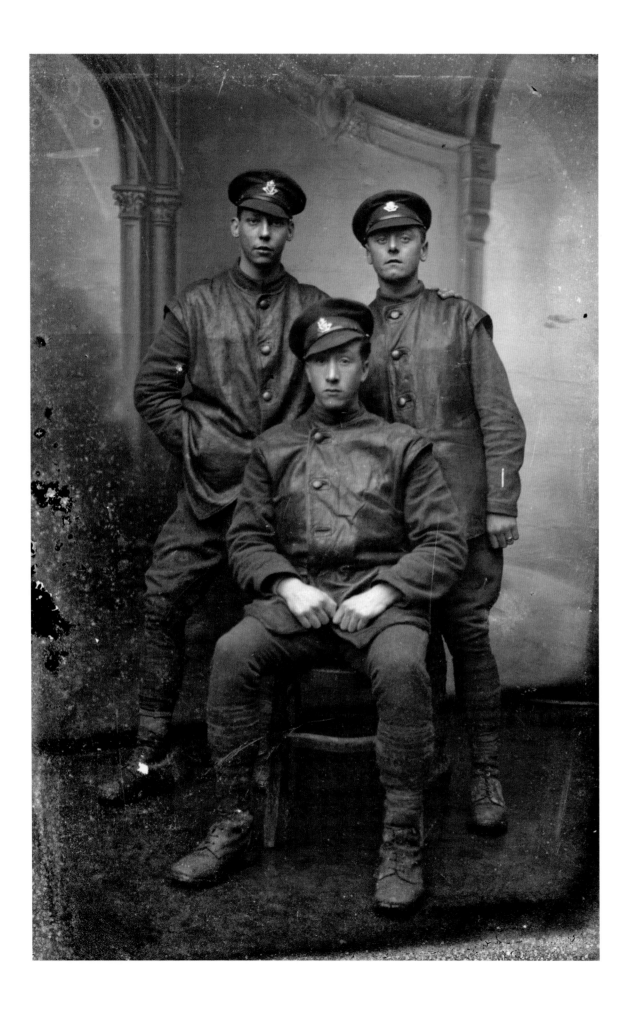

PLATE 274 Three North Irish soldiers wearing thick wet-weather coats. The soldier on the right has a wound stripe on his left sleeve.

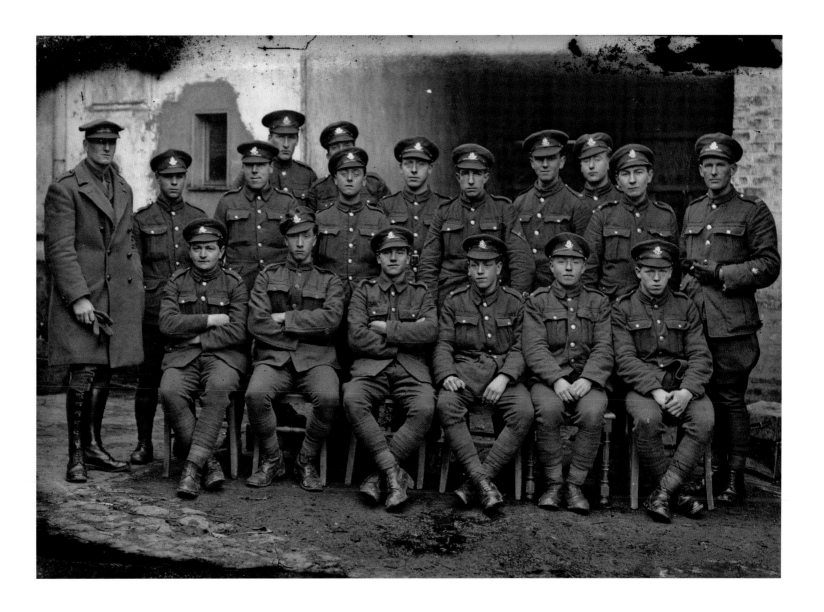

PLATE 275 A group of North Irish Horse soldiers, officer standing on the left.

In feats of breathtaking courage, West was to win a posthumous Victoria Cross in addition to two other gallantry medals. During 1918, in command of a tank battalion, his horse was shot from under him three times in two major battles, and in the final clash on 2 September he rode his horse out in full view of the Germans to rally his troops despite heavy machine-gun and rifle fire. In the knowledge that he was facing almost certain death he inspired his men by shouting from his horse: 'Stick it men; show them fight; and for God's sake put up a good fight.' West was then hit by machine-gun fire. His Victoria Cross citation records: 'The magnificent bravery of this very gallant officer at the critical moment inspired the infantry to redoubled efforts, and the hostile attack was defeated.'[87]

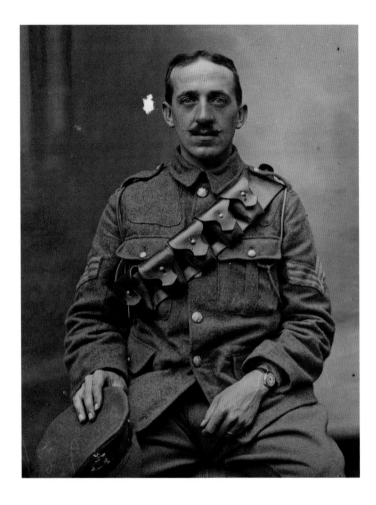

THE 6TH INNISKILLING DRAGOONS

There are also men of the Irish 6th Inniskilling Dragoons horse cavalry regiment among the North Irish Thuillier images, which can be explained by the fact that in June 1916 a 2nd Infantry Regiment of the North Irish Horse was formed from units of the North Irish and the 6th Inniskilling Dragoons. These Inniskilling Dragoons had come from members of the Ulster Volunteer Force but, like most of the cavalry regiments, were retrained as infantry by 1917. The regiment was first raised in 1689 when King James II attempted to overthrow William of Orange; the mounted troops were named the 'Enniskillen Dragoons' after Enniskillen Castle that features on the badge. It was a sad moment in history when they dismounted once and for all during the First World War because the 6th Inniskilling Dragoons was one of the oldest cavalry regiments in British military history; it had fought at the Battle of the Boyne (1690), Waterloo (1815) and Balaclava (1854). Captain Lawrence 'Titus' Oates, a member of Robert Falcon Scott's doomed second South Pole expedition, who sacrificed himself in an Antarctic blizzard in 1912, was also an officer of the regiment. Today the Inniskilling Dragoons is part of the Royal Dragoon Guards but its soldiers still proudly retain the castle and name in their cap badge.

PLATE 276 A sergeant of the 6th Inniskilling Dragoons.
PLATE 277 The badge of the 6th Inniskilling Dragoons.

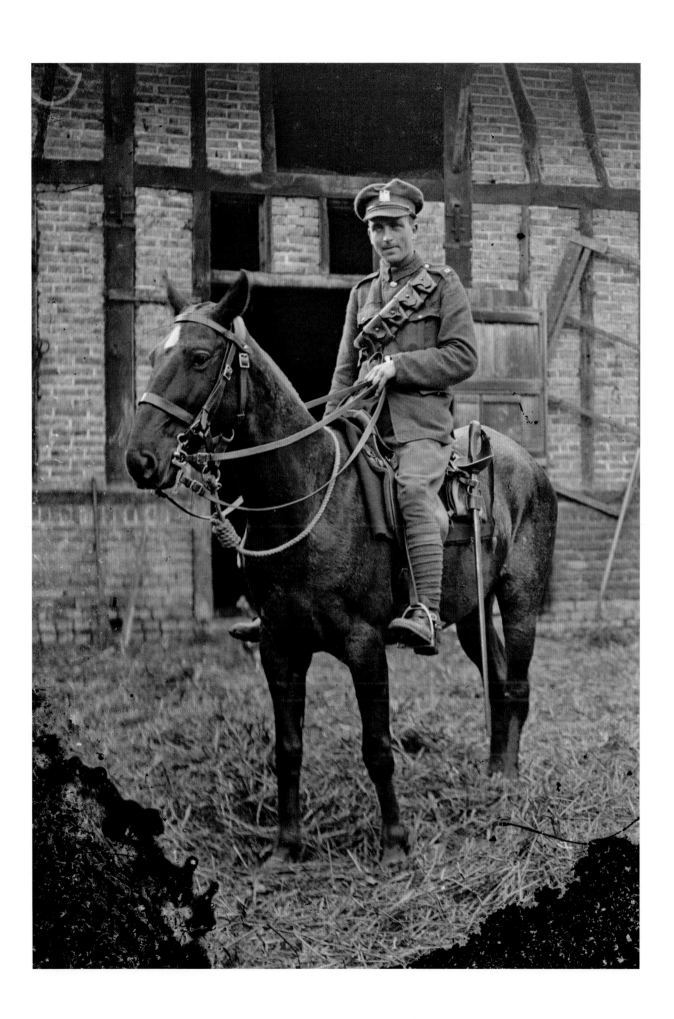

PLATE 278 6th Inniskilling Dragoon.

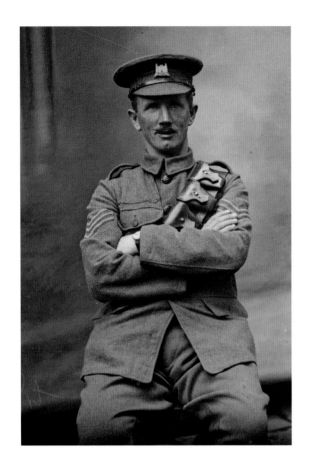

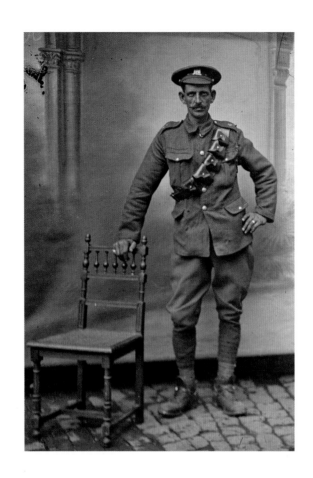

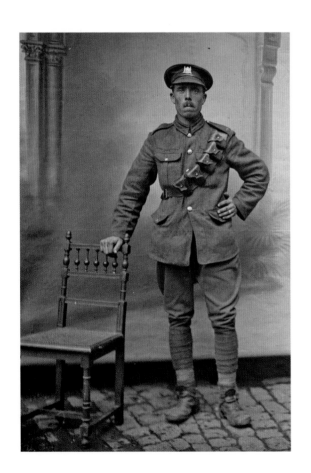

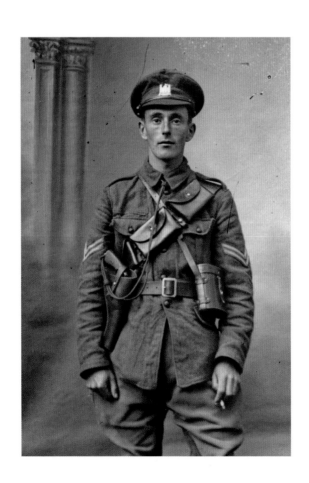

PLATES 279–281 6th Inniskilling Dragoons.
PLATE 282 (Bottom, near left) A corporal of the 6th Inniskilling Dragoons fully equipped with binoculars, revolver and bandolier.

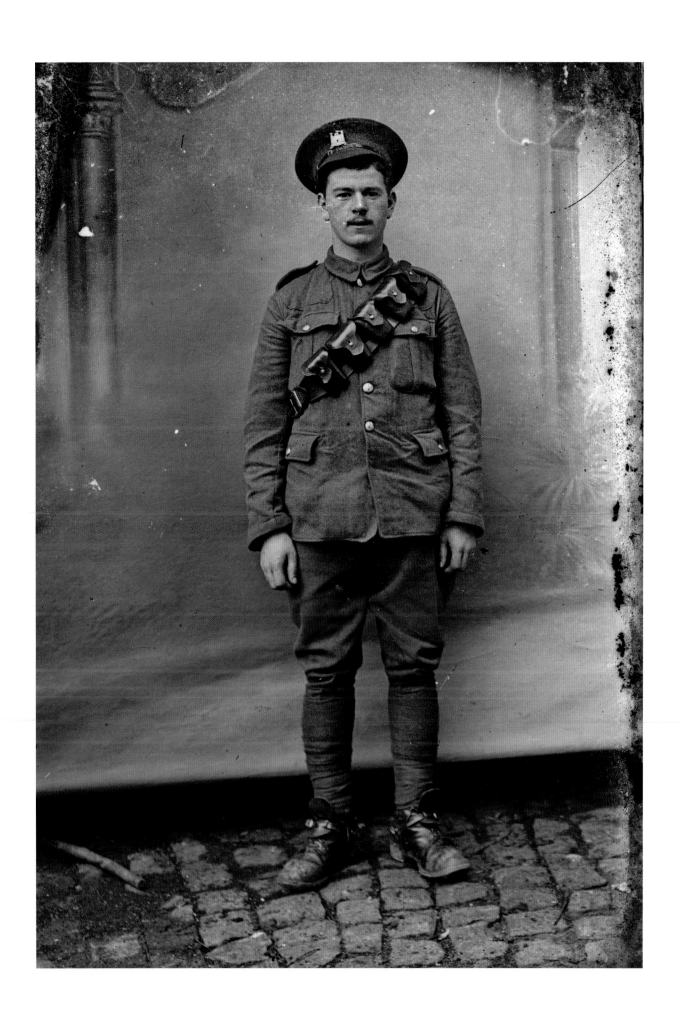

PLATE 283 6th Inniskilling Dragoon.

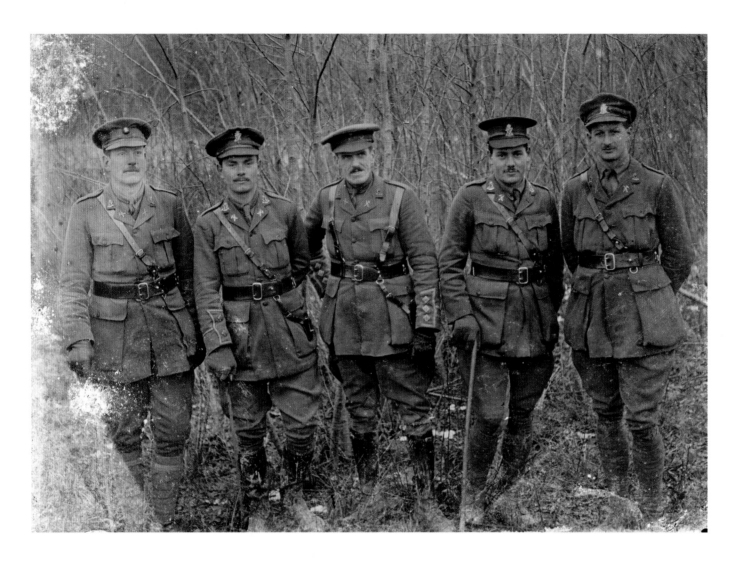

THE ROYAL IRISH RIFLES

There are many men from the Royal Irish Rifles Regiment (now known as the Royal Ulster Rifles) in the Thuillier images. An infantry regiment formed under King George III in 1793, it raised twenty-one battalions during the First World War and lost 7,010 men to the conflict. Conscription was never introduced in Ireland, making the patriotic fervour and sacrifice shown by so many volunteer Irish soldiers for Britain even more extraordinary. An estimated 300,000 Irish soldiers served in the Great War; 30,000 of them lost their lives. As James Taylor has written in his history of the Rifles: 'Ireland gave approximately 30,000 of her young men … to a cause that they thought worth fighting for at the time. Their country would soon find it convenient to forget that sacrifice.'[88]

On the first day of the Somme the 9th Royal Irish Rifles Battalion was in an advance on Thiepval Wood. One Irish Rifles officer, Lieutenant Colonel Frank Crozier, gave a solemn account of how, as they advanced, his men cheerily marched to almost

PLATE 284 The four men from right to left are officers of the Royal Irish Rifles in the field. The officer in the centre is a captain. All wear pioneer battalion badges. The regiment of the officer on the left is unidentified.
PLATE 285 The cap badge of the Royal Irish Rifles – their motto 'Quis Separabit' means: 'Who shall separate us'.

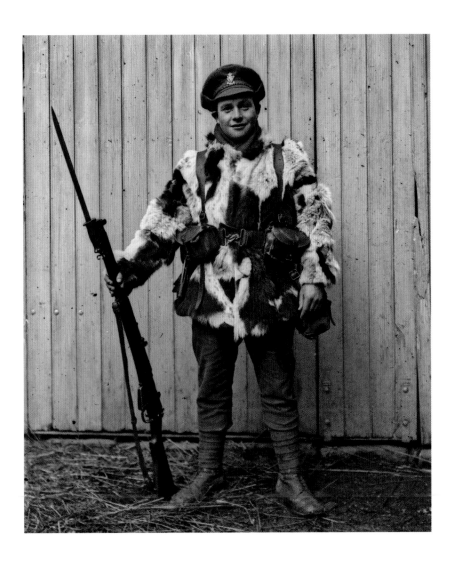
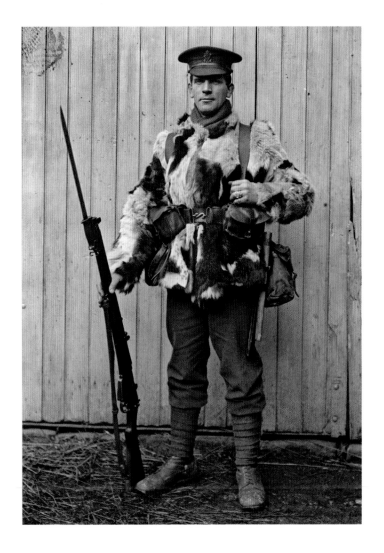

PLATES 286–287 Two charming photographs of Royal Irish Rifles soldiers wearing calfskin jackets and posing with full kit, rifle and bayonet; probably taken in the winter months.

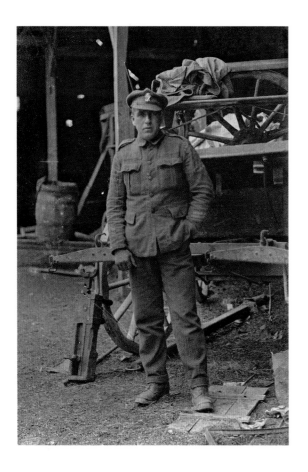

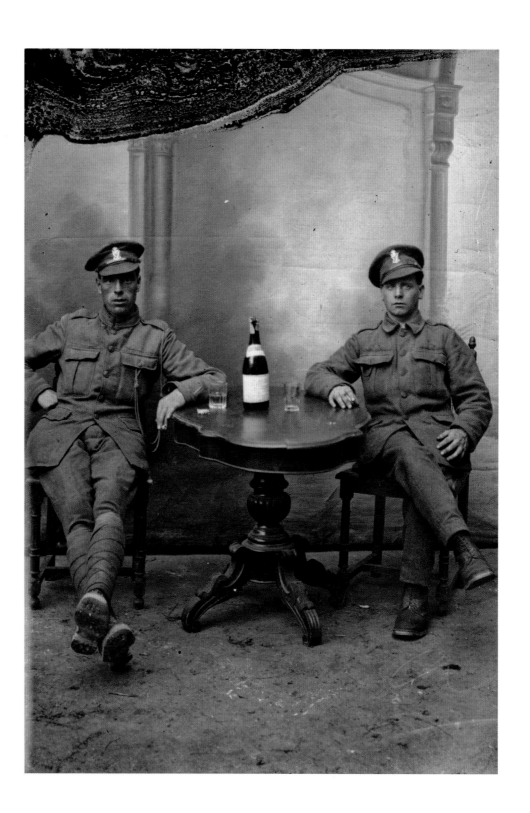

PLATES 288–289 Privates of the Royal Irish Rifles.
PLATE 290 Two sombre Royal Irish Rifles drowning their sorrows with a bottle of French champagne.

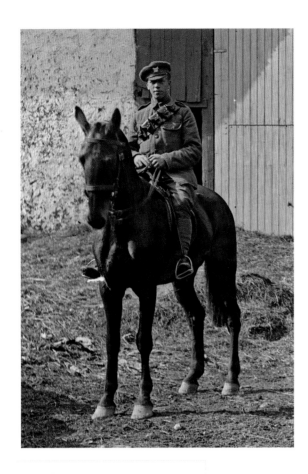

PLATES 291-292 A single image of a cavalry soldier from another famous Irish regiment – the 5th Royal Irish Lancers, another cavalry regiment with a history dating back to the Battle of the Boyne (1690). The 5th Royal Irish Lancers, now part of the Queen's Royal Lancers, suffered the loss of the last British soldier to die in the Great War: Private George Ellison from Leeds, shot by a sniper just ninety minutes before the Armistice. Below, a close-up of the 5th Royal Irish Lancers cap badge.

certain death, one calling: '"Goodbye Sir! Good luck." He shouts to me en passant, "Tell them I died a teetotaller, put it on the stone if you find me!"'[89] So many of them did die; Crozier made it through the advance to a position known as the Sunken Road to learn that his fellow 10th Rifles Battalion had been wiped out. When he called for his bugler to sound the advance to rally the troops that were left, the bugler fell dead at the colonel's feet. By the end of the day, as one private wrote: 'Trenches and tops were blocked with the dead, but on days like that there's no sympathy in your heart.'[90]

The Irish served with great distinction in the First World War, no matter the suspicions of British commanders about their republican sympathies. The terrible losses Ireland suffered during the conflict no doubt played a significant part in Sinn Fein winning the Irish election in 1918, which led eventually to another war, the War of Independence from 1919 to 1922. It culminated with a partitioned Ireland, with much of the country breaking from the United Kingdom to form the Irish Free State.

One other contribution the Irish made to the war was the song 'It's a long way to Tipperary'. First noted by a *Daily Mail* correspondent on 13 August 1914 as the Connaught Rangers marched through Boulogne towards the front, it became one of the classic songs of the war, and was always an unspoken, jaunty lament for what the men were all missing back home:

> *It's a long way to Tipperary,*
> *It's a long way to go,*
> *It's a long way to Tipperary,*
> *To the sweetest girl I know!,*
> *Goodbye Piccadilly,*
> *Farewell Leicester Square,*
> *It's a long long way to Tipperary,*
> *But my heart's right there.*

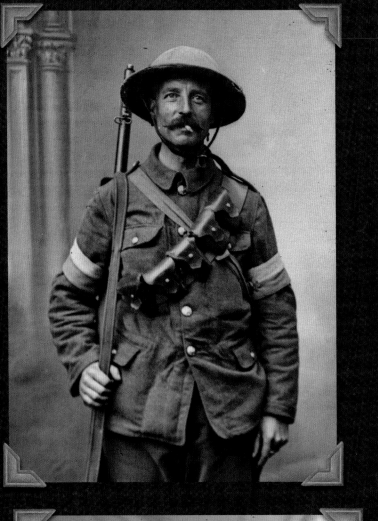

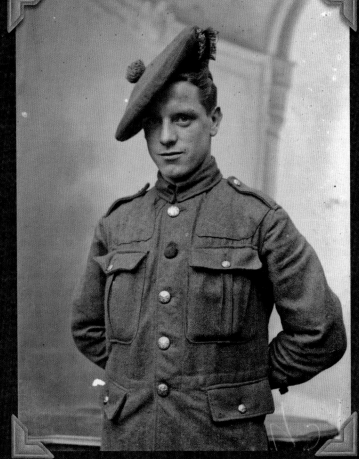

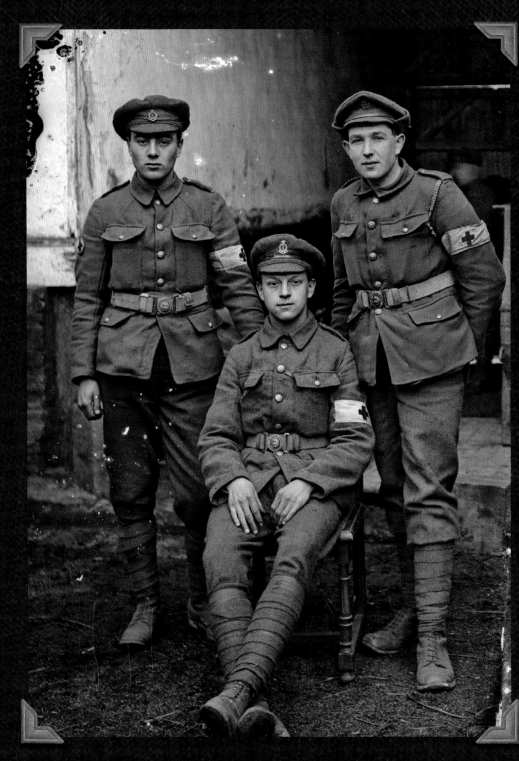

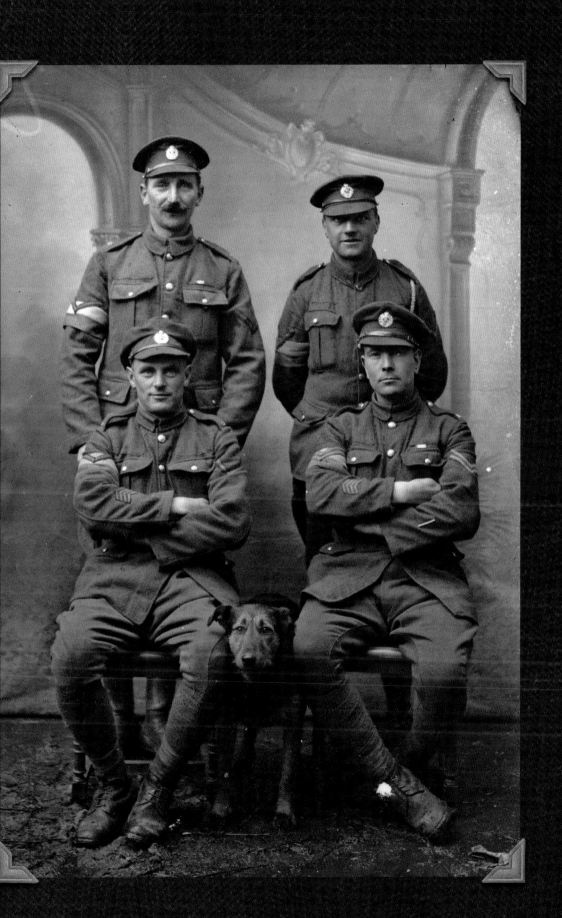
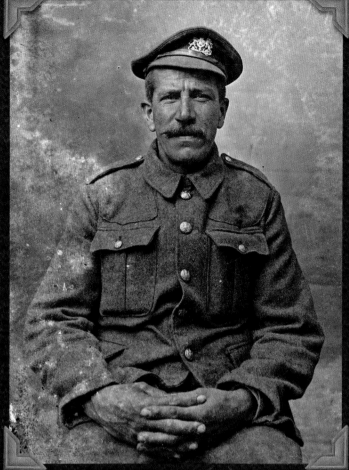
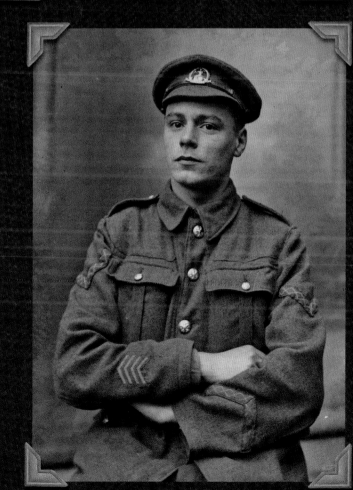

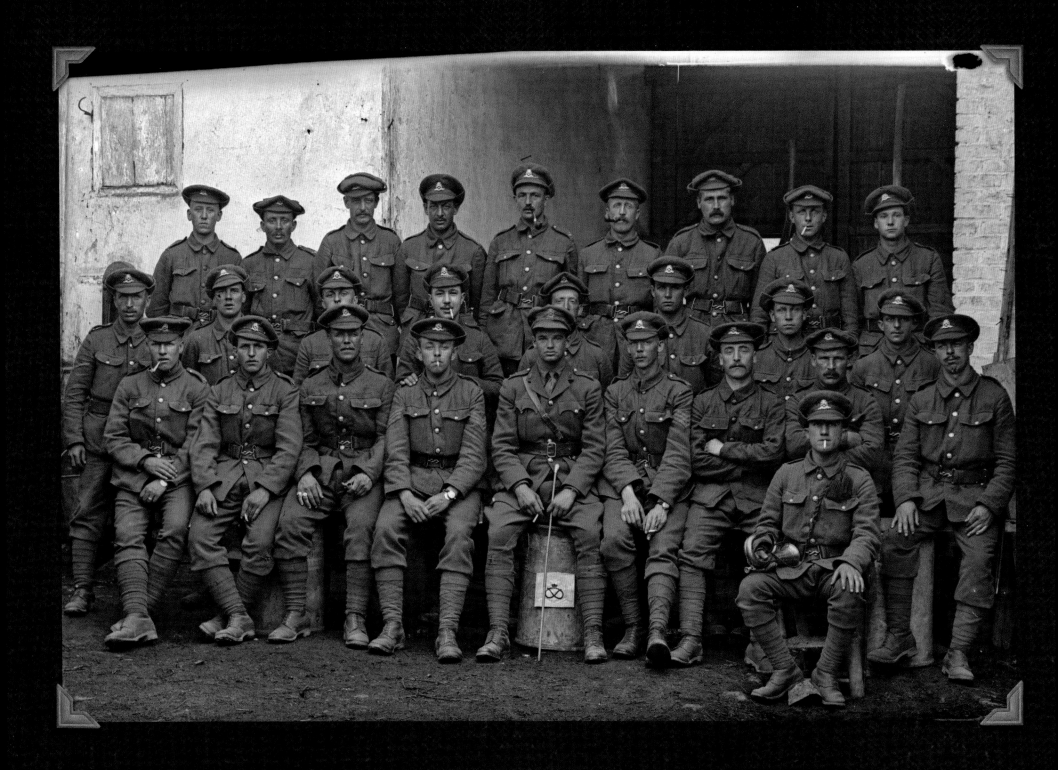

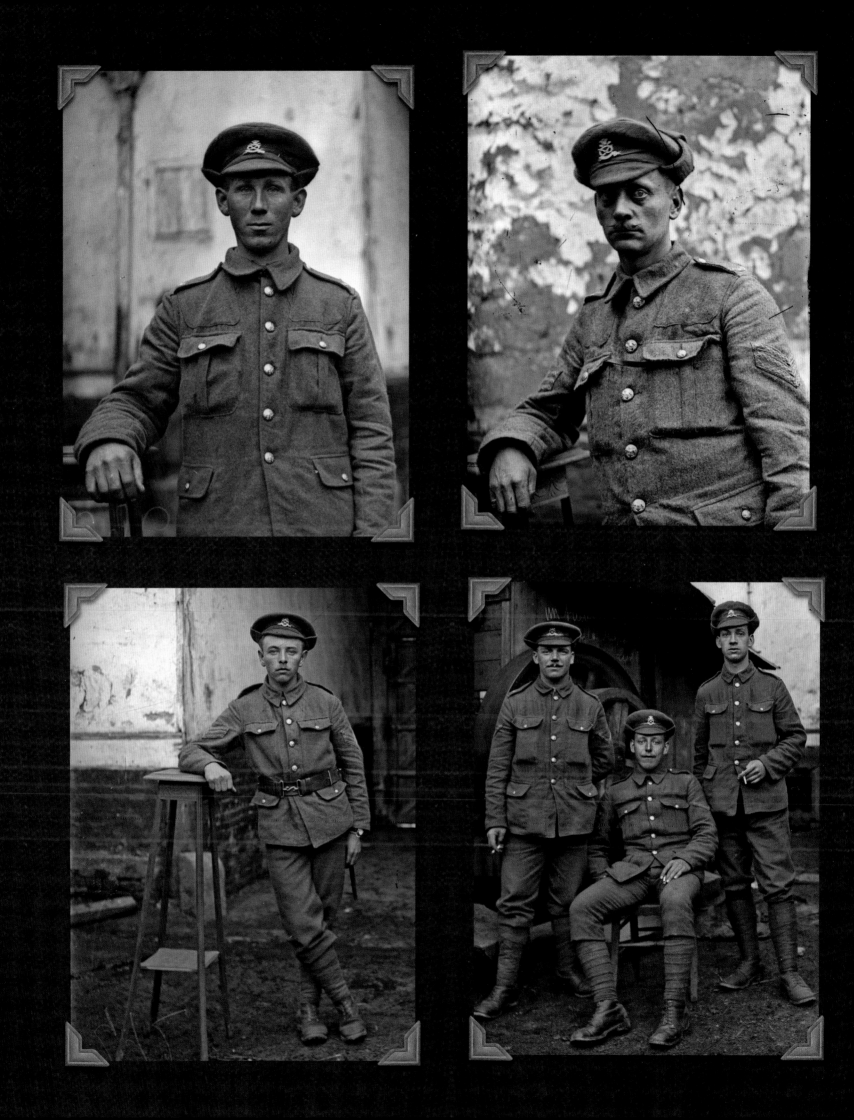

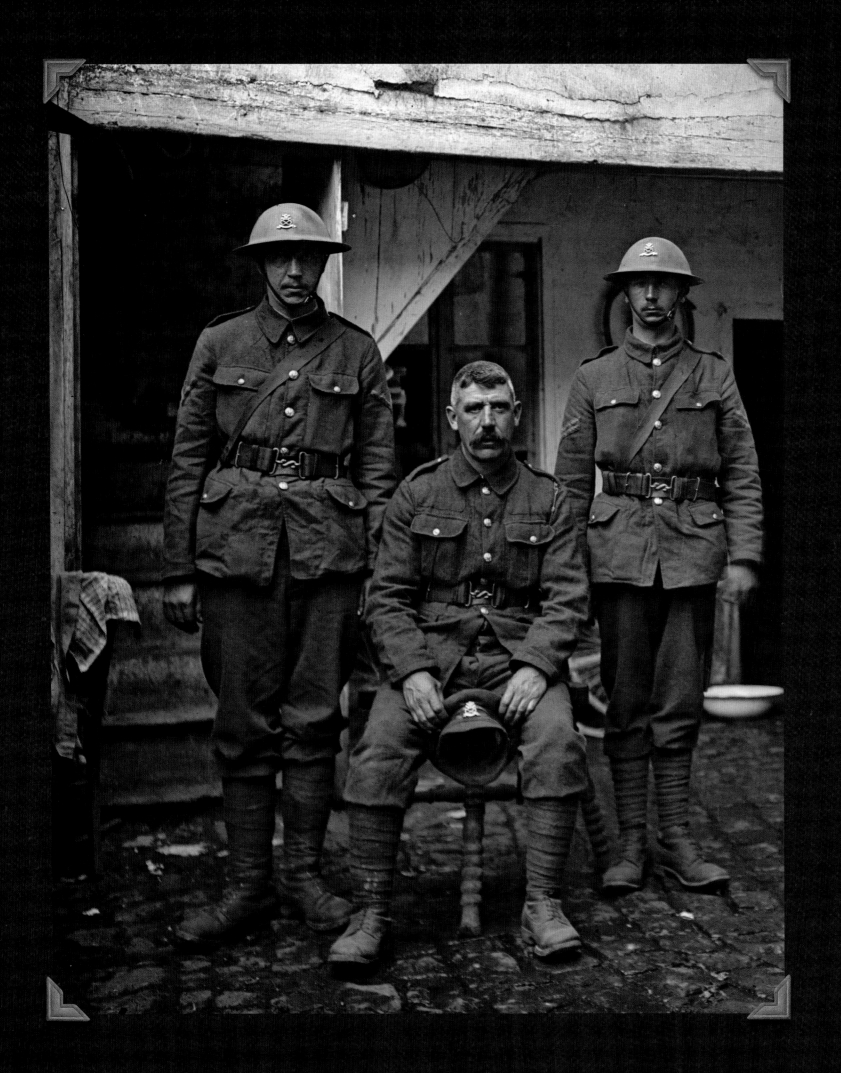

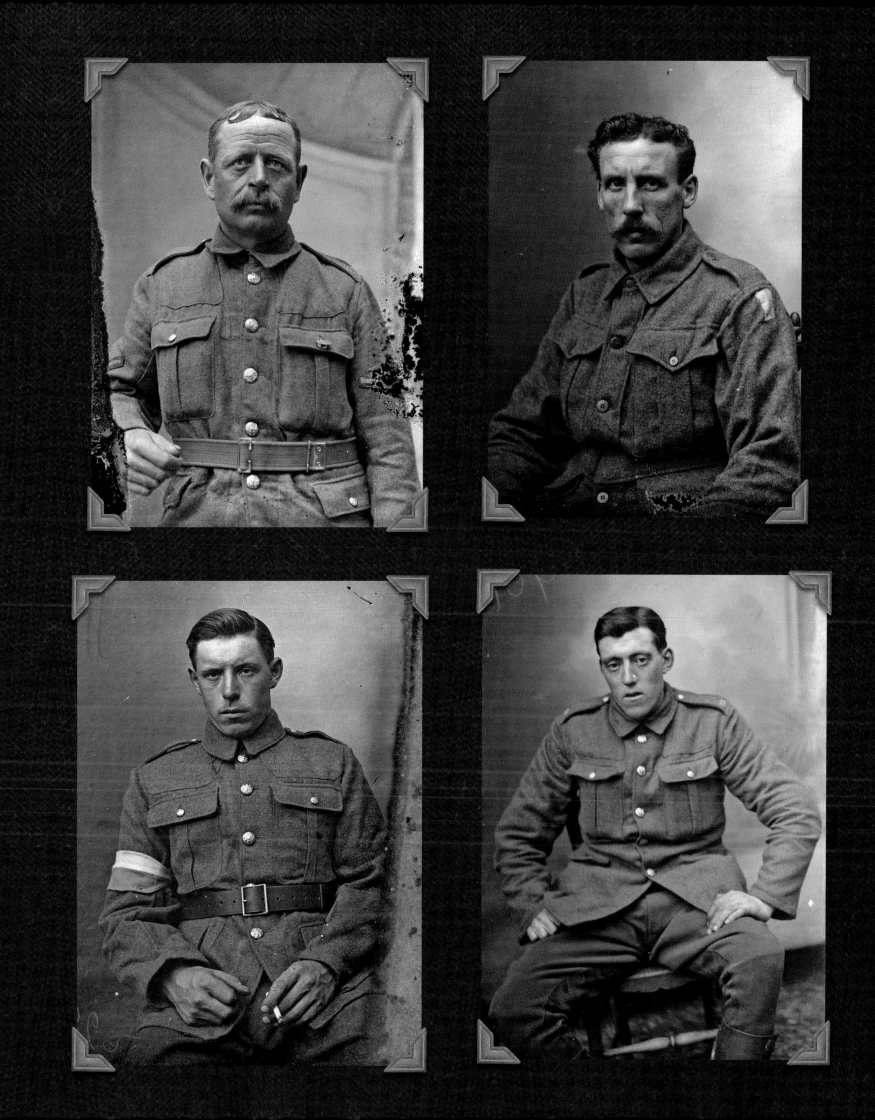

The Padres and the Chaplains

At the end of July 1916, as Allied troops trudged, laden with kit, under heavy enemy fire past the position known as the Chalk Pit on their way to fight at Pozières, Australia's Official War Historian Charles Bean noticed a chaplain who was ignoring the thump of falling shells, bent over at a task by the side of the road; Bean recorded with admiration how the padre had taken it upon himself to ensure that the corpses of the Allied dead strewn across the road were not seen by the men marching into the hell of Pozières. He was burying them as quickly as he could in a shell hole. Bean had just returned from a nightmarish journey into the front-line trenches full of blackened and shattered dead men, and he understood well why the chaplain was protecting the new soldiers from the imminent shock of war as much as possible. 'It does not encourage new troops to see a sight like that,' Bean wrote.[91] The chaplain's selfless consideration for the passing soldiers exemplifies the best of the men who took not weapons but humanity and, incongruously, the Christian message of peace, love and forgiveness into the carnage of the front lines. Once there, though, most chaplains realized there was little tolerance from the men for sermonizing at the front and their pastoral care took on a very different role that often made them among the most respected and valued men in a battalion.

Many ministers of religion left their parishes and volunteered for service with regiments on the First World War front lines. The difficulty was working out just what their role should be; many of the chaplains were not exactly welcomed with open arms when they arrived in France – there are stories of chaplains reaching their destinations to find no one waiting to meet them and then never being told what was expected of them. In August 1914, there were fewer than 120 chaplains working with the British Army. By 1918, there were almost 3,500 and more than half of these were Anglicans. Robert Graves' *Goodbye to All That* relates how one sergeant told the young officer he did not hold with religion in time of war, opining that the Indians were right in relaxing

PLATE 293 The British Army chaplain cap badge.

PLATE 294 A padre at one of the British Army camps set up near Vignacourt. He also appears in the group image in Plate 297 on p. 259.

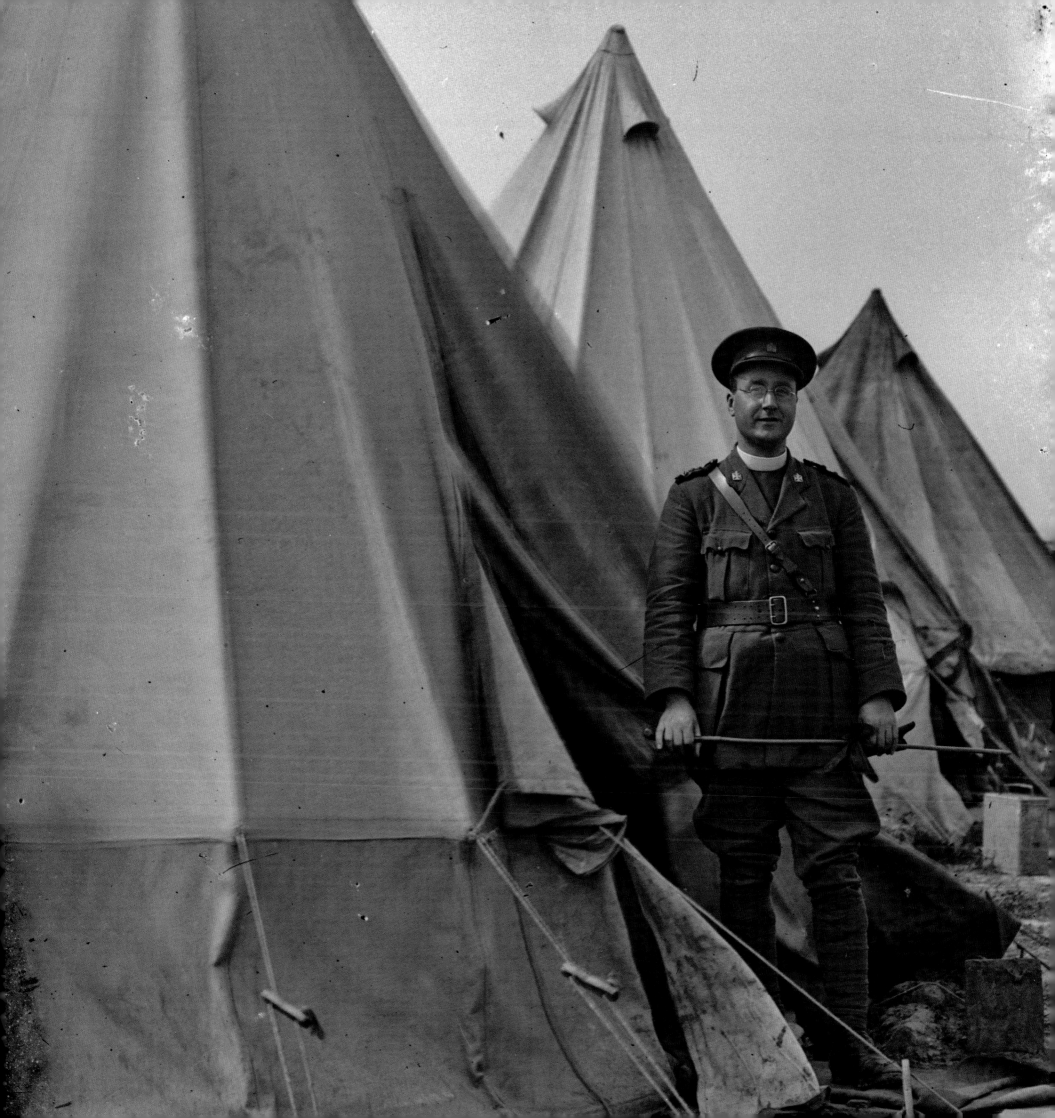

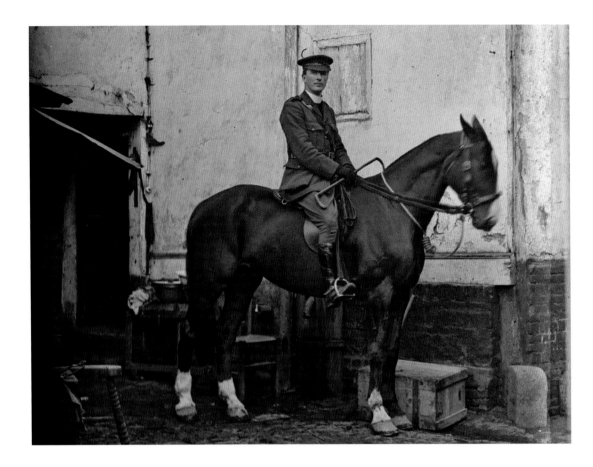

their religious rules while fighting.[92] Graves was scathing about Anglican chaplains in particular:

> *For Anglican regimental chaplains, we had little respect. If they had shown one-tenth*
> *the courage, endurance and other human qualities that the regimental doctors showed,*
> *we agreed, the British Expeditionary Force might well have started a religious revival.*
> *But they had not, being under orders to avoid getting mixed up with the fighting and to*
> *stay behind with the transport.*[93]

By contrast, Graves wrote that the Roman Catholic chaplains could always be found in the trenches with the men: 'We had never heard of one who failed to do all that was expected of him and more.'[94] But this is almost certainly an unfair perception; for, in the early stages of the war, British commanders had discouraged chaplains from going up to the front lines, reasoning that they would only get in the way. As a result, the Anglican Church ordered its chaplains to remain behind the lines, while the Catholic Church gave no such orders. By the end of 1916 the rules had been softened and, as at Pozières, chaplains of all denominations could often be found in or near the front-line trenches doing what they could for the soldiers and also burying the dead.

PLATE 295 A British Army chaplain astride his horse in the Thuillier farmyard.

PLATE 296 A close-up of the Reverend Richard Whincup from Plate 130 on p. 115. He was padre to the 6th Battalion, West Yorkshires.

PLATE 297 Two army chaplains – standing second from left and second from right – with a group of RAMC officers at a camp near Vignacourt. Note that not all chaplains on the Western Front chose to wear the clerical collar.

PLATE 298 Two army chaplains (first and third from left), an officer from the York and Lancaster Regiment (second from left) posing with a Royal Army Medical Corps officer (right), probably taken at the military hospital set up on the outskirts of Vignacourt. This photograph was taken in late March 1916 and these men are most likely from the 70th Brigade – Yorkshiremen who went into the Thiepval attack on the first day of the Somme (see further details on the York and Lancaster Regiment at p. 108)

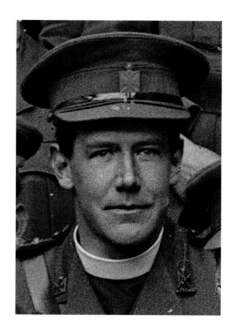

Behind the lines, many chaplains were attached to ambulance units and field hospitals and it fell to the individual to make himself useful; many even helped out in the forward dressing stations and casualty clearing stations. More often than not, this care involved doing everything except holding church services and leading patients in prayer, which many soldiers rejected. It was very easy to lose one's faith in a loving God in the hell of the Western Front.

In *Wounded: The Long Journey Home from the Great War*, Emily Mayhew tells of chaplains who worked as stretcher-bearers, hospital assistants, tea makers and general repairmen around the camps:

> *Many padres joined the bearers and attended the RMO's weekly lectures to gain some*
> *medical knowledge. By the end of 1915 many chaplains knew a bearer's pannier as well*
> *as their prayer book, and soon wounded soldiers were no longer surprised when they saw*
> *the man bending over them was a padre and not a doctor.*[95]

Chaplains also made lists of those who had been killed, collected their identification tags and wrote letters home to families and loved ones. They also buried the dead, conducted services and prayers – often on the battlefields where the soldiers had died. During the war, a total of 170 chaplains died and others suffered terrible wounds often in acts of enormous self-sacrifice, most notably as they attempted to rescue wounded soldiers. Three chaplains were awarded the VC in the First World War. Almost 250 others were awarded Distinguished Service Orders, Military Medals or Military Crosses. One of them, the Reverend Theodore Hardy, won a VC, DSO and MC, and is remembered as one of the most decorated non-combatants of the war. He was killed on the battlefield, aged fifty-four, trying to rescue more wounded men at Rouen in France just a few weeks before the end of the war.

The 6th West Yorkshires were so fond of their Anglican chaplain, the Reverend Captain Richard Whincup MC, that they held a farewell concert for him on 25 August 1917. He was returning to England to be demobilized:

> *He had served with the Battalion from August 1915 and by his unselfishness and*
> *constant anxiety to serve the best interests of officers and men he had gained a unique*
> *influence in the Battalion. Frankly and unblushingly a civilian in outlook and sympathy,*
> *he helped to counteract some of the evil tendencies of military life – a narrow sympathy*
> *and low moral standard – but always without a trace of priggishness.*[96]

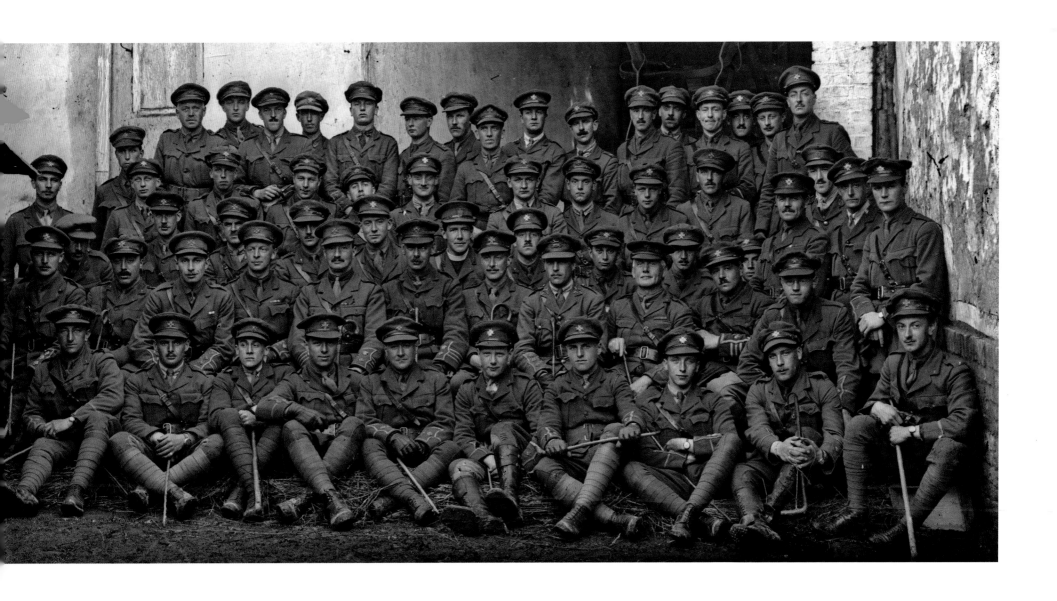

PLATES 299–300 A padre seated in the middle of a company of unidentified soldiers, also shown in close-up (left).

The Concert Parties

At first the audience sat silent, with glazed eyes. It was difficult to get a laugh out of them. The mud of the trenches was still on them. They stank of the trenches, and the stench was in their souls. Presently they began to brighten up. Life came back into their eyes. They laughed! … Later, from this audience of soldiers there were yells of laughter, though the effect of shells arriving at unexpected moments, in untoward circumstances, was a favorite theme of the jesters. Many of the men were going into the trenches that night again, and there would be no fun in the noise of the shells, but they went more gaily and with stronger hearts, I am sure, because of the laughter which had roared through the old sugar-factory.[97]

One of the biggest challenges for military authorities during the war on the Western Front was how to keep up the morale of soldiers when they were out of the line.

One way of managing this was to keep the men occupied with route marches, physical training, military lectures, training courses and sporting tournaments. But the need for quality entertainment was also well recognized because bored troops got into trouble, frequenting the bars and brothels of the larger towns like Amiens, which all too often resulted in rampant drunkenness and the more serious problem of venereal disease (that alone could take a soldier out of the line for months of treatment). Concert parties and performances became an important part of an evening entertainment schedule. The British actress turned performance manager Lena Ashwell organized numerous concert parties that toured the lines just behind the fighting areas during the course of the war and she won an OBE for her efforts. What was particularly special about her troupes was that many of her performers were women, risking their lives by getting so close to the front lines. Ashwell was a pioneer who strongly believed that the arts would help protect troops from the brutalizing effects of war; her ideas initially met

PLATE 301 A soldier performer poses in his Pierrot costume.

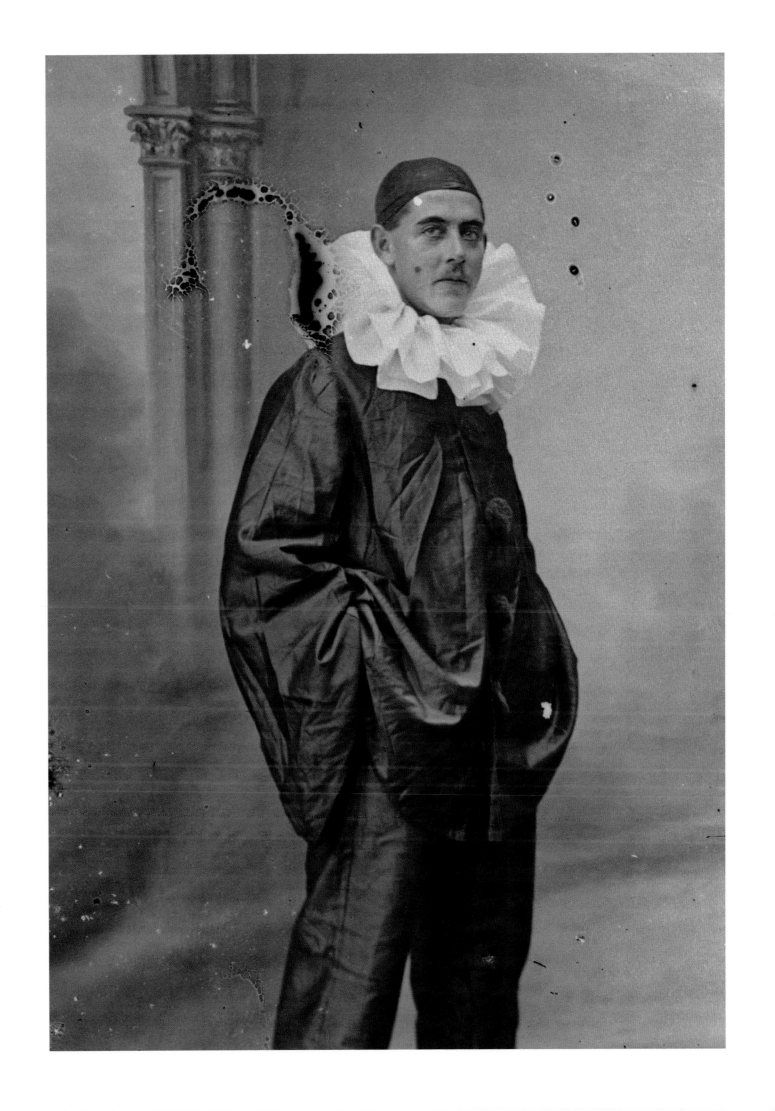

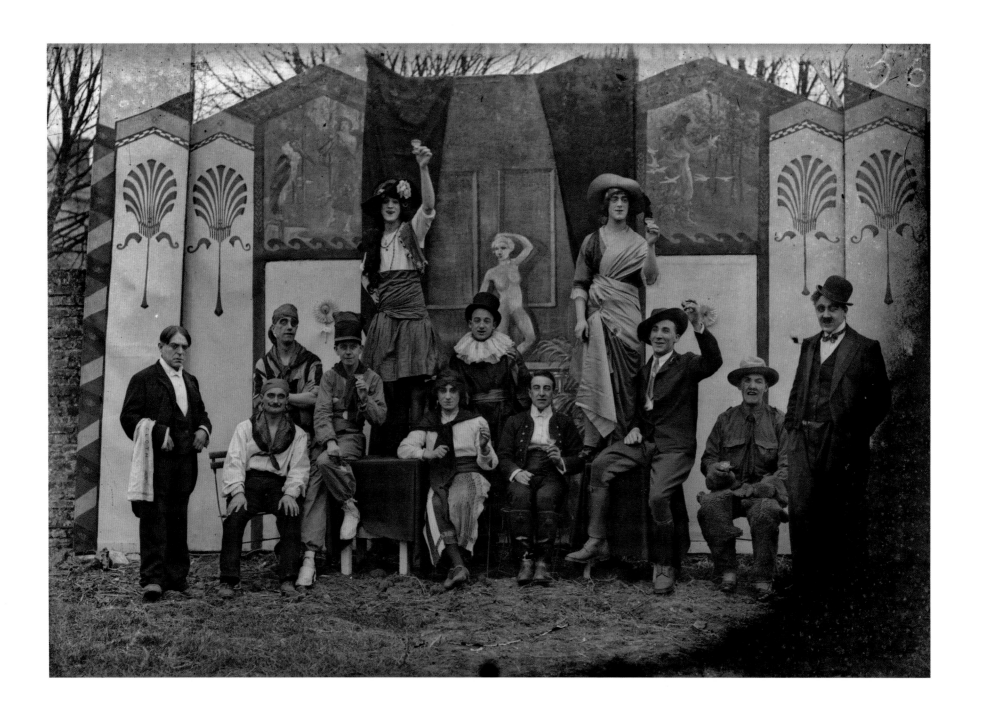

PLATE 302 An unidentified performance troupe in front of their painted set somewhere near Vignacourt.

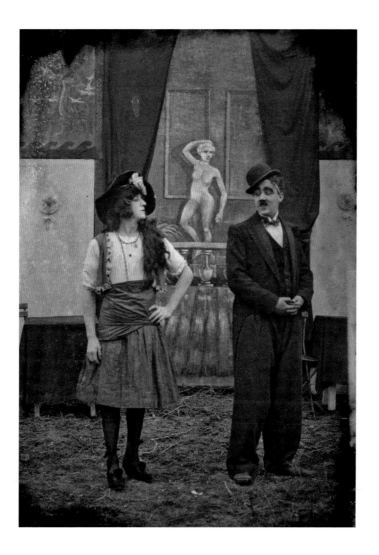 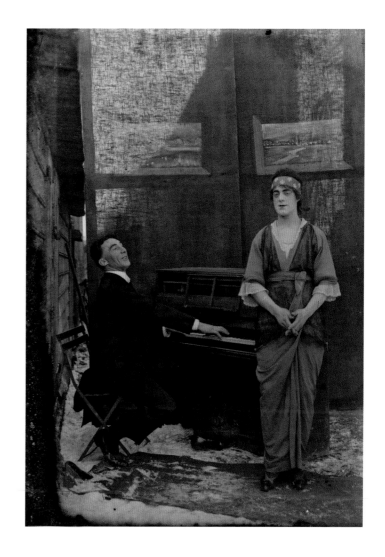

PLATE 303 A Charlie Chaplin lookalike poses with a shapely female impersonator. There were women in some of the Lena Ashwell troupes but mostly men dressed up as women for the performances.
PLATE 304 Another soldier female impersonator (on right). Note the snow on the ground, indicating this is the winter season.

strong military resistance but, with support from a royal patron, by 1918 she had taken more than 600 performers into war zones, including around 350 women. One of her most famous actresses was a former Bristol chocolate packer named Elsie Griffin, who joined the Lena Ashwell Concert Party in France, where girls were locked up in a caravan at night for their own protection from lovelorn troops. Griffin's two songs 'Danny Boy' and 'Roses of Picardy' became two of the most popular of the war.

More often, though, the male soldiers themselves provided the entertainment; those with singing and acting ability were recruited to form troupes and, by 1917, each division had at least one military theatre company. Many individual battalions also had their own performance groups (see the sad story of the Royal Fusilier performer on p. 200). There were many names for performance groups including 'the Follies', 'the Bow Bells', 'the Jocks', 'the Whizz-Bangs', 'the Brass Hats' and 'the Tykes'.

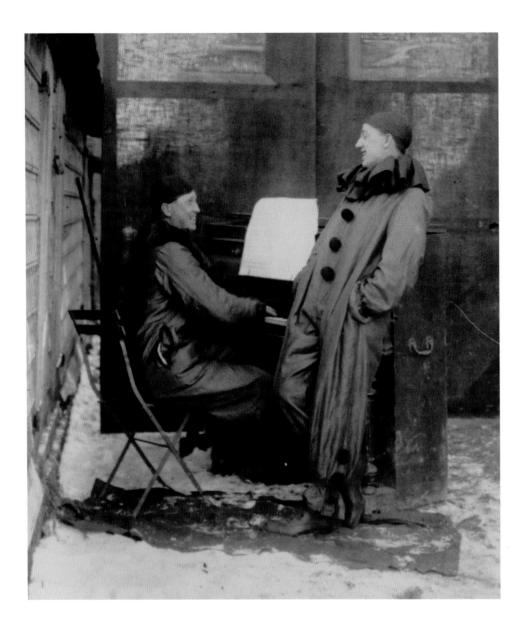

The concerts were held in barns, fields or old factories – wherever there was space for the troops to gather. Some performers imitated the Pierrot troupes that were popular in British theatres and music halls at the time. A New Zealand group made up entirely of these costumed figures was formed on the Western Front in 1917. Called 'the Digger Pierrots', it continued to perform around the United Kingdom and Europe after the war. Pierrot pictures are frequent in the Thuillier images and it is easy to understand why: Pierrot was a sad clown, naïve and trusting, but always a fool and the butt of jokes and pranks. Troops no doubt empathized with his unfulfilled love for the female character, Columbine, who was part of any Pierrot performance. What also made Pierrot so especially popular was that he was a character well known across England and Western Europe.

PLATE 305 Two Pierrot performers in the Vignacourt winter snow.

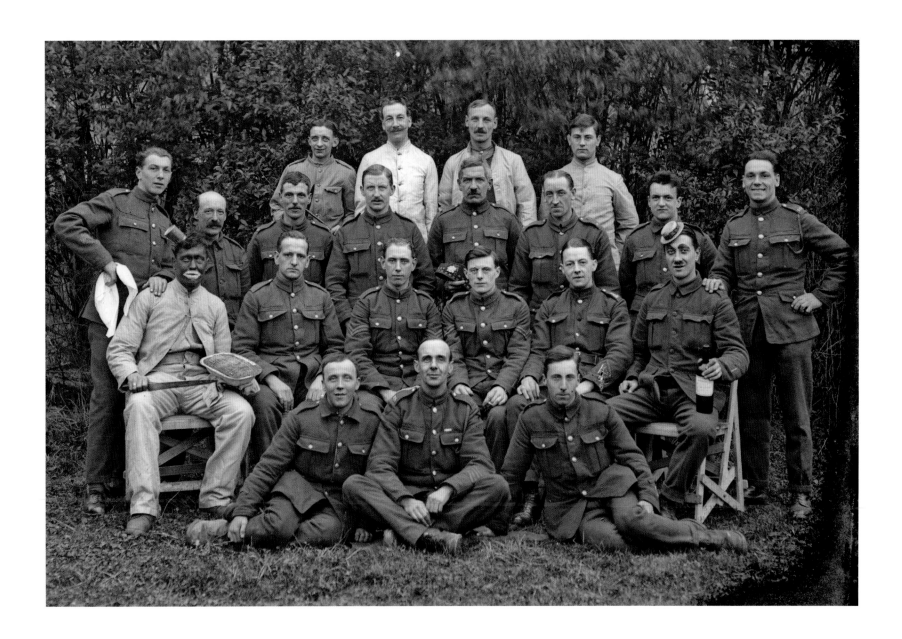

PLATE 306 This delightfully casual picture – note the soldier with bottle of red wine in hand – includes concert party performers, as well as men from the Royal Artillery, Royal Field Artillery and, as shown from the cap badge featuring the Order of the Thistle in the hand of the soldier standing, centre (second row from the top), a Scots Highland regiment, perhaps from the Highland Light Infantry.

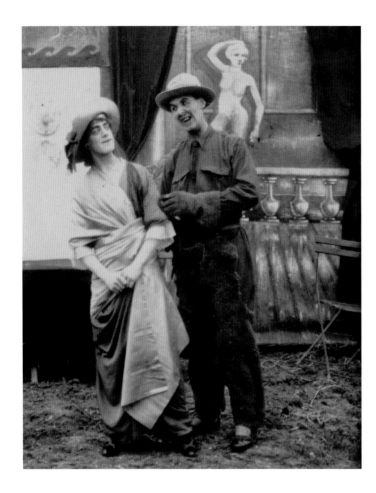
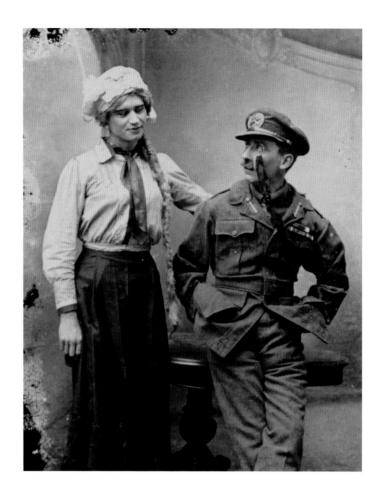

For the soldiers, by far the most popular character in any of these performances was the female impersonator.

Probably the names best known throughout the Division were those of men belonging to 'The Tykes' (49th Division), such as Lt J.P. Barker, and Marsden, Coates and Smith. It was an incredible luxury after the mud and horror of the trenches to come to the small theatre behind the line: to hear good music and singing and humour often highly seasoned: and to see Barker arrayed in the latest robes from Paquin, showing a finely turned leg, shapely enough to have been the envy of a chorus girl at the Empire.[98]

One of the possibly apocryphal stories that did the rounds was that of a general so taken with the attractive 'female' performer in one show that he sent 'her' his card, not realizing that it was Lieutenant Barker of the 6th West Yorkshire Regiment's concert party troupe. 'Occasionally French civilians watched the performance from the back of the crowd, and were mystified with the appearance of a charming girl, altogether English, who sang with a captivating innocence, whose smile seemed charming in the half-light of the stage, and who bore her dresses like a mannequin in a West End show room. If it is

PLATE 307 A rather alarming flirty pose from two concert party performers.
PLATE 308 A performer dressed as a highly decorated senior Machine Gun Corps officer flirts with a dainty 'lady'.

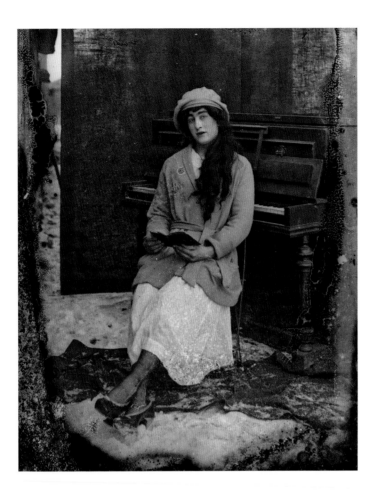 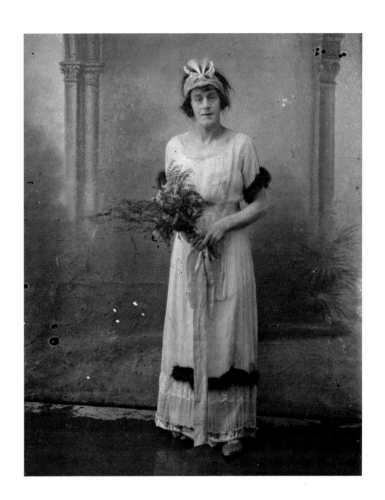

PLATES 309-310 Two soldier female impersonators in their finery at Vignacourt. Note the snow on the ground (left).

not true that Barker was more than once offered a card by some old beau … after one of his turns – it deserved to be!'[99]

The 6th Battalion West Yorkshires, which features prominently in the Thuillier collection, held its own concert in mid-April 1916 in Vignacourt as part of its first anniversary on the Western Front. It is possible also that at least some of these Thuillier images are from a series of concerts that took place over several evenings in late October 1918 just outside the village. There are references in Australian and British battalion war diaries to preparing the local RAF hangar for a series of concerts at this time that included one of the Ashwell troupes as well as soldier groups. The correspondent Philip Gibbs attended a number of these performances throughout the war and stressed how important they were for the battle-scarred soldiers no matter where they were held:

What mattered was the enormous whimsicality of the Bombardier at the piano, and the outrageous comicality of a tousle-haired soldier with a red nose, who described how he had run away from Mons 'with the rest of you', and the light-heartedness of a performance which could have gone straight to a London music-hall and brought down the house with jokes and songs made up in dug-outs and front-line trenches.[100]

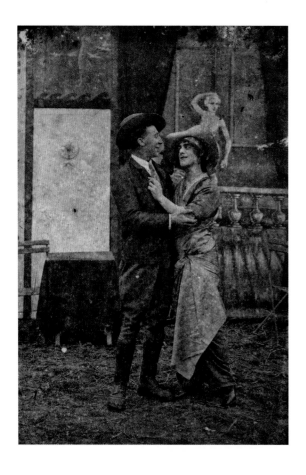

PLATES 311–312 A very mannish female impersonator with her 'beau' and (right) a performer with a local dog.
PLATES 313–314 Two performers in a Vignacourt garden and (right) perhaps this is the French family with whom these performers were billeted in Vignacourt?

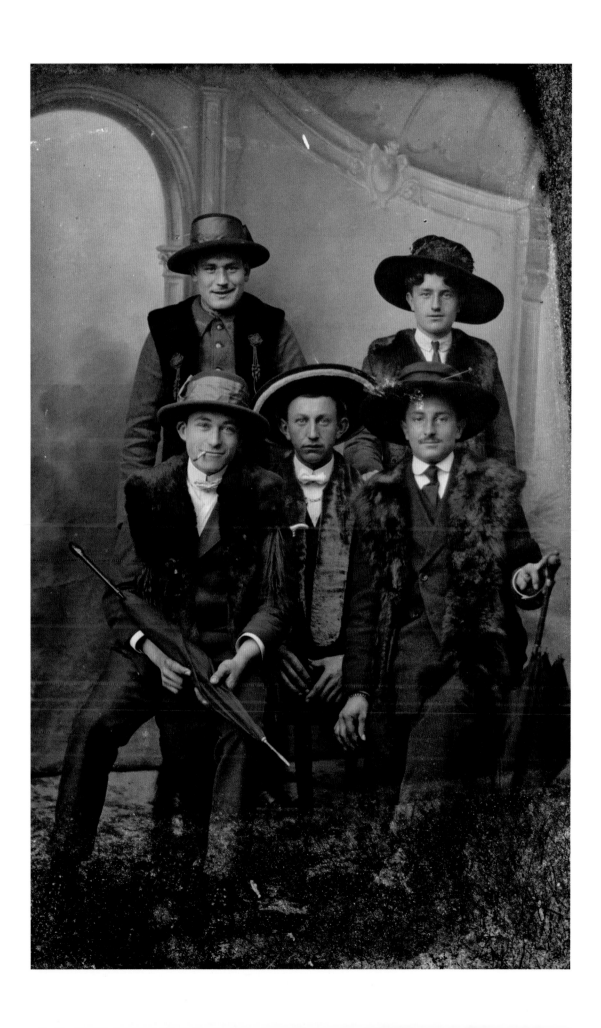

PLATE 315 These soldiers have dressed, either for a performance or for a lark to amuse families back home, in what appears to be the Sunday-best clothing of the local French villagers.

The Army Services Corps

The Army Services Corps, or ASC, was often unfairly dubbed by other combat troops as 'Ally Sloper's Cavalry', an unkind reference to a red-nosed, rather lazy, scheming character, a comic-strip shirker who made his first appearance in the British magazine *Judy* in 1867 and continued in the later 1800s in a popular cartoon named 'Ally Sloper's Half Holiday'. Even when the ASC acquired its well-earned Royal prefix in 1918, to become the Royal Army Services Corps, this did not stop the unfair nicknames; the RASC acronym was frequently derided, very cruelly, as 'Run Away, Someone's Coming'.

Infantry soldiers often scoffed at the service corps soldiers, dismissing them as not being 'real soldiers' because of a perception that ASC men enjoyed relatively comfortable and safe conditions behind the front lines. But in reality these front-line soldiers could not have functioned without the ASC. It was responsible for maintaining the supply lines of food, water, fuel and other necessities, running barracks and the fire service; its role was essentially to supply all provisions other than military equipment, weapons and ammunition. The various units included labour companies, motor transport, horse transport, field kitchens and butcheries, field bakeries and laundries. At the peak of the war, the ASC had 10,500 officers and more than 315,000 men. There were also thousands of Chinese, Indian and Egyptian labourers and more from several British colonies.

It is difficult to determine when the Thuillier images of the Army Services Corps soldiers were taken. Vignacourt was a rest and training area and a major railhead, which made it a hub for supplies and transport, so it is reasonable to assume the ASC was in the area throughout the war. There were several periods when Vignacourt was also the location for a casualty clearing station.

PLATE 316 The Army Services Corps cap badge.

PLATE 317 The insignia on this Army Services Corps soldier's left sleeve indicates he is a warrant officer first class. It is difficult to discern the exact colour of the armband but a black one denoted a state of mourning. A blue armband came in various shades and was used to denote the different stages of convalescence of a wounded soldier.

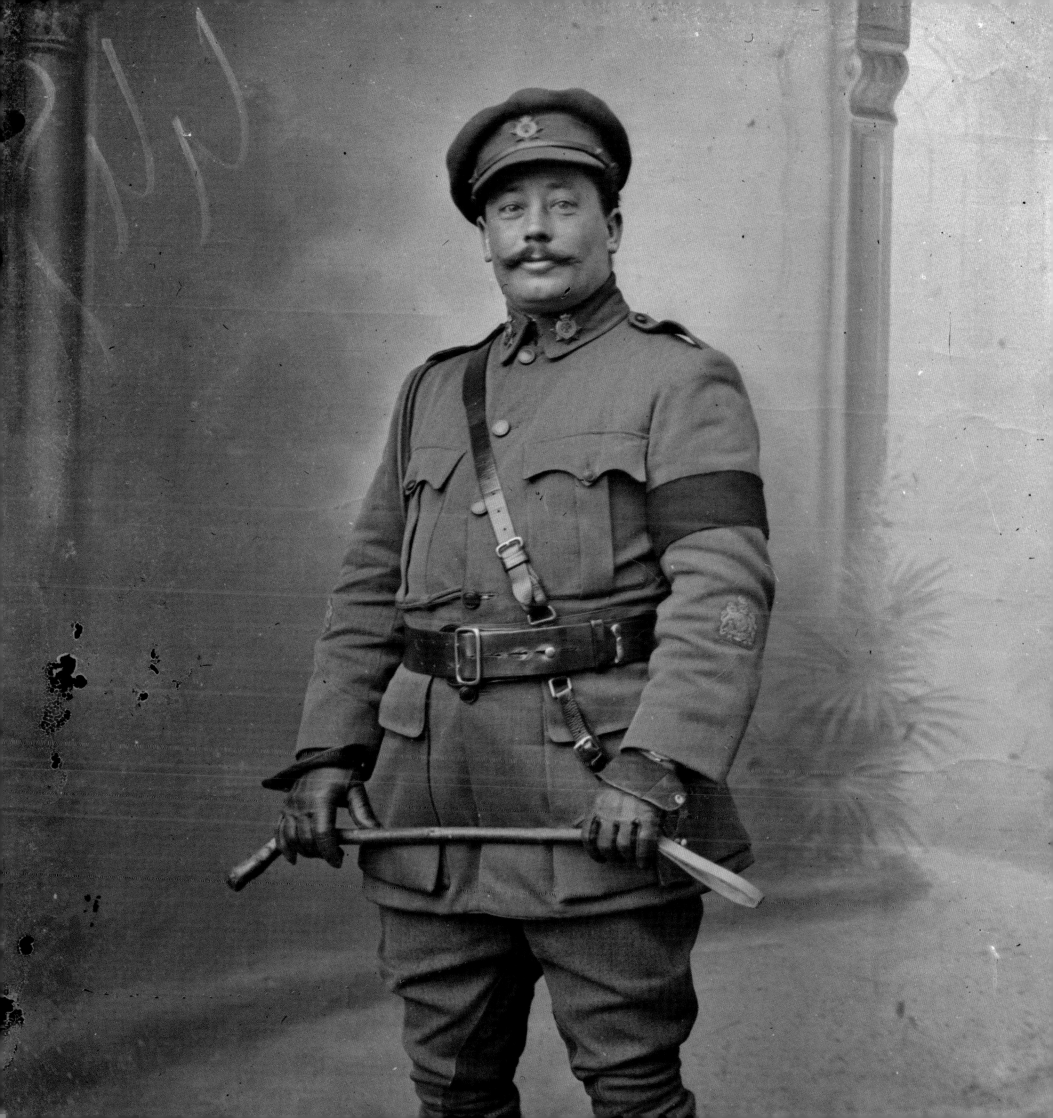

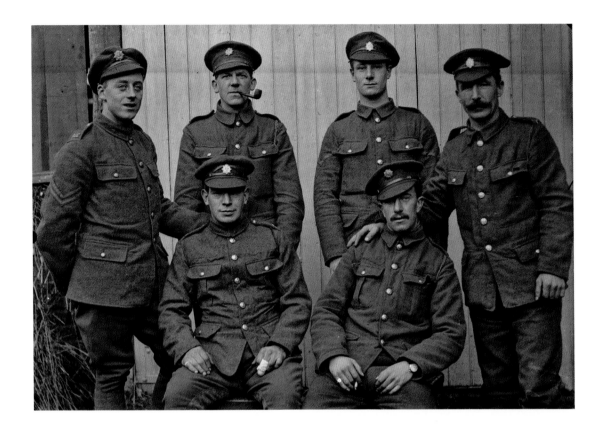

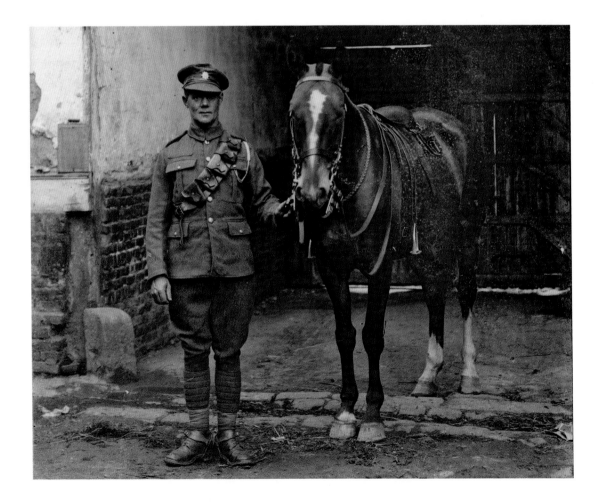

PLATE 318 A lance corporal of the Army Services Corps (left) with other privates of the corps in Vignacourt.

PLATE 319 A mounted Army Services Corps soldier, probably Horse Transport. Likely to be after January 1918 because of the overseas-service chevrons he is wearing on his lower right sleeve.

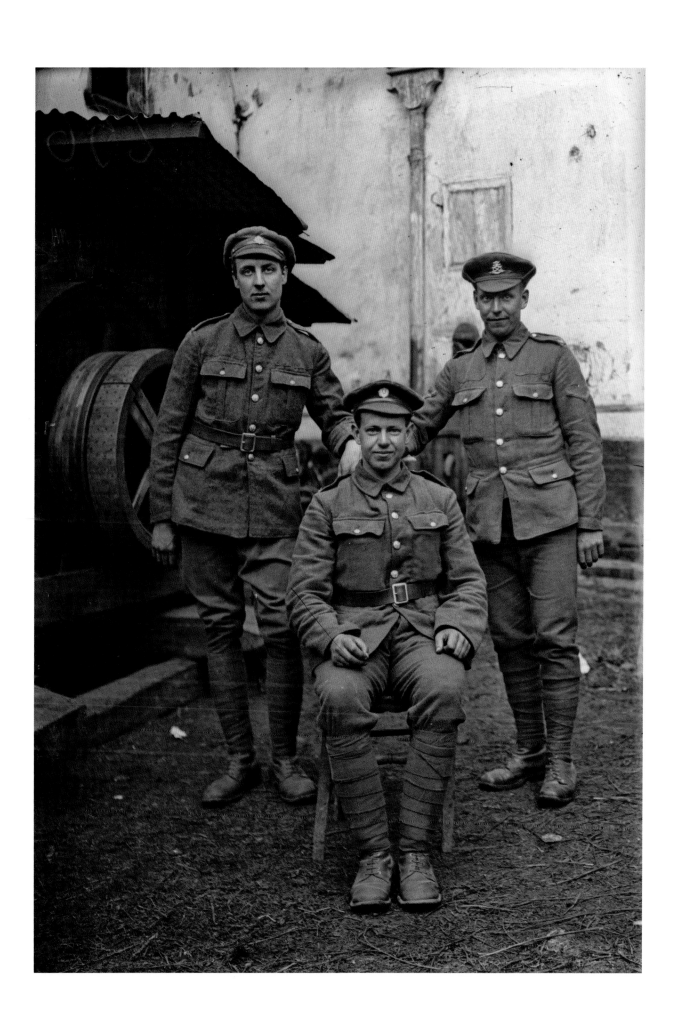

PLATE 320 Two Army Services Corps soldiers with a soldier of the North Staffordshire Regiment (right). Soldiers of the North Staffordshire are also pictured on 252–54.

PLATE 321 Soldiers of the Army Services
Corps Horse Transport.

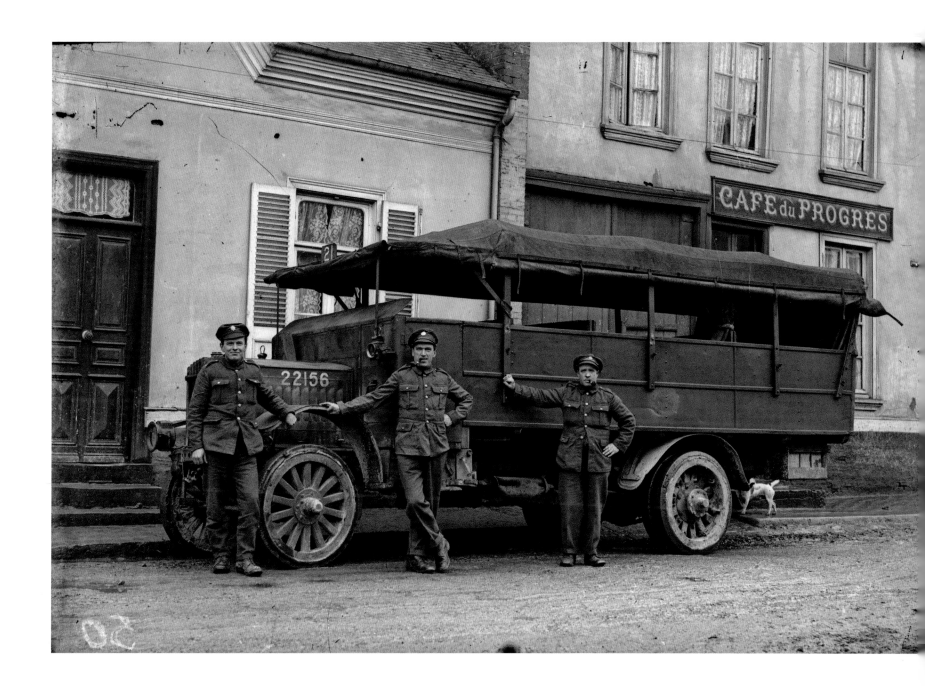

PLATE 322 As well as its transportation corps, the ASC had labour battalions to help in the disembarkation and loading of stores and supplies. By the end of 1915 these labour battalions comprised about 21,000 labourers and dock workers but by April 1917 the Army Services Corps's twenty-eight labour companies had been absorbed into the Labour Corps which was formed in January 1917.

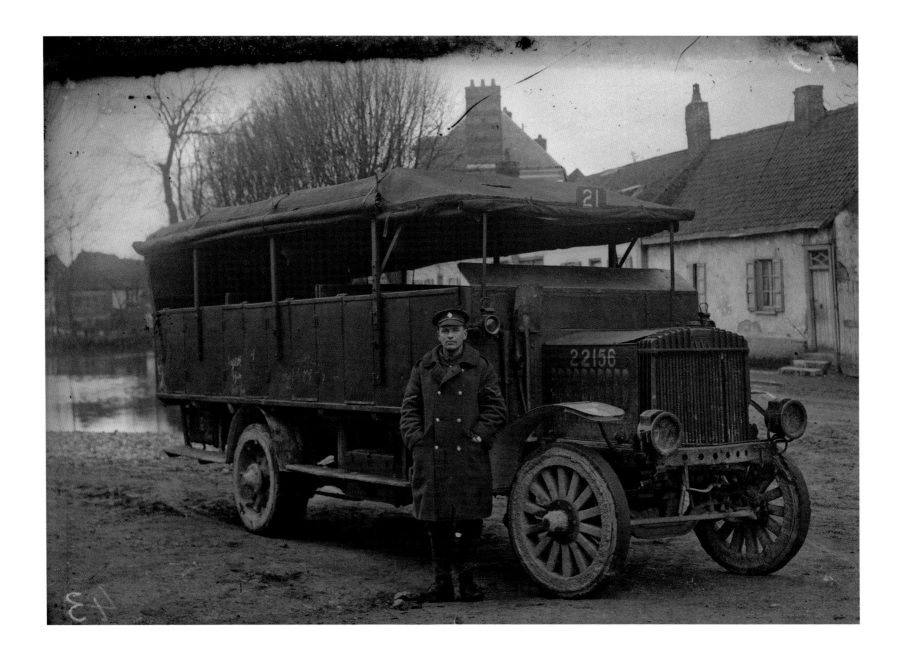

ASC soldiers were also in Vignacourt during the colder months so many of the images featuring corps soldiers were possibly taken during one of the coldest winters on record at the time in 1916–17. There are a number of images of soldiers wearing fur-lined overcoats that are different from the standard overcoat and the trench coat most often associated with British officers. The coats were made from rubberized canvas; designed to protect the wearer from the rain and the cold with a sheepskin lining.

PLATE 323 An Army Services Corps lance corporal poses in front of a troop-carrier truck.

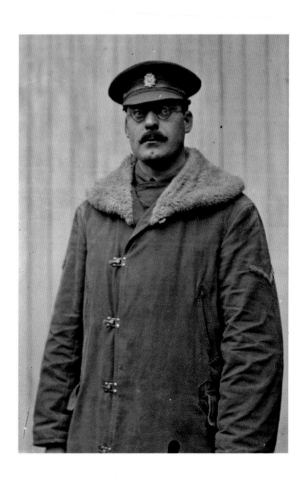

PLATES 324–325 An ASC driver with goggles and heavy overcoat, and (right) another ASC soldier with bandolier.
PLATE 326 Army Services Corps soldiers wrapped up against the cold.
PLATE 327 An ASC lance corporal.

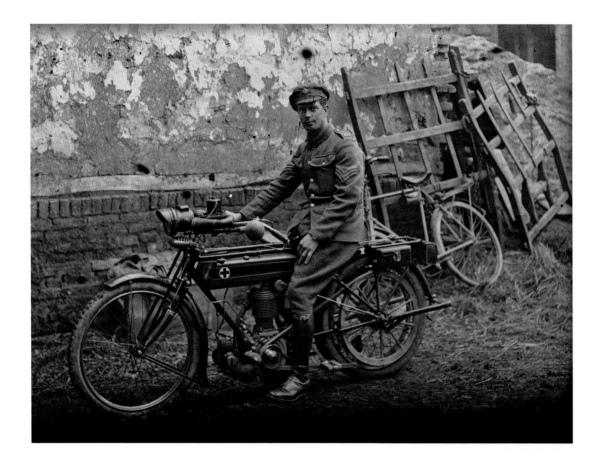

PLATE 328 An ASC soldier poses on his motorbike.

PLATE 329 An Army Services Corps soldier poses in front of his field ambulance. Closer scrutiny of the photograph reveals overseas-service chevrons on his lower right sleeve. This indicates it is after January 1918 and that he is in his third year of overseas service.

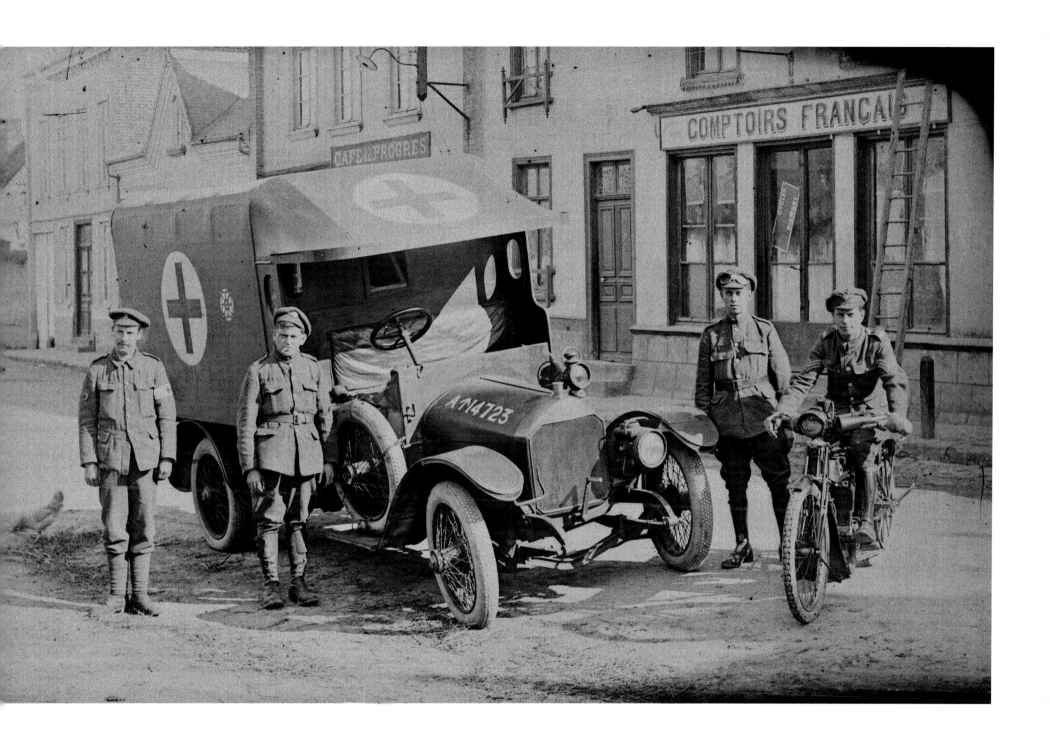

PLATE 330 Army Services Corps soldiers pose with ambulance and motorcycle in Vignacourt's main street.

The Labour Corps

Very early in the war it became obvious that the immense task of moving millions of men, supplies and equipment meant there was a desperate need for labourers to build and maintain the railway tracks, roads, camps, dumps, rear trenches, communications networks and to provide a plethora of other logistical services to keep the troops supplied and fed. For much of the war, infantry battalions used their own troops for a lot of their labour needs, creating specialized pioneer battalions. These pioneers were fully trained soldiers but they were also experienced with a pick and a shovel, many of them tradesmen or labourers from civilian life. They were complemented by the Royal Engineers, the Army Services Corps labour companies, and by conscientious objectors serving in a non-combatant role. Tens of thousands of men from the colonies were also called upon to serve. But throughout much of the war there was never enough labour to do all the jobs required. So, in January 1917, it was decided that the Labour Corps would be formed. Within a year, it peaked at just under 400,000 men, 175,000 in Britain and the rest on the various war fronts.

> *Labour units during the war were the poor relative of the Army, made up of the old, unfit and foreigners. A majority of the men were non-combatant. At the time, and since, they have not been given the recognition they deserved. Their work may not have been glamorous but can be summed up in four words: No Labour, No Battle.*[101]

The corps's work may not have been glamorous but it was vital and often challenging; one of their jobs was the exhumation and burial of bodies, after all. Many soldiers deemed unable to fight in the infantry through injury or because of poor eyesight or age or general level of fitness were often assigned to the Labour Corps. It is one of the grievances of men who served in the corps that the many former fighting soldiers who died while serving in it are not commemorated as Labour Corps men but instead

PLATE 331 The two badges worn by soldiers of the Labour Corps. The General Service royal arms brass badge was used until almost the end of the war (above top). In October 1918 a new badge was approved (above), comprising a pick, shovel and rifle with the motto 'Labor Omnia Vincit' – 'Work Conquers All'. This became the badge of the Royal Pioneer Corps.

PLATE 332 A soldier wearing the badge of the Labour Corps, issued first in late 1918, stands in front of the graves of two Australians, Privates George Gilbert Grose and Richard Mitchell Bradshaw (right). This was taken in Vignacourt's wartime cemetery, now a Commonwealth War Graves cemetery, where Labour Corps men carried out the burials and eventual exhumation for the new limestone tombstones in the official war graveyards. Louis Thuillier took many photographs of these original graves to send to families of overseas servicemen who could not afford to visit France.

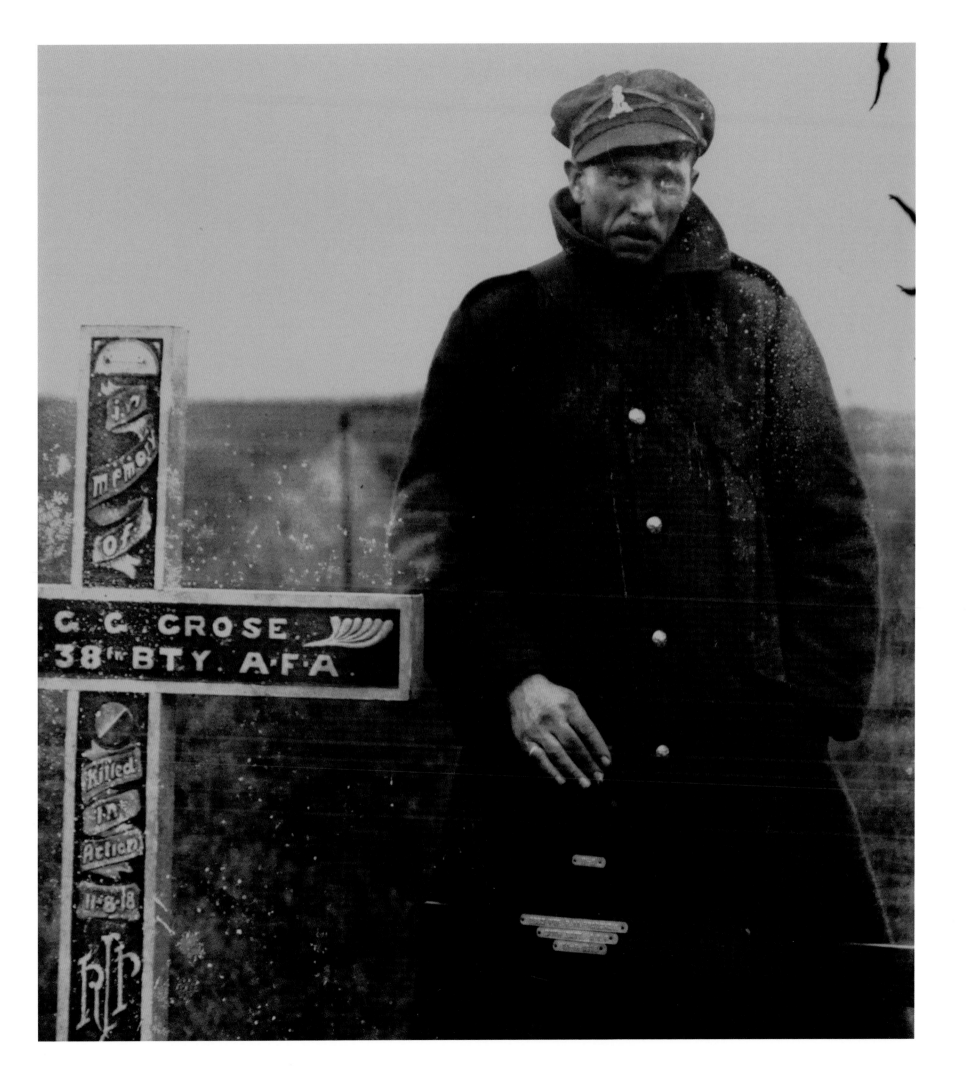

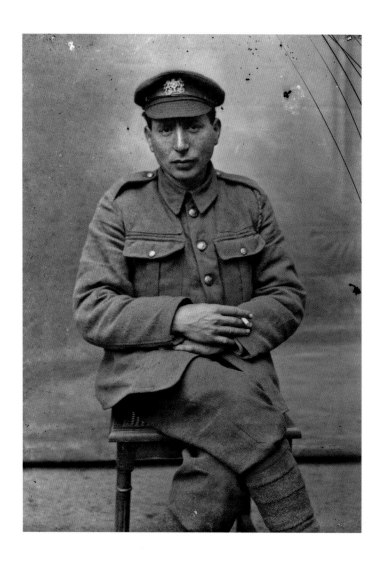

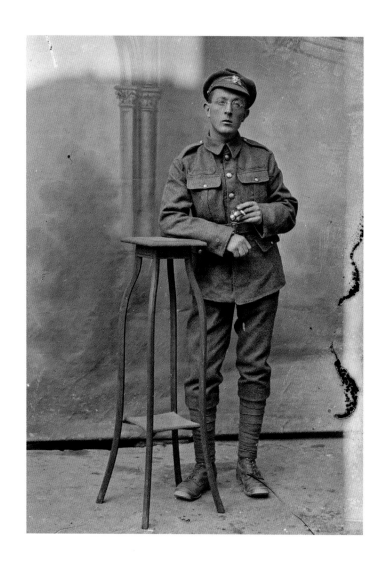

are remembered under their original regiment. Until October 1918, the Labour Corps badge was the General Service coat of arms. In the final month of the war, it was changed to an emblem of pick, rifle and shovel, which eventually became the badge of the Royal Pioneer Corps.

Because the majority of the Labour Corps men came from other regiments, they maintained their loyalty to these regiments and so they often wore two different badges denoting both their regiment and the corps. Many soldiers who were assigned to the corps from other regiments resented having to change their old regimental badge to the General Service badge. For these reasons the role of the Labour Corps went unacknowledged all too often for its substantial sacrifice in men and its massive contribution to winning the war. While they were supposedly primarily non-combatant troops the Labour Corps soldiers did their work often under heavy enemy fire and, when the Germans launched their massive offensive in March 1918, the corps was given combatant status, many serving as fighting soldiers in the desperate battle to hold the lines. About 2,300 men of the Labour Corps were killed in action or died of wounds between May 1917 and November 1918.

PLATE 333 A unidentified soldier of the Labour Corps wears the original General Service Corps badge.

PLATE 334 Perhaps this bespectacled private was assigned to the Labour Corps because of his poor eyesight.

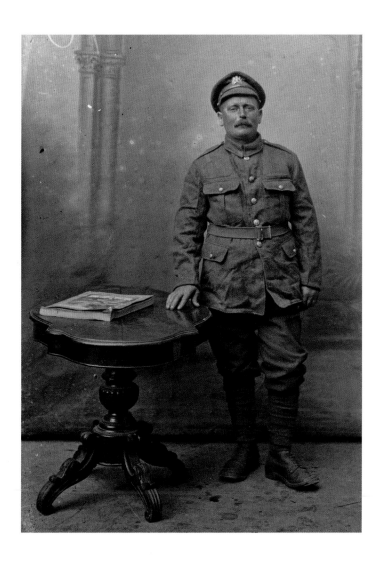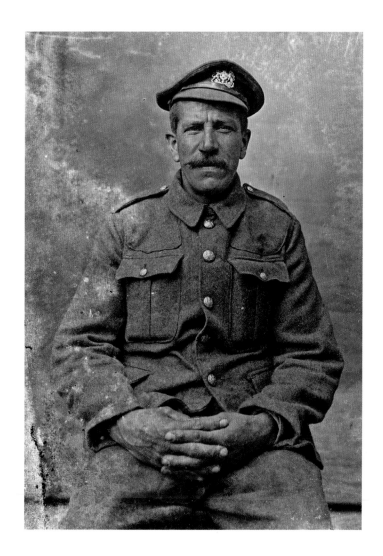

PLATES 335–336 Labour Corps

Many men came to the Labour Corps after seeing service in other regiments. Often they had been wounded or suffered an illness which made them unfit for the infantry and so they transferred to the Labour Corps instead. This change from regiment to the corps perhaps explains the group images in the Thuillier collection, where there are both Labour Corps soldiers and soldiers bearing the badges of other regiments.

Even in the Labour Corps, the men often ran the same risks as soldiers in the trenches: in May 1918, some three officers and 286 men from the 101st Labour Company were gassed; all the officers and 134 of the men were killed.[102] In one post-war memoir a Corporal J. C. Morgan, who was assigned to the Labour Corps because of his poor eyesight, took issue with the claim that the Labour Corps men always worked in safe areas.

The delusion existed, and probably still exists, that no labour companies were ever nearer the line than twenty miles. But when I tell you that the company to which I belonged – originally half of a Scottish labour battalion – was for the last seventeen months of the War never at any moment out of range of Jerry's guns, and that when he did get us he got

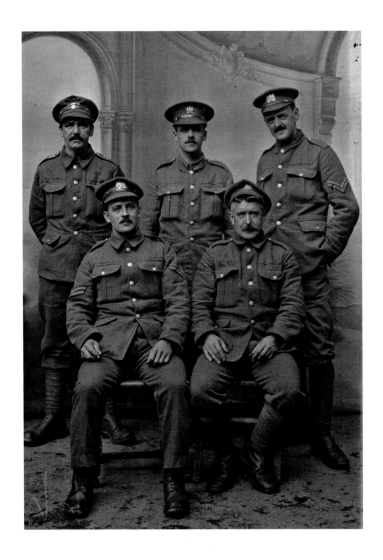

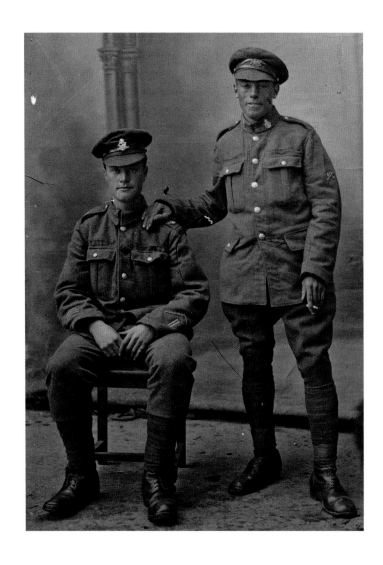

us with his biggest guns and with his high-velocities, from which there was no dodging, and
that during the struggle for Passchendaele in the autumn of 1917 our company were awarded
a Military Cross, a D.C.M., and eight M.M.'s – well, we must have been within hearing
distance, anyway.[103]

Most of the Labour Corps companies did not keep war diaries so trying to track the
movement of its men and when they might have been in Vignacourt is almost impossible.
The images of the Labour Corps soldiers in the Thuillier collection must have been taken
between February 1917, when it was created, through to the end of the war, and very likely
post-war as well, since men from the corps remained in France mopping up and some did
not return to Britain for up to two years after the war had ended.

After the First World War, the Labour Corps and the Army Services Corps eventually
became the Royal Pioneer Corps and then, in 1993, this was included in the one body called
the Royal Logistic Corps along with the Royal Army Ordnance Corps, the Royal Engineers
Postal Service, the Royal Corps of Transport and the Army Catering Corps.

PLATE 337 Two Labour Corps corporals
and a private pictured with a fusilier
(possibly Northumberland) private,
standing on the left, and a King's Liverpool
private, seated right.
PLATE 338 The Labour Corps soldier,
standing, wears the skills badge of a
bandsman on his upper left sleeve and
the lapel badge of the Essex Yeomanry
Regiment. His seated companion is from
the Duke of Wellington's West Riding
Regiment. The overseas chevrons on his
lower right sleeve indicate this is after
January 1918 and he is in his fourth year
of overseas service. He has also been
wounded twice.

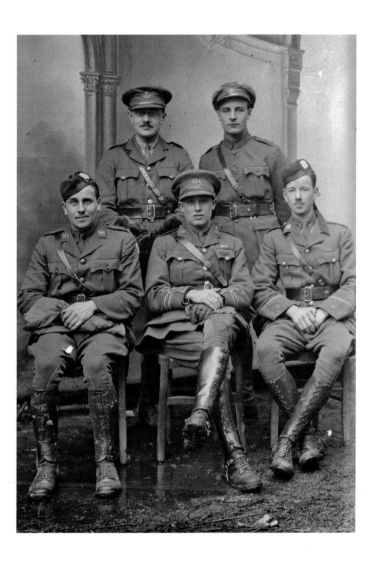 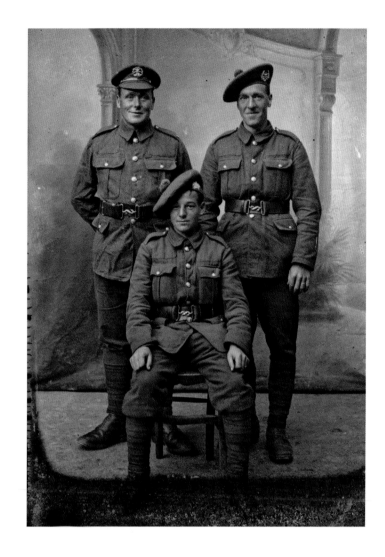

PLATE 339 The Scottish officer seated on the left has an injured hand and, although he wears the Labour Corps badges on his lapels, he also wears the glengarry with a Royal Scots Lothian Regiment badge (like the officer seated on the right). The Labour Corps captain, seated middle, wears a Military Cross ribbon. The officer standing behind (left) is Durham Light Infantry and the officer standing to his right is possibly Canadian army.

PLATE 340 The young seated soldier wears the Labour Corps badge on his Scottish tam o'shanter. Behind him the soldier on the left wears the badge of the South Lancashire Regiment and the Scot, standing on the right, wears the Cameronian Scottish Rifles Regiment badge.

The Scots

It is still a hot issue for debate as to just how many Scots soldiers died in the First World War. Some claim it was as high as 147,000. Historian Sir Hew Strachan of Oxford University has disputed this, saying it was closer to 100,000 men, challenging what has become for many an accepted wisdom in Scotland that a higher number of Scots died in the Great War as a percentage of the total population than any other country involved in the conflict.[104] Scottish nationalists have used the Great War losses to suggest (inaccurately) that as many as 26 per cent of Scots soldiers died in the war, claiming the Scottish population was depleted as a consequence by 3.1 per cent compared with a 1.6 per cent drop in England. Eminent historian Niall Ferguson has also presented figures showing that '… the Scots were (after the Serbs and the Turks) the soldiers who suffered the highest death rate of the war; yet the Scots regiments fought on to the end'.[105] Most recently, it has been suggested that even those figures are exaggerated.

There is perhaps something ghoulish about the notion of quantifying the sacrifice of those who fought in the war by measuring the relative amounts of blood spilled by each nationality. Such claims risk validating the morally bankrupt strategy of attrition employed by Allied commanders, the idea that grinding down the Germans by killing as many of them as possible could win the war. The best last word on this argument comes from a wartime commander quoted by Ferguson: 'Some foolish people on the allied side thought that the war would be ended on the Western Front by killing off the Germans. Of course this method could only succeed if we killed a great many more of them than we lost ourselves.'[106] As the available casualty data records, for most of the war the Germans actually inflicted heavier casualties on British forces – so much for the strategy of attrition winning the war.[107]

What is indisputable is that an appalling number of those who died fighting Germany were Scots. As happened with patriotic young men across the United Kingdom, thousands of young Scotsmen leapt to join up in 1914 and all too many suffered and sacrificed terribly in some of the bloodiest battles of the First World War.

PLATE 341 The regimental badge of the Scottish Highland Light Infantry Regiment. It includes the star of the Order of the Thistle, with a bugle and a battle honour – Assaye – from services in India against the Mahrattas in 1803.
PLATE 342 A soldier of the Highland Light Infantry Regiment.

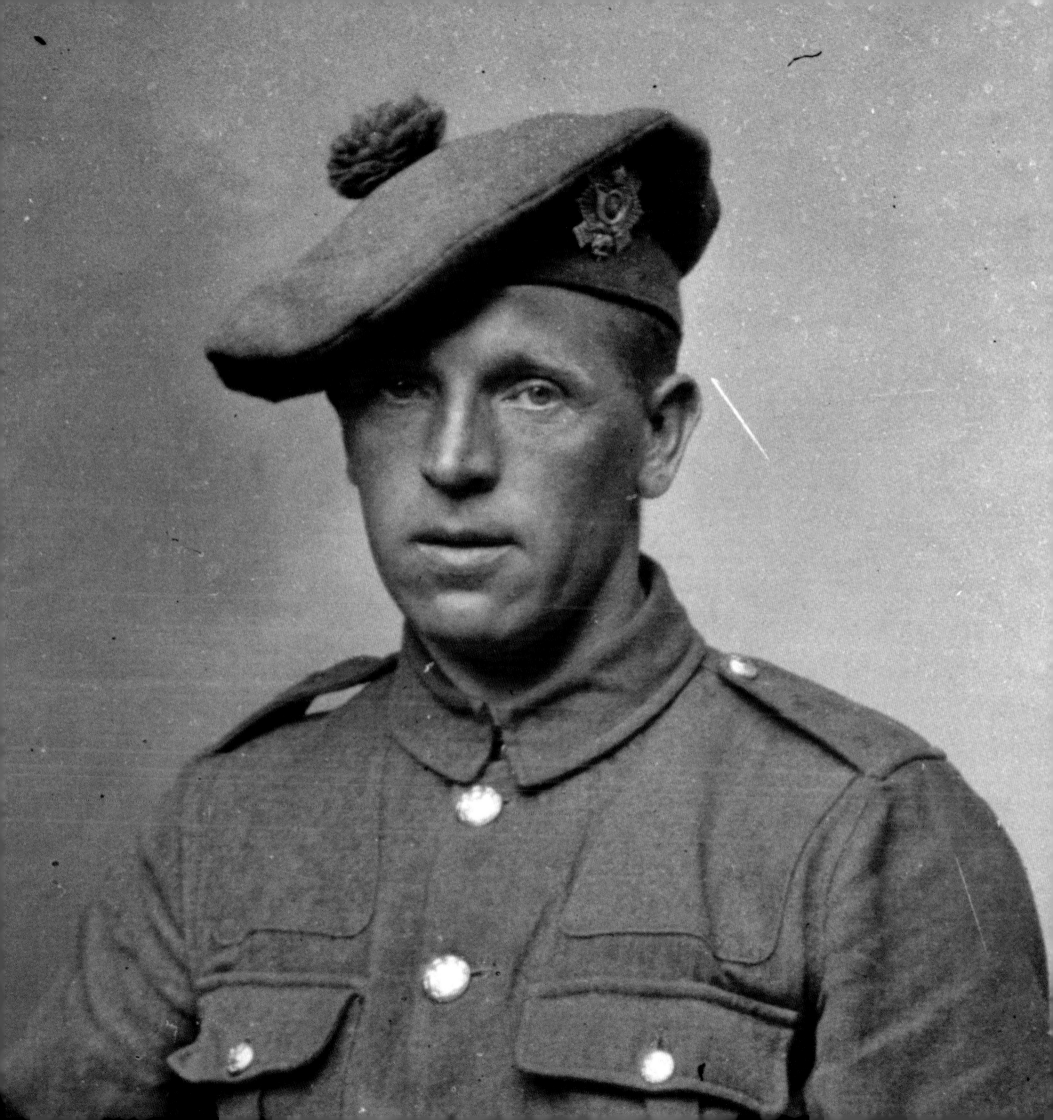

Before they came to Vignacourt and the Somme in 1916, the Highland Light Infantry Regiment and the Gordon Highlanders had fought together at the Battle of Loos, the largest British offensive on the Western Front, in late 1915. Loos took a dreadful toll on the Scottish regiments; of all the regiments that fought in that wretchedly disastrous battle, five Scottish regiments were the most represented among the dead. There are 697 Highland Light Infantry names remembered on the walls of the Loos Memorial, 829 Black Watch Regiment, 814 Cameron Highlanders, 678 Gordon Highlanders and 671 King's Own Scottish Borderers. Among them is Captain Fergus Bowes-Lyon of the Black Watch, the brother of the late Queen Mother. Britain was woefully ill prepared for the Battle of Loos; it had insufficient men, guns and ammunition; but, despite pessimism about its chances of success within the command, the attack was pressed.

During the Battle of the Somme numerous Scottish regiments suffered dreadful losses as they slowly marched in steady lines across no man's land, bagpipes swirling, towards the German lines. So many of the men on the battlefield on that first day of the Somme were Pals and other volunteer regiments; the battle was largely fought by men from northern England, Scotland, Northern Ireland, London and the north Midlands and it is wretchedly sad to see their rugged young faces staring down the lens of Louis and Antoinette Thuillier's camera, many no doubt in the weeks before they walked to their deaths on the Somme. All six of the Royal Scots 'New Army' volunteer service battalions were thrown into the Somme as well as territorial battalions. There are many young men from the Cameronians (Scottish Rifles) in the Thuillier pictures. History records how, two weeks into the Somme battle, on 14 July 1916, the Cameronians were sent in to take German trenches in front of Longueval. After three days of bloody close-quarters fighting, much of it among the ruins of the shattered village, four battalions of the Rifles had lost a shocking 2,000 men, killed, wounded or missing.

There were also young soldiers of the Royal Scots Regiment resting and training in Vignacourt before going into battle on the Somme in July 1916, and many of their faces can be seen in the glass plate negatives. The Royal Scots ranks as one of the most famous and oldest infantry regiments of the British Army, dating back to 1633. Because its

PLATES 343–344 A kilted Gordon Highlander poses at Vignacourt and (below) the regimental badge. 'By Dand' means to be watchful. The stag comes from the crest of the Duke of Gordon, when the regiment was raised in 1794. Most of the Gordons were recruited from Aberdeen or the north-east of Scotland.
PLATES 345–346 A soldier of the Cameronians (Scottish Rifles) and (below) the regimental badge. The five-pointed star comes from the coat of arms of the first colonel of the regiment in 1689, the Earl of Angus, from the Douglas family.

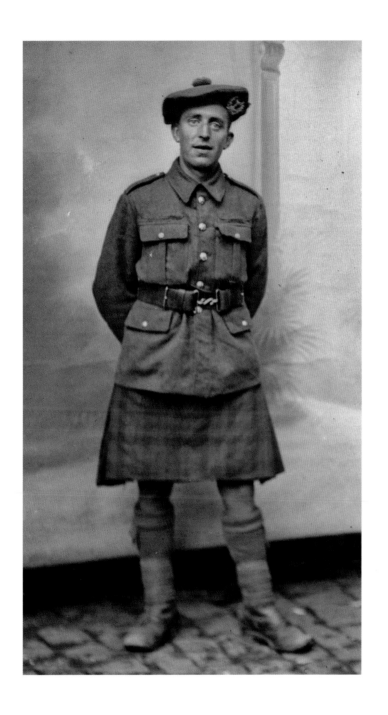

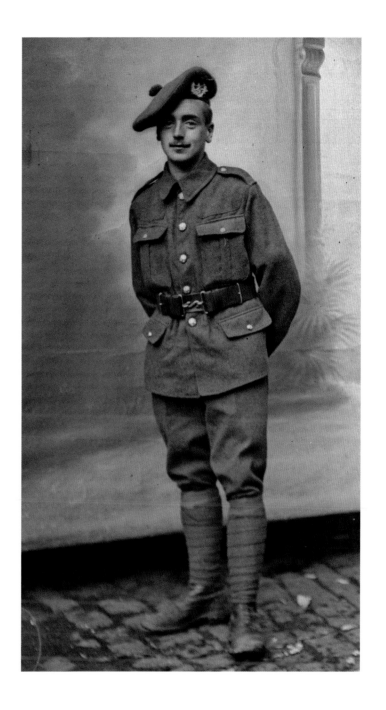

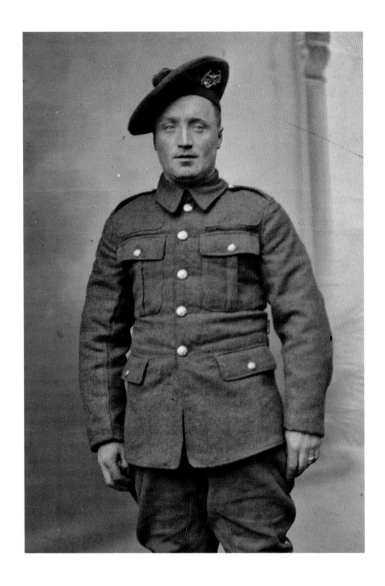
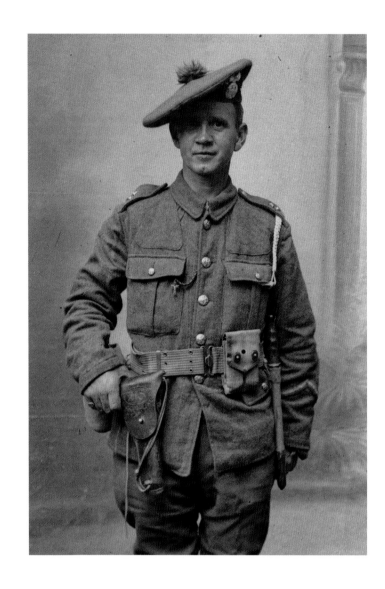

origins go back to its role as the county regiment of the Edinburgh district, its full name is the Royal Scots (Lothian) Regiment. A huge regiment, it raised more than thirty-five battalions of infantry during the war, over 100,000 men, and 11,000 of those who served in it were killed and more than 40,000 wounded, including many men from the territorial and New Army battalions of civilian volunteers. At the Battle of Mons in 1914 it was the Royal Scots that was assigned to hold up the German advance in what became a desperate fight, as one soldier later told:

> *Before leaving Plymouth one of the machine-gun section said that no German would ever take him alive. At Cambrai he was the only man left with our machine gun and he was severely wounded. He had three rounds of ammunition left in his rifle. With the first round he blew the machine gun out of action; with the second he shot a German; with the third he blew his own brains out.*[108]

PLATE 347 Cameronians Scottish Rifles.
PLATE 348 A diminutive young soldier of the Royal Scots Fusiliers. He has a US-branded holster for his revolver and carries a pick axe, so possibly belonged to a Pioneer unit. Note the small crucifix attached to his right breast pocket.

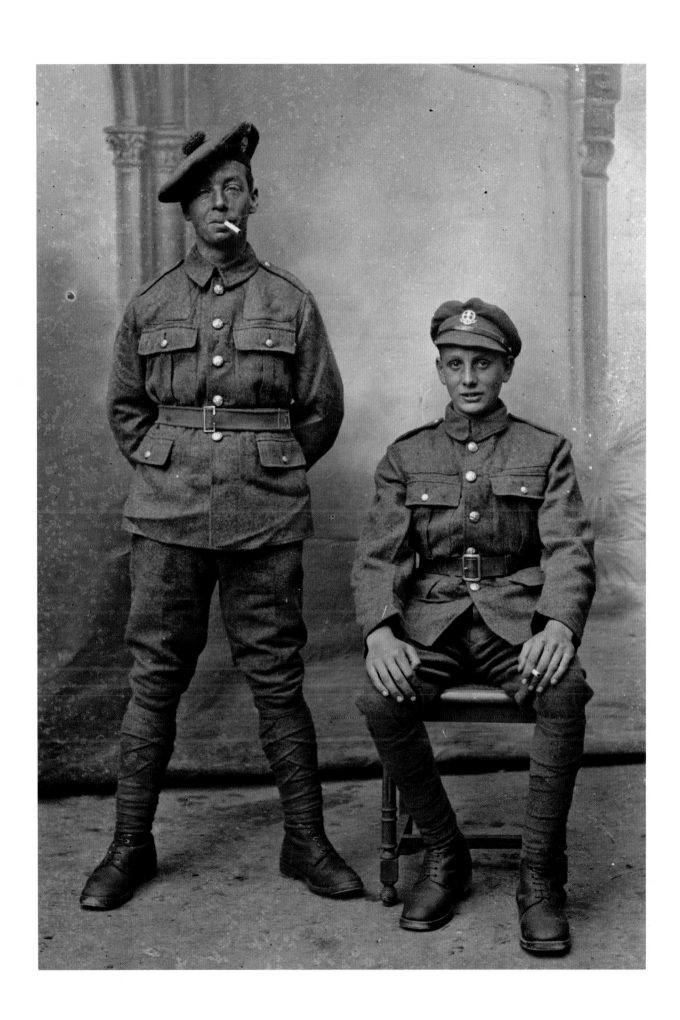

PLATE 349 A painfully young-looking soldier (right) from the Middlesex Regiment with a Scottish soldier.

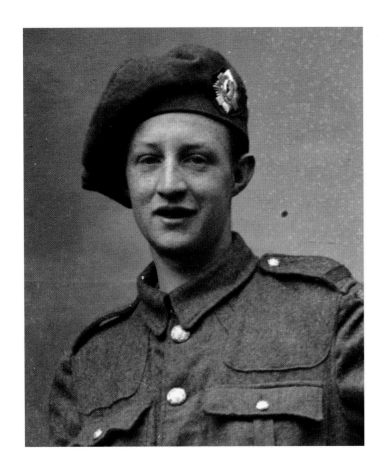

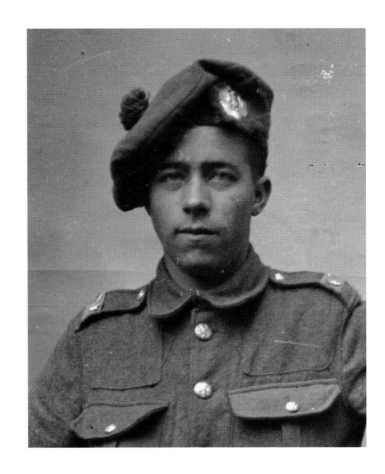

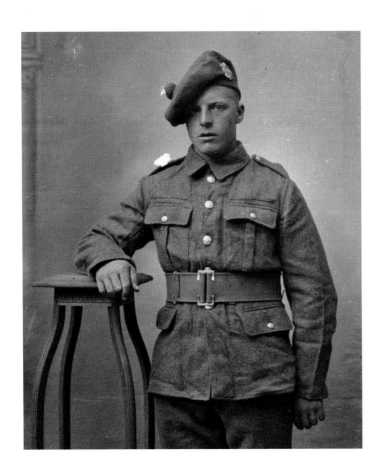

PLATES 350–352 Royal Scots (Lothian) soldiers.
PLATE 353 The regiment's badge.

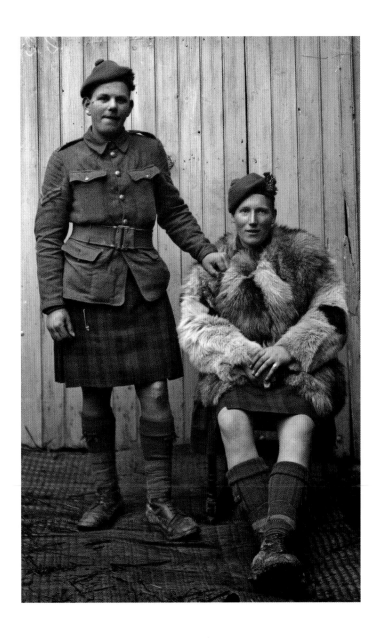

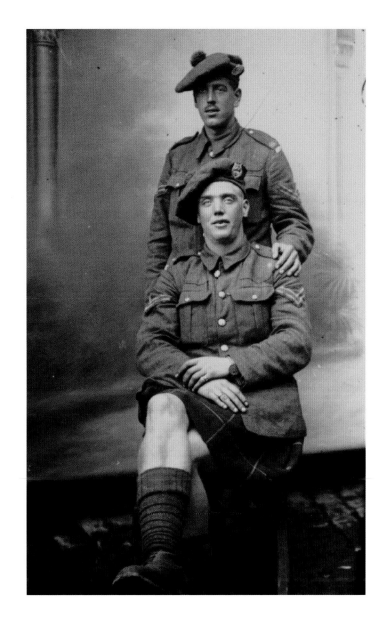

PLATE 354 The seated soldier is a Gordon Highlander.

PLATES 355–356 Possibly Liverpool Scottish the King's Regiment – see cap badge.

The Black Volunteers

The First World War posed a curious dilemma for the bureaucrats of the War Office because thousands of black men from the West Indies in particular, as well as those living in the United Kingdom, were offering to join up to fight for Britain. For many West Indian and Indian men, as it was for the Irish, showing their patriotism was their way of pushing for constitutional reforms that they hoped would bring more representative government in their own countries. But using black recruits was a particularly sensitive issue in the army; less so in the Royal Navy because it had been hiring men of colour to their vessels from across the Empire for years. The British Army's 1914 *Manual of Military Law* actually suggested that 'any negro or person of colour' was an alien; and that meant that such 'aliens' would never be allowed to hold a rank higher than a non-commissioned officer and that their numbers should be limited to just one in fifty in the ranks. However, the manual tied itself in knots because, in total contradiction of this declaration, it also said a serving black man was 'entitled to all the privileges of a natural-born British subject'.[109] British nationality legislation also clearly said that anyone born within Britain's dominions was a natural-born British subject and entitled to all the rights and privileges thereof. It all led to an erratic and often inconsistent recruitment strategy for people of colour during the war as recruiters first discouraged West Indians in particular from joining up; they then recanted as the Somme took its toll and the government finally allowed the formation of a West Indies Regiment. The Thuillier images support the idea that black soldiers were allowed to serve in many British Army regiments; they show black soldiers serving in regiments such as the Royal Engineers (especially) and the West Yorkshire Regiment.

Sadly, what lay behind the reservations was a racist view among many white commanders that black soldiers lacked the discipline to be good soldiers. In *Jamaican Volunteers in the First World War* Richard Smith describes how a senior War Office mandarin suggested that '… "coloured men … would be most dangerous to the efficiency … of the

PLATE 357 A black Royal Engineers lance corporal.

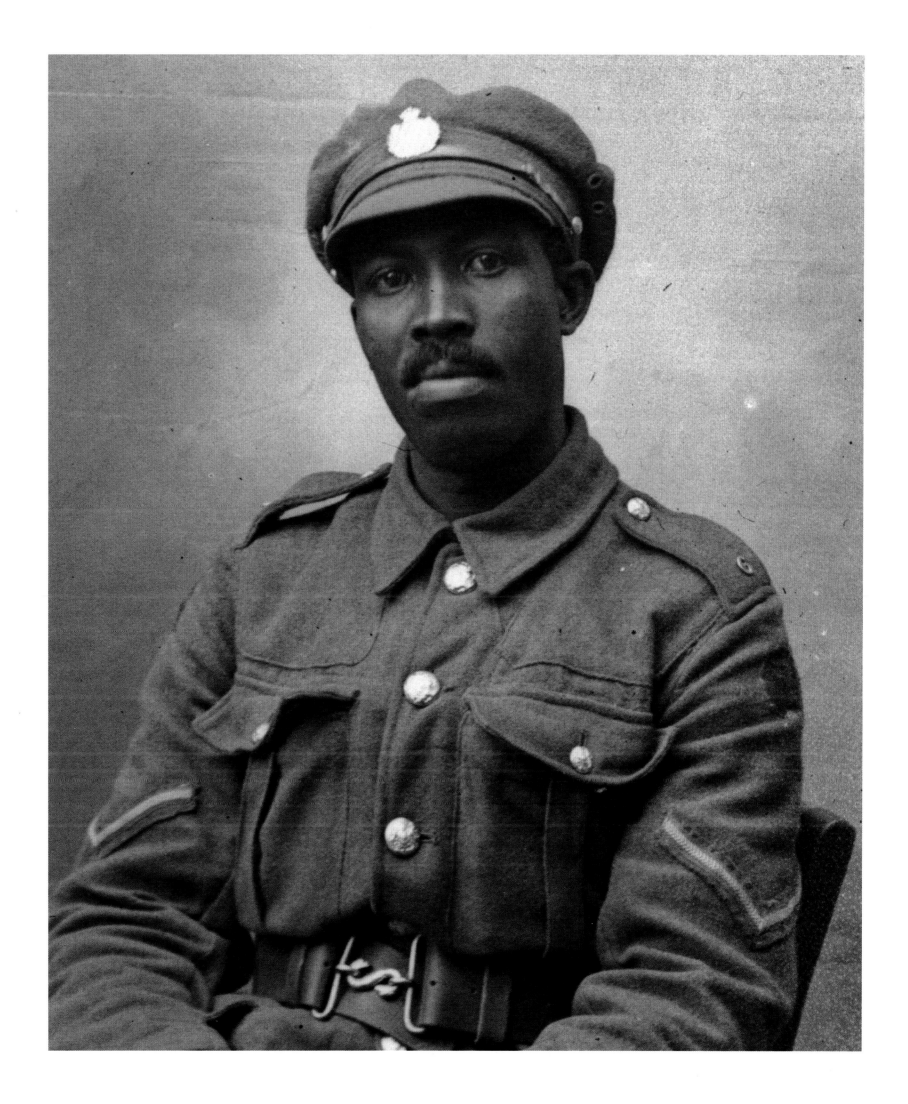

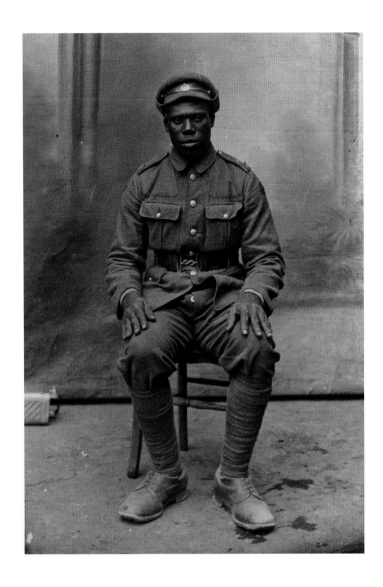
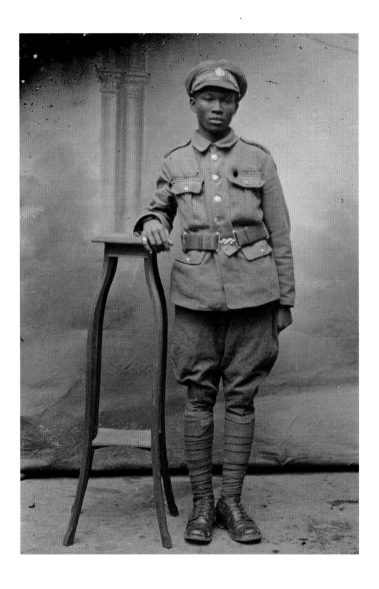

armies in France." Although they had played a significant role in many Imperial campaigns, black soldiers came to be regarded as objects of curiosity to be paraded at ceremonial occasions as a signifier of Imperial unity.'[110] In contrast to that view, some of the Thuillier images in fact suggest a warm acceptance of black servicemen by their fellow soldiers, as in the West Yorkshire Regiment image on p. 303.

In the end the huge losses of men on the Western Front meant that such unwarranted reservations about black soldiers were thrown aside because of pragmatic necessity. Indian soldiers were first allowed into the front lines very early in the war; they fought at the Battle of Ypres in 1914. More volunteers came from India than any other part of the Empire; by 1919 India had provided about 1.5 million volunteers and about 800,000 of their troops fought. A disproportionate number of them were Sikhs, an ethnic and religious group with a proudly fierce military tradition; their distinctive turbans feature prominently in many Thuillier images.

PLATE 358 A black soldier wearing the regimental badge of the Royal Engineers.
PLATE 359 A very young black Royal Engineer.

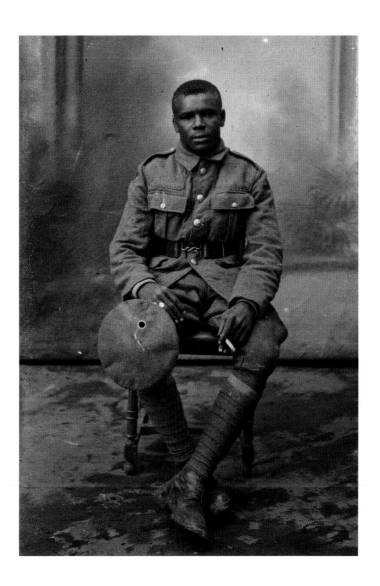
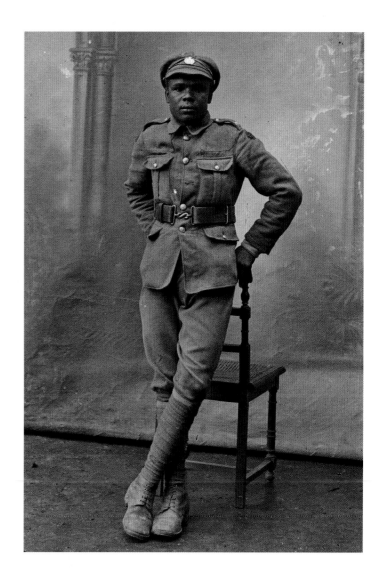

PLATES 360–361 A solemn young black soldier, wearing his cap that identifies him as a Royal Engineer (right).

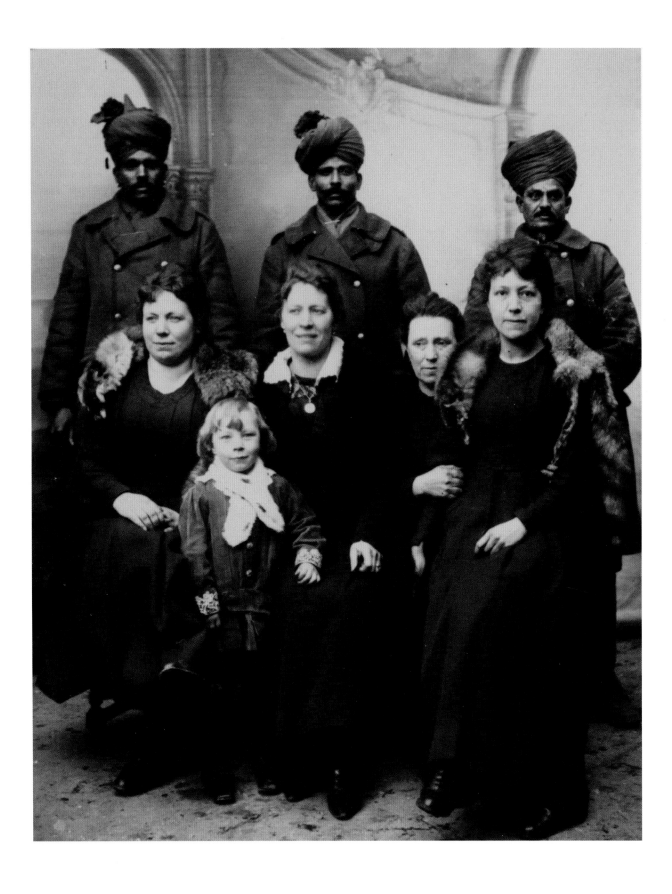

PLATE 362 Unidentified Indian Sikh soldiers posing with a French family. Perhaps they were billeted with this family?

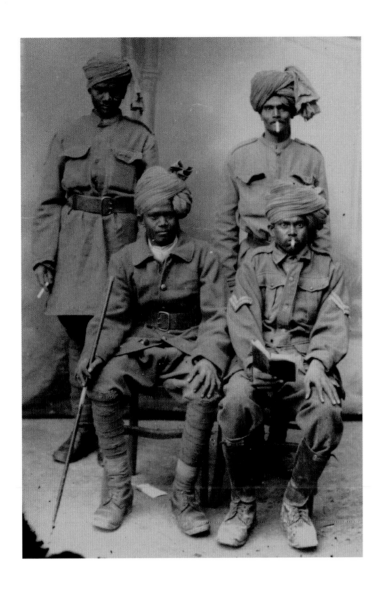
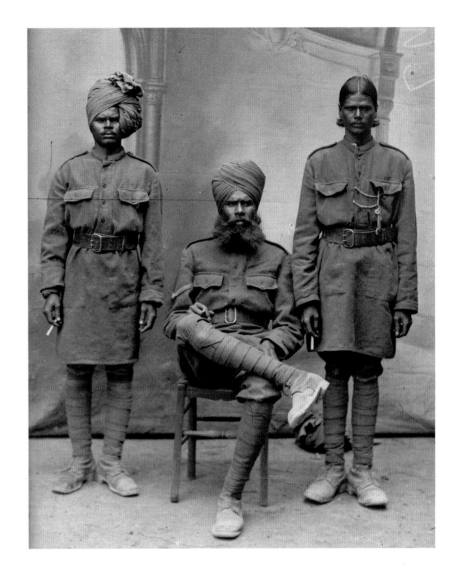

PLATE 363 Very young Indian Sikh soldiers – most probably non-combatants in a labour battalion.

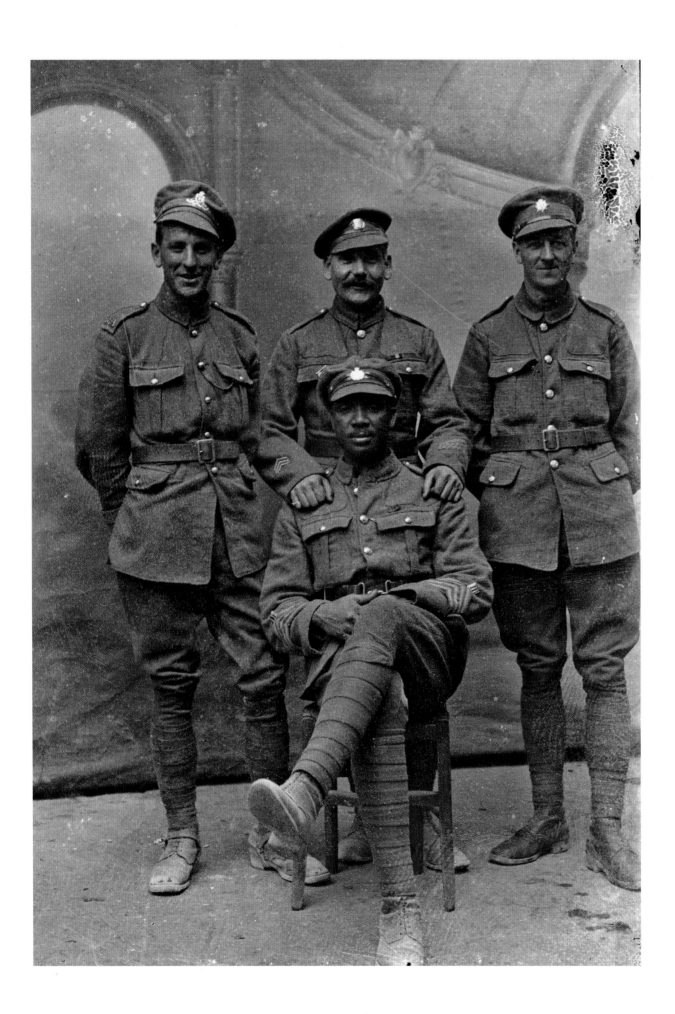

PLATE 364 The seated black Royal Engineer wears a medal ribbon and has a long history of good conduct as the chevrons on his lower left sleeve denote. The soldier standing behind him also wears a medal ribbon and is from the Army Ordnance Corps. The soldier standing on the left is Royal Field Artillery and the soldier on the right is Army Services Corps.

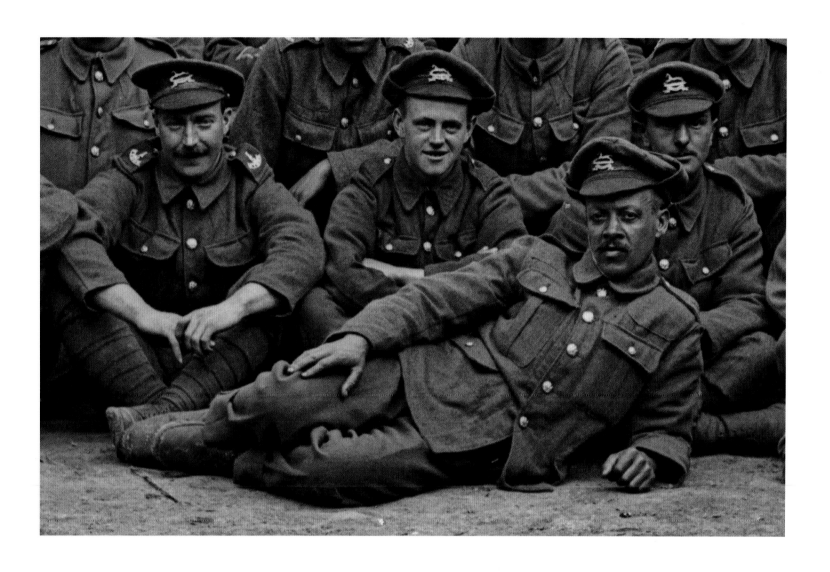

PLATE 365 An unidentified black soldier of the 6th Battalion West Yorkshire territorials.

West Indian troops, however, were not deployed on the Western Front until 1915, and even then the prevailing view was that white soldiers should be doing the fighting and black soldiers were at first given dangerous non-combatant jobs such as trench digging, laying communications wires or carrying and loading ammunition. Very soon, though, they found themselves in combat. The first British West Indies Regiment was finally formed in late October 1915. There were only 1.7 million people in the British Caribbean colonies at the time but over 1,200 West Indian soldiers were killed in the war, and more than 2,500 wounded.

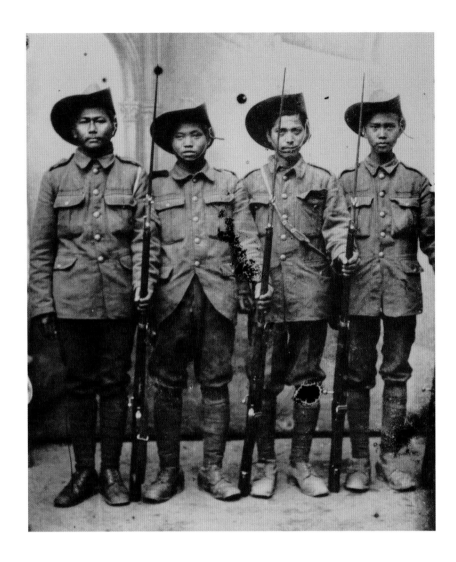

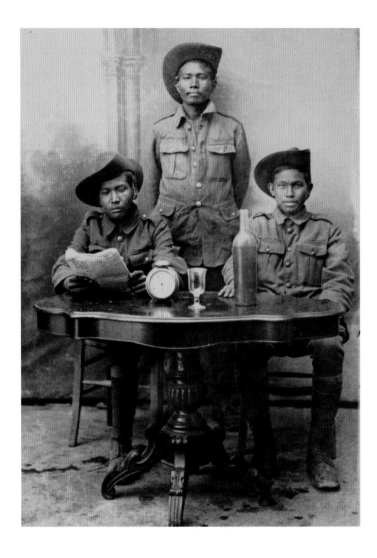

More than 200,000 Nepalese also served in the British Army during the war, in thirty-three battalions. Many were non-combatants, serving in the Labour Corps, but many were the legendary Gurkha soldiers, who fought in combat battalions on the Western Front, as well as in Turkey and the Middle East. At Loos in 1915 a battalion of Gurkhas fought to the last man, cementing the almost mythical status accorded them by one former Indian Army Chief of Staff, Field Marshal Sam Manekshaw, who said: 'If a man says he is not afraid of dying, he is either lying or is a Gurkha.'[111] The Germans were so impressed by the bravery of one Gurkha – Kulbir Thapa – at Loos, as he rescued several men in full view of their lines, that they lowered their guns and applauded him. Thapa would win the Victoria Cross for his gallantry.

PLATES 366–367 Nepalese soldiers, possibly Gurkhas.

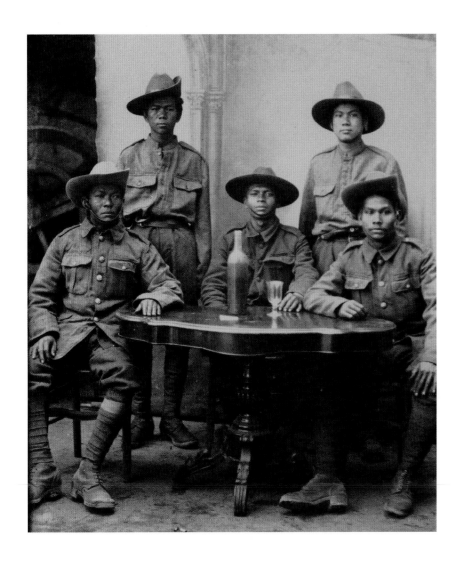

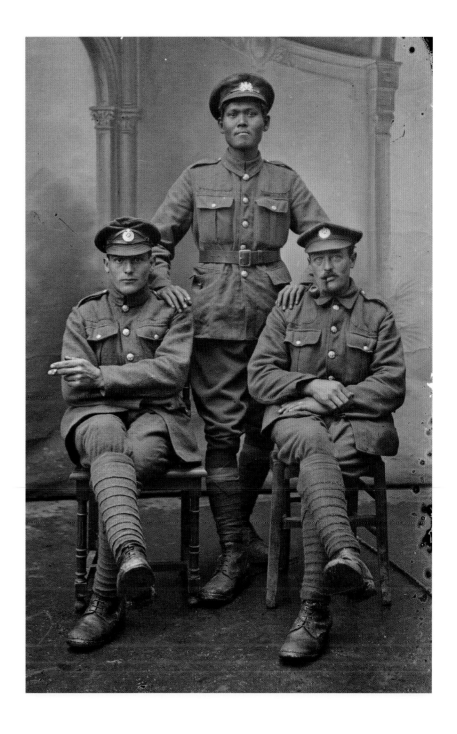

PLATE 368 Five Nepalese soldiers – possibly Gurkhas.
PLATE 369 A Nepalese soldier from the Labour Corps with two Royal Engineers.

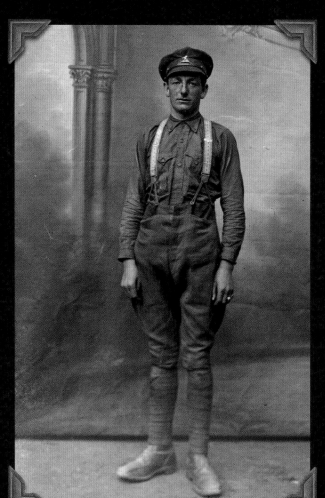

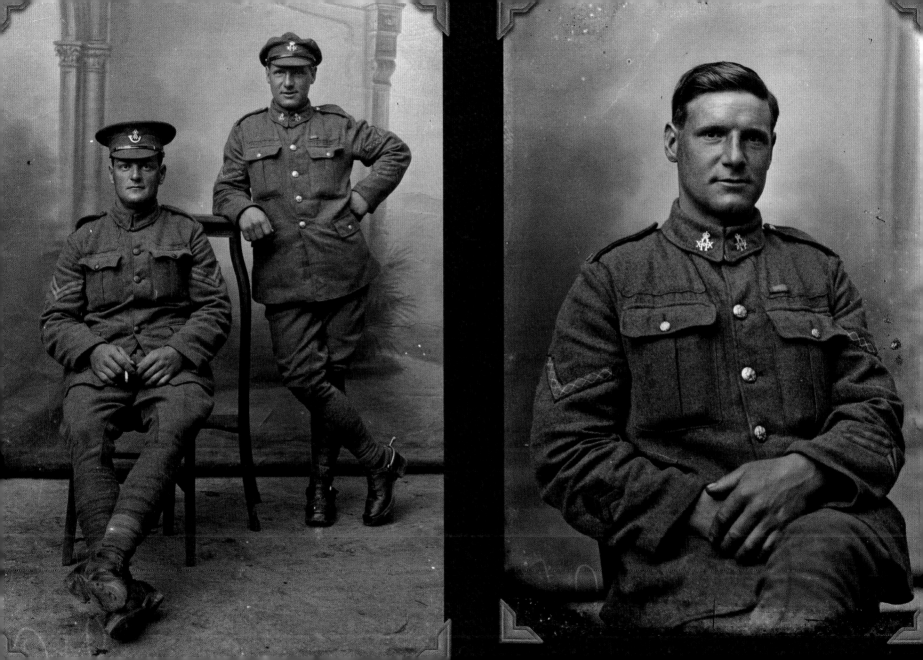

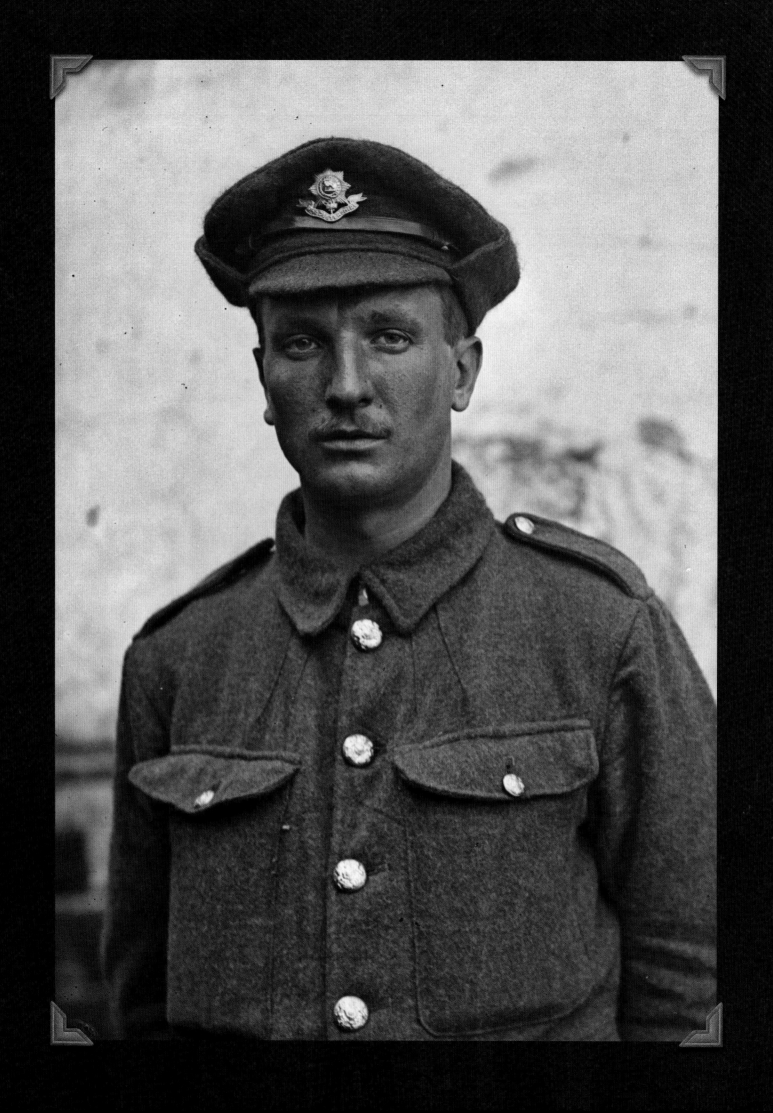

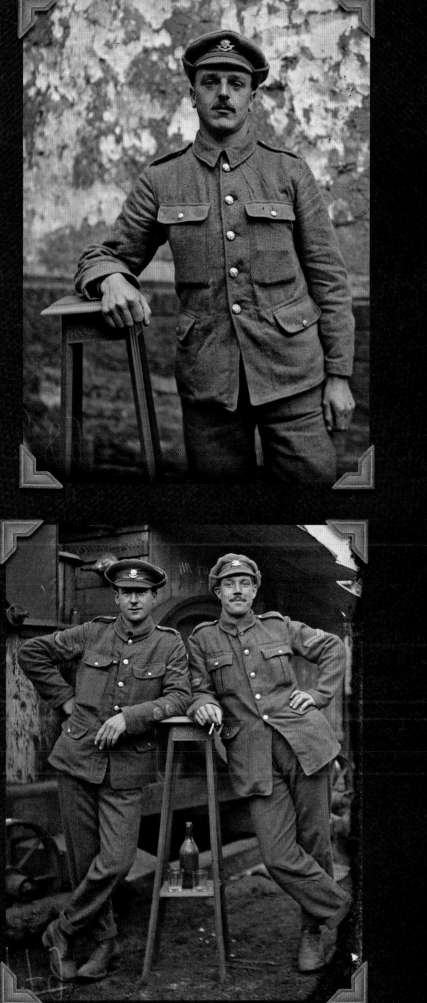
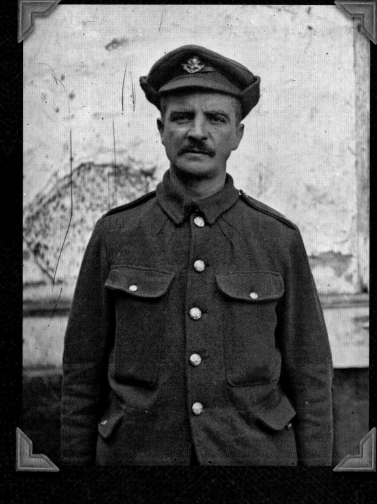
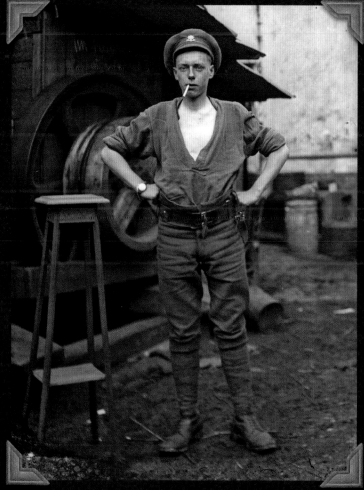

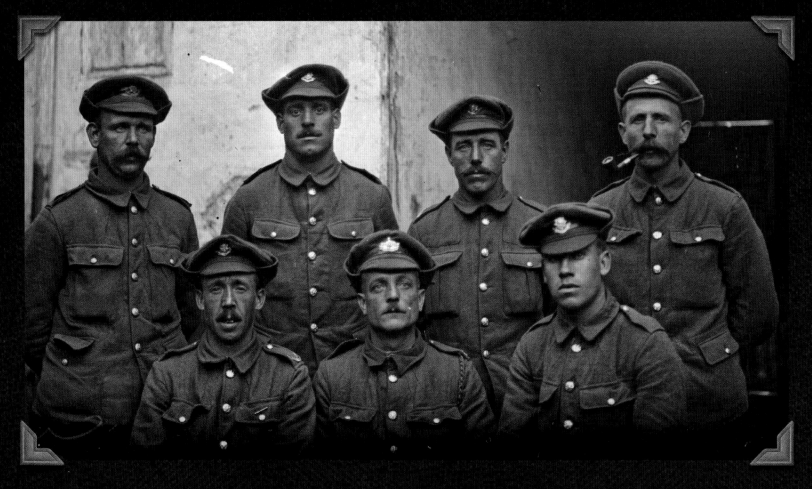

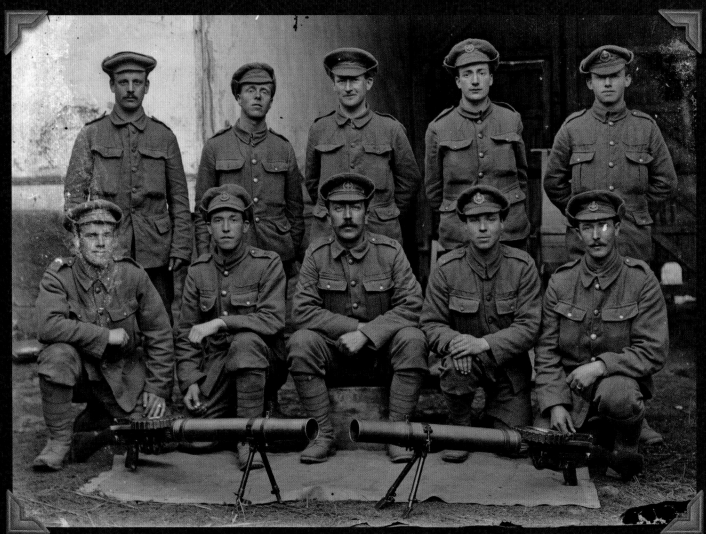

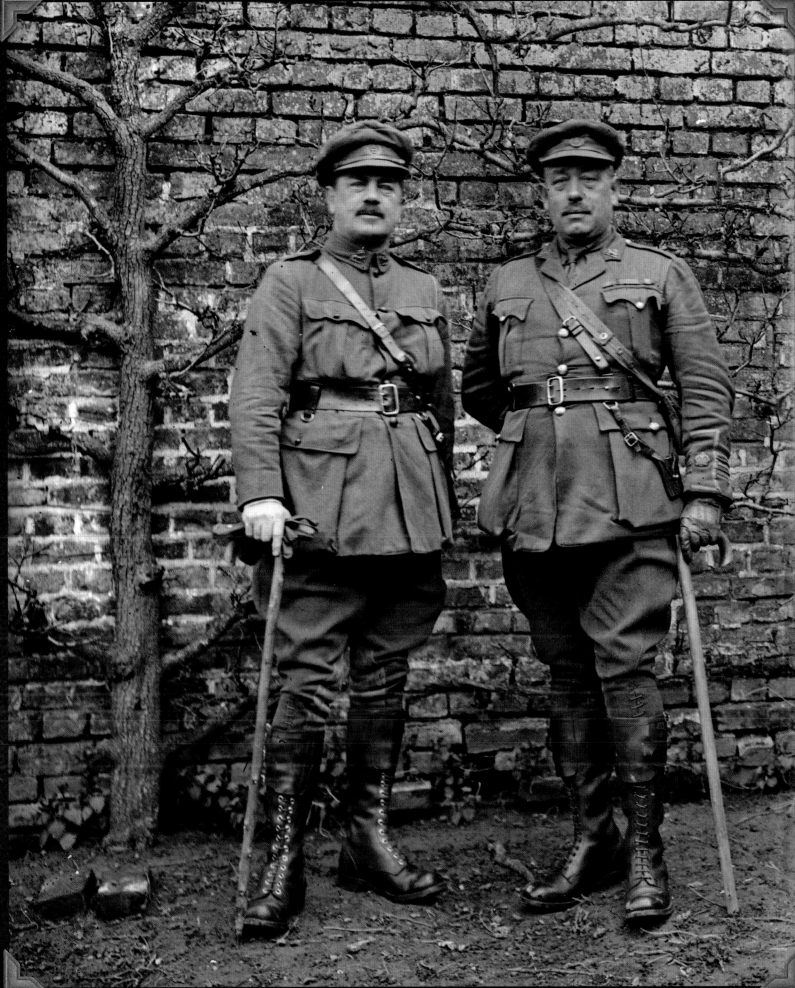

The Sappers

They have long been known as the 'Sappers', a sobriquet derived from one of the most dangerous jobs for which the Royal Engineers Corps became renowned; the 'saps' were the trenches and tunnels that the engineers built so that bombs could be detonated close to the enemy trenches, hence 'sappers'. The successful execution of the First World War quite simply would not have been possible without the massive engineering works that supported it. It was the Royal Engineers who built and operated roads and railways, maintained communications, and who fortified troop and artillery front-line positions as well as maintaining their weaponry. At the beginning of the war the corps was tiny, with about 10,500 men, but by the end of the war it had a force of over 300,000 soldiers under its command. The sappers were attached to field companies that served with different regiments throughout the army – and they were expected to fight just like any other combat soldier when required. They repaired everything and they also specialized in demolition. There are over one hundred Royal Engineers images in the Thuillier collection, no doubt because they were continually based in Vignacourt throughout the war.

As the Western Front sank into a trench-war stalemate, one of the strategies used to break the German lines was tunnelling – 'moling' – under their lines and then exploding massive mines from underneath at the moment of an attack. These tunnels became so complex that it fell to officer engineers to actually map the underground shafts to keep track of the whole system. The album of Lieutenant Colonel F. J. Salmon, held at the Royal Engineers Museum at Gillingham in Kent, describes how he had to take his theodolite and steel measuring tape into open front-line areas to attempt a survey map. He also conveys a sense of the enormous hazards the miners faced underground in a battle of wits with the Germans, who were also tunnelling from the other side of the front line:

> *On one occasion when my two corporals and I were working next to a shaft in one of the*
> *forward saps, the enemy blew it with a counter-mine. There was only a small puff at the*

PLATE 370 The cap badge of the Royal Engineers Corps.

PLATE 371 A wonderfully sharp Thuillier image – it looks as if it was taken yesterday rather than a hundred years ago – of two young Royal Engineers Corps soldiers. The man on the left wears the armband of a signaller.

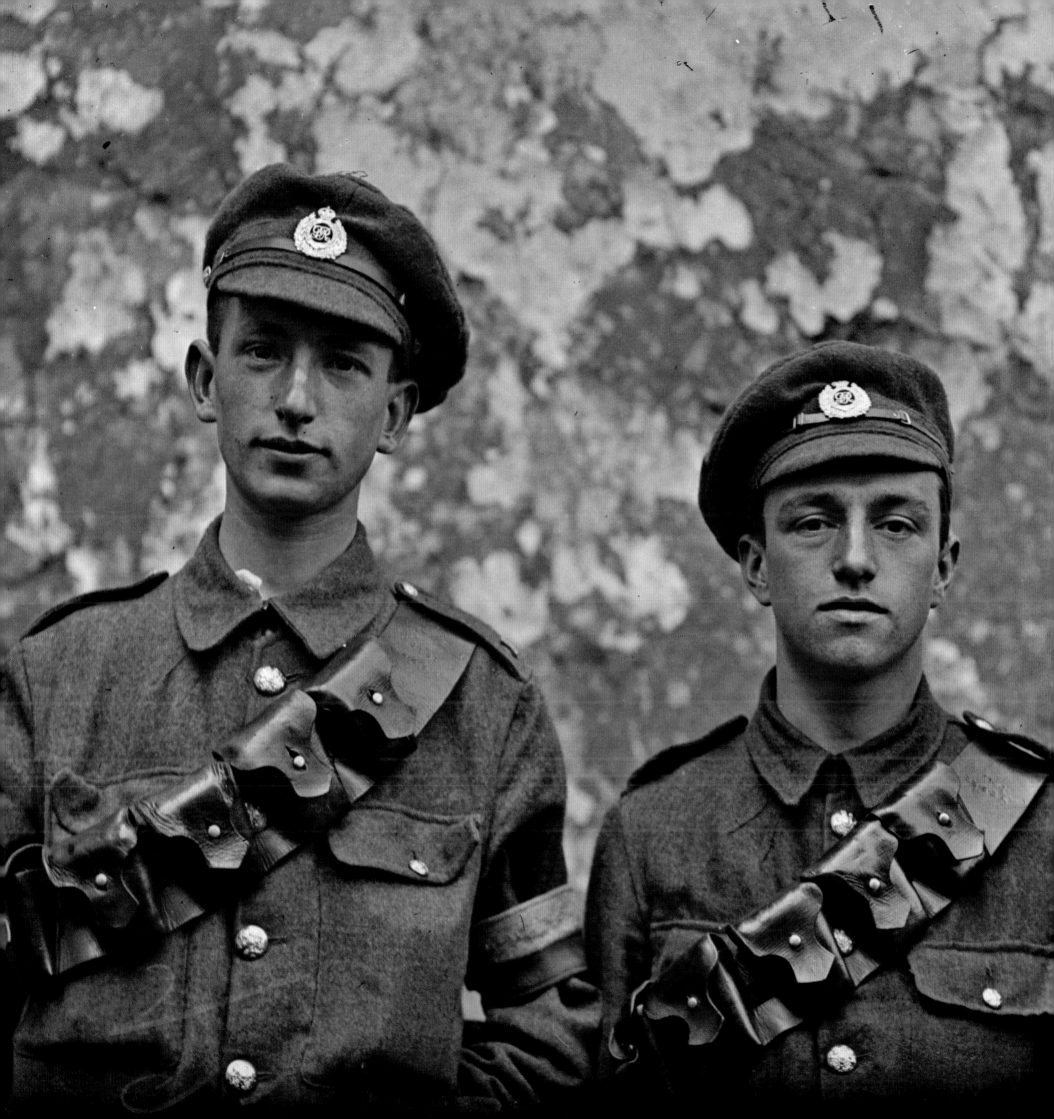

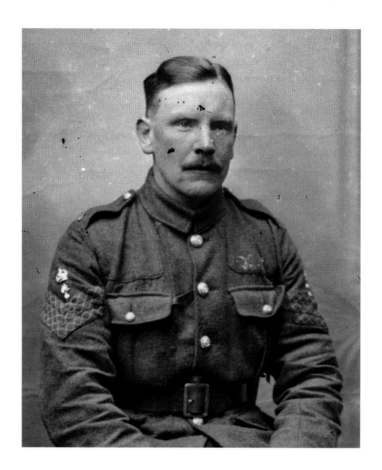

surface but when Lieut. Humphreys of the Tunnelling Company went down the shaft he found
that the two men who had been there had been killed by gas. The usual test with a canary
had indicated gas but that didn't stop Humphreys going down on a rope. He was pulled up
unconscious but he had the two pay-books in his pocket so the story was clear enough before he
recovered sufficiently to tell it himself … Our job got done in the end, the only casualty being
Corporal Gardiner's cap – it was before the days of tin hats – which had a sniper's bullet
through the head-band and which he kept as a souvenir.[112]

One of the biggest mines planted by the Royal Engineers was at Beaumont Hamel
on the first day of the Somme. An enormous 18,500 kilograms of explosives was detonated
ten minutes before the infantry was due to go over the top, an explosion heard across the
English Channel. At the Battle of Messines in June 1917 the engineers dug tunnels nearly
one kilometre long under the German lines, setting off nineteen mines in one massive
explosion.

The Royal Engineers distinguished itself with its constant inventiveness; one of
the cleverest innovations was the so-called Nissen hut, a semi-circular-shaped building
made out of corrugated iron sheets, designed by a Royal Engineers captain (later major)
Peter Nissen. It became one of the most common buildings used by the British Army.

PLATES 372–373 Both these Royal
Engineers wear grenade arm badges
indicating they are sergeants in the corps
and (right) the crown on the soldier's
sleeve indicates he is a staff sergeant or
a company sergeant major.

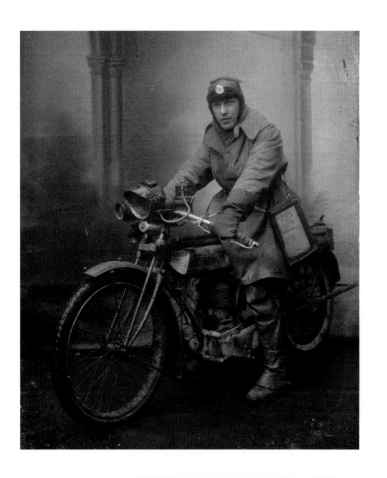

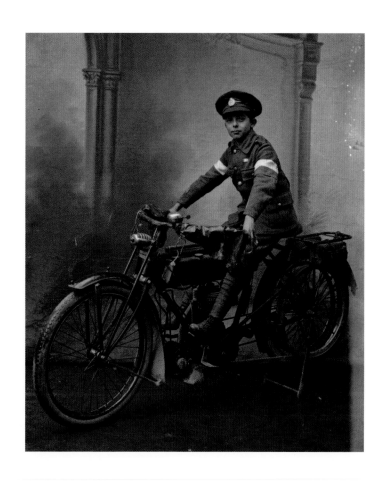

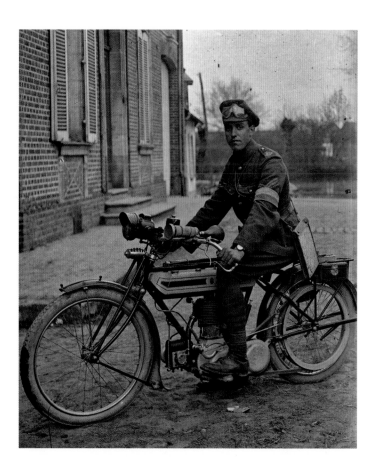

PLATES 374–375 A Royal Engineers dispatch rider wrapped up against the winter cold – note the map case on his side and (right) one of the local Vignacourt children has been given a cut-down Engineers cap and uniform to pose on a motorbike.
PLATE 376 Another Royal Engineers dispatch rider poses in the street outside the Thuillier house.

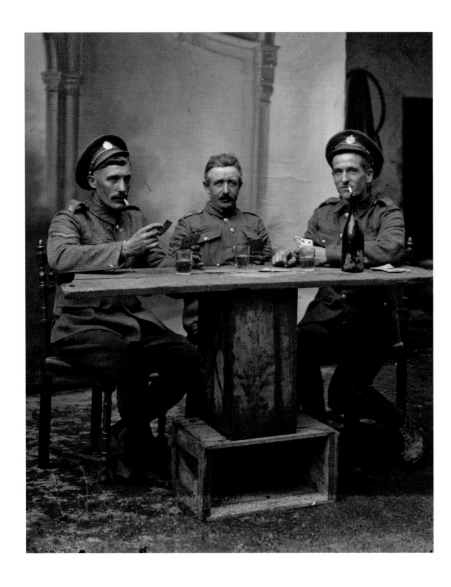

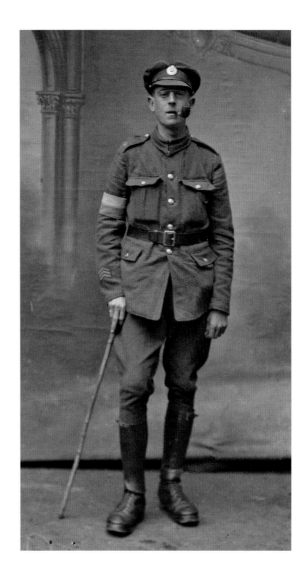

An incredible 47,600 huts were ordered in preparation for the Battle of Arras and, by the end of the war, 100,000 more were sent to France in addition to a further 10,000 longer hospital versions. The engineers also produced many of the specialist weapons used in trench warfare: grenades, knobkerries (clubs), Bangalore torpedoes, periscopes, duckboards, mounted machine-gun posts and barbed-wire entanglements. They also recruited artists and carpenters from the trenches into a specialist camouflage unit. Decoy dummy human heads were also used to locate the position of enemy snipers; spotters would use a periscope to track back to the position from where the bullet was fired. They made use of wooden silhouette figures dressed up to look like British soldiers advancing through no man's land – called 'Chinese attacks', they were used to divert attention from another attack or to flush out the position of an enemy machine-gun post. They used dummy tanks as well, also made out of wood.

It was all achieved at a dreadful cost: the Royal Engineers' death toll from the war was 1,166 officers and 18,589 other ranks.

PLATES 377–378 Some tough-looking Royal Engineers letting off steam in Vignacourt and (right) a bookish-looking Royal Engineer wearing a signaller's armband in front of the Thuillier backdrop.

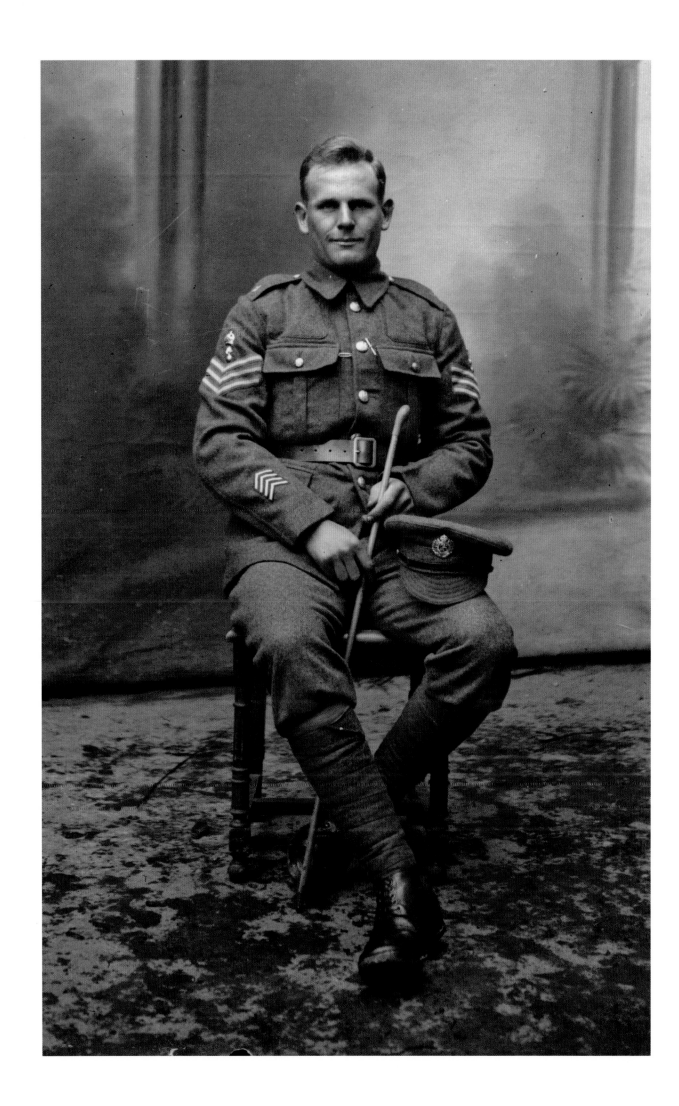

PLATE 379 The crown indicates a staff sergeant or a company sergeant major. The four chevrons on his lower right sleeve mean he is in his fourth year of overseas service (they also place this image as being after January 1918, when they were introduced.) The grenade arm badge is worn above the chevrons by sergeants and staff sergeants in the Royal Engineers.

'They Had No Choice'

'*They Had No Choice*'. These simple words are inscribed on the Animals in War Memorial just outside Brook Gate in London's Hyde Park. The monument commemorates all animals that served and died with British Allied forces in theatres of war – horses, donkeys, dogs, goats, pigeons – even glow worms which soldiers used to read their maps when no light was available. By far the greatest number of animals to die in the conflict were the horses and mules; more than a million were shipped to all theatres of war. Almost 260,000 perished on the Western Front.

> *They were with the BEF from the very start. They were with the BEF at the very end. They served at the Front, in the rear and in the support lines. They stumbled through the hell of no-man's land, closely following every British and Commonwealth push. In the mud, rain and terror of the trenches they supplied their comrades with food, water and ammunition, even though they themselves were starved, sodden and spent. They died in their thousands.*[113]

In the first decade of the twentieth century, when the cavalry was still considered the backbone of any fighting force, a horse census was conducted in Britain. It listed the availability of all horses in the event of war. It quickly became obvious that horses were invaluable for more than just the cavalry and as officers' mounts. They were used for everything from hauling artillery guns and machine guns to delivering supplies, ammunition and pulling ambulance wagons. Britain could not supply enough and so she sourced more animals from the United States, Canada, Australia and South America. But such was the attrition rate of the horses in the war that the War Office also compulsorily requisitioned horses from the civilian population. In *Animals in War* Jilly Cooper, the granddaughter of Chaplain Whincup mentioned earlier, tells the story of a touching plea to Lord Kitchener from three young children, Poppy, Lionel and Freda Hewlett, who were fretting that their horse might be taken. The letter read in part:

PLATE 380 A British Army draught horse.

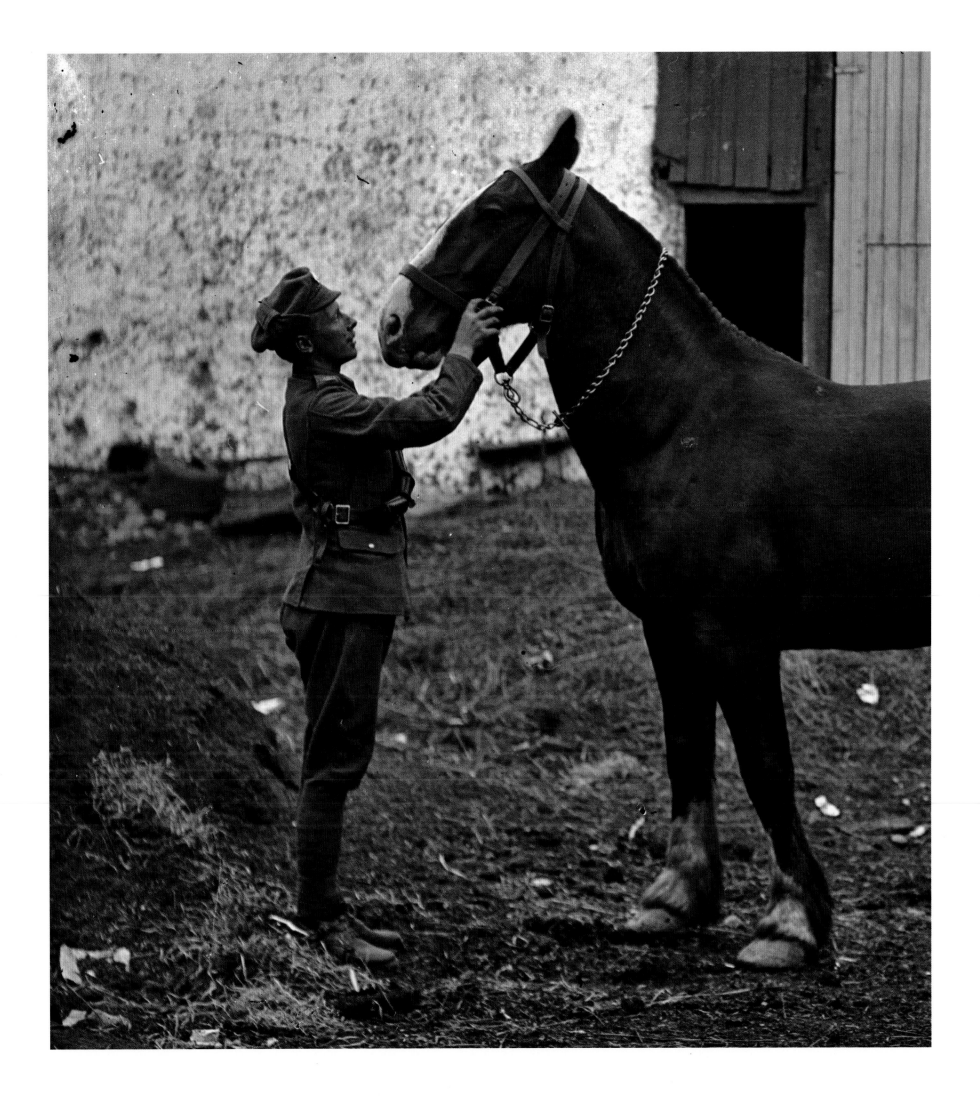

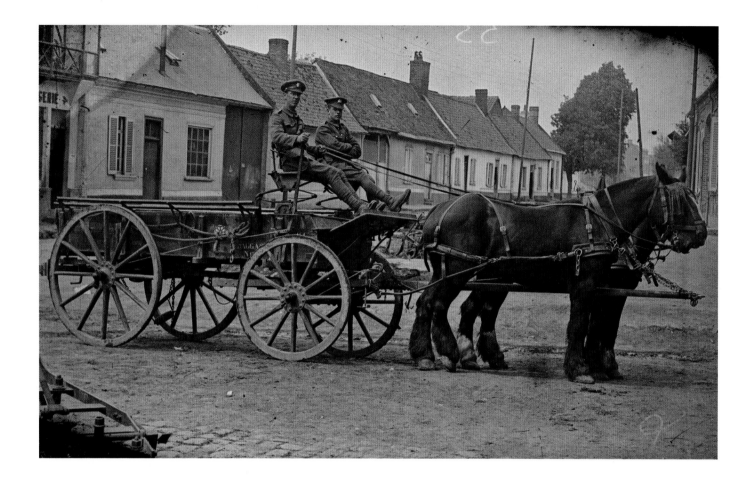

Dear Lord Kitchener

We are writing for our pony, which we are very afraid may be taken for your army.

Please spare her.

Lord Kitchener's private secretary wrote back assuring the children their seventeen-year-old pony was safe.[114]

As well as being affected by the shell and artillery fire close to the front, horses suffered from fatigue, poor nourishment, lack of shelter and exposure. Thousands died in the first winter, many because of the army's policy of shaving horses as a precaution against disease. The poor animals simply could not survive without their winter coats and adequate shelter. The practice of close clipping was duly dropped as the war progressed.

English poet, novelist and First World War Royal Fusiliers officer Robert Graves wrote that the demand for good horses was such that there were many instances of theft, with regiments and corps actually stealing animals from other units. His regiment went searching for two of its best horses and found them with the 4th Division machine-gun company, where the machine-gunners were nabbed trying to remove the regimental marks with stain.[115] Good horses would be clearly branded to ensure they remained with their rightful owners and many of these brands can be seen in the Thuillier images.

PLATE 381 Heavy draught horses towing an army supply wagon. The majority of the horses used were 'light draught' – between fifteen and sixteen hands – weighing about 1,200 pounds. The First World War was the first mechanized war but it still relied heavily on horses and other animals – often at terrible cost.

PLATES 382–383 A West Yorkshire Regiment soldier with his mount and (right) a Royal Army Medical Corps soldier.
PLATE 384 This horse from the West Yorkshire Regiment is lucky enough still to have its winter coat.

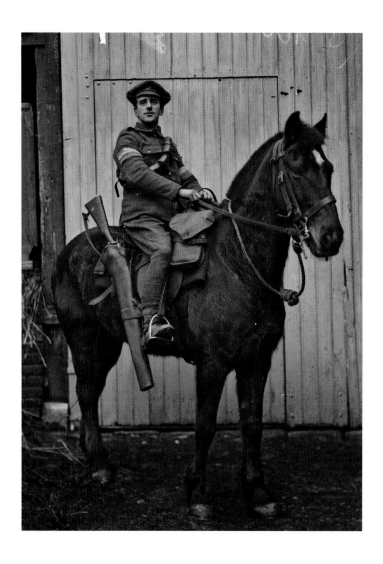

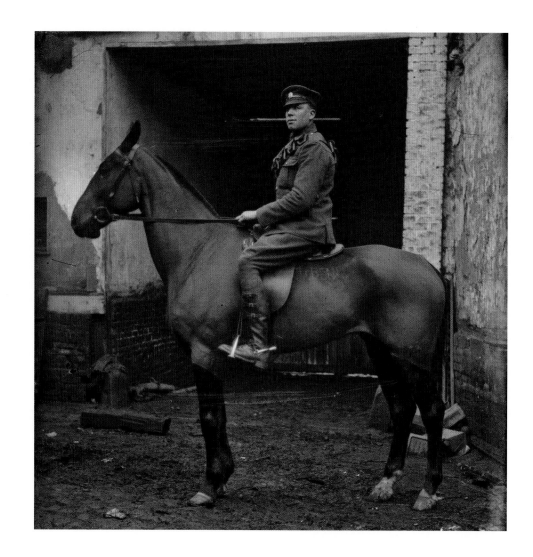

PLATE 385 A lovely picture of a Royal Engineer astride his magnificent steed. Note the holster for his service weapon.
PLATES 386–387 This horse clearly has the name 'McBean' marked on its flank, as can be seen in the close-up image.

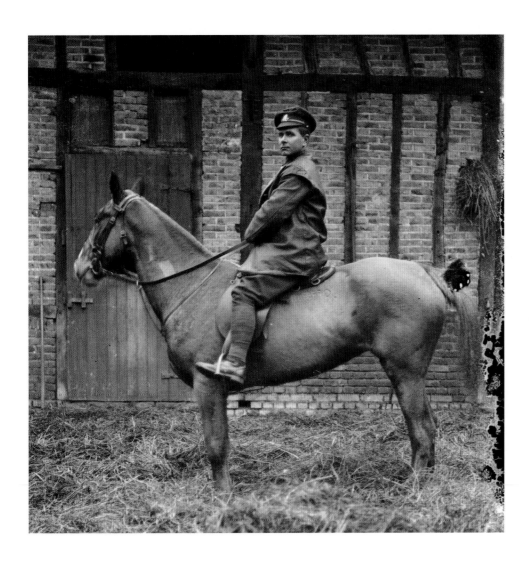

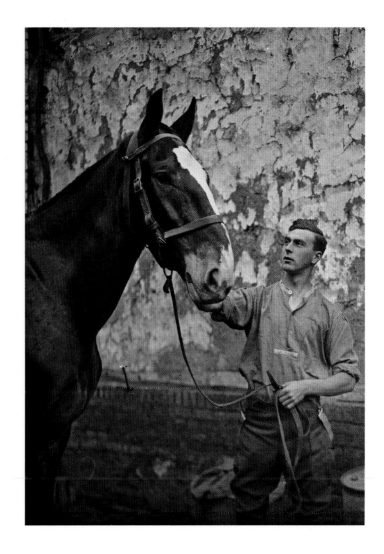

PLATES 388–389 This horse has the name 'Hubbard' branded on its flank.
PLATE 390 A young soldier with a regal-looking horse.

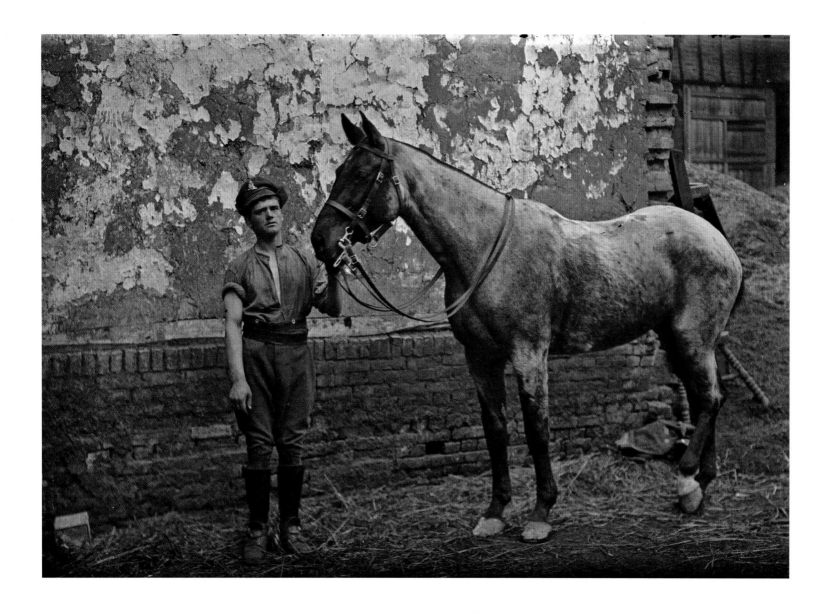

Donkeys and mules were also an important part of the war transport system; despite their reputation for stubbornness, they were respected on the front lines for their sturdiness and stamina. They could get into places that horses and vehicles could not access and they also didn't spook as easily as horses often did when confronted with the sights, sounds and smells of the front lines.

Working animals injured during the war were cared for by soldiers of the Army Veterinary Corps (the 'Royal' title was added in the final months of the war). Mobile veterinary sections were attached to brigades and divisions and cavalry horse hospitals were set up in several strategic areas. The veterinary surgeons and AVC soldiers managed to nurse thousands of animals which might otherwise have died, but many tens of

PLATE 391 The soldier's cap bears the badge of the Royal Artillery.

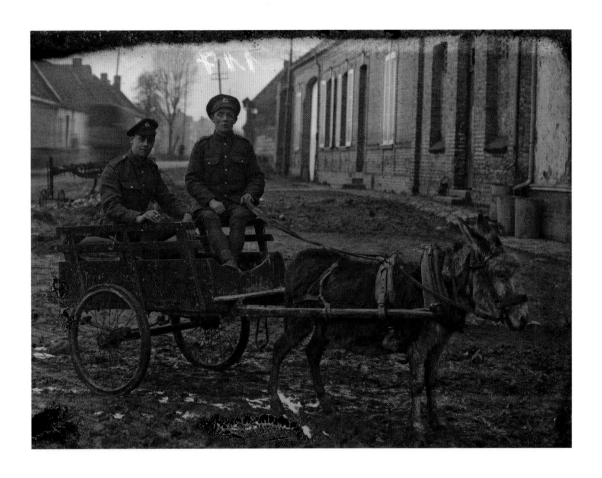

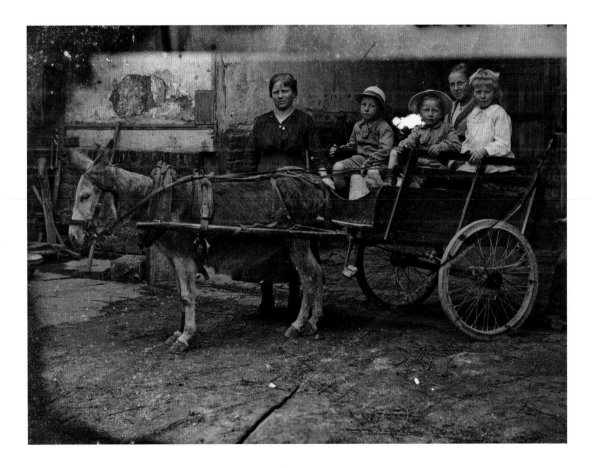

PLATE 392 A mule tows soldiers from the Duke of Cornwall's Light Infantry (left) and the Middlesex Regiment.
PLATE 393 These French children sit in what appears to be the same mule and cart as in Plate 392, above.

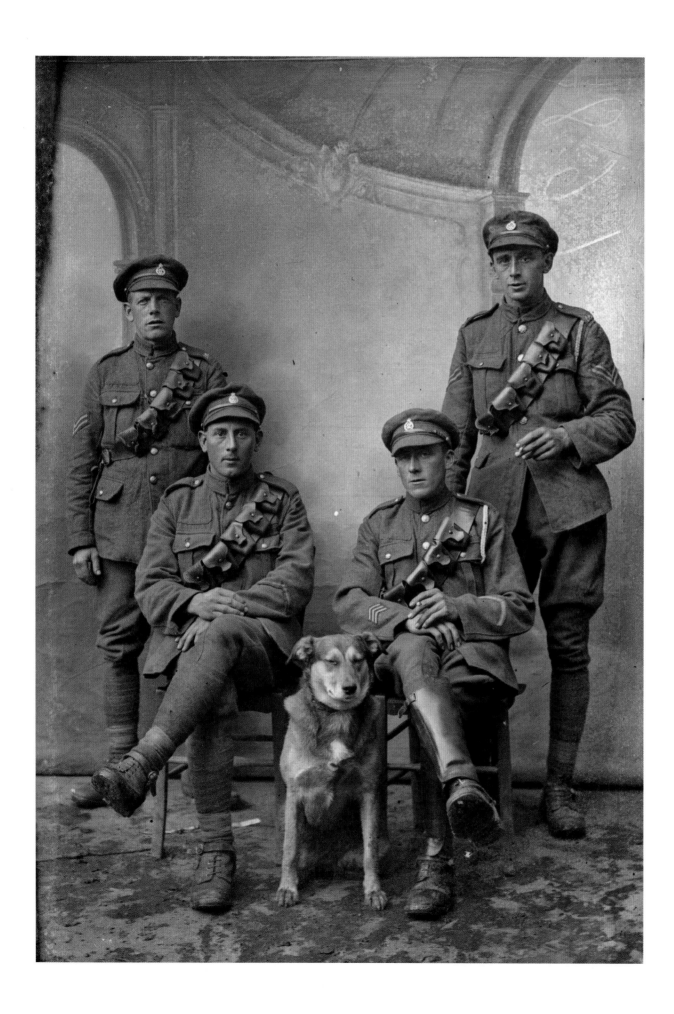

PLATE 394 Two Army Veterinary Corps corporals (standing) and two privates (seated) posing with a dog. The overseas-service chevrons on the right sleeve of the soldier seated on the right indicate this was taken after January 1918.

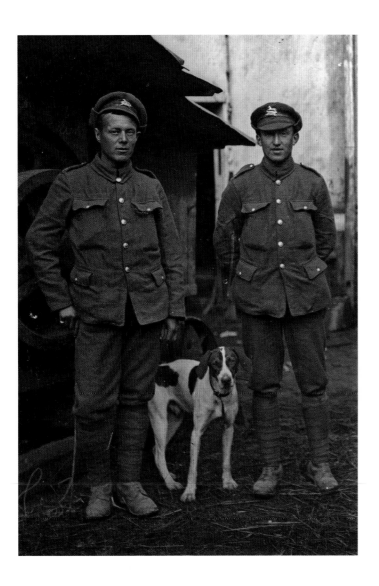

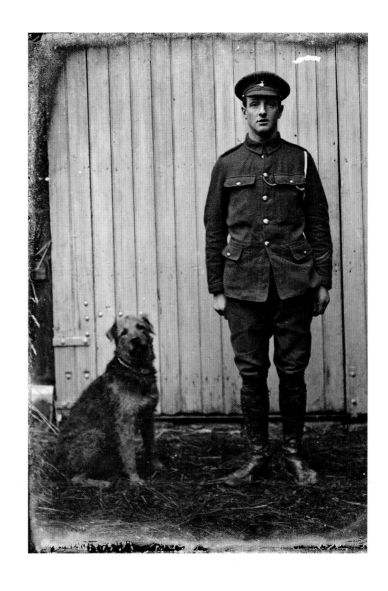

PLATE 395 Two West Yorkshire Regiment soldiers with a rather elegant pointer.
PLATE 396 A soldier of the 19th (Queen Alexandra's Own Royal) Lancers with an Airedale, one of the most popular breed of dogs at the front.

thousands of animals suffered terrible injuries and death during the conflict. The dog in the AVC image in Plate 394 may have been just a local village pet but dogs also served with the British Army; they were used to carry ammunition and supplies, deliver first aid materials, act as sentries and even to guard prisoners of war. The value of dogs at the front led to the establishment of a war dog school at Shoeburyness in England in 1917 and about two thousand dogs were specially trained for war service. The best breeds were found to be Airedales, bloodhounds, pointers and retrievers but the school accepted other dogs if they proved up to the task. There was even an appeal for the family pet to be offered up for war training.

It seems very likely that many of the soldiers posing with obviously much-loved puppies and dogs in these photographs were missing their family pet back home or they simply could not resist the charms of a small puppy.

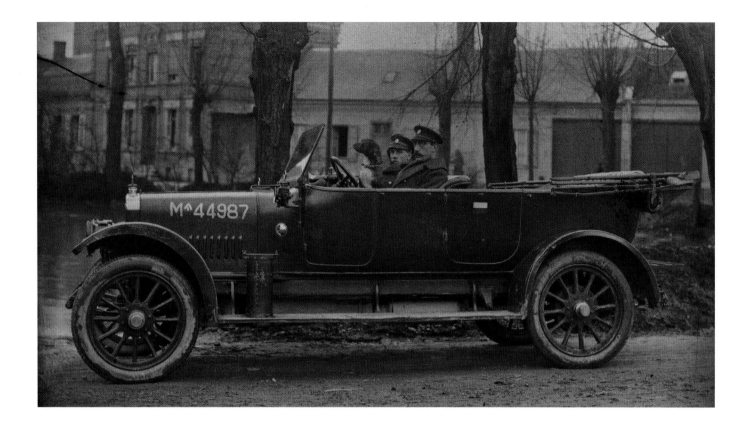

Some battalions even took their own dogs with them to France. When the newly enlisted ranks of the 7th (Service) Battalion of the Royal Sussex were in barracks at Colchester in August 1914, they found a puppy at the gates. He was of no particular breed but a label tied around his neck said his name was Harold and included the plea: 'Please take care of me.'

And so, the battalion did. Harold became their mascot and he remained with them throughout the war. According to the battalion history, when they were on the march Harold would run up and down the length of the line as though he was inspecting the men:

> He disliked all civilians and possessed an uncanny instinct for distinguishing members of the battalion (especially the cooks), and it was popularly believed that he could recognise the Royal Sussex badge.[116]

The men also had some sport keeping Harold's official conduct sheet. He was reported for being absent without leave for a period of three weeks as well as committing crimes, one of which was 'making love in the presence of the battalion'. Wounded in action twice, Harold survived the war and returned to England in the care of one of the officers.

PLATE 397 Two Army Services Corps soldiers and four-legged friend cruising through Vignacourt.

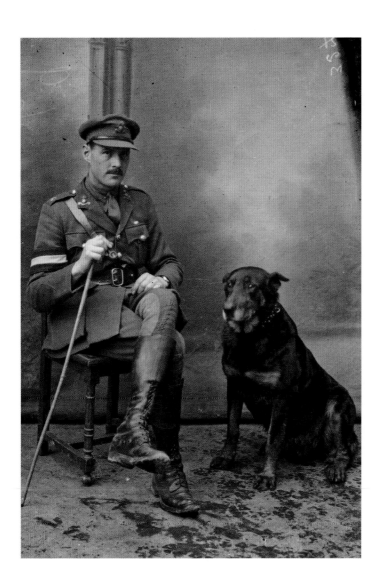

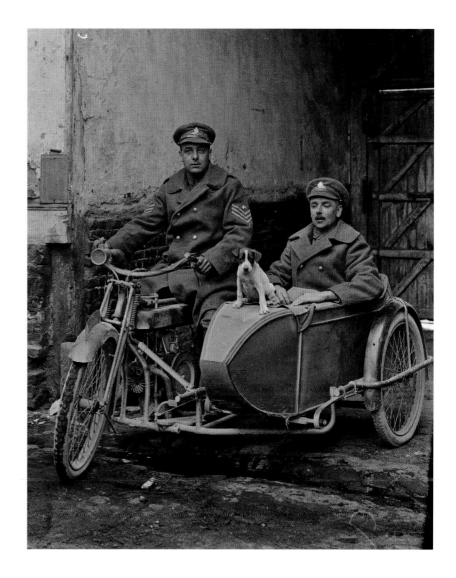

PLATE 398 A Royal Dublin Fusiliers officer poses with his dog.
PLATE 399 These ASC soldiers were clearly very taken with this local puppy.

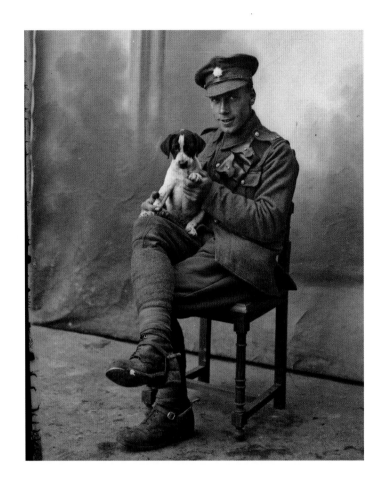

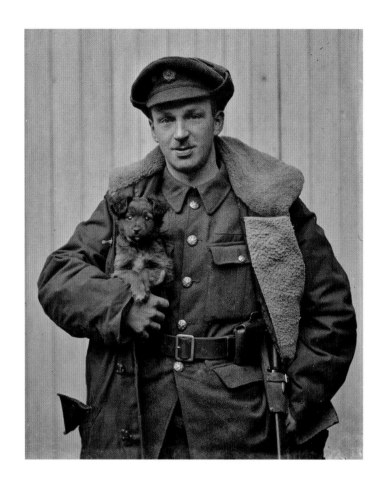

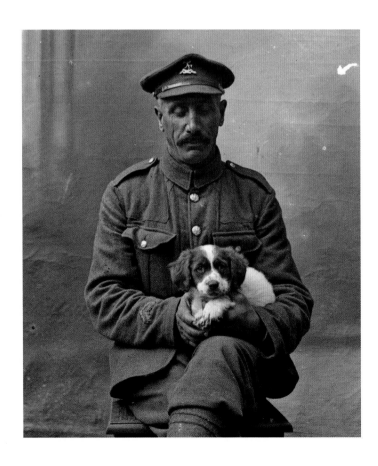

PLATES 400–402 Three more puppies feature in these Thuillier images. The puppy being held by the seated soldier (top left) is the same dog featured in Plate 339 – obviously a local favourite.

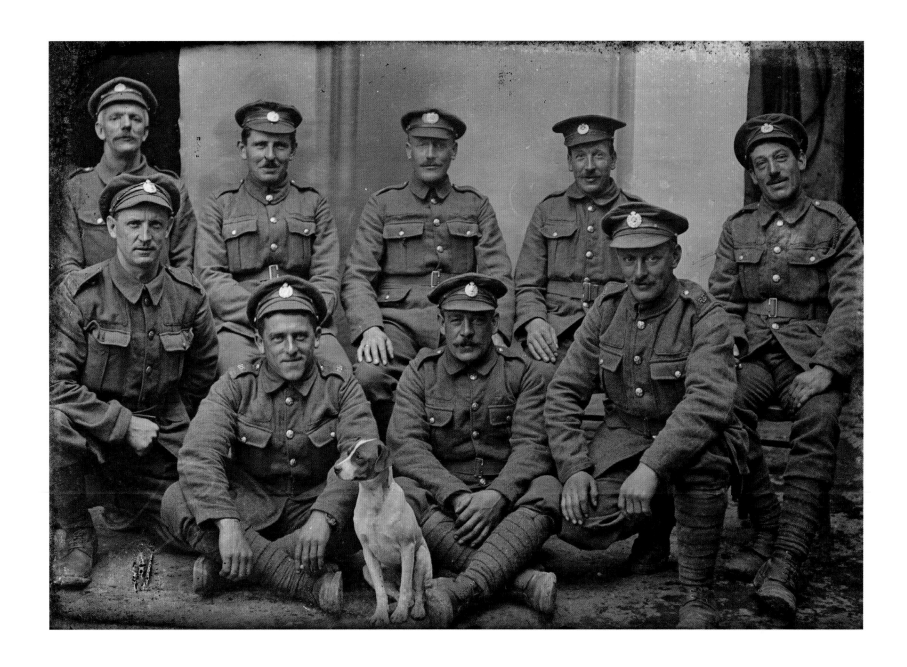

PLATE 403 Royal Engineers in the company of a small terrier. These little dogs were often used as 'ratters' to help get rid of the vermin which plagued soldiers in the trenches.

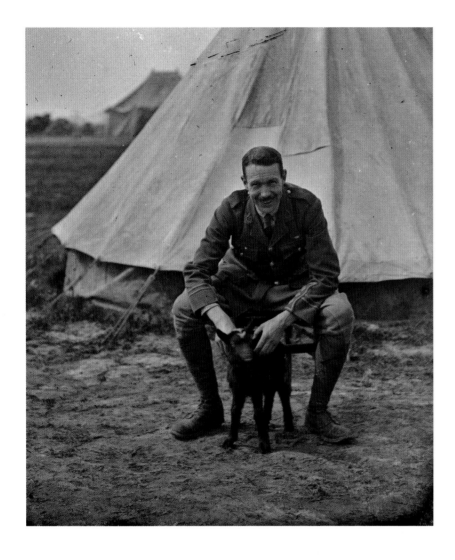

The most unusual animal pictured with soldiers in the Thuillier images appears in a photograph of Australian soldiers from the 52nd Battalion. If you look very closely at Plate 405, opposite, a monkey can be seen standing on the shoulder of the soldier standing in the middle of the middle row. The Australians received much of their training in Egypt before their deployment to the Dardanelles and then Western Europe, so it is very possible that one of the Australian diggers secreted the monkey in his haversack on the boat from Alexandria to Marseilles. Most of the Australian soldiers in this image were from Western Australia. The soldier sitting in the front row, fourth from left, is a sergeant named John Spence. He joined up with the Australian 12th Battalion in November 1915 but was assigned to the newly formed 52nd Battalion when he arrived at the Tel-el-Kebir training camp in Egypt in early March 1916 – so these men

PLATE 404 Goats were also a common mascot, featured in some Thuillier images. Here a Royal Army Medical Corps officer poses with a kid goat outside his tent in fields on the outskirts of Vignacourt.

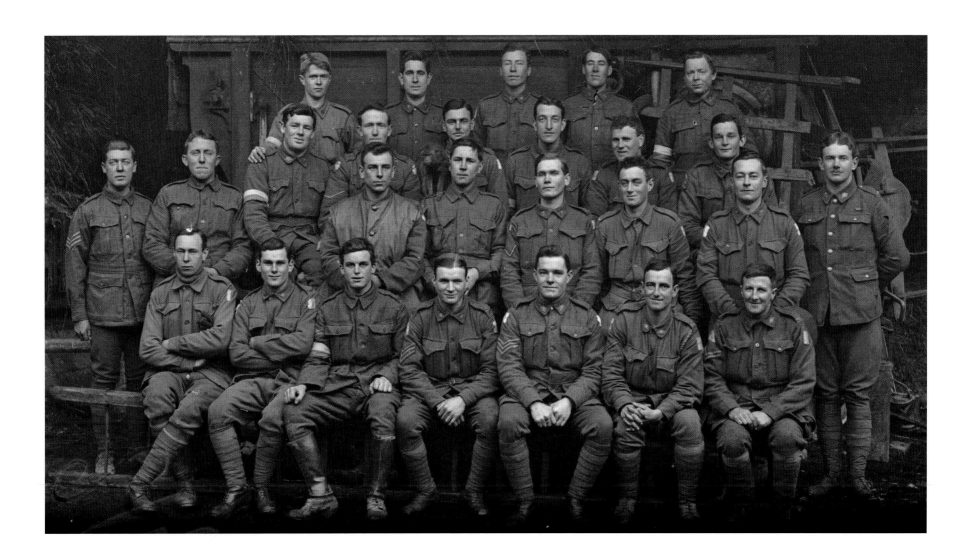

PLATES 405–406 Spot the monkey on the shoulder of the Australian soldier standing in the middle of the middle row. (The close-up above makes it much more evident). The soldier has been identified as Corporal James Renner from the Australian 52nd Battalion and the monkey, who became the battalion mascot, was named Jenny.

did spend time in the exotic bazaars of Cairo where buying a monkey would have been easy. Sergeant Spence went on to win a Distinguished Conduct Medal – a DCM – for his gallantry at Messines in 1917 and a Military Medal in 1918 at Dernancourt.

When the war was over, there was more injustice for the animals that had served: only horses belonging to officers were guaranteed to make it home to England. Those that remained behind were sold to local farmers and other civilians. Sadly, some horses whose war service had taken too much of a toll were sold to local knackers. Some of the dogs enjoyed a kinder fate – the RSPCA agreed to help soldiers who wanted to bring dogs back home with them. The soldiers themselves would pay two pounds per dog with the RSPCA footing the bill for the remainder of the quarantine and other expenses.

The Gunners

It took British Army commanders a long time to realize the importance of artillery but it soon became the most important weapon of the war. By the end of the Great War 548,780 officers and men were serving in the Royal Regiment of Artillery in Western Europe – and there were many hundreds of thousands more who served through other empire regiments. At the Battle of Loos in September 1915 the failure by Allied commanders to provide adequate artillery in support of their advancing troops had contributed significantly to an appalling toll of 60,000 British casualties. Historian Niall Ferguson argues that up until the Battle of the Somme in 1916 the British Army was 'out-gunned, lacking powerful enough guns and adequate stocks of shells'.[117] General Sir Martin Farndale's history of the Royal Regiment of Artillery records how this changed: 'The gun became the real Queen of the battlefield. It could not win battles alone but, where it was properly used, the cavalry and infantry could win – where it was not, they could not. Guns were the catalyst that made success possible.'[118]

Early in the war the science of targeting artillery was poor; gunners could only hit targets they could see and there was little understanding of how important it was to properly coordinate shelling with the infantry. One history of the artillery records that in 1914, 'the only communications which an OP [Observation Post artillery] officer had to his guns was a telephone line reeled out as he moved forward or by using signalling flags or even runners; radio was not yet available'.[119] Often an artillery commander had to use messages delivered on horseback or by dispatch motorcycle to communicate with his guns in the field. Allied commanders also held excessive faith in the power of heavy bombardments; British commander Sir John French held: 'If sufficient ammunition is forthcoming, a way can be blasted through the enemy line.'[120] This obdurate view dominated thinking about how to break through enemy front lines on the Somme in July 1916; the expectation was that the heavy guns could smash the German defences and fortifications and clear the way for an Allied advance all the way to Berlin. What was not

PLATE 407 The Royal Regiment of Artillery cap badge. Its motto translates as 'Where right and glory lead'. 'Ubique' means everywhere.
PLATE 408 A private of the Royal Artillery.

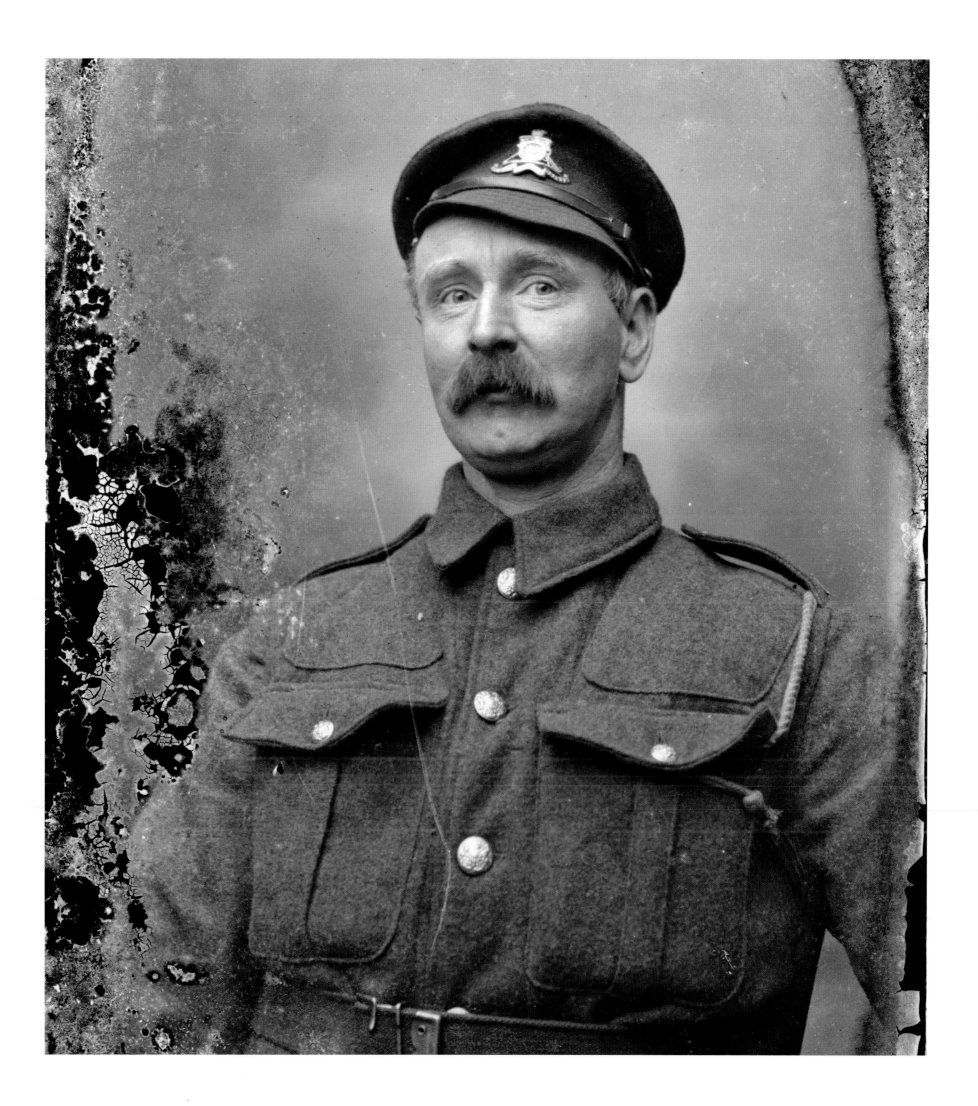

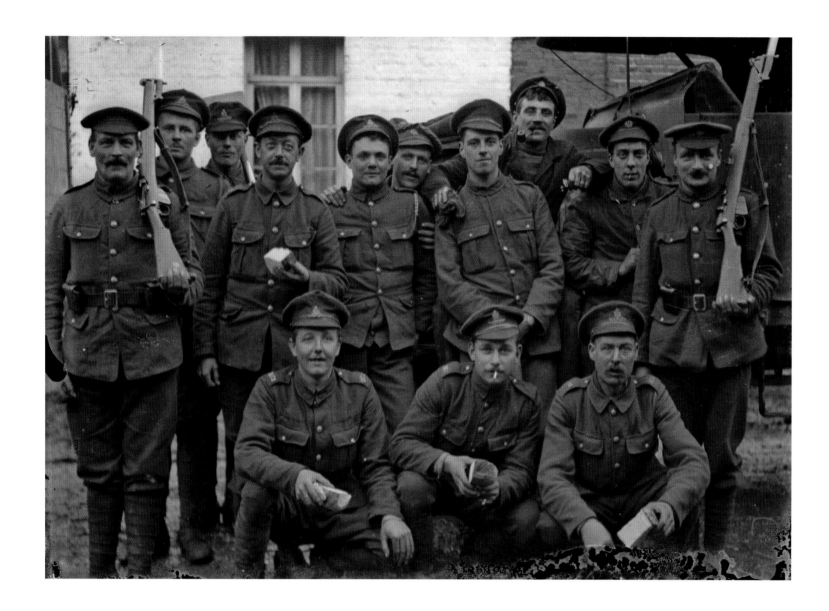

fully appreciated was the need for pinpoint accuracy. As the Allies soon learned, even one surviving German machine gun or artillery battery could wipe out a whole battalion.

By 1916, when most of the young artillerymen pictured in the Thuillier images were arriving in Vignacourt in the run-up to the Battle of the Somme, the arrival of military aircraft was beginning to change artillery strategy completely; observer planes allowed aerial reconnaissance of enemy lines, which then meant gunners had to know how to hit a target even when they could not see it. It made bright youngsters like eighteen-year-old Ronald Skirth very important. Employed for his mathematical ability, Skirth believes he was the youngest battery commander's assistant in the entire war; he worked with the 6-inch or 9.2-inch heavy howitzer that could drop 100-pound (45-kilogram) shells from a great height directly on top of an enemy trench. But the artillery commanders needed maths wonks like Skirth to do the calculations necessary to

PLATE 409 A delightfully informal image of Royal Field Artillery Regiment soldiers posing with some Army Services Corps troops in a Vignacourt street.

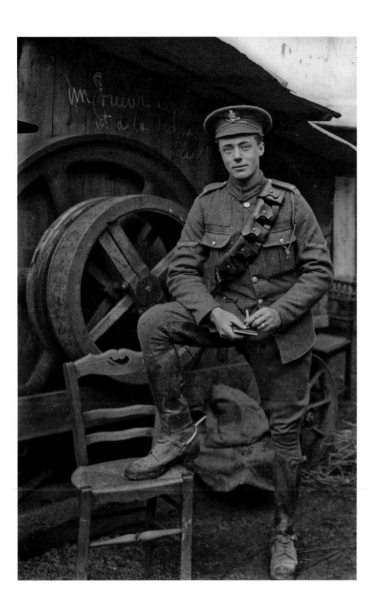

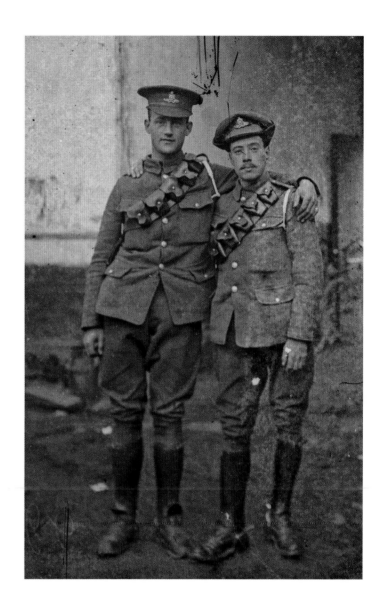

PLATE 410 Artillery was the new weapon of this industrialized war but the soldiers still used horses to take the guns into position. This Royal Field Artillery Regiment cavalry lance corporal has the spurs and mud on his boots from the field.
PLATE 411 RFA chums.

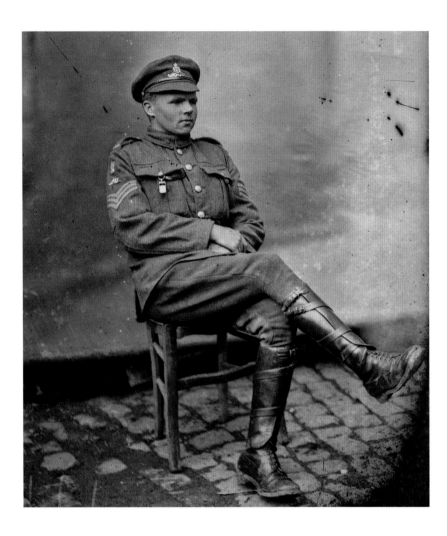

ensure the shell dropped where intended. 'I had to know ground and air temperatures, wind direction and velocity, humidity, barometric pressures and all the other factors which affect the trajectory of a flying shell. The final operation was to put all the "pieces" together and calculate angles of sight, elevation etc. to be handed to the O.C for transmission to the guns. Every gun had to have separate figures compiled,'[121] Skirth wrote in his often perceptive diary account of the war, as told by Duncan Barrett's *The Reluctant Tommy*. He paints a sharp picture of the class system clash between his resentful public school-educated commanding officer (who could not do the sums) and Ronald, '… a Grammar school, 100 per cent amateur; he the oldest soldier in the entire battery, me the youngest. Moreover, he the gentleman, me no better than a worm. In the whole of the British Army overseas there could never have been a more undesirable, incompatible partnership.'[122]

 In the weeks before the Battle of the Somme an immense concentration of men and machinery was brought into the small part of Picardy traversed by the Somme river

PLATE 412 A young Royal Artillery sergeant wears regimental sleeve badges. The one just above the sergeant chevrons denotes an NCO in the Artillery. His whistle was used to warn artillerymen that their gun was about to fire.

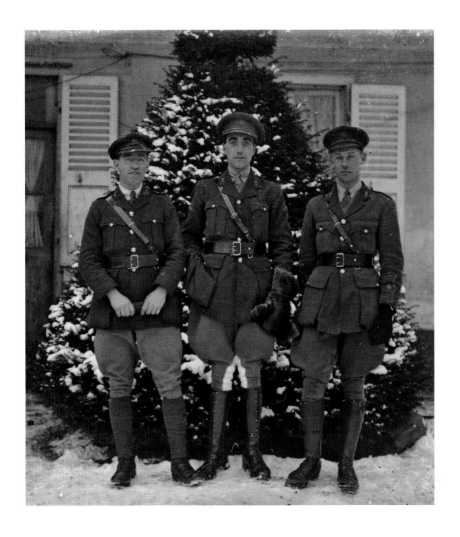

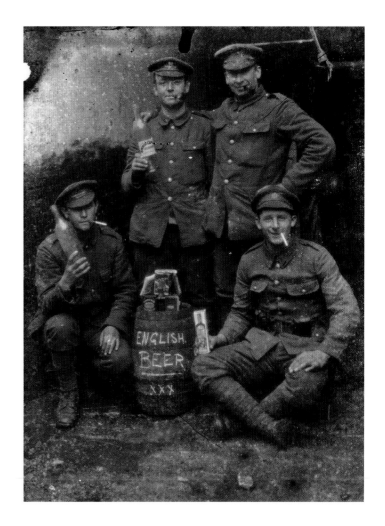

PLATE 413 Officers and gentlemen of the
Royal Field Artillery.
PLATE 414 The barrel may say 'English
beer' but the bottle label in the hands
of the man standing on the left shows
these Royal Artillery soldiers are drinking
French Grenache wine.

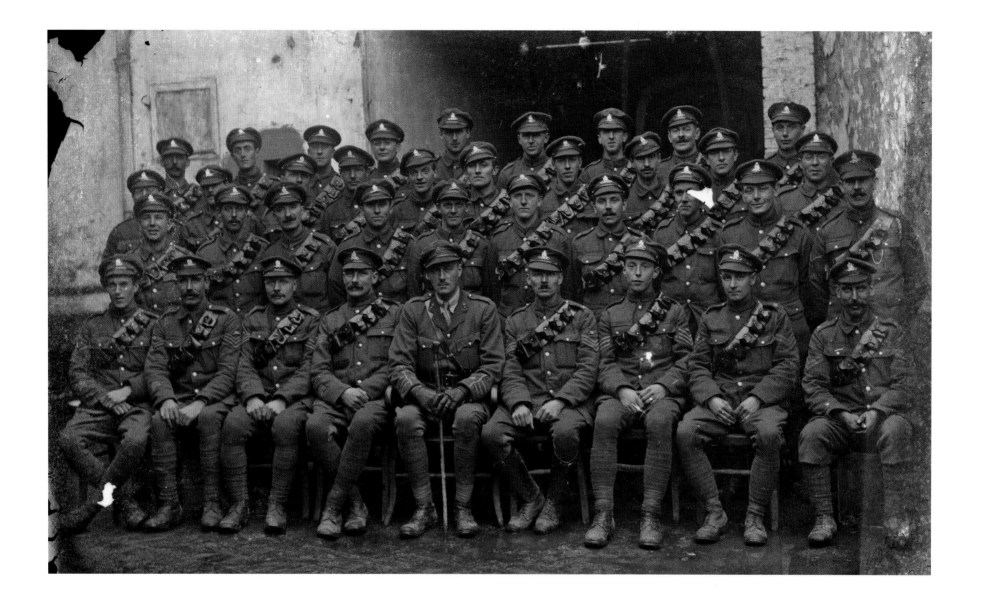

PLATE 415 Royal Artillery soldiers with their officer – a Major – in Vignacourt. It would be these men who, within weeks, would ride their mounted cavalry gun teams into front-line firing positions on the Somme, at huge cost.

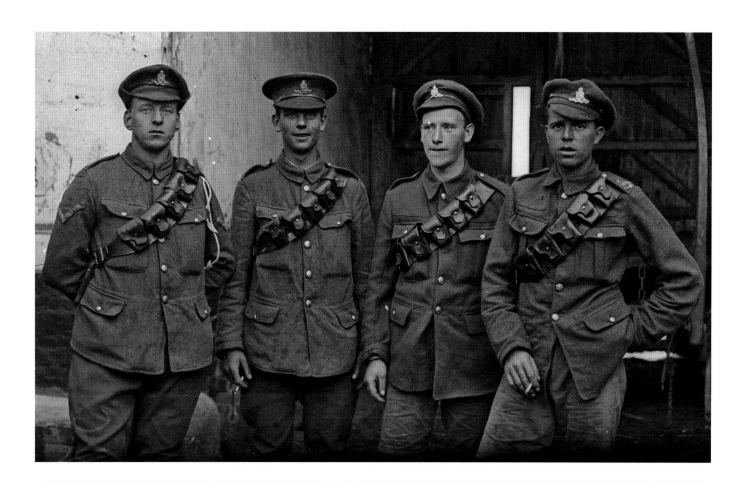

PLATE 416 Young artillery soldiers – the lad on the right has a 'T' on his shoulder lapel, indicating he was attached to one of the territorial battalions.

valley front lines and many of those men and their weapons came through Vignacourt's railhead from the main city of Amiens. General Haig's strategy for the break through the German lines was a massive deployment of artillery – it meant 1,537 field guns and howitzers would be pummelling the German lines for six days prior to the 1 July infantry offensive; a concentration of one field gun to every 18 metres of front and one heavy gun to every 53 metres. A huge amount of work was put into reinforcing fortifications to protect the Allied gun positions – many guns were covered with steel girders layered with sandbags, earth and trees. An extraordinary 11,000 kilometres of communications cables were buried six feet underground to protect them from enemy shellfire. (There were a further 70,000 kilometres of cables on the surface as well.)

On the day the infantry went over the top the plan was to protect their advance with a creeping barrage in front of them.

The plan was that the gunners should put down a massive barrage lifting forward at fixed times, with the assaulting infantry creeping forward as close behind it as they could get, at most 100 yards, some said forty! The infantry were to move forward in waves. The first wave was not to mop up but to carry on to its objective, taking both its time and direction from the artillery. The fire was to be controlled by forward observers moving

342

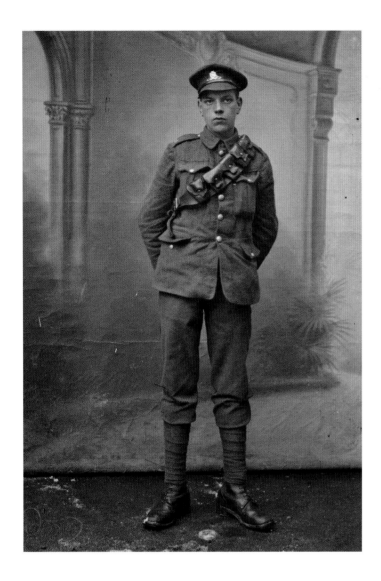

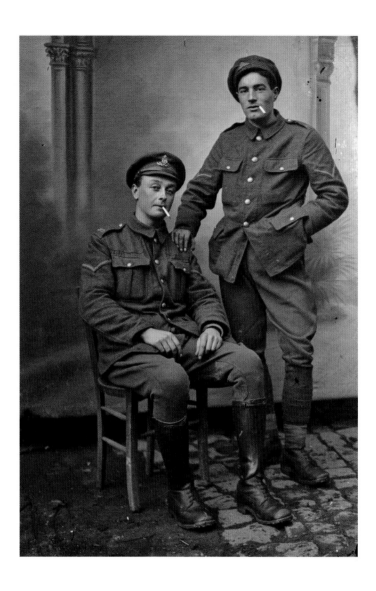

PLATE 417 A very young artillery cavalryman.
PLATE 418 Two young lance corporals.

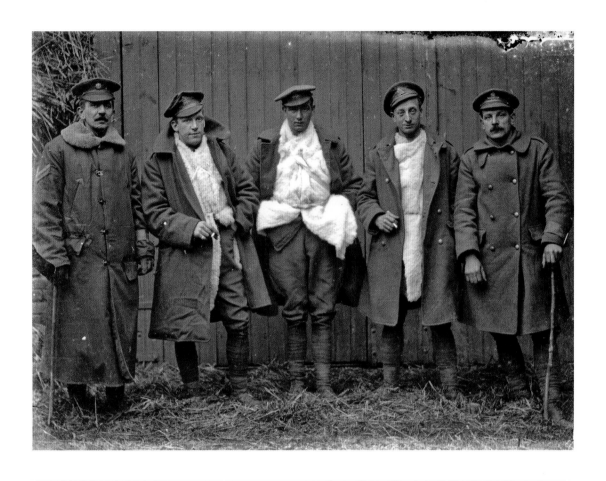

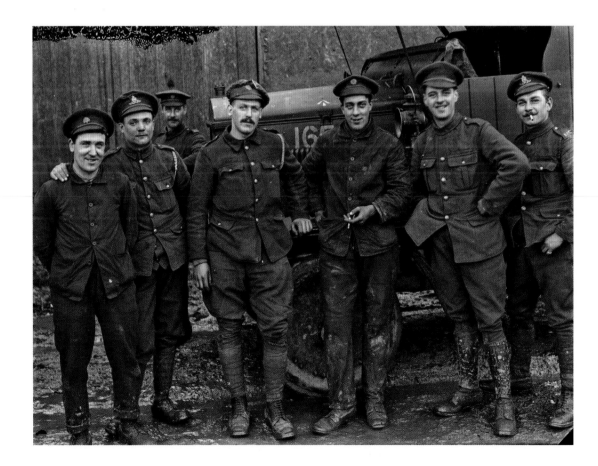

PLATE 419 Artillerymen wrapped up in some unconventional woollen vests to protect them from the cold. The soldier in the overcoat on the left is an Army Services Corps corporal.

PLATE 420 Artillerymen pose with Army Services Corps soldiers in front of a truck.

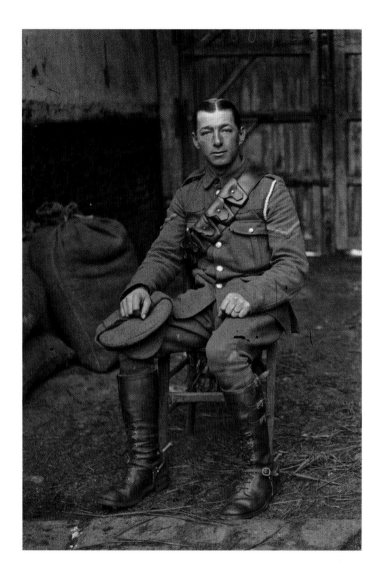 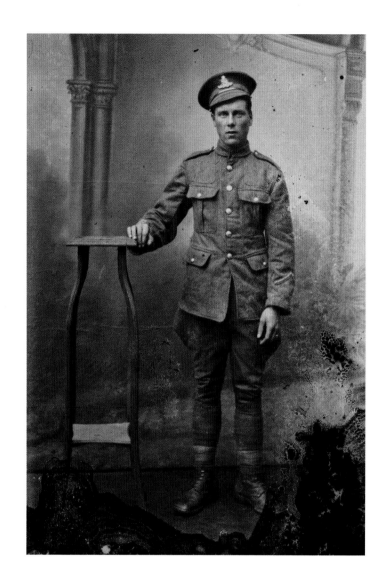

with the leading waves, reeling out cable as they went. Second waves were to mop up and secure objectives.[123]

While this strategy was all very well in principle, it did not work in practice on the day. Not all of the artillery corps stuck to the concept of the 'creeping barrage'; some commanders only half-heartedly followed the creeping barrage instruction, and others ignored it completely. It left many infantry companies terribly exposed to enemy fire.

For the young men serving in these artillery batteries during the Somme battles, it was an unrelenting slog:

> *There was no rest or respite for them day or night: the Gunners did not leave 'the line',*
> *they were always in action. Life was a never-ending nightmare of meeting streams of fire*

PLATES 421–424 Unidentified artillerymen.

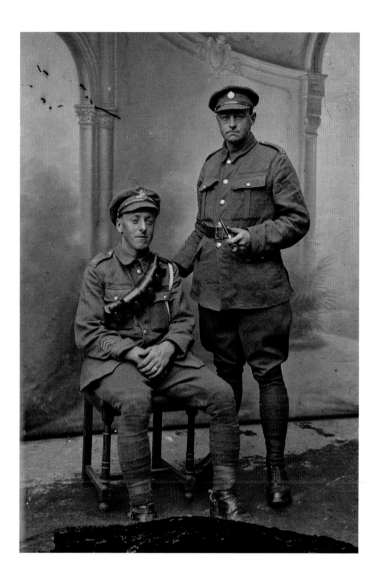

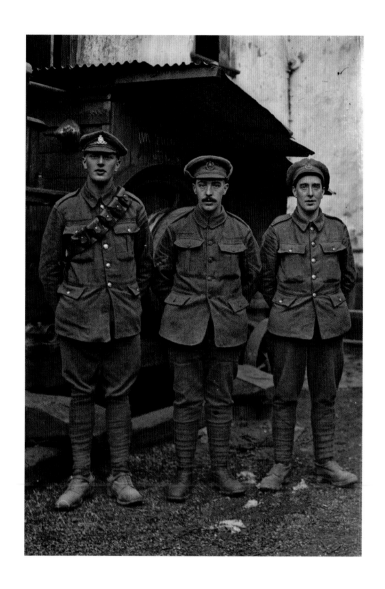

orders, of constructing and improving dugouts and of maintaining communications to their forward observers in the front trenches. Tons and tons of ammunition had to be moved, sorted, stacked and prepared for firing; fuses sorted, tested and fitted to shells. Rations and water had to be brought up at night, roads and tracks built, horses to be attended to. There was little time for rest and, to add to the misery, every time a battery fired the enemy guns would open up on them and there were casualties that needed attention and repairs to be carried out and the whole cycle of living and working and engaging targets began again.[124]

If the artillerymen were spotted by the Germans then they could not move, but had to try to survive the return fire as best they could. And it took a toll; at least 48,949 Royal Artillery officers and men died in service during the war.

Sport

Boxing was used during the war as a way of burning off soldiers' excess energy, boredom and sexual frustration during down time away from the trenches. It was also encouraged as a good way to foster esprit de corps and to inculcate the aggressiveness in a man necessary to allow him to kill an enemy at close quarters, with a bayonet. It was all very well shooting a uniformed figure from a distance, but the hand-to-hand fighting in which combat troops sometimes engaged in the trenches required men to stare into the eyes of the person they were trying to kill; and so boxing instruction that mimicked the motions of a bayonet in battle was strongly encouraged (although it should be acknowledged that only a small fraction of the casualties on both sides of the conflict were ever caused by close-in bayonet fighting – most men died from artillery or machine-gun fire). A lot of effort was put into regimental boxing championships. Post-war, one British general even made the exaggerated claim that it was football and boxing that had won the war. In a preface to what became the British Army's sports handbook, *Games and Sports in the Army*, General Sir Charles Harington, claimed:

> *many reasons were advanced on the cessation of hostilities to prove who or what won the War. No one could say for certain but I am confident that 'leather' played one of the greatest parts. Few have realized what we owe to the boxing glove and the football – the two greatest factors in restoring and upholding 'moral' [sic]. How many times did one see a Battalion which had come out of the line in the Ypres Salient and elsewhere, battered to pieces and sad at heart at having lost so many officers and men, hold up its head again and recover in a few hours by kicking a football or punching with the glove …*[125]

In a quaint attempt to maintain the respectful distance between officers and other ranks, there were separate competitions for officers. But huge emphasis was put on officers involving themselves in games played by the soldiers they were to command, not by fighting

PLATE 425 Lancashire-born boxer and sapper Arthur Vanderstock (left), who served with the Australian 1st Division Signal Company, striking a pose in the Thuillier farmyard. The soldier 'refereeing' wears the cap badge of the Royal Artillery.

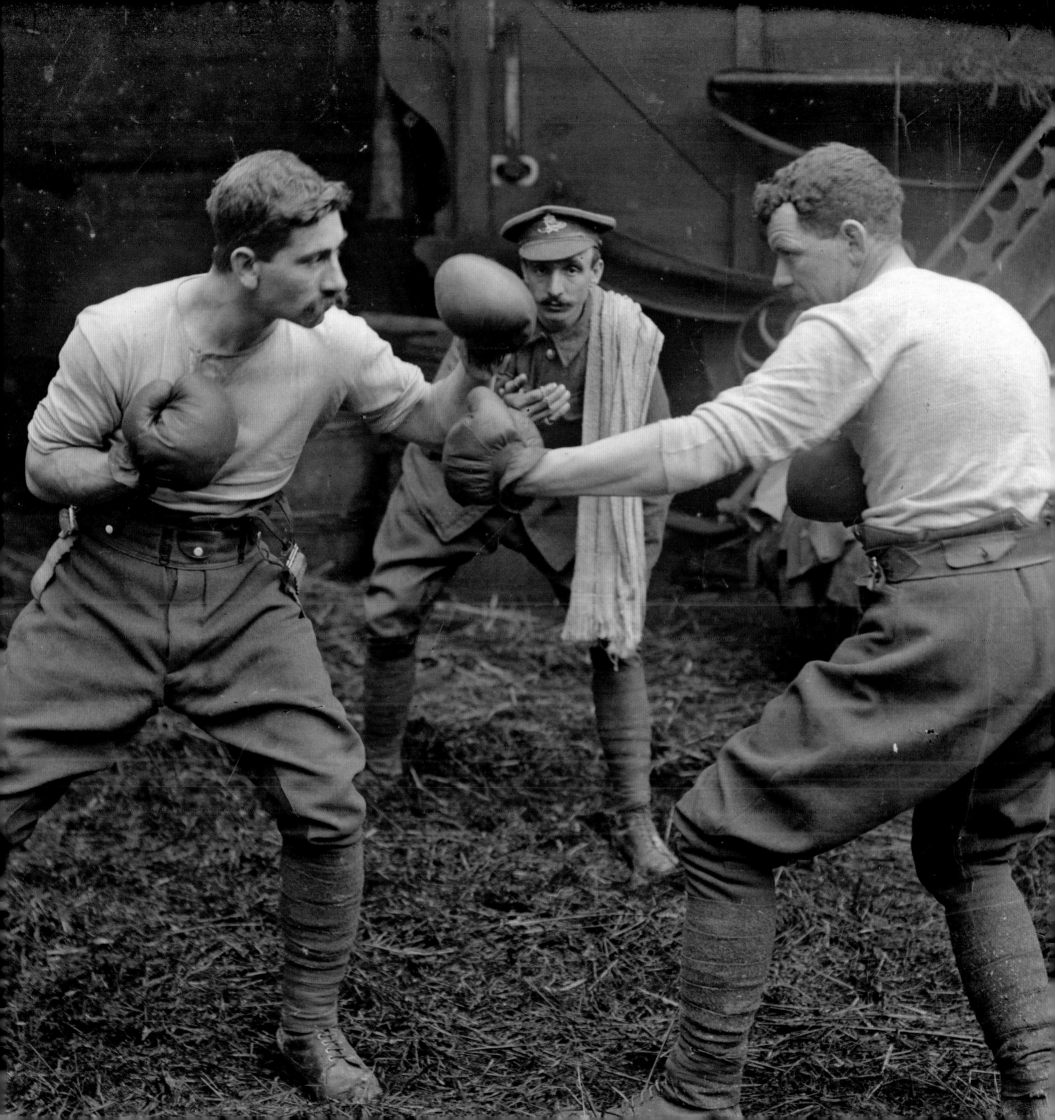

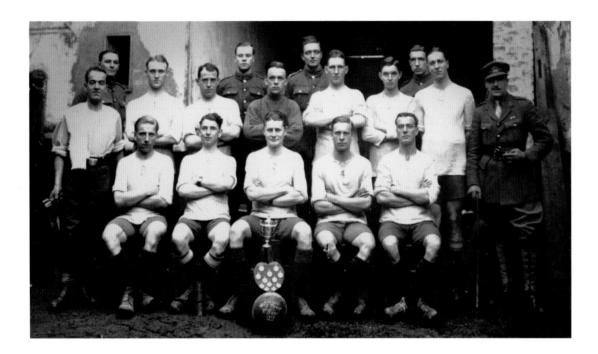

with them but by exhorting them as a coach or referee. There was a lot written by British Army officers in particular about the way that sports such as boxing could bring units together as a fighting force. A Captain Knight-Bruce in the British Royal Warwickshire Regiment claimed that for an officer to referee a game

> *established the same bond of sympathy between himself and his men that exists between the officer and private who shove together in the pack, who run together between the stumps, or who pass together on the wing of an army 'soccer' eleven. He establishes a trust and faith that, when the day comes will take his men, if needs be, to Hades for him.*[126]

By the end of 1916, sport had become an official part of the army system and there was a strong emphasis on physical training, incorporating skills such as boxing, not least from the man heading the British Army's Army Gymnastic Staff, Major R. B. Campbell, who was a former middleweight boxing champion. 'What qualities prevail in games?' Campbell once said. 'Physical fitness, executive action, and confidence – the three essential qualities for war.' Boxing competitions were often held very close to the front lines; one history of sport in the British Army records that three boxing semi-finalists were killed by a bursting shell; the survivor won by default.

By October 1918, Allied soldiers based in Vignacourt were hearing the rumours of a possible peace agreement with the Germans, and Allied commanders were looking for ways to ensure that the prospect of an end to the war did not diminish the troops' esprit de corps and willingness to fight again if called upon. One solution was to hold regular battalion sporting competitions, and a major tournament was held on the aerodromes

PLATE 426 A football team from 'No. 8 Troop – E Squadron' of an unidentified British regiment, posing with their trophy sometime in 1919. The lieutenant on the right has a Military Cross ribbon.

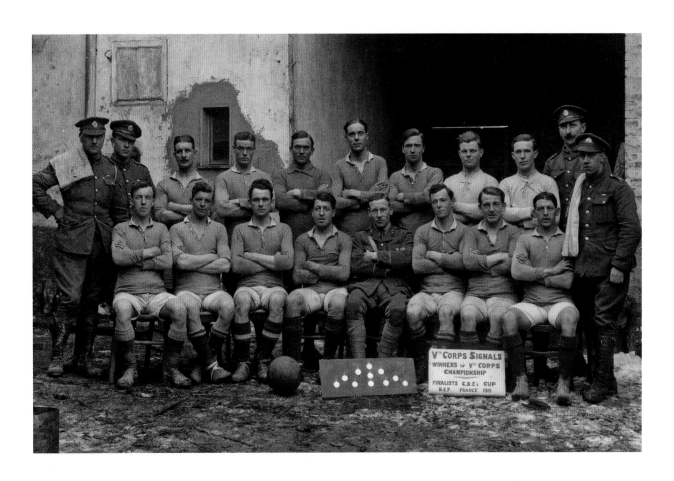

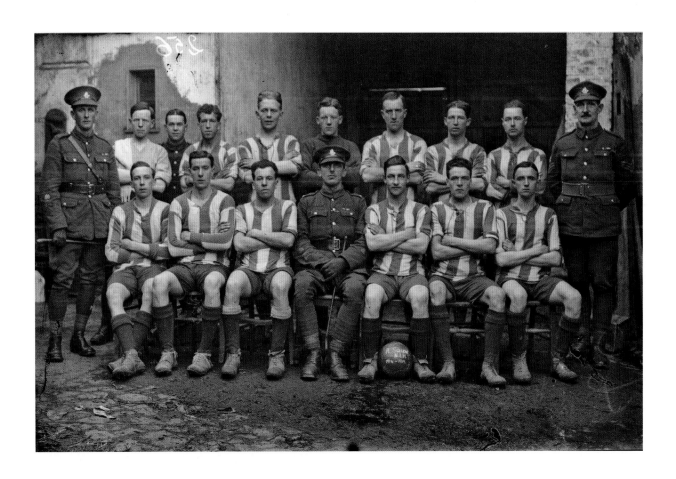

PLATE 427 Royal Engineers of the British V Corps Signals company celebrate their corps's football championship victory in 1919.

PLATE 428 The writing on the ball suggests this is the North Irish Horse A Squadron football team in Vignacourt in early 1919, post-war. Standing on the left is Boer War veteran and keen footballer, Warrant Officer, Jack Wright. Seated in the middle of the front row is Warrant Officer Class 2, Humphrey Boyd. He was awarded a Military Medal in late 1918 and he wears it here above his left breast pocket. In 1919, he became one of only two men who served in the NIH to receive a Bar to the Military Medal.

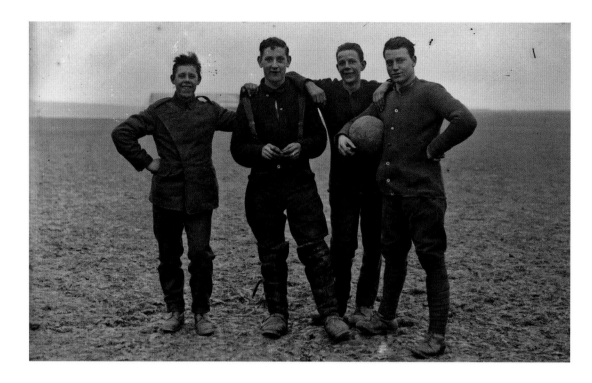

just to the north of Vignacourt on 19 October 1918, as recorded in the Australian 18th Battalion's diary:

> *1300: Battalion sports meeting held on aerodrome ground, Vignacourt. 2/Lt R Hendy, assisted by an energetic committee had prepared the ground in fine style. There was a very good attendance and a very enjoyable afternoon was spent. Great assistance was rendered to us by the officers and men of the R.A.F squadron and their efforts helped us in no small measure to ensure the success of the meeting.*

A boxing match was held by the same battalion in Vignacourt on 24 October. There is also a reference in the 9 November 1918 diary notes of the 18th Battalion to a rugby match between the 18th Battalion and the 5th Battalion's Light Mortar Battery. This is perhaps when Plate 430 (opposite) was taken; the 18th won the day – eight points to three.

Military commanders recognized that one of the biggest threats to a tight unit was not providing a safety valve to work off stress and the inevitable boredom, especially when troops found themselves in places like Vignacourt at rest behind the front lines. There are numerous references in regimental diaries to sporting competitions, held to keep up morale. In the weeks and months after the Armistice, there were even more sporting competitions and several of these teams are featured in the Thuillier pictures.

In October 1918 there was great excitement about the Imperial Services Boxing Tournament, which was to be held in Britain. Major Sydney Albert Middleton, a former Australian rugby union international, was commandeered to attend to the

PLATE 429 Four young lads from the Royal Flying Corps – one of a small number of Thuillier images featuring RFC airmen.

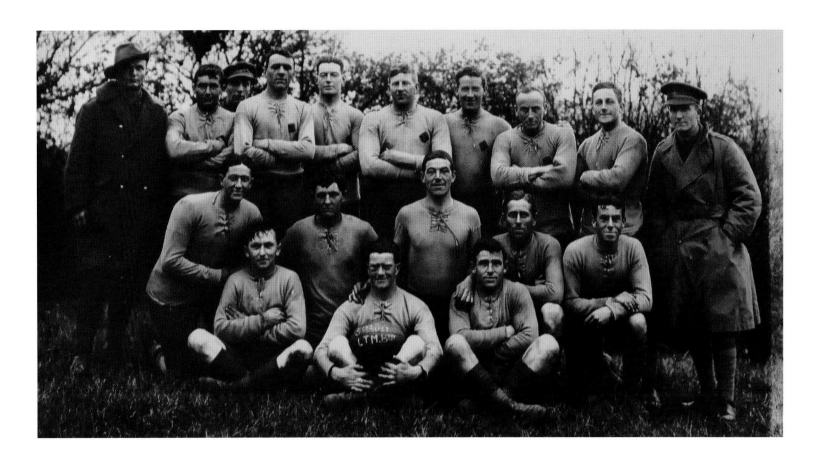

training of soldiers at Vignacourt who were to be part of the divisional boxing team. In 1910 Middleton had captained the New South Wales and Australian teams in tests against the New Zealand All Blacks. He made thirty-three appearances playing for Australia, including four tests – three of these as captain.

A. W. Keown's *Forward with the Fifth*[127] refers to a large sporting competition held near Hennencourt Wood on 11 June 1917. It was a 1st Divisional Sports Day and 20,000 soldiers watched or took part. In his book *Campaigning with the Fighting 9th*,[128] C. M. Wrench describes a sporting competition held at Châtelet near Charleroi in Belgium, called the Corps Rugby Union Cup. It was an inter-divisional contest, which was won by the Australian 1st Division team. An Australian team toured France and England before returning to Australia after the war.

Rugby was not the only popular team sport – football was also played while the battalion was at Châtelet after the Armistice. Wrench points out that these Sunday afternoon games were also hugely popular with the locals, who formed their own team and became fiercely competitive. Amusingly, the local Belgians took the games so seriously that they drew on a professional team from Brussels to supplement their team with four players, but they still could not beat the 9th, as its official diary records: 'On Sunday 16th March, a combined team for the 9th and 10th Battalions met a Belgian team on the Chatelet grounds and it was a 2-all draw.'

The Duke of Cornwall's Light Infantry

It may seem incomprehensible to us a century on but in the aftermath of the First World War few wanted to talk about the war and even fewer in the Duke of Cornwall's Light Infantry 1/5th Battalion wanted to see a history written about their experiences. Today many Britons are keen to learn the stories of their relatives who served (and they are often frustrated by the paucity of archival information or first-hand accounts) but it needs to be understood that in the years after the Great War there was a strong public determination to assign the horrors of war to the past, to move on, to try and forget. In late May 1916 thirty-four officers and 998 men of the 1/5th Battalion of the Duke of Cornwall's Light Infantry had left England for France. When it came to the writing of their history five years later, its author, Ernest C. Matthews, lamented in his introduction that there was so much apathy in response to his appeal for support to defray the costs that he was forced to write his history single-handed:

> *At the outset I met with much opposition and discouragement. Very few were interested at all in the History – most of us were sick and tired of anything connected with War – we wished to forget, and we were quite content to allow the mud and misery of those days to recede into the limbo of the past. But there were some to whom the suggestion of a History was sacred, and rightly so. The Roll of Honour of the Duke of Cornwall's Light Infantry alone justifies their emotions. I have no doubt but that those who read the 'In Memoriam' columns in* The Times *find their minds wandering back to the old front line, the grey dawn of 'zero' hour, with the sight of those glittering, cold bayonets, the crouching figures, the dismal silence of that prelude, the forced laugh of old 'Tommy' as he swallowed his last ration of rum and lastly, the aftermath – 'something accomplished, something done'.*[129]

Knowing now what they went through, it is no surprise the Cornishmen preferred to forget. They were territorials, these men of the 1/5th Battalion, New Army civilian

PLATE 431 The Duke of Cornwall's Light Infantry badge.
PLATE 432 Six pioneers of the Duke of Cornwall's Light Infantry Regiment. The soldier standing, right, has a signals badge on his sleeve.

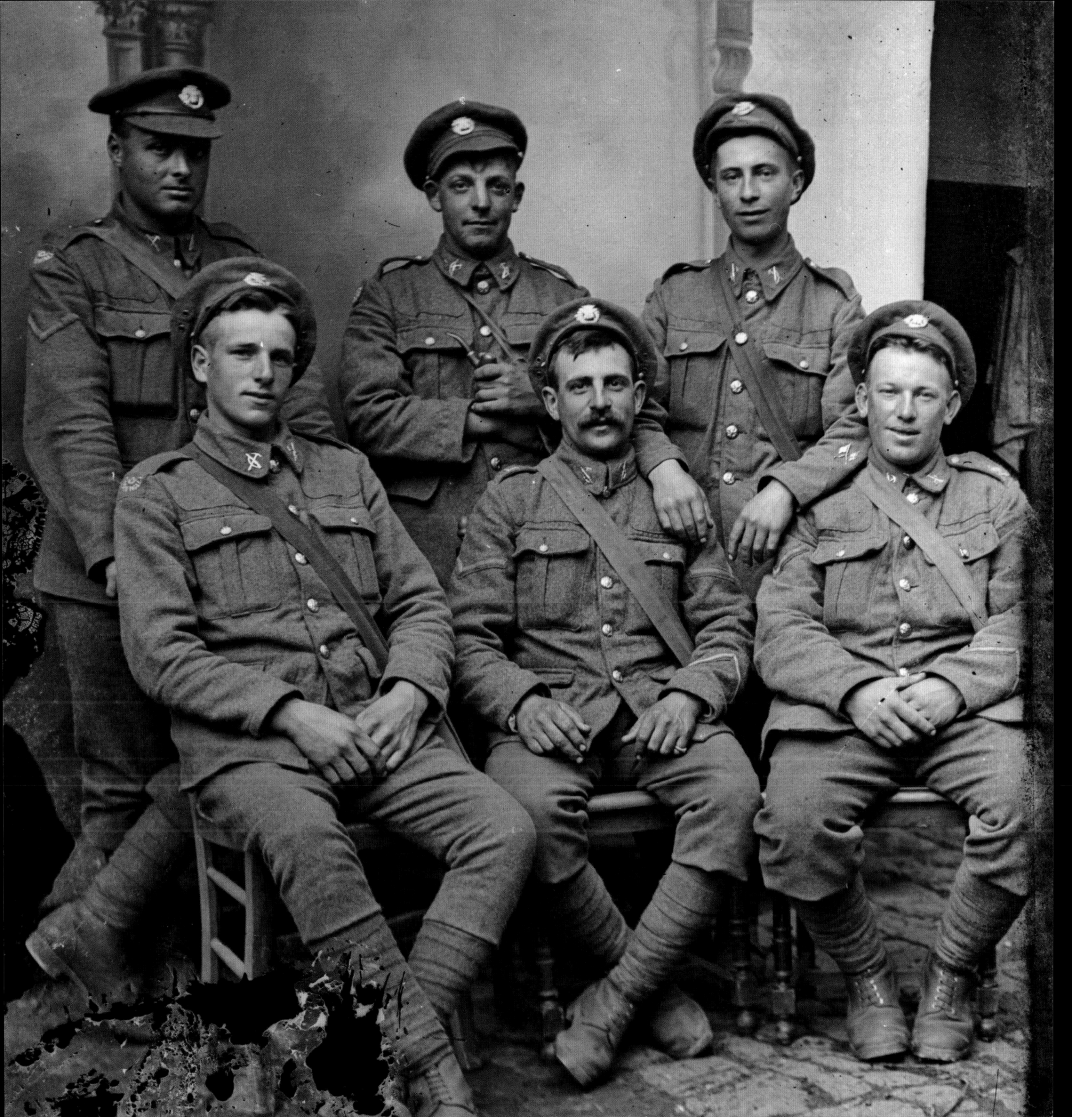

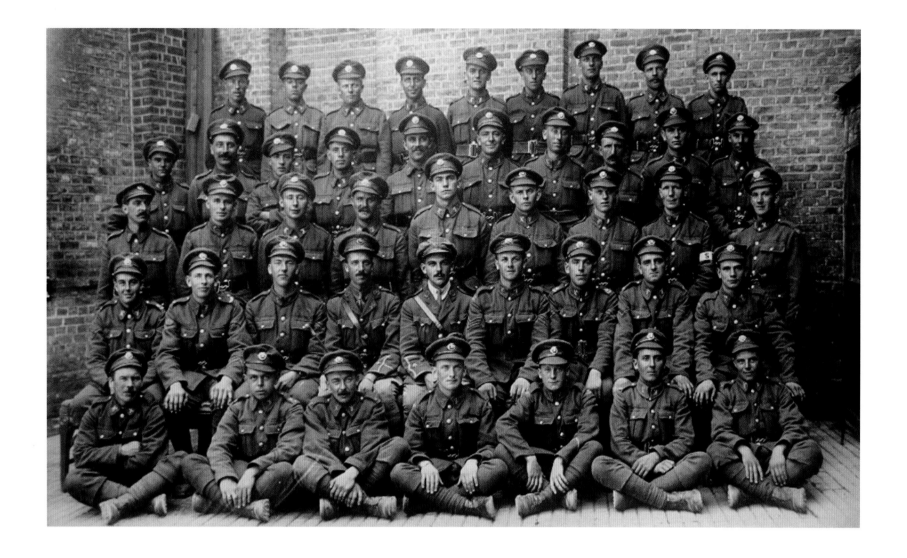

volunteers into a regiment with a history going back to 1702, when it was raised by a
Colonel Fox and known as Fox's Marines. The regiment had shed blood for the Empire in
France in 1756, in the American War of Independence, and in the Indian Mutiny of 1857,
then again in Egypt and the Boer War; now on 21 May 1916 the 1/5th Battalion arrived
in France to come under the command of the British 61st Division, where it would remain
for the rest of the war. Ernest Matthews was right. The story of this valiant group of
ordinary Cornishmen should be told, and there is a unique opportunity presented in the
Thuillier images. For it is likely that all or most of the Thuillier images of soldiers wearing
the badge of the 'Dukes' (as the regiment was affectionately known) came from just one
company of that one small 1/5th Battalion – miners, labourers, navvies, tradesmen – who
found themselves serving in a unit that endured some of the bloodiest battles of the war.

 Within eight weeks of their arrival on the Western Front, the 1/5th Battalion took
part in a battle that has largely disappeared from British history books but which is still
remembered in Australia as the most disastrous twenty-four hours in Australia's entire

military history. Australian and British 61st Division troops, including the 1/5th, were given just a few days to prepare for a feint attack intended to draw German troops away from the main Allied advance eighty kilometres south at the Somme. Australian Brigadier General Pompey Elliott realized early on that what would become known as the Battle of Fromelles would be a slaughter; he and a British officer inspected the battlefield and predicted the attack would be a 'bloody holocaust'. But, despite strong misgivings from within General Haig's command, the commanding British general, Richard Haking, decided to proceed.

On 19 July 1916 at 5.30 p.m. the 1/5th Battalion pioneers were part of the 61st Division attack; many were immediately cut to pieces by machine guns and artillery. Soldiers were mown down in swathes as they marched across open ground towards the heavily entrenched German fortifications; many had dreadful wounds in their legs and groins from the machine guns, and were unable to move, screaming in pain and slowly dying of thirst if they were not caught earlier by the German sharpshooters picking them off one by one. This supposed feint attack was a debacle, a shambolic failure of command, poor intelligence and bad planning. Yet, a century on, many history books still push the canard that the attack somehow succeeded in its objectives, and this probably has its origins in an official communiqué issued by the British Army at the time describing the attack as merely raids, rather than an attack intended to seize the position: 'Yesterday evening, south of Armentières, we carried out some important raids on a front of two miles in which Australian troops took part.'[130]

The losses were appalling that day; 7,000 of the British Empire soldiers who fought in the battle were killed or wounded. The 61st Division men, including the 1/5th Battalion, failed to capture any ground and, most depressing of all, the attack failed to distract the Germans away from the Somme. Yet, in communiqués and briefings to war correspondents, British intelligence officers falsely claimed the attack was a great success. Australian Official Correspondent Charles Bean, who was a first-hand witness to the battle's bloody aftermath, was furious about the claim, writing in his diary: 'That is not true – it is the opposite.'[131]

During their time in France some men of A Company of the 1/5th Battalion had their photograph taken (see Plate 433, opposite). This image, which does not appear to be a Thuillier picture, comes from the family album of the relatives of a soldier named Sergeant Cecil Westlake, who is sitting fourth from the right in the second row next to a second lieutenant; tantalizingly, it offers a key to possibly identifying the men within a number of Thuillier pictures.

PLATES 433–434 (Left) Pioneer soldiers of A Company of the 1/5th Battalion of the Duke of Cornwall's Light Infantry, taken in France sometime between late 1916 and early 1918. Cecil Westlake is sitting on the right of the officer in the middle of the second row (close-up above). (Courtesy Myra Ellacott – Cecil Westlake's daughter)

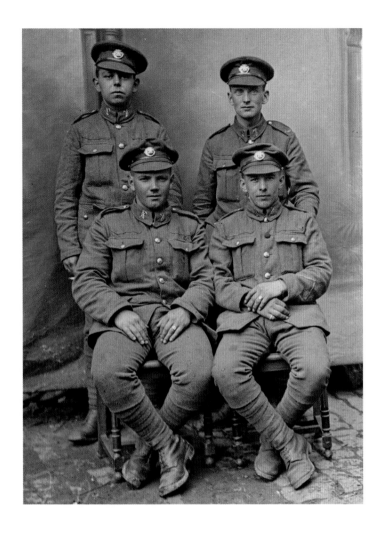

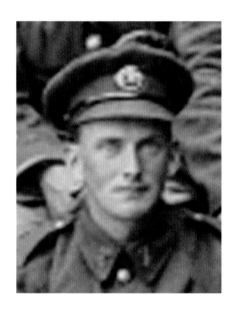

By cross-matching the faces of men in this photograph with images in the Thuillier collection it is possible to identify several men who were members of A Company in the photograph when it was taken later in the war. There are no images of Westlake but the men in these Thuillier images were his close comrades-in-arms, who served with him in a company of about a hundred men. Many soldiers from A Company came from Liskeard and the surrounding area, an ancient market town community in south-east Cornwall between Bodmin and Plymouth. Cecil had already lost his brother Horace at Loos but he was keen to enlist and was a sergeant by 1918, refusing an officer's commission, his family proudly recalls, because he wanted to stay with his men. Cornwall is a close community, even today, and it is hoped that by publishing these pictures it might be possible for readers to identify these men known to have served in A Company; few of their service records survived the Second World War but perhaps someone can give these fellows the dignity of names to their faces.

Before it left England, in April 1916 the 1/5th Battalion was designated as a pioneer battalion, which is why the men in it wear the crossed-rifle-and-pick infantry pioneers' collar badge. The Royal Engineers Corps was overstretched so the army picked

PLATES 435-437 The pioneer soldiers standing in this Thuillier image both appear as members of A Company in the photograph in Plate 433 taken later in the war – as the close-ups from that other image reveal.

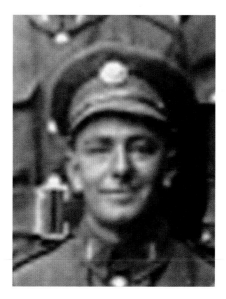
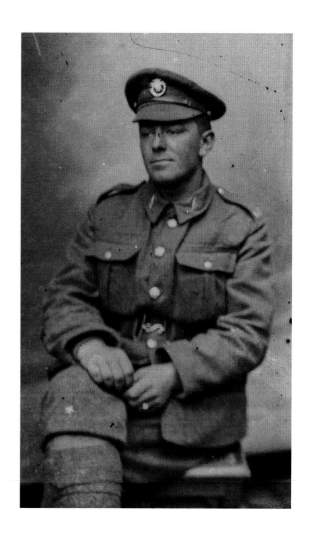

PLATES 438–439 Another A Company pioneer in the Thuillier images, with a close-up of his face from the A Company group picture on the left.

men with a background in mining, construction, labouring or other trades, to become pioneers. It was a hard job; the pioneers received an extra twopence a day on their army salary to compensate for the risks and extra rigours of their role. They were also given additional supplies of tools, explosives and other engineering equipment. They built railways, felled trees, built bridges and roads and fortifications. 'The role of the pioneer battalions was to provide "organised and intelligent" labour for the Royal Engineers but it was stressed that they would remain fighting infantry.'[132] It is very likely their photographs were taken by the Thuilliers when the pioneers of the 1/5th were working in Vignacourt, which was a railhead and a key area behind the lines in the lead-up to the Somme battles of 1916. Some or all of the Duke of Cornwall's Light Infantry Regiment images were probably taken before October 1916 when it moved into a Somme front-line position between Contalmaison and Pozières, near Albert. 'Although the great battle of the Somme was breathing its last exhausted gasps, there was still much work for the infantry pioneers. The laconic entries in the War Diary stating "The Battalion did pioneer work as usual" hide the reality of the nightly labour carried out under fire at the cost of many casualties,' one history records.[133] They also had to contend with massive

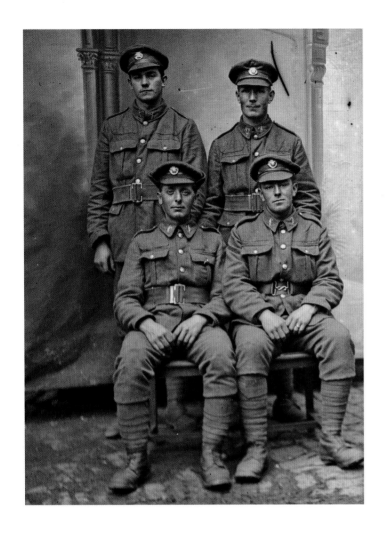

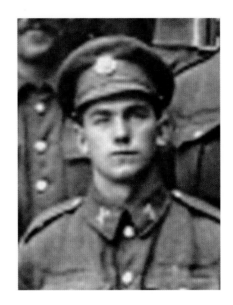

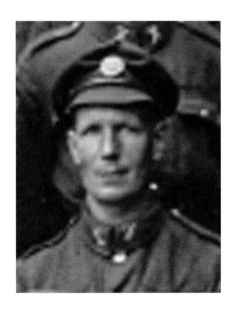

numbers of rats that, distressingly, fed on the bodies of dead men in no man's land and devoured anything remotely edible in the trenches, including leather and clothing.

When the Germans withdrew from their front-line trenches to the new Hindenburg Line in March 1917 the pioneers were kept very busy laying new communications lines (often under heavy fire) and defusing the numerous booby traps left by the Germans. They then suffered through the Third Battle of Ypres in August and September of 1917, otherwise known as Passchendaele. 'Nowhere was safe in the Ypres Salient, where every road and track was subject to heavy artillery fire or aerial bombing.'[134] The great misconception about the pioneers was that they were seen as unglamorous, compared with the front-line combat infantry troops. The truth was that battalions like the 1/5th did both – they built the fortifications, communications and transport links for the battle and then fought on the front lines when called upon.

It was during the massive German offensive in March 1918 that the men of the 1/5th would distinguish themselves with battle honours. At St Quentin Canal on 23 March, Cecil Westlake and the men of the 1/5th found themselves in a fierce fight. The pioneers were ordered at short notice to seize the village of Verlaines from the Germans,

PLATES 440–442 Another shot of the soldier (seated right) from A Company of the 1/5th Battalion of the Duke of Cornwall's Light Infantry. The two soldiers standing in this Thuillier picture are also A Company men. The man at top right was a stretcher-bearer by 1918.

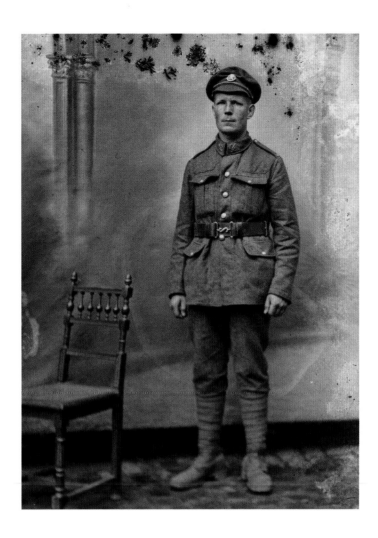

without the benefit of reconnaissance or solid planning. The pioneers not only captured Verlaines, they pushed the Germans off a nearby ridge with such courage that the 1/5th earned the rare distinction of being especially mentioned in Field Marshal Sir Douglas Haig's official dispatch of the German offensive. It was achieved at huge cost; many men of the 1/5th Battalion died or were wounded in the battle, including Captain Tyacke, the commanding officer of A Company, the same unit photographed at Vignacourt. During the desperate fighting of March and April 1918, the Germans repeatedly tried to break the British lines. It is the stuff of regimental legend, and a measure of the bloodiness of the fighting, that when the 1/5th Battalion's commanding officer Lieutenant Colonel Trevor Carus-Wilson was himself mortally wounded he told his batman, 'Give my love to the Battalion,' and died before he reached hospital. Hugo White's history of the Duke of Cornwall's Light Infantry Regiment records the battalion's extraordinary sacrifice: 'At a time when the outcome of the entire war hung in the balance, the 1/5th had made a significant contribution to the action which had absorbed, slowed down, and finally halted the massive German offensive.'[135] The Cornish volunteer territorials had paid a terribly high price for their bravery; in just ten days of fighting they suffered 214 casualties.

There was little rest for the Allied forces along the entire Western Front in these desperate days. The men in the Thuillier images who had survived the St Quentin battle now found their ranks being reinforced with 400 very raw and young troops brought across from England, all under the age of nineteen. 'At this stage of the war, Britain was scraping the barrel for men, and the standard of drafts being sent to France reflected this serious shortage,' White admits.[136] Cecil and these raw recruits were thrown with the surviving veterans of the 1/5th into the front line near a village called Merville. In the subsequent Battle of Estaires on 12 April 1918 Cecil Westlake and numerous other Duke of Cornwall's men from A Company were cut off and attacked from the rear, eventually being forced to withdraw with terrible losses. Sixteen officers and 467 men were wounded, killed or, like Cecil, taken prisoner by the Germans. The family still has Cecil's tiny diary in which he recorded the story of his internment in a prisoner-of-war camp just behind the German lines. It was not until eight months later, on 22 December 1918, that British Army officers finally reached his POW camp, telling Cecil and his mates that they were finally leaving for England on Boxing Day. He returned home, married, had children, and – as so many families of Great War veterans remember – he never discussed his wartime experiences. At least some of the men from Liskeard had survived in A Company; the nearby hamlet of Hille lost every single man who went off to fight in the First World War and it was abandoned after the war. Apt, too, to mention that the First World War veteran who lived the longest was also a member of the Duke of Cornwall's Light Infantry. Harry Patch lived from 1898 until 2009, and served as a machine-gunner in the 7th Battalion. He never spoke about the war either – at least not until he turned 100 years old.

If any man tells you he went into the front line and he wasn't scared – he's a liar. You were scared from the moment you got there. You never knew. I mean, in the trench you were all right. If you kept down, a sniper couldn't get you. But you never knew if the artillery had a shell that burst above you and you caught the shrapnel. That was it …

It wasn't worth it. No war is worth it. No war is worth the loss of a couple of lives let alone thousands. T'isn't worth it … the First World War, if you boil it down, what was it? Nothing but a family row. That's what caused it.[137]

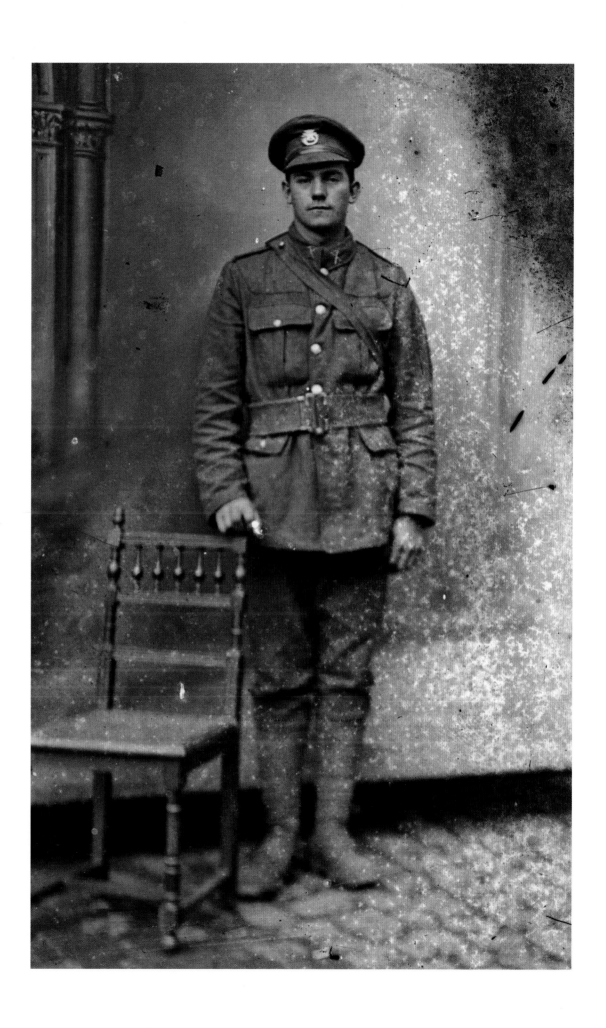

PLATE 444 The same young man standing on the viewer's left in Plate 440 (p. 358). He also appears in the group portrait of A Company of the 1/5th Battalion DCLI.

The Crosses

When soldiers died in action on the Western Front, many were simply buried where they fell as there was often no safe means of getting their bodies out of the area. Others were transported to casualty clearing stations near the battlefield, where they died. Wherever they were buried, their battalion mates erected makeshift crosses if they could – and often these crosses quickly disappeared on the battlefield under the next artillery barrage. But when soldiers died in casualty clearing stations they were buried in the nearest war cemetery.

For much of the war, the 61st Casualty Clearing Station was at Vignacourt, and more than 584 Allied soldiers are buried in the village graveyard. By March 1918, when the Germans began their last desperate advance, the 20th Casualty Clearing Station was also based in the town to help deal with the enormous number of casualties from the Allied defence of Amiens. The Vignacourt cemetery was begun in April 1918 and closed in August and most of the graves within it are those of 424 Australians; as the Commonwealth War Graves Commission acknowledges, 'the burials reflect the desperate fighting of the Australian forces on the Amiens front'. One hundred and fifty-one servicemen from the United Kingdom forces also rest in Vignacourt Cemetery. All those who served and died are now buried under the standard Commonwealth War Graves headstone, but for several years after the war, while the headstones now in place were being prepared in the new cemetery sites, makeshift crosses featured in the Thuillier images honoured the dead.

There were many such makeshift crosses photographed by the Thuilliers, presumably because a dead soldier's mates or family arranged for a photograph to be sent back to the relatives. For the majority of families, this was their only chance ever to see the grave of their loved one because for most people the cost of travel to Europe at that time was prohibitively expensive. In the early 1920s, the wooden crosses – some carved from the branches of trees, others made from old rifles and even roughly crossed propellers –

PLATE 445 The grave of Private William Fielden of the 89th Company of the Machine Gun Corps (Serial Number 9754). The plaque reads 'accidentally killed' on 28 September 1916.

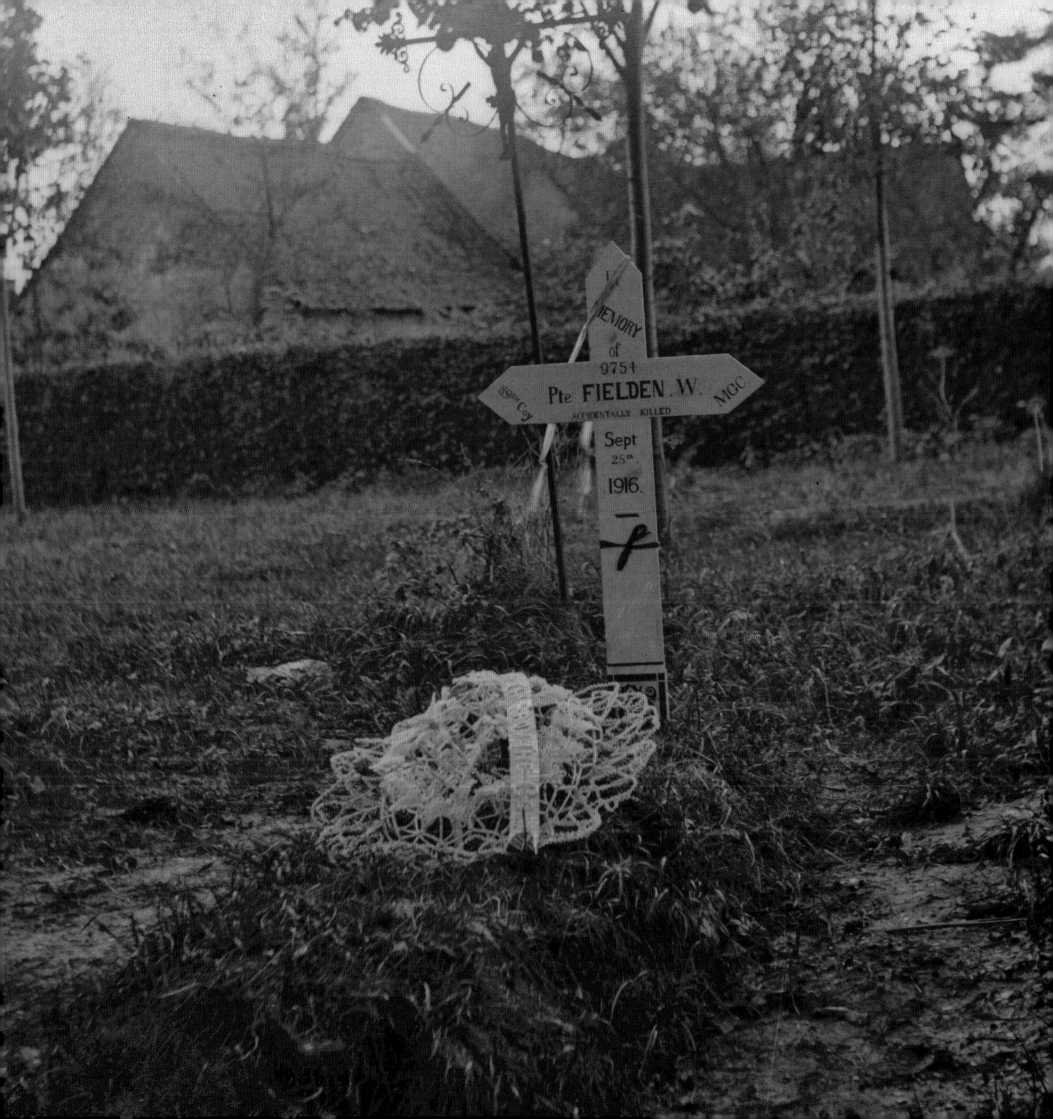

In
MEMORY
of
9754
Pte FIELDEN.W.
89th Coy ACCIDENTALLY KILLED MGC
Sept
28th
1916.

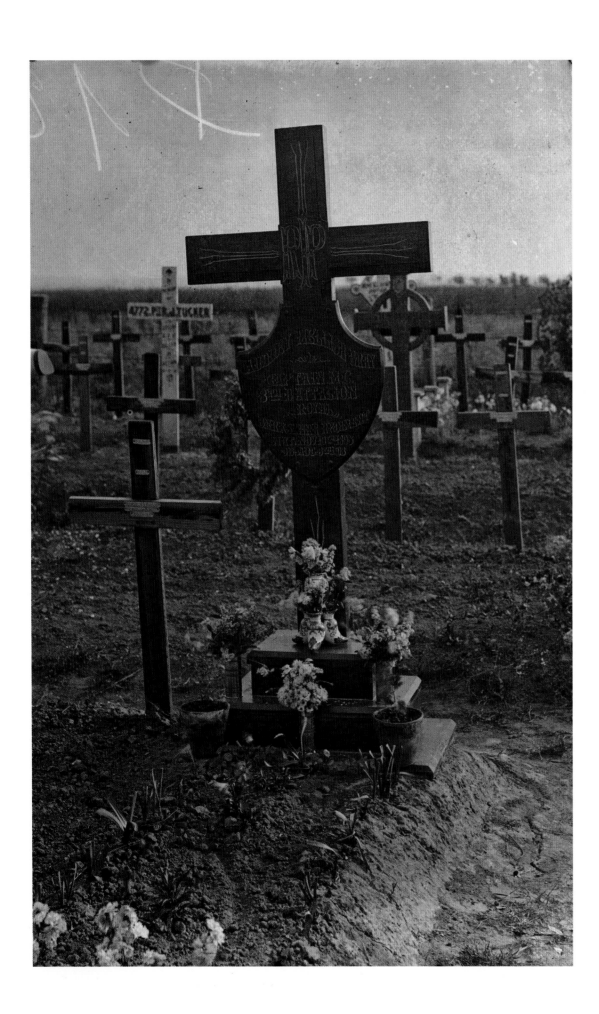

PLATE 446 The gravesite in 1918 of Captain Aubrey Bray MC, 8th Battalion Royal Berkshire Regiment, now a Commonwealth war grave with a stone headstone.

were gradually removed and replaced by the generic white memorial stones which are today a distinctive feature of the Commonwealth war cemeteries across the old Western Front. Most of the crosses photographed in Vignacourt were those of young Australians – whose families had probably commissioned the Thuilliers to send them a photograph of the grave to remember their sons buried on the other side of the world. Many of the letters home to the families of Allied soldiers at this time, including British servicemen, refer to photographs provided of their loved one's grave, as well as an explanation of the circumstances of their death.

One of the British images photographed by Louis or Antoinette Thuillier is a carefully painted wooden cross over the grave of Lancashire Private William Fielden of the 89th Company of the Machine Gun Corps whose epitaph records that he was 'accidentally killed' on 28 September 1916 aged just twenty-one. Burial records show he was the son of cotton weavers Esther and William Fielden, of Shore Street, Littleborough, near Rochdale. Like so many bright young lads he transferred into the new Machine Gun Corps. The fact that his grave appears in the Thuillier images suggests Louis or Antoinette was possibly commissioned by his grief-stricken friends to record this solemn picture. There is also a large wreath in the photograph that rests across his grave saying: '…from the Company'. Whatever the circumstances of his death, it clearly hit Fielden's pals hard. Sadly, the full story of the circumstances of his accidental death appears to be lost to history; like so many other records, those of the Machine Gun Corps were mostly destroyed in bombing during the Second World War. But young William Fielden was and still is remembered.

Another British soldier whose early grave was photographed by the Thuilliers was that of Captain Aubrey Mellish Bray of the 8th Battalion of the Royal Berkshire Regiment. His strikingly well-made wooden cross and plinth was erected over his grave soon after he was killed in action on 8 August 1918. Bray was the son of Lieutenant Colonel Reginald Edward Traherne Bray, who was commanding the 7th Battalion of the Royal Berkshires in Salonika at the time of his son's death. Captain Aubrey Bray died a hero; he earned a Military Cross either just before or during the action that resulted in his death. The Government Gazette of 13 September 1918 records that Captain Bray was awarded the MC in recognition of his conspicuous gallantry and devotion to duty in the field during an enemy advance. 'He went out in front of the position and conducted a valuable reconnaissance which materially helped to clear up the situation. Two days later he went all along the line under heavy shell and machine-gun fire, giving

each officer instructions for the withdrawal.' Tragically such risk and sacrifice came at a dreadful price; Captain Bray's no doubt grief-stricken family probably helped pay for his prominent wooden cross. The Bray family suffered terribly in the war, losing another son to the conflict. George 'Reggie' Bray, a lieutenant in the 7th Battalion, died on 16 August 1916 while serving under his father in Salonika.

Now in Vignacourt's Commonwealth War Graves cemetery, the early wooden crosses hand-made by friends and dedicated by family have all gone, replaced by white headstones that were erected during the 1920s. It most probably had to be done this way, but what was lost was the care, sentiment and emotion that must have gone into creating the original crosses – and a tangible symbol of the connection of the surviving soldiers to their fallen mates.

PLATE 447 Vignacourt Commonwealth War Graves cemetery today, looking towards the village. (Photo Ross Coulthart)

Today, Vignacourt Cemetery is immaculately maintained. A memorial erected by the grateful villagers also stands watch over the graves. It is a statue of a French soldier and on its base are the words '*Frère D'armes de L'Armée Britannique, tombés au Champ D'Honneur, dormez en paix. Nous veillons sur vous.*' Translated, it reads, 'Brothers in Arms of the British Army, fallen on the field of honour, sleep in peace; we are watching over you.' Even through an icy winter there is a constant, steady flow of families to this tiny cemetery – many of them leaving flowers, photographs, poems and flags on the gravestone of a fallen father, a grandfather, a great-uncle. It is a moving and sombre place. The people of Vignacourt have not forgotten either; the townsfolk's eyes glow with pride as they describe escorting a lost young backpacker to her great-great-uncle's grave and of welcoming a foreign visitor to the cemetery into their homes. They will never forget.

The Royal Sussex Regiment

'The day Sussex died.'

The Royal Sussex Regiment was one of the last British Army units to be based in Vignacourt during the war, and by the time it arrived its battalions had suffered dreadfully. Early in the war the Germans had dubbed the Royal Sussex 'the Iron Regiment'; it was an extraordinary chivalrous tribute by an enemy, so bravely had the Sussex's 2nd Battalion fought at Ypres in November 1914. But such chivalry would quickly seem anachronistic because of what happened in a diversionary attack the regiment was sent into one day before the beginning of the Battle of the Somme. It is still mourned as 'the day Sussex died'.

At the Battle of the Boar's Head at Richebourg l'Avoue, in the Pas-de-Calais department, members of the South Downs Pals battalions of the Royal Sussex had been ordered into an ill-planned attack on 30 June 1916. In five hours of brutal fighting, the South Downs lost almost all their officers and 349 men killed; its 13th Battalion was effectively wiped out; a thousand men were wounded or captured; twelve sets of brothers died, including three from one family. It is better known today as 'the Boar's Head Massacre'. It is all too often ignored in histories because it is overshadowed by what happened the following day: the opening day of the Battle of the Somme, where over 20,000 young men were killed in just twenty-four hours.

In June 1918 another of the Royal Sussex volunteer service battalions arrived in Vignacourt; they were the men of the 7th Battalion, a service battalion formed as part of Kitchener's New Army. Those few who had survived the three years of war had arrived on the Western Front in July 1915 as part of the 36th Infantry Brigade with the 12th Division. By the time they found their way to Vignacourt in this summer of the final year of the war the 7th, like most of the Royal Sussex battalions, was shockingly depleted from years of grinding battles – from Loos in 1915, through Albert and Pozières in 1916, the Battles of Scarpe, Arleux and Cambrai in 1917, and most recently Bapaume, Arras and Ancre in the

PLATE 448 The cap badge of the Royal Sussex Regiment.
PLATE 449 Royal Sussex men, several with medal ribbons for gallantry.

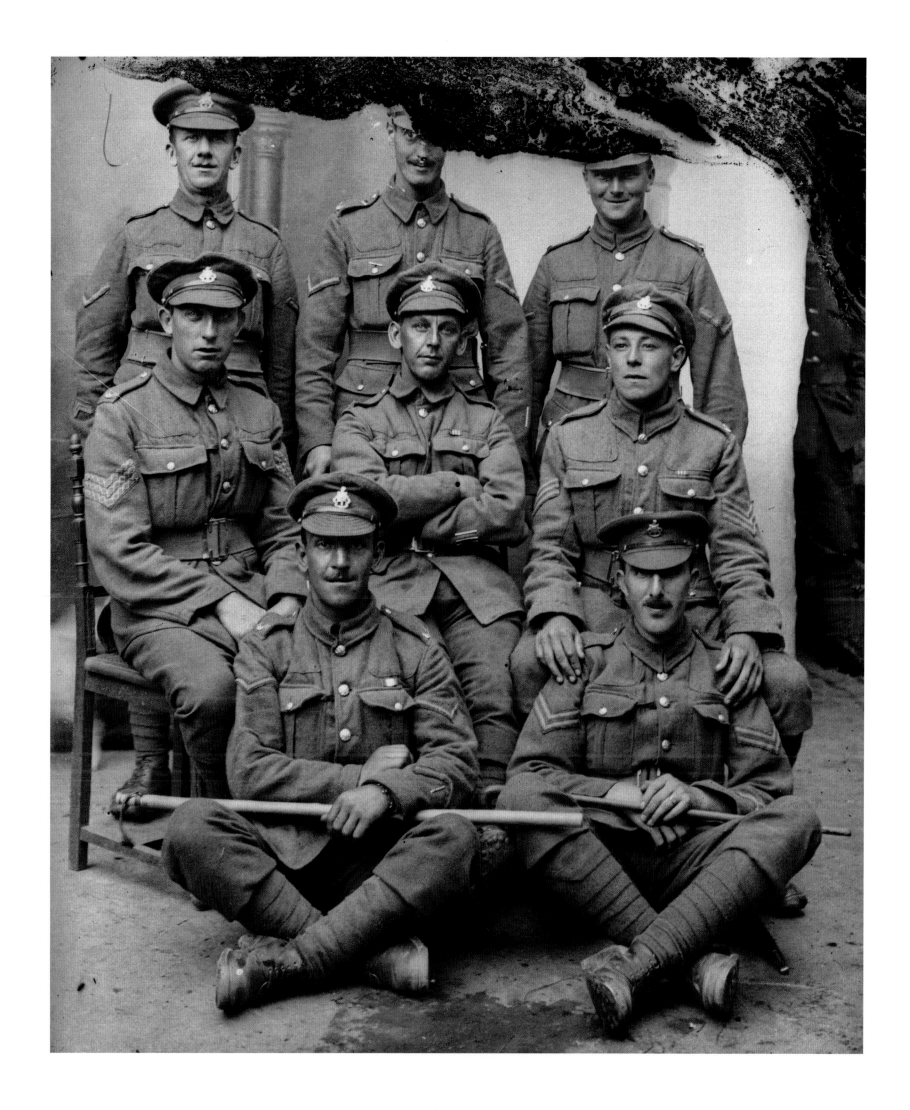

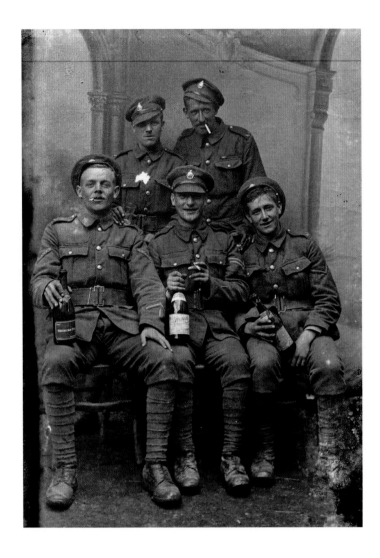
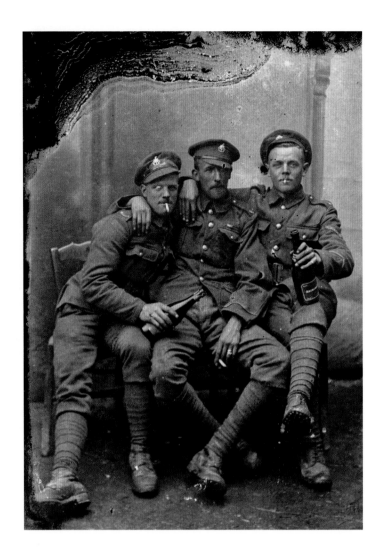

first few months of 1918. There are many images of the Royal Sussex Regiment in the Thuillier collection and because we know from the overseas-service chevrons on at least one of the uniforms that these men must have been photographed during 1918, it is very likely they were from the 7th Battalion when it visited the town in July that year.

The 7th had spent three weeks in Vignacourt in June 1916, just before the Battle of the Somme, training in the surrounding fields: 'The country round Vignacourt provided a delightful training ground – woodland, pasture and arable land,' a regimental history records.[138] It returned to Vignacourt in late July 1918 just before the battalion was called into the defence of Amiens in August to hold off the final major German offensive of the war. Little wonder that by the time they were billeted in Vignacourt the men were keen for some fun.

The soldier standing on the right in the left-hand photograph above, and seated in the middle in the right-hand image, has a medal ribbon so maybe he and his friends were celebrating this award – or perhaps they were just letting off steam after months in the trenches.

PLATES 450–451 Soldiers of the Royal Sussex enjoying a drink and some of the same men a little bit later in their celebrations. They are drinking American spirits and French wine ... and a lot of it, by the looks of it.

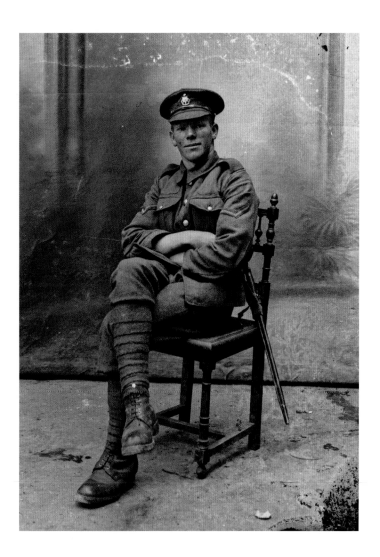

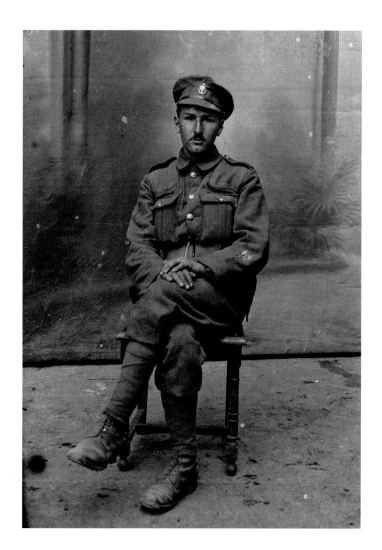

PLATES 452–453 Men of the Royal Sussex Regiment. The soldier on the right is a signalman.

The 7th Battalion of the Royal Sussex went on to fight in the Battles of Amiens, Albert and St Quentin Canal before taking part in the final advance to Artois and the capture of Douai at the end of the war. It is very likely some of the 7th Battalion men in these images fell in the remaining few months of the war because the 7th was thrown into a bloody series of battles at Morlancourt, Fricourt, Nurlu and Epehy before the fighting ended; 666 of their number would become casualties by the Armistice.

The telegram announcing the Armistice arrived when the battalion was in Landas, near Lille, in north-eastern France. But in a reflection of the general response by most soldiers to the Armistice, the news was greeted with a 'very feeble cheer'. They were too exhausted from years of fighting to get excited; the men were close to breaking point:

> *Our already much reduced rations had been still further lessened during the past month*
> *owing to the necessity which had arisen for feeding the French population in the regained*
> *territories … and epidemics of influenza and bronchitis were becoming serious in*
> *the battalion … in fact it is true to say that at no period during the whole war were*
> *rations and other necessities more scarce. If the war correspondents of some of the more*
> *bloodthirsty newspapers had been living with us in those times, we should not perhaps*
> *have heard so much about fighting our way to Berlin, nor should we have been told the*
> *Armistice was premature.*[139]

The 7th Battalion of the Royal Sussex Regiment was disbanded in early 1919; it had existed for little more than four years. All twenty of its battalions had seen action and the regiment lost 6,800 men during the conflict.

PLATE 454 A close look at the soldier seated far left in this photograph reveals overseas service chevrons on his lower right sleeve. This suggests this image was taken during 1918, which is when the 7th Royal Sussex was training in Vignacourt, in the summer running up to the end of the war. So it is likely that these men were from the 7th Battalion.

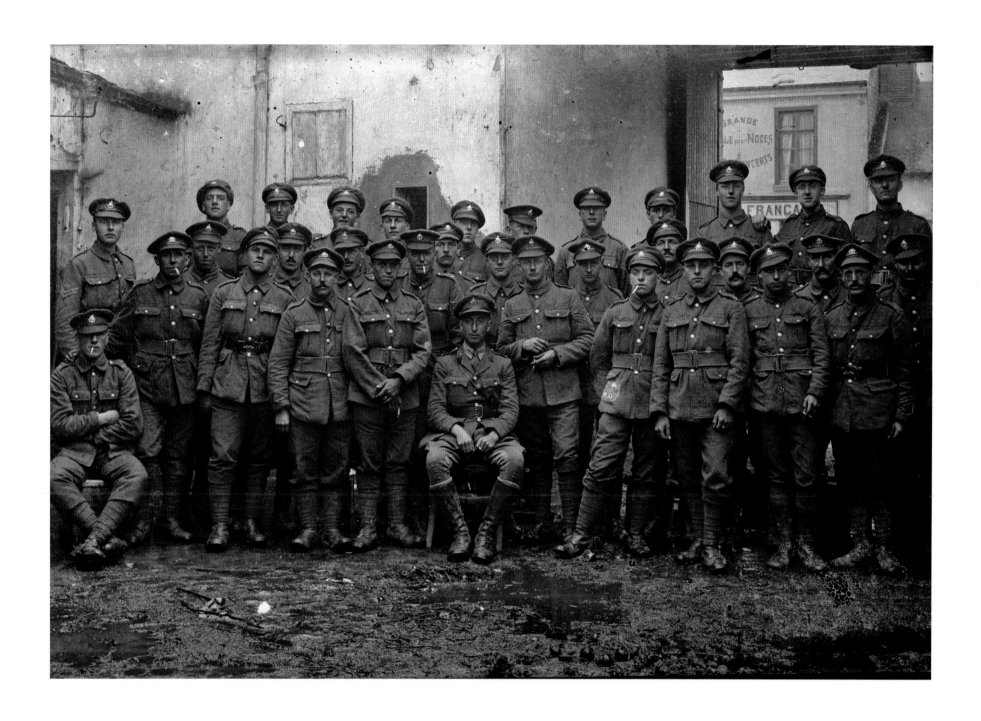

Armistice Day

On 10 November 1918, Captain Raymond Hepper of the West Yorkshire Regiment's Leeds Pals 15/17th Battalion was just nine kilometres from the Belgian border in the Nord-Pas-de-Calais department of France. At 5.30 a.m. he and the men of his C Company Bantam Battalion marched into the ancient town of Maubeuge. They knew the Germans had previously besieged the town and they were expecting to go into combat on the other side of its fortified ramparts. But today was different:

> On the way during one of the halts, we talk to an old man and his wife who bring
> their chairs for the officers to sit on. The C.O. calls all the company commanders to
> pass down the news that the Kaiser has abdicated and that no sign of the Boche can be
> found just in front of us. The old man calls out 'Vive les Anglais' and the old woman
> bursts into tears of joy ...[140]

After four long years of almost constant fighting, Raymond Hepper realized for the first time that he was going to be an unlikely survivor of one of the worst conflicts in human history. The next day – 11 November 1918 – he excitedly recorded in his diary how hostilities had ceased at eleven o'clock that morning. 'The woman at the billet is highly pleased when I tell her and she catches me under the chin with both hands and kisses me, much to the amusement of our servants who dance and scream with laughter.'[141] When he read out the terms of the Armistice to his men, however, Hepper noted that there was very little exuberance.

One hundred and seventy-four kilometres south-west, the tiny village of Vignacourt was letting its hair down. Victoria Cross winner Joe Maxwell and his Australian 18th Battalion colleagues were in Vignacourt when the joyful news came through that the war was finally over. The battalion's war diary records:

PLATE 455 Vignacourt Armistice Day celebrations in the main street, 11 November 1918. The colour patch on the Australian soldier in the crowd tells us he is 2nd Division and most likely to be from the 20th Battalion which had a triangular patch with white on the top and dark green below. The Australian 5th Brigade was in the town on the day the war ended.

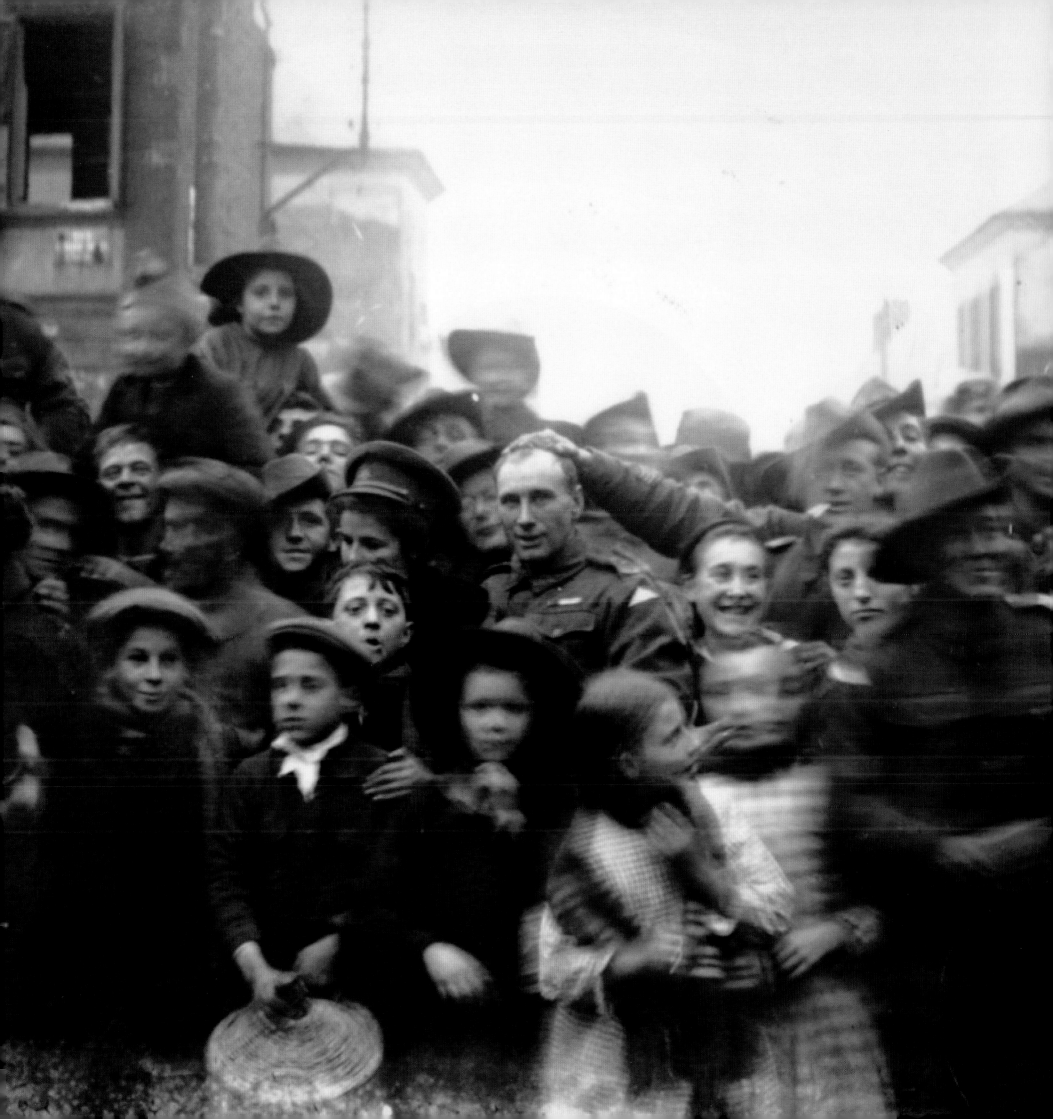

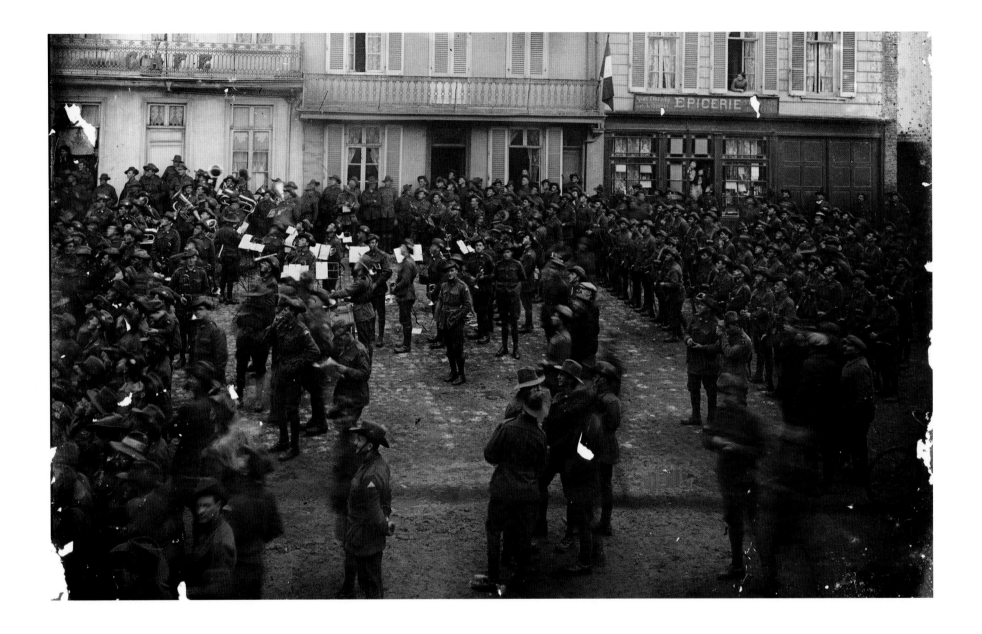

11.30am – Wire through Brigade reads Message of General Foch to Commander in Chief: Hostilities will cease along the whole Front on 11th November at 11 o'clock French time. All companies paraded ... The C.O. read the wire to the Battalion. The Australian, French and British flags were hoisted on the Church. Bands of the 18th and 20 Battalion played the Marseillaise on the General Salute. A photograph was taken by the village photographer. The remainder of the afternoon was declared a holiday.

The battalion diary barely does justice to the ebullience of that moment; for Vignacourt, and the whole of France, erupted in joy that the war was finally over. Until the Thuillier collection was uncovered in 2011, there were no known photographs of Allied troops celebrating the end of the war near the French front lines. Close to a

PLATE 456 Celebrations in Vignacourt village square on Armistice Day 1918. The very moment described by Joe Maxwell VC.

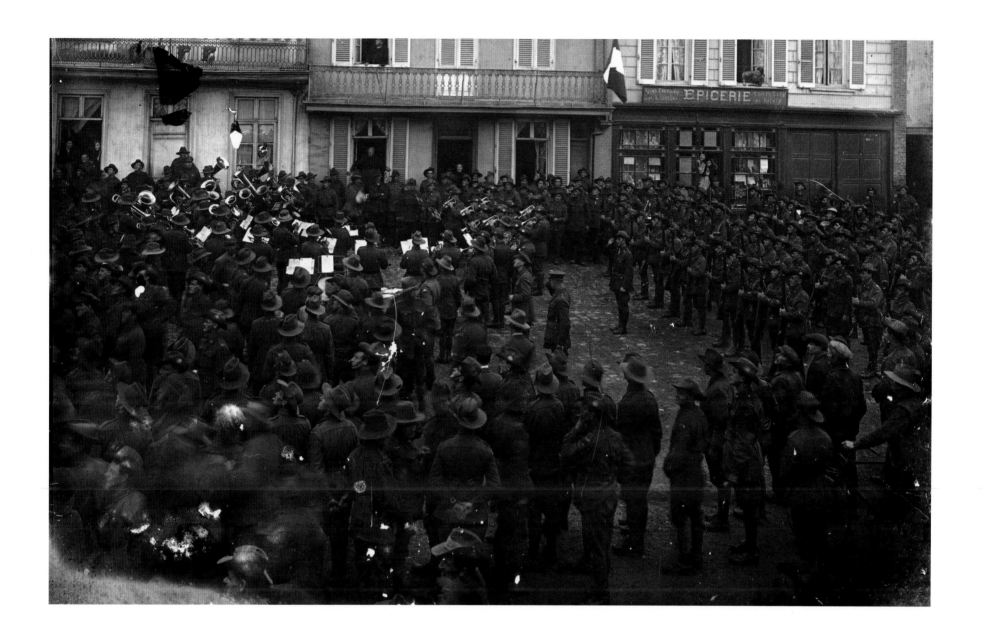

PLATE 457 Another Thuillier picture of the Vignacourt Armistice celebrations. Louis took this picture on an extra large glass plate – probably recognizing the importance of what he was recording for history. Note the men staring up at the cathedral, where Australian and French flags had been raised at the moment of peace.

hundred years after Louis and Antoinette Thuillier took these extraordinary pictures, they can be seen for the first time – snapshots of one of the most important moments in twentieth-century history.

Lieutenant Joe Maxwell VC wrote up the tumultuous day in his classic First World War autobiography *Hell's Bells and Mademoiselles*:

> *What a day! The strain snapped. Everyone in Vignacourt went mad with joy. The battalion was lined up in the main square and the colonel read the conditions of the Armistice. Surging wildly into the square came the whole civil population dancing and singing. Their bands blared the British, French, and American national anthems. The battalion 'clink' was opened. Restraint was flung to the winds. The villagers opened their cellars and wine flowed among the troops.*[142]

PLATE 458 Another extraordinary, never-before-seen image of the very moment the French national flag – the Tricolour – was raised on Vignacourt Cathedral on Armistice Day 1918.

Private Alfred Binskin, of the 20th Battalion, described the moment he and a mate raised the French and Australian flags by climbing to the top of the Vignacourt Cathedral steeple on Armistice Day:

> *We are billeted in a place called Vignacourt. An armistice signed. Great fun with the French people … A mate and I went to the church and climbed up to the steeple and hoisted the French and Australian flags … The band played the National Anthem and God save the King.*

The very moment that Alfred Binskin released the Tricolour was recorded for posterity by the Thuilliers (see opposite).

In the days after the Armistice was declared, a number of solemn celebrations were held in Vignacourt with French locals by the Allied forces. The Australian 19th Battalion's diary records:

> *On November 12, there was a hastily arranged thanksgiving service in the village Church at 10.30am attended by the whole Brigade and the local civilian population. Catholic Chaplain, father Francis Clune MC, stalwart ex-padre of the 19th, gave the sermon. After the band played the relevant national anthems, the French mayor of Vignacourt gave a speech of gratitude to the assembled troops on behalf of his fellow citizens. A Brigade sports carnival was held on the same afternoon.*

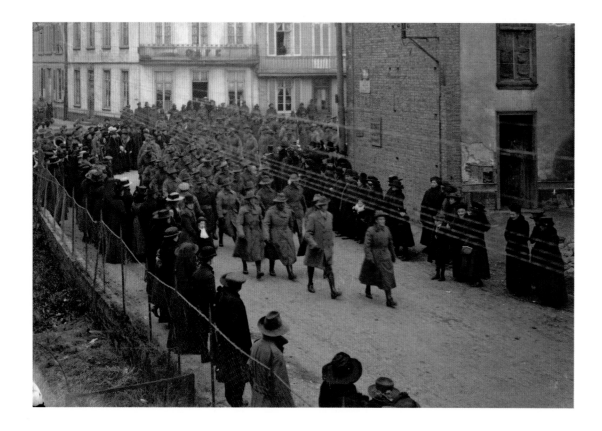

PLATE 460 Australian soldiers leading the march down the Rue de Station in Vignacourt to the cemetery, watched by local people.

PLATE 461 A second image of Allied soldiers – mostly Australians – marching with Vignacourt locals to the cemetery to honour the war dead, 17 November 1918.

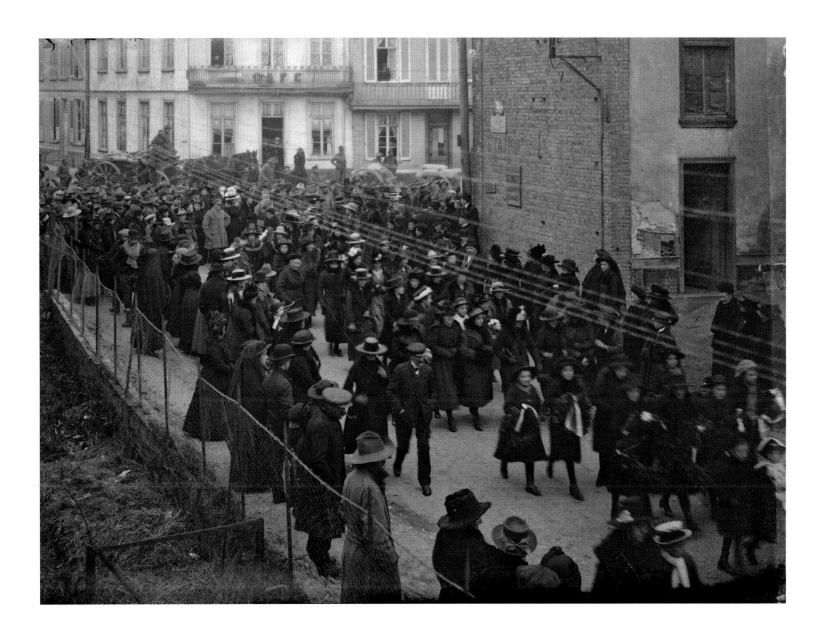

PLATE 462 Another view of the procession down to the Vignacourt cemetery on a chilly November 1918 morning.

What happened at Vignacourt six days after the Armistice, on 17 November 1918, a cold and bleak autumn morning, is recorded in this series of Thuillier images (Plates 460–463).

In a moving moment in the cemetery ceremony, every child in Vignacourt was given an individual soldier's grave to tend; all this was recorded by the Thuilliers. Plate 463 shows the village children standing by their assigned soldier's cross.

The speech made that Sunday morning by Paul Thuillier-Buridard, a Somme valley senator and mayor of Vignacourt, was a powerful tribute to the sacrifice made by the men whose remains now lie in Vignacourt's cemetery and in hundreds of other such Commonwealth cemeteries across France and Belgium. (He was probably a distant relative of Louis and Antoinette Thuillier, but the name is a common one across the

Picardy region.) Very few British soldiers were there that day but an entire Australian brigade was standing to attention as the mayor honoured them all. They were, he said:

> *the bravest amongst the brave ... On this great day we remember and weep. We remember those that by their lives paid the price of victory ... Soon the French people will be forever the keepers of those precious cemeteries. Amongst our villages you will have the same care as our own graves, paying tribute of love and gratitude. We thought that our British friends, represented by an Australian Brigade – bravest amongst the brave – would be sensible to this tribute and we invited them to attend ... To you my dear children, boys and girls already under the direction of your teachers, you have taken charge and you have flowered these graves. Your fathers and brothers were thinking of you on the battlefield or in the trenches during the four years and a half of this terrible war. You – because of the deeds of these greatest soldiers of the world associated with us to defend the noblest ideal – you shall never have to suffer what they have suffered. You shall reap the benefit of peace paid by the lives of these fallen heroes. You have to accomplish a great duty which you shall fulfil. Each of you forever will adopt a grave or more to keep them with flowers ... Soon we shall erect a fine monument so as to perpetuate to the coming generations the memory of the heroes that have saved the world. Each year we shall come to this memorial. By so doing generation to generation as George Clemenceau said, 'You shall follow your fathers and be soldiers of Ideal.' And to you fallen men, voluntary champions of Justice and Liberty, who came from all over the world to help France, your memory be blessed forever. Your great victory is proclaimed. Your work is done. Everlasting France, remembers you.*

Captain Raymond Hepper's war was over but he followed his West Yorkshire Regiment battalion into Germany, as part of the occupying forces after the war. Stationed near Cologne, he made one final entry in his diary before finally returning to England in late January 1919.

> *Four and a half years have slipped by since 1914 and I go back to make-up those lost years – lost in one sense yet gained in another for have I not learnt to realize the sterling qualities of my friends, learnt a little more confidence in myself, gained a wider outlook on life and learnt that might is not always right? I draw a curtain over times in which there have been many glimpses of sunshine thro' the thunder clouds and I look forward to the Happiness of Peace.*[143]

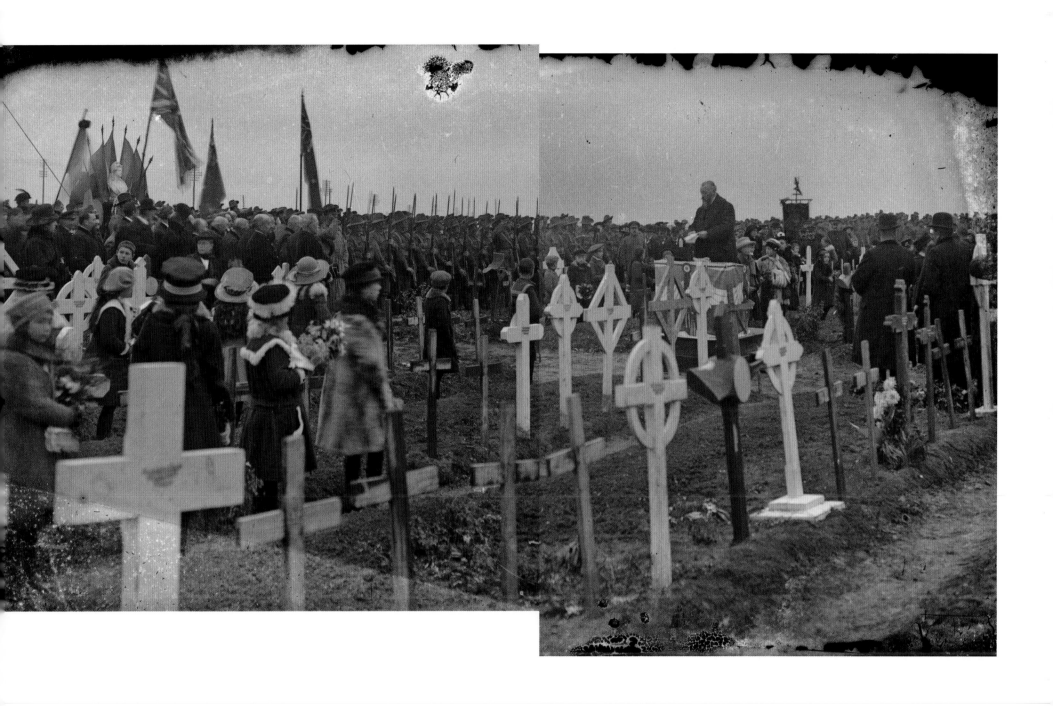

PLATE 463 In this composite image, children stand beside graves at Vignacourt Cemetery as Allied soldiers present arms and the mayor of Vignacourt, Paul Thuillier-Buridard, delivers his speech of gratitude, 17 November 1918.

Shocked

*No pen will ever in one book, or in hundreds, give the full record
of the individual agony, the broken heart-springs, the soul-shock
as well as the shell-shock of this frightful struggle.*[144]

The bitter legacy of the First World War has endured through generations, and traces of its pain still linger. For so many of the survivors, the trauma they suffered during the conflict was just the beginning of a life-long struggle to cope with the awful memories of what they had experienced. For, as well as the physical losses that soldiers and their families suffered in this unforgiving war, there was also the mental hurt. This condition had many names – 'war neurosis', 'combat fatigue', 'the shivers', 'jelly shakes' – but they all described the same general phenomenon, most commonly known at that time as 'shell-shock'. Stephen Garton's *The Cost of War*[145] describes how by December 1914 medical officers at the front were reporting that a tenth of all casualties seemed to be suffering from 'shell-shock' conditions of chronic shaking, stammering, deafness, muteness, uncontrollable fits and even blindness without any 'apparent organic cause'. It most commonly happened when men were tossed around by exploding artillery shells; they might not have been visibly hurt but, as Garton writes, these soldiers had quickly developed alarming signs of injury and distress. Because some soldiers suffering shell-shock had not even been in combat, there were suggestions that it was a form of hysteria and in 1922 the British War Office rejected 'shell-shock' as a misleading term and recommended it be replaced by 'war neurosis'. It has been commonly asserted in the medical literature that these symptoms were psychological in cause, but 100 years on there is mounting evidence suggesting that there is indeed a physiological basis for the symptoms caused by traumatic brain injuries sustained in combat. Whether physiological or psychological, the industrial scale of modern warfare, the pounding artillery and machine-gun fire and days under constant fire in

PLATE 464 The war-worn officers of the 6th Battalion West Yorkshires.

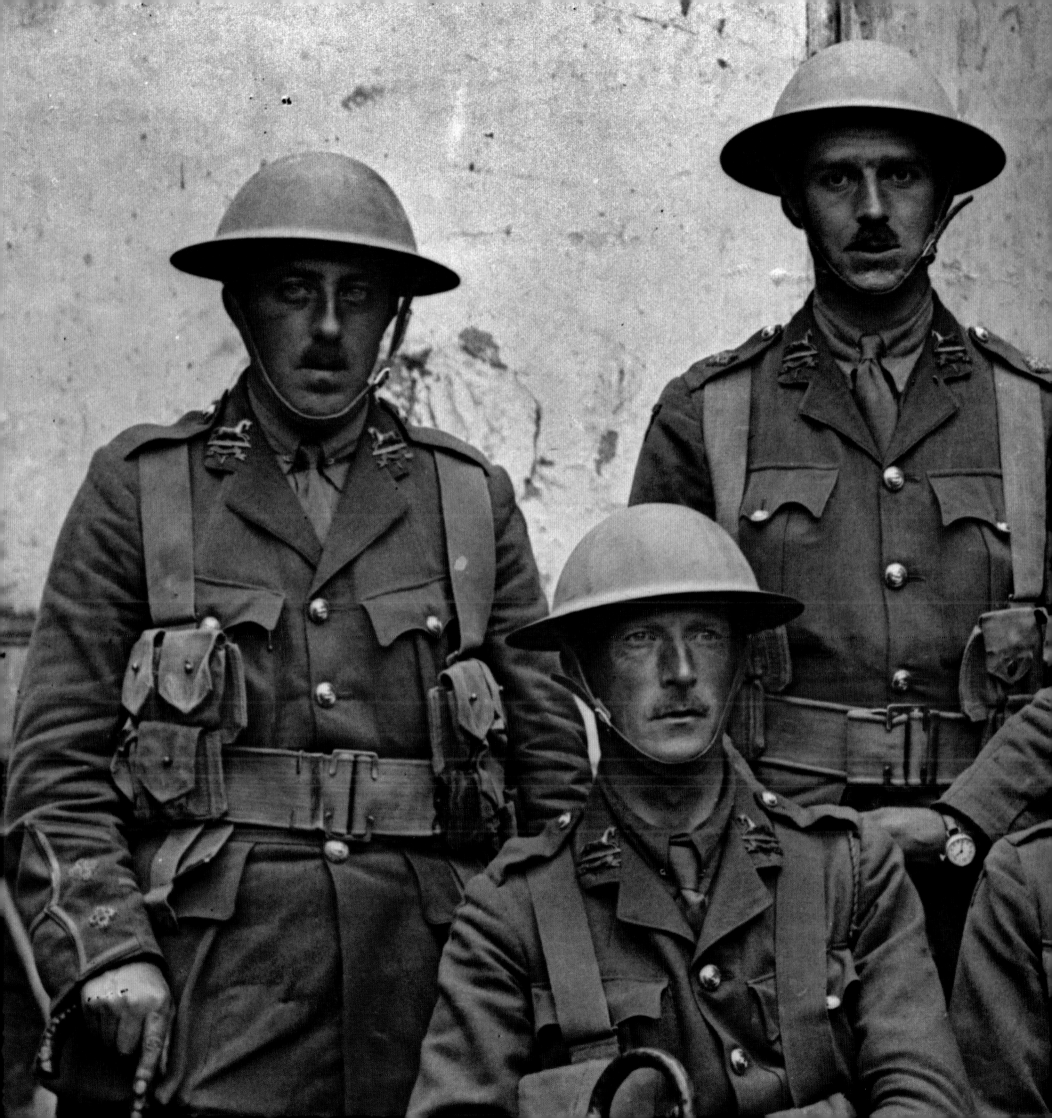

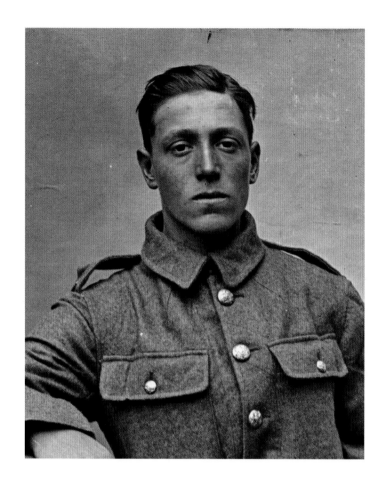 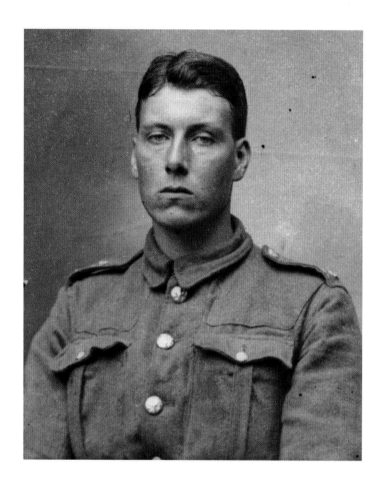

the front-line trenches took a dreadful toll on men's psyches even if they were not directly under fire. Sadly, attitudes that such men were genetically weak or cowards or malingerers also persisted.

One of the most harrowing images to show the effects of war on men's faces is the Thuillier image on the preceding page of the British officers from the 6th Battalion of the West Yorkshire Regiment, whose story we read on pp. 114–121. They were photographed in Vignacourt soon after months in the trenches in Thiepval and just before their devastating losses in the early Battle of the Somme in July 1916. If ever a face was etched with the pain of what a man has endured in battle, this photograph of the battalion headquarters' officers perhaps says it all; each of these dignified men has the horrors of war in his eyes and the lines on his face. Each man seems to be struggling to keep himself together and there is also something about the composition of this image; Madame or Monsieur Thuillier has kept the framing wider than necessary, perhaps because they felt to zoom any tighter into the men's shattered faces at that time would have been an intrusion. On close inspection, the two forlorn officers seated on the left and in the middle barely seem to register their photograph is being taken as they stare off into the distance; it is a wretched, yet dignified and painfully sad image.

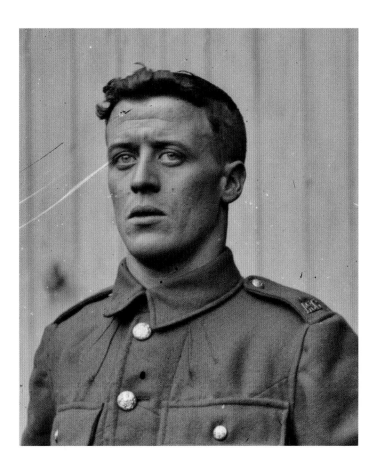 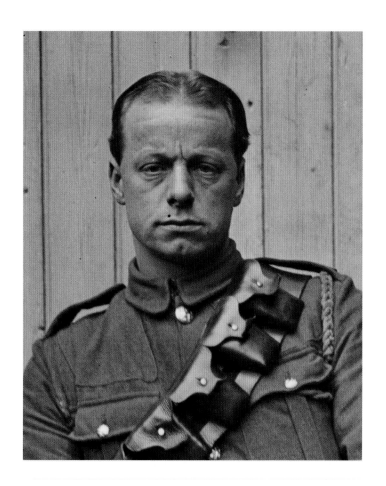

In the very early stages of the war, the British Army was already treating cases
of what it called nervous shock or neurasthenia. It was soon commonly described as
'shell-shock' with the term appearing in the medical journal *The Lancet* in February 1915.
By the end of the war, the army had treated an estimated 80,000 cases. It is impossible to
know the full number of men who suffered the condition as only those who were treated
are recorded in the figures. After the war, only those who continued to be treated, or
who were granted a pension specifically for the condition, were recorded. It is probable
that thousands more suffered, as did their families and loved ones trying to cope with the
consequences.

Time and time again in the Thuillier images one comes across pictures of young
men who look fearfully sad, old beyond their years, haggard and depressed from months
of grinding misery in the trenches. They have the look that soldiers have dubbed 'the
thousand-yard stare'. So many of them carried that mental wound for the rest of their lives.

Many of the Thuillier images depict young men larking about as they enjoyed a
bit of rest and recreation behind the lines. But there are a large number of portraits where
a young soldier stares forlornly off into the middle distance with that classic 'thousand-
yard' stare. Why did these men pose when so often they look so uncomfortable about their

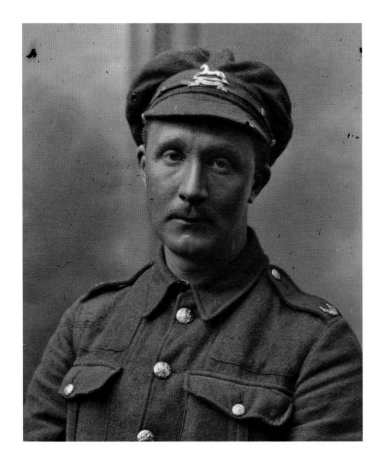

image being captured? In this modern age where every mobile phone is a camera and images can be captured, uploaded and disseminated in an instant, perhaps we have lost the capacity to wonder at an image. The Thuillier images speak of a very different time – when a photograph was more of a novelty and capturing an image was not an everyday occurrence. But as Philip Larkin lamented in his poem 'XCMXIV' (1914), these men who had rushed to enlist in 1914 were shattered by war's end, and it shows in these images.

> …*Never such innocence,*
> *Never before or since,*
> *As changed itself to past*
> *Without a word – the men*
> *Leaving the gardens tidy,*
> *The thousands of marriages,*
> *Lasting a little while longer:*
> *Never such innocence again*

PLATE 467 A wistful private from the West Yorkshires.
PLATE 468 A haggard Royal Engineer; the cut of his tunic suggests it was most probably taken in 1916.

So many of the images of soldiers in the Thuillier portraits are probably the only images captured of these young men at that time in their lives, and for so many of them, sadly, they would also be their last. Perhaps these men stepped up to be photographed just for a lark or just for a memento to keep or send home to their families, or perhaps they felt a deeper need. For a soldier in the front-line trenches there was so little he could control about his life, and it may often have seemed that death or serious injury was almost inevitable. At a time when life was so precarious, when every day in the trenches was a battle to survive, perhaps many of them sensed that a photograph at least would endure even if they did not. When faces are so clear that you can pick out every wrinkle and frown, or zoom in on haunted eyes and harrowed expressions, it seems impossibly sad that we do not yet have names for all of these men. When they posed for the Thuilliers a century ago, they wanted to be remembered to those who loved them. The publication of these long-lost images offers an opportunity to bring them home and tell their stories. They deserve an identity.

When the mayor of Vignacourt spoke to Allied troops and villagers gathered at the cemetery just after the Armistice, he told the local children that the soldiers buried there had helped defend the 'noblest ideal' so that, as a result, 'you will never have to suffer what they suffered'. None of those gathered there that day could possibly have imagined just how wrong he was and that, incredibly in just over twenty years, they would again be embroiled in yet another world war. Folksinger and songwriter Eric Bogle captured this so eloquently in his song 'The Green Fields of France':

> And I can't help but wonder oh Willy McBride
> Do all those who lie here know why they died
> Did you really believe them when they told you the cause
> Did you really believe that this war would end wars
> Well the suffering, the sorrow, the glory, the shame
> The killing and dying it was all done in vain
> Oh Willy McBride it all happened again
> And again, and again, and again, and again.

What is incomprehensible is that the generals at the time, Haig and his colleagues, spoke so coldly of the 'acceptable cost'. Perhaps if these military men had stared into the eyes of these men as it is now possible to do with the thousands of Thuillier photographs, they would have been less inclined to treat battalions full of soldiers as numbers and more inclined to see them as human beings. Almost one hundred years on, these photographs can stand in mute witness, so that we will never forget, as Eric Bogle puts it, 'man's blind indifference to his fellow man and a whole generation that was butchered and damned'.

PLATE 469 A glass plate negative with what appears to be Louis Thuillier's signature scrawled across the glass.

Acknowledgements

This book's genesis came out of the extraordinary support and generosity of Kerry Stokes AC, the chairman of the Seven TV Network in Australia and an unstinting supporter of the commemoration of our war history and the sacrifice of our men and women in military service. Thanks are again especially due to my wonderful wife and fellow history buff, Kerrie Douglass, whose research skills, insights and patient encouragement have shepherded me through this mammoth project. Thanks also are due to my colleagues and friends at the Seven Network's *Sunday Night* TV public affairs programme.

Thank you also to Arabella Pike, publishing director of HarperCollins UK, for her support and advice throughout this project, and to editors Kate Tolley and Richard Collins, assistant editor Joe Zigmond and art director Julian Humphries. Thank you as well to the management of HarperCollins Australia, CEO James Kellow, Shona Martyn and Katie Stackhouse, for their continued enthusiastic support for this extraordinary project. The companion to this volume is *The Lost Diggers*, the first book on the Thuillier images, featuring the stories of the Australian soldiers in the collection, which was published in 2012.

The staff of the Australian War Memorial again deserve warm thanks for their kind and patient assistance, especially the staff of the AWM Research Centre. I particularly want to thank my friends and senior AWM historians Ashley Ekins and Peter Burness for their sage advice and diplomatic tips. The AWM has an extraordinary archive on every major conflict in which

Australia has fought, especially the First World War, and I thank and congratulate the AWM Director Dr Brendan Nelson for his continued efforts to preserve and build on this extraordinary monument and international archive.

One of the great life-savers for us in enabling the identification of the regiments and battalions in the Thuillier images was the excellent book *British Cap Badges of the First World War* by Peter Doyle and Chris Foster (Shire Publications, 2010). This invaluable guide became our bible for identifying which regimental badge was featured in any Thuillier image and it also assisted us in recognizing the arm badges and other insignia on soldiers' uniforms.

Sadly, so much of the British military records and archives were destroyed in the Second World War and it is apparent to us that many regimental museums and associations were insufficiently funded to adequately cope with the volume of public inquiries for research assistance that was inevitable around the centenary of the Great War. Several institutions, however, went to great lengths on our behalf and we owe them special thanks. We must thank in particular Stephanie Killingbeck, assistant curator from the Royal Fusiliers Museum in London. In addition, the museum's volunteer researcher David Carter (himself an author) was enthusiastic and generous with his assistance. Warm thanks are also due to Amy Dimmock, assistant curator of the Royal Engineers Museum in Gillingham, retired Major Hugo White of the Duke of Cornwall's Regimental Museum in Bodmin, Tony Wainwright, Secretary of

the Liverpool Pals Memorial Fund, Roger Pyke of the website www.southpetherwin.com, Australian historian Phillip Tardif of the website www.northirishhorse.com.au and author of the recent book *The North Irish Horse in the Great War*. Thank you also to Dawn Robertson of Hayloft Publishing for her assistance with the Captain Hepper story; and Tricia Platts, from the Bradford World War I Group, and Jim Greenhalf, from Bradford's *Telegraph & Argus* newspaper, for their assistance in telling the stories of the West Yorkshires and the Bradford Pals. Thanks, too, to novelist Jilly Cooper for sharing her family story of the Reverend Richard Whincup and to her late husband Leo Cooper whose voluminous Pen & Sword military history publications have proved invaluable in researching regimental stories.

Jeff Barrett, from the Heaton Parish Church in Bradford, provided invaluable information and sources on the Canon Whincup 1/6th Battalion West Yorkshire Regiment story; as did Dr Michael Hamilton, the son of Dr Archibald Hamilton (who also served in the 1/6th Battalion), and Michael's cousin, Marie Padgett, who helped us make the connection.

Thank you also to Frances Radford and Anne Magarey for helping us fill out the story of their father Lieutenant Bryant Hamilton of the North Irish Horse. Special mention is also due to Laura Gardiner and her colleagues from the Archives and Local Studies Service of the Clifton Park Museum in Rotherham for their assistance with the York and Lancaster Regiment, and for allowing us to use the 'Tiger & Rose' Journal of 1970.

Warm thanks are also due to Alan Smith, Director of the State Library of South Australia, for introducing us to his colleagues at the British Library. Thank you also to the staff of the British Library, especially Board Secretary and head of International Engagement Andy Stephens, and to Mark Walton, Welcome Team Manager at the British Library. We also want to acknowledge with gratitude the research advice available online through the website Forces War Records who provided expert help in interpreting esoteric uniform markings and insignia.

In France, the citizens of Vignacourt and the Picardy district opened their hearts to us and we especially thank the mayor Stéphane Ducrotoy and the members of Vignacourt's town council. Warm thanks to Lucile Werkin and Valerie Vasseur from the Vignacourt Youth Centre, who have now established a museum in Vignacourt which displays many of the images for visitors and tells more of the history of the Thuillier collection. The passion and perseverance of my friend Laurent Mirouze, in first bringing the collection to light and then helping us to rediscover it twenty years later, deserves very special mention. Laurent accompanied us on all of our French location filming and research and his good humour and love of the Thuillier pictures has made working with him a pleasure. His wife, Delphine, was also of invaluable assistance in preparing the photographic plates. Thank you also to the Thuillier, Crognier and Bacquet families who allowed the Thuillier collection to be brought back to Australia for public display, preservation and research. Thanks to them, their extraordinary ancestors' photographic passion for a defining moment in history can be enjoyed by future generations.

Thanks are especially due to the many extraordinary historians and personal war histories whose work I have drawn on for anecdotes and first-person accounts of the battles in which many of the Lost Tommies fought. I sincerely thank all of the copyright holders whom I have been able to contact and sincerely beg the forbearance of those whom we could not trace despite considerable effort.

Thanks once again to my literary agent, Lyn Tranter, and her husband, John, for shepherding me so professionally and with good humour through another book. And we send our love and special thanks to my sister Ngaire and her husband Daniel Osmer, and their young daughters Heidi and Eva, for providing an English base camp for *The Lost Tommies* research, and for their food, love, fine wine, entertainment and support throughout this project. Once again, many thanks and much love to my wife Kerrie and my two daughters, Lucy and Millie, for their support and forbearance during this huge project.

Ross Coulthart

Bibliography

BOOKS

C. E. W. Bean, *Official History of Australia in the War of 1914–1918*, Australian War Memorial, Canberra, 1941, Vol. 3, *The AIF in France 1916*, 12th edition, 1941

C. E. W. Bean, *Official History of Australia in the War of 1914–1918*, Australian War Memorial, Canberra, Vol. 5, *The Australian Imperial Force in France During the Main German Offensive 1918*, 8th edition, 1941

Bradford in the Great War, edited by Mike Woods and Tricia Platts, Sutton Publishing, NPI Media Group, Chalford, Stroud, Gloucestershire, 2007

David Carter, *The Stockbrokers' Battalion in the Great War. A History of the 10th (Service) Battalion Royal Fusiliers*, Pen & Sword Books, Barnsley, South Yorkshire, 2014

A Doctor's War – Extracts from the letters and diaries of Dr Frederick George Chandler, Lieutenant, later Captain, RAMC 1914/15 and 1917/18, edited and published privately by Sir Geoffrey Chandler, printed by Riley Dunn & Wilson, Huddersfield, 2009

Winston Churchill, *World Crisis 1916–1918*, Part 2, Charles Scribner's Sons, 1928

Ann Clayton, *Chavasse Double VC, The Highly Acclaimed Biography of the Only Man to Win Two Victoria Crosses During the Great War*, Pen & Sword Military, Barnsley, South Yorkshire, 2014

Jilly Cooper, *Animals in War*, William Heinemann, London, 1983

George Coppard, *With a Machine Gun to Cambrai*, Cassell Military Paperbacks, London, 1999

Peter Doyle and Chris Foster, *British Army Cap Badges of the First World War*, Shire Publications, Oxford, 2013

J. E. Edmonds, *History of the Great War Based on Official Documents (British Official History), Military Operations: France & Belgium 1915*, Vol. 2, Battery Press/ IWM, 1928

Everyman At War: Sixty Personal Narratives of the War, edited by C. B. Purdom, Cambridge University Library, J. M. Dent, London, 1930

General Sir Martin Farndale, *History of the Royal Regiment of Artillery, Western Front 1914–18*, Royal Artillery Institution, Old Royal Military Academy, Woolwich, London, 1986

Niall Ferguson, *The Pity of War*, Basic Books – Perseus, New York, 1999

Games and Sports in the Army 1933–34, The Army Sport Control Board, War Office, London, 1933, preface by General C. H. Harington

Stephen Garton, *The Cost of War: Australians Return*, Oxford University Press, Melbourne, 1996

Philip Gibbs, *The Battles of the Somme*, George H. Doran Co., New York, 1917

Philip Gibbs, *Now It Can Be Told*, Harper & Brothers, London and New York, 1920

Iain Gordon, *Lifeline: A British Casualty Clearing Station on the Western Front, 1918*, The History Press, The Mill, Brimscombe Port, Stroud, Gloucestershire, 2013

Robert Graves, *Goodbye to All That*, first published by Jonathan Cape 1929, revised edition Cassell 1957, The Folio Society, London, 1981

Peter Hart, *The Somme. The Darkest Hour on the Western Front*, Pegasus Books, New York, 2008

Captain E. Raymond Hepper's Great War Diary 1916–1919 – A Battalion of the West Yorkshire Regiment on the Somme during the First World War, edited by Nigel Hepper, Hayloft Publishing, South Stainmore, Kirkby Stephen, Cumbria, 2011

Richard Holmes, *Tommy: The British Soldier on the Western Front 1914–1918*, Harper Perennial, London, 2005

Richard Holmes, *The Western Front*, BBC Books, London, 1999

Charles H. Horton (RAMC), *Stretcher Bearer: Fighting for Life in the Trenches*, compiled and edited by Dale le Vack, Lion Books, Lion Hudson, Oxford, 2013

Ralph N. Hudson, *The Bradford Pals*, 2nd edition published by Bradford Libraries, Central Library, Princes Way, Bradford BD1 1NN, 1993 (Bradford Pals Old Comrades' Association)

John Keegan, *The First World War*, Hutchinson, London, 1998

Machine Gunner 1914–1918. Personal Experiences of the Machine Gun Corps, compiled and edited by C. E. Crutchley, Pen & Sword Books, Barnsley South Yorkshire, 2013

Graham Maddocks, *Liverpool Pals. 17th, 18th, 19th and 20th Service Battalions. The King's Liverpool Regiment 1914–1919*, Leo Cooper – Pen & Sword Books, Barnsley, 1991

Tony Mason and Eliza Riedi, *Sport and the Military: The British Armed Forces 1880–1960*, Cambridge University Press, Cambridge, 2010

Ernest Matthews, *With the Cornwall Territorials on the Western Front*, The Naval & Military Press Ltd, 2004. First published 1929

Lieutenant Joe Maxwell VC, *Hell's Bells and Mademoiselles*, first published in Australia by Angus & Robertson in 1932, this edition published by HarperCollins, Sydney, 2012

Emily Mayhew, *Wounded: The Long Journey Home from the Great War*, Vintage, London, 2014

Martin Middlebrook, *The First Day on the Somme*, Penguin Books, London, 1984

William Moore, *The Durham Light Infantry*, Leo Cooper, London, 1975

J. H. Newton, *A Stretcher-Bearer's Diary*, Arthur H. Stockwell, London, 1931

H. C. O'Neill OBE, *The Royal Fusiliers in the Great War*, W. Heinemann, London, 1922

Jeremy Paxman, *Great Britain's Great War*, Viking, London, 2013

William Philpott, *Bloody Victory. The Sacrifice on the Somme and the Making of the Twentieth Century*, Little, Brown, London, 2009

J. B. Priestley, *English Journey*, Heinemann, London, 1934

Julian Putkowski and Julian Sykes, *Shot at Dawn*, Pen & Sword Books, Barnsley, South Yorkshire, 1996, first published by Wharncliffe Publishing, 1989

David Raw, *Bradford Pals*, Pen & Sword Military, Barnsley, South Yorkshire, 2006

Anthony Seldon and David Walsh, *Public Schools and the Great War*, Pen & Sword Books, Barnsley, South Yorkshire, 2013

John Sheen, *Durham Pals, 18th, 19th and 22nd (Service) Battalions of the Durham Light Infantry. A history of three battalions raised by local committee in County Durham*, Pen & Sword Books, Barnsley, South Yorkshire, 2007

Richard Smith, *Jamaican Volunteers in the First World War: Race, Masculinity and the Development of a National Consciousness*, Manchester University Press, Manchester, 2004

John Starling and Ivor Lee, *No Labour No Battle*, Spellmount – The History Press, Port Stroud, Gloucestershire, 2014

James W. Taylor, *The 1st Royal Irish Rifles in the Great War*, Four Courts Press, Dublin, 2005

Captain E. V. Tempest DSO, MC, *History of the Sixth Battalion West Yorkshire Regiment*, Vol 1, *1/6th Battalion*, originally published 1921 by Percy Lund, Humphries & Co., The Country Press, Bradford, 2004 reprint by Naval & Military Press

The History of the Seventh (Service) Battalion, The Royal Sussex Regiment 1914–19, edited by Owen Rutter, The Times Publishing Company, Printing House Square, London, 1934

The Reluctant Tommy, Ronald Skirth, edited by Duncan Barrett, Pan Macmillan, London, 2010

Richard Van Emden, *Boy Soldiers of the Great War*, Bloomsbury, London, 2012

Lawrence Weaver, *The Story of the Royal Scots (the Lothian Regiment)*, Country Life, London, 1915

Hugo White, *One and All: A History of the Duke of Cornwall's Light Infantry*, Tabb House, 7 Church Street, Padstow, Cornwall, 2006

Harold R. Williams, *The Gallant Company. An Australian Soldier's Story of 1915/18*, Angus & Robertson, 1933

WEBSITES AND JOURNAL ARTICLES

Lord Michael Ashcroft, 'The ultimate sacrifice of a true British hero', *Daily Telegraph* (London), 30 July 2014, accessed online 4 September 2014

C. E. W. Bean, War Diary, 1 August 1916, AWM38 3DRL606/52/1, Australian War Memorial, Canberra/Australia, www.awm.gov.au

Diary of Charles Bean, Australian Official Correspondent, 20 July 1916, AWM38 3DRL606/52/1, Australian War Memorial, Canberra

Lieutenant Colonel Roland Bradford VC, 9th Battalion DLI, *Report of the Attack on the Butte De Warlencourt*, 5 November 1916, Durham Light Infantry Museum & Art Centre

'Noel Chavasse: The First World War doctor who braved hell for others', by Michael Ashcroft, www.telegraph.co.uk, accessed online 10 March 2015

The Great War Forum website – 2nd Lt Cuthbert George Higgins: http://1914-1918.invisionzone.com/forums/index.php?showtopic=123246, accessed online 16 February 2015

Stephen McGinty, 'Great War worst for Scots troops "a myth"', *Scotsman – Scotland on Sunday*, 10 August 2014, accessed online 28 March 2015

Craig McQueen, 'The Big Read: The small men of the "bantam battalions" who stood tall amid the carnage of World War I', Dailyrecord.co.uk, 14 December 2013

Laurent Mirouze, 'Images from the Great War: The Louis Thuillier Collection (2)', *Military Illustrated*, no. 43, December 1991

Harry Patch interview, accessed online 9 April 2015, bbc.co.uk/history/worldwars/wwone/last_tommy_gallery_03.shtml

'Recollections of La Boiselle and the Glory Hole', Album of Lieutenant Colonel F. J. Salmon, CMG, MC, Field Survey Officer, 3rd Army (also published in the Royal Engineers' magazine *The Chequers*), Royal Engineers Museum & Library, Gillingham, Kent

Simon Rees, 'The Forgotten Army', www.firstworldwar.com/features/forgottenarmy.htm, accessed online 2 April 2015

Dissertation by David Thompson, *The Durham Light Infantry in the First World War 1914–1918*, School of Historical Studies, University of Newcastle upon Tyne, 2014, http://www.westernfrontassociation.com/education/universities/dissertations-post-graduate/the-durham-light-infantry-in-the-first-world-war-1914-1918.html, accessed online 7 March 2015

'Who Are Gurkhas?', The Gurkha Welfare Trust, http://www.gwt.org.uk, accessed online 31 March 2015

'World War One executions', www.historylearningsite.co.uk, accessed online 10 April 2015

www.northirishhorse.com.au – Website compiled by Philip Tardif

www.southpetherwin.com – The story of Cecil Westlake and the Duke of Cornwall's Light Infantry

Notes

1 J. B. Priestley, *English Journey*, Heinemann, London, 1934, p. 11.

2 Jeremy Paxman, *Great Britain's Great War*, Viking, London, 2013, p. 32.

3 Horace Calvert's account of the declaration of war in Bradford as cited in Richard Van Emden, *Boy Soldiers of the Great War*, Bloomsbury, London, 2012, p. 21.

4 George Morgan interview with Malcolm Brown, as cited in David Raw's *Bradford Pals*, Pen & Sword Military, Barnsley, South Yorkshire, 2006, p. 319.

5 Captain E. V. Tempest DSO, MC, *History of the Sixth Battalion West Yorkshire Regiment*, Vol. 1, *1/6th Battalion*, originally published 1921 by Percy Lund, Humphries & Co. Ltd, The Country Press, Bradford, 2004 reprint by Naval & Military Press, p. 83.

6 Ibid., p. 87.

7 Everard Wyrall, *The West Yorkshire Regiment in the War 1914–1918*, Vol 1., John Lane, The Bodley Head Ltd, London, 1924, pp. 220–221.

8 Richard Holmes, *Tommy: The British Soldier on the Western Front 1914–1918*, Harper Perennial, London, 2005, p. xv.

PART ONE: THE DISCOVERY

1 Laurent Mirouze, 'Images from the Great War: The Louis Thuillier Collection (2)', *Military Illustrated*, no. 43, December 1991, p. 44.

2 Harold R. Williams, *The Gallant Company. An Australian Soldier's Story of 1915–18*, Angus & Robertson, 1933, p. 108.

3 John Keegan, *The First World War*, Hutchinson, London, 1998, p. 310.

4 Ibid., p. 313.

5 Ibid., p. 316.

6 Sebastian Faulks, *Birdsong*, Vintage, 1994, p. 422.

PART TWO: THE LOST TOMMIES

1 'Tiger & Rose', Regimental Journal of the York and Lancaster Regiment (1970), p. 23. Held at the Clifton Park Museum in Rotherham.

2 Ibid.

3 Ibid.

4 Account of Lance Corporal John Cook, 9th Battalion York and Lancasters, accessed online 2 August 2015 at: http://www.wartimememoriesproject.com/greatwar/allied/alliedarmy-view.php?pid=4986

5 Anthony Seldon and David Walsh, *Public Schools and the Great War*, Pen & Sword, Barnsley, South Yorkshire, 2013, p. 57.

6 Tempest, op. cit., p. 76.

7 Ibid., pp. 78–9.

8 For more information on the Bradford Rifles see *Bradford in the Great War*, edited by Mike Woods and Tricia Platts of the Bradford World War I Group, Sutton Publishing, Chalford, Stroud, Gloucestershire, 2007, pp. 27–31.

9 Tempest, op. cit., p. 84.

10 Ibid., p. 85.

11 Ibid., p. 87.

12 Ibid., p. 89.

13 Diary typescript, Captain Charles May, 22nd Battalion, Manchester Regiment, 91st Brigade, 7th Division, Imperial War Museum, 17 June 1916, as quoted in Peter Hart, *The Somme. The Darkest Hour on the Western Front*, Pegasus Books, New York, 2008, p. 106.

14 Tempest, op cit., p. 94.

15 Ibid.

16 Ibid., p. 95.

17 *Bradford in the Great War*, op. cit., pp. 13–14.

18 Jilly Cooper, letter to the author, 10 March 2015.

19 Winston Churchill, *World Crisis 1916–1918*, Part 2, Charles Scribner's Sons, 1928, p. 345.

20 David Raw, *Bradford Pals. A Comprehensive History of the 16th–18th & 20th (Service) Battalions of the Princes of Wales Own West Yorkshire Regiment 1914–1918*, Pen & Sword Books, Barnsley, South Yorkshire, 2006, p. 27.

21 *Captain E. Raymond Hepper's Great War Diary 1916–1919 – A Battalion of the West Yorkshire Regiment on the Somme during the First World War*, edited by Nigel Hepper, Hayloft Publishing, South Stainmore, Kirkby Stephen, Cumbria, 2011, p. 103.

22 Ibid., p. 22.

23 Ibid., 11 February 1916, p. 36.

24 Martin Middlebrook, *The First Day on the Somme*, Penguin Books, London, 1984, p. 270.

25 Hepper (ed,), op. cit., p. 70.

26 Ibid., 12 July 1916, p. 73.

27 Ibid., 30 July 1916, p. 75.

28 *Bradford in the Great War*, op. cit., p. xvi.

29 Ralph N. Hudson, *The Bradford Pals*, 2nd edition published by Bradford Libraries, Central Library, Princes Way, Bradford, 1993 (Bradford Pals Old Comrades' Association), quote from Sergeant Major G. Cussons, p. 40.

30 Ibid., p. 53.

31 Ibid., p. 15.

32 Graham Maddocks, *Liverpool Pals. 17th, 18th, 19th and 20th Service*

Battalions. The King's Liverpool Regiment 1914–1919, Leo Cooper – Pen & Sword Books, 1991, p. 68.

33 Ibid., p. 27.

34 Ibid., p. 28.

35 Ibid., p. 116.

36 Ibid., p. 130.

37 Ibid., p. 137.

38 Ibid., p. 181.

39 Robert W. Service, *Rhymes of a Red Cross Man*, William Briggs, Toronto, 1916. The version published here is that previously popularly attributed to Tommy Crawford.

40 Dissertation by David Thompson, *The Durham Light Infantry in the First World War 1914–1918*, School of Historical Studies, University of Newcastle upon Tyne, 2014, accessed online 7 March 2015: http://www.westernfrontassociation.com/education/universities/dissertations-post-graduate/the-durham-light-infantry-in-the-first-world-war-1914-1918.html.

41 John Sheen, *Durham Pals, 18th, 19th and 22nd (Service) Battalions of the Durham Light Infantry. A history of three battalions raised by local committee in County Durham*, Pen & Sword Books, Barnsley, South Yorkshire, 2007, p. 11.

42 William Moore, *The Durham Light Infantry*, Leo Cooper, London, 1975, p. 19.

43 Robert Graves, *Goodbye to All That*, first published by Jonathan Cape in 1929, revised edition Cassell 1957, The Folio Society, London, 1981, p. 137.

44 Ibid., p. 140.

45 Sheen, op. cit., pp. 97–8.

46 Ibid., p. 98.

47 Lieutenant Colonel Roland Bradford VC, 9th Battalion DLI, *Report of the Attack on the Butte De Warlencourt*, 5 November 1916, Durham Light Infantry Museum & Art Centre.

48 Hudson, op. cit., p. 20.

49 Julian Putkowski and Julian Sykes, *Shot at Dawn*, Pen & Sword Books, Barnsley, South Yorkshire, 1996, first published by Wharncliffe Publishing, 1989, p. 111.

50 'World War One executions', www.historylearningsite.co.uk, accessed online 10 April 2015.

51 Craig McQueen, 'The Big Read: The small men of the "bantam battalions" who stood tall amid the carnage of World War I', Dailyrecord.co.uk, 14 December 2013.

52 Philip Gibbs, *The Battles of the Somme*, George H. Doran Co., New York, 1917, p. 184.

53 Tempest, op. cit, p. 38.

54 *The History of the Seventh (Service) Battalion, The Royal Sussex Regiment 1914–19*, edited by Owen Rutter, The Times Publishing Company, London, 1934, p. 90.

55 J. H. Newton, *A Stretcher-Bearer's Diary*, Arthur H. Stockwell, London, 1931.

56 Ibid., p. 6.

57 Ibid., p. 15.

58 Ibid., p. 19.

59 Ibid., p. 20.

60 Ibid., p. 29.

61 Ibid.

62 Ibid., p. 49.

63 Ibid., p. 74.

64 Corporal W. H. Atkins, 'The Stretcher-bearers', from journals of Charles H. Horton (RAMC), *Stretcher Bearer, Fighting for Life in the Trenches*, compiled and edited by Dale le Vack, Lion Books, Lion Hudson, Oxford, 2013, p. 9.

65 Ibid., p. 18.

66 *A Doctor's War – Extracts from the letters and diaries of Dr Frederick George Chandler, Lieutenant, later Captain, RAMC 1914/15 and 1917/18*, edited and published privately by Sir Geoffrey Chandler, printed by Riley Dunn & Wilson, Huddersfield, 2009, pp. 46–7.

67 'Noel Chavasse: The First World War doctor who braved hell for others', by Michael Ashcroft, www.telegraph.co.uk, accessed online 10 March 2015.

68 Letter to Margaret Twemlow, 26.6.1915, as cited in Ann Clayton, *Chavasse Double VC: The Highly Acclaimed Biography of the Only Man to Win Two Victoria Crosses During the Great War*, Pen & Sword Military, Barnsley, South Yorkshire, 2014, p. 123.

69 David Carter, *The Stockbrokers' Battalion in the Great War. A History of the 10th (Service) Battalion Royal Fusiliers*, Pen & Sword Books, Barnsley, South Yorkshire, 2014, p. 9.

70 J. E. Edmonds, *History of the Great War Based on Official Documents (British Official History)*, Vol. 2, *Military Operations: France & Belgium 1915*, Battery Press/IWM, 1928, p. 388.

71 Carter, op. cit., p. 107.

72 H. C. O'Neill OBE, *The Royal Fusiliers in the Great War*, Heinemann, London, 1922, p. 116.

73 Ibid., pp. 127–8.

74 Hart, op. cit., p. 145. From an anonymous German officer.

75 Ibid., p. 100. From an account by Lieutenant Edgar Lord, 15th Battalion, Lancashire Fusiliers.

76 C. E. W. Bean, *Official History of Australia in the War of 1914–1918*, Australian War Memorial, Canberra, Vol. 5, *The Australian Imperial Force in France during the Main German Offensive 1918*, 8th edition, 1941, pp. 460–61.

77 Hart, op. cit., p. 211. Account of Miss Llewellyn, Sheffield schoolteacher.

78 Richard Holmes, *The Western Front*, BBC Books, London, 1999, p. 73.

79 Ibid., p. 58. (From an account by Captain G. C. Wynne.)

80 *Machine Gunner 1914–1918. Personal Experiences of the Machine Gun Corps*, compiled and edited by C. E. Crutchley, Pen & Sword Books, Barnsley, South Yorkshire, 2013, p. 13. (From a preface by Colonel Sir George Wade MC, Chairman, MGC Old Comrades' Association.)

81 William Philpott, *Bloody Victory. The Sacrifice on the Somme and the Making of the Twentieth Century*, Little, Brown, London, 2009, p. 241.

82 George Coppard, *With a Machine Gun to Cambrai*, Cassell Military Paperbacks, London, 1999, p. 122.

83 *Machine Gunner 1914–1918. Personal Experiences of the Machine Gun Corps*, op. cit., p. 40.

84 Ibid., p. 122.

85 Ibid., p. 123.

86 Coppard, op. cit., p. 135.

87 Michael Ashcroft, 'The ultimate sacrifice of a true British hero', *Daily Telegraph* (London), 30 July 2014, accessed online 4 September 2014.

88 James W. Taylor, *The 1st Royal Irish Rifles in the Great War*, Four Courts Press, Dublin, 2005, p. 5.

89 Hart, op. cit., p. 154.

90 Ibid., p. 155.

91 C. E. W. Bean, War Diary, 1 August 1916, AWM38 3DRL606/52/1, Australian War Memorial, Canberra/Australia, p. 48.

92 Graves, op. cit., p. 169.

93 Ibid.

94 Ibid.

95 Emily Mayhew, *Wounded: The Long Journey Home from the Great War*, Vintage, London, 2014, p. 132.

96 Tempest, op. cit., p. 175.

97 Philip Gibbs, *Now It Can Be Told*, Harper & Brothers, London and New York, 1920, p. 128.

98 Tempest, op. cit., p. 54.

99 Ibid.

100 Gibbs, op. cit., p. 128.

101 John Starling and Ivor Lee, *No Labour No Battle*, Spellmount – The History Press, Port Stroud, Gloucestershire, 2014, p. 20.

102 Ibid., p. 17.

103 Corporal J. C. Morgan, accessed online 28 March 2015 at www.firstworldwar.com/diaries/labourcompanyatypres.htm. From the book *Everyman at War: Sixty Personal Narratives of the War*, edited by C. B. Purdom, Cambridge University Library, J. M. Dent, London, 1930.

104 Stephen McGinty, 'Great War worst for Scots troops "a myth"', *Scotsman – Scotland on Sunday*, 10 August 2014, accessed online 28 March 2015.

105 Niall Ferguson, *The Pity of War*, Basic Books – Perseus, New York, 1999, p. 298.

106 Ibid., p. 300. The comment was made by J. B. Seely, who commanded the Canadian Cavalry Brigade.

107 Ibid.

108 Lawrence Weaver, *The Story of the Royal Scots (the Lothian Regiment)*, Country Life, London, 1915, p. 211.

109 Richard Smith, *Jamaican Volunteers in the First World War: Race, Masculinity and the Development of a National Consciousness*, Manchester University Press, Manchester, 2004, p. 60.

110 Ibid., p. 61.

111 'Who Are Gurkhas?', The Gurkha Welfare Trust, accessed online http://www.gwt.org.uk 31 March 2015.

112 'Recollections of La Boisselle and the Glory Hole', Album of Lieutenant Colonel F. J. Salmon, CMG, MC, Field Survey Officer, 3rd Army, (also published in the Royal Engineers' magazine *The Chequers*), Royal Engineers Museum & Library, Gillingham, Kent.

113 Simon Rees, 'The Forgotten Army', www.firstworldwar.com/features/forgottenarmy.htm, accessed online 2 April 2015.

114 Jilly Cooper, *Animals in War*, William Heinemann, London, 1983, p. 29.

115 Graves, op. cit., p. 213.

116 *History of the Seventh (Service) Battalion, The Royal Sussex Regiment 1914–19*, op. cit., p. 4.

117 Ferguson, op. cit., p. 307.

118 General Sir Martin Farndale, *History of the Royal Regiment of Artillery, Western Front 1914–18*, Royal Artillery Institution, Old Royal Military Academy, Woolwich, London, 1986, p. 332.

119 Ibid., p. 2.

120 Ferguson, op. cit., p. 308.

121 *The Reluctant Tommy, Ronald Skirth*, edited by Duncan Barrett, Pan Macmillan, London, 2010, p. 37.

122 Ibid., p. 45.

123 Farndale, op. cit., p. 143.

124 Ibid., p. 151.

125 *Games and Sports in the Army 1933–34*, The Army Sport Control Board, War Office, London, 1933, preface by General C. H. Harington, p. 23.

126 Tony Mason and Eliza Riedi, *Sport and the Military: The British Armed Forces 1880–1960*, Cambridge University Press, Cambridge, 2010, p. 96.

127 A. W. Keown, *Forward with the Fifth. The Story of Five Years' War Service, Fifth Infantry Battalion, A.I.F.*, Specialty Press, Melbourne, 1921.

128 C. M. Wrench, *Campaigning with the Fighting 9th: In and Out of the Line with the 9th BN A.I.F, 1914–1919*, Boolarong Publications, Brisbane, 1985.

129 Ernest Matthews, *With the Cornwall Territorials on the Western Front*, The Naval & Military Press, 2004, pp. xv–xvi.

130 C. E. W. Bean, *Official History of Australia in the War of 1914–1918*, Australian War Memorial, Canberra, 1941, Vol. 3, *The AIF in France 1916*, 12th edition, 1941, p. 446.

131 Diary of Charles Bean, Australian Official Correspondent, 20 July 1916, AWM38 3DRL606/52/1, Australian War Memorial, Canberra, pp. 25–6.

132 Starling and Lee, op. cit., p. 83.

133 Hugo White, *One and All: A History of the Duke of Cornwall's Light Infantry*, Tabb House, 7 Church Street, Padstow, Cornwall, 2006, p. 232.

134 Ibid., p. 233.

135 Ibid., p. 237.

136 Ibid.

137 Harry Patch interview, accessed online 9 April 2015, bbc.co.uk/history/worldwars/wwone/last_tommy_gallery_03.shtml.

138 *The History of the Seventh (Service) Battalion, Royal Sussex Regiment, 1914–1919*, op. cit., p. 79.

139 Ibid., p. 263.

140 Hepper (ed.), op. cit., p. 148.

141 Ibid.

142 Lieutenant Joe Maxwell VC, *Hell's Bells and Mademoiselles*, first published in Australia by Angus & Robertson in 1932, this edition published by HarperCollins, Sydney, 2012, p. 236.

143 Hepper (ed.), op. cit., p. 164.

144 Gibbs, op. cit., p. 444.

145 Stephen Garton, *The Cost of War: Australians Return*, Oxford University Press, Melbourne, 1996.

Index of Names

William Collins

An imprint of HarperCollins*Publishers*

1 London Bridge Street

London SE1 9GF

WilliamCollinsBooks.com

First published in Great Britain by William Collins in 2016

1

A catalogue record for this book is available from the British Library

ISBN 978–0–00–810331–6

Cap badges reproduced with permission of the MOD.
Photographs by North East Medals.

Original internal design by Matt Stanton, HarperCollins Design Studio
Set in Monotype Baskerville and Foundry Wilson by Richard Marston

Printed and bound in China

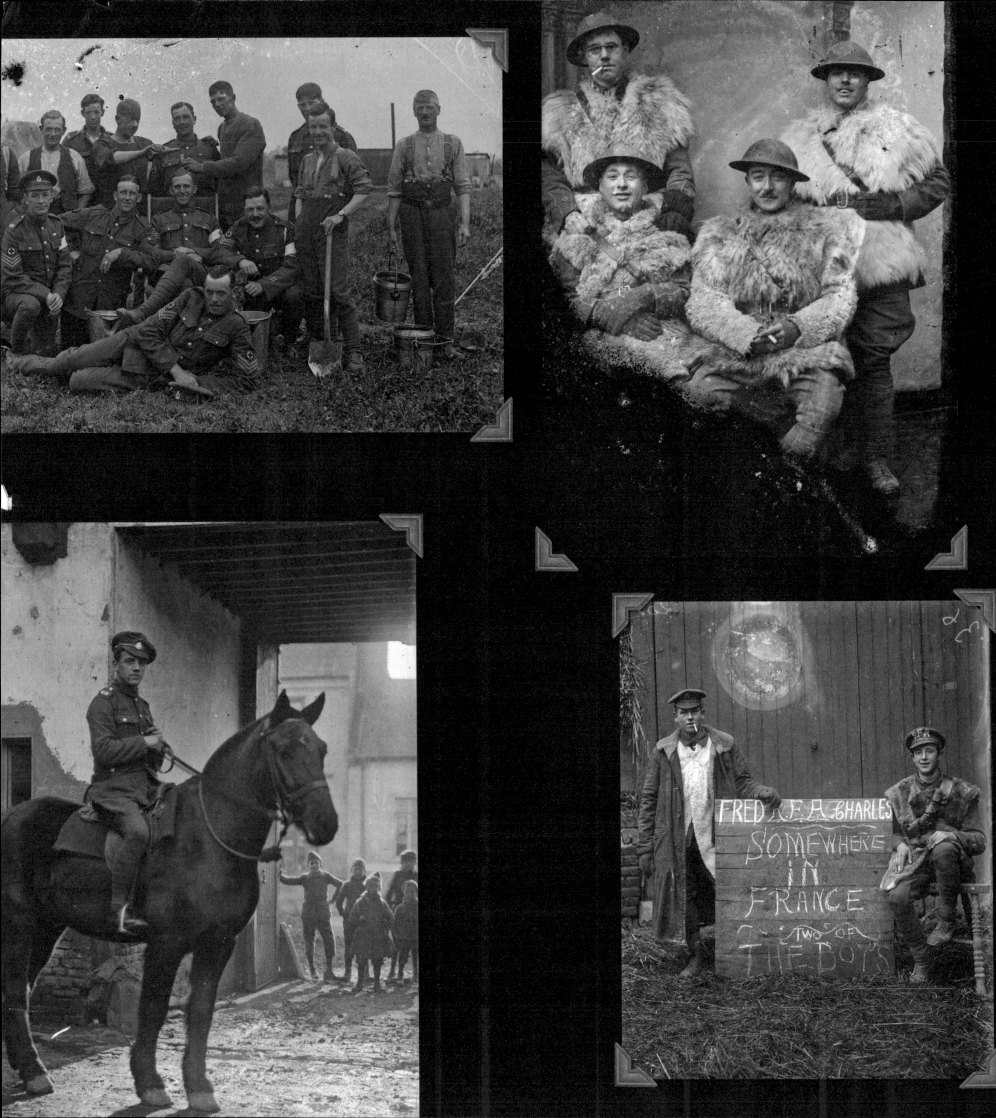

FRED & F. A. CHARLES
SOMEWHERE
IN
FRANCE
TWO OF
THE BOYS